NATURAL HISTORY OF THE WORLD

NATURAL HISTORY OF THE WORLD

A PHOTOGRAPHIC EXPLORATION OF EARTH'S ANIMALS, PLANTS AND LANDSCAPES

TOM JACKSON

This book first published in 2025 by

Amber Books Ltd
United House
North Road
London N7 9DP
United Kingdom
www.amberbooks.co.uk
Facebook: amberbooks
YouTube: amberbooksltd
Instagram: amberbooksltd
X(Twitter): @amberbooks

Copyright © 2025 Amber Books Ltd

All rights reserved. With the exception of quoting brief passages for the purpose of review no part of this publication may be reproduced without prior written permission from the publisher. The information in this book is true and complete to the best of our knowledge. All recommendations are made without any guarantee on the part of the author or publisher, who also disclaim any liability incurred in connection with the use of this data or specific details.

ISBN: 978-1-83886-537-5

Project Editor: Anna Brownbridge
Picture Research: Adam Gnych
Design: Jerry Williams and Keren Harragan

Printed in China

CONTENTS

INTRODUCTION	6
TROPICAL FOREST	11
SAVANNAH	72
DESERT	132
PRAIRIE AND STEPPE	172
TEMPERATE FOREST	202
TAIGA	256
FROZEN LANDS	296
MOUNTAINS	326
SALTWATER	356
FRESHWATER	412
INDEX	444
PICTURE CREDITS	448

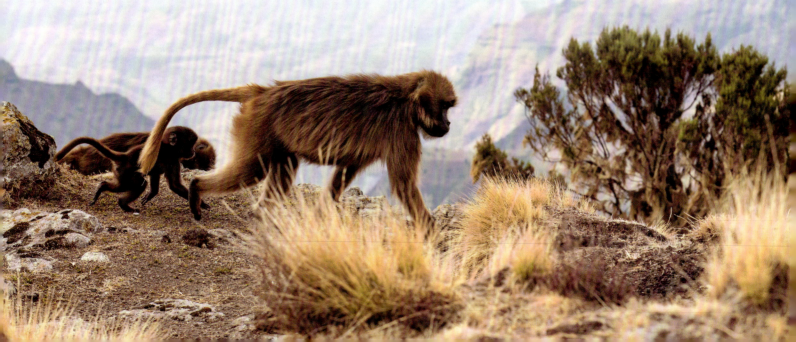

INTRODUCTION

Earth is a tiny blue dot in a seemingly endless cosmos. As far as we know, everything that has ever lived and everything that ever will live comes from down here on our planet. On the face of it that sounds quite limiting, with life constrained to survive in one place. However, viewed close-up, our blue dot world is a gargantuan sphere with an ever-changing surface of land, sea and air. Life is not constrained by it at all; it has found millions of different ways to survive. All those unique life forms, from bacteria to blue whales and conifers to corals reefs, are adapting and exploiting certain footholds or niches on our crowded planet, where they are best able to thrive.

To make sense of all this diversity, biologists have identified a way to divide up Earth into large regions called biomes. Biomes are defined by their climate and geographical features. These overarching characteristics create a common set of ecological challenges for the life that lives there. As a result, far-flung locations on the opposite sides of the planet, can occupy the same biome. The wildlife that lives in each need not be the same, but it faces a common set of factors that control how it can live.

CONVERGING FROM AFAR

Looking at the living world this way reveals many stories of natural history. For example, South America, Africa and Australia all have significant areas of grassland. In the drier parts of Africa the grasses are grazed by small antelopes, such as the impala. Over in South America, the grasses and shrubs are cropped by deer and guanacos. The former is only

RIGHT:
SURINAM HORNED FROG
The rainforests and freshwater wetlands of northern South America host this mighty frog, named for the fleshy spikes above the eyes. In recent decades horned frogs have earned the modern nickname of Pacman frogs, because they are mostly all mouth, which is used to gobble up whatever crosses the amphibians' path – lizards, mice and even other horned frogs.

OPPOSITE:
GREATER PASQUE FLOWER
The hardy purple blooms sprout against the odds in this high meadow in the mountains of eastern Europe. Such mountain plants have to contend with wind, snow and extreme sunshine, and so must take every opportunity to grow and breed.

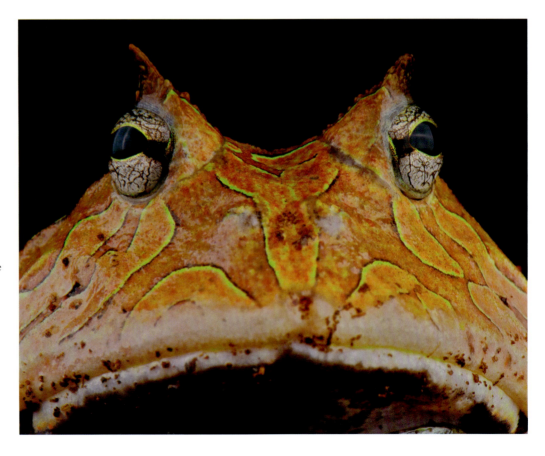

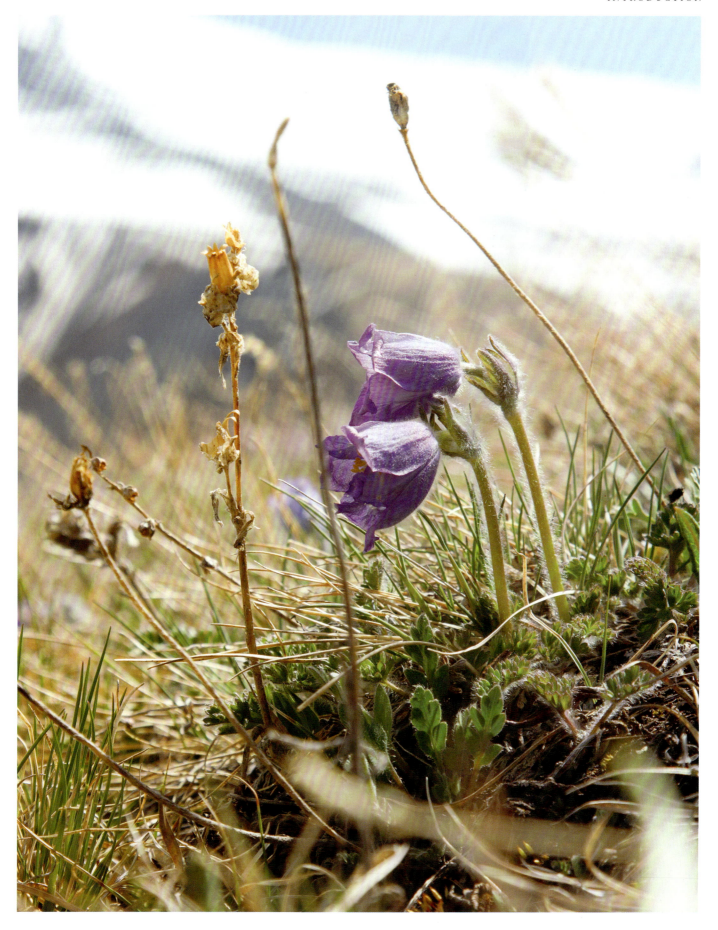

INTRODUCTION

RIGHT:
CORSAC FOX
A pair of corsac foxes sit outside their den during the deep winter in Central Asia. This region is dry, dry enough to be a desert in places, but it is also cold. These conditions are no impediment to the foxes, a group of small but effective hunters that have made their home across much of Europe, Asia and the Americas.

BELOW:
ALTAI MOUNTAINS
Located at the boundary between Siberian forests and Central Asian steppe, these bleak but majestic peaks are home to snow leopards, brown bears, mountain goats and red dogs.

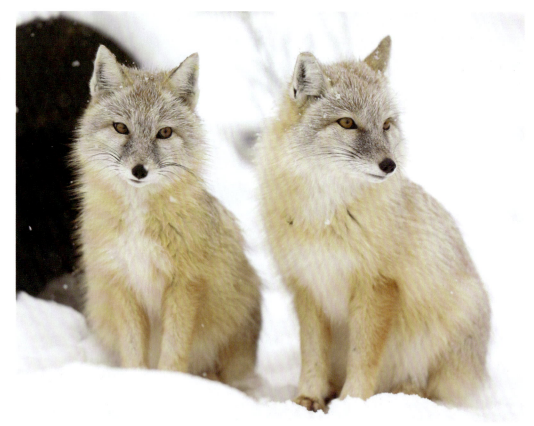

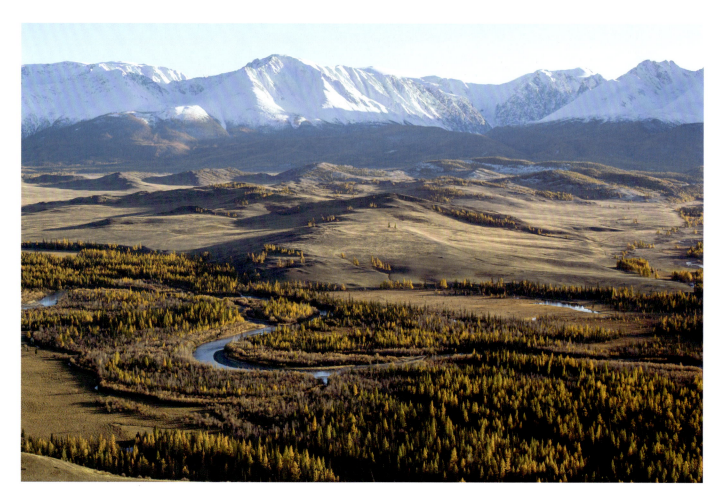

INTRODUCTION

distantly related to the antelopes but looks similar and lives in much the same way. Meanwhile the guanaco is a humpless relative of the camels that live far away in Asia and Africa. Over in Australia, the grazing role is taken up by the kangaroos, which could not be more different. And despite all this, all three regions have tall, flightless birds, the ostrich, rhea and emu, which have become dominant members of these lands separated by geography but brought together by ecology.

CLIMATE REGIONS

This book divides the world into ten biomes. As well as tropical grassland, there are also colder prairies and steppes. Forests are represented in three biomes. The tropical rainforests occupy the warmest and wettest regions, while the taiga is the forest that grows in much colder places. In between is the temperate forest, which is famed for the changes of its autumn colours and the rush of regrowth in spring.

A crucial factor in defining a biome is the availability of water. The deserts are obviously dry places, and the plants and animals that cling on to life there must capture and store every possible drop of water. However, when water freezes to ice, it becomes unavailable for life to use, and so the tundra and polar ice caps are even drier still than the searing-hot Sahara and its ilk.

At the other end of the spectrum are aquatic habitats, where water is the medium in which animals and plants live. Water worlds are divided between marine habitats where the water is salty, and freshwater systems, where it is not.

The mountain biome is perhaps the most complex of all. While other biomes contain a single climate picture, the steep slopes of a mountain range creates bands or zones of different kinds of living space, some wet, some dry, others windy and cold. To ascend a tall mountain is to cross the globe in microcosm and visit several biomes at once.

Now we are better equipped, let's prepare to explore the world's biomes. It will be an amazing journey through Earth's natural history.

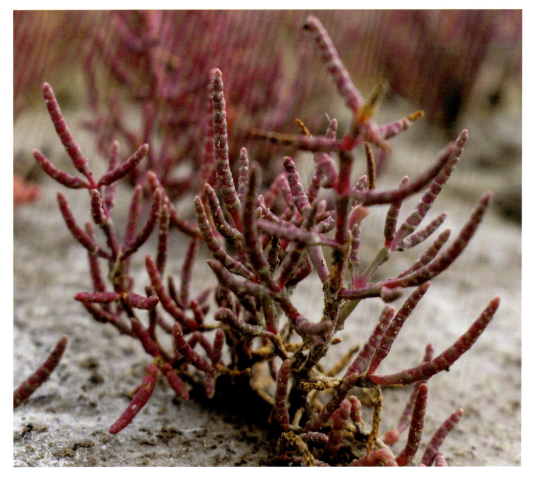

LEFT:
RED SALTWORT
Sometimes Earth's ecology creates organisms that look alien. These fleshy red spines are the flowers of the red saltwort, an American plant that is able to survive in the cold deserts of North America.

INTRODUCTION

BIOME MAP
This is the world divided into the biomes used in this book. (Tundra and Polar regions are discussed together in Chapter 8, Frozen Lands.) Freshwater includes all rivers and lakes, including Lake Baikal in Siberia, Russia and The Great Lakes spanning the Canada–United States border. The locations of these biomes is defined by the ecological conditions, such as the amount of water, daylight, and average temperature. These in turn are the products of climate and latitude. What biome do you live in?

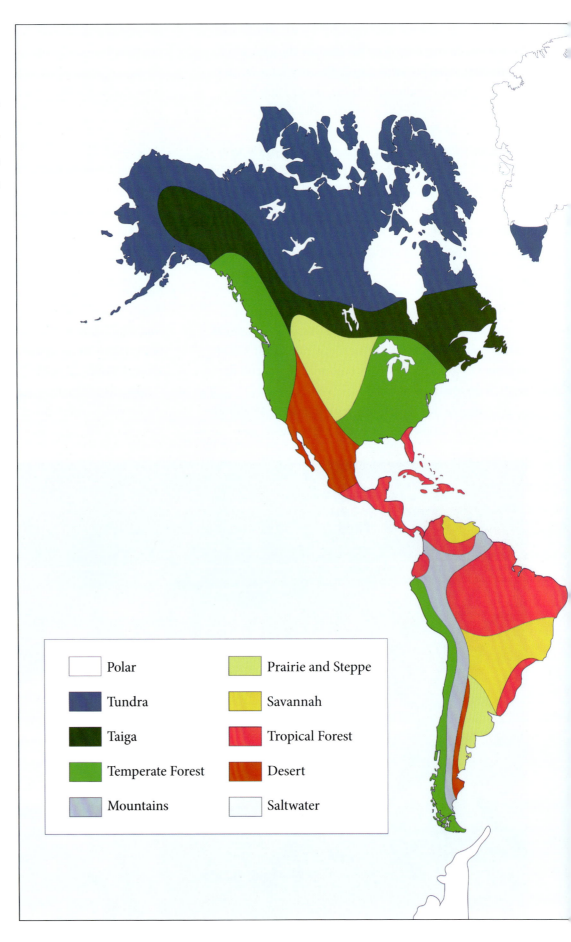

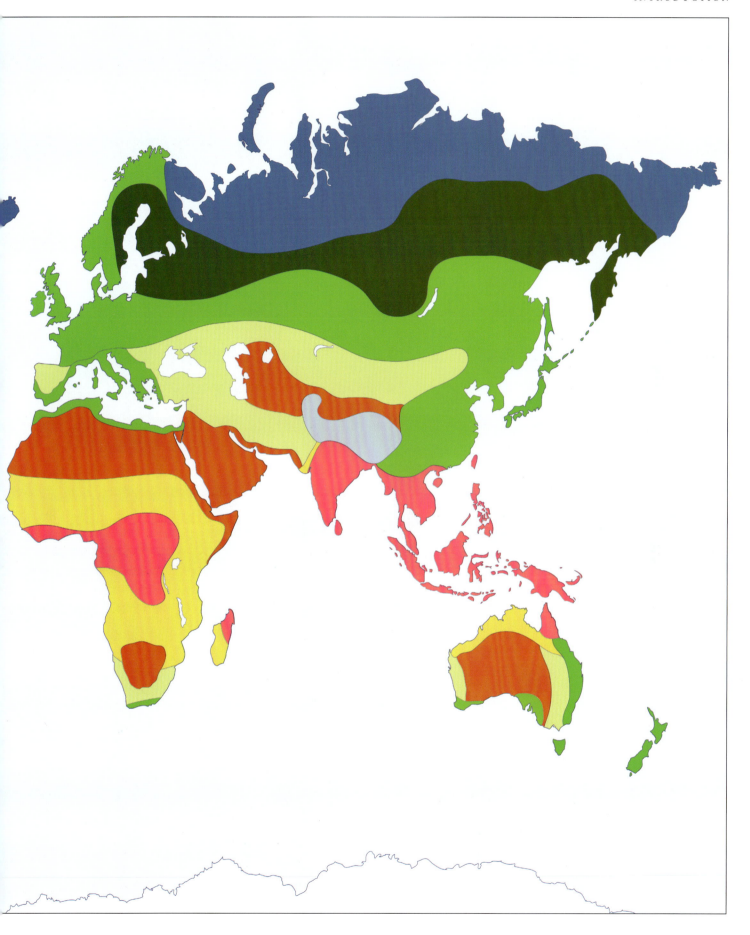

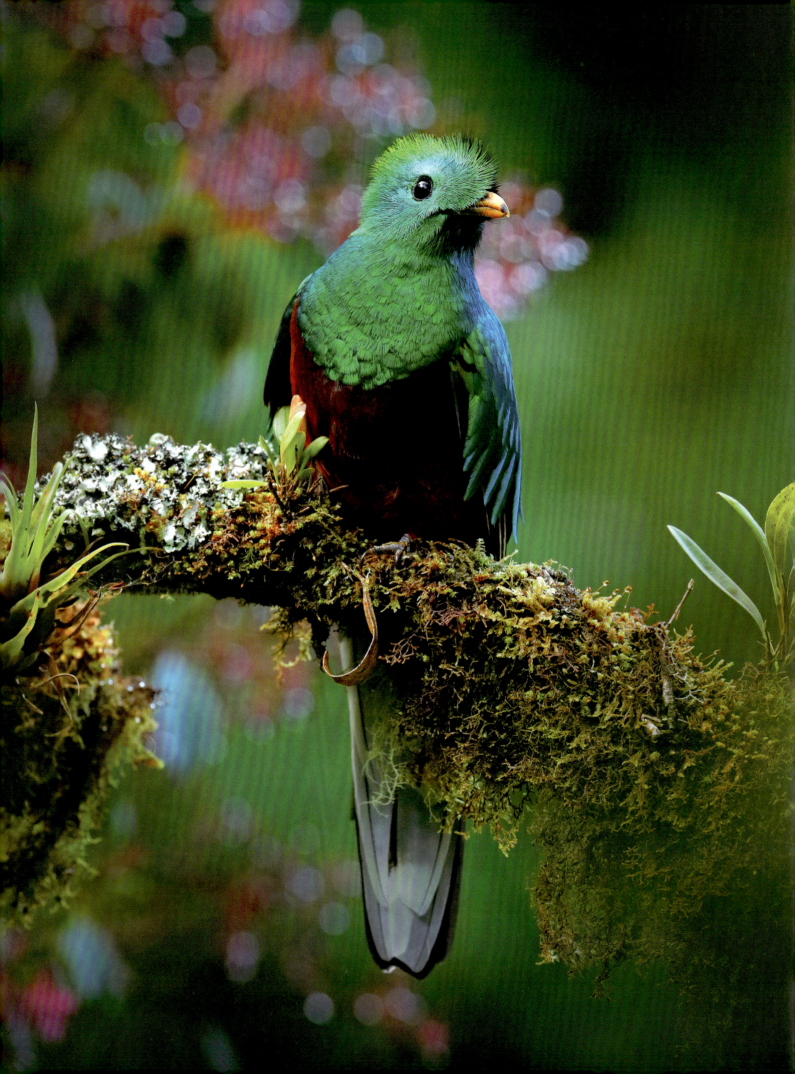

TROPICAL FOREST

The tropical forest is the most luscious and fertile habitat, the one most densely packed with life. It is often interchangeably described as a rainforest, although there is a significant distinction there as we will see later. Nevertheless, a tropical forest is defined by rain, and lots of it. It is not uncommon for some tropical forests to receive more than 3m (10ft) of rain each year. That is five or six times the amount received by a city like London, England, which is known for its wet weather. (Some rainforests get more than 4m/13ft of rain a year.) However, while this water is a crucial factor, tropical forests also need heat to power their growth, and so they occupy the central region of Earth around the equator. Here, the distinctions between the hot and cold seasons are muted, and the warm Sun is always beating down from high overhead most days of the year.

EQUATORIAL CLIMATE

Of course, the description of tropical forests growing in this region of Earth is a little disingenuous because the equatorial zone is part of the tropics, and so every

OPPOSITE:
QUETZAL
Quetzals are among the most colourful birds in the jungles of Central America. The males have iridescent feathers whereas the females are a more muted brown and grey. The males use their bright plumage of reds and blue to get noticed by mates among the endless green.

RIGHT:
TREETOPS
The tropical forest is a mass of plant life, densely packed into several layers. From the air, the ground is hidden by the canopy, a platform of branches formed by trees spreading to capture light. It is possible for animals to spend their whole lives up here. There is no need to touch the ground.

TROPICAL FOREST

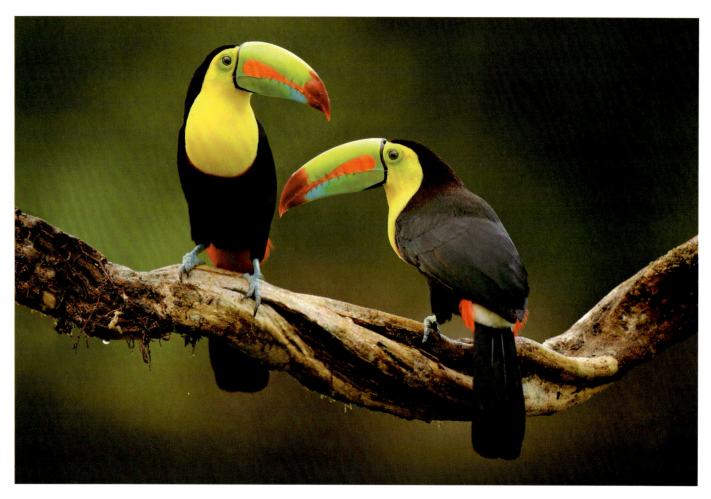

ABOVE:
KEEL-BILLED TOUCAN
The chunky bill, or beak, of these toucans is mostly for show. It is less robust than it appears, being built from a honeycomb structure that reduces the weight considerably. Without that the birds would have trouble flying. Nevertheless, the beak has a sharp serrated edge for gripping fruit in flight and slicing into them.

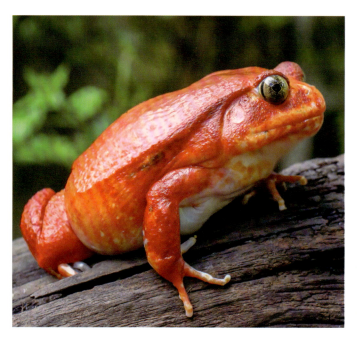

habitat type here is 'tropical' to some extent. The term 'tropics' refers to the turning places of the Sun, better known as the Tropic of Cancer in the Northern Hemisphere and the Tropic of Capricorn in the south.

Like the equator, these are both horizontal imaginary lines that circle the globe. The Tropic of Cancer is the northern most point on Earth (at about 23.3°N) where the Sun can be viewed directly overhead. It reaches this position only once a year, the summer solstice (the northern one), which is the day that the Northern Hemisphere experiences its longest period of daylight. Six months later, Earth has changed its position and now the Sun is located above the Tropic of Cancer. Summer has returned to the Southern Hemisphere, and the Northern Hemisphere is at midwinter with the winter solstice, the shortest day of the year.

However, the belt between the tropics has benefitted from the Sun's warmth and light all year around, and so this tropical region is warm 12 months around and does not have

LEFT:
TOMATO FROG
This bright red frog from the forests of Madagascar does not use camouflage. Instead it exudes a sticky substance from its skin and any predator that attempts to eat it soon finds that frog difficult to eat. The gooey skin gums up the nose and eyes and makes the mouth go numb. Next time the predator will avoid these red frogs.

TROPICAL FOREST

a particularly discernible period of winter cold and summer heat. However, there are wide variations in the amount of rain that falls across the tropics month to month.

RELIABLE RAIN

The heat from the Sun is a constant factor above the equator and the surrounding land and sea. And it is out at sea that the heat has its most consequential effects, steadily evaporating away the water to form columns of warm, wet air that rise into the sky. That air is close to 100 per cent humidity, as steamy as a hot bathroom after a shower. As the air rises, it must spread out to make room for the fresher air billowing up from underneath. The rising, spreading air cools as it goes, and the water vapour condenses into thick clouds, especially as they move above cooler areas of land. These clouds grow and darken rapidly during the day and by the evening, if not before, they will drop a torrential downpour of rain delivering vast amounts of water, enough to fill a few million swimming pools daily. The air that remains is now much drier and spreads further north and south, blowing dry over hot habitats, such as desert and

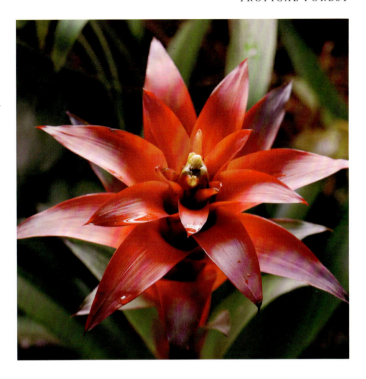

BELOW:
UNDER THE CANOPY
A sunlit gap forms in the forest when an old tree falls down. This space is filled with a lower layer of plants called the understory. The understory is filled with shrubs and smaller trees. There are also tiny saplings that have been waiting for years for the chance to grow into a space in the canopy.

ABOVE:
BROMELIAD IN BLOOM
This lush plant grows in the pools of sunlight that make it through the thick forest canopy above. They often sprout on the branches of the trees. What look like petals are in fact bracts, colourful leaves that have been repurposed to be part of the flower. Jungle bromeliads attract birds, bats and a wide array of insects to them.

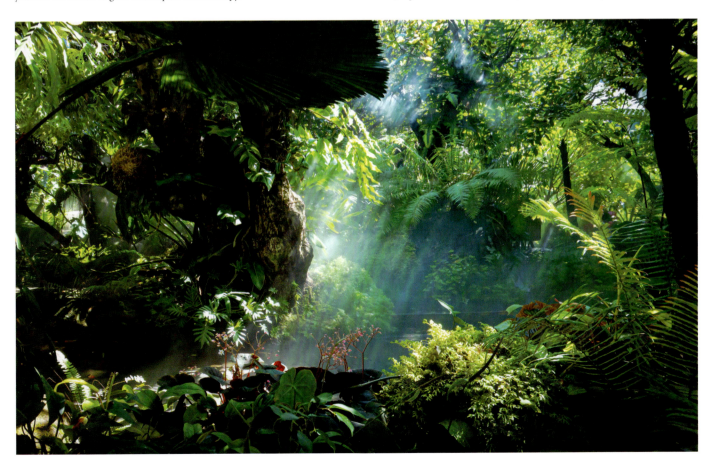

TROPICAL FOREST

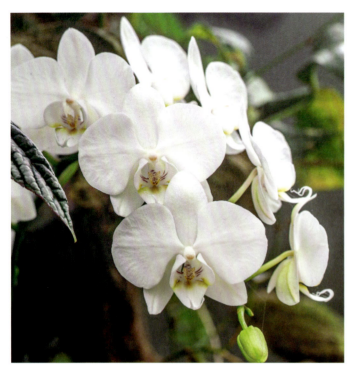

savannah. However, closer to the equator, the rainfall ensures that it is tropical forest that grows here.

TYPES OF TROPICAL FOREST

The climate is suitable for tropical forests in Central America, northern South America, Central Africa, Madagascar, southern and Southeast Asia, Indonesia, plus the northern fringes of Australia. There are essentially three types of tropical forest, although there are a myriad of variations seen from place to place around the world. The flat lowland areas have rainforests, where the next rain shower is never far away. On more rugged landscapes, the tropical forests are described as montane or cloud forests. Partly, as the name suggests, the distinction is

OPPOSITE:
TARSIER, TANGKOKO NATIONAL PARK, SULAWESI, INDONESIA
The tarsier is a non-simian primate and thus a distant relative of ours. It lives across the Indonesian forests. The tarsier is a nocturnal insect eater – it may also prey on small frogs and lizards if the opportunity presents itself. It clambers between branches, holding on with long fingers and toes, using its bigs eyes to find the way in the dark. The two eyes take up more room inside the tarsier's head than its brain.

ABOVE:
MOON ORCHID
This white orchid lives mainly in the montane rainforests of Southeast Asia. It is an epiphyte, which means it grows on another plant, sending out fleshy roots to cling to its host.

BELOW:
DANUM VALLEY, BORNEO, MALAYSIA
This lowland rainforest in Sabah on the island of Borneo is a pristine and ancient ecosystem. There has been forest here for 130 million years. The forest is now protected, not least because it is home to the endangered Bornean orangutan, along with rare gibbons, leaf monkeys and the clouded leopard.

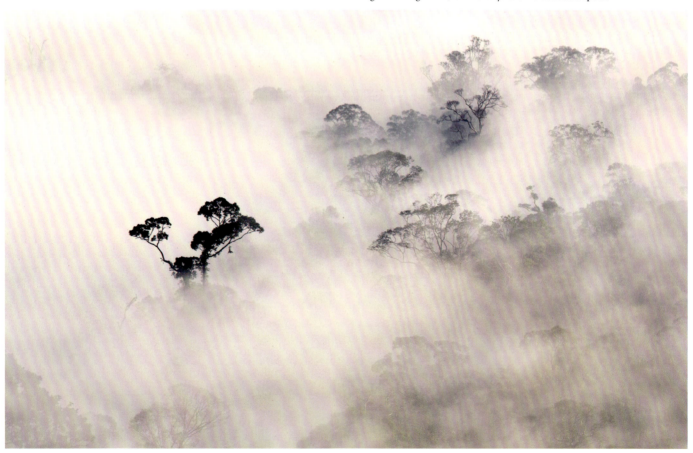

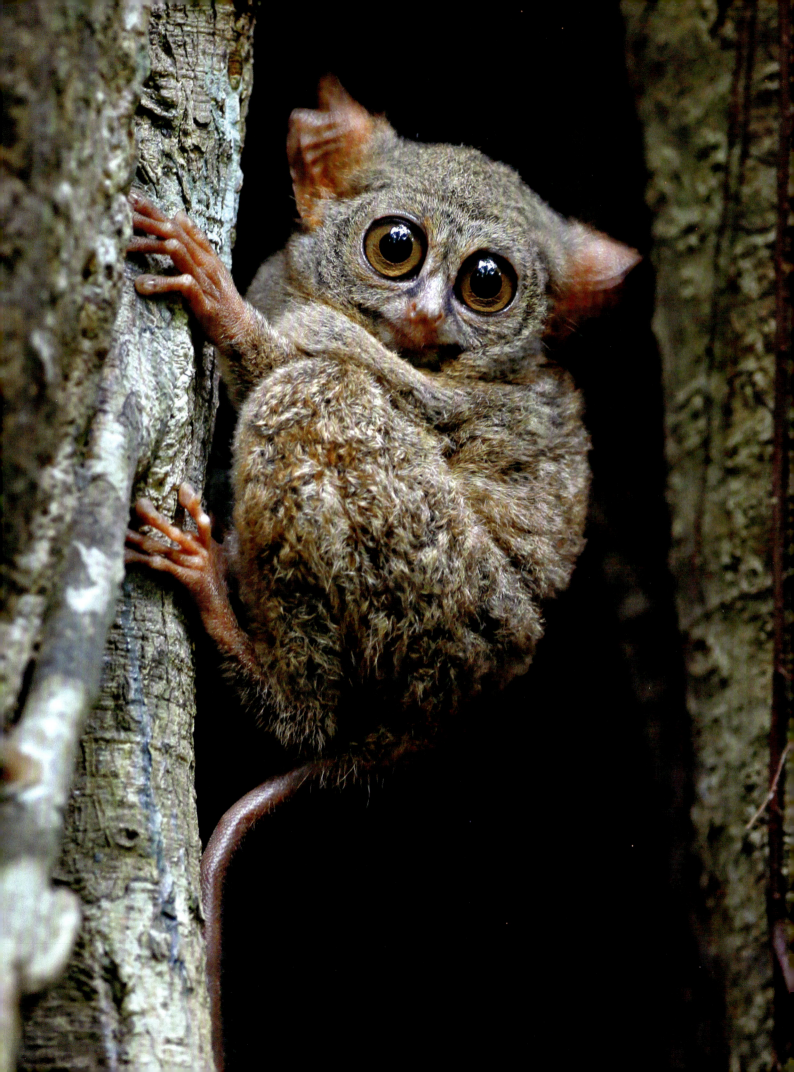

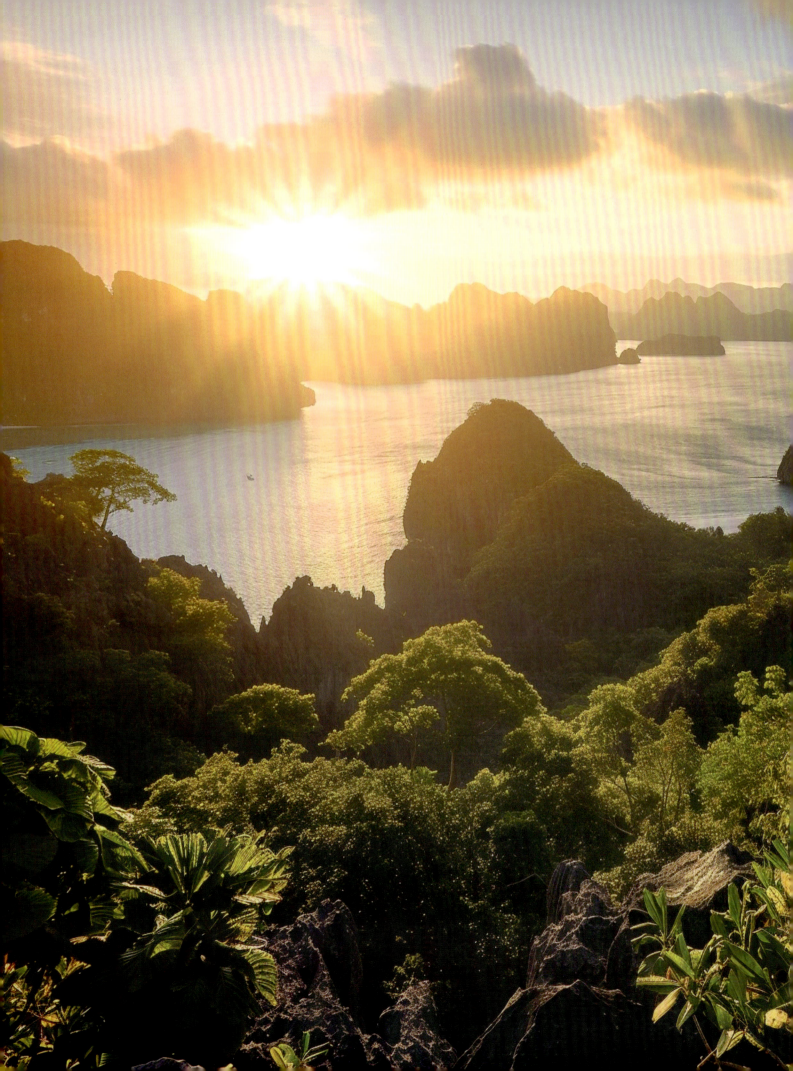

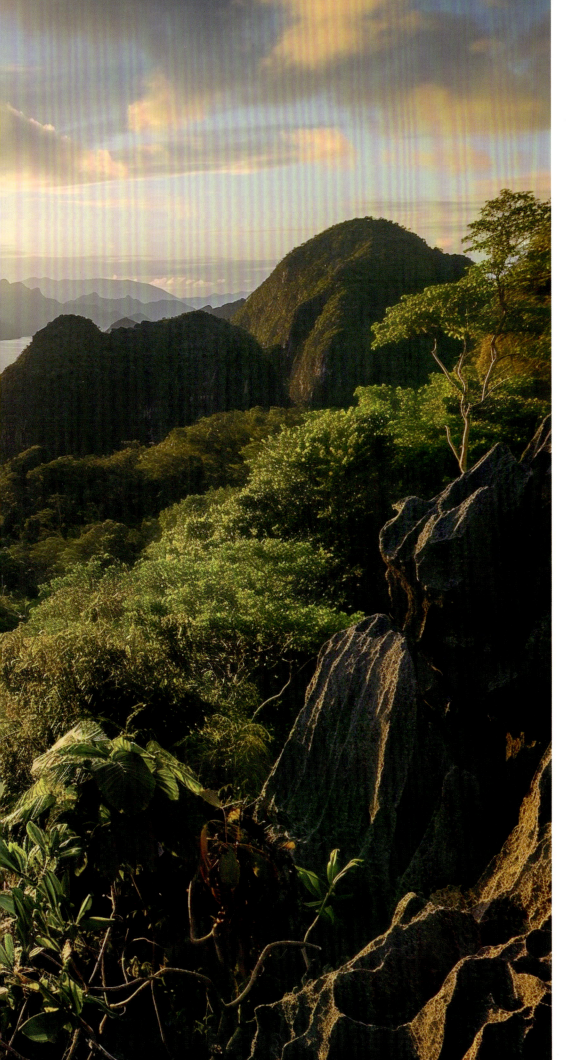

TROPICAL FOREST

CORON, PALAWAN, PHILIPPINES
These steep, forested islands are just a few of many that make up the Philippines. The Philippines is a megadiverse country thanks mostly to its forests. About 67 per cent of the plants and animals there are endemic, meaning they are found nowhere else. These include the carabao, a swamp-type water buffalo.

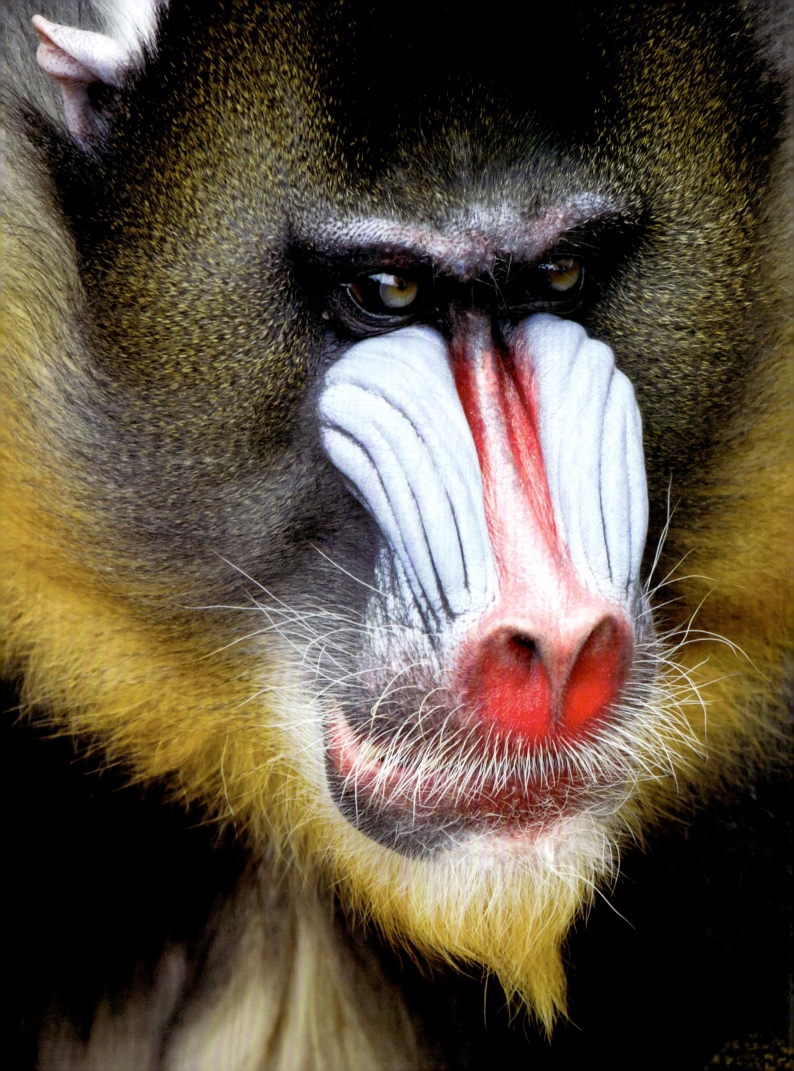

due to the higher, colder elevations, where the water supply is present as a mist or fog that clothes the slopes. Also the gradient of hills and mountains changes the structure of the forest, and a different community of plants and animals is adapted to live there.

The third type of tropical forest is monsoon forest. These are places that have a marked wet and dry season, but the wet season brings a single downpour of rain, which within three or four months is enough by itself to support a lush jungle, even one that begins to dry out later in the year. Monsoon forests are the dominant tropical forests in India and the mainland of Indochina. They are also the main forest in northern Australia, while in Central Africa, the core rainforest around the Congo

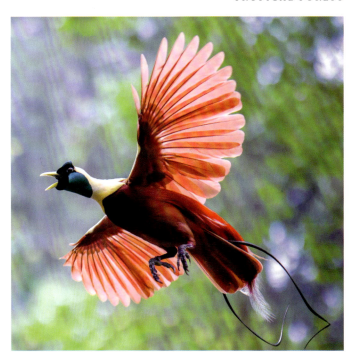

OPPOSITE:
MANDRILL
This adult male mandrill is displaying its dominance in the social group. Blood rushes to the face to enhance the colours and he will snarl to show off his long canines. Mandrills live in the Congo and are the world's largest monkeys. They are of a similar size to chimpanzees, and spend most of their days browsing for leaves on the forest floor.

BELOW:
EMERGENT TREES, TAMBOPATA RESERVE, PERU
The tallest trees are able to stand far above the canopy. These here in the Peruvian Amazon rainforest are like islands above a sea of leaves. Flocks of macaws fly between them and howler monkeys will use their height to broadcast their bellowing calls.

ABOVE:
BIRD OF PARADISE
The bird of paradise, such as this species with the local name 'cendrawasih', live in the forests of New Guinea. They are famed for their elaborate tail feathers and other colourful adornments used by the males to impress a mate.

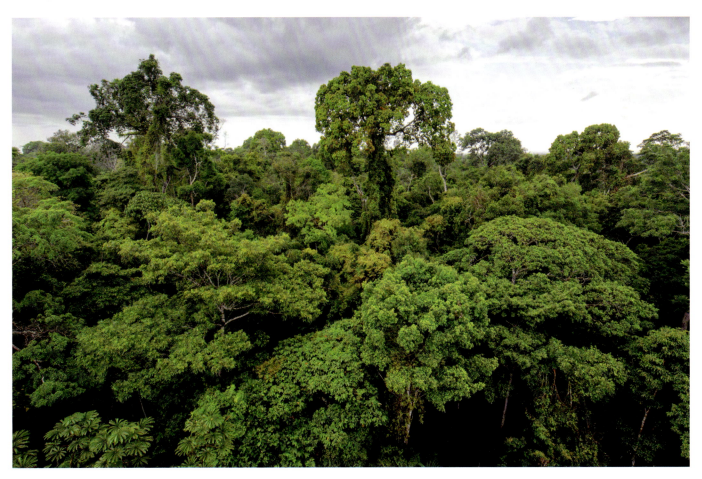

TROPICAL FOREST

Basin is met north and south with areas of monsoon forest that gradually merge into the more arid grasslands for which Africa is famed. Similarly the Atlantic Forest of western Brazil is a monsoon forest.

A monsoon climate system is formed where the prevailing winds switch direction between the wet and dry season. In the cooler months the temperature of land drops faster than the temperature of the ocean. As a result, the air above the land is cooler and denser than the air over the ocean. This creates a circulation where warm air rises above the ocean, creating rain out at sea, before the dry air is pushed over land. Once there, this air cools and drops before circling back out over the ocean again, picking up heat and moisture and thus returning to the start point. As the temperature warms up a little in summer, it is the land that heats up faster, and so the air current changes direction. Warm dry air rises over the land, and is pushed out over the sea. There it cools and sinks down nearer to the ocean's surface, picking up moisture before it blows back inland. Over land this colder, wet air is heated and so rises, thus forming clouds that then produce gargantuan rainstorms that inundate the land. The forest soaks up this monsoon water when it comes, becoming a steamy, lush habitat for a short while. Some forests will literally flood, with patches of dry land becoming rare. Every animal is in the water or up a tree. But then the winds change again and the forest enters a long period of drought. It will not rain for months to come and the forest life does all it can to cling on.

There are also microclimates that produce tiny patches of tropical forest. For example, lush jungles will grow in the spray

RIGHT:
JUNGLE ELEPHANTS
While most Asian elephants live in captivity, there are some wild populations. One of those lives in the forests of northern Thailand. Elephants eat at least 100kg (220lb) of food a day, which requires a large space for them to roam. Each elephant needs about 100 sq km (38 square miles) of forest to provide a sustainable food supply.

BELOW:
JAVAN RHINO
The rhinoceros is normally associated with the grasslands of Africa, but there are smaller forest species that live in the jungles of Southeast Asia. (They are about 3m/10ft long and weigh more than a tonne, but that is small for a rhino.) The Javan rhino is among the rarest with barely 100 living in the wild, confined to the forests on the western tip of Java. For centuries these creatures were hunted for their horns and may have been an inspiration for the myth of the unicorn.

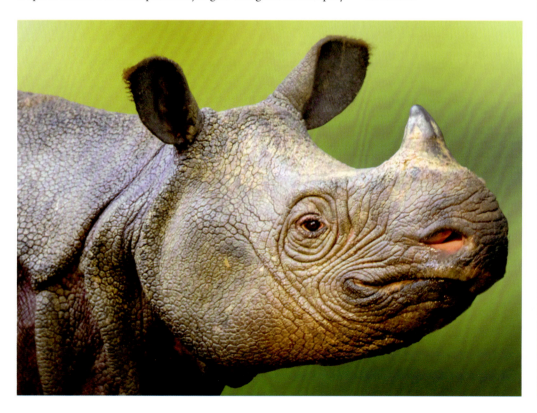

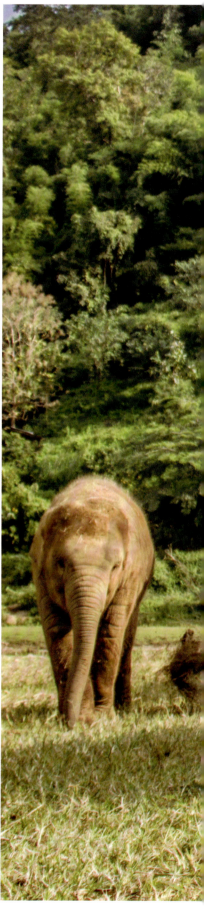

TROPICAL FOREST

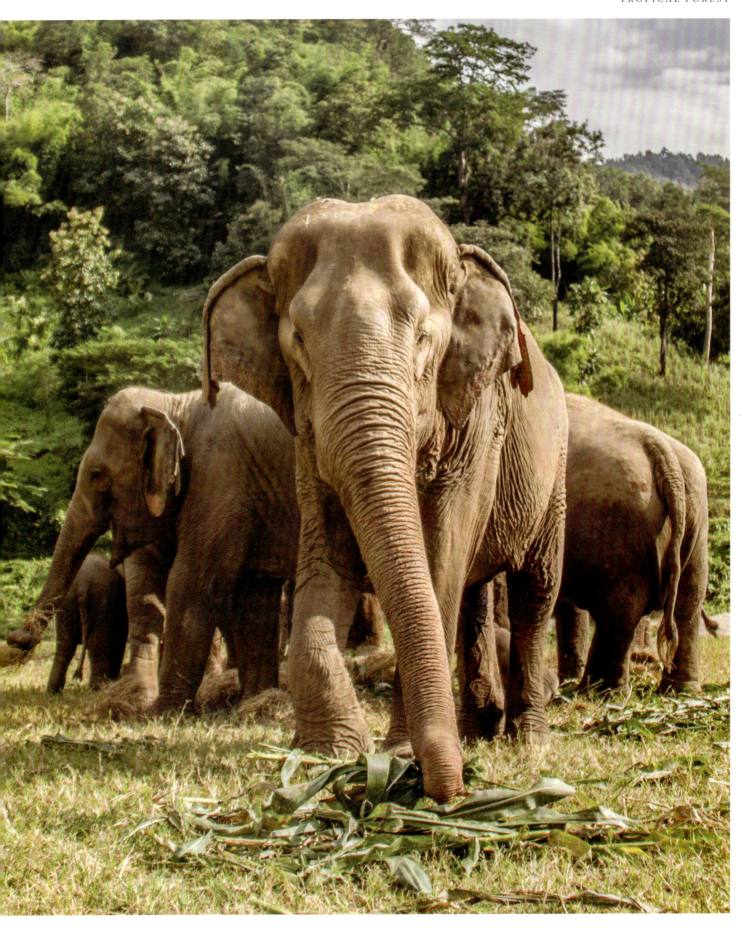

TROPICAL FOREST

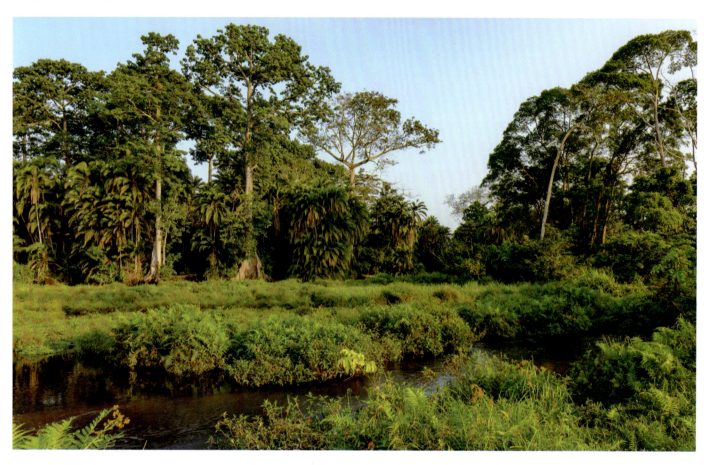

ABOVE:
ODZALA-KOKOUA NATIONAL PARK, DEMOCRATIC REPUBLIC OF THE CONGO
This forest reserve in the Congo has been protected for nearly 100 years, making it one of Africa's oldest nature reserves. It has some old-growth forests, which have been untouched by human activity.

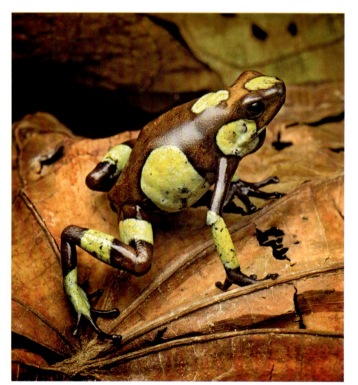

of a waterfall that is otherwise surrounded by more arid lands. A good example is the forest that grows in the gorges beneath the Victoria Falls between Zambia and Zimbabwe. There are forest plants and animals living in this jungle oasis hundreds of kilometres from the nearest tropical forest. Similarly verdant 'gallery forest' will grow along the banks of rivers, their roots being fed by the water table flowing through the sandy soils instead of frequent rainfall. These long narrow fingers of forest can form wildlife corridors between denser regions separated by climate differences.

FOREST RESIDENTS

Tropical forests are crowded places. Combined they cover around 13 per cent of Earth's land and less than 4 per cent of the planet's total surface. Nevertheless, there is more living material packed in here than any other dry land habitat. Half of the world's plant roots are growing in the soils of tropical forests (the assumption being that above the ground is

LEFT:
POISON DART FROG
This colourful frog from Central America is much smaller than it appears in photographs. It would happily perch on a person's fingertip, but the owner of that fingertip may be less happy about it. There are about 170 species of poison dart frogs, which consume a diet of ants and other insects. They convert the toxic chemicals in their food into a powerful poison that is stored in the skin. Simply touching the frog exposes you to the poison but only in harmless amounts. However, eating the frog makes the predator very unwell. Local people extract the poisons from the skin to coat the tips of their hunting darts.

TROPICAL FOREST

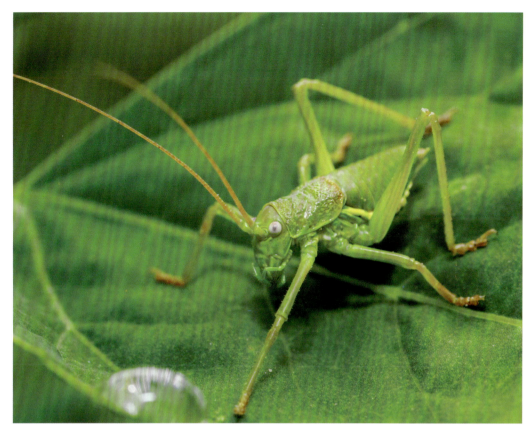

LEFT:
KATYDID
This is a jungle relative of grasshoppers and crickets. Its name is said to come from the sounds of its nocturnal calls. This particular katydid (there are at least 8000 species) is an adolescent. It is near adult size but has not yet developed wings.

BELOW:
BUTTRESS ROOTS OF A TELEPHONE TREE
This tree in the forests of Suriname is known as the telephone tree by local people. They send messages through the jungle by hitting the buttresses that grow out from the trunk. The buttresses are there to give the tall tree stability.

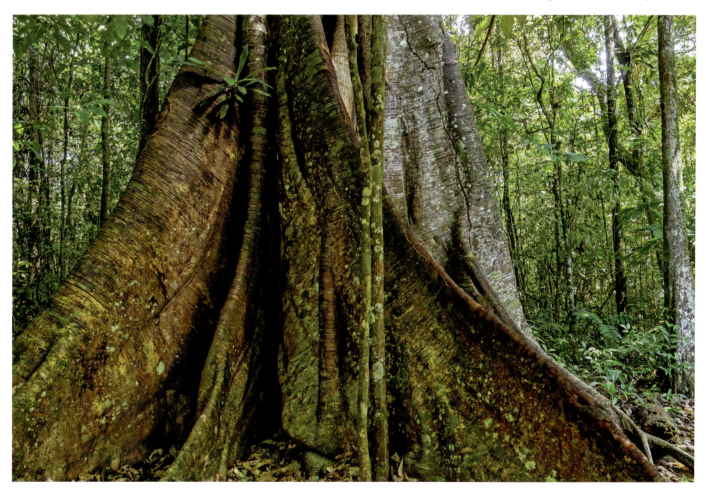

TROPICAL FOREST

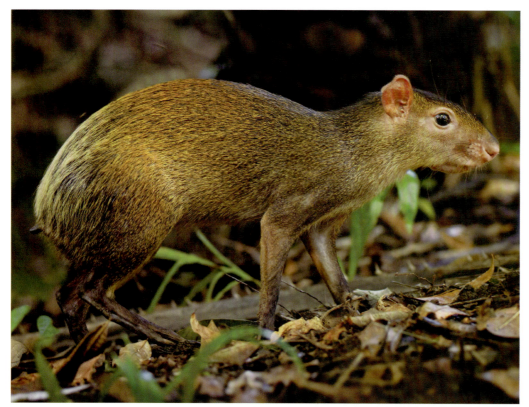

LEFT:
AGOUTI
This slender-legged animal looks like a tiny deer, but is actually a type of rodent, a relative of the guinea pig. It lives in burrows under the forest floor and comes out at night to find nuts and seeds. It uses its long incisors to crack nutshells.

OPPOSITE:
EMERALD TREE BOA
This small but muscular constrictor is biding its time until night, hoping to blend in with the green background. As night falls it slithers off to find warm-blooded prey such as a bird or rodent. It uses heat-sensitive pits in its snout to track and find victims in the dark.

BELOW:
GREEN IGUANA
This is one of the largest lizards in South America at around 1.5m (5ft) long, and it is wide ranging from mountain scrublands to wetlands and tropical forests. The lizard is primarily a herbivore and seeks out food by climbing into low branches as well as tunnelling among the roots.

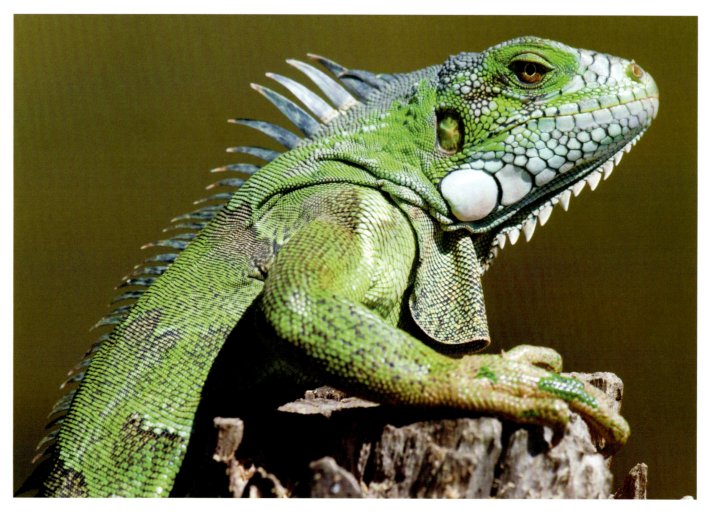

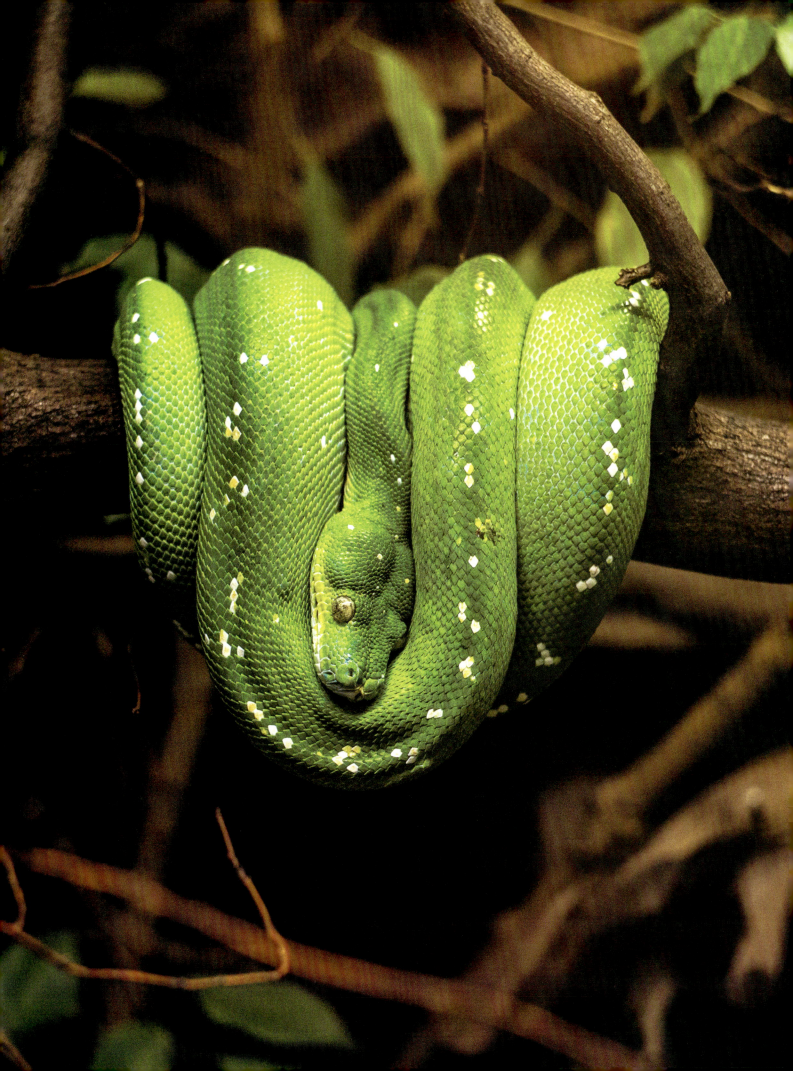

a plant of some kind from a mighty tree to climbing creeper). Meanwhile nearly two-thirds of all vertebrates, or animals with a spine and spinal cord, live in tropical forests. Looking at individual groups, three-quarters of the world's frogs and other amphibians live in a tropical forest. That proportion is nearly matched by birds, with 72 per cent of species living in jungles, while 63 per cent of mammals are tropical forest creatures.

The representation of terrestrial invertebrates (those far more numerous animals without a spine) is harder to estimate, but informed guesswork suggests that there are 6 million different species of insect, spider, worm and whatever else in this biome – far more than is known to science today. Each one is adapted to live in a very specific ecosystem, which is testament to the fact that the tropical forests are the oldest of all the major habitat types on Earth. There are forest glades in Australia, for example, that have grown in that place for 180 million years.

The habitat map of Earth is constantly changing, it always has and always will be in flux. (That is not to say that the dangerous changes to tropical forest and the planet in general currently caused by human activities are a natural phenomenon, of course. There have been similarly rapid changes in the past, and they have always been catastrophic to the diversity of life on Earth.) The land cover of tropical forests has grown and shrunk many times over the last few dozen million years, with slow and cyclical climate changes creating colder, drier 'icehouse' conditions that foster grasslands and deserts giving way to a warmer, wetter 'greenhouse' world where jungles become a dominant feature of the tropical region. But in all that time there have always been patches of tropical forest that persist unchanged even as the forest cover shrinks. These pockets of relict forests were refuges for jungle species until the return of wetter conditions, and plants and animals living in each refuge evolved in different directions, cut off from their neighbours. When forest cover grew again millions of years later, these unique communities spread out, competing with or complementing other species from elsewhere, and each time ratcheting up the species diversity

BELOW:
CANOEING
The Amazon rainforest is a world in reverse. The dry land is impassable, covered in a dense undergrowth that is too difficult to move through. The water by contrast creates a network of roads through the jungle.

RIGHT:
ORANGUTAN
The name orangutan is derived from the Malay for 'old man of the forest'. This is a juvenile Bornean orangutan, and it is still living with its mother. It takes nine years for the mother orangutan to teach its child how to survive in the treetops. This is the longest dependence period of any wild animal. Only human children are cared for by their parents for longer.

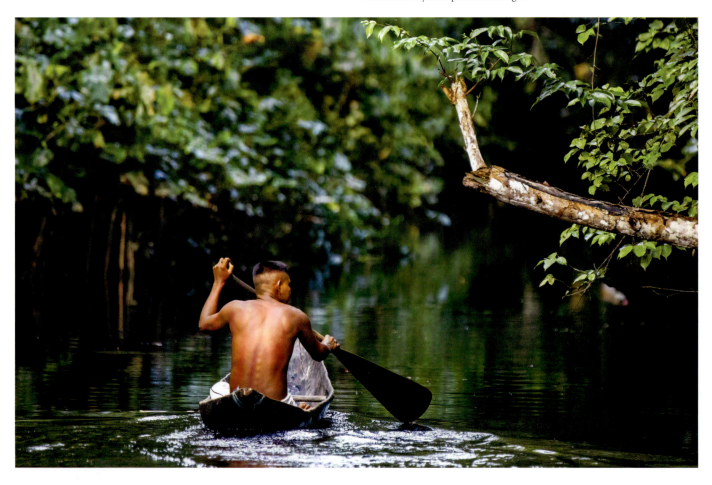

TROPICAL FOREST

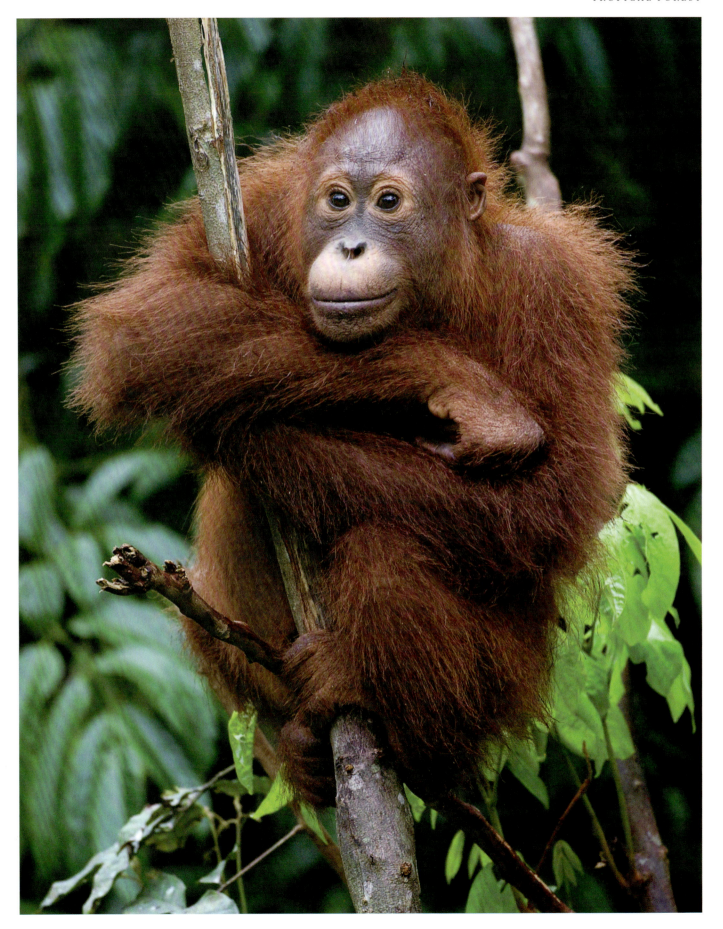

TROPICAL FOREST

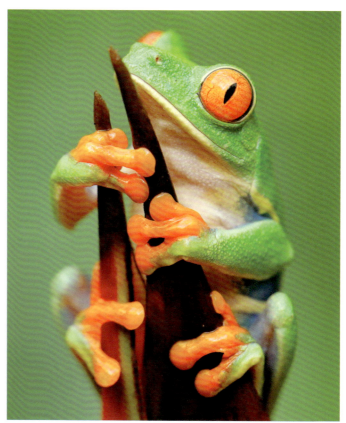

ABOVE:
RED-EYED TREE FROG
This distinctive tree frog is equipped with suction pads on its toes that allow it to grip on to flat surfaces such as leaves and stems. The vertical irises show that the frog is looking for insect prey that are walking up and down plant stems.

LEFT:
ATLANTIC FOREST
This creek is running through South America's other great rainforest, the Atlantic Forest, which once covered the mountains along the eastern coast of Brazil. It is home to many species, such as tamarins and the maned sloth that survive only here. Since the arrival of European settlers 500 years ago, 85 per cent of this forest has been cut down.

of tropical forests. This is why today's ancient jungles are repositories of biodiversity that far outstrip our knowledge even as we steadily destroy them.

WELCOME TO THE JUNGLE

Every habitat region, or biome, has what is called a climax community, which represents the maximal wildlife community. Lush rainforest dripping with life is the climax of the tropical forest biome – and it could be argued the climax habitat of life on Earth. This is where all factors that govern biological activity are maxed out, and the result is a density of life that is hard to imagine. For example, it is estimated that there are 18,000 distinct animal species in every hectare (2.5 acres) of forest. A single tree can be home to more than 1000 distinct creatures, many of which will never have been observed by scientists. (Collecting samples is a rather blunt process. A large sheet is spread beneath the branches of a target tree

TROPICAL FOREST

RIGHT:
GREEN GLASS FROG
The glass frogs are so called because their translucent skin allows the colours of the leaf beneath to be transmitted through the body to help it blend in with the background.

BELOW:
GECKO
This kind of lizard is famed for its climbing abilities. The pads of the toes have nanoscopic folds that increase the surface area of the toe enormously. It is not a glue or suction system that stops the lizard from falling. The folded pads grip any surface, even the smoothest leaves.

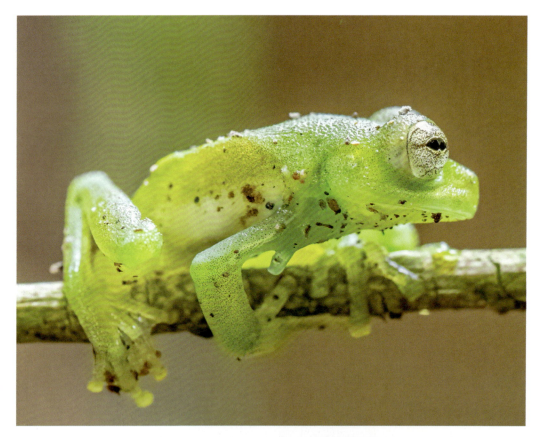

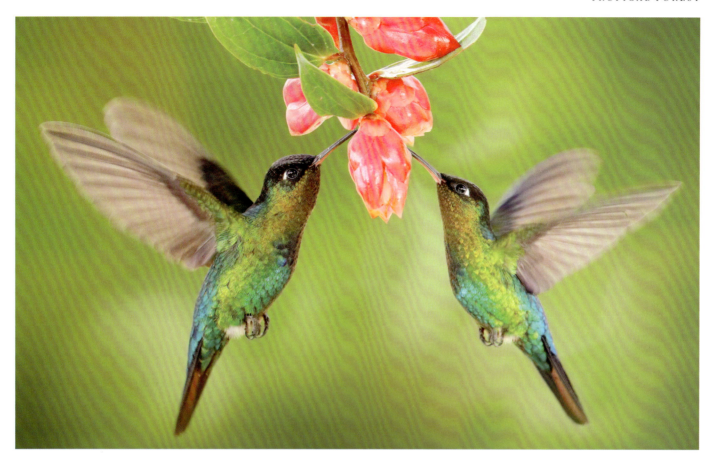

and a mechanical tree shaker, as designed for fruit harvesting, is used to literally shake the animals out of the tree to be collected and classified.)

A tropical forest ecosystem works like any other. It is based on the same food chain as all terrestrial habitats. Plants form the basis of the food pyramid, fixing carbon from the atmosphere and using it to create the chemicals needed for growing and powering a living body. Then herbivorous animals will eat the plants to access those chemicals – and the carnivorous animals will do the same by eating the herbivores.

The input of energy that feeds the entire ecosystem comes from sunlight, which is captured by plants to drive photosynthesis. Sunlight is not in ample supply in this region and so competition for growing space is fierce. Another limiting factor for plant growth is water. Water's most basic role is to swell a plant's cells and be the medium for the other chemicals of life to carry out metabolic processes. However, water is also used to transport materials up and down the plant using a complex chemical pump system. In a tropical forest – as in all forest types – the supply of water is generally not a limit on this pump action, and plants will grow big and

ABOVE:
HUMMINGBIRDS
A pair of hummingbirds hover by a forest flower to lap up nectar with their long tongues. Their bills are long and pointed in order to probe deeply into the flower. They target trumpet-shaped flowers where the nectar is far down inside. The tongue's tip is feathery so it can slurp the liquid more effectively as it flickers in and out of the mouth. To hold their position in mid-air, the hummingbird is able to flap its wings dozens of times a second.

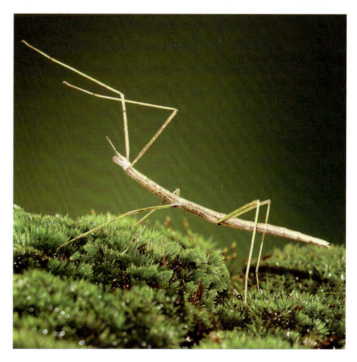

RIGHT:
STICK INSECT
Known by the scientific name of phasmid, it is obvious where these insects got their common name. The insect's single aim is to avoid being seen by predators, and it goes to great lengths to ensure this, even swaying from side to side as if being blown in the wind like a real stick.

TROPICAL FOREST

tall to stand over their competitors and dominate the supply of sunshine. The evolutionary result is a tree, a tall plant that devotes its resources to growing tall and sturdy with the intention of occupying a place in the sun for decades, if not longer.

The competition for light gives a mature rainforest a multi-storey structure with the main growth of trees creating a blanket of branches that forms a roof-like canopy about 60m (197ft) above the forest floor. Above the canopy there is an ocean of leaves as far as the eye can see, bathed in the sunshine (whenever it emerges from behind the frequent rain clouds, of course). Below the canopy, the forest is plunged into gloom because at least 90 per cent of the sunlight never makes it below the canopy. In most rainforests that 10 per cent

RIGHT:
PINK MOTH ORCHID
This orchid originates in the wilds of Southeast Asian forests, especially those in Indonesia and the Philippines. It is grown much more widely by horticulturalists and enthusiasts the world over. The flowers often dangle from the host plant using fleshy, green roots that can photosynthesize like leaves.

BELOW:
RING-TAILED LEMUR
Madagascar is home to a distinctive group of catlike primates – the lemurs. The ring-tailed lemur is by far the most familiar and widespread of this group. It has a more generalist approach to feeding, eating a range of foods and insects. These lemurs live in small groups, or troops, and the long, striped tails are used for communication. As well as making visual signals, the tails are used to waft smells at rivals in so-called stink battles.

OPPOSITE:
CLOUDED LEOPARD
This, the most elusive of the roaring cats, the clouded leopard spends the day hiding out in tree branches and then climbs down to the forest floor to hunt at night. Despite being a relative of the big cats, the clouded leopard is only about the size of a Labrador dog.

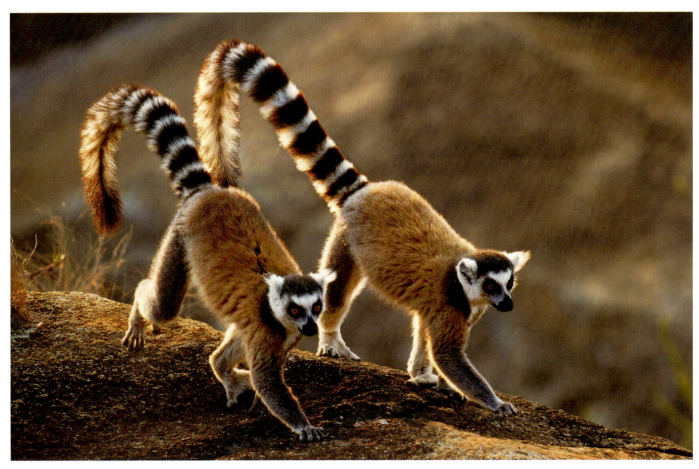

TROPICAL FOREST

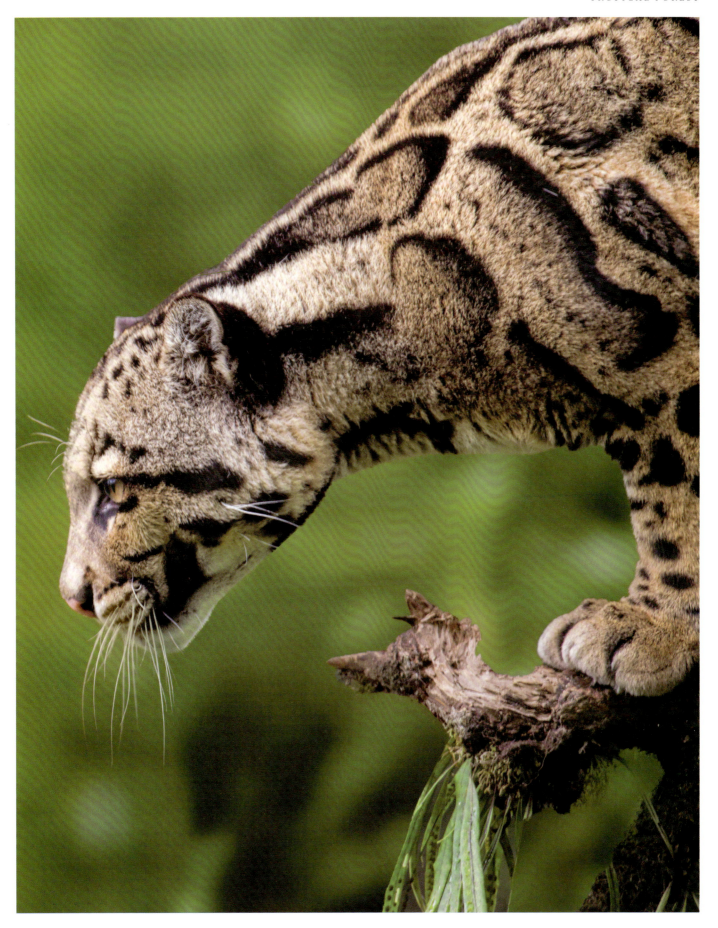

TROPICAL FOREST

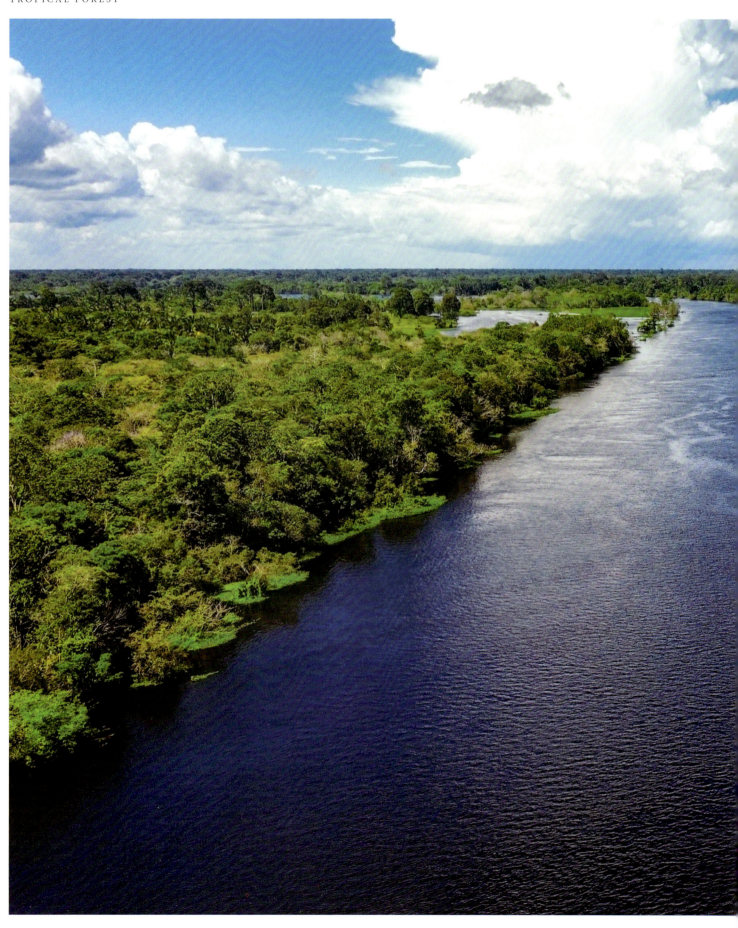

TROPICAL FOREST

AMAZON RAINFOREST
The world's largest rainforest grows in the drainage basin of the Amazon River. It is so big that 17 Britains and Irelands could fit into it. There are 40,000 types of plant, 2.5 million insect species, 400 mammal species, 3000 kinds of fish and 1300 species of bird.

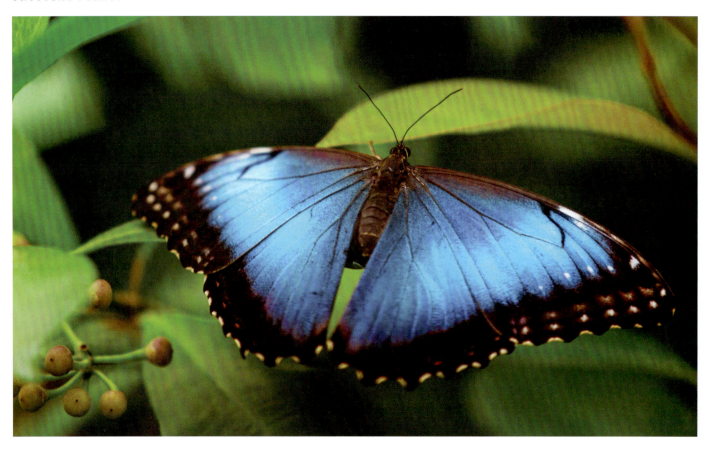

ABOVE:
BLUE MORPHO
The undersides of this South and Central American butterfly has a drab pattern of browns and black. When the male unfolds its wings it reveals a shimmering blue that attracts attention from mates as it flutters through the forest. And then, as it lands and folds up its wings again, the bright butterfly seemingly disappears.

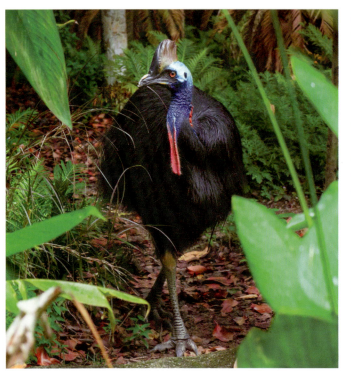

is enough to support an understory of smaller trees and slow-growing bushes, which eke out a living in the dark netherworld. Below that, the forest floor is darker still, dappled in a few shafts of sunlight that flicker through the shifting layers of branches above.

REACHING FOR LIGHT

Heat is also a factor here. On average the daytime temperature in a tropical forest is 20–25°C (68–77°F) all year round. In fact the bigger temperature fluctuations are seen between night and day, not between winter and summer (such as they are in the equatorial zone). Tropical forests are just the right temperature for biological activity, not too hot and not too cold. (However, a visiting human might think otherwise. The humidity of the jungle air makes it hard for us to shed heat by sweating, so it can feel sweltering despite not really being much warmer than a summer's day in more temperate parts of the planet.) The steady forest temperature engenders optimal growing conditions. There are bamboos in the Amazon that can grow 91cm (3ft) in a single day as they race to reach the sunshine.

LEFT:
SOUTHERN CASSOWARY
A relative of the emu, this flightless forest bird is sometimes said to be the most dangerous bird species of all. This reputation is somewhat overblown, based on stories spread by American soldiers stationed in New Guinea in World War II. The rumour is based on the way these tall birds – they are 170cm (5ft 5in) high – run head first through the jungle, slicing their way through using a stiff casque on their heads. Presumably a collision would be bad.

TROPICAL FOREST

RIGHT:
SPECKLED TANAGER
This little songbird from Central America is one of 240 tanager species, most of which live in tropical forests. They tend to live in small flocks and gather an eclectic mix of plants and animal foods.

BELOW:
LADY SLIPPER
This kind of orchid is found across Southeast Asia and Indonesia. A chemical in the flower oil and scent are being investigated for their qualities as a cancer drug. The lower petal forms a pouch, which traps visiting insects temporarily, forcing them to escape via a route that dusts them with pollen, which they will take to the next flower.

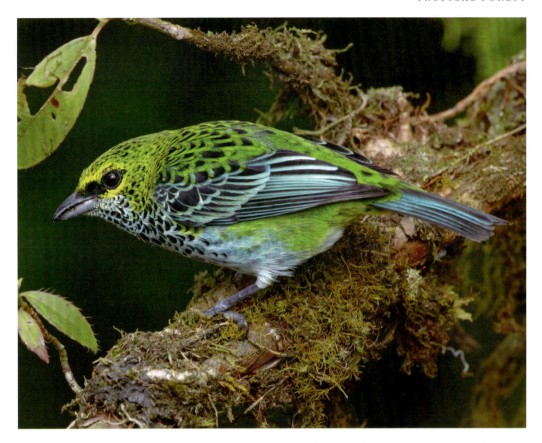

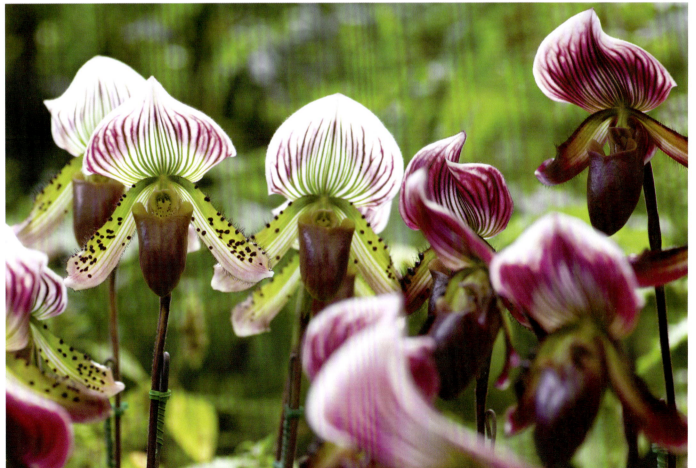

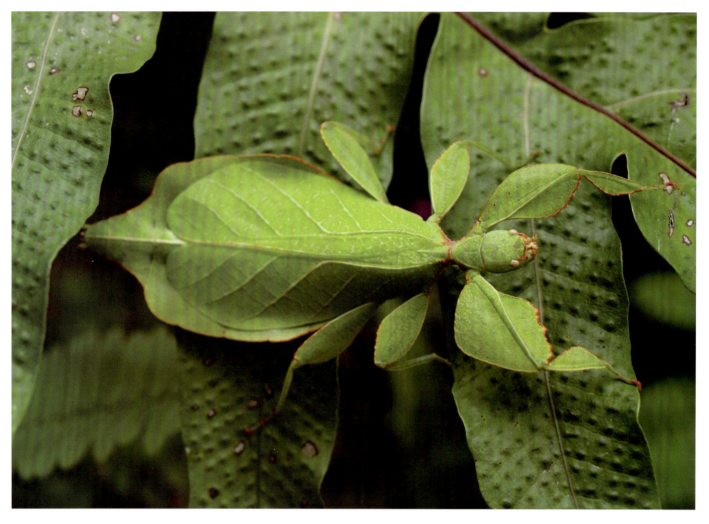

ABOVE:
LEAF INSECT
As the name suggests, this relative of the stick insect has taken another route to camouflage in the rainforest. The body is elongated into leaf shapes, with the wings generally repurposed to help with the disguise. The leaf body even has brown fringes that imitate where a large leaf may be damaged or drying out. The largest of the leaf insects lives in Malaysia and is around 10cm (4in) long.

RIGHT:
GRENADA TREE ANOLE
Anoles are a common feature of American rainforests. The lizards communicate by flashing a colourful dewlap that is folded against the throat. In most species it is just the males that have these little semaphore flags with a distinctive colour. The flags are also waved with a rhythm specific to each type of lizard.

The sheer pace of growth can be seen in a forest gap. When a venerable tree falls, as it must eventually, it leaves a space for new plants to grow. The fastest sprouting plants like shrubs and bamboos will fill the gap making the most of the sunlight until the inevitable day that the slower-growing but sturdier tree will outsize them and spread up and out blocking out the sun for another century or more.

Height is at a premium in the rainforest and in common with trees worldwide, tropical species rely on secondary growth (a thickening of stems) to create a sturdy wooden trunk. However, trees also rely on roots to anchor them into the ground. This is less effective in tropical forests where the soil is surprisingly shallow. One might have assumed that the soils in this most fertile of places is deep and packed with nutrients, but the rate of biological activity is so great that nutrients are constantly being added and removed and there is little chance for a store of organic chemicals to build up. This is the main reason why areas of rainforest that are cleared for cattle pasture and crops prove to be poor farmland – and, tragically, are often abandoned after only a few years.

To create more structural stability in lieu of deep roots, rainforest trees develop buttress roots that spread out in all directions above ground to create tripod-like supports that absorb the sideways swaying of the towering tree. This structural trick makes it possible for some trees, such as kapoks, to push through the leaf ceiling and emerge above the canopy. These are the emergent trees, which reach more than 100m (320ft) tall to tower above the other trees and bask in the sunlight beyond the shade cast by any rival. These trees must be able to bring water up from the forest floor. The water pressure needed to push water up this high is at the limits of the biophysics of plants. A water column that is 100m (320ft)

TROPICAL FOREST

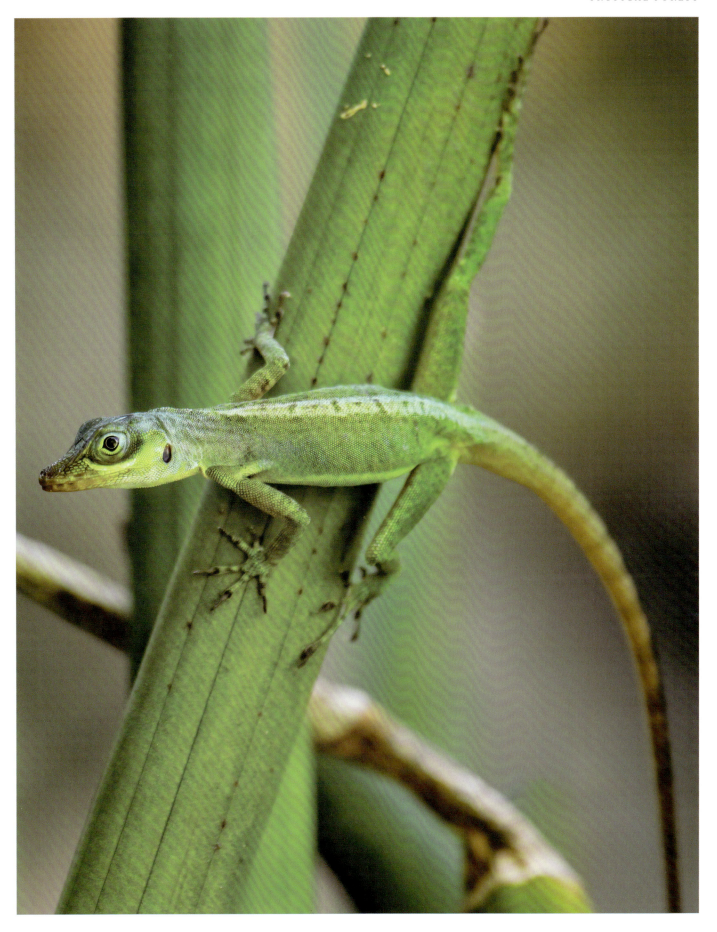

TROPICAL FOREST

tall is at a pressure 10 times higher than atmospheric pressure. Adding much more force than this to the water will break its surface tension, which would collapse the column. However, trees in the emergent layer just about manage it and in so doing form isolated islands, a haven for life such as howler monkeys, hummingbirds and macaws, among a sea of green leaves. Emergent trees are less common in montane forests, where the gaps between the canopy and understory are also less pronounced. The gradient of the land in hilly areas rather negates the competition for light and space.

UNDER THE CANOPY

The forest floor is home to leafy herbs and ferns that can thrive here despite the limited light. There is plenty of water – too

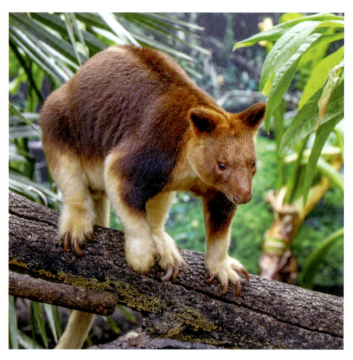

RIGHT:
ORNATE TREE-KANGAROO
In a demonstration of convergent evolution, the rainforest of Queensland, Australia, does not have monkeys, lemurs or civets. Instead kangaroos have evolved to exploit the treetops. This kangaroo hops less than its terrestrial kin. Instead it climbs on all fours and uses a very long tail to help keep balance as it searches out fresh leaves to eat.

BELOW:
PITCHER PLANT
These jug-shaped leaves are filled with a delicious-smelling liquid – delicious that is to insects. They fly inside to feast on nectar or another food, and find that they are trapped by the smooth inner walls of the pitcher. Inevitably they will succumb to the effort of climbing out and drown in the liquid, where they are digested and absorbed by the killer plant.

OPPOSITE:
CRESTED OROPENDOLA NESTS
These birds from the forests of South America make hanging baskets for nests. Dozens of males will weave a nest from grasses and twigs to create a breeding colony. The females choose a mate based on the quality and location of the nest.

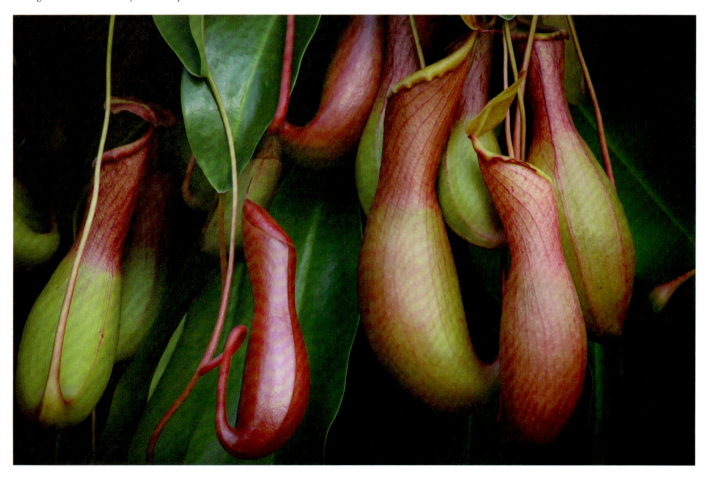

TROPICAL FOREST

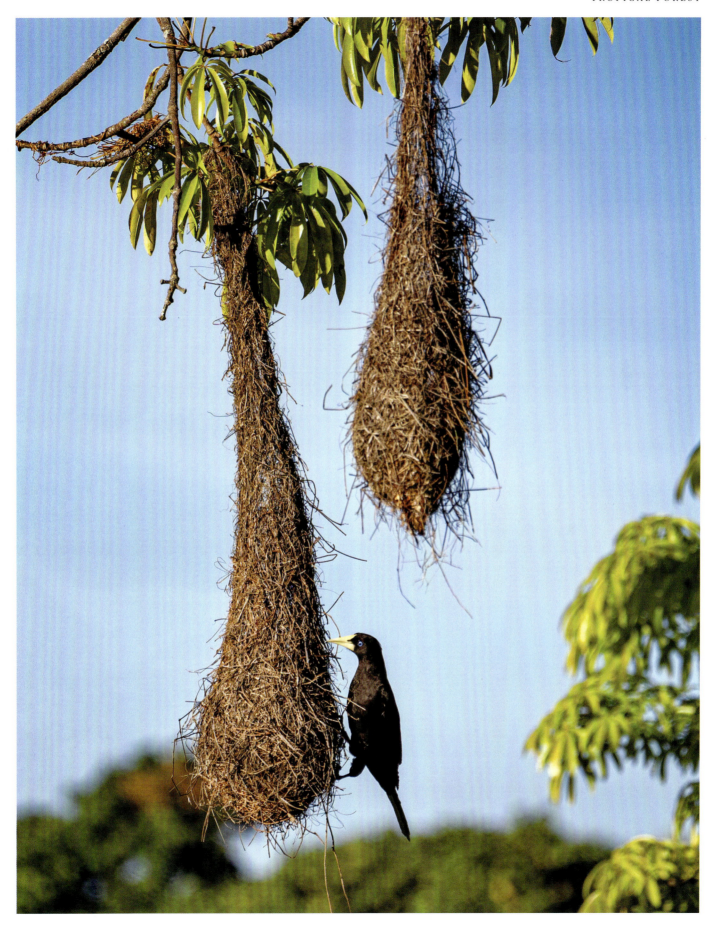

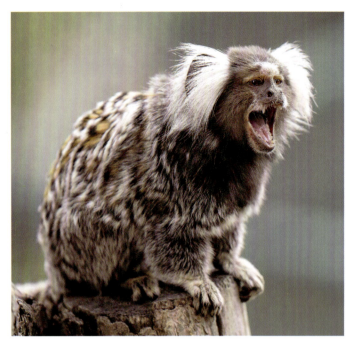

ABOVE:
COMMON MARMOSET
Marmosets are the smallest kinds of monkeys. This species lives in the Atlantic Forest of Brazil and is 18cm (7in) tall. The males display dominance using tufts of white hair on the head.

RIGHT:
WEST AFRICAN GABOON VIPER
Always hard to see among the leaf litter on the forest floor, this dangerous snake from Central Africa has the longest fangs of any venomous snake. They are 5cm (2in) long. The snake preys on smallish forest animals such as ground birds and rodents, and it kills with a single violent bite.

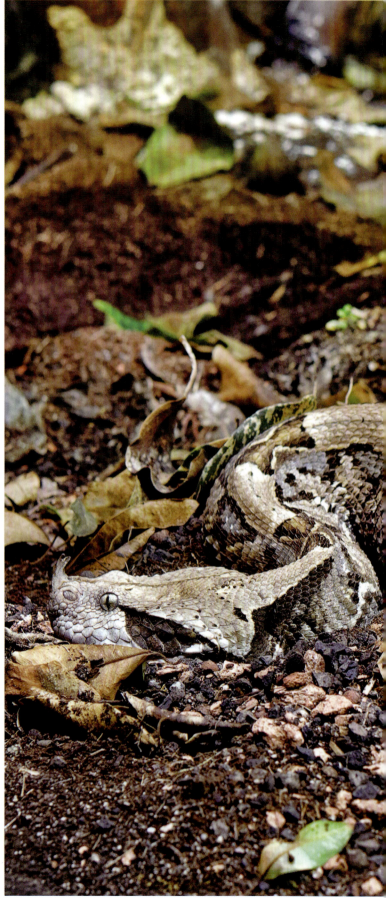

much in fact. The sheer weight of water falling onto a tree's leaves would be enough to damage the branches if it cannot be shed as quickly as it arrives from above. The plants in a tropical forest frequently have the same elongated shape with a sharply pointed tip. Rainwater trickles towards this 'drip tip' and flows away – to fall on several smaller, shorter plants as it makes its way down to the forest floor.

All this water combined with the productive power of the tropical forest means there is plenty of room for smaller plants that have a different survival strategy to the light-hogging trees. They are the epiphytes, which is a catch-all term for small plants that grow on other larger ones. (There are even epiphytes here, if one looks hard enough, which are tiny plants that grow on an epiphyte.) The essential idea is that the epiphyte makes use of the host tree's height and rigidity (it is normally a tree) as a platform to reach the sunlight. For example, bromeliads are common jungle epiphytes that use a web of roots to cling to branches and trunks. In common with many epiphytes, these roots are of limited use in collecting water, and so the plants take in water directly from the air. (Their domesticated forms are sometimes sold as 'air plants' because of this.) Epiphytes often have fleshy leaves and stems that maintain a store of water to sustain them during

TROPICAL FOREST

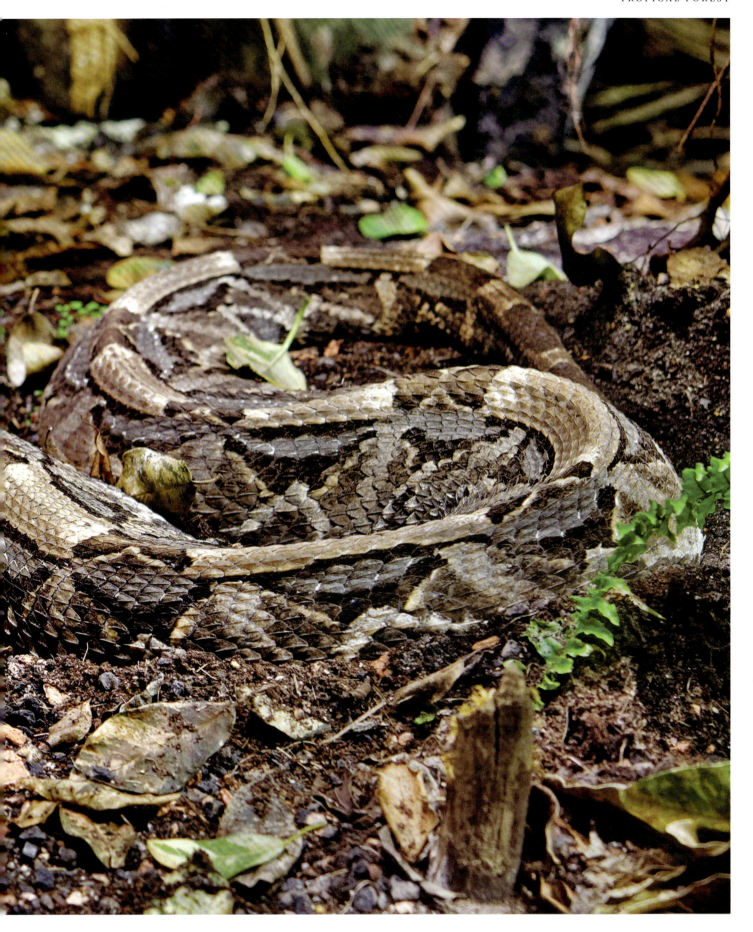

TROPICAL FOREST

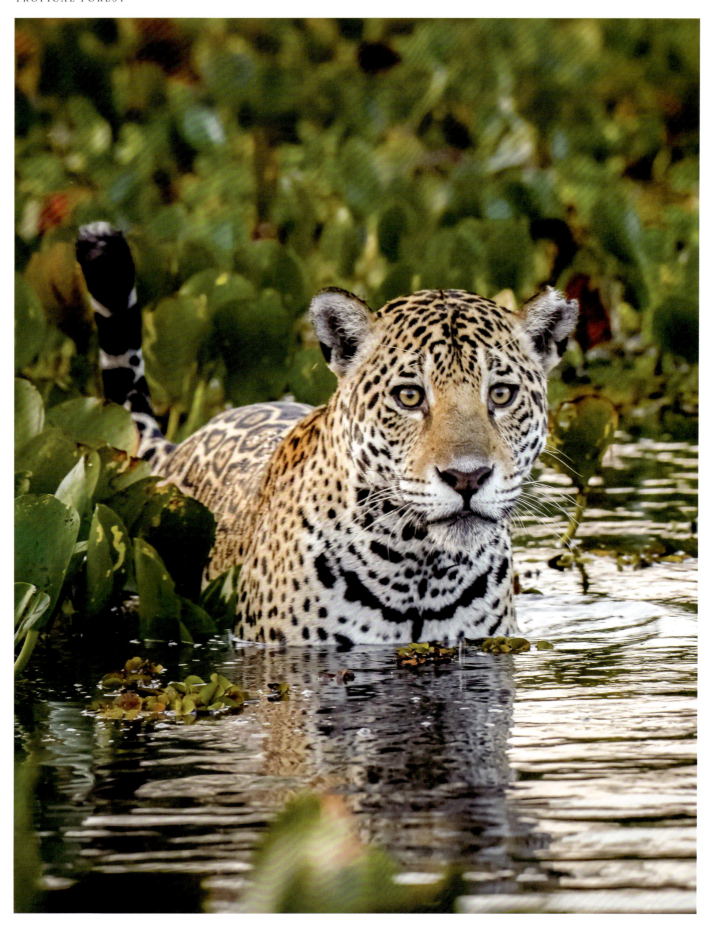

droughts. One type called bromeliads are famed for forming tiny reservoirs in the base of their leaves, which acts as a water supply and provides a habitat for aquatic animals, such as tadpoles, many metres up in the air.

Other epiphytes take a more domineering strategy compared to the little air plants sprouting here and there. Lianas, for example, are tropical vines that grow from the soil at the base of a tree and twist and tangle their way up the trunk and through the high branches, spreading far and wide. Some lianas have a total length of more than 200m (650ft). Although these creepers look like the kind of thing Tarzan might have swung on, they are actually quite stiff with a wooden stem. They can provide support for flimsy trees by anchoring them to sturdier neighbours, but in general lianas are an unwelcome addition. They weigh down the host tree and get in the way of their growth – and they steal the sunlight.

Strangler figs do not sound like harmless plants either. These adopt a similar life plan to the lianas only they sprout from seeds deposited high in the branches. (A monkey or similar fig-eating animal will have done that job.) The sprouting fig plant sends up branches to fill the host trees' boughs and it also sends down roots that grow down the trunk to the soil. An

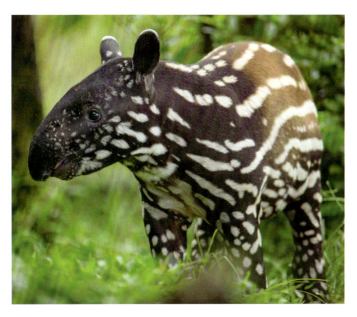

ABOVE:
TAPIR CALF
This young South American tapir will lose its distinctive stripes as an adult. The tapirs are an ancient group of forest animals that are found in both Central and South America as well as Southeast Asia. They use their short nose trunks to strip leaves from bushes (though they are relatives of the horse and rhinoceros not elephants.)

OPPOSITE:
JAGUAR
The biggest predatory mammal in the South American rainforest is the jaguar. This big cat lives and hunts alone. It will often set up an ambush in a tree and leap down onto prey that walk underneath. The jaguar has the strongest bite of all the cats, and can crush the skull of its victim with its jaws.

BELOW:
AMAZON RIVER
The Amazon is by far the largest river on Earth. It releases 200,000 litres (44,000 gallons) of fresh water into the ocean every second. The Nile beats the Amazon into second place for length, even though the South American river is 6400km (4000 miles) long.

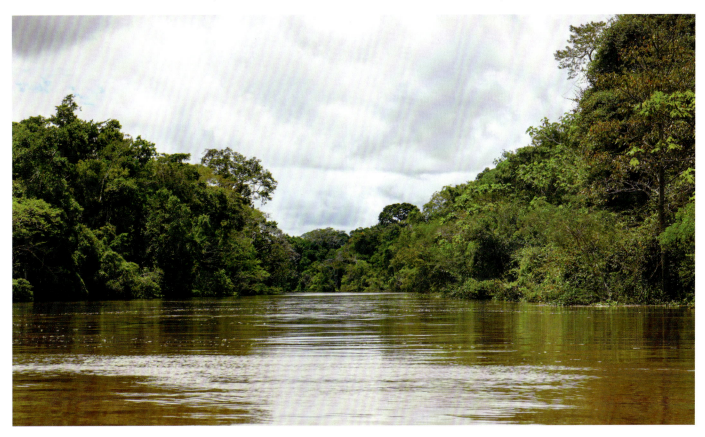

TROPICAL FOREST

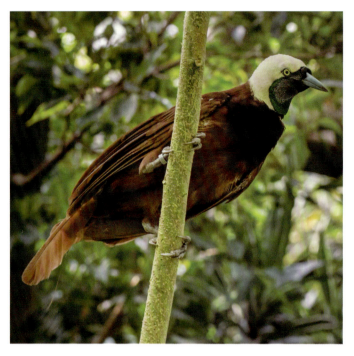

ABOVE:
GREATER BIRD OF PARADISE
This species is native to southwest New Guinea and the Aru Islands of Indonesia. The story goes that this group of birds were named because early stuffed specimens to reach Europe had no legs. It was assumed therefore that these birds never touched the ground, like angels from paradise.

RIGHT:
HARPY EAGLE
This is the largest bird of prey in South America, and one of the biggest of all eagles. It hunts high in the rainforest, where there is more room for a bird with a 2m (6ft 5in)-wingspan to fly. The bird swoops in to snatch monkeys, sloths and other mammals from the branches.

established fig will eventually surround its host trunk with thickly knotted roots. The host may die inside creating a hollow tube of wood that is supporting the branches high above.

DROPPING LEAVES

The constant supply of water and sunlight ensures that most plants in a tropical rainforest are evergreens, meaning they are clothed in leaves year round. However, in a perhaps surprising analogue to temperate forests, some of the trees in a monsoon forest are deciduous, meaning they drop their leaves for a portion of the year and regrow them when times of plenty return. In the case of the monsoon forest, the trees drop their leaves as the rains fade away and so reduce the routes by which the plant can lose water. Evergreen plants do, of course, drop their leaves as well, only they are falling away at the same rate, more or less, as new ones sprout. The result is a thick layer on the forest floor made up of dead leaves in a varying state of decomposition. This leaf litter is a habitat all of its own, a moist haven for animal life such as frogs, snakes and insects.

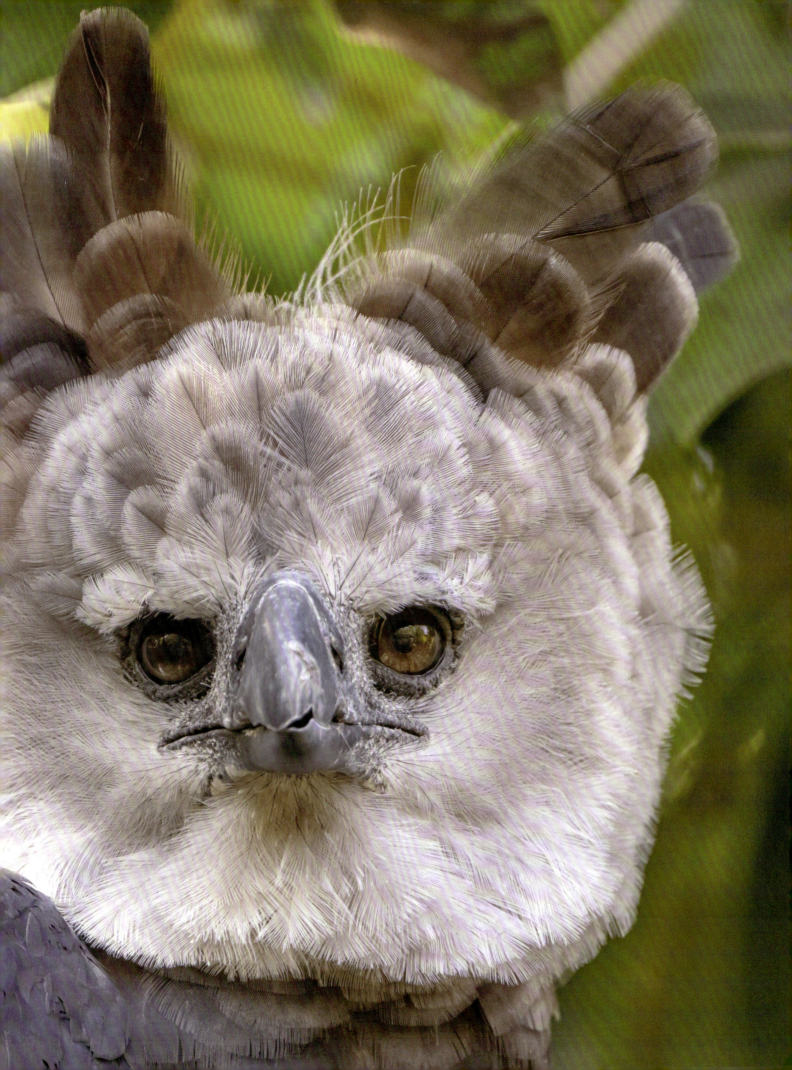

TROPICAL FOREST

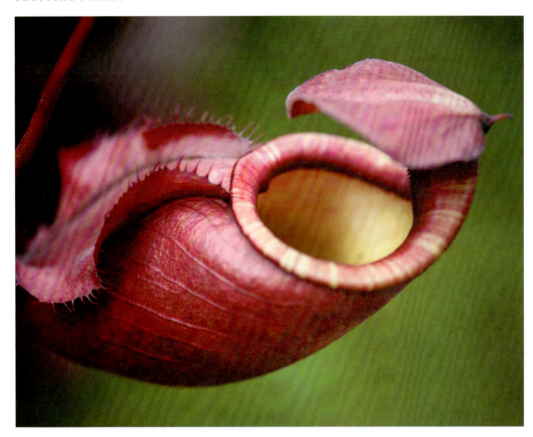

LEFT:
MONKEY CUP
This is another name for the pitcher plant. The pitcher section has a lid over it to stop it filling up with rain.

BELOW:
MOTHER AND BABY
This infant western lowland gorilla is taking a rest on its mother. The western lowland gorilla is the most numerous ape after humans. There are 100,000 of them living in forests across West and Central Africa. Nevertheless, the species is critically endangered.

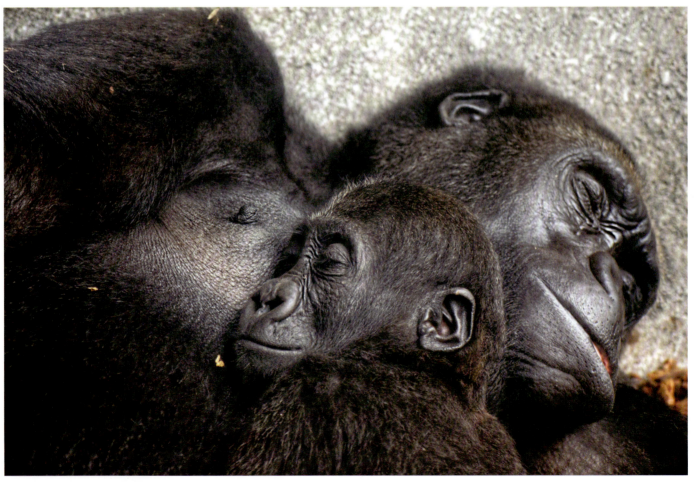

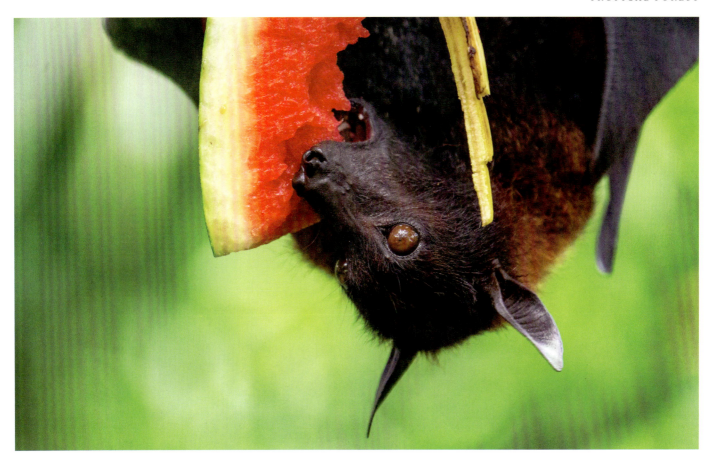

ABOVE:
FRUIT BAT
Fruit bats (also known as flying foxes or megachiroptera) are diurnal relatives of the much smaller and more abundant microchiroptera. The larger bats are most associated with warmer tropical habitats like forests. The fruit bats use their sense of sight to locate foods, such as this watermelon. Small bats rely on echolocation.

FOOD SUPPLIES

From the point of view animals, a tropical forest has food everywhere – of varying quality, but whatever your tastes, there will be something to eat nearby. This is in contrast to other habitats, where the food is of limited variety and quality or widely and thinly dispersed over a much larger area. This simple difference has a far-reaching impact on the animal life that makes a home in the forest. First and most obvious there many more ecological niches, or spaces in the ecosystem, for an animal species to exploit and this is why the diversity is so large compared to other habitats. The forest is a three-dimensional habitat, at least 60–70m (190–230ft) deep, extending from the tops of the trees to burrows among the leaf litter, tree roots and soil. All this living space has offered evolution a multifaceted canvas on which to create animal species.

A good example are the frogs, which in most parts of the world are limited to damp habitats like a riverbank, a meadowland pond or the moist floor of a soggy woodland. However, in the humid jungles, frogs have added a new dimension and are found climbing high in the trees, with some never visiting the gloomy forest floor or taking a dip in a river or stream. The long gangly legs once used to leapfrog over land and paddle through the water have been repurposed into rangy climbing tools that reach from branches and grip twigs. Some tree frogs have hooked claws for gripping bark, while others have disc-shaped suckers that cling to flat surfaces like a large leaf. Some tree frogs from Southeast Asia have kept the webbing between the toes once used to work like an oar in water. However, up in the trees, the webbed feet have become parachutes that allow the frogs to glide as they make extended leaps between trees.

TREE LIFE

Gliding is not flying but a kind of slow falling. It has been arrived at by several independent evolutionary lines. As well as the flying frogs of Malaysia, there are also flying snakes, which curve their flattened bodies into a gliding surface as they fling themselves across gaps between the branches, and all kinds of flying lizards and flying squirrels. There is even the colugo, often misnamed as a flying lemur, which uses a patagium, or membrane of skin that runs down its body to connect the limbs front and back.

Another key feature of tree-living animals is the shape of the eye, especially so in amphibians and reptiles. Each tree snake, climbing lizard and frog is ready to snatch a meal at the next opportunity and is often highly adapted to target one part of the tree. The small predators that are looking for ants or

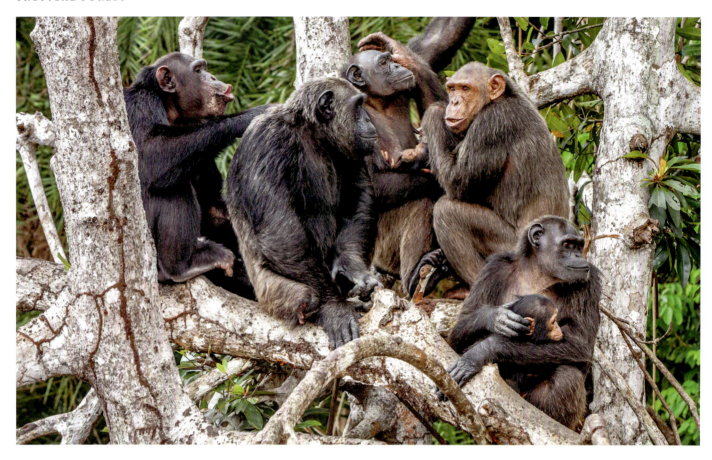

BELOW:
FOREST GECKO
This arboreal lizard does not have the suction pads of other geckos and instead relies on claws to cling to bark as it climbs through the trees. The lizard can modify its skin colouring to help blend in with the forest surroundings.

ABOVE:
CHIMPANZEES
A small troop of chimps gathers for a rest in the boughs of a tree. Chimpanzees live in complex societies that are thought to resemble the group living of our early prehuman ancestors. Without language, chimps communicate motivations, moods and needs through facial expressions, body shapes, touching and sounds.

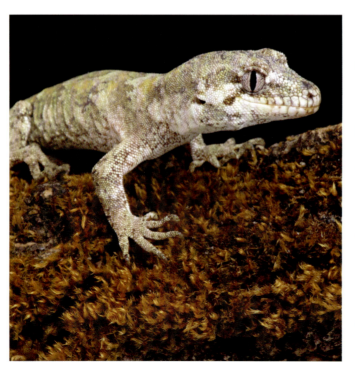

other insects marching up and down the tree trunk will have vertical pupils that open side to side. These are calibrated to detect vertical motion. Meanwhile, a hunter that watches for prey on a branch will have horizontal pupils that spot side-to-side activity. All-round predators, like jaguars or eagles, use rounded pupils that give them a more rounded view.

MONKEYS AND RELATIVES

Primates are generally plant eaters, not hunters of prey, but they too have rounded pupils so they can take in the full complexity of their surroundings. We are primates and we do that as well, and our primate body and brain is born out of the jungle. Primates include monkeys, which have tails, that live in all regions of tropical forest bar those linked to Australia. African and Asian jungles host apes, such as gibbons and chimps, which are primates without tails. The island of Madagascar has its own group of primates, called lemurs, which are more cat-like than their mainland relatives. Finally, there are a group of more primitive bush babies and lorises, which are nocturnal jungle primates that can look more like cuddly toys than wild animals.

TROPICAL FOREST

All of the primates are built for life moving in and out of trees. They have hands and feet that are good at gripping branches with hairless, fleshy palms and fingers that mould around shapes to create a powerful frictional lock that can hold the body weight as the animal moves from one precarious position to another. One wrong move, one wrong calculation and that could be it – ending in a fatal fall. To ensure against that, primates have quick-thinking brains that are good at detecting patterns, estimating distance and creating a three-dimensional view of the branches in front of them. The animals plan ahead, at least into the very near future to think, 'Will that branch hold if I jump on to it?' However, primates are also thinking more in the long term. Their pattern-matching mind is building a complex map of the forest in not just three but four dimensions. The fourth dimension takes into account the changing availability of foods, so the maps tell the animal which trees are in fruit or flower at that moment and where to find food elsewhere when they are not.

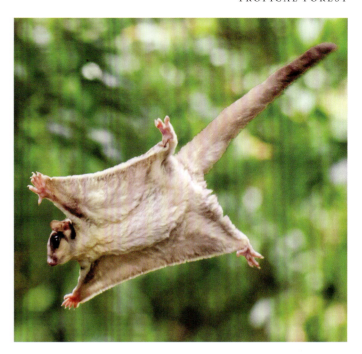

BELOW:
BROWN-THROATED SLOTH, CENTRAL AMERICA
This is the most widespread and abundant of the five sloth species, all of which live in the jungles of Central and South America. Sloths famously spend their time hanging upside down from long hooked claws and not doing much as they digest their leafy food. Algae grows in their fur making it look green.

ABOVE:
SUGAR GLIDER
Forests all over the world are home to gliding animals. This is a sugar glider, a marsupial from the forests of Australia and New Guinea. It moves from tree to tree by gliding on a membrane of skin strung between the limbs. This is a very useful way of escaping from attacks by taking a route that the predator can't follow.

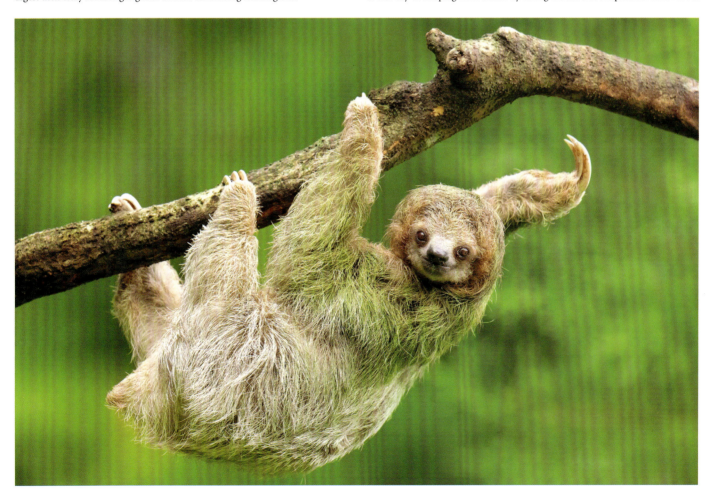

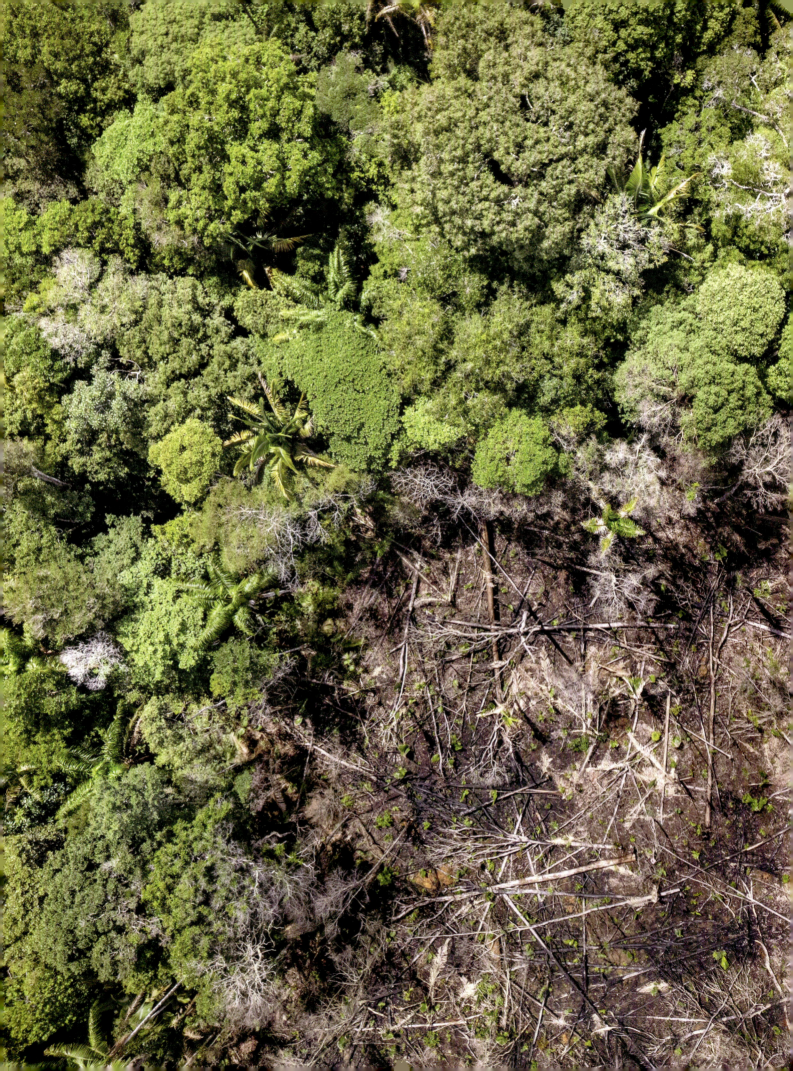

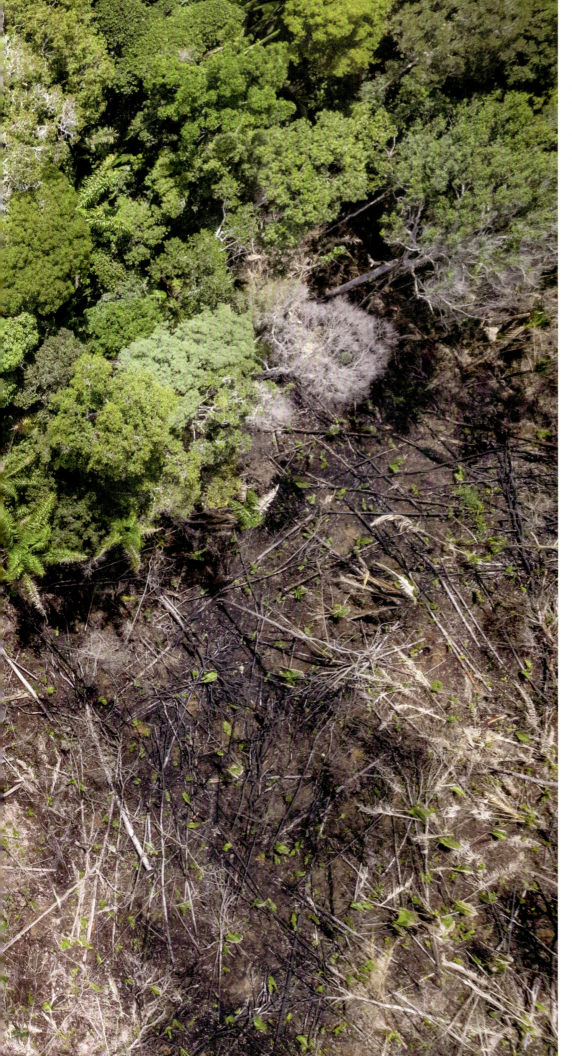

TROPICAL FOREST

DEFORESTATION
About one-fifth of the Amazon rainforest has been cut down during the last 40 years. The trees are cut down to make room for cattle pasture and for plantations of soya beans and oil palms.

TROPICAL FOREST

LIVING ARRANGEMENTS

Primates are largely fruit and leaf eaters, although some will collect insects and sweet plant exudates, such as resins, sap and nectar. The food choices have an impact on the social scene for primate species. Mostly, primates are gregarious animals that live in bonded social groups that display degrees of cooperation to secure food sources and guard young. An obvious exception is the orangutan, which is the only great ape species living outside of Africa (if we discount ourselves from that group, that is). The red-haired ape spends its days alone with the only long-term connection being between mother and child. A baby orangutan stays with its mother for nine years, the longest childhood in the animal kingdom, in which it learns how to climb and find food.

RIGHT:
OIL PALM SEEDS
Palm oil is extracted from the seeds of oil palm trees. It is used in foods as a substitute for butter and is also used in soaps and shampoos. About 70 per cent of personal care products contain palm oil.

BELOW:
SCARLET MACAW, PANAMA
The macaws are large parrots that lives in South America. They are distinguished from parrots elsewhere by the long tail and a bright almost sartorial plumage. The parrots are residents of forests where they target unripe fruits, using their vicious beaks to cut into hard foods.

OPPOSITE:
PALM OIL PLANTATION
The ordered palms of a plantation abuts a wild forest. Palm oil is a huge business. In Malaysia and Indonesia, two million farmers are supported by the crop but at the expense of natural tropical forest habitat.

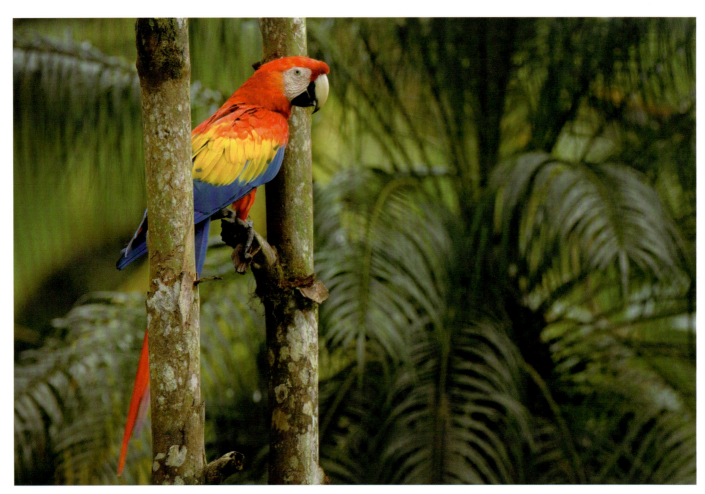

TROPICAL FOREST

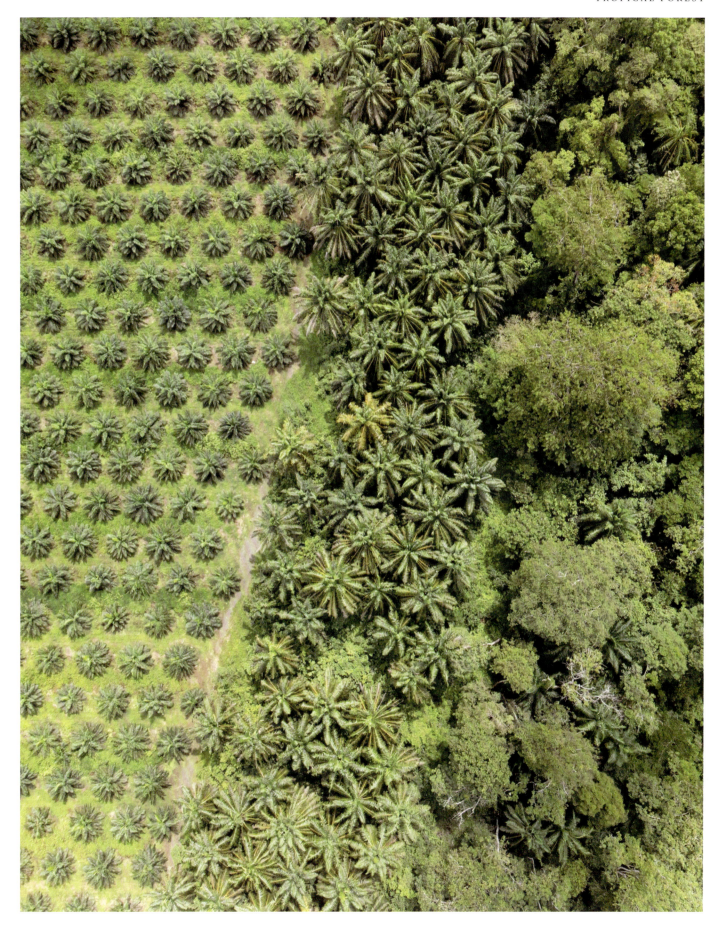

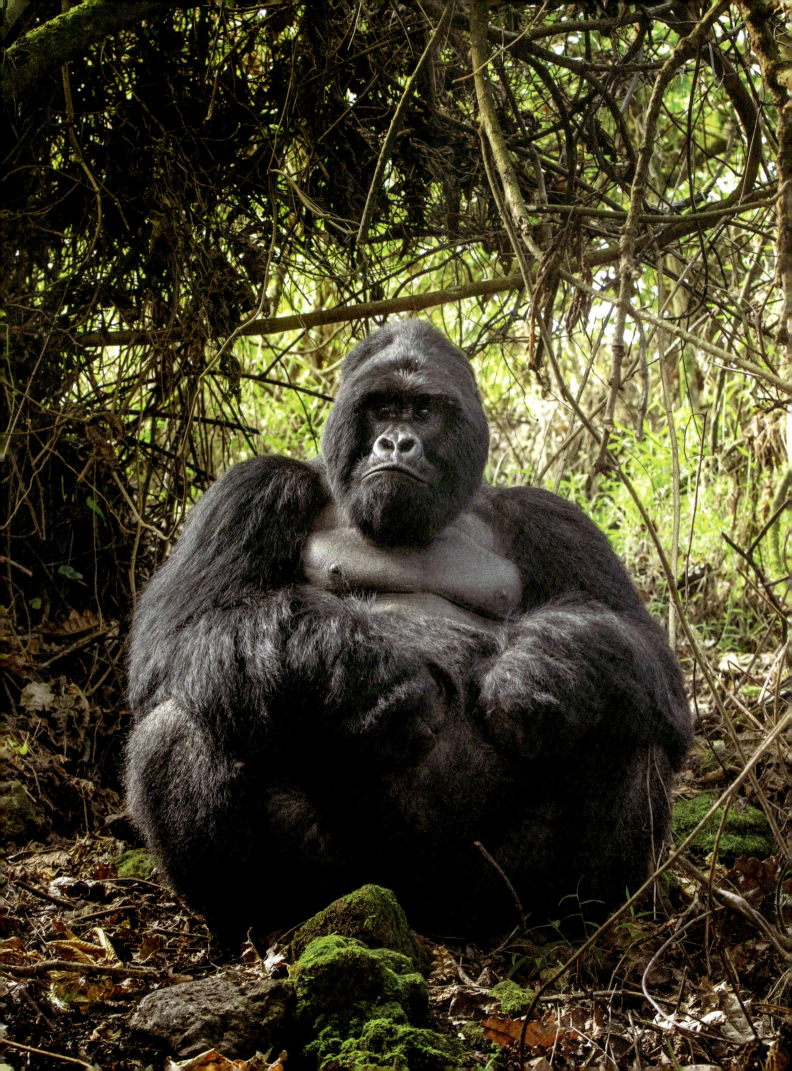

TROPICAL FOREST

OPPOSITE:
MOUNTAIN GORILLA, UGANDA
This mighty silverback is a leader of one of the few mountain gorilla troops in the wild. The mountain gorillas are a subspecies of the eastern lowland gorillas. They number less than 1000 in the mountains of Uganda, Democratc Republic of Congo and Rwanda.

RIGHT:
WILD ORCHIDS, HAWAII
Tropical orchids are used in the traditional medicines of forest people. However, collection of the flowers in the wild has put pressure on many types.

BELOW:
MANTLED HOWLER MONKEY
This noisy monkey lives in Central and South America. The males make the loudest calls thanks to a large hyoid bone that allows them to expand the larynx. The howls of a male can be heard 5km (3 miles) away.

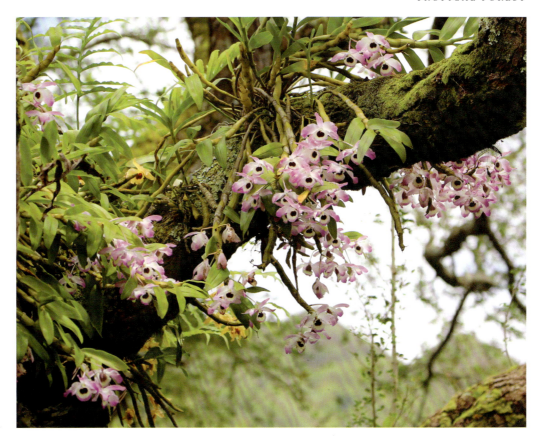

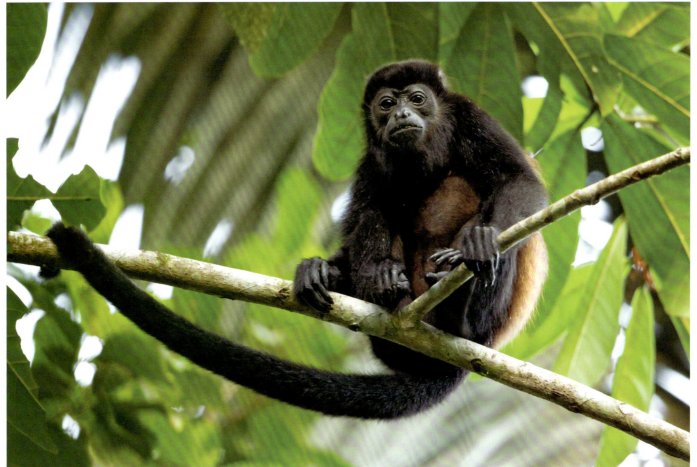

TROPICAL FOREST

RIGHT:
SLOW LORIS, INDONESIA
The loris is a nocturnal primate, a distant relative of monkeys and a closer one to bush babies and galagos. It has adopted an unusual strategy to stay unnoticed in the dark forest: it moves very slowly.

BELOW:
BUSH DOG
The dog family is divided in two between the solitary vulpine foxes and the pack-like lupines, or wolves. The bush dog is the only pack-living dog species in South America. Despite being 60cm (2ft) long and weighing 7kg (15lb), they are not the hunting force of wolves or wild dogs. The species is confined to tropical forests with more foxy relatives living elsewhere.

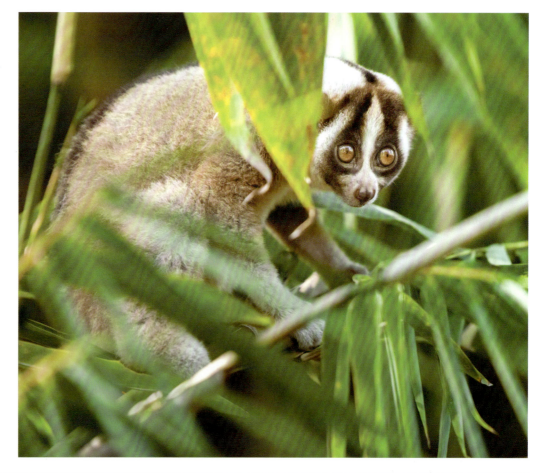

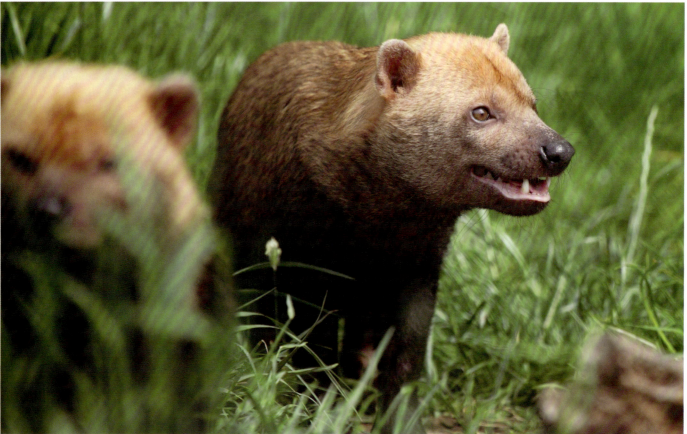

TROPICAL FOREST

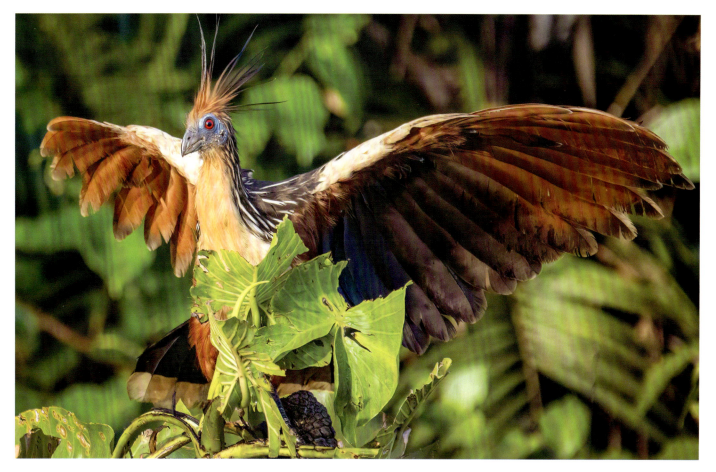

ABOVE:
HOATZIN
This unique species lives in the Amazon and the Orinoco basins in South America and has many features linking it to early birds. For example, the chicks have claws on the front of the wings that help them to climb up through the trees, as early birds may have done to help them get the elevation they needed for flight. The hoatzin is not a great flier but this is largely due to the weight of its large digestive system, which is constructed to digest leaves and other plant matter.

RIGHT:
OKAPI PARENT AND CHILD
This odd-looking creature from the jungles of the Democratic Republic of the Congo is the nearest living relative of the giraffe.

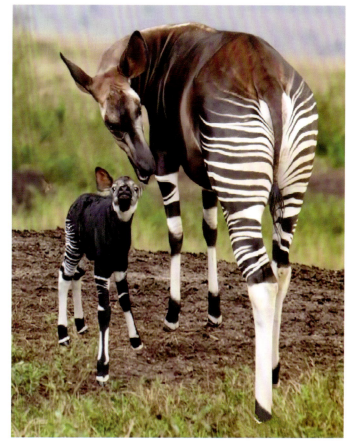

In Africa the great apes, such as chimps and gorillas, live in larger troops with a leader, mostly a tough but venerable male. Another exception is the bonobo, or pygmy chimp, which is the closest genetic link to the human species. These apes live in less hierarchical groups, where females also dominate.

The social organization of animals can be quite flexible, to suit the ecological conditions. In jungles, larger ground-living animals that might form herds in more open habitats follow a more solitary existence. For example, the African elephant, the largest land animal on Earth, has relatively recently been split into two separate species. The bush elephant remains the giant tusker out on the wide-open savannah, while the forest elephant is a smaller animal seldom seen but out there somewhere in the dense forests of Central and Western Africa.

TROPICAL FOREST

Bush elephants live in larger groups than their forest cousins, which is a trend seen across all large jungle mammals.

SIZE MATTERS

Being smaller has obvious advantages in the forest where moving around on the ground through the dense undergrowth can be a problem. The tapirs have a wedge-shaped body with shoulders narrower than the rump so it can cut through the bushes. However, size has its advantages when it comes to balancing energy and food. Bigger bodies are more efficient, and so animals with less food or supplies of food with low-nutrient value, tend to be larger. In a forest, there is more better quality food around and so that trade-off is not needed, and the elephants, rhinos and deer that live there tend to be smaller for that reason too. Being smaller is a win-win.

Without the need to defend food sources or other scare resources, the ground animals are also less inclined to fight. And again this reduces the pressure to be large. As a result, it is no surprise that the world's smallest deer, such as the pudus of South America and chevrotains of Africa, are all forest animals, and they do not need to show off with grand antlers. Unlike deer living in more open habitats, these species largely live alone. They mark a territory with scents and stay out of each other's

LEFT:
BRAZIL NUT TREE
This tall tree is the source of Brazil nuts. The trees are not easily cultivated and so the world's supply of these nuts is generally harvested from the wild.

BELOW:
BUSHMASTER SNAKE
This is a relative of the rattlesnakes and lanceheads and is the most venomous snake in the Americas. One bite is enough to kill a person.

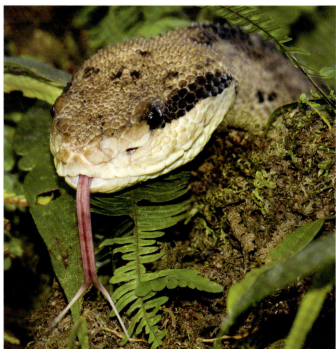

TROPICAL FOREST

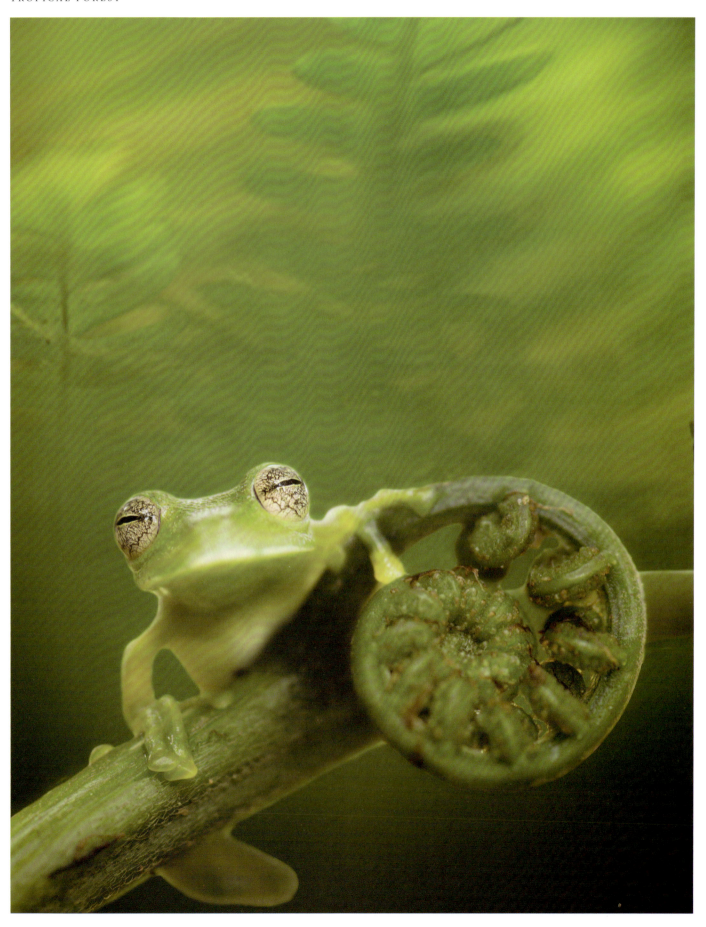

TROPICAL FOREST

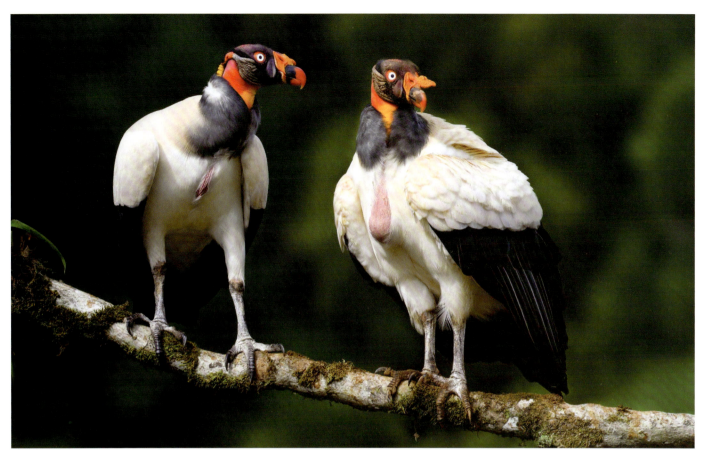

OPPOSITE:
GLASS FROG EYES
Most frogs have eyes that point sideways to survey the wider area for danger. Glass frogs have eyes that point forward so they can spot prey right ahead of them.

ABOVE:
KING VULTURES
Even with their elaborate colouring, these scavengers still exude a menace. The king vultures are the world's largest vulture species. They are the primary scavenging bird in the Amazon rainforest.

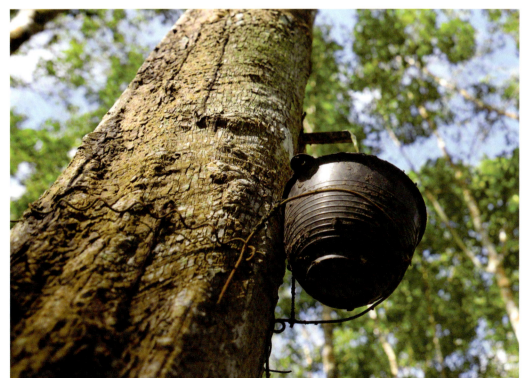

LEFT:
RUBBER TREE
Natural rubber is a product created from the latex of the rubber tree. Latex is a kind of elaborate defence system used by the tree to seal up injuries and make the plant less palatable to predators. When tapped and exposed to the air, the latex hardens into a flexible solid. Originally from the Amazon, rubber trees were relocated across the tropics, especially to Asia, to make rubber plantations. Natural rubber was a significant technological product until synthetic versions were invented in the mid-20th century.

TROPICAL FOREST

way, until it is breeding time that is. This social organization is similar for other forest species, with even wild cattle known for living in large herds elsewhere opting for smaller groups.

GETTING NOTICED

All large animals find it easy to hide among the dense foliage of the rainforest. In fact anyone walking in a forest will struggle to see any animals at all, certainly vertebrates. And that is a problem for some animals – and an advantage for others. Glass frogs and clearwing butterflies have come up with a clever solution for staying unseen by predators. They are largely transparent and so we only see what is behind them, not in front of them. Jaguars and other spotted predators, which include smaller cats like ocelots and margays as well as cat-like genets and civets, use this colour to blend in. That is hard to imagine when these animals are seen out in the open, but their home is in the dappled light of the deep forest, where everything is dark with a few shimmering spots of light shining through the gaps in the branches above. The fur rosettes and spots blend in much better there.

However, some animals want to be noticed by others of their kind and find a mate. Forest birds, especially the males, are skilled in using bright colouring to be seen – and to impress. The resplendent colouring and symmetrical plumage is a clear sign of health and fitness. Anoles are American lizards that signal for mates using a bright dewlap, or chin flap, which they open and close to flash colour signals through the leaves. Anoles are also able to change the colour of their skin over a few minutes, a trait more commonly associated with chameleons, which live in Africa and Asia. Contrary to popular belief, chameleons cannot take on the patterns of their surroundings, but will adopt a background green or brown when relaxed. However, when stressed by rivals or hoping to impress a mate, they take on a more vibrant colour.

BELOW:
BLACK PANTHER
Contrary to popular belief these majestic creatures are not a distinct species in their own right. In Africa and Asia, where they are most common, these jungle cats are melanistic leopards. The dark spots are still there, it is just that the fur around them is also dark, not a paler yellow-brown. In South America, black panthers are jaguars.

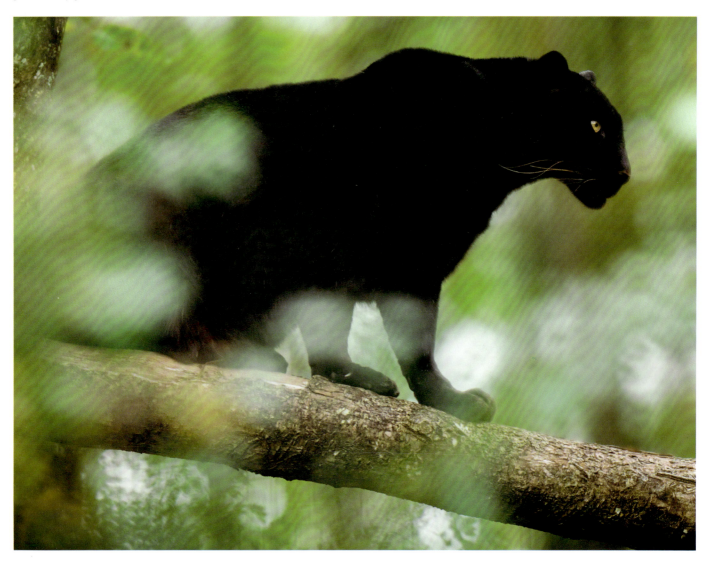

TROPICAL FOREST

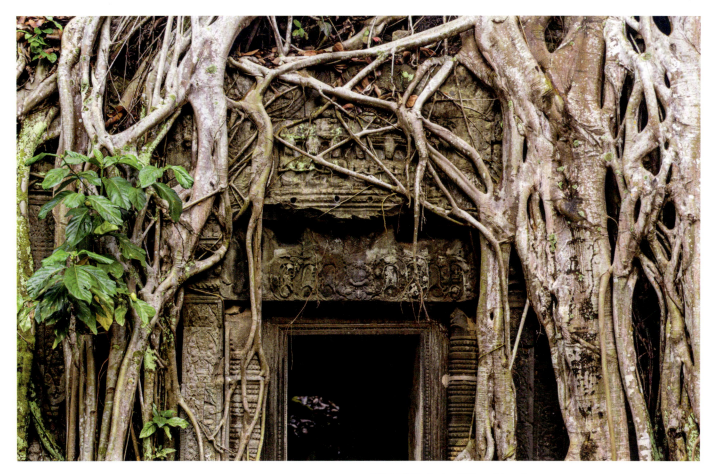

ABOVE:
STRANGLER FIG, TA PROHM, ANGKOR WAT, CAMBODIA
The thousand-year-old temple complex of Ta Prohm in Angkor Wat, Cambodia, has been taken over by the forest, specifically strangler figs. The doorway here is surrounded not by stems but by roots. The strangler fig seeds are deposited on high branches in the droppings of a frugivorous monkey. They sprout up there and branches spread out through the canopy, while roots are sent down the trunk of the host plant to the ground. The roots eventually form a wooden sheath around the host, which dies leaving a hollow structure that supports part of the heavy plant up above.

RIGHT:
MAHOGANY TREES
This dense hardwood tree is a widespread species in tropical areas. The wood is resistant to attack from termites and wood-boring beetles. This fact, along with the distinctive red wood, is a reason why mahogany species are routinely cut for use in furniture and other construction. As a result, the species are mostly endangered worldwide.

DANGEROUS FUTURE

Tropical rainforest across the world is in great danger. The story has been repeating for decades now as forests are cleared on an industrial scale. First loggers or miners cut a road into the forest to access the largest and most valuable hardwoods, the gold or gems. Their temporary camps become more established settlements as displaced people come looking for a place to live. They need farmland and so clear the forest, slashing the trees and burning the wood to create a richer soil. This is used for grazing cattle or growing crops, and often this land descends into an infertile and eroded dustbowl. Where agriculture is more viable, the land becomes a vast monoculture for soy or oil palms.

TROPICAL FOREST

AFRICAN FOREST ELEPHANT, DEMOCRATIC REPUBLIC OF THE CONGO

In recent decades it has been agreed that the African elephant should be treated as two distinct species. The bush elephant is the mighty beast we are all familiar with that walks the African savannah. The African forest elephant, which lives in smaller groups in the jungles of Central Africa, is less visible, less familiar and less superlative so gets less attention. It has shorter tusks and is about 2.5m (8ft) tall to the shoulder (the bush elephant is 3.5m/11ft). In 2013, only 30,000 forest elephants remained in the wild, with the numbers sure to be lower now due to poaching.

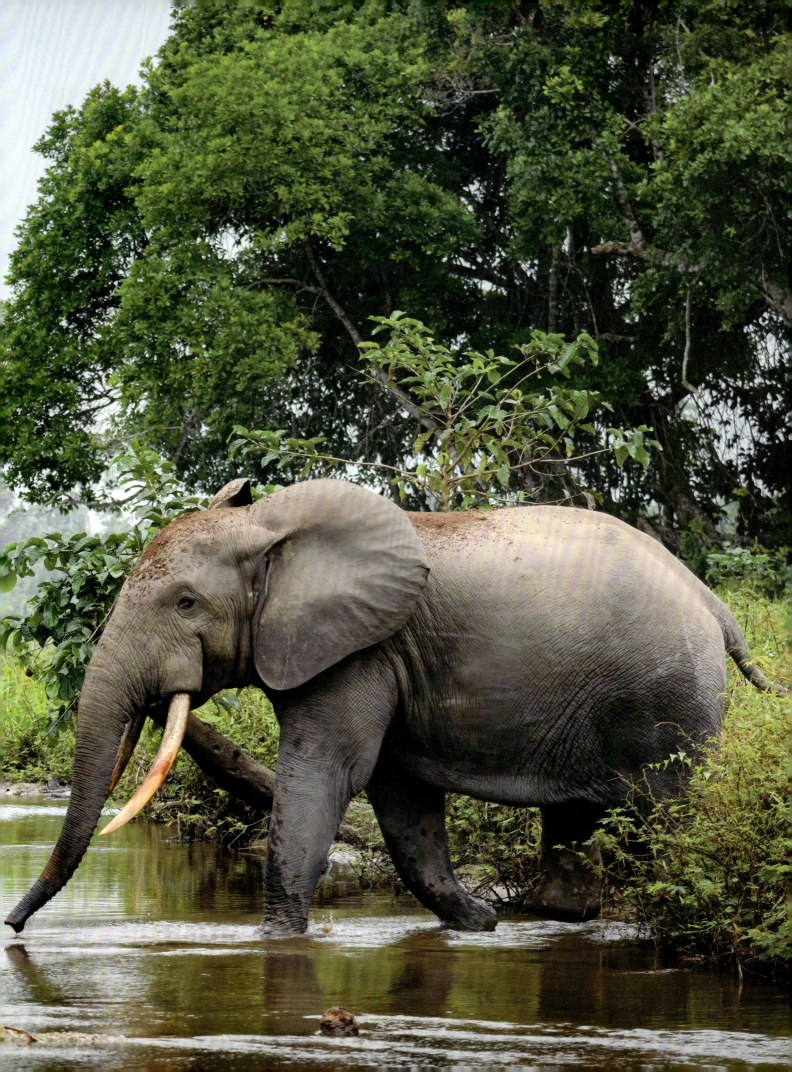

TROPICAL FOREST

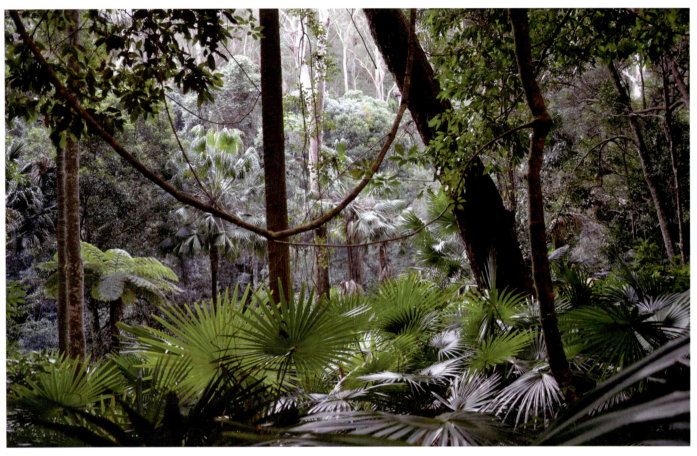

ABOVE:
UNDERSTORY
This understory shows that the habitat is under pressure from grazing animals or more likely human activities. The understory of the most pristine lowland forests is like a forest within forest, rising several metres above the floor with very few plants growing at ground level. Here a mix of plants are racing to occupy this habitat and are be frequently thwarted by outside factors.

OPPOSITE:
AYE-AYE, MADAGASCAR
This is one of the most bizarre species of primate. The aye-aye is a nocturnal lemur from Madagascar. It has an extended middle finger with a hooked claw-like nail. The primate taps branches with the finger listening for the sounds of hollow burrows under the bark made by beetle grubs. When it finds a target, it will dig out the juicy larva with its hooked finger.

LEFT:
GLASSWING BUTTERFLY
As the name suggests, these forest butterflies from Central America and neighbouring regions have transparent wings. This helps the butterfly disappear from view as it perches on forest plants.

The once all-pervading jungle is reduced to dislocated fragments that are too small to support the diversity of life that once lived here, and animals have no means to survive in the artificial farm habitats that stand between one pocket of forest and the next.

The tragedy is that if these fields were left to return to nature, the primary rainforest that once stood here can never return in its original form. That diversity is probably lost. Instead a secondary forest stripped of variety will sprout but even that may not be possible. The humid climate that supports forests are in part sustained by the forests. The blanket of trees gives out vast amounts of water vapour, which fuels the rain clouds. With fewer trees there are fewer clouds, and with fewer clouds there are fewer trees. Conservationists are building up seed banks and rescue nurseries so they can replant and restore the forest as best they can. But for that to happen the forest must be protected from further destruction.

TROPICAL FOREST

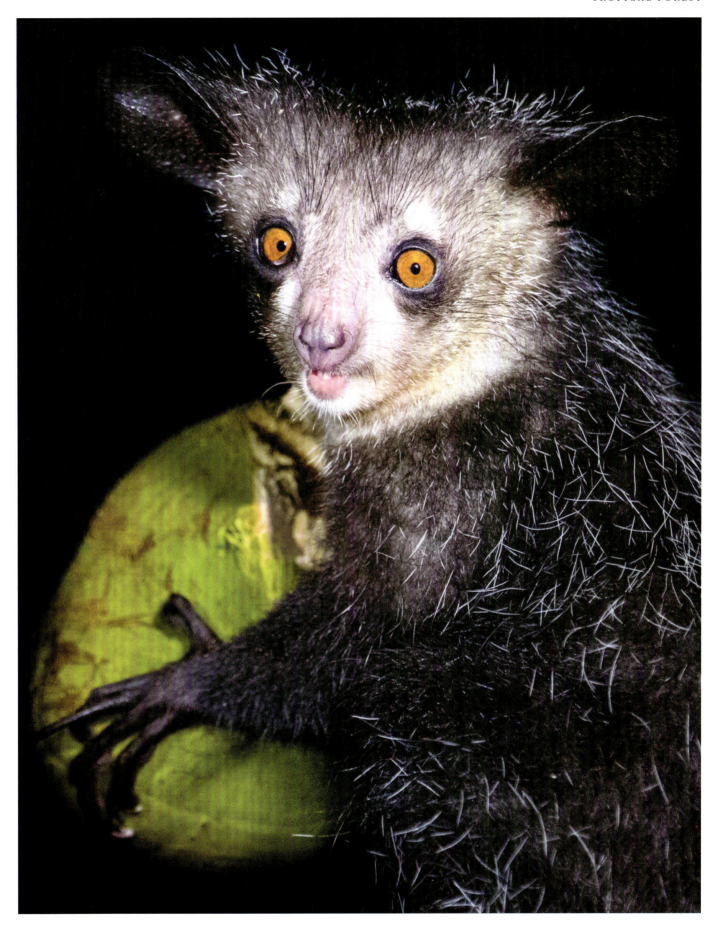

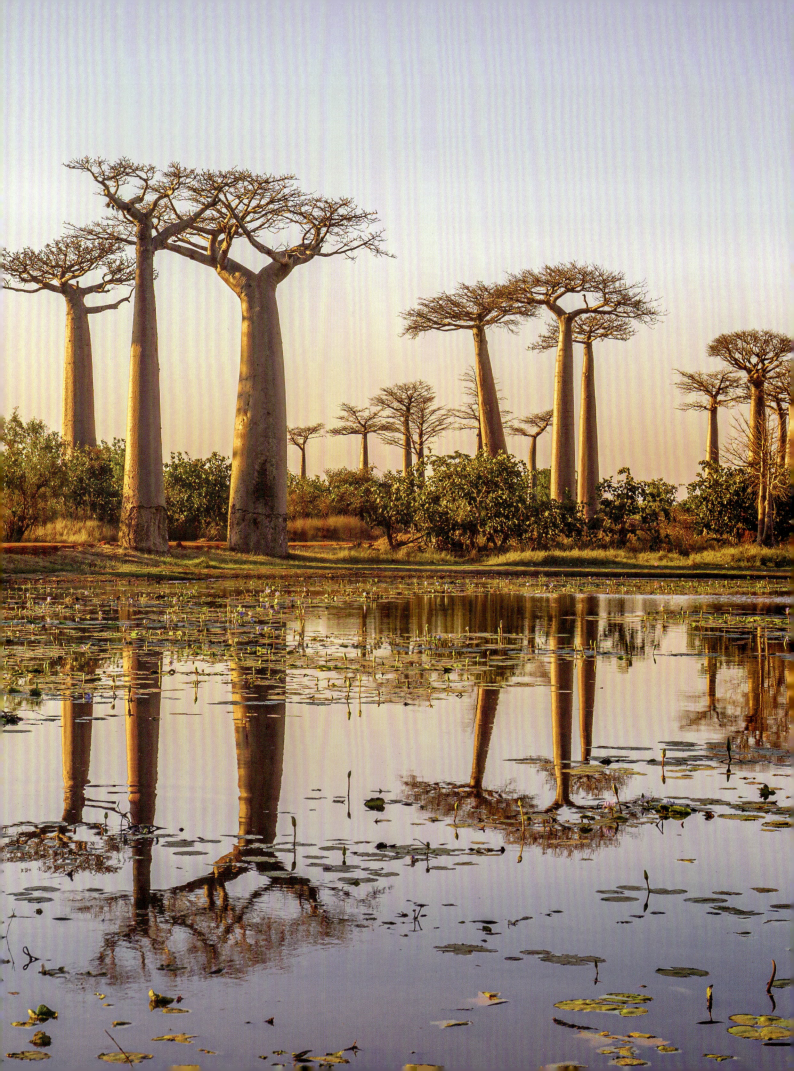

SAVANNAH

The wide open savannah is one of the most familiar natural habitats. This is where many of the world's animal icons live. A savannah is a lowland area, largely flat in all directions with clear views that go on for miles. This is all thanks to the fact that most of what grows here is just grass and smaller plants.

Here is where elephants roam, lions prowl and vast herds of hoofed beasts chew mindfully watching out for ever present dangers. Savannah – or savanna – is a storied term, borrowed by Spanish conquistadors from the Taino, the indigenous people of the Caribbean. To them the word meant a grassland without trees, but today it has a wider application. Savannah is a tropical habitat, and grass is always a dominant features, but aside from grass savannahs, there are shrub savannahs where there are small, woody perennials (or plants that live for several years), with areas of grass and earth in between. In a tree savannah, the shrubs give way to trees, which are essentially the same class woody plants but have the resources to grow larger. How big is a tree? Above 10m (33ft) tall would be a good rule of thumb. Also a tree is distinct from a shrub in that there is an obvious trunk and crown of branches. The fourth type of savannah is the woodland savannah, where the trees are close enough to form a loose canopy. (There are plenty of gaps for glades of grass or smaller plants.)

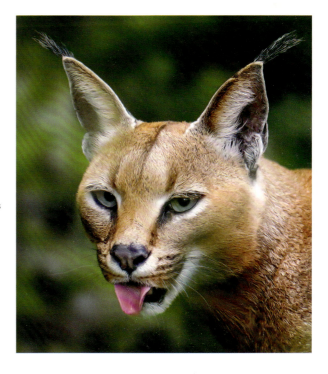

OPPOSITE:
AVENUE OF THE BAOBABS
This stand of majestic baobab trees is in western Madagascar. The baobabs are 30m (100ft) tall and are the largest plants by far in the surrounding arid shrublands. The tree is able to store water inside its swollen trunk, making it able to grow through even the driest parts of the year.

RIGHT:
CARACAL
This elusive creature is one of the less known wild cats. Its name means 'black ear' in Turkish; the species has distinctive dark tufts on its ears. The cat lives in the dry grasslands and broken habitats of Africa, Arabia, the Middle East and over to the west of India. It is about the size of a spaniel dog, and is distinctive for its ability to leap 3m (10ft) into the air and snatch birds on the wing.

SAVANNAH

WHERE IN THE WORLD

The determining feature of the four savannah types is rainfall. This is enough to stop the land becoming a desert – although that distinction is blurred during some months. However, the rainfall is not enough to sustain a forest, where the tree boughs spread out and upwards to form a closed canopy, that soaks up all the sunlight.

Savannahs are tropical grasslands and ecologically distinct from the prairies, plains and steppes of more temperate regions. These are cooler (sometimes frozen) lands that have fewer trees and a different pattern of rainfall (see page 172). Tropical grassland is found on all continents except Europe and Antarctica. It is rare in Asia, only seen in patches in the Indian subcontinent, such as at the windward base of the Himalayas. Similarly this habitat type is not well represented in North America, with a few grasslands occupying the coastline of the Gulf of Mexico.

RIGHT:
AFRICAN ELEPHANT
The African bush elephant is the largest land animal on Earth. It measures more than 3m (10ft) to the shoulder and weighs 6 tonnes. (The biggest ever recorded was 4m/13ft tall and weighed 10 tonnes.) This large adult lives on the savannahs beneath Mount Kilimanjaro. Females and young elephants live in large, well-bonded families. The male bulls tend to spend most of their lives alone or in smaller all-male groups.

BELOW:
ELEPHANT GRASS STEMS
Also called Uganda grass, this hardy perennial is a mainstay of Africa's savannahs. It does not need much water or minerals and grows in small thickets that can reach 7m (23ft) high in just four months – unless an elephant or another grazer crops it short first.

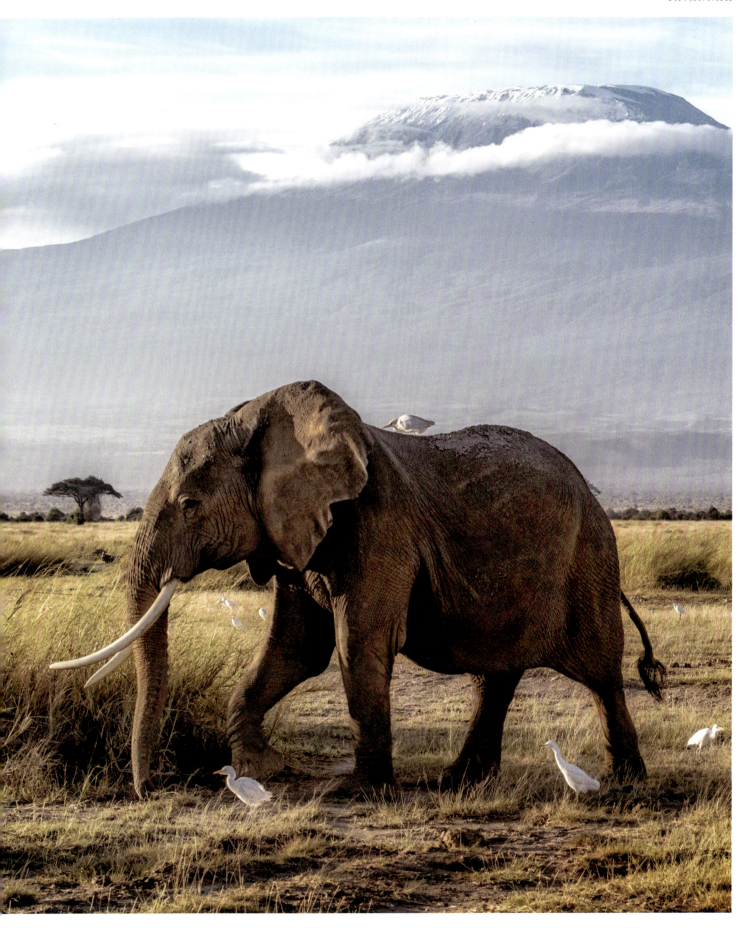

SAVANNAH

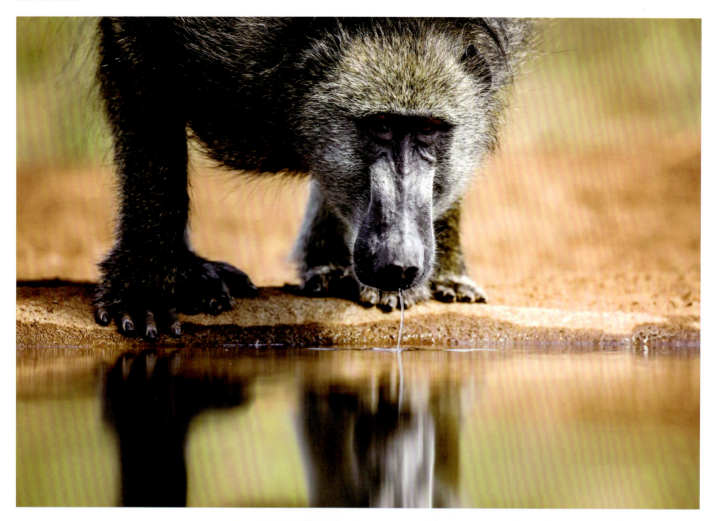

ABOVE:
CHACMA BABOON
A baboon takes a drink from a watering hole. This large monkey is a common feature of the savannahs of southern Africa. It lives in organized groups called troops led by the larger males. The males are often aggressive to each other as they jostle for dominance in the group.

RIGHT:
DUCHESS PROTEA
This flower is from the Cape Floristic Region, a highland savannah that grows in the mountains along the coast of South Africa. The hardy shrub blooms in the spring, producing large rounded flowers. Another name for the flower is sugarbush. Areas where there are large amounts of these flowers are known as fynbos, which means 'fine plants'.

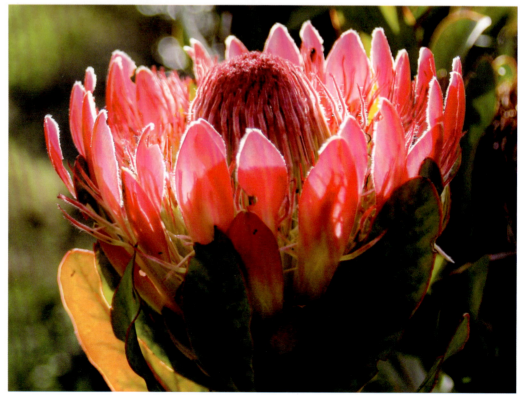

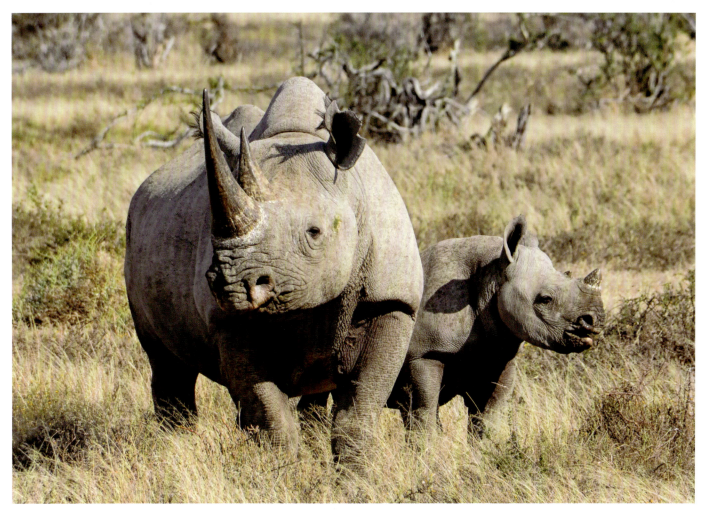

ABOVE:
BLACK RHINO AND CALF
This giant savannah animal is one of the rarest mammals on Earth. It has long been persecuted, shot by hunters who want only the long horns of the adults. There are just a few thousand left, but numbers are rising as protection against poaching has been stepped up. The black rhino is a browser. It has a beak-shaped mouth for cropping leaves from bushes.

The tropical grasslands of South America go by different names. The Llanos of Venezuela is a vast grassland that fills the lowland region of the Orinoco Basin. It is home to deer, giant armadillos and anteaters. These animals also appear in the Chaco, a drier savannah with thorny trees and shrubs that occupies the rain shadow behind the Andes Mountains, mostly in Argentina and Paraguay. (The wind here, rolling down from the peaks is mostly dry because all of its rain was dropped as it rose up the western slopes.) To the east into Brazil, is the Cerrado, a vast savannah that is almost as large as the Amazon rainforest to the north. One of the residents here is the maned wolf, which despite its name is actually better characterized as a fox with long legs – and a scruffy mane.

Across the Pacific Ocean, the outback of much of northern and eastern Australia is essentially a tropical shrubland albeit with some unusual flora to match the famously unusual marsupial fauna. For example, this includes thickets of spinifex grasses, known for the crystals of glass-like silica inside that stiffens the blades and deters grazers from taking a bite. The famous red soils of these parts are low in nutrients, and so there is not enough grazing for large numbers of big mammals, such as kangaroos. Reptiles, smaller marsupials and ants and termites take on that role of eating the plants available.

The nutritional situation is quite different in the African grasslands, especially those in East Africa such as the Serengeti and Masai Mara. Here the grass grows thickly and provides the basis for an immense food chain that includes giraffes, warthogs, rhinos and vast herds of antelopes. There are similar scenes to the south, where the grasslands are also known as the Afrikaans veldt, meaning field or meadow. The other major grassland in Africa is the Sahel, which is to the north of the Congo Basin. Its name means coast or shore in Arabic, and the grassland and acacia thickets steadily thin out to the north giving way to the arid sea of rock and sand that is the Sahara Desert.

GRASSLAND CLIMATE

Readers may have noted that these tropical grasslands are often neighbours of tropical forests, generally in slightly higher latitudes. Most tropical savannahs will be between 8 and 20

SAVANNAH

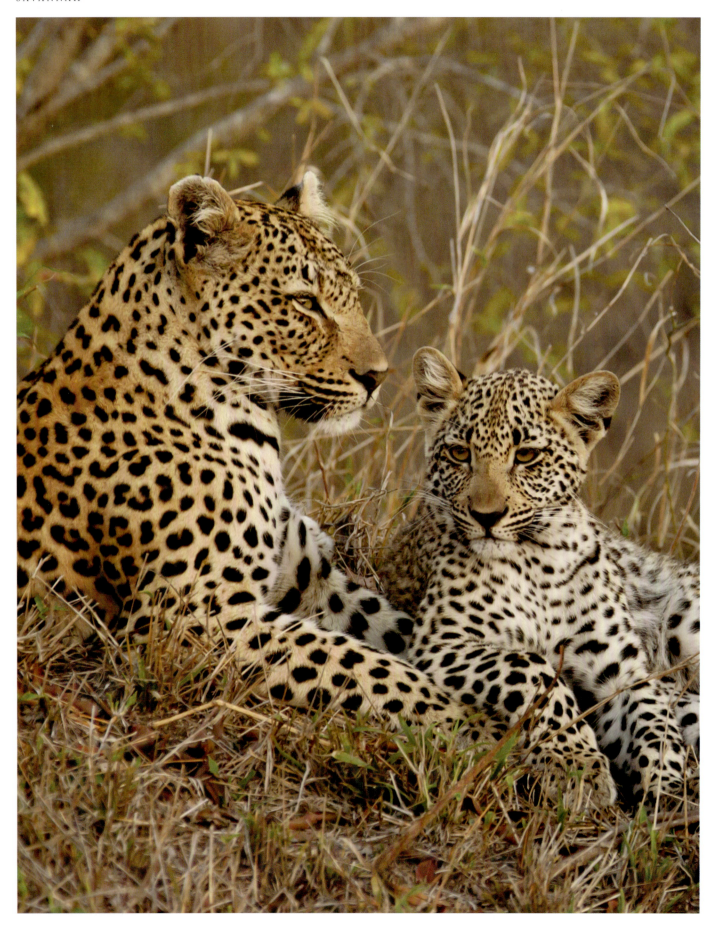

SAVANNAH

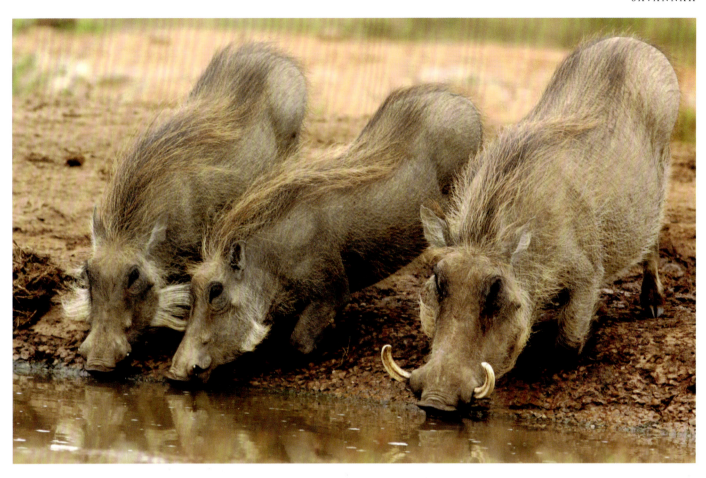

ABOVE:
WARTHOGS AT A WATERING HOLE
A trio of warthogs need to kneel down so they can get at a watering hole. Warthogs are named for the lumps on their faces. They are grazers after the wet season but in the dry season they will use their feet and snouts to dig out bulbs and roots to eat.

LEFT:
LEOPARD AND CUB
These hunters are number three in the big cat ranks, after the tiger and lion. Leopards are the most widespread of the big cats, ranging from southern Africa, through the Middle East, India and Tibet to Indonesia. In the eastern part of its range, the cat is confined to tropical forests but it is most common and abundant in the savannahs of Africa.

RIGHT:
ZEBRAWOOD
Also known by the local name msasa, this savannah tree is growing in the Chimanimani Mountains of Zimbabwe. The tree bursts into life after spring rains and produces leaves that are a red colour to start with before changing to green.

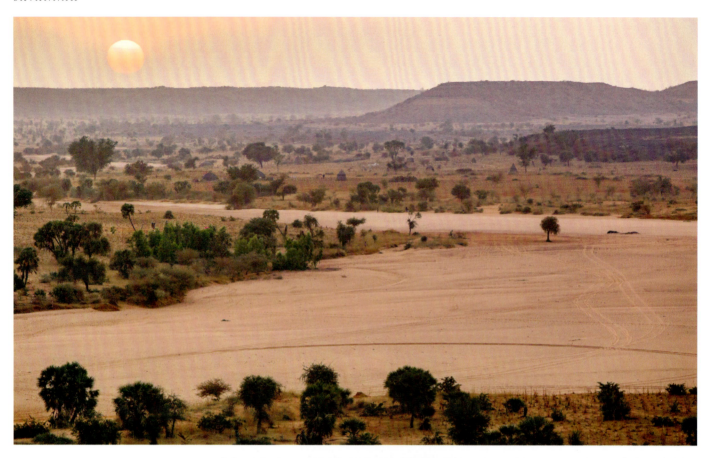

ABOVE:
SUNSET OVER THE SAHEL
The Sahel in Niger is a transitional region where Africa's grasslands fade into the Sahara to the north. It is a place where long droughts frequently decimate the local flora and fauna. The herbivores here, such as the dama gazelle and scimitar-horned oryx, are highly adapted to living in near-desert conditions.

RIGHT:
RED GRASS
These are the spikelets, or flowers, of a widespread grass plant. This particular species is common across southern and eastern Africa, but it is also found in South Asia and Australia (where it is called kangaroo grass). It has few commercial applications and so remains a largely wild grass that forms thick tussocks.

degrees north or south of the equator. As the warm, wet air billows up from the equatorial region, it leaves its rain on the forests and is largely a dry wind by the time it reaches the grasslands. Tropical grasslands always experience a dry season when rain is rare and showers are short. However, grassland regions receive between 50cm (2ft) and 150cm (5ft) of rain each year, and most of that arrives in the wet season. In a so-called 'wet savannah' the dry season will last less than five months, and it could be seven months long in a dry savannah.

During the dry season, the grasses will die back and dry out, leaving little more than bare earth. The larger, woody plants are able to tap deeper into the soil to reach the water table. These plants typically have oily bark and leaves. The oils help them to resist drying out in the long days of baking sunshine. Nevertheless the dry seasons in tropical grasslands and woodlands are the colder parts of the year – although the reduction in temperature is minimal, perhaps only a few

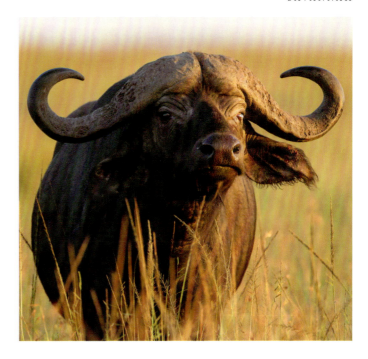

ABOVE:
CAPE BUFFALO
Once a term used by game hunters, and now used by tourists on an African safari, the Big Five refers to the five most important animals to encounter. The cape buffalo is the fifth animal (and least remembered) of that quintet. (The others are elephant, rhino, lion and leopard).

BELOW:
SPOTTED HYENA
This is the largest and most dangerous of the hyenas, which are an unusual group of mammals that mostly get their food from scavenging for carcasses. Despite looking like dogs, hyenas are more closely related to the mongooses and beyond that the cats. The spotted hyena is tough enough to kill for food, but also uses its brutish strength to defend the carrion food it has found. The hyena relies on its bite strength, which rivals that of polar bears, to crack open the bones of larger animals to access bone marrow. Few other animals are able to do this.

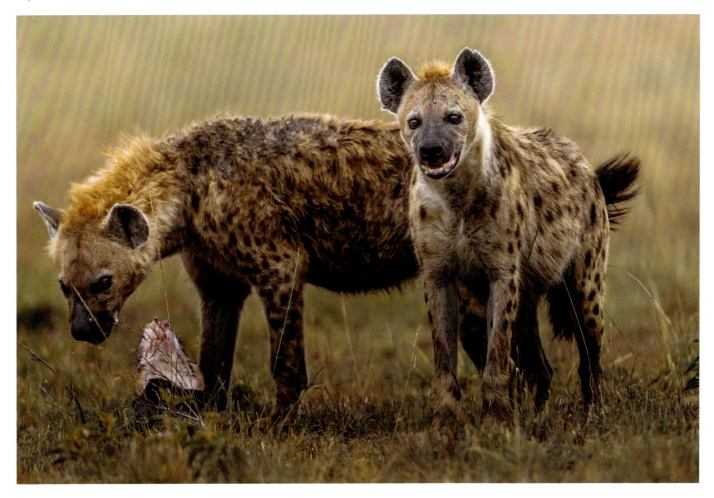

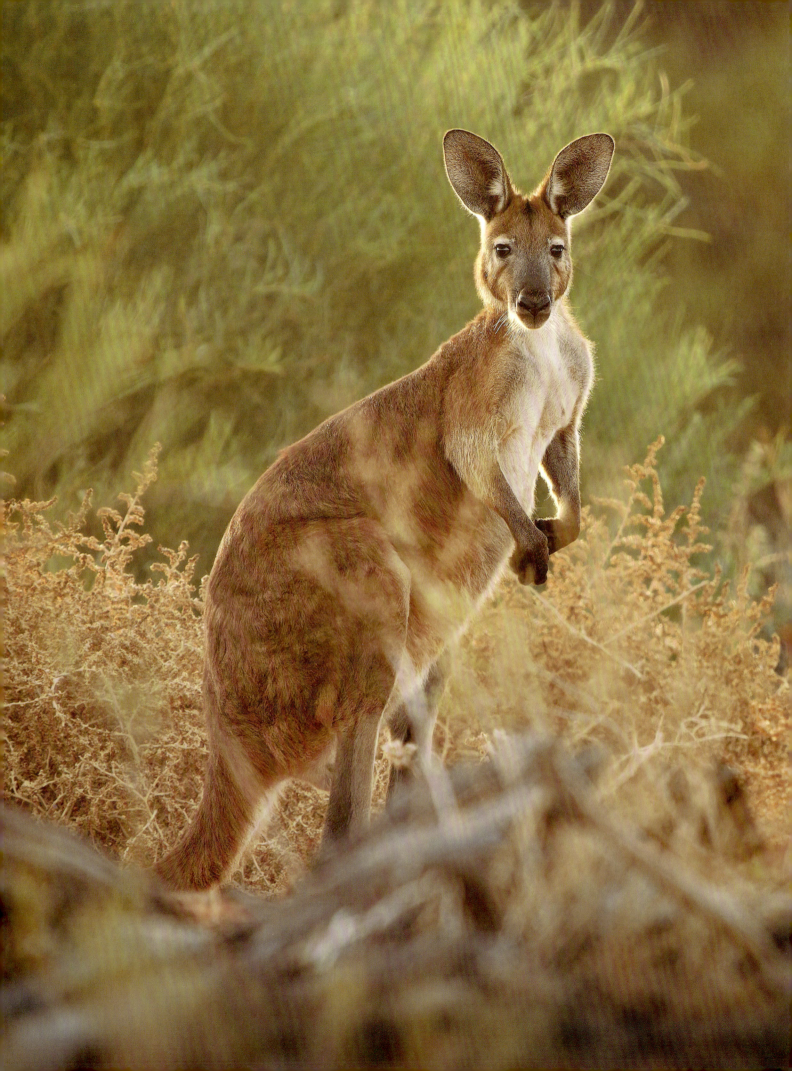

SAVANNAH

LEFT:
COMMON WALLAROO
Also known as the euro, this small relative of the kangaroo is widespread across Australia. It is normally solitary and mostly active at night, grazing on grass shoots.

BELOW:
KOALA MOTHER AND JOEY
This mother and baby are up a eucalyptus tree in New South Wales, Australia. These leaf eaters can be found in dense forests but are also at home in more open savannah woodlands, where the trees are widely spaced.

degrees. In the warmer times, more moisture comes off the oceans, making the air more humid, and this is what feeds the rain clouds of the wet season.

READY TO GO

The grasses may look dead but they are lying dormant under the soil. As soon as the water trickles back into the earth, the grass plant begins to sprout blades that shoot up. Wet savannahs have more grasses that grow to taller heights than dry savannahs, where the flora has more thornbush. This is the catch-all name for woody savannah plants that are often equipped by long thorns and other spiked features. In the dry season, their leaves are one of the few sources of food and they need to defend themselves from hungry browsers.

Grass is ideally suited to occupy dry soils when the water resources are available. The growth point, or meristem, is in the base of the stem and blade-like leaves, which is unusual. Most plants have meristems near the periphery of their growth as they look to spread out in all directions. Grasses will never have the time for this and so just grow up and up, surging from the base. (The fastest-growing land plants are bamboos, which

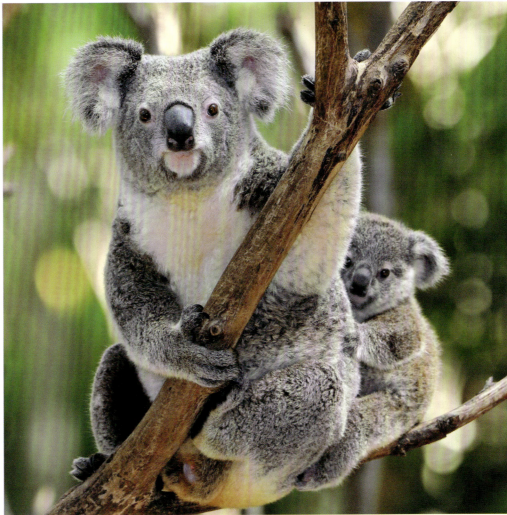

SAVANNAH

GIRAFFE AND UMBRELLA TREES
The giraffe is a famous product of evolution during which its neck evolved to be enormously long so it could reach the leaves beyond the reach of other savannah herbivores. Evolution has done something similar to the umbrella trees, a tall kind of acacia plant found on the savannah. The canopy is wide and high, so nothing but a giraffe can reach it.

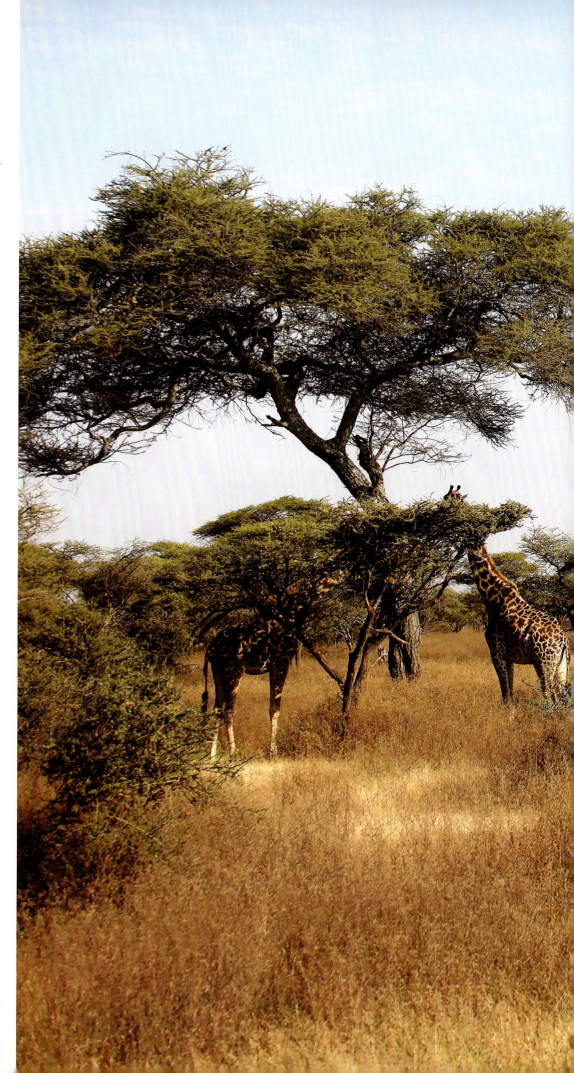

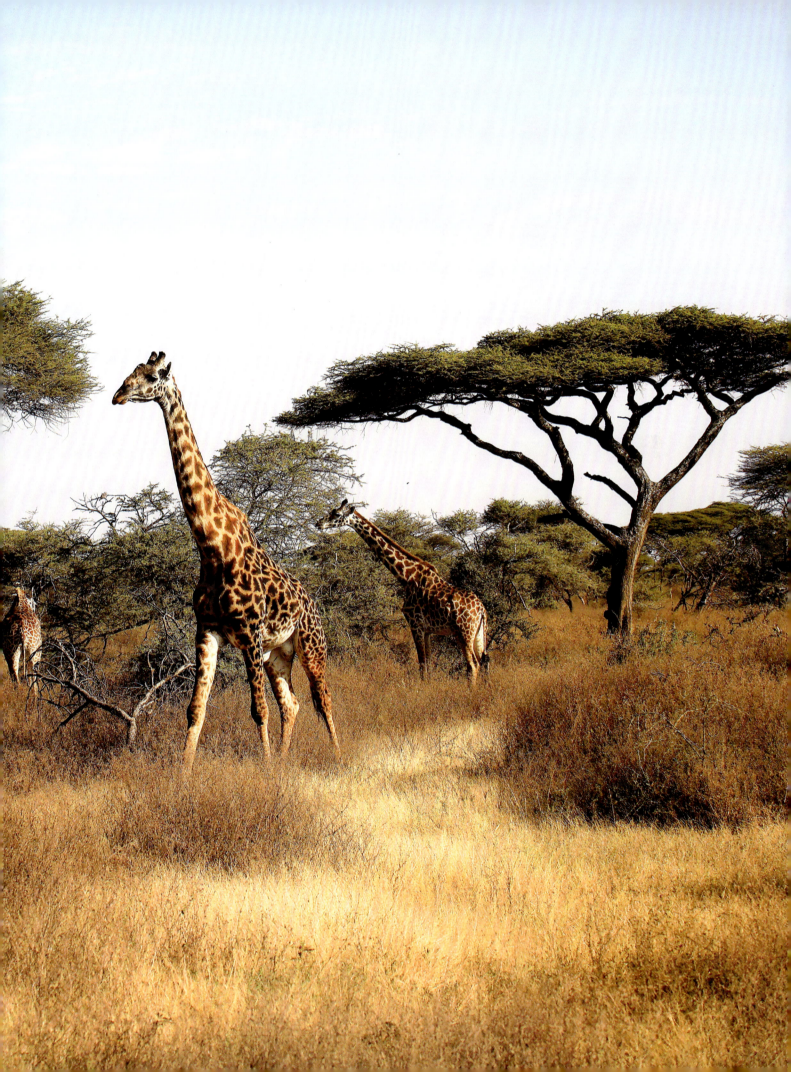

SAVANNAH

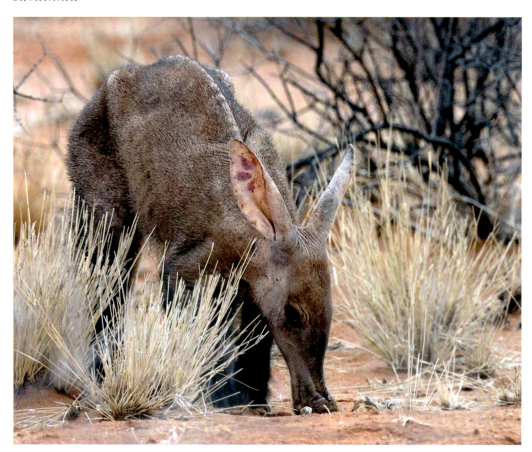

LEFT:
AARDVARK
This name means 'earth pig' in Afrikaans. Despite the snout shape, the aardvark is a distant relation to hogs. Instead it belongs to an eclectic group that includes manatees (sea cows), hyraxes and elephants. The aardvark eats ants and termites using its snout to sniff them out.

BELOW:
TERMITE MOUNDS
In the Northern Territory of Australia, the biggest plant eaters are the termites. Each one of the cathedral termite mounds is home to more than a million termites. They eat the hardy spinifex grasses that are too tough for other animals. Each mound can consume as much grass as a beef cow.

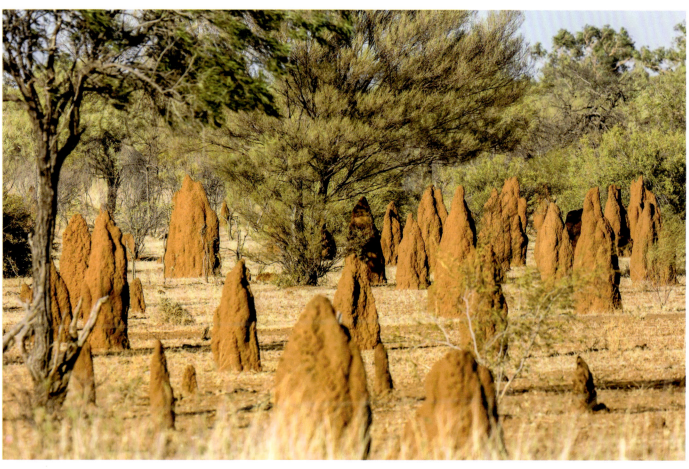

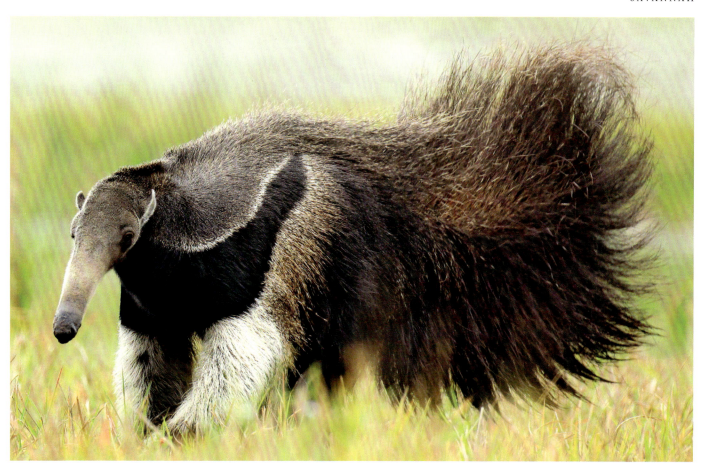

ABOVE:
GIANT ANTEATER
The giant anteater of South America uses its forelegs and hooked claws to dig into anthills and termite mounds. The anteater is able to eat 35,000 ants or termites a day, licking them up with a 60cm (2ft)-tongue that flicks in and out of the small mouth on the tip of the long face. The tongue is coated with sticky saliva and tiny hooks also grab several ants at once.

are a kind of grass.) The grass plants' only aim is to flower, disperse pollen and set seeds within weeks of the first rains. Those seeds might germinate straight away and do the same, or if the wet season is only short, fresh seeds will sit out the dry season and sprout next time.

FOOD SUPPLY

All the while, the lush grass is a food source for the grassland's animals. From rhinos down to grasshoppers, the food web of the savannah is built on grasses. Grazing animals crop the grasses as close to the ground as they can, but this does not kill the plant. The basal meristem stays intact and fresh blades shoot up taking another shot at completing the life cycle and producing seeds.

A wet savannah is a sea of grass. It is literally everywhere. In a dry savannah, the less palatable thornbushes and trees are equally spread across the land. There is no one spot that has appreciably more food than anywhere else. This simple fact has a significant impact on the ecology of the savannah.

Herbivorous animals are not able to control a feeding territory when food is more or less everywhere. Instead they simply eat whatever is in front of them. If the food runs out then they move on. Fresh food is seldom very far away.

As is common in biology, several unconnected factors conspire to create a typical herbivorous grassland mammal such as an antelope, deer or kangaroo. Firstly, grass and leaves are a poor source of nutrition. They are mostly made from cellulose that is indigestible to mammalian stomach enzymes. (Cellulose in human diet is treated as 'fibre' that goes right through us, and keeps our bowels healthy and regular.) Herbivorous mammals use a variety of methods to extract nutrition from it. This invariably involves fermenting it in the stomach with bacteria, which are able to break down the cellulose to simpler sugars that can be absorbed and used by the body. Ruminants, such as antelopes, which are relatively close relatives of cattle and sheep, will chew the cud, for example. This involves regurgitating partially digested food into the mouth where it is given another chew to aid its mechanical breakdown.

The economy of eating grasses and leaves promotes large bodies. The volume of an object – any object, including an animal body – increases exponentially compared to its surface area. Doubling the surface area of a body increases its weight and volume by a factor of four. That means larger bodies have a relatively smaller surface area than smaller ones, and so

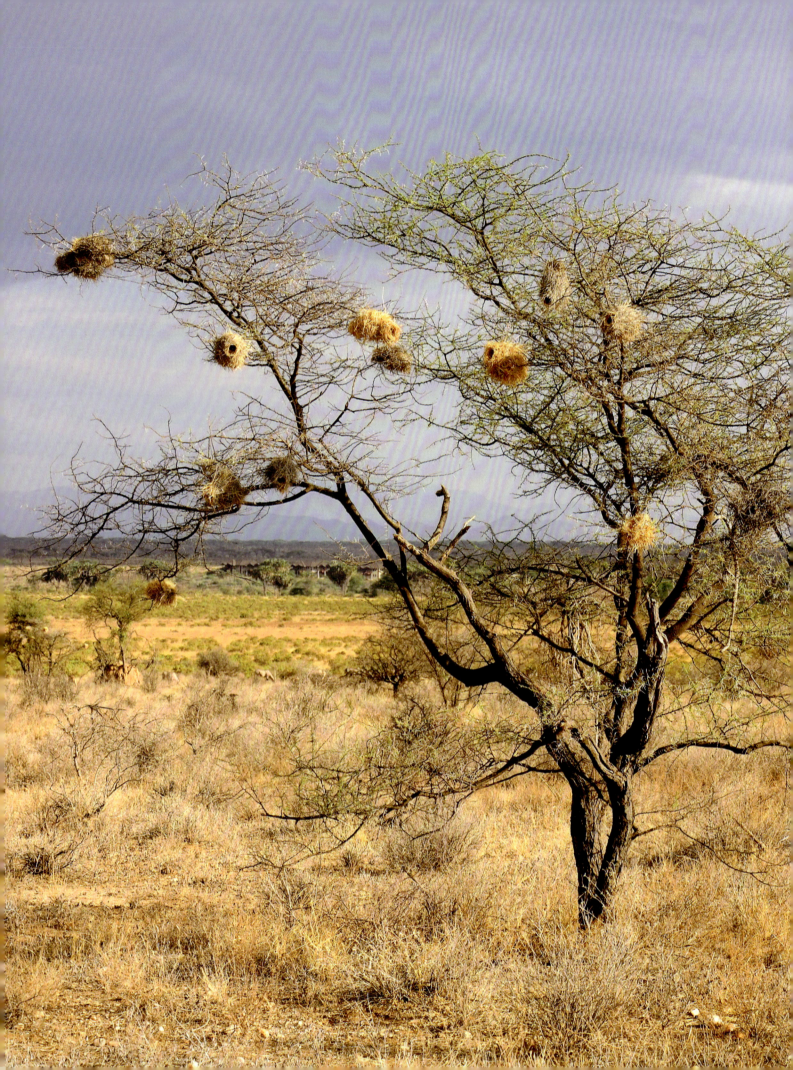

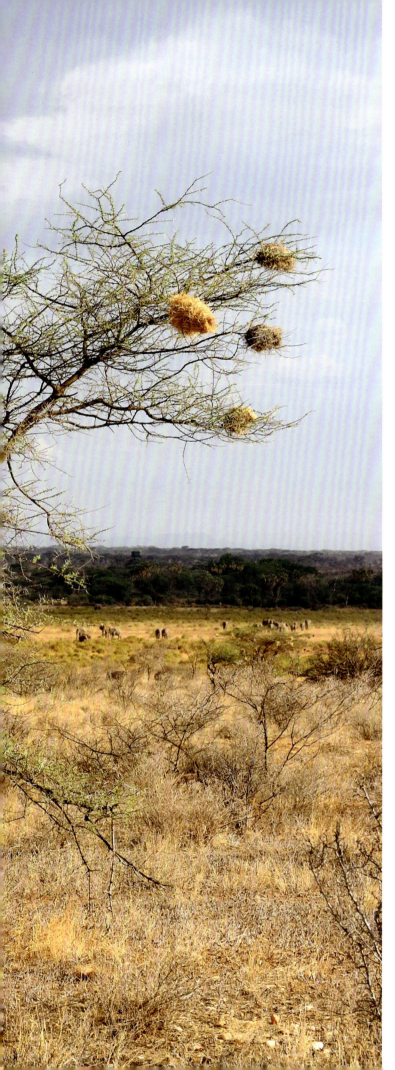

SAVANNAH

ABOVE:
BAYA WEAVER
This male baya weaver is defending its nest in a savannah area of Thailand. It is the male weaverbirds that build and maintain the nest that they use as a signal to attract a mate. It takes at least two weeks for the male to complete his handiwork.

LEFT:
WEAVERBIRD COLONY
The weaverbirds are an an African species of small songbirds known for creating round nests from woven strands of dried grass. Several birds have created a nesting colony in this acacia tree in the Masai Mara National Reserve in Kenya. These sociable birds can have colonies with up to 300 breeding pairs, each with their own nest – and all in one tree.

they are easier to maintain with lower rates of heat, water loss, infection and so on. This means an animal that eats grass does better if it is bigger, as is evident on a grassland. The animals here are among the largest in the world. The largest land animal, the African bush elephant, is able to survive on very low-quality food such as bark and wood, which has even fewer nutrients that grass.

LIVING TOGETHER

The grass also dictates the social structures of the grassland mammals that live there. These are by a huge margin the herbivores, which far outnumber the carnivores. For example, there are about half a million Thomson's gazelles in the

SAVANNAH

ABOVE:
BLACK MAMBA
This young black mamba snake is still small and agile enough to live and hunt in savannah trees. The adults are the largest venomous snakes in Africa, often exceeding 2m (6ft 5in) in length, and they are among the most dangerous. A bite from one of these snakes can kill in hours if treatment is not sought. The snake is also the fastest slitherer in the world – able to hit speeds of 12km/h (7mph) or more in short bursts.

RIGHT:
BUFFALO THORN
This savannah shrub from southern Africa grows to a height of around 10m (33ft). It flowers in summer producing small yellow-green flowers. It will then drop its leaves in winter when the savannahs are dry and produce red fruits. The fruits attract birds, which spread the seeds inside.

Serengeti National Park in Tanzania – just one of several antelope species living there. By contrast there are only 3000 lions in the park.

Unable to defend territory on the savannah, the herbivores will cluster into herds. Herds are loose associations with no particular leader. Each member joins the herd after a trade-off of benefits and harms. The harms are that the other herd members will eat food that the individual would otherwise have for themselves. However, if there is plenty to go around that is a very minor problem. Once the food becomes scarce, the herd will thin out.

Being in a herd makes it much more likely that the animals will be found by predators. However, out on the grasslands there is nowhere for these big beasts to hide. Being in a herd does attract attacks, but also reduces the chance that any one individual will be the one targeted. Additionally, with so many eyes, ears and noses on the look out for danger, any attack is very likely to be spotted at an early stage. Those that see the danger will move away, and that motion will be transmitted through the group of animals thanks to their herding instinct. The animals follow each other, so the whole herd moves away from danger.

STAYING ALIVE

The battle between predator and prey on the grassland is a question of speed. The large herbivores are mainly hoofed mammals, of which there are two distinct groups, the even-toed and odd-toed. The latter is represented on the savannah by zebras and rhinos while the former is a larger group that includes deer, antelopes and giraffes. The hooves of these animals are essentially massively thickened claws or fingernails. The grassland animals are in effect walking on the tips of their toes, with the bones of the foot not being used to make contact with the ground, but this adds length to the leg. Longer legs enable faster running, and when there is nowhere for a big animal to hide in the wide-open, flat grassland, running is the only way to escape danger.

Danger comes in the form of big cats, such as lions and leopards in Africa and jaguars and pumas (which technically are actually very large small cats). African savannahs carry the threat of wild dogs and spotted hyenas, which have one of the strongest bites of any animal. In Australia, the main predator is the dingo, a short-haired subspecies of wolf that

BELOW:
HIDDEN IN PLAIN SIGHT
A herd of zebras graze beneath a rock hill known as a *koppie* in Afrikaans. There are three species of zebra, which are the exclusively African relatives of the wild horse and ass. While its relatives have been domesticated into horses and donkeys, no zebra species has ever been used this way. They are more aggressive and live in large, loosely affiliated herds lacking the close-knit social structures that have enabled people to tame the other equids in the horse family.

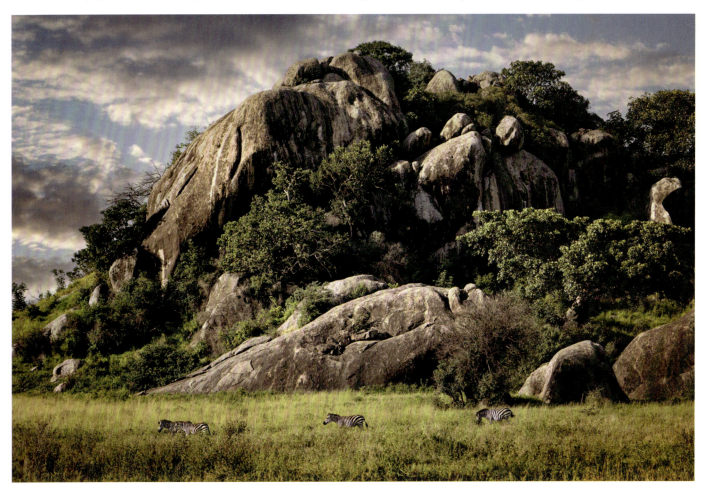

SAVANNAH

QUIVER TREE
This spectacular tree, growing in the Namaqua National Park in South Africa, is so named as its straight and tubular branches are ideal for making arrows.

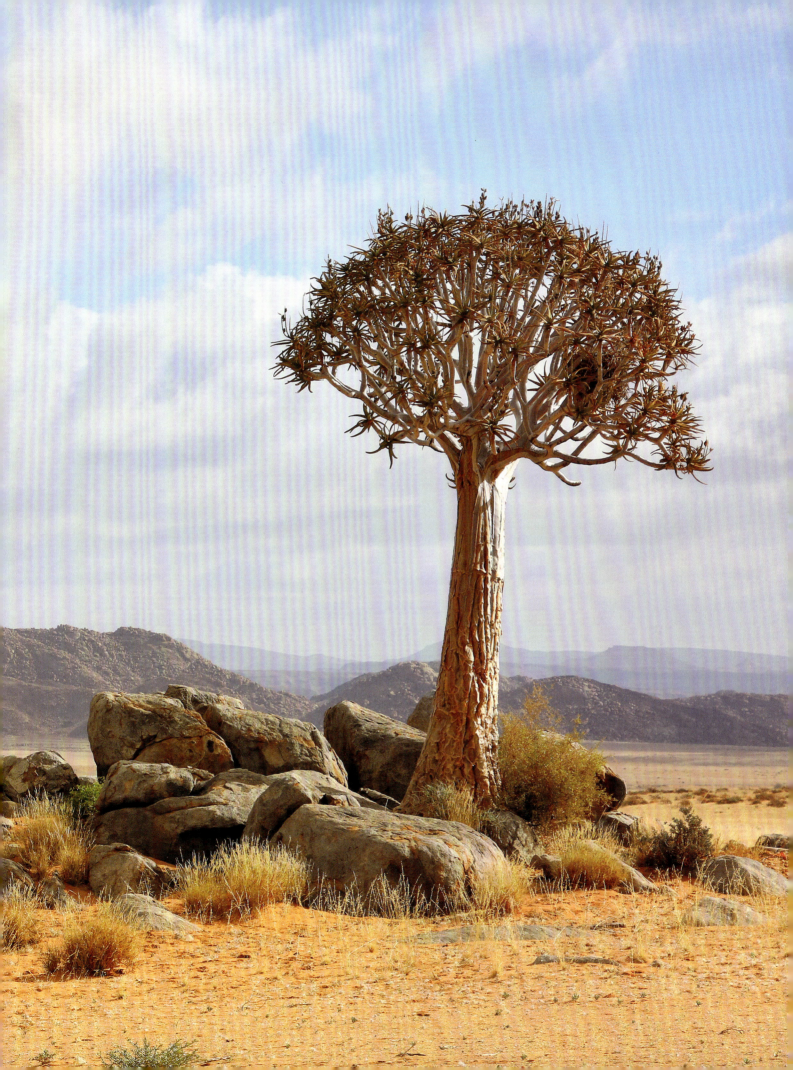

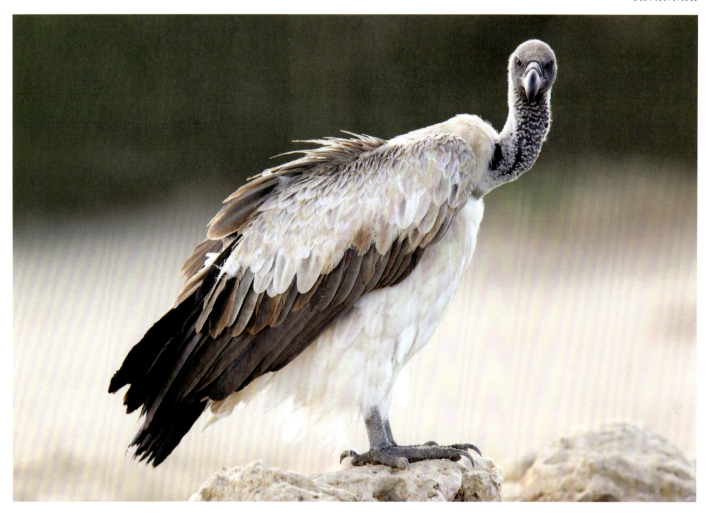

ABOVE:
WHITE-BACKED VULTURE
This scavenger is a common sight in the skies above the savannah. The big birds will soar on thermals waiting to pick up the scent of rotting flesh, often the left overs from a big cat kill. It can then use its aerial advantage to be the first on the scene. The long neck allows it to reach into the carcass to get at the scraps.

LEFT:
JARRAH TREE
This is one of the largest trees in Australia, which can reach heights of 50m (160ft). It is found in the southwest of Western Australia. It provides a habitat for many native birds and mammals and its dark reddish timber is used to create distinctive furniture and floorboards. In open savannah habitats it forms a mallee, where several slender stems sprout from an underground tuber.

BELOW:
CANDELABRA TREE
Also known as the milk tree or naboom, this euphorbia produces a milky latex that is very poisonous and irritates the skin. The succulent branches store water so they are able to withstand droughts.

was brought across the narrow seaway from New Guinea by human travellers around 4000 years ago (no one is quite sure when exactly). These first dogs were domesticated, but at some point escaped back into the wild. Feral dingoes have become the continent's biggest predator, and changed the population dynamics of Australia fauna. Nevertheless the dingo is regarded as a natural Australian animal today, albeit one that needs to be managed.

In Australia, the kangaroos have adopted a famously different mode of locomotion through hopping. Their two elongated hind feet work as immense springs that allow them to bound along at a fair speed. However, at the lowest

SAVANNAH

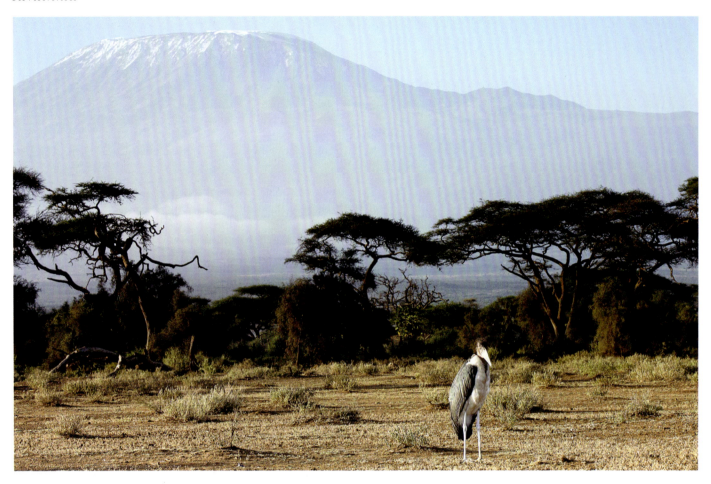

ABOVE:
MARABOU STORK
Known as the undertaker bird, due to its formal attire and morbid looks, this tall African bird is a scavenger. It is often found on the periphery of large congregations of wildlife as it waits for something to die.

RIGHT:
CRUCIFIX TOAD
Also know as the holy cross frog due to the pattern of dots on its back, this Australian frog spends most of the year buried underground. It lies dormant in a burrow, secreting thick mucus around it to retain moisture in the dry ground. After heavy rains, the water trickling in to the soil, reactivates the frog, which digs its way to the surface and breeds in the temporary ponds that form in the outback.

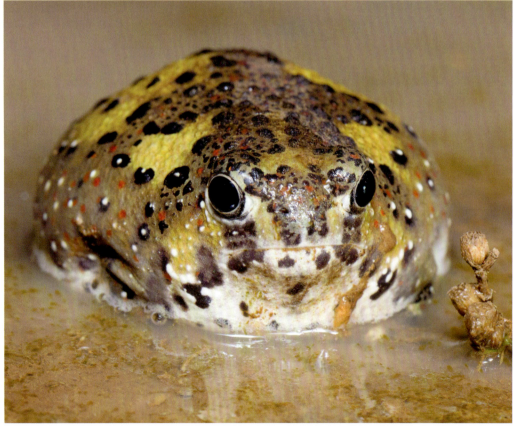

SAVANNAH

RIGHT:
CATTLE EGRETS
These insect-eating birds are some of the most successful and widespread savannah birds of all. They have a simple foraging strategy of following behind herds of large herbivores – domestic cattle will do just as well as antelopes. The hundreds of hooves disrupt the dusty ground forcing insects and other small animals to come out into the open. The egrets then snap them up with their long beaks. This way of life has seen egrets set up home in all continents except Antarctica.

BELOW:
TEMPORARY WETLAND
The fynbos landscape around Table Mountain above Cape Town in South Africa, can become a temporary wetland in winter months.

SAVANNAH

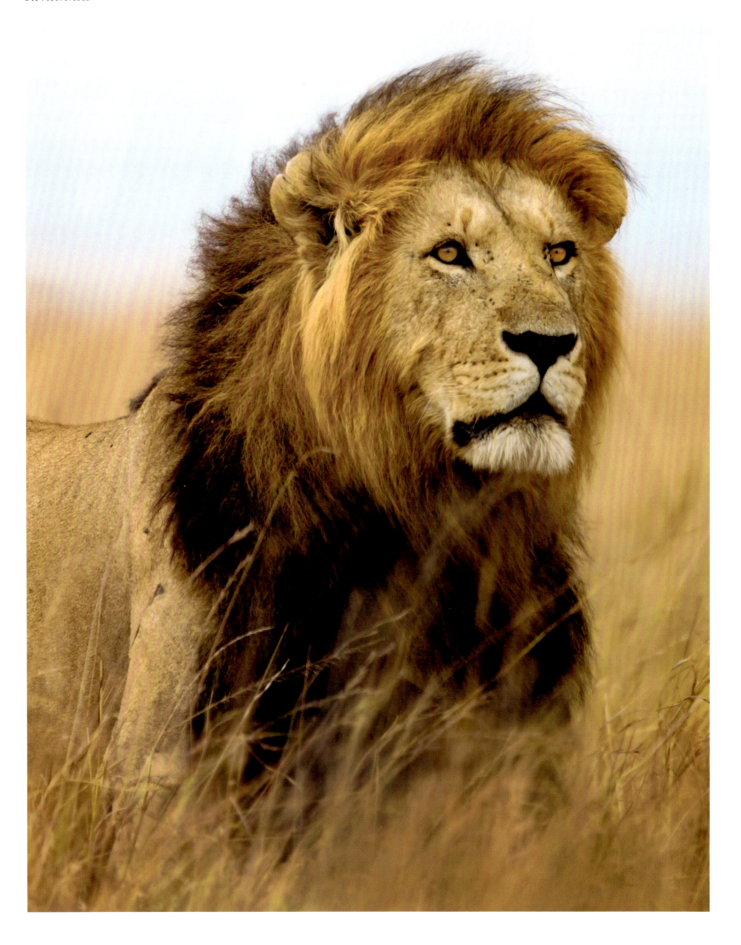

speeds it is not a very efficient way of moving as it cannot achieve the turn of speed possible with running. Kangaroos have only needed to outrun dingoes and other marsupial predators (now extinct), whereas on other savannahs the predators have a much faster pace.

SPEED AND ENERGY

The cheetah, which lives mostly in African grasslands but clings on in the semi-deserts of southern Asia, is famed as the fastest land animal on the planet. Its speed stats are often overblown. It can comfortably hit 100km/h (60mph), which means it can do 100m (330ft) from a standing start in less than six seconds. However, there is an inevitable cost to this ability. The exertions make the cheetah very hot, with the heat building up faster than the body can shed. The cat will slow down after its initial burst of speed and after about 30 seconds of running (covering around 500m/0.3 miles in total) the heat would be so intense that the cat's brain would begin to suffer seizures. The speedy hunter has only a few seconds to catch and kill.

Meanwhile its victims rely on getting as big a head start as possible. Cheetahs are small compared to lions and leopards and so target less hefty prey, such as gazelles and ostriches. The latter are the fastest running birds of all, and they give the cats a run for their money. Gazelles are not slouches, but a cheetah can catch them up from a standing start if the antelope's head start is less than 150m (490ft).

LEFT:
ON THE LOOKOUT
A male lion, the leader of a pride, watches as the lionesses in his group prepare to hunt in the Masai Mara grasslands of Kenya. The pride leader does not hunt himself but is the first to eat whatever the lionesses kill. However, most male lions do not live in a pride. Alone or in pairs they have to work much harder to find enough to eat.

BELOW:
IMPALAS
These small antelopes are a common feature across southern and eastern Africa. They move in medium-sized herds, generally with fewer than 100 individuals. Some herds are male-only, others have females and their young, and during the breeding season dominant males, with long impressive horns, assemble small harems of mates.

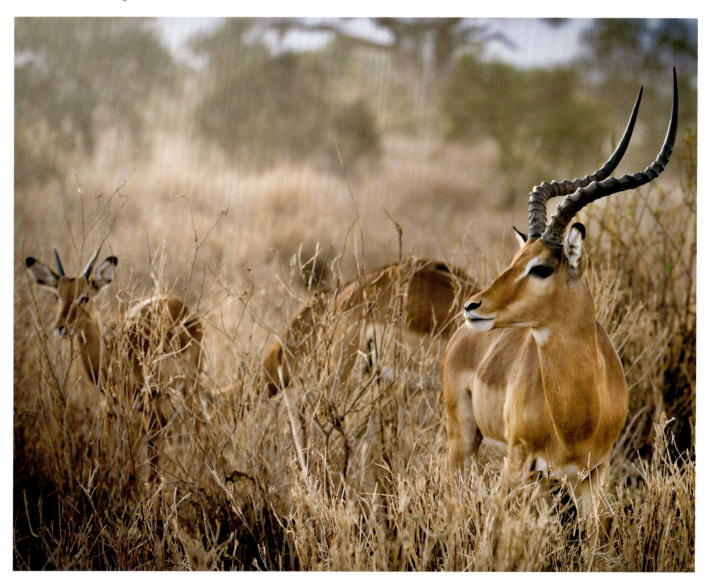

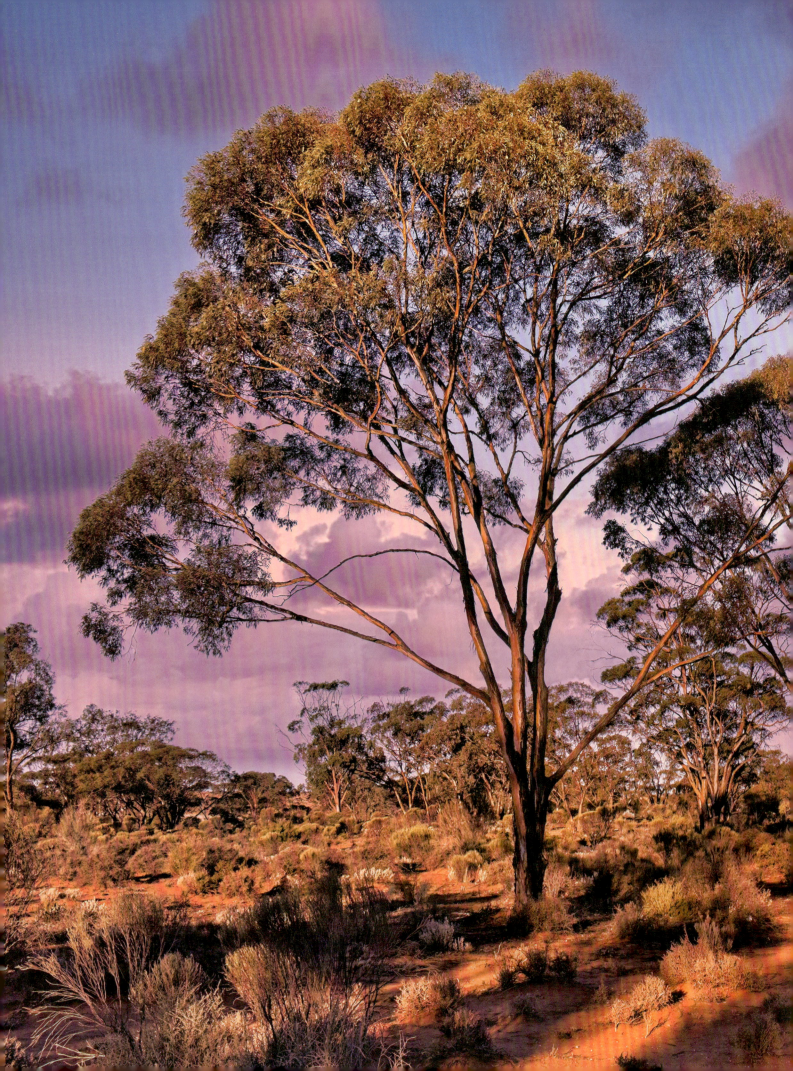

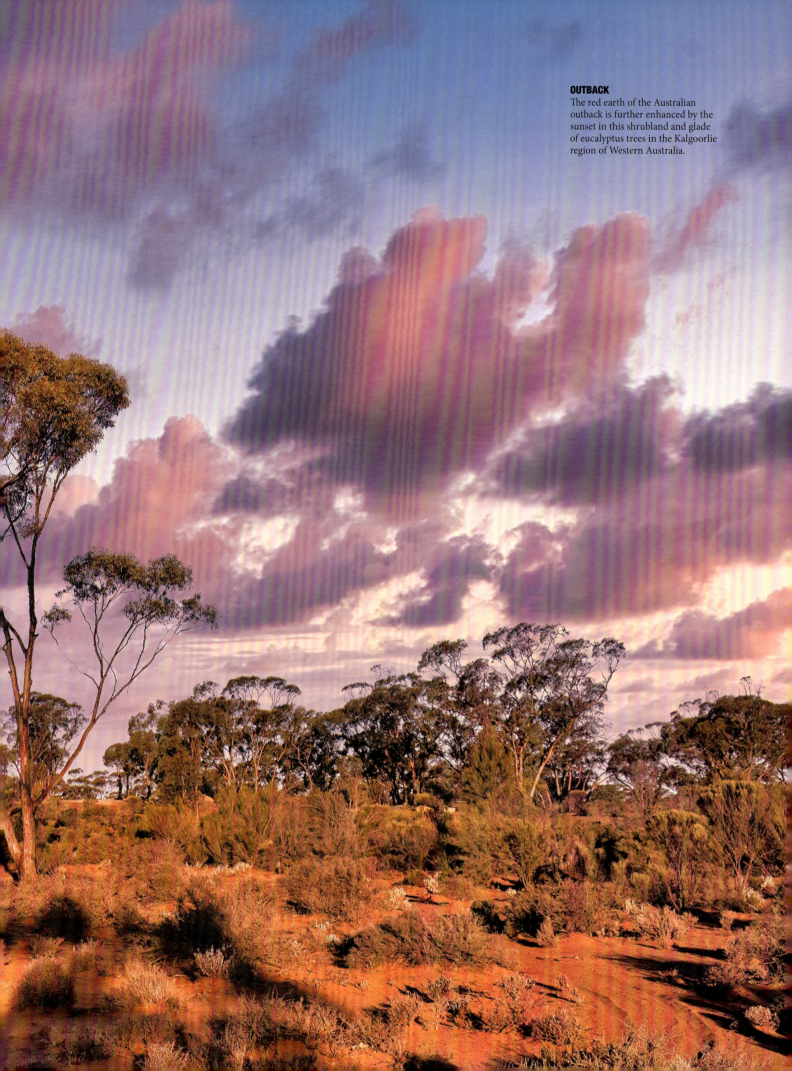

OUTBACK
The red earth of the Australian outback is further enhanced by the sunset in this shrubland and glade of eucalyptus trees in the Kalgoorlie region of Western Australia.

Antelopes, like gazelles, just need to keep going. If they can stay out of reach of their pursuer then eventually – in fact quite quickly – the predator will abort the attack. The smaller and more agile of them may pronk or stott (both words with links to 'prance' and 'strut' respectively). These terms refer to the way a pursued animal may leap as they go. This is assumed to startle the predator in pursuit and throw them off as they prepare to launch a final assault. All this buys more time, as the heat clock counts down. (Antelopes and other bovids, including sheep, will stott and pronk when not in danger. Quite why is a mystery. It may be a signal to watching predators that a particular animal is strong and agile and so they should consider targeting another when the attack commences. It may be a signal of health and fitness to the other herd members or it might be a message of unease that danger is perhaps near.)

The even-toed, hoofed animals are represented on Old World savannahs by antelopes and in the Americas by deer. They have a superpower that allows them to outrun high-speed carnivores and also cool their brains more effectively than their attackers. They do this with an intricate web of blood vessels around the base of the brain known as a rete mirabile, or 'marvellous net'. The network is a heat exchanger. The hot blood arriving from the body passes through the net before it reaches the brain. Some of its heat is transferred to vessels nearby that are carrying cool blood out of the brain. Heat always moves from hot to cold, and the rete mirabile ensures that the opposing blood flows have this beneficial temperature difference. The brain chiller allows the antelope and deer to keep on going for those crucial seconds more than the predator.

WEAPONRY

Of course, grassland predators will inevitably win the foot race from time to time. A lion hunting alone will triumph in about one in six attacks – which means they might only eat a few times a week. That success rate doubles to one in three if the lions team up to hunt together, in pairs or as a larger pride. A lion will bring their victim down by grappling it with

BELOW:
JACKALBERRY GROVE
This grove of these ebony trees is in South Luangwa National Park in Zambia. The wood is so hard that it is impervious to attack from insects, even termites. As a result the tree lives in close association with termites, which live among its root crown. The insect tunnels aerate the soil and that benefits the tree roots.

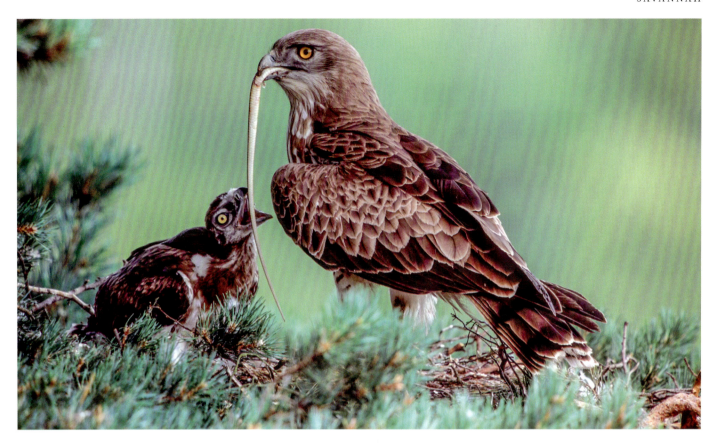

ABOVE:
SHORT-TOED SNAKE EAGLE
This snake eagle has returned to the nest with some food. The bird targets smaller snakes, and can get trapped in the coils of larger targets.

RIGHT:
SERVAL CAT
This wild cat lives across the tropical savannahs of Africa. It locates prey primarily using its sense of smell. It will sit motionless for long periods until it picks up the sound of a target. Mostly it hunts small animals such as rodents, frogs and birds. It will stalk the target and then strike with a single leap, stamping on the prey with its front paws. If the prey is still alive, the cat kills with a bite to the neck.

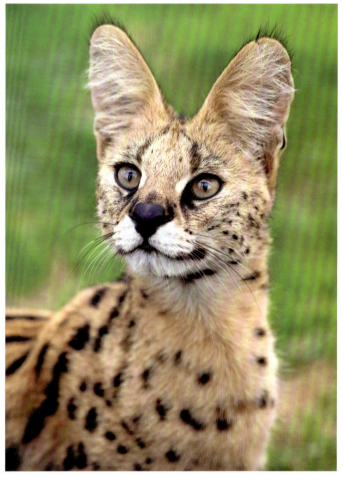

its claws and using its weight to topple its target. Then it kills with a prolonged bite to the neck that either cracks bones and severs the blood and nerve connections or blocks the windpipe leading to asphyxiation.

If a lion is in this position, then the unfortunate herbivore has probably run out of road. However, there is a last line of defence in the form of head-mounted weapons. Antelopes are equipped with a pair of horns on the head, while deer have antlers. Despite outward appearances these two features are quite distinct and probably evolved for different reasons. Horns are a spur of bone that is coated in keratin. This is the same tough protein in hair, claws, hooves and fingernails. (It is also in the skin of many land vertebrates to make it waterproof.) The horn grows after birth and will continue to grow throughout life, although the rate slows considerably in adults. In antelopes both sexes have horns but the males tend to have the larger and more elaborate pair. This and the fact

SAVANNAH

ABOVE:
NAKED MOLE RAT
These rodents, aptly named for being largely hairless and for spending their lives tunnelling under the arid savannahs of East Africa, are a rare example of eusocial mammals. Eusocial animals are ruled by a single reproductive queen and her young are used as workers and carers for offspring. (Ants and bees are a more familiar example.) The average colony has 75 mole rats working together.

BELOW:
DINGO
This Australian wild dog is descended from a domestic dog that was brought to Australia at least 3500 years ago by a wave of migrants from the islands to the north. DNA analysis suggests the dingo is descended from dogs originally domesticated from wolves in what is now China several thousand years before that.

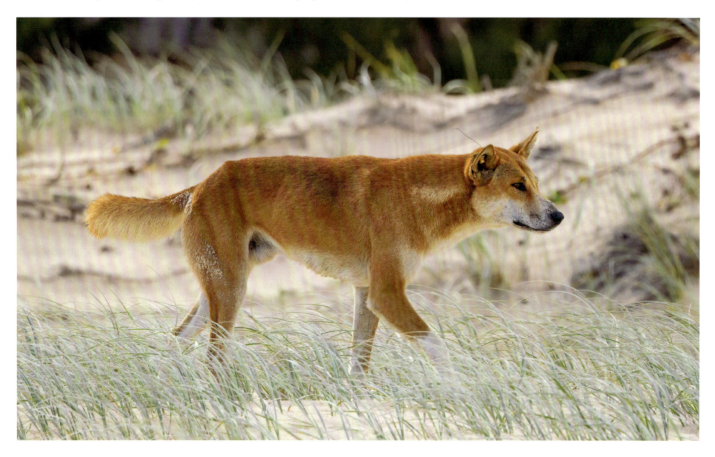

SAVANNAH

ABOVE:
TERMITE MOUNDS
This vast open grassland in Emas National Park, Brazil is dotted with tall termite mounds. The termites inside will store cropped strands of grass to make hay piles. This store of food will see the insects through any periods of scarcity.

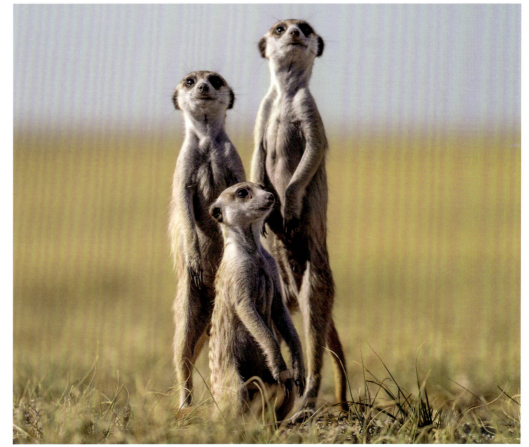

RIGHT:
ON GUARD
A trio of meerkat sentinels keep a lookout over the savannah of Botswana. They will have checked that all is safe before the rest of the meerkat mob clambered out of the nest to hunt for insects and scorpions in the surrounding area. The lookouts give a frequent squeak, which indicates they are safely still on duty. If that stops, the other meerkats know to run. If the lookout spots danger it will sound an alarm, using different calls for particular threats, such as air attacks or snakes.

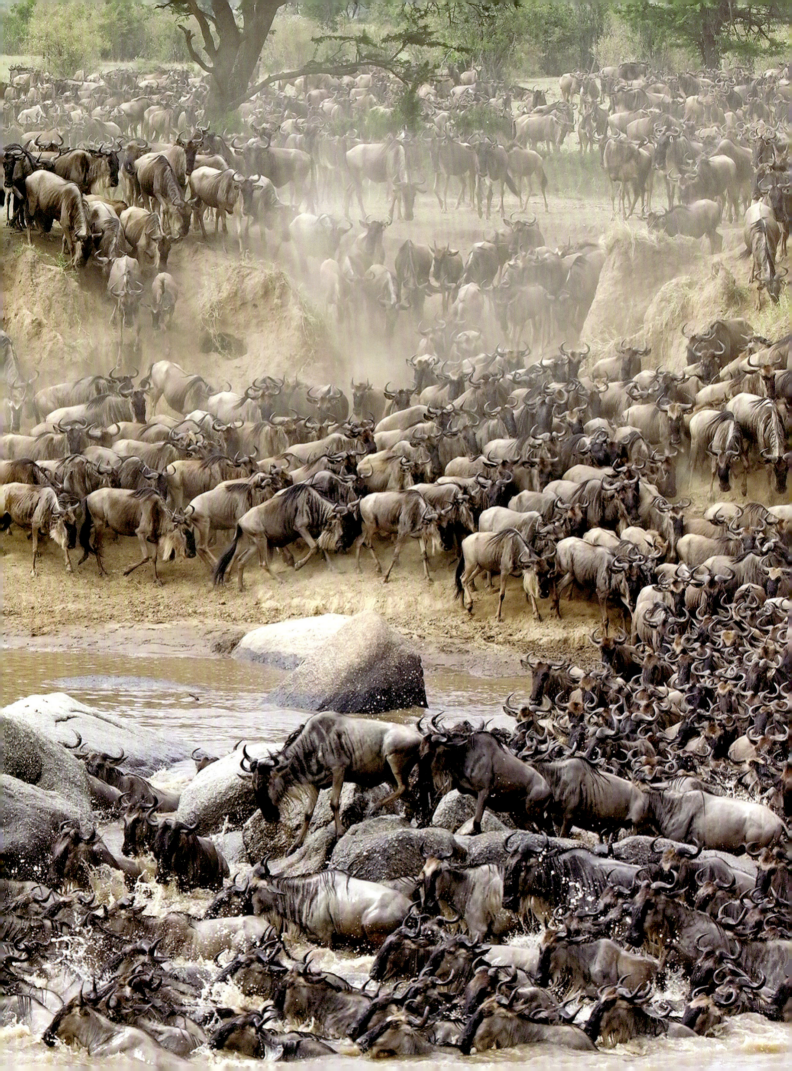

SAVANNAH

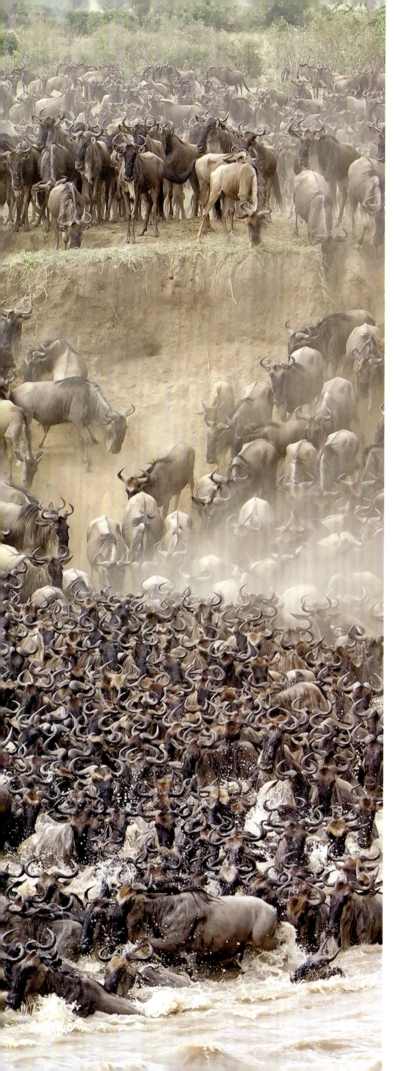

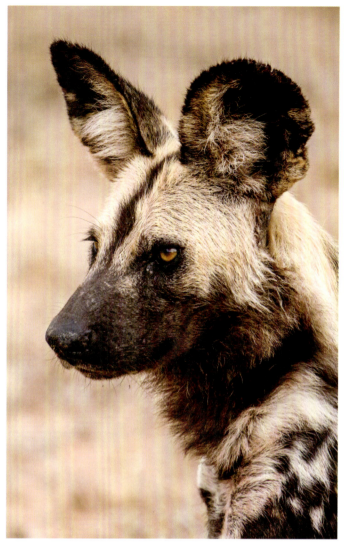

ABOVE:
AFRICAN WILD DOG
This species is a pack animal that lives across sub-Saharan animals. It lives in groups of two dozen adults with their pups. Most of the pack is male, often brothers and sons. The adult females leave the group and join a neighbouring one, where they are able to breed with unrelated males. The dogs were once widespread but are now pushed to the periphery of most habitats. They are most common in arid areas.

LEFT:
RIVER CROSSING
A torrent of wildebeest swim across the Mara River in the Serengeti National Park, Tanzania. They must make this crossing to reach new pastures beyond. And Nile crocodiles are ready to pick off the antelopes in this most vulnerable part of their migration.

that horns are retained throughout the animal's life indicates that these features evolved initially as a weapon for fending off attacks by predators. However, since then they have become a sexual characteristic.

Antlers are also made from bone, but they are distinct from horns in that they are branched. The number of spikes or tines in the antler is a good indicator of the deer's age. The antlers grow each year and are then shed after a matter of months. In almost all cases, only the males produce them.

SAVANNAH

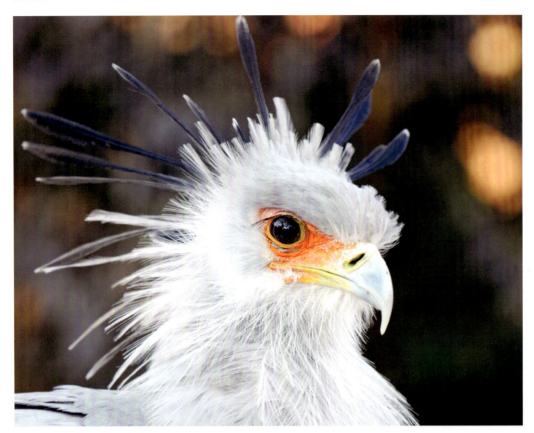

LEFT:
SECRETARY BIRD
This species is a bird of prey along with eagles and hawks. It can fly but hunts for insects, lizards and snakes on the ground, walking along on long legs. There is debate about the origin of the common name. Some say it is a corruption of an Arabic phrase that means 'hawk of the semi-desert.' Others contend the name refers to the feathers around the head, which resemble the quills used by a secretary centuries ago.

BELOW:
LEAF-CUTTER ANT
Beneath the savannah are vast ant nests built by leaf-cutter ants. On the surface the ants are collecting chunks of leaf. They carry these underground and use them to feed a fungus, which the ants then consume.

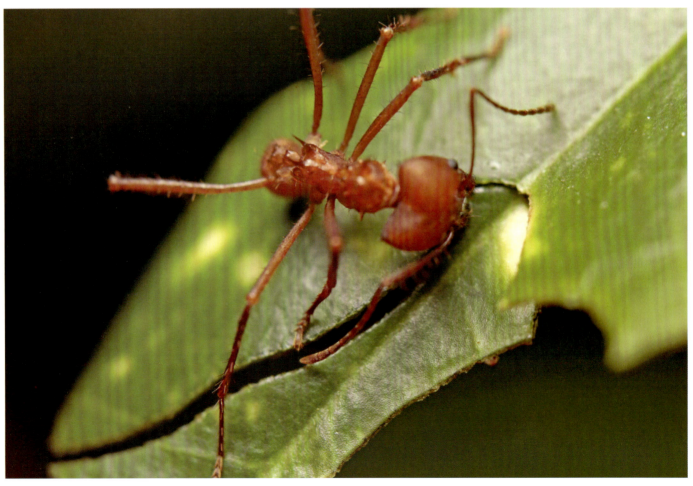

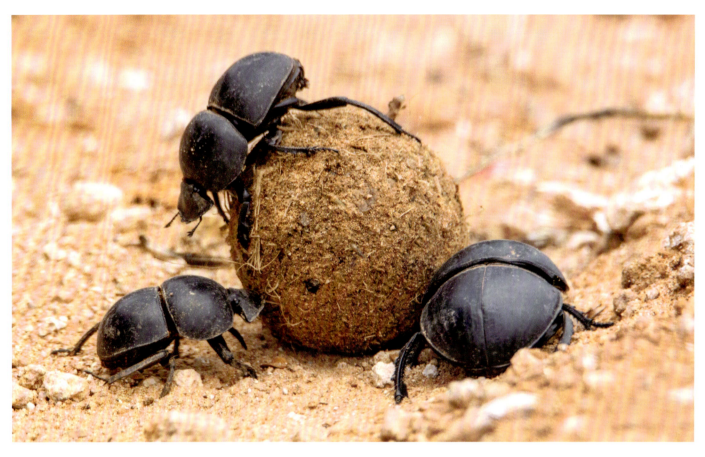

ABOVE:
DUNG BEETLES
Chunky beetles are busy moving a ball of dung. The three beetles are competing for control. The winner will roll the ball away and bury it. The dung is a source of food for the adults and the larvae. Without these beetles, the dung from large savannah herbivores would rapidly build up.

BELOW:
SPLENDID FAIRYWREN
The male of this Australian outback songbird is splendid (especially compared to the distinctly more drab female). The bird is an insect eater primarily, and adds in seeds and fruits when it can. Males have a face fan, where pale feathers can be made to stick out from the side of the head, which is used to attract mates.

Antlers are initially covered in a highly vascularized skin known as velvet, but this eventually breaks away leaving only the bone. Antlers do come in handy when fending off attacks from a predator, but they exist primarily as a signal of social and sexual status. Males will size up each other's antlers and only resort to a jousting battle if the opponent's antlers are not obviously wider than theirs.

Giraffes are related to both deer and antelopes and have a halfway house between horns and antlers. The permanent head ornaments, which are sported by both male and female, are called ossicones. They have a core of bone covered by skin (and fur).

GETTING BIGGER

The name rhinoceros, means 'nose horn,' and as that suggests these mighty beasts are famed for the horns on their snouts. These are made of solid keratin, effectively a mass of hair fibres (and certainly nothing magical in their constitution.) The two largest rhino species live in the grasslands of Africa. The white rhino is a grazer in that it eats grasses low to the ground. The term 'white' does not

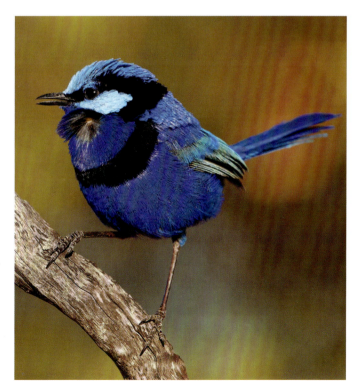

SAVANNAH

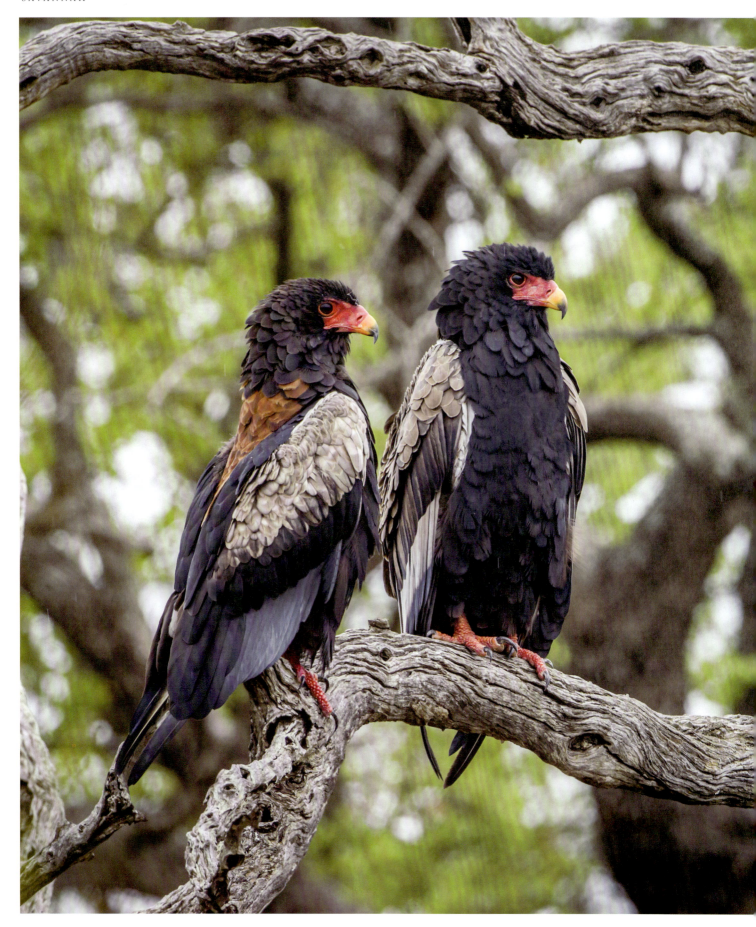

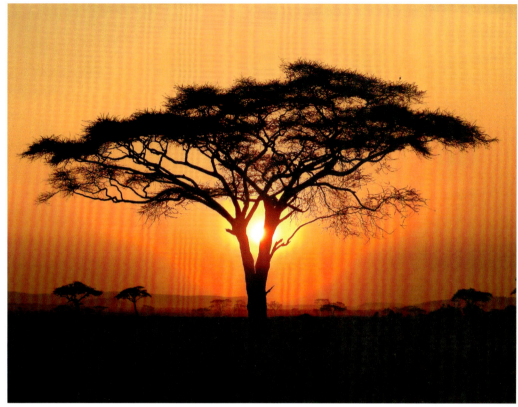

ABOVE:
THE SERENGETI
The name of this savannah ecosystem in Tanzania means 'endless plain'.

LEFT:
BATELEURS
This is one of the most distinctive of Africa's savannah birds of prey. The common name is the French word for 'street performer' and refers to the bird's highly acrobatic flying skills. It mostly makes complete sideways rolls.

refer to a colour. Instead it comes from the Dutch word for wide. The mouth of a white rhino is wide and square so it can take big mouthfuls of grass with each bite. By contrast the black rhino (which is also darker than the white) has a beak-like mouth that is an adaptation to browsing. In contrast to a grazer, which mows grasses and herbs close to the ground, a browser is a leaf eater that is more selective as it crops the freshest foods from trees and shrubs. (A giraffe is a browser that evolved to get the freshest leaves of all, which grow at the tops of trees beyond the reach of other large herbivores.)

The rhino is a huge animal, third only on land to the elephants and hippos in terms of sheer heft. That size is partly a response to the economy of scale from eating low quality foods and partly as a defence against attack. In Africa, rhinos are under threat from lions (who will attack them when starving) and their calves are vulnerable to wild dogs, leopards and hyenas. Even crocodiles will take a baby rhino if it strays too close to the water. Over in India and Nepal, the Indian rhino is at home in the Terai-Duar savannah, where the grasses (a wild relative of sugar cane) grows to several metres tall – reputedly the tallest grassland in the world. Among this forest of grass, the Indian rhinos have few enemies, and with their single horn (most rhino species have two) are reputed to be a source of the myth of the unicorn.

The rhinos have opted for offence being the best form of defence. They charge at threats, which to them is anything that gets too near. The first charge is likely to be a mock attack that scares threats away, but if that does not work

SAVANNAH

DEFENCE SPECTACLE
One frill-necked lizard is attempting to scare off the other. It is extending the colourful frill around the neck and gaping the mouth with the intention of making itself look as big as possible. These lizards feed in the Australian outback and use this defence tactic to startle predators for a few seconds. The lizard then sprints to the safety of the nearest tree.

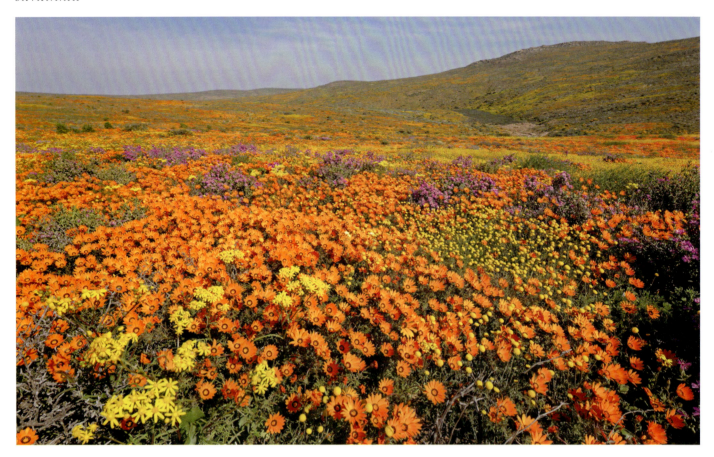

the rhino will run head on at the threat in the knowledge that their thick skin and long horn will be a match for any attacker. The animals are quite short-sighted, and perhaps not that bright, so rhinos have been seen to charge passing trains and trees stumps. Few actual enemies hang around long enough to take them on.

Elephants are well known for their tusks, of course. These are formidable weapons and a charging bull elephant can do a tremendous amount of damage. The tusks are actually the upper incisors, which have erupted through the upper lip. They are used primarily for digging for water, bulldozing over trees and stripping bark. Other savannah tuskers are the warthogs of Africa and the peccaries of South America. Both are relatives of the wild boar, the peccaries more distantly than the hog. The tusks in these cases are long canine teeth. They are used for digging and as a weapon.

ABOVE:
IN BLOOM
After the rains, the grassland of Namaqualand in the Northern Cape of South Africa bursts into colour as millions of flowers race to attract insects and make seeds, and all before the land dries out again.

RIGHT:
EMU CHICK
The emu is the largest bird in Australia that, like its relative the ostrich, is too heavy to fly and so runs instead. This chick is being looked after by its father, which will have built a nest made of a ring of sticks around a patch of grass. Males will mate with several females, and look after all their eggs and chicks.

SAVANNAH

BREEDING SYSTEMS

The size of the rhino and its elaborate curved horns also indicate that evolution has stepped in to repurpose it toward sexual characteristics. Each rhino defends a territory from other rhinos. Only calves are allowed to share this space. So the heft and menace of the rhino is as much about warding off rivals as it is to seeing off predators. When ready to mate, females will tolerate a visit from a male and choose him as a mate based on the shape and length of his horn. As a general rule, animals look for symmetry as a clear sign that an individual has been able to withstand the trials of life, and this indicates they have a good set of genes that fit with surviving in that habitat.

Other grassland herbivores are subject to the same evolutionary pressures, which are described as sexual selection. This is what gives the antelopes – especially the

RIGHT:
CANDELABRA FRUITS
The flowers of the candelabra tree bloom along the ridges of the branches. These develop into purple fruits with three lobes.

BELOW:
CROWDED SAVANNNAH
These zebras are in the Ngorongoro Crater, a vast volcanic caldera surrounded by hills. This savannah has a higher density of life than other areas of East Africa.

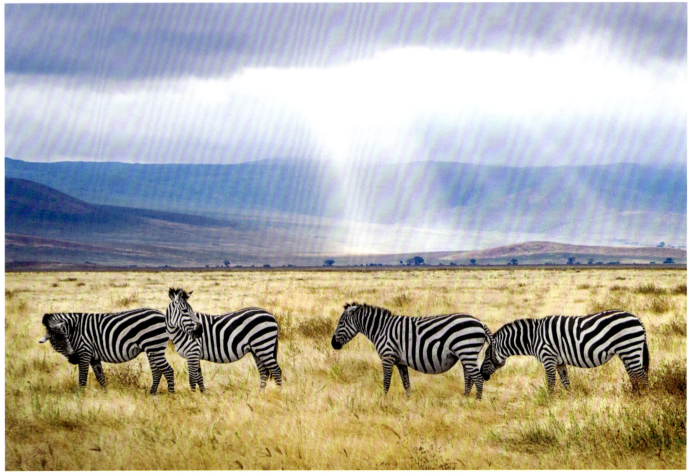

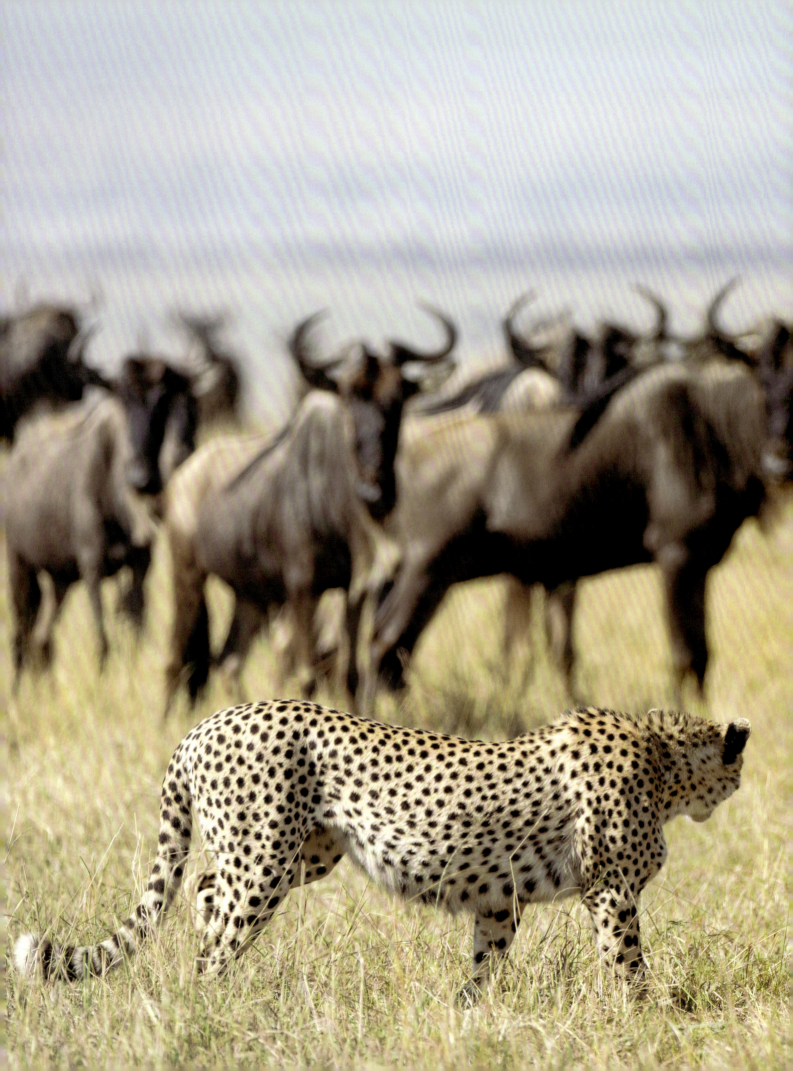

SAVANNAH

LEFT:
CHEETAH
The cheetah is the fastest runner on Earth, which can hit speeds of 120km/h (75mph), for a few seconds at least. Nevertheless it is a slight predator. These wildebeest are too big and burly for it to take on. The cheetahs are more likely to attack smaller antelopes and gazelles.

RIGHT:
PITSTOP
This red billed oxpecker is feeding on mites and ticks that are living on the ears and face of their impala host. The antelope tolerates the bird because it is helpfully clearing away the parasites.

BELOW:
INDIAN RHINO
A lone male Indian rhinoceros wanders on the grasslands of Pobitora Wildlife Sanctuary in eastern India. This big species is distinctive for its single horn. Indian rhinos live in the tallest grasslands in the world, the Terai-Duar savannah in the foothills of the Himalayas, where the grasses grow to 7m (23ft) high.

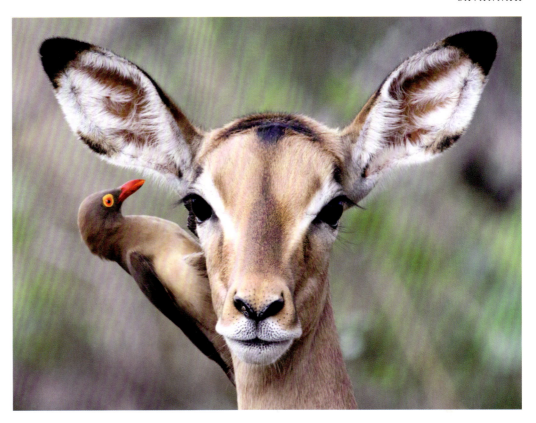

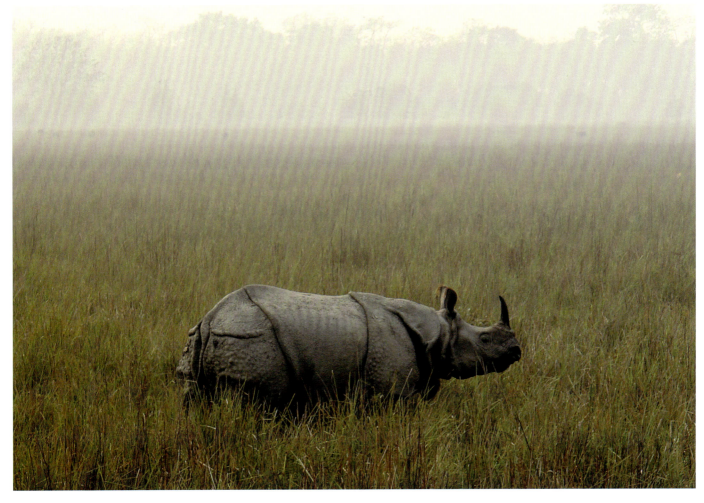

males – their elaborate horns, which are twisted and curled or arched back like a scimitar. The horn is an 'honest signal' of the animal's fitness, honest because an animal must devote considerable resources to growing the horns and any weakness from parasites, disease or injury will be cast into their structure.

Without the ability to defend a feeding territory, herd animals try to defend other resources, most notably females. While breeding strategies vary widely, during the breeding season on the savannah, reproductive males will stake a claim to a small patch of land, significant only by its relative position. The patches in the middle are held by the tougher males. Females enter this male zone largely to escape harassment from the adolescent males that are too young to breed. This is also why bovid males (which include buffaloes, bison and goats) have evolved to be larger than the females, so they can fight it out during the breeding season. However, to reduce unnecessary violence the horns are used as a status signal.

RIGHT:
CERRADO
Pipewort flowers bloom over the Cerrado, a savannah region in Brazil.

BELOW:
SLOTH BEAR
This Asian species is one of the smaller bear species. It eats ants and termites, plus some fruits. The bear's name comes from its shaggy coat and long claws, which resemble a sloth's. This bear is in Ranthambore National Park in India, where it forages in meadows and woodlands.

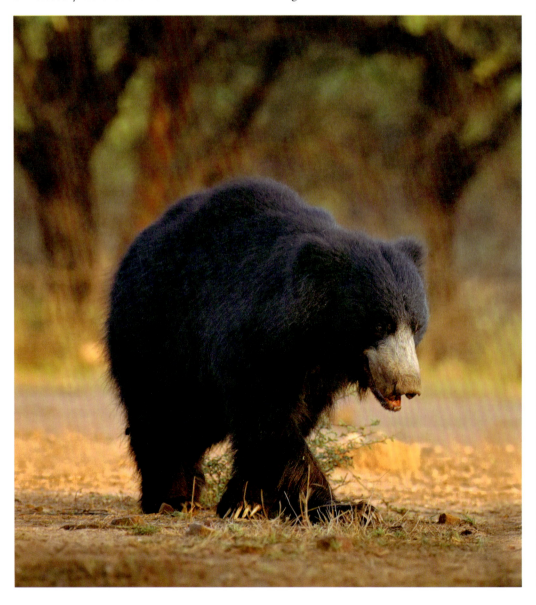

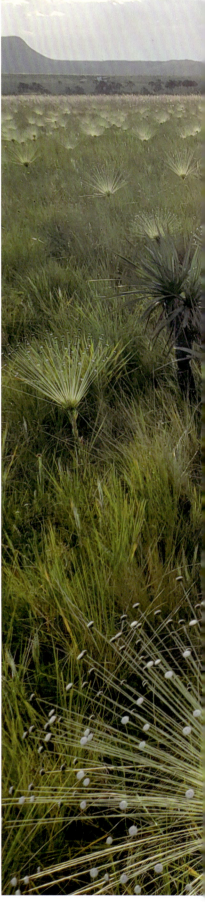

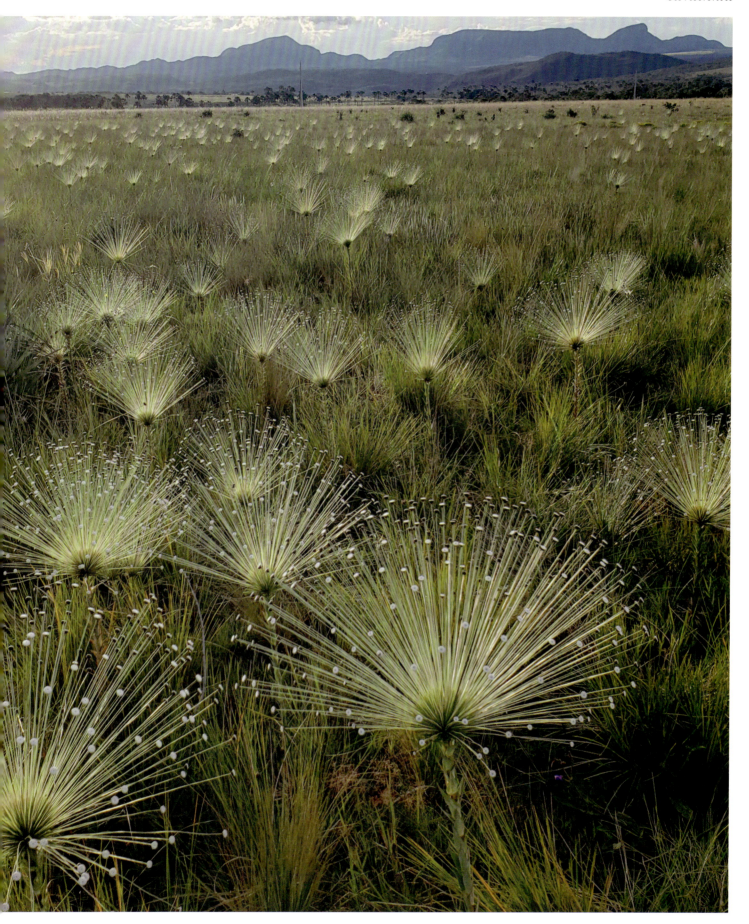

Generally, it is obvious which male would be the winner in a fight simply by comparing horns.

ON THE MOVE

Breeding is an essential component of the migrations that are seen on some tropical grasslands. The most famous is the Great Migration that sees two million wildebeest (also called gnus), zebras and gazelles taking a circular route through the Serengeti and Masai Mara regions of East Africa. However, Africa hosts an even larger migration between South Sudan and Ethiopia, where upwards of six million antelopes, including tiangs, kobs and reedbucks are on the move each year. In both cases, the herds are following the rains, which arrive in different places in a predictable pattern.

In the case of the Great Migration, the animals gather during the dry season in the Masai Mara straddling the border of Kenya and Tanzania. This is a lush long-grass savannah that gets more rain than the Serengeti to the south. However, as the wet season arrives in the Serengeti, the herds move in that direction with the promise of plenty of short grass on their arrival. They arrive in January and will stay here for three months. There are fewer predators established in this area, so this is a time of plenty for the herds, in which that year's calves are born. Calving season finishes by the end of March, when the herds are slowly following the fresher grazing that sprouts to the north and west. The dry season returns in May, by which time the youngest calves are able to keep up with the herd as they migrate north heading back to the Masai Mara. This is the most perilous part of the journey. Not only does the herd now have half a million calves, but they are also moving towards fertile grasslands that are crossed by two major rivers. The first is the Grumeli River. The herd pauses for a few weeks on the southern side, as the young ones grow stronger, but all the while lions, leopards and spotted hyenas will attack each night.

LEFT:
RED-LEGGED SERIEMA
These diurnal ground-dwelling birds live in the savannahs of Brazil and the neighbouring countries. This is a male with a reddish beak; the females have a black beak. The birds are highly territorial and make loud calls at dawn and dusk to assert their territory. The birds scratch out a living among the dusty ground and grasses, including insects, lizards, snakes and frogs, plus fruits and seeds.

BELOW:
GEMSBOK
A male gemsbok shows off its long, straight horns among the wildflowers of Namaqualand in southwestern Africa. The females have longer, thinner and slightly curved horns, which they use to fend off predators. The males use their chunkier adornments in battles over breeding territories. The battles are generally performative and males with the longer horns are normally the bloodless winners.

SAVANNAH

By July the herd has no choice but to cross the rivers, where they are easy pickings for Nile crocodiles. It is estimated that a quarter of a million animals die during each migration. The survivors arrive back in Kenya by the start of September. The rains start falling to the south in November when the long trek back to the Serengeti will begin all over again.

GOING UNDERGROUND

There are, of course, many smaller animals that live in the savannah including snakes, frogs and rodents. The few trees are often a refuge for the grassland's birds. For example, the secretary bird is the only raptor, or bird of prey, that hunts on the ground. It stalks insects, vipers and other small critters through the grass on its long legs, and pins them to the ground with its clawed feet. However, this tall bird can fly, and each night it flaps up to its nest atop one of the umbrella-shaped trees. It is unlikely to share its tree with sociable weavers, despite their name. These small songbirds build enormous

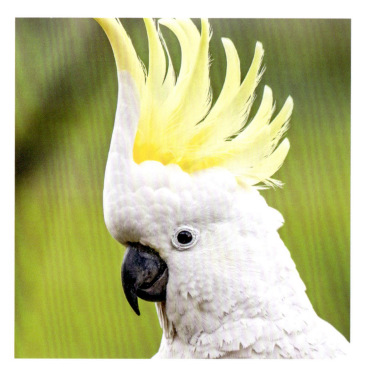

BELOW:
RED KANGAROO
The red kangaroo is the largest living marsupial and the largest species on the Australian grasslands. Blessed with a highly efficient locomotion system – hopping – the big grass eater can cover large distances across arid savannah as it searches for fresh grazing. It will also eat dried plants if needed. The kangaroos move in large mobs of up to 1500 individuals. They are mostly active at night and spend the warm parts of the day resting in shaded areas.

ABOVE:
SULPHUR-CRESTED COCKATOO
The cockatoos are a kind of crested parrot that are common across Australasia. This white species, named after the yellow headgear, lives in the Top End of Australia and New Guinea. In Australia, the birds forage for seeds, grasses and small animals among the arid savannah and in ploughed fields.

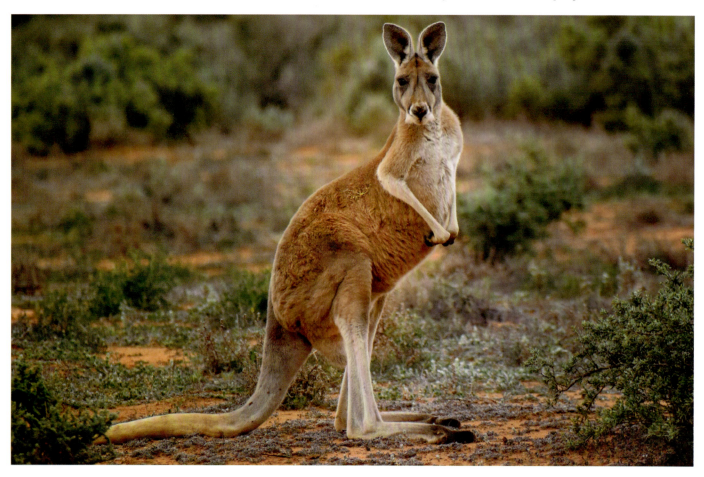

SAVANNAH

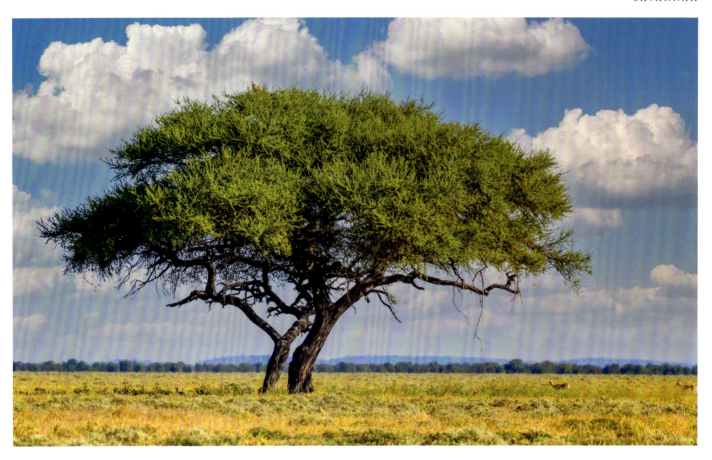

ABOVE:
GIRAFFE THORN TREE
This acacia tree is thriving after a spell of rain in the grasslands of the Kalahari, a particularly arid region in southern Africa (much of it is desert). Like most acacias, this tree will fend off attack from grazers using bulbous thorns. The leaves and wood are also impregnated with bitter oils that put off herbivores. However, the giraffe is undeterred and uses its long blue tongue and flexible lips to strips leaves without injury.

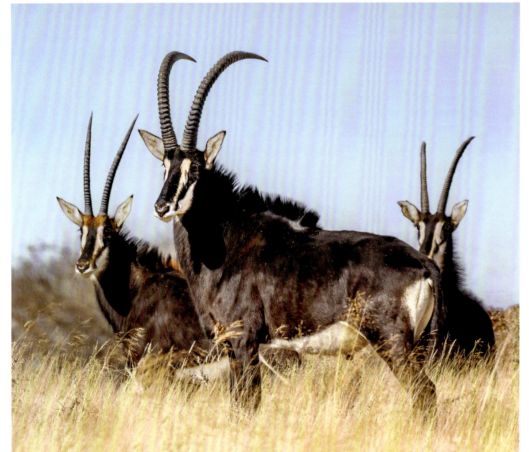

LEFT:
SABLE ANTELOPE
This antelope from southeast Africa, especially the high veldt grasslands of Zambia and Zimbabwe, is notable for its magnificent curved horns and the dark, near-black coat of the males. Females have a brown coat.

SAVANNAH

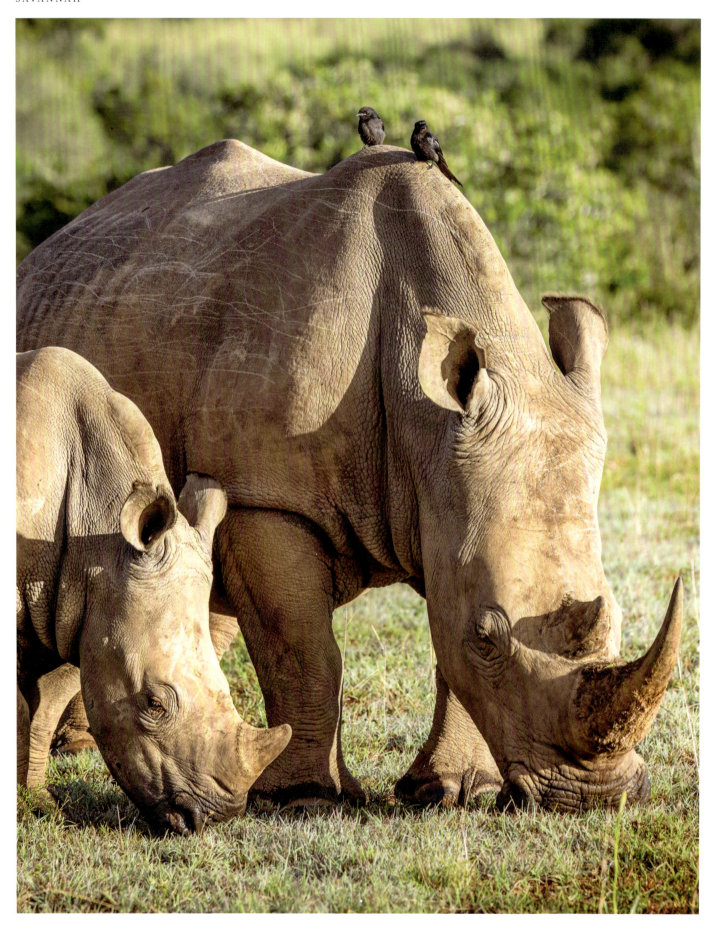

LEFT:
WHITE RHINOCEROS WITH CALF
Named for the 'wide' squared-off mouth that is adapted for cropping short grasses and not the colour of its thick hide, this African species is the largest of all rhinoceros species. It is also the most numerous, but a leader among some very rare species indeed. There are less than 18,000 living in the world, mostly in the south where they are better protected. A northern subspecies is centred in the unstable borderlands between Uganda, Democratic Republic of Congo and South Sudan. The wild population was as low as 15 in the 1980s. After a slow recovery, there are worries over a recent decline due to an upsurge in poaching therefore the status of this northern group is now highly uncertain.

BELOW:
JAVELINA
It might look like a pig but this is a peccary, belonging to a group of odd-toed hoofed animals that is distinct from (but closely related to) wild pigs, hogs and boars. The common name for this peccary, which is found from Texas all the way to Argentina, is the javelina due to its downward-facing upper canines that are too small to be called tusks but are still a significant feature. Hogs and boars only have upward-facing tusks.

ABOVE:
JAGUARUNDI
This medium-sized wild cat lives in most habitats throughout Central America to the temperate regions of South America, east of the Andes. Its name means 'dark jaguar' in an Amazonian language. The hunter is found across the Cerrado and Llanos grasslands where it hunts for small prey, ranging from deer fawns to frogs.

SAVANNAH

communal, bag-like nests by weaving dried grasses with their beaks. Each pair has its own chamber but there can be hundreds of pairs living side by side in one tree.

With trees sparse and thorny, smaller savannah animals seek refuge underground, and beneath the soil there is another world of burrows and nests. Ant colonies are an often disregarded member of the grassland community. It is estimated that nearly 3 per cent of all animal biomass on Earth comes from ants. The grasslands of Australia and South America are also well known for their enormous termite populations, many of which build immense mounds of earth. Unseen inside the mounds are a warren of chimneys and chambers that have the purpose of allowing air to flow through the colony, to remove unwanted heat and prevent the build-up of moisture that would otherwise cause the spread of mould, which would be deadly for the insects.

Several small mammals seek refuge in burrow systems. In Africa these include the warthogs and meerkats, the latter of which are famously cautious as they emerge from hiding at dawn to hunt on the surrounding parched land. In Asia, the mongooses, a relative of meerkats, fill a similar role.

RIGHT:
WILLANDRA PLAINS
This area of New South Wales, Australia is a low-lying area of grassland. The few trees that grow here are black box, a kind of eucalyptus, that is able to withstand long periods of drought.

BELOW:
WOMBAT
Along with the koala and kangaroo these savannah animals are icons of Australian fauna. They are burlier than they appear and are able to knock down a person with a well-timed charge – and they bite too. The nocturnal wombats create large burrows to rest in by day. They have a distinctive pouch for their young. The opening faces backwards to stop earth from getting in as they dig. The wombats graze on grasses and herbs and are known for producing cube-shaped droppings, which are used to mark territories.

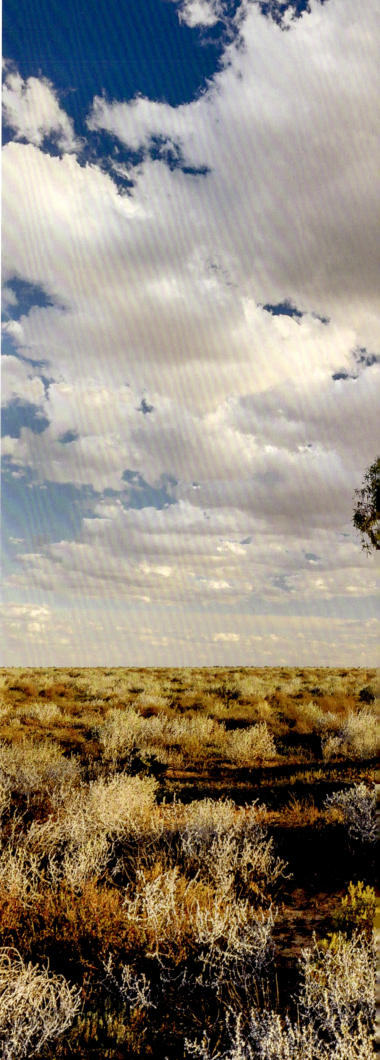

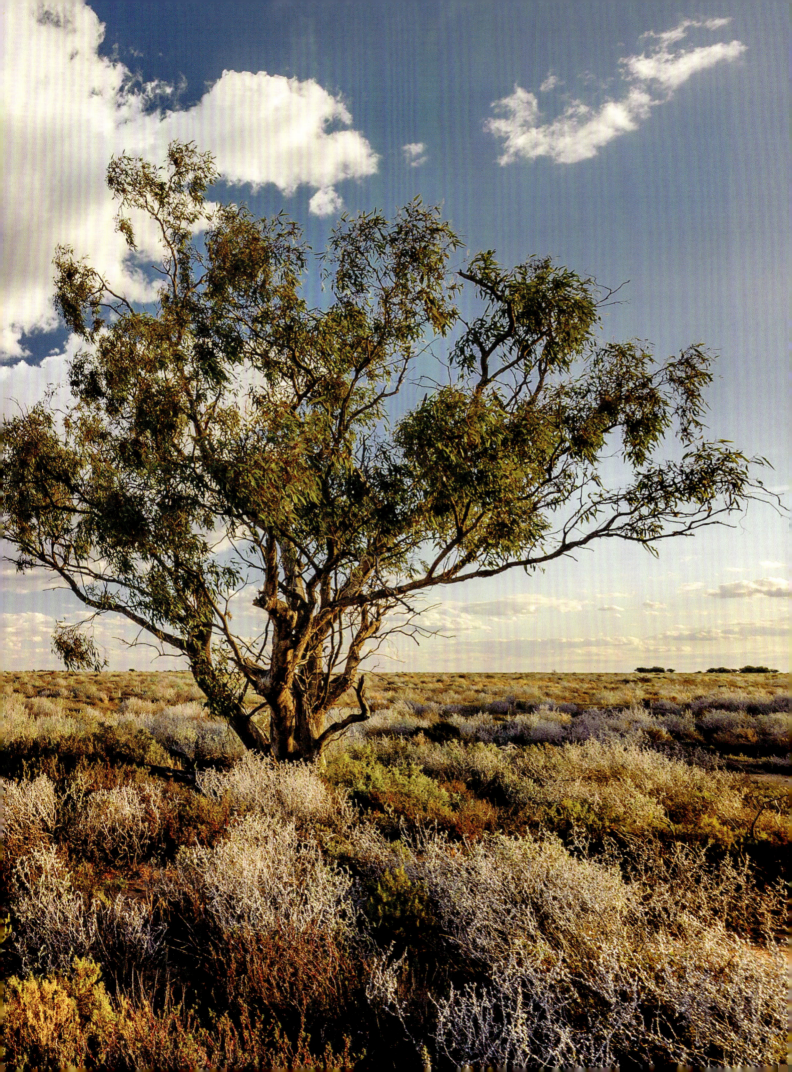

ABOVE:
SAND GOANNAS
A pair of male san goannas, also called sand monitors, are wrestling for the right to mate with a female. These are among the biggest lizards living in Australia, the last descendants of much larger, dragon-like creatures that once roamed this continent. The lizard is nearly always on the move during the day searching for small prey. By night it hides out in a burrow.

LEFT:
GROUND PANGOLIN
Despite first impressions, this creature is a mammal. The body is protected by tiles of horny keratin, not dissimilar to a thick fingernail. This ant- and termite-eating animal is able to coil itself into an armoured ball when threatened.

RIGHT:
SAHEL
The arid Sahel region, seen here in northern Burkina Faso, along the southern 'shore' of the great Sahara Desert, is mostly bare earth in the dry season. The umbrella thorn acacia trees have roots that reach down to the water table far below the surface, but the grasses and smaller herbs are waiting for the rains before they reappear above the surface.

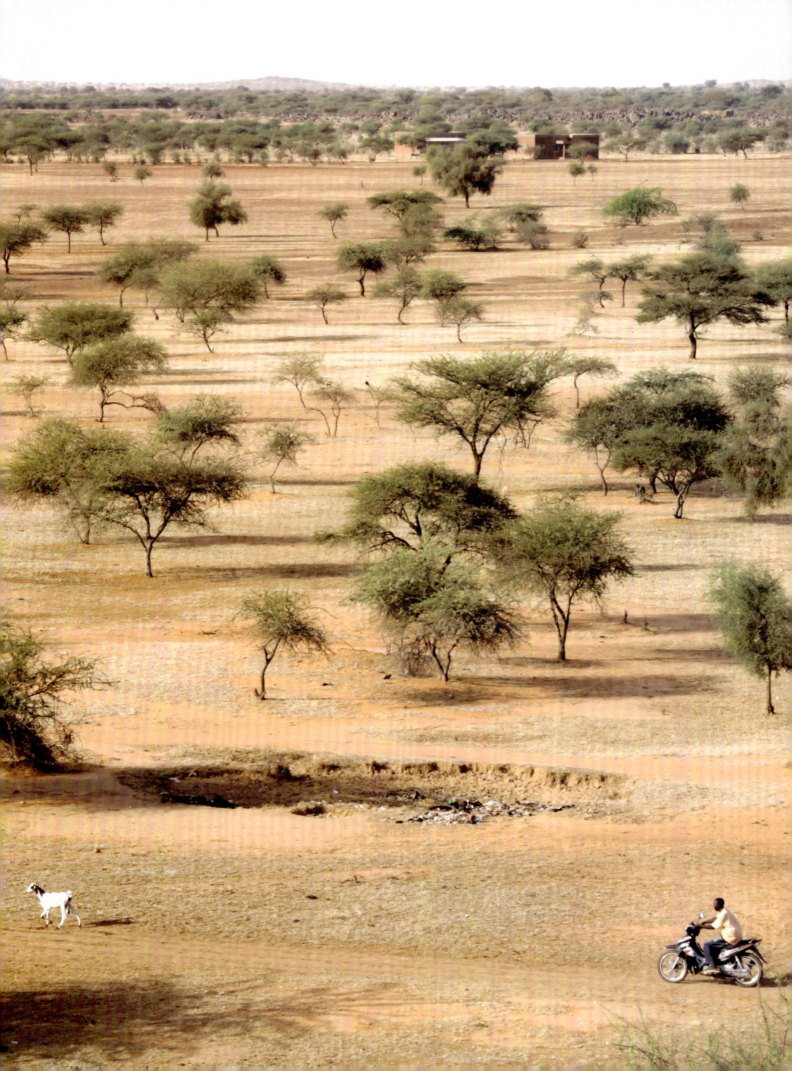

PREDATORS ABOVE

The grassland is a largely two-dimensional habitat. The action is taking place all around you. However, looking into sky reveals that grassland wildlife is up there too. The world's grasslands have their own panoply of raptors. These are often perch hunters that wait for prey to come near and they are not often seen in the sky. They are too easy to spot. Meerkats even have a specific alarm call that alerts the mob to an aerial attack. However, there are birds in the savannah sky that do not care if a ground animal sees them. They will only meet when that animal is dead. These soaring birds are the vultures. In South America a common species is the king vulture, which has distinctive red patches on its largely featherless head. The same bald look features in the Old World vultures too. It stops the dried blood and flecks of meat from getting tangled up in feathers and creating infection risks. The long neck helps these big birds reach deep inside a rotting carcass to snaffle every last scrap of flesh.

It sounds disgusting, but without ravenous vultures homing in on the smells of decay and death to feast on animal remains, the savannah would be a hellish landscape of dead bodies. Together with other scavengers, such as striped and brown hyenas, jackals and an army of beetles and flesh flies, the vultures ensure that the remains of an antelope felled by lions will be bare bones within weeks. Spotted hyenas, which hunt as well as scavenge, have a bite strong enough to crack through bone to get at the nutritious marrow inside. This is a rare ability, shared by few other animals. Evolutionary anthropologists have proposed that our early human ancestors, living in Africa many hundreds of thousands of years ago, were also scavengers that could break bones to access the fatty marrow. And this fuelled the development of the large human brain. We should remember that we ourselves are a species of the savannah.

RIGHT:
JAGUAR
This big cat is among the most widespread and adaptable. It is a feature of rainforests but is also found in the savannahs and scrublands of South America where it targets deer, peccaries and smaller prey.

BELOW:
COMMON DEATH ADDER
With a name like this, one needs to be wary of this snake. It is widespread across wilderness areas of eastern and southern Australia, and is among the most venomous snakes in the world. The snake is at home in savannah and shrublands, but will also find a home in rainforests in more tropical areas. It is not actually a relative of the Eurasian adder, but a kind of cobra. It is an ambush predator that strikes with great speed, and has a venom that will kill within seconds, so it does not have to search out its victims if they escape its clutches.

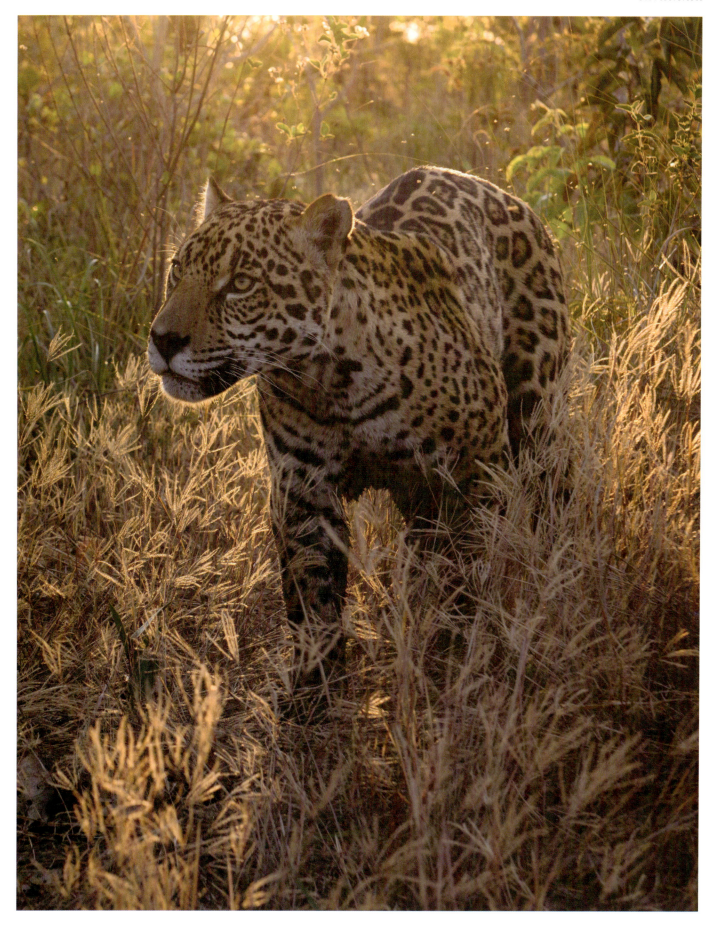

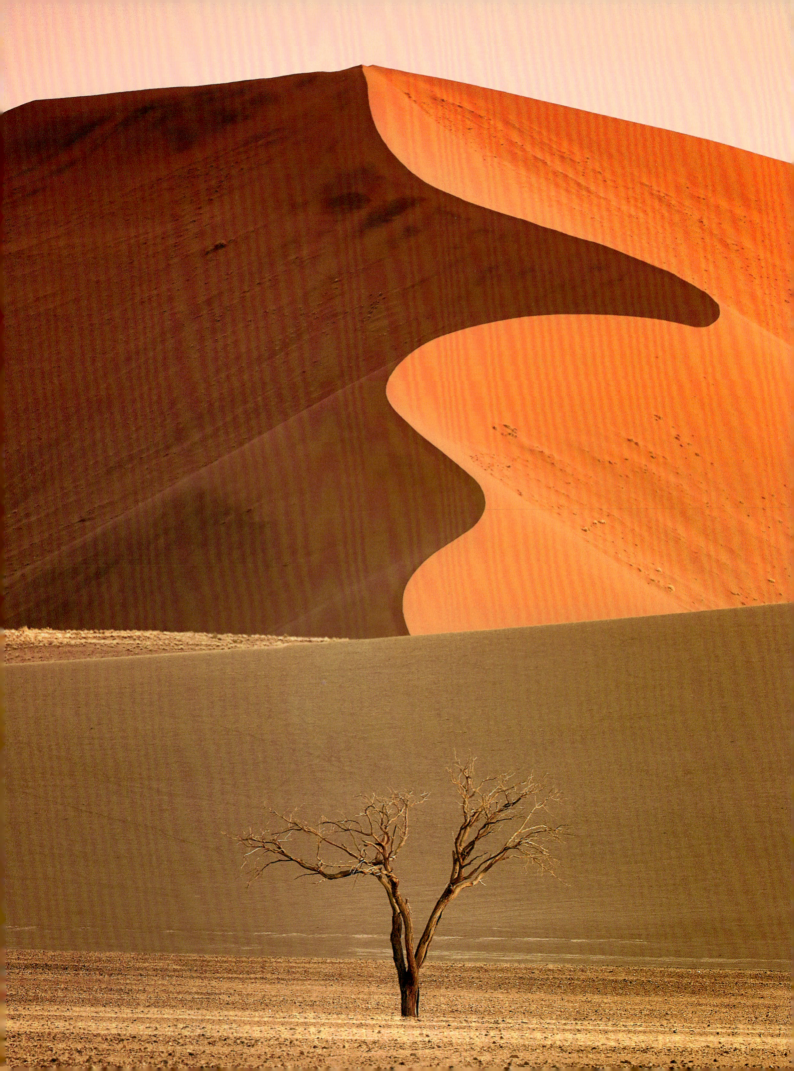

DESERT

About a fifth of Earth's land is classified as desert. There is one single characteristic that needs to be met for land to qualify: it must be dry, very dry. Anywhere that receives less than 25cm (10in) of rainfall in a year is a desert, and places that get less than 50cm (20in) are semi-deserts. Some desert lands receive much less rain than even that small amount. Parts of the Atacama Desert along the western coast of South America have had no appreciable rainfall at all between 1570 and 1971. Even today rain is exceedingly rare, and this region is commonly described as the driest place on Earth.

All deserts are dry but they are not necessarily warm despite popular beliefs. Instead the temperatures there are another example of how extreme the desert climate is. In tropical deserts, such as the Sahara, the midday temperatures regularly reach above 30°C (86°F), yet within hours that heat is gone as the Sun sets, and the arid environment plunges fast to below freezing. This rapid change in conditions is among the fastest of any biome and is another reason, along with the lack of water, why deserts look like they are devoid of life. True enough, desert life is very tough but there is life there,

OPPOSITE:
SAND DUNES
The Sossusvlei sand dunes in the Namib Desert are millions of years old and stand more than 150m (492ft) tall.

RIGHT:
NAMIB DESERT GECKO
This little lizard comes out at night in the lower, flatter areas of the Namib Desert to prey on beetles and ants. It has webbed feet to help it walk across the loose sands without sinking in.

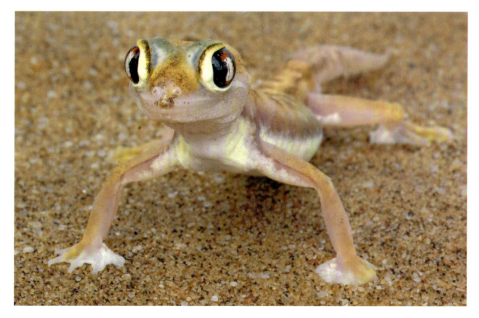

DESERT

ABOVE:
GILA MONSTER
This is the largest lizard in North America. It lives in the deserts of the southwestern United States and northern Mexico. It is distinctive for the beaded scales that cover the body and its venomous bite. This venom is not pumped in through fangs but rather the lizard chews on its victims, mixing in toxic saliva. The venom is non-fatal to humans.

RIGHT:
JERBOA
The original desert rat, this North African and Asian jerboa is a close match to the kangaroo rat of North America, but not closely related. The hopping locomotion, or saltation, means these little rodents can hit speeds of 24km/h (15mph). They are nocturnal and search for seeds, insects and scraps of plants among the sand.

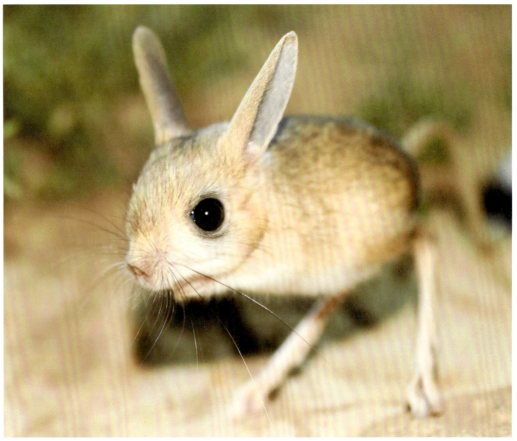

in fact some of the most fascinating forms of life on Earth. Nevertheless, you need to know where to find it. The extreme conditions of the hottest deserts ensure that the biomass density of deserts (the total amount of living material by land area) is the lowest of any biome. For example, there are 2.5kg (5lb) of biomass in every square metre of marshland, and 2kg (4lb) in the same area of tropical forest. In a desert there are just 3g (0.1oz) of living material per square metre. The next nearest biome is the vast open ocean, which has nearly 50 times the biomass density of a desert.

HOW DESERTS FORM

With this information in mind, it is easy to know when you are in a desert. The landscape is mostly a mix of rock and sand that would not look out of place on the Moon or Mars. But where do these habitats form? And why? The answer to the second question is surprisingly involved. The habitat is deprived of the factors needed for life, and there are four ways that deserts can form.

The first is the most obvious one. The ultimate source of rain is the ocean, and so deserts form in the deep interior of large continents that are hundreds of miles away – perhaps more – from the ocean. Any winds and weather systems that reach these distant hinterlands will have dropped their moisture in storms near the coast, and will be bone dry. The deserts of Central and East Asia have formed for this reason. They include the Gobi and Taklamakan deserts, both of which are among the most northerly of the world's deserts. They are surprisingly cold despite all the sand dunes. In winter, the Gobi can drop to −30°C (−22°F), so anything that lives here has to have a means of withstanding extreme cold as well as extreme aridity.

As discussed, cold temperatures are a feature of most deserts some of the time. The reason is that the dry sands and rocks are very good at absorbing the heat of the sun during the day – and without rain clouds there is always plenty of sunshine. However, as the sun sets that source of heat energy is lost. The dry ground and air are very poor at holding on to any heat energy. Therefore the dry desert substrate rapidly radiates heat

BELOW:
ALOE VERA
These succulent plants are widespread among desert flora. All have a gel-like sap in their thick leaves that acts as a store of water. Aloe vera is a particular member of the group that is now cultivated for this gel, which is used medicinally. It is originally from the Arabian Peninsula.

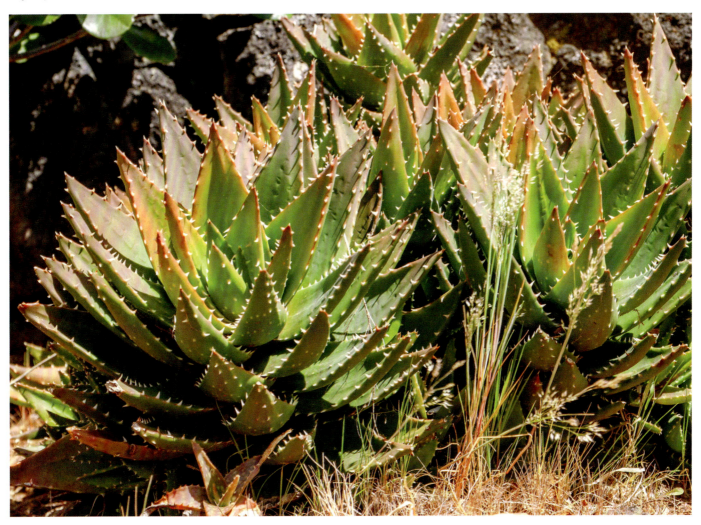

DESERT

RIGHT:
GIANT HAIRY SCORPION
This is the largest scorpion in North America with large specimens reaching 14cm (5.5in) long. Stiff hair-like setae cover the body hence its name. The venom from the fierce tail sting is not a danger to humans.

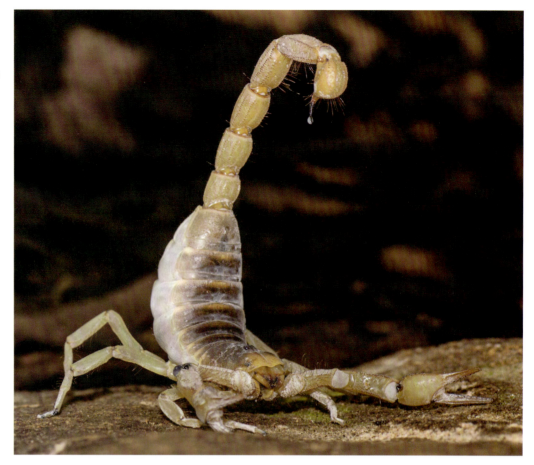

BELOW:
BOTTLE TREE
This unusual tree is named for the way the stout trunk serves as a reservoir, or bottle, for water. The tree, which is endemic to North Africa and Arabia, produces flowers popularly known as the desert rose.

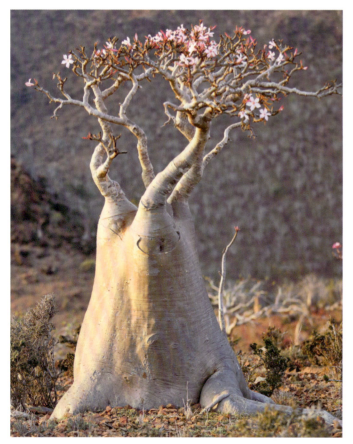

away into the cloudless sky. A hot desert in tropical areas can see a temperature drop of nearly 40°C (104°F) in a matter of hours. Adding in the northern latitudes of the Asian deserts, with the shorter day lengths of winter, the desert is unable to hold the heat from one day to the next and receives less radiant heat each day, losing it all overnight. As such its temperatures ratchet down to extreme cold. Wetter habitats at the same latitudes can hold heat long term and therfore have a much milder temperature range.

TROPICAL LATITUDES

The hottest deserts are found in the latitudes close to the Tropics of Cancer and Capricorn. The weather systems here are linked to the air flows that billow out from the equator. This is very warm air that is filled with moisture evaporating from the oceans. The air is pushed up and away from the equator, and it cools as it rises and moves north and south. That cooling reduces the amount of water vapour the air can hold, and droplets of liquid water appear forming clouds. These clouds dump vast amounts of rain in the tropical forests and the

OPPOSITE:
BARREL CACTI
This plant, one of the most common in the Sonoran Desert in Arizona and Mexico, is a single rounded stem that can be wider than it is tall. The leaves are reduced to spikes, as water is stored in the fibrous flesh inside the barrel. The barrels can live for more than 100 years.

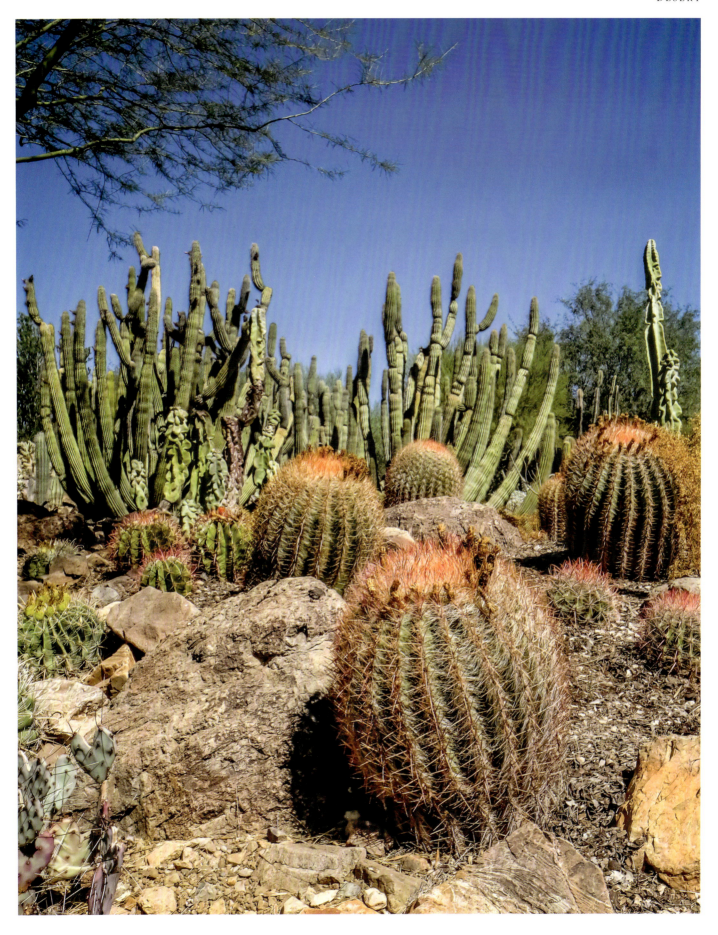

DESERT

leftover moisture will make it to the savannahs and shrublands that neighbour the jungles. Beyond those areas, the air has a very low humidity, and it continues away from the equator steadily sinking to a lower altitude. It reaches the ground by around 30° north and 30° south whereupon it reverses direction and forms a low-level flow that heads back to the equator – picking up moisture as it goes. The land around 30° from the equator very seldom witnesses rain, and the heat of the tropical sun ensures it is hot all day. The Arabian Desert, which covers most of the Arabian Peninsula, is formed

RIGHT:
SALTWORT
This hardy plant is able to withstand high levels of salt in its tissues. It is originally from arid parts of central Asia, where it is known as Russian thistle, but has since spread to North America.

BELOW:
ROADRUNNER
This North American bird can fly but is most often seen racing along through the desert. It generally keeps to a straight line, which means it can appear to be running along a road though it will run on a road occasionally. The bird is an unfussy eater and will tackle insects, lizards and even small snakes, as well as scratch around for plant foods.

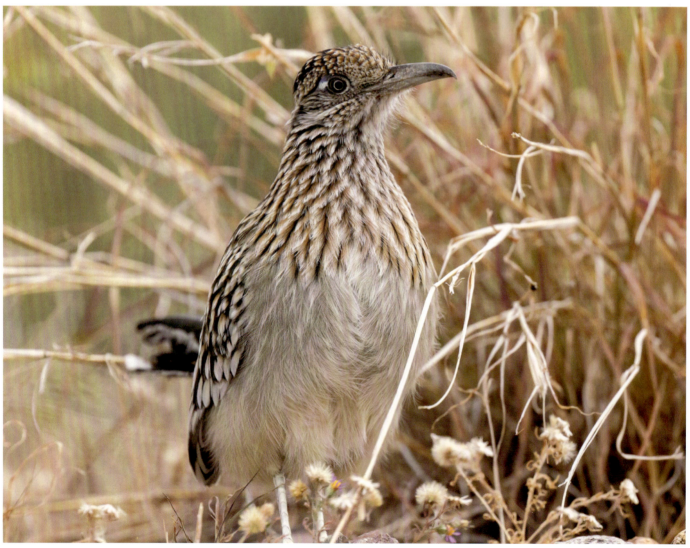

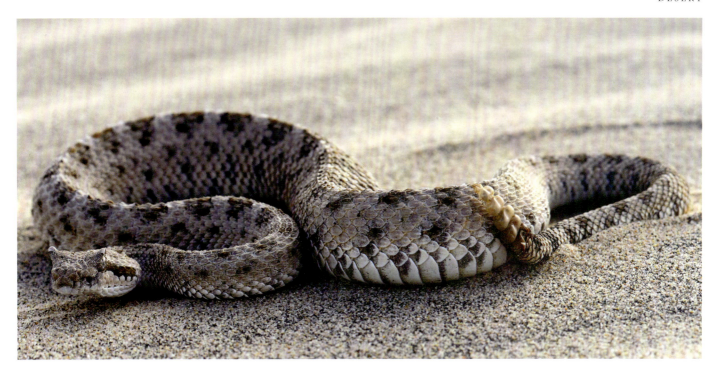

by this process, as is the patchwork of deserts in the Australian interior, including the Great Victoria Desert.

BLOCKING OUT THE RAIN

The third desert location is in so-called rain shadows. These are located on the leeward side of a mountain range. The prevailing winds must get over high peaks to reach these places, and along the way they run out of rain. The winds rise up the windward side of the mountains. As they rise, they cool and as they cool, they form clouds and drop rain. The windward slope of the range is lushly forested. In fact in the Pacific Northwest and British Columbia the rain is so intense on the ocean-facing ranges that the habitat here is described as a rainforest, albeit a temperate rather than a tropical one. The mountains here are the Rockies and other ranges in the Western Cordillera, a set of compressed ridges that run all the way to the geological active faults along the West Coast. In the rain shadow to the east of the Rockies are the Great Plains of Canada and the prairies of the United States. The rainfall is much reduced but is still enough to elevate that vast continental region out of desert status. However, to the south in the so-called Sun Belt states like California, Nevada and Arizona, where is is warmer and drier (as one might expect), the rain shadow is enough to create deserts beyond the mountains. These include the Mojave of southern California, the Sonoran, which spreads into Arizona and Baja in Mexico, and the Chihuahuan Desert, which runs from New Mexico and West Texas to the central region of Mexico.

COASTAL DESERT

In South America, the Atacama Desert, is located in a counter-intuitive position between the ocean and the Andes. This desert

ABOVE:
SIDEWINDER
Also known as the horned rattlesnake, this American desert reptile, is named after the unusual way that it moves over soft sands. A normal snake locomotion would see the snake bury itself in the ground, so instead it holds its body in a zigzag with most of it lifted off the ground and only touching it in three places that push the snake forward.

BELOW:
ROUND-TAILED GROUND SQUIRREL
This cute little desert rodent lives in northern Mexico and the southwestern United States. It builds shallow burrows in the sand to avoid the heat of the day. This one is climbing into a creosote bush to eat the fruits, but the species also preys on insects.

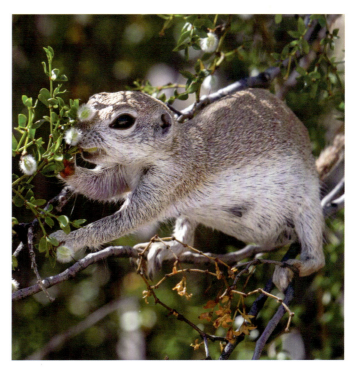

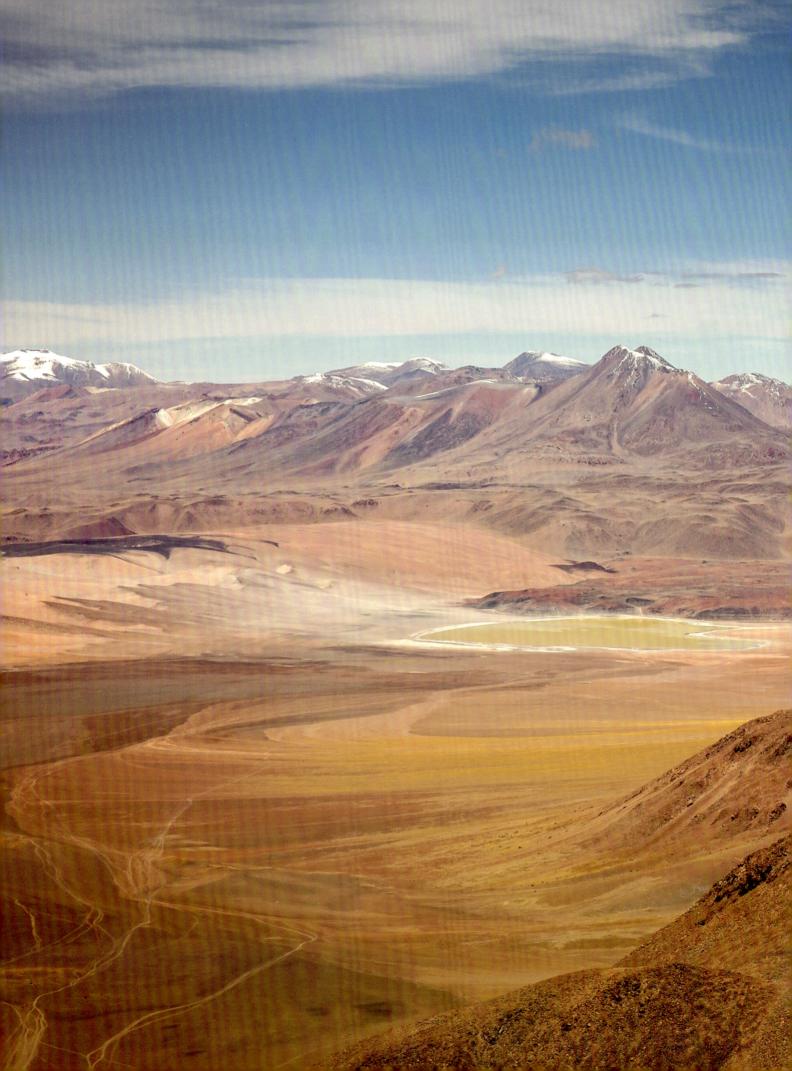

DESERT

ATACAMA DESERT
With a chain of volcanoes to add to the drama of this landscape, the Atacama of Chile is so dry and seemingly lifeless it looks like a scene from another planet.

is created due to its location on a western-facing shoreline. The Namib Desert in southern Africa, famed for its tall orange dunes, is created the same way. The process relies on the way ocean currents move in wide circles, large enough to fill a region of ocean. In the Northern Hemisphere they are moving clockwise, and in the Southern Hemisphere, they turn the other way. However, in both instances the currents that are carrying cold water from the high polar latitudes will travel along the western coast. In the case of the Atacama, it is the Humboldt Current moving up from Antarctica, while for the Namib it is the Benguela Current, similarly carrying cold water from the south.

The cold water is packed with oxygen and nutrients so these coastal waters are among the most productive ocean zones on the planet. However, cold water does not evaporate into the air particularly quickly, and so the air above these areas of sea is

OPPOSITE:
ARABIAN HORN VIPER
This terrifying desert hunter is able to spend long hours buried in the sand with just the head in view. It will wait for a bird or other small animal to come close and then strike with devastating speed and precision. The 'horns' are a pointed scale above each eye. They may have a role in shielding the eye from sand grains, but they are also larger in males than in females, and are therefore used in mate selection.

BELOW:
TAKLAMAKAN DESERT
The early morning light illuminates the chains of barchans. These are crescent-shaped sand dunes that are in constant motion due to the relentless winds. Some can reach up to 300m (1000ft) high.

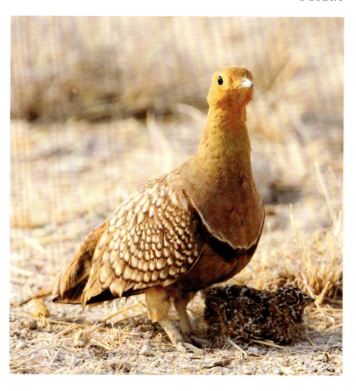

ABOVE:
NAMAQUA SANDGROUSE
A chick is taking a nap in the shade cast by its parent. This is a South African species of sandgrouse, a family of birds that live in many desert areas. The ground birds are all seed eaters, but also supplement their diet with insects during the breeding season. This particular species is noted for being able to store water from a watering hole soaked into its belly feathers.

DESERT

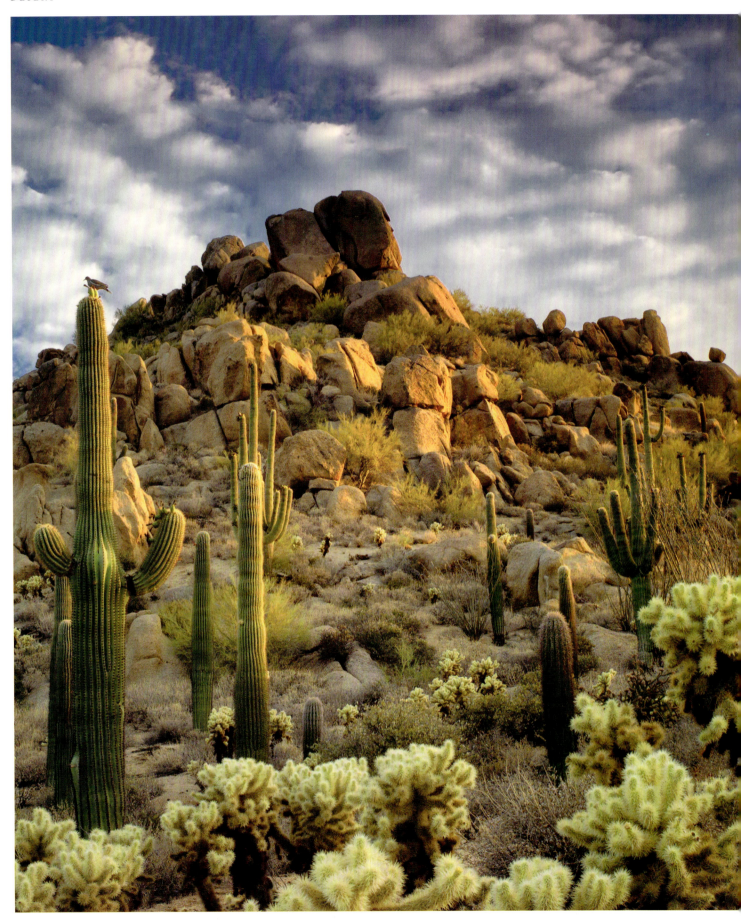

LEFT:
CACTI
The iconic branched columns of a saguaro cactus are picked out by the setting Sun's light in Arizona's Sonoran Desert. In the foreground are cholla cacti – their sausage-shaped branches are covered in barbed spines.

BELOW:
AARDWOLF
A slightly built relative of the hyena, this is a specialist predator of termites. The aardwolf (or earth wolf) lives in southern Africa. It can slurp up 30,000 termites in a single night using its sticky tongue, which is impervious to the termites' bites.

low in humidity. And as a result, they deliver almost no rain to the coastal zones nearby, so whereas the seas teem with life, the lands are arid and empty.

THE SAHARA

So far we have not touched on the largest and most famous of the world's deserts: the Sahara. This ocean of sand and rock spread from the western shore of North Africa, across the northern interior of the continent that straddles the Tropic of Cancer all the way to the Red Sea and the Middle East. This description goes some way to explain why this desert is so vast. (Map projections squash this region and stretch others, so can be misleading. However, the Sahara is larger than all 48 states of the continental United States and is only slightly smaller than China.) The Sahara is created by three of the four desert-forming processes that work together to create such an enormous desert.

However, the Sahara was given a helping hand by humans. Around 6000 years ago, pastoralist communities, which relied on herds of cattle and especially goats came to this area. The rapacious grazing of the animals reduced the root biomass in the land fringing the desert and this disabled the soil's ability to hold on to water. This created a feedback loop, where the arid soil could not hold moisture and the dryness spread into previously fertile areas. This process of desertification has been witnessed many times over the centuries, and is especially

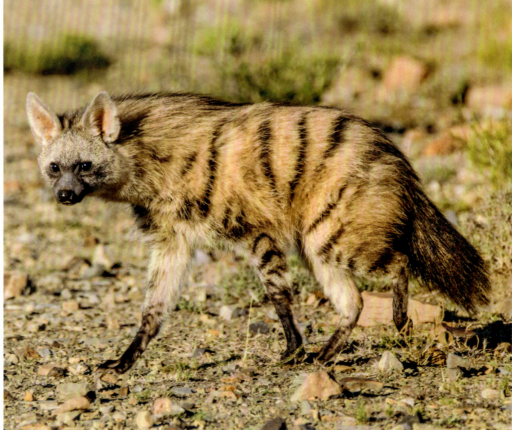

DESERT

prevalent in western China, where great efforts are being made to hold back the spread of the sands. Drought-resistant shrubs and trees are being planted in vast numbers and with some success, that is until the effects of climate change are taken into account. This is increasing the length of droughts and producing extreme downpours and even snow in desert regions. More water arrives during these events than is perhaps normal for past years, but it is delivered all at once and with such force that it undermines the soil through flash flooding. Climate change is making deserts grow, and it is predicted that parts of southern Europe, such as Spain and France, will shift from a Mediterranean shrubland to widespread semi-desert habitat before the end of this century.

RIGHT:
THORNY DEVIL
This Australian lizard is taking no chances. Its body is covered in spikes that make it a tough meal for many predators. If one decides to have a go, it will generally aim for the head. But which one? The thorny devil has a false head behind the real one made from rounded lumps (also spiked). The lizard is an ant eater and forages for them by day among the arid tussock grasses. To avoid detection it walks very slowly, aiming to blend into the reds and yellows of the desert. It also sways gently as it walks, imitating the rustle of a fallen leaf. The lizard rises early to restock is water supplies. Dew condenses on the spikes and trickles along channels to the mouth.

ABOVE:
TAMARISK
This bushy, evergreen tree can grow up to 18m (59ft) tall. The tamarisk has slender branches, grey-green foliage and scale-like leaves that overlap each other along the stem. It is native to the desert regions of Africa and Asia.

BELOW:
SUPERBLOOM
The Mojave Desert in California is transformed in a superbloom, with a vast number of poppies appearing at once. This phenomenon occurs after persistent rains have transformed the desert soil.

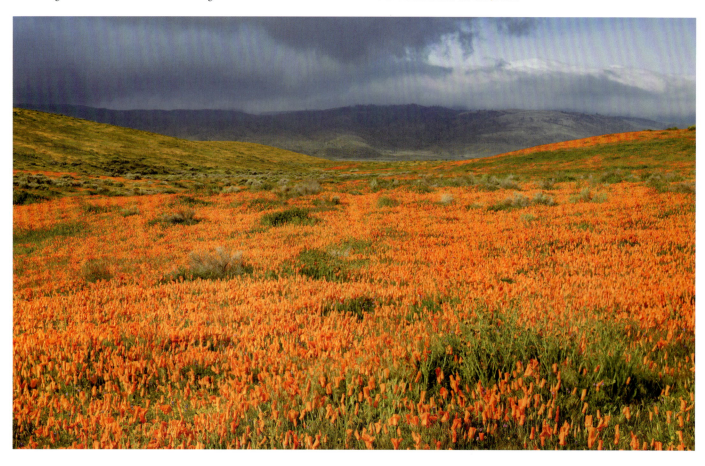

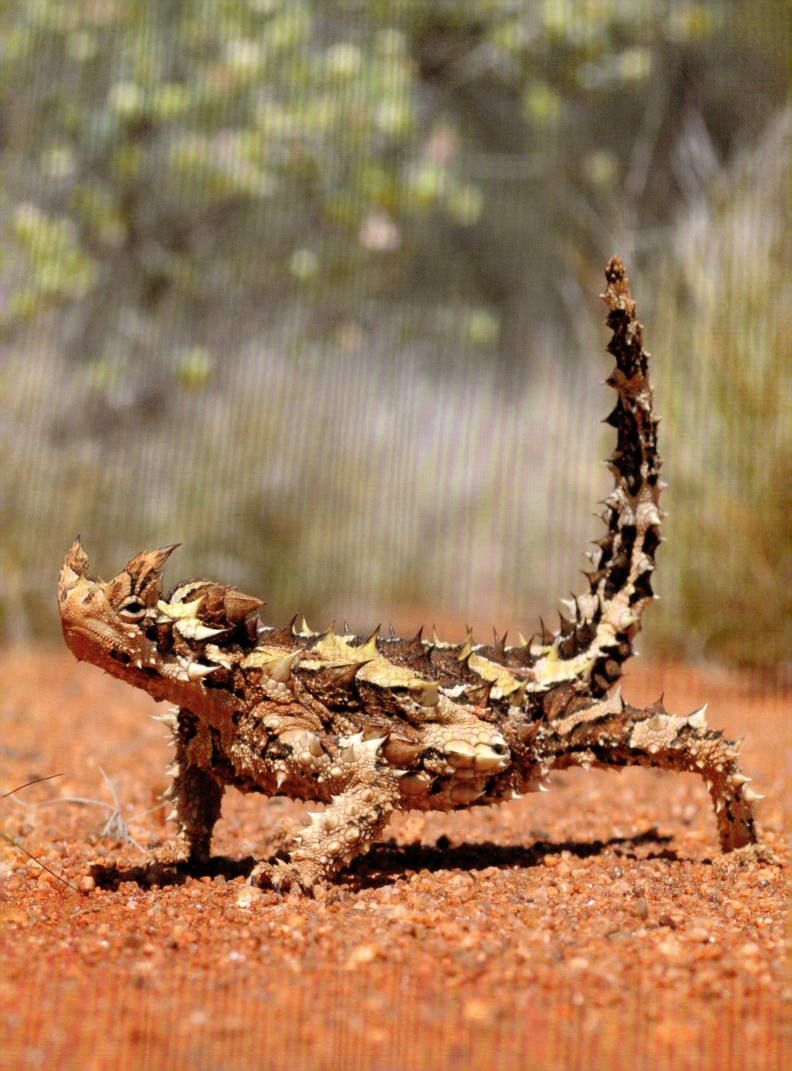

DESERT

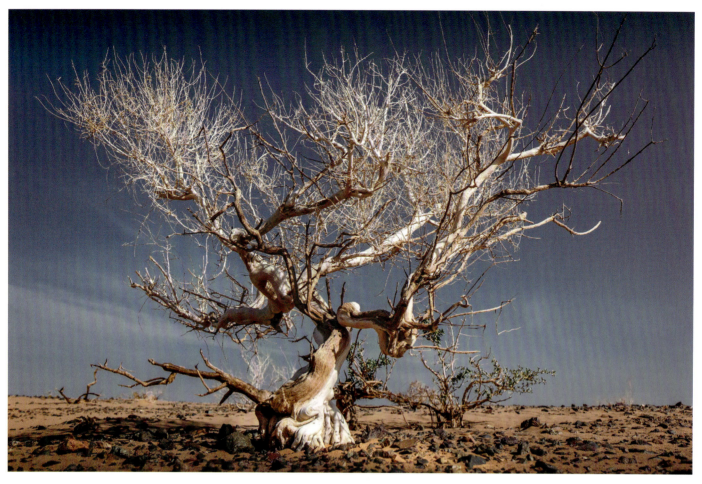

ABOVE:
SAXAUL TREE
This saxaul tree is one of the few that grows in the desert regions of Central and East Asia. The tree's roots help to bind the sand, which prevents the soil from degrading. Large numbers of saxaul trees are being planted in Asia, and China especially, to prevent desertification.

BELOW:
DESERT RAIN FROG
This frog lives along the coast of the Namib Desert. When it is too dry on the surface, it burrows deep into the ground and is able to absorb water from the damp soil directly through its skin. It will restrict its time above ground to the wet season in June and July.

SAND AND SOIL

Soil is a composite of minerals and organic materials – or at least it should be if anything much is going to grow in it. Desert soil has plenty of the former and very little of the latter. The organics are a complex mixture of chemicals derived from the waste and decay of once living things. It is this stuff that clings to the mineral grains, adding a soft stickiness and making the soil cling together as a coherent material. Between the solids are spaces that hold water and air, both needed for the plant roots that grow into the soil. Desert soils are caught in a negative feedback loop. They lack these organic components and so cannot support plant life. And being unable to support plant life in any great degree, they have no source of fresh organic material to maintain fertility – and support plant life. Even when rain does fall, often in large amounts, the water trickles through the loose sand rapidly out of reach of roots. Any water that does wet the sand near the surface is soon evaporated away once the sunshine returns.

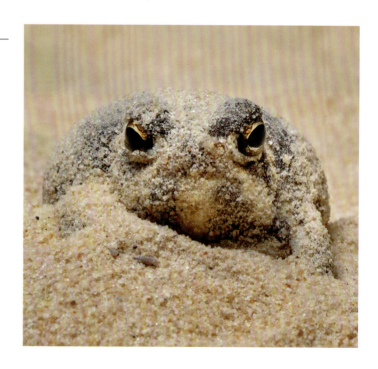

DESERT

The result is a near lifeless substrate that is made from loose grains of dry sand or smaller dust particles. Without the roots and organics binding it together, the sand is unstable and prone to shifting. It will flow downhill under gravity with the slightest disruption and the dry winds whip up sandstorms that blow the grains into dark clouds. The winds are primary creators of sweeping dunes and vast 'seas of sand' called ergs. However, even here life has found a way to survive, with lizards that swim through the soft sands and beetles that climb the dunes to catch droplets of life-giving moisture carried by the wind.

DESERT MISTS

The fact that deserts do not get much rain is obvious enough but these habitats do receive water in other ways. The coastal deserts are among the driest in terms of rain, but they are also prone to thick fog. Fog is essentially a cloud that is forming at ground level, and thick fogs will regularly roll over the Atacama, Namib and Thar deserts, the latter of which straddles the border between India and Pakistan. The fog is especially common at dawn and dusk, where the air blowing in from the sea is chilled by the cold land, and what little moisture it holds condenses into a thin mist. Plants and animals in these deserts

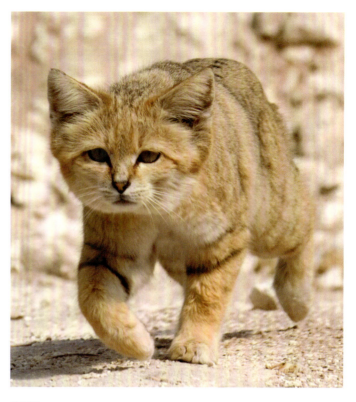

ABOVE:
SAND CAT
This cute killer lives in parts of the Sahara, Arabia and Middle East. It is camouflaged for desert life, and mostly targets birds and rodents, as one might expect. They cover large distances as they hunt at night, sometimes up to 10km (6 miles).

BELOW:
FOG BEETLE
When not collecting water from the air, this beetle is a scavenger. It eats whatever remnants have been leftover by plants and animals, and will also graze on the fungi that grows on them.

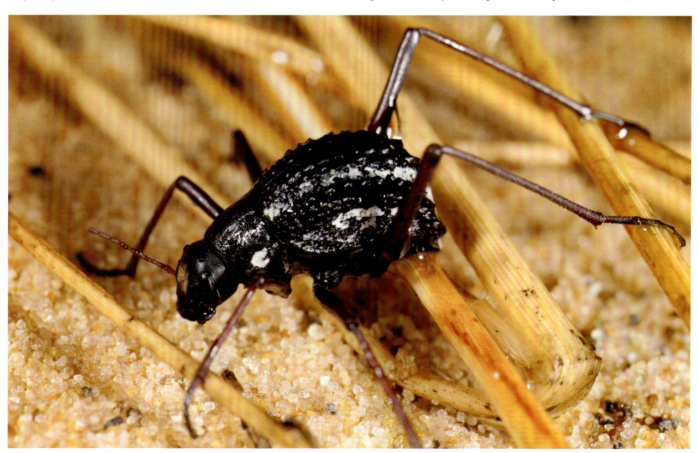

have ways of collecting the water. For example, the Atacama has hardy Tillandsia plants. These are close relatives of the epiphytes that live in the humid jungles a world away across the Andes. These epiphytes grow on the branches of tall trees and so have no roots to speak of. Instead they take the water they need from the steamy air all around them. This is precisely the strategy of the desert varieties. They take in their water through their leaves – and any specks of mineral dust trapped in the mist – and barely use their roots.

One of the wonders of nature are the fog beetles of the Namib Desert. Beetles are easily spotted because they have rounded wing covers, or elytra, that fold over their backs. The fog beetles of the Namib also have these features, but they are not used to protect delicate wings underneath. There are no wings at all, and the elytra are fused into a solid surface that is able to collect water from the air. The small, black flightless beetles climb to the top of a towering dune early in the morning and then do a headstand. More precisely, they lift their abdomens high into the air, to catch the misty wind. The elytra have a series of bumps with a hydrophilic coating. Water droplets in the air stick to these bumps so that they are not blown away in the wind. Gradually the tiny droplets coalesce and grow into bigger drops that eventually drip off their bumps and trickle into the channels in between. These channels have a hydrophobic coating so the water flows downward to the head, where it is eagerly slurped up by the insect's mouthparts.

OASIS

An oasis is a place where life blooms in the desert. The word is borrowed from the ancient Egyptian term for 'place to live.' A green oasis set among all that aridity looks miraculous but

RIGHT:
DROMEDARY
The one-humped camel originated in Arabia and the Horn of Africa. It was domesticated in this region around 4000 years ago. As such there are no wild camels in the region, but their supreme adaptations to desert living means they are a widespread desert animal across North Africa and the Middle East. Large herds of feral camels, the largest wild population in the world, live in the Australian outback, where they were introduced (and then escaped) nearly 200 years ago.

BELOW:
DATE PALM
These palms originated in the part of the Middle East known as the Fertile Crescent, the land where civilization and agriculture first took root. The fruits of these palms have been an important part of the human diet here for 9000 years. Today the palms are cultivated across desert regions from North Africa to South Asia, Australia and California.

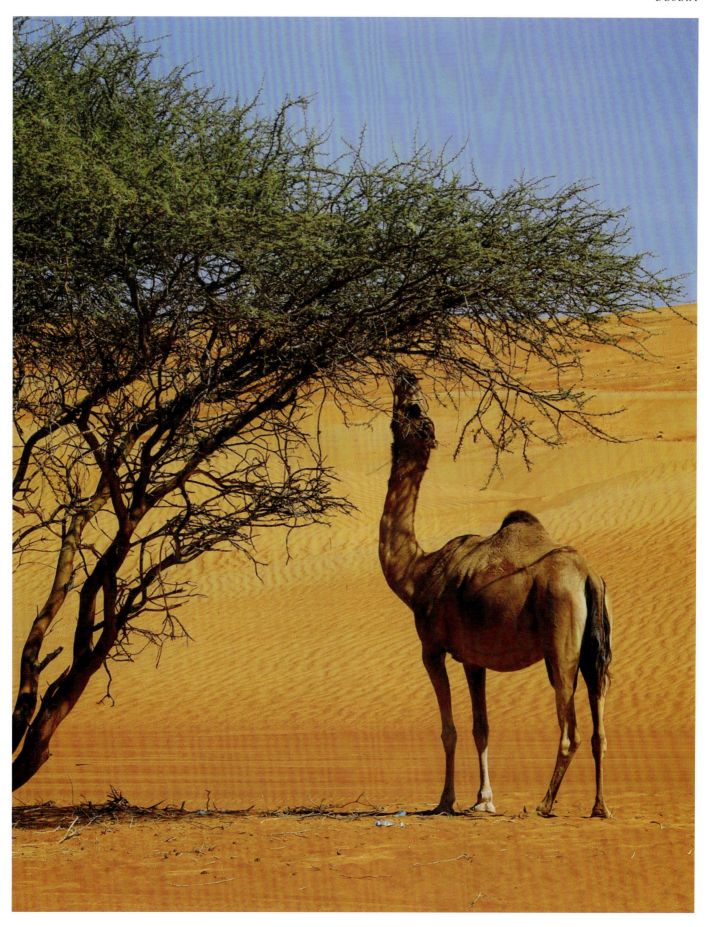

DESERT

OASIS
The trees show that there is water beneath the sands at this oasis in the Sahara. The water attracts all kinds of life, including the Berber people who live in this North African desert.

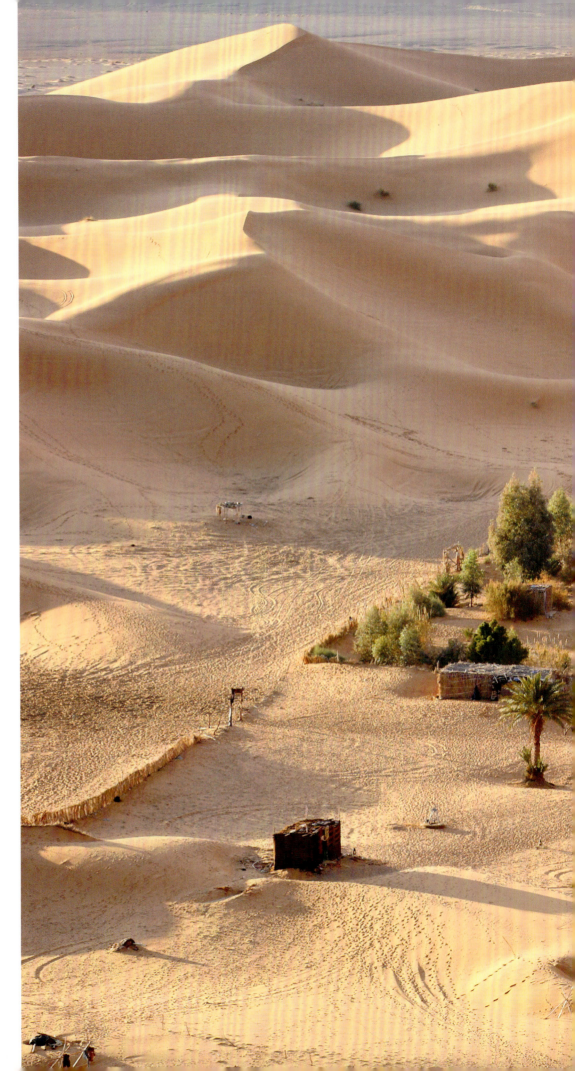

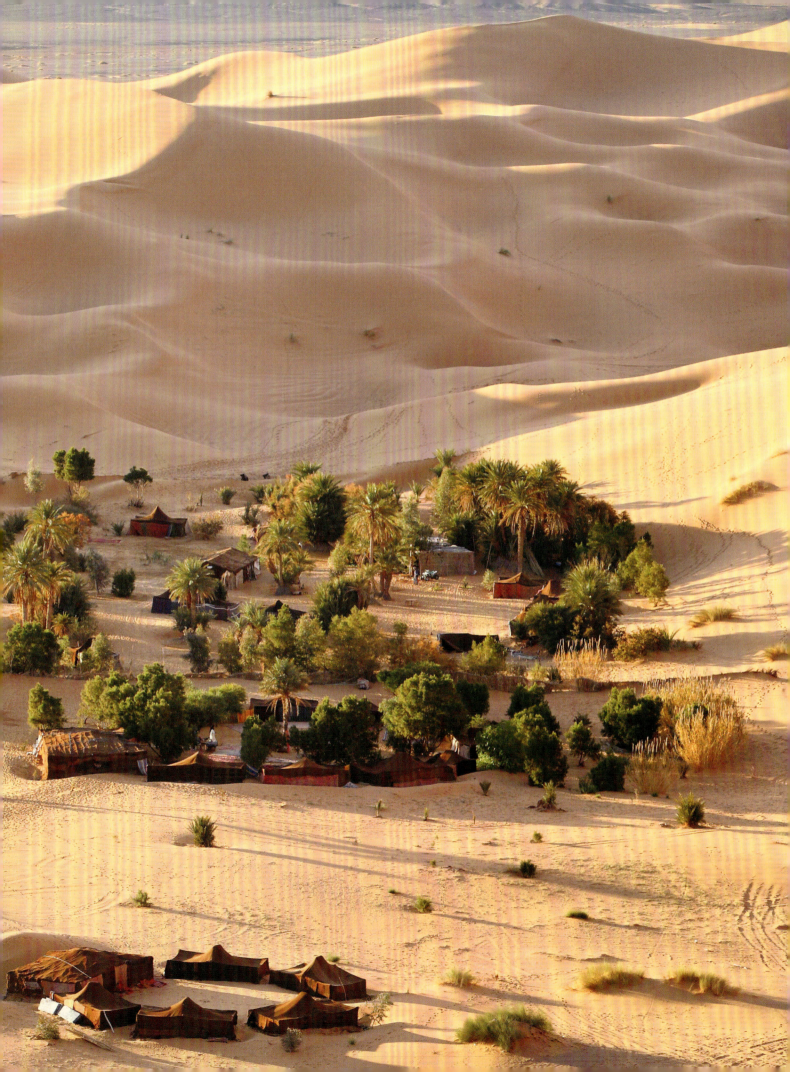

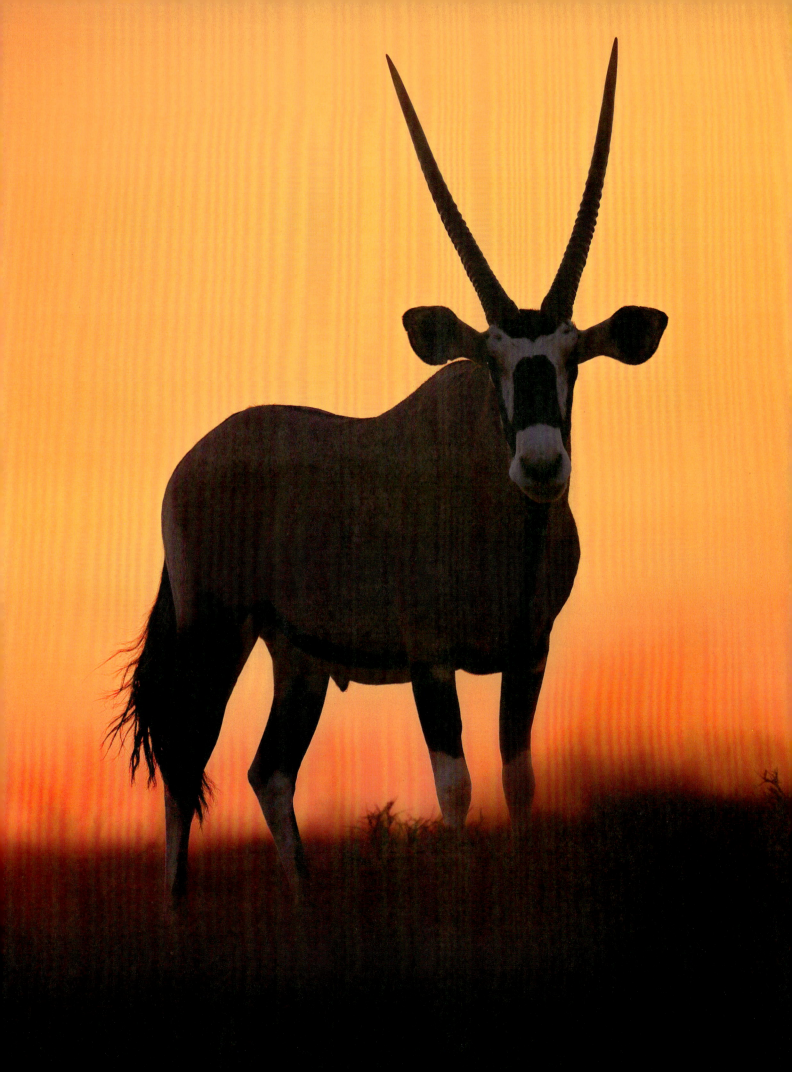

it is a simple enough geographical feature that forms wherever groundwater reaches the surface. There is always water in rocks under the ground. This water table can be very close to the surface but generally in a desert it is tens of metres down. The water beneath the desert fell as rains far away, probably in a mountain range with porous limestone rocks. The water trickles into these rocks and flows downhill through the limestone seam or strata. Eventually it is locked away deep under a desert. Above and below the sodden limestones are impermeable rocks that stop the water leaking away. This subterranean water feature is called an aquifer, and the seam of rock may rise and fall but the pressure of all that water behind leading back to the mountain entry point is enough to push the groundwater up the inclines. It then gushes (slowly) down the other side.

An oasis forms in two ways. First, the aquifer arrives at the surface in a lowland area, creating a spring that fills a depression or basin to make a lake. Second, the aquifer is blocked by a fault where the seam of permeable rock is blocked by impermeable rock. As a result the water is pushed up the fault to the surface. Springs formed in this way tend to be in highland deserts where the land is being thrust upwards by deeper geological forces.

ABOVE:
TUMBLEWEED
As the name suggests, this plant spreads by breaking off from a parent and rolling along in the wind until it arrives at a suitable habitat. Although it is an iconic symbol of the American West, this plant was introduced from Russia in the 19th century.

RIGHT:
GIBSON DESERT, AUSTRALIA
This arid land in Western Australia is in the midst of a drought. Once the rains return, maybe years into the future, the desert will bloom once again.

OPPOSITE:
GEMSBOK
This antelope from the deserts of southern Africa belongs to the same group of species as the oryx, which lives in the deserts of North Africa and Arabia. They do not need to drink any water as they get the moisture they need from their foods.

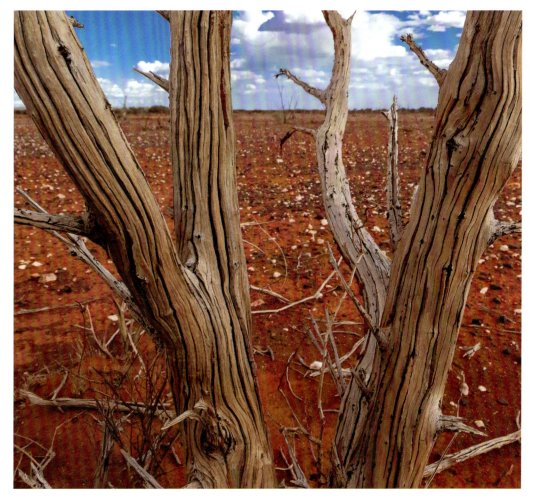

LEFT:
SPINIFEX
This hummock-forming grass is a dominant plant in Australia's dry areas. As the plant grows it expands into green rings that spread across the sand.

BELOW:
GOITERED GAZELLE
This small antelope is common across the deserts of Western and Central Asia. Its name refers to the species' thick neck, which is more obvious in the male.

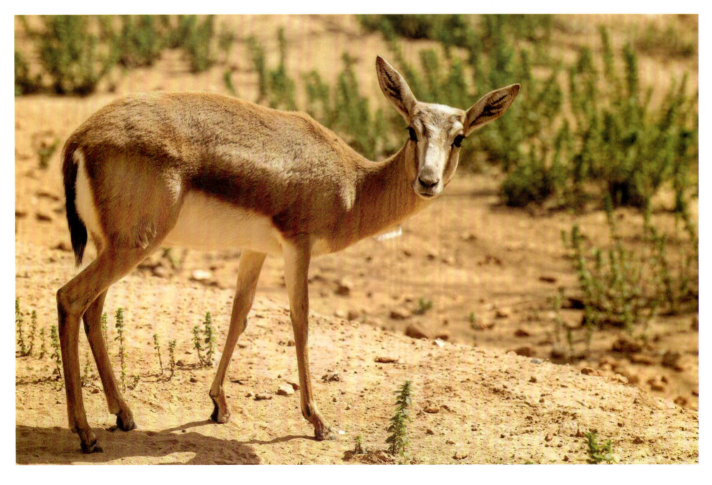

FIND WATER AND KEEP IT

Despite being few and far between in the wild, desert plants are very familiar to us. The main reason for this is they are so tough and resilient to drought that they survive well as houseplants even when largely neglected. (The internal conditions of a modern home are not dissimilar in aridity and heat to a desert.) Perhaps the most familiar desert plants are cacti and succulents, such as agave, aloe and yucca. Both these types of plant follow the same strategies to find water and hang on to it. The roots of these plants are shallow and wide. The idea is to create a rain net that grabs as much water as possible whenever rain falls in the area and before it trickles away. Once collected, the plants store the water for later – as it might not rain again for years. A cactus stores water in the stem, which is swollen into a fleshy cylinder or barrel shape. Inside the stem is filled with spongy fibres that are soaked with water. The outer surface of the stem is thick and leathery to prevent the water inside from evaporating away. The flimsier body parts that we

ABOVE:
BEARDED DRAGON
This Australian lizard has a prehistoric appearance. The beard refers to the spiked neck pouch. It is more obvious in the male, as seen here.

RIGHT:
WEDGE-TAILED EAGLE
Also known as the eaglehawk, this is the largest bird of prey in Australia and it is one of the most prominent desert hunters (although it is also found in other habitats). It is a generalist and will target snakes, lizards and native mammals; it has no problem killing rabbits and other small invasive animals. It is a perch hunter, in common with many eagles. It stands on a high leafless spar or on a rocky cliff and watches for prey below.

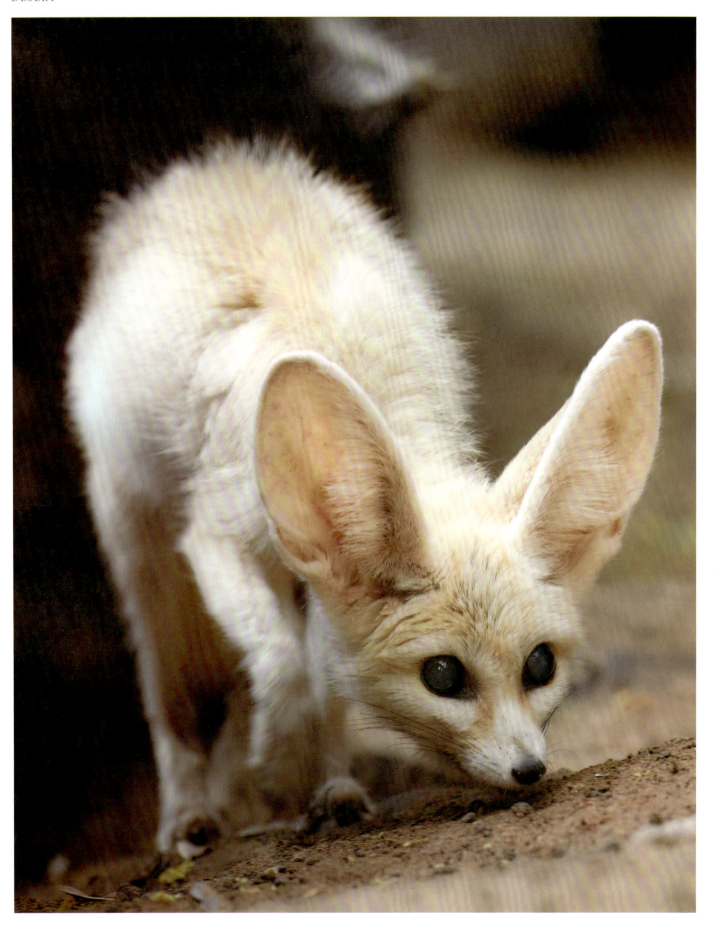

DESERT

OPPOSITE:
FENNEC FOX
Renowned for its enormous ears, this is the smallest species of fox found anywhere. It lives in the Sahara where it uses its acute sense of hearing to find small prey to eat during the cool of the night.

RIGHT:
WADI RUM DESERT
This scenic valley in the deserts of Jordan is bone dry most of the year. Yet it is prone to flash floods. 'Wadi' is Arabic for river valley, and on occasions water flows through this place.

BELOW:
NAMAQUA CHAMELEON
This ground-living lizard from the Namib Desert is able to match its skin colour with the surrounding sands. It will also become paler during the day to reflect away the unwanted heat. At dawn and dusk, it turns darker to absorb more of the warmth.

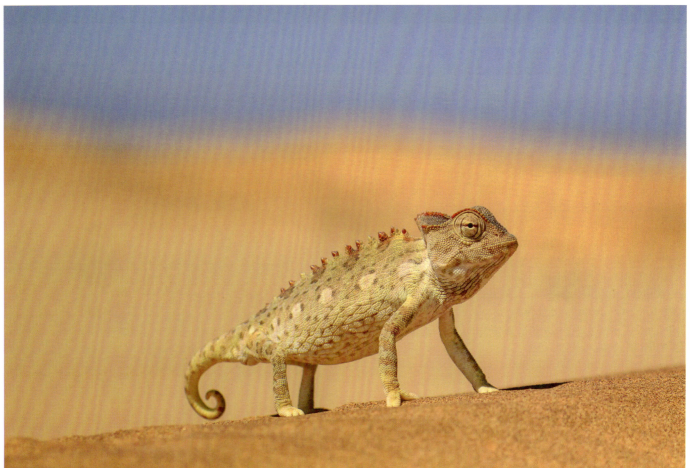

159

DESERT

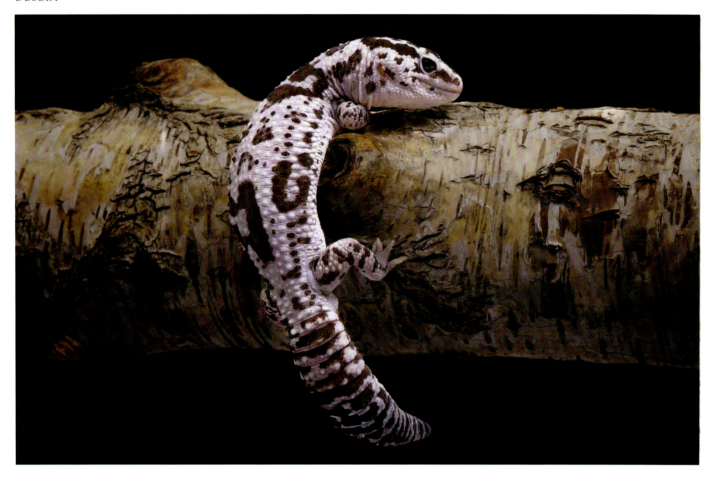

ABOVE:
FAT-TAILED GECKO
It is perhaps obvious how this African desert lizard got its name. This specimen does indeed have a plump tail, which indicates that it has ready access to foods. In the wild, the lizard uses its tail in the same way a camel uses its hump. The fats in the tail are a store of energy and nutrients that will sustain the small insect-eating reptile in times of scarcity.

expect plants to have, most notably the leaves, are not present (not in the same way at least) to reduce the surface area and so cut back on water loss. However, the cactus needs to up its defences further. Animals will want to get at its water, and so those unused leaves are repurposed as spikes, which make it very uncomfortable when getting too close to the plant. Of course, the cactus still needs to photosynthesize, and so its green chlorophyll is in the surface of the stem.

Succulents have a different approach. They store the water in their leaves, which are thick and fleshy protuberances. Often the water is stored as a thick gel that fills the core of the leaf. As with cacti, the water stores are well protected, often with tooth-like serrations along the edges. The gels and thick saps make desert succulents useful to us. Fragrant aloe gels are added to lotions, soaps and drinks, while agave syrup is used to make mezcal and tequila.

TAPPING IN

Some desert plants have a different method for getting the water they need. Some areas do not have the rainfall or mist to support air plants or water-storing plants. However,

RIGHT:
THYME
This familiar herb is a desert plant. It is used most prolifically in African and Middle Eastern cuisines and has since spread to Europe, America and beyond.

if the water table is near enough to the surface, then woody desert shrubs have a chance to survive. These plants are set up above the surface to withstand the heat and reduce water loss. The leaves are small and have a coating of wax that helps with waterproofing. The leaves are a much-sought food source and to put off potential predators, they are filled with pungent oils that make them taste sour and will upset the stomach. Below ground, the plants, which include mesquite and the creosote bush, have a deep tap root. This thick root grows straight down with few branches until it reaches deep enough to tap into the water table. There are few shallow roots spreading out wide to capture rain, but the tap root is a constant supply of water that sustains the slow-growing plants all year round.

DESERT ODDITY

The *Welwitschia mirabilis*, sometimes called the tree tumbo, is a truly amazing desert plant. The plant is found in the Namib Desert and the dry lands of the Western Cape. It lives for centuries despite its half-dead appearance. Thinking back to classroom biology experiments, readers might remember how seeds sprout a root, a stem and two leaves and then build from there. *Welwitschia* is unique in that it does not go any further, and just gets larger and larger. The plant has only two leaves, which grow out up to 4m (13ft) from the stumpy stem. The tips of the leaves dry and fray into tatters that break off (rhinos like to eat them) but they keep on growing from the centre – and keep going (very slowly) for more than 2000 years. Below ground a thick root goes down several metres to tap into the water table. The Afrikaans name for this plant is *tweeblaarkanniedood*, which means 'has two leaves, cannot die'.

DESERT ANIMALS

The archetypal desert animals are the camels of Africa and Asia, which are famous for carrying a hump or two. This hump is popularly thought to carry water, but it is actually a store of oily fat that is an energy dense food store. This resource means that the camel can go without water for about 10 days and does not need solid food for several weeks. It is common for animals to store energy as fat in deposits under the skin, but a camel would overheat if it did that, hence the humps.

Animal bodies are much more energy intensive than those of plants. As a result smaller desert animals cannot carry food resources with them for long periods. Their smaller bodies are less

BELOW:
INLAND TAIPAN
This Australian desert snake is the most venomous reptile in the world. It is also called the fierce snake because it attacks more readily than other snakes, which tend to avoid confrontation. Encounters with this creature are rare, nevertheless. A bite is a very serious emergency, but rapid medical intervention is generally a complete success.

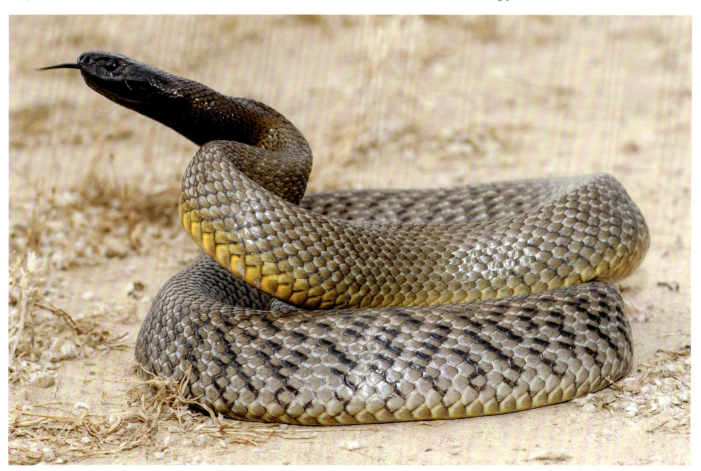

efficient than a larger one, using energy faster while losing body heat and water more quickly relative to their size. Therefore desert animals use a different survival strategy, opting to sit out periods of scarcity while waiting for the arrival of rain and food. The desert rain frog found in the coastal deserts of Namibia and South Africa is a good example. A desert is an unusual place to find a frog, which is normally associated with water and moist habitats. This species coats its skin with a sticky secretion that glues a dusty layer of sand to the body. This helps to waterproof the body and retain water and keep it camouflaged. Like many desert animals, the frog sits out the heat of the day in a deep burrow where the sand is cool. On foggy nights it will come to the surface and sniff out dung left by mammals – there are feral horses in this area along with elephants and other grassland animals that eke out a living along the edge of the desert. The dung is not the frog's food, but attracts beetles, moths and other insects, which it does eat.

RIGHT:
JOSHUA TREE
This woody form of yucca plant grows in just a small patch of the Mojave Desert and the surrounding scrublands. It is highly protected. The tree sends out shallow roots to cover wide areas and so grabs as much water as possible. It also sends out underground stems, or rhizomes, from which daughter trees sprout.

BELOW:
ADDAX
This pale antelope moves mostly at night, like a desert ghost. It will trudge across the Saharan sands for days to find grazing. It moves alone or in small herds, with each addax following in the footprints of the animal in front to make it easier to traverse the sands. In the day, the animals stand in whatever shade they can find.

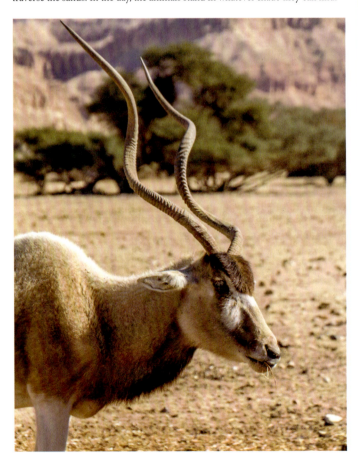

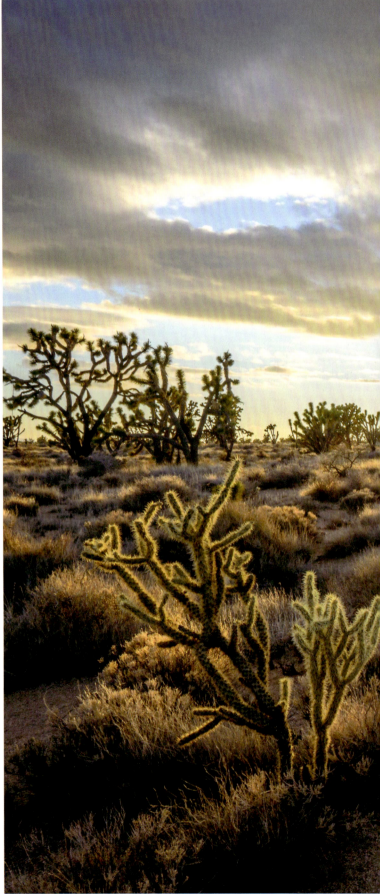

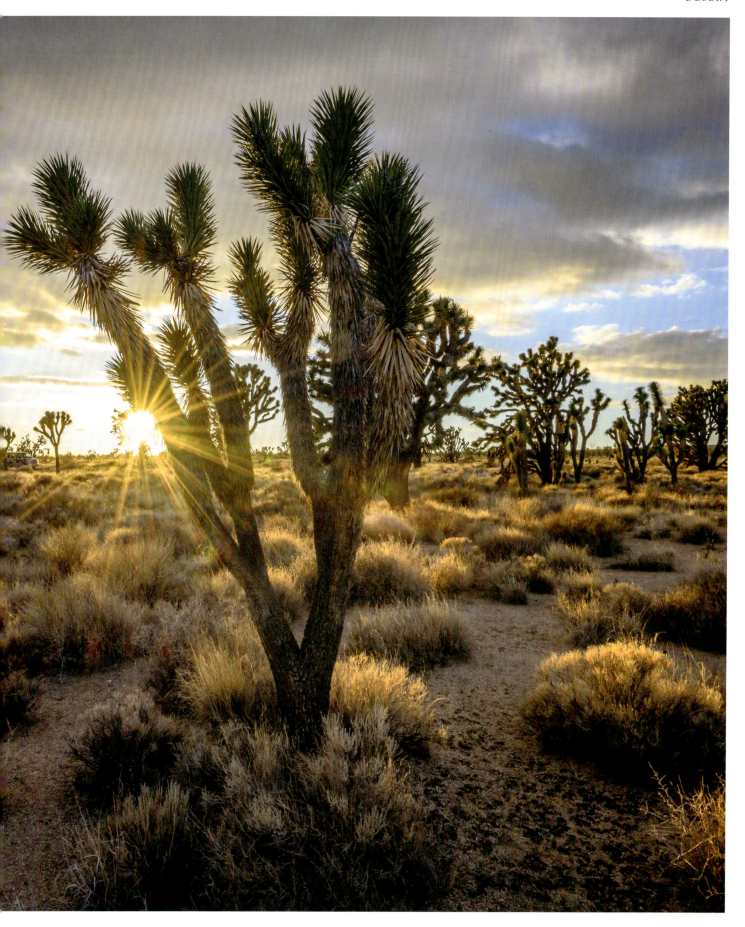

DESERT

LEFT:
CAMEL SPIDER
This fearsome desert creepy-crawly is not strictly speaking a spider, but it does belong to the larger arachnid group. They are seen scuttling around during the day in arid places, hunting for insects and even small lizards and birds. Local myths say that they can outrun a man, and their bite is strong enough to disembowel a camel. Fortunately this is not true.

RIGHT:
BACTRIAN CAMEL, GOBI DESERT, MONGOLIA
The Central and East Asian deserts are home to the two-humped Bactrian camel. It is much colder here and the camel grows a woolly coat in winter.

BELOW:
DEAD TREE
This trunk is the remains of a giraffe thorn tree in the Kalahari Desert of Botswana.

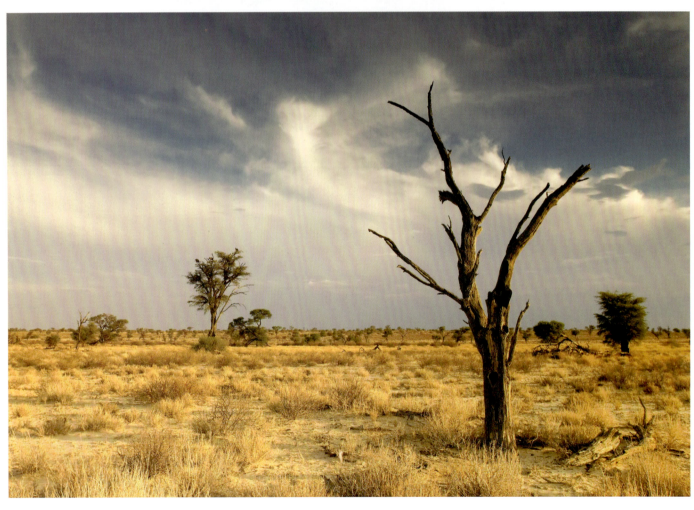

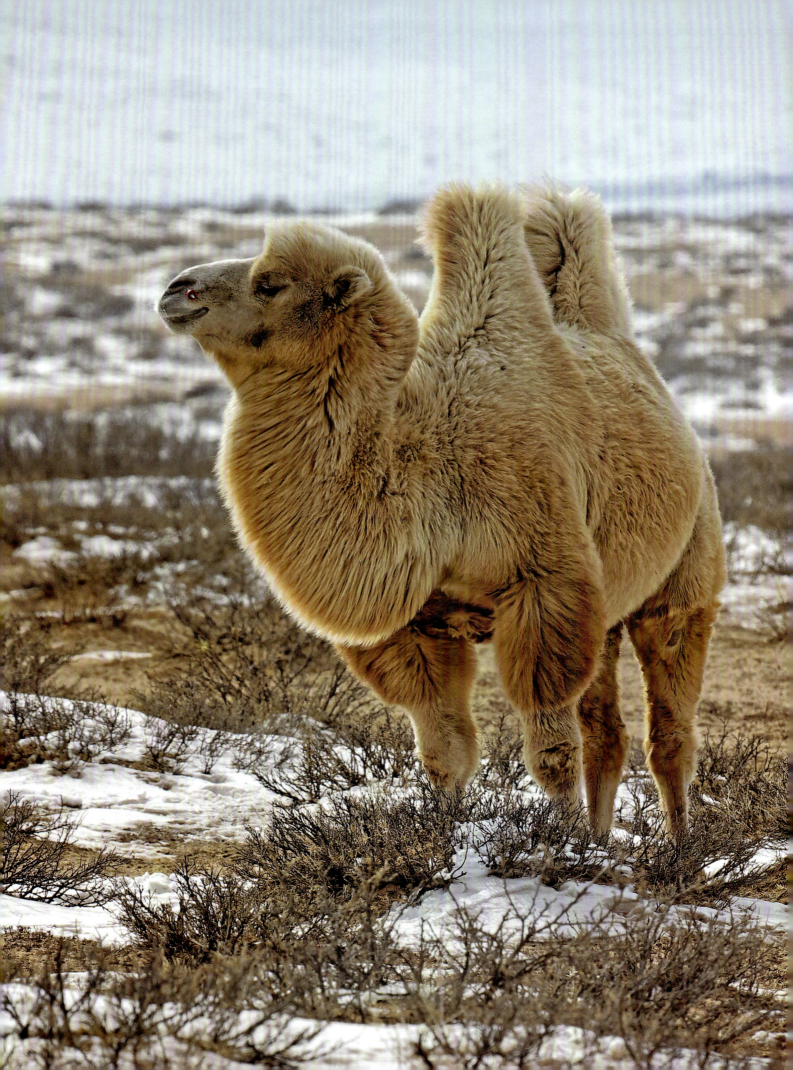

DESERT

RIGHT:
SANDFISH
Don't be fooled by the name, this is a skink, a kind of lizard with a long body and short legs. However, this desert species does 'swim' through the sand, using its shovel-shaped snout to burrow through the soft grains.

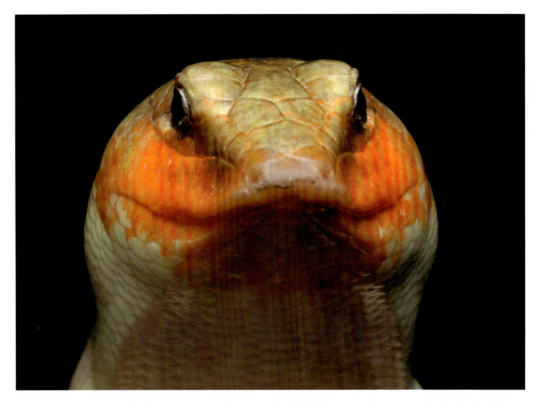

BELOW:
SAXAUL FLOWERS
These tiny flowers are pollinated by wind. The seeds develop inside winged fruits that catch the dry breeze and are blown far from the parent plant. The seeds provide food for desert songbirds.

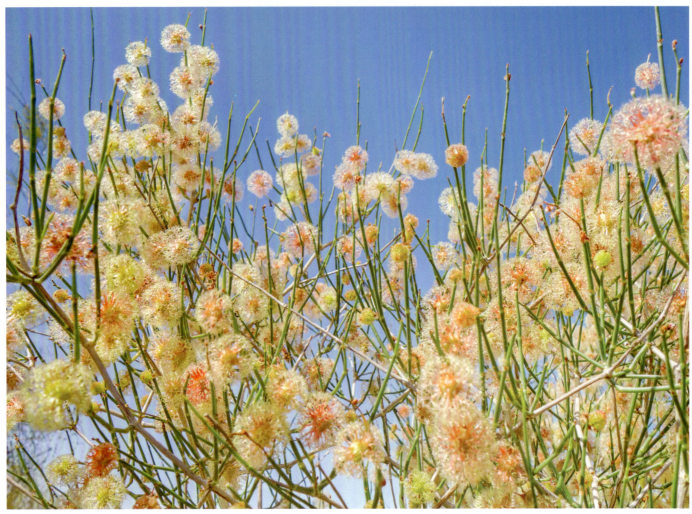

The western water-holding frog of Australia goes one step further. It stays in its burrow for up to seven years creating a moisture-filled bag to keep it hydrated by loosening the outer layer of skin. The frog becomes dormant and uses its bladder to store a supply of fresh water – something that Aboriginal people would traditionally make use of, sipping from the frog when they were in dire need of a drink.

HUNT AND KILL

For many of the carnivorous desert animals, insects are on the menu. The burrowing owls of North America's red-rock deserts have developed a very canny method of securing a meal. As their name suggests, these little owls nest in holes commandeered from ground squirrels. They hiss like a snake from inside to make sure larger predators think twice about taking a look. Unlike other owls, the burrowing owls hunt by day, emerging early in the morning to avoid the worst heat of the midday sun. They snatch flying insects and snare them on the ground. They also collect dung and array it before their burrow. Soon the smell will attract dung beetles, which are among the owl's favourite foods.

The bigger hunters in deserts are much smaller than would be found in other biomes. The African and Asian desert cats are not much bigger than domestic breeds, and together are probably the wild ancestors of our pets. They target mostly birds and rodents. There are small foxes hunting for insects in Old World deserts as well, and birds of prey are among the biggest dangers for lizards and snakes out in the open during the day. The top predators in many deserts are large venomous snakes, such as rattlesnakes in the Americas and desert vipers in Africa and Asia. All of these snakes can sense the body heat of their prey – quite the weapon when hunting in the dark – and they will deliver a paralyzing bite in a lightning-fast attack. Australia is the world centre for venomous animals, and the desert snakes are world-beating in their toxicity. In fact the most deadly snake of all, the inland taipan, lives in the Australian desert. A single bite has enough poison to kill 100 adult humans.

BELOW:
SAND GOANNA
Like snakes, these Australian desert lizards have a forked tongue that allows them to taste the air. Each tip will sample different amounts of a scent offering information about the direction from which that smell came. The lizard will follow the smell wherever it leads, including up trees, over rocks or into burrows.

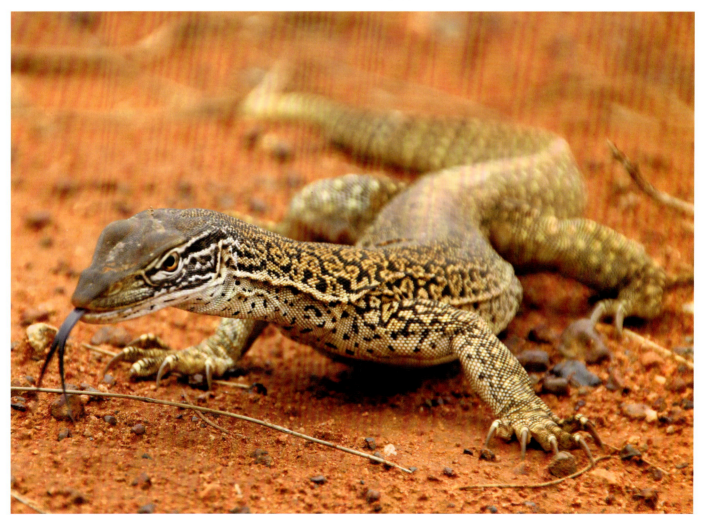

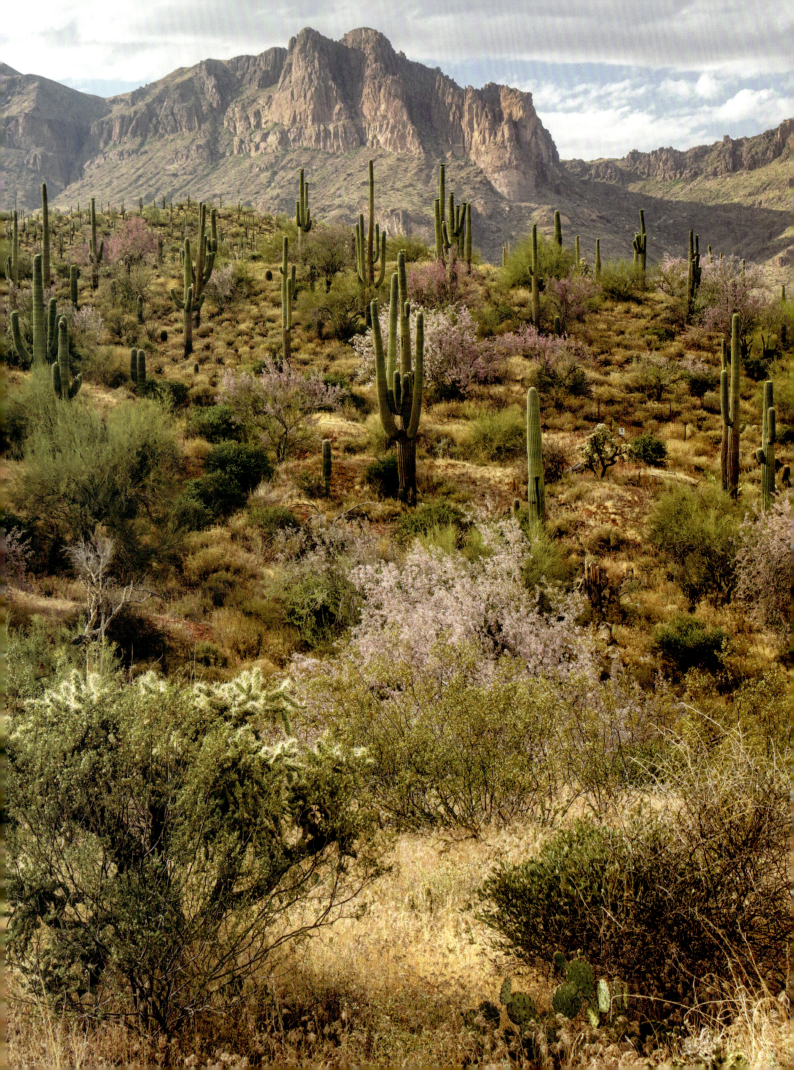

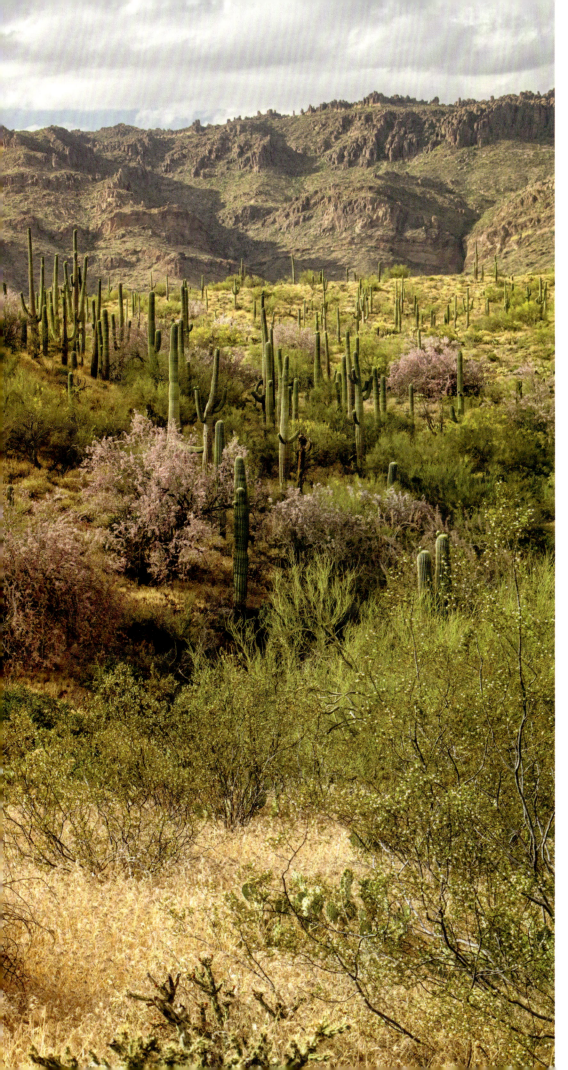

SONORAN DESERT
The deserts of North America are famed for their tall saguaro cacti. The biggest ones will live for 150 years or more and grow to a height of 15m (50ft). These ones are near Phoenix in Arizona.

DESERT

ABOVE:
BROWN HYENA
The brown hyena is a desert scavenger. It is also called the strandwolf because of the way it patrols the beaches of the Namib looking for washed-up marine life.

RIGHT:
LONG-EARED HEDGEHOG
This little insectivore lives across southern Asia, a largely desert region from the Mediterranean to the Gobi Desert. The long ears work like radiators and help the animal shed unwanted heat.

OPPOSITE:
BADWATER BASIN
These salt flats on the floor of Death Valley in California experience the hottest temperatures on Earth. The air is so hot and the soil so salty (the salt crust is 50cm/20in thick in places) that almost nothing survives here beyond bacteria, pickleweed, a few insects and one species of snail.

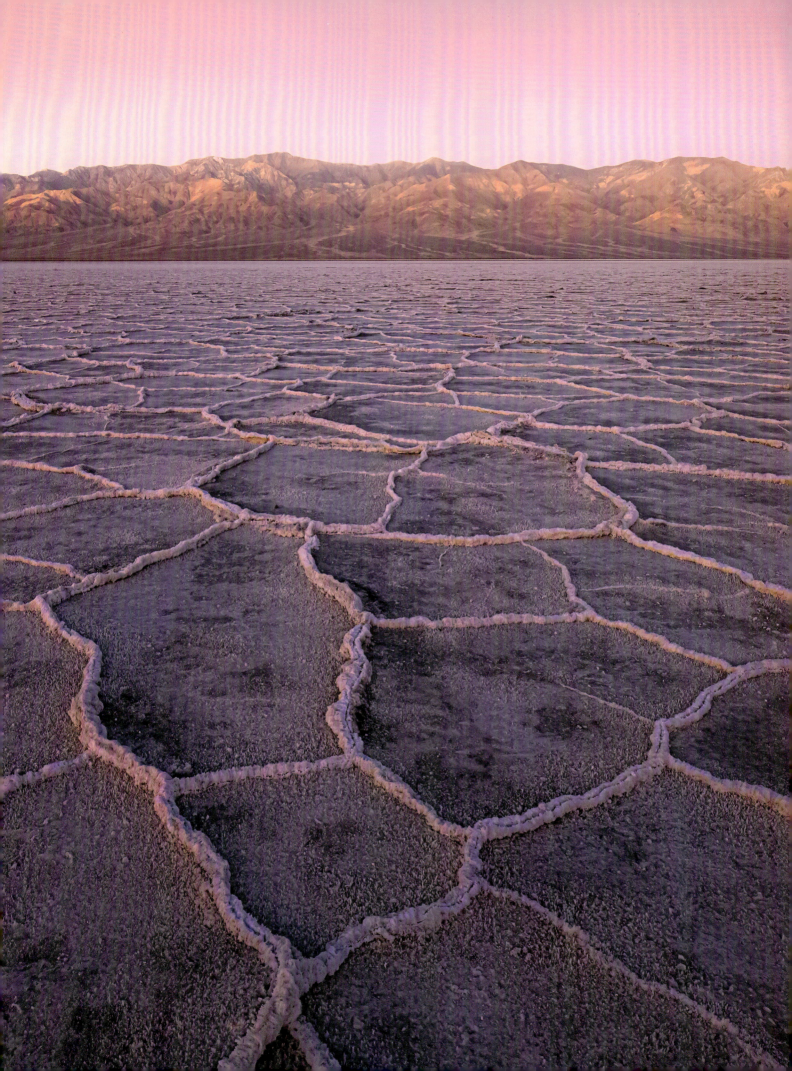

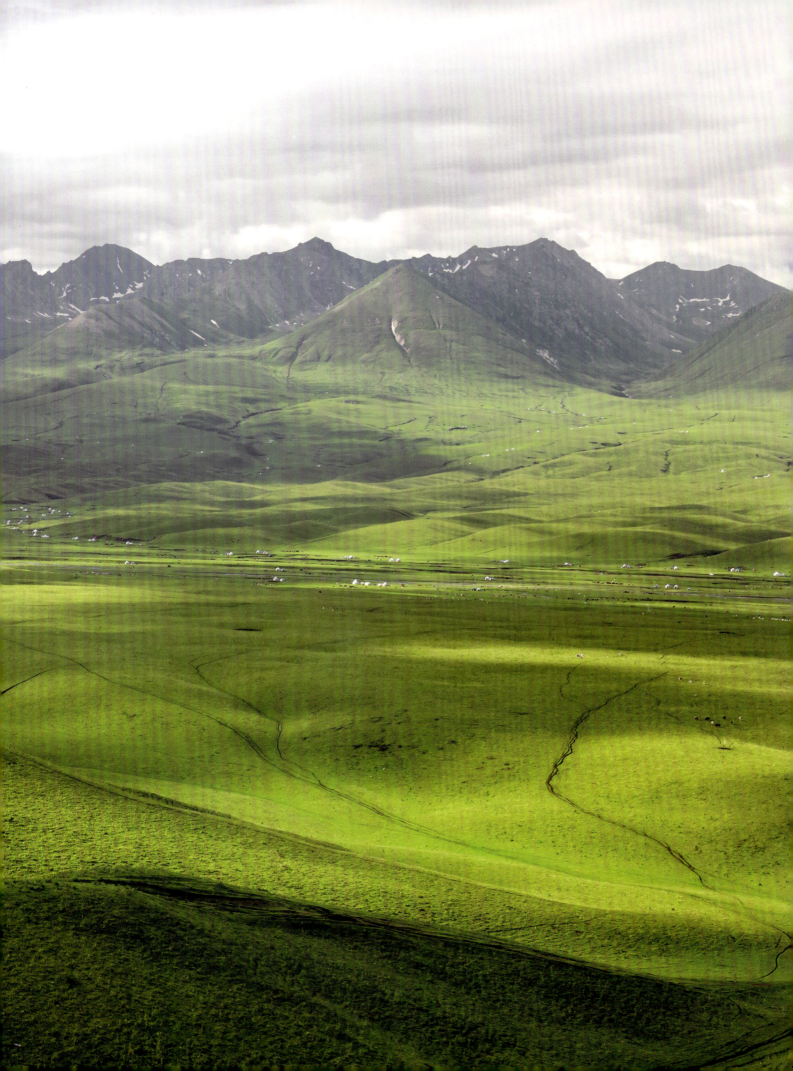

PRAIRIE AND STEPPE

A climax habitat is one that forms in a region where nature is left to take its course. In a place with plenty of rain, a forest grows, and in a place with next to no rain desert develops. So what happens in between? In the regions with more than 50cm (20in) of rain a year (but far less than the metre or more that produces a forest) a grassland grows. As we have seen in Chapter 2, in warmer, tropical zones these grasslands, mixed in with small trees and shrubs, are better known as savannahs. In cooler, temperate zones, the grassland areas go by other names. Perhaps the most familiar is prairie, the name used in North America. This word evokes the wide open plains of the West, where, in the words of the song, 'the buffalo roam [and] the deer and the antelope play.' Zoologists wince a little at these lyrics. As we will see, prairies have neither buffalo nor antelopes, but what they do have is an amazing wildlife community adapted to the wide-open ocean of swaying grasses.

The animal life could not be more different in the temperate grasslands of South America, which are known as the pampas. These lowland grasslands are mostly in Argentina and Uruguay. While 'prairie' is

OPPOSITE:
NARAT PRAIRIE, XINJIANG, CHINA
The Narat region of Xinjiang in western China makes up that country's second-largest grassland reserve. It covers 400 sq km (154 square miles), or about the same area as Barbados. The Chinese name for Narat is 'Sky Grassland'.

RIGHT:
AMERICAN BISON
The bison, often misidentified as a buffalo, is the largest animal on the American prairies. These wild cattle once roamed in vast herds numbering into the millions. They were persecuted by ranchers wanting to clear the wild lands to make room for domestic cattle.

PRAIRIE AND STEPPE

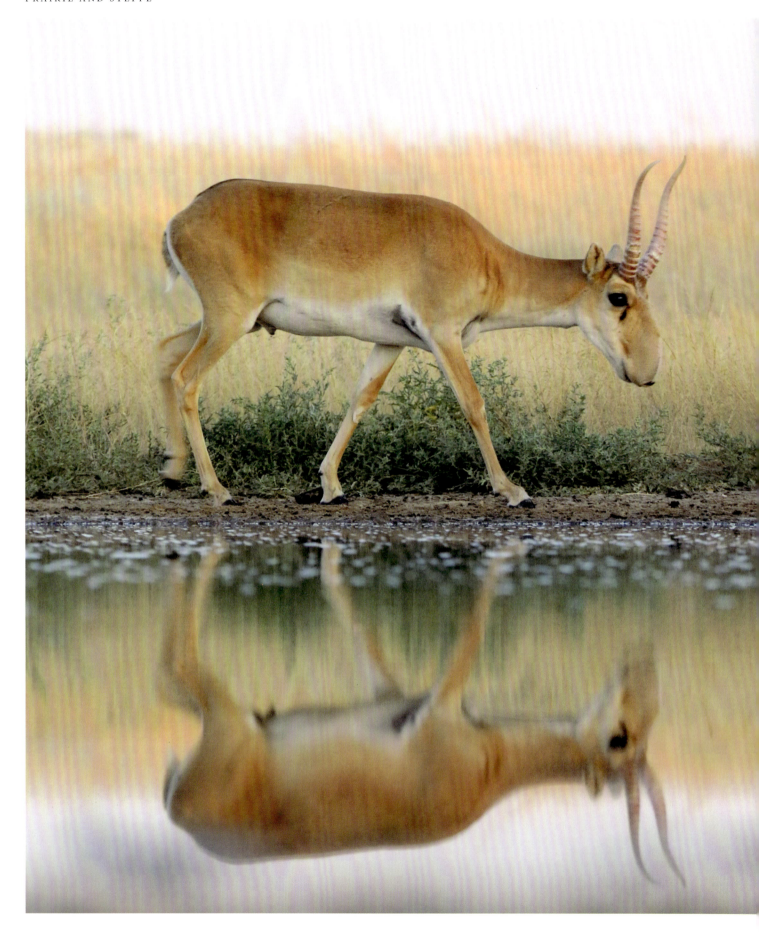

PRAIRIE AND STEPPE

LEFT:
SAIGA
This strange-looking herbivore is found in large herds on the steppes of Central Asia. Its fleshy nose is an adaptation to the challenge of life in a treeless sea of grass. In summer the nasal hairs filter out the dust that fills the dry air. In winter, the ice-cold inhalations are warmed by the blood around the nose before they go into the lungs. Persecution for its unique horns has meant that this species is critically endangered.

BELOW:
GIANT KANGAROO RAT
This well-named rodent is one of many species that live among the prairies of the American West. They hop like kangaroos but otherwise are very distantly related. The rats live in burrows by day and come out at night to search of seeds to eat.

a loanword from the French word for 'meadow', pampas comes from the local word for 'the plains' in the Quechua language of the Inca Empire. Over in Eurasia, vast grasslands once swept across the interior of the continents from Hungary in the west to Mongolia in the east. Today these habitats have been fragmented by agricultural development and large-scale irrigation projects in Central Asia have meant that the ancient steppes are increasingly transitioning into desert. The etymology of steppe comes from the Russian word for 'flat, grassy plain', which pretty much sums it all up.

RAIN SUPPLY

Prairies, pampas and steppe are restricted in their rain supply for similar reasons as deserts. The prairies of the United States, which are known as the Great Plains in Canada, are the product of the rainshadow effect. The westerly winds blowing in from the Pacific are blocked by the Rocky Mountains. Any air that rises up and over these towering peaks will have lost much of the water they carried on the way. Thus rains on the prairies are generally quite limited with only about 1–2cm (0.3–0.7in) falling in a winter month. In the heat of the summer the warmer air holds more water, and rainfall increases tenfold.

The pampas in the pointed tip of South America are dry due the shadow of the Andes and there are patches of grassland in Central Asia, which are formed for the same reason with the Himalayas and other smaller ranges blocking most of the rain systems moving in from the Indian Ocean.

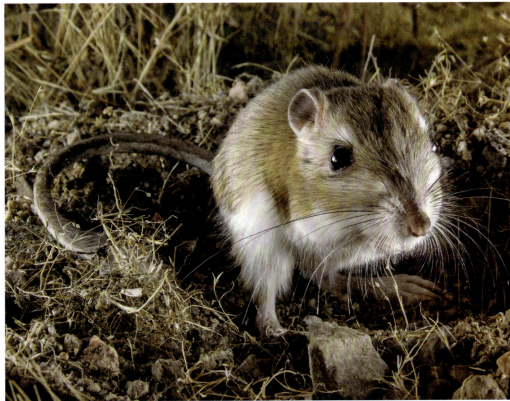

PRAIRIE AND STEPPE

Another factor in the creation of these grasslands is the sheer distance to the ocean. The grasslands of North America are all far from the sea, a geographical fact that defines their ecology and sets them apart from the cultural and economic milieux of the East and West Coasts. This isolation is also the driving factor behind the Asian steppes, which cut a swathe through the continents equidistant from the Indian and Arctic oceans.

SEASONAL FACTORS

The landlocked locations of the world's temperate grasslands is highly significant for understanding how these lowland habitats differ from the savannahs in the tropics. The term 'temperate' means mild or moderate, and it refers to parts of the world that are not prone to the extremes of heat seen in the torrid tropical zones. Nevertheless, while the temperate grasslands will rarely compete with the savannahs for heat and aridity, they have a pretty extreme climate, with the animals and plants living here having to contend with a radical shift

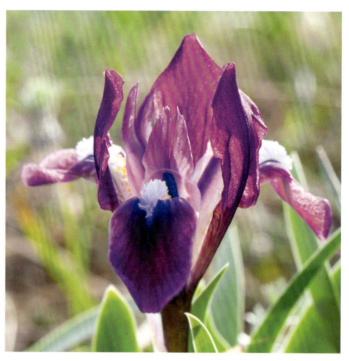

BELOW:
PRAIRIE LAKE
This shallow body of water is a feature of the plains of western Canada. This one is in Police Outpost Provincial Park, Alberta, but there are many others in that region. They form from meltwaters that drain into temporary pools. They may dry out by later summer or drain into the long rivers that flow into the Arctic Ocean in these parts.

ABOVE:
PYGMY IRIS
This purple bloom grows on a short stem from rhizomes running through the soil. (This is a distinction from irises more common in horticulture that sprout from bulbs.) The pygmy iris is common in Eastern Europe's steppes.

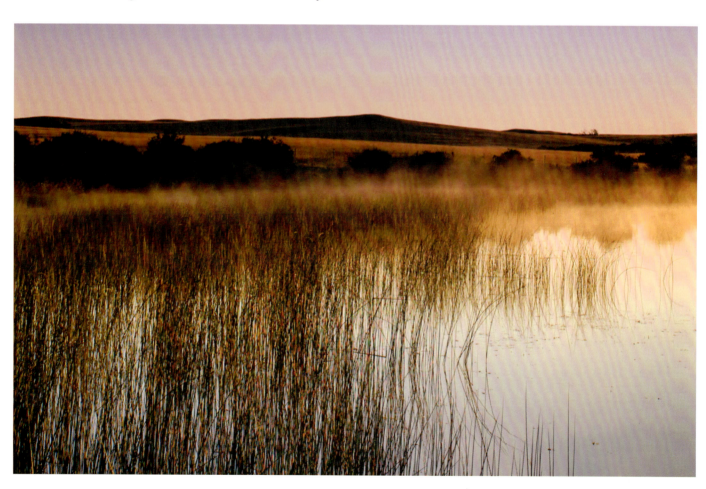

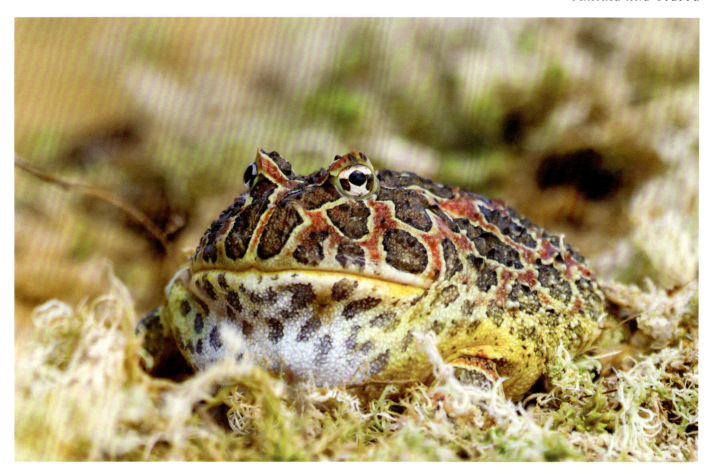

ABOVE:
HORNED FROG
The ornate horned frog lives in the pampas grasslands of Argentina and the surrounding region. It is an ambush hunter that lies in wait for a suitable prey animal to wander too close. It is an unfussy eater and will snap up anything that it can get in its mouth. It can swallow prey that is almost as large as itself. It is able to pull its bulging eyes down into its head to help push large meals down its throat.

RIGHT:
INDIGO BUNTING
In summer this songbird flocks north out of Central America to the prairies to feast on the seeds of grasses and other fast-growing plants. This specimen is a male, suited up in dark blue to attract the females, which have a much more sensible cryptic plumage of greys and browns.

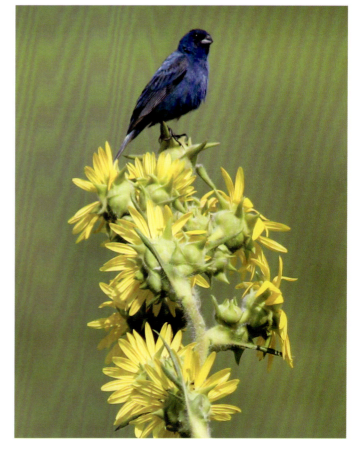

in maximum and minimum temperatures over the entire year. A summer's day here could be over 30°C (86°F) in high summer, and drop to −30° (−22°F) in the depths of winter. The world record of the biggest temperature change in 24 hours was recorded in the prairie town of Loma, Montana. At 9 a.m. one January morning it was −48°C (−54°F) but by 8 a.m. the next morning it had warmed up to 9°C (48°F), a rise of 57°C (134°F).

Temperate regions are the parts of the world that have a clear distinction between the four seasons. This is due to their location in the mid-latitudes, which means summer days are long but not that long and winter days are short but not that short. In between, the transitional seasons of spring and autumn have time to show a character of their own, with life in less of a rush to make the most of a short, warm summer

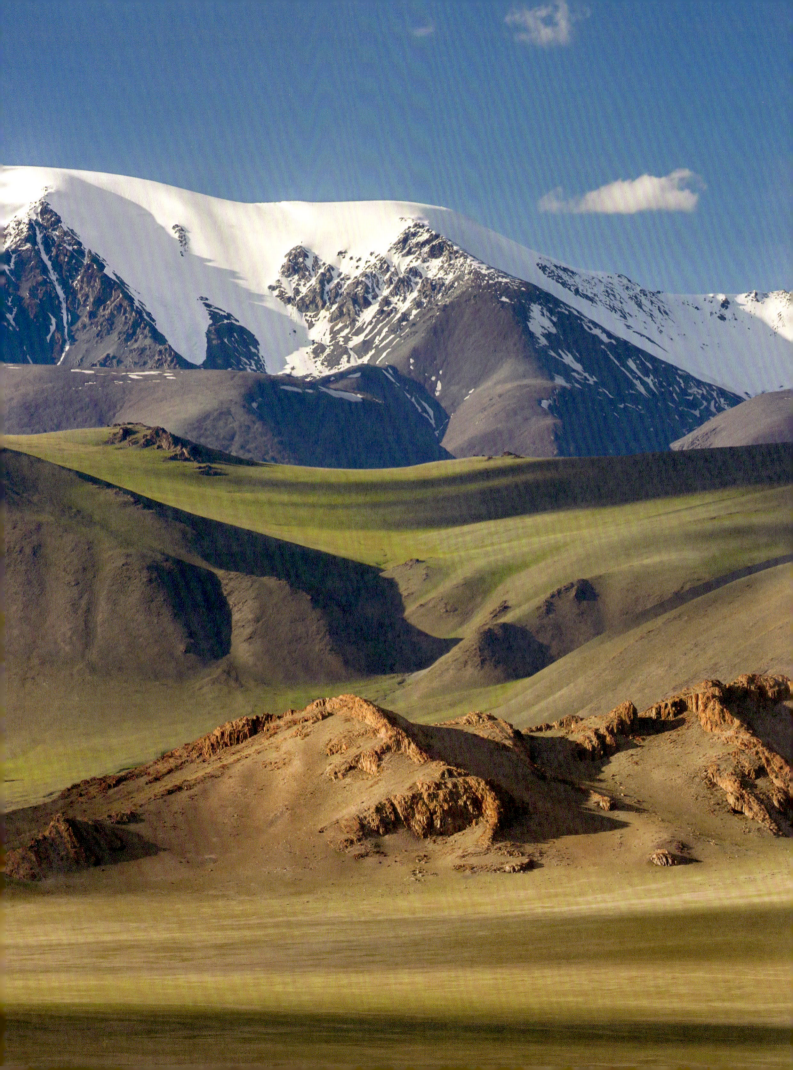

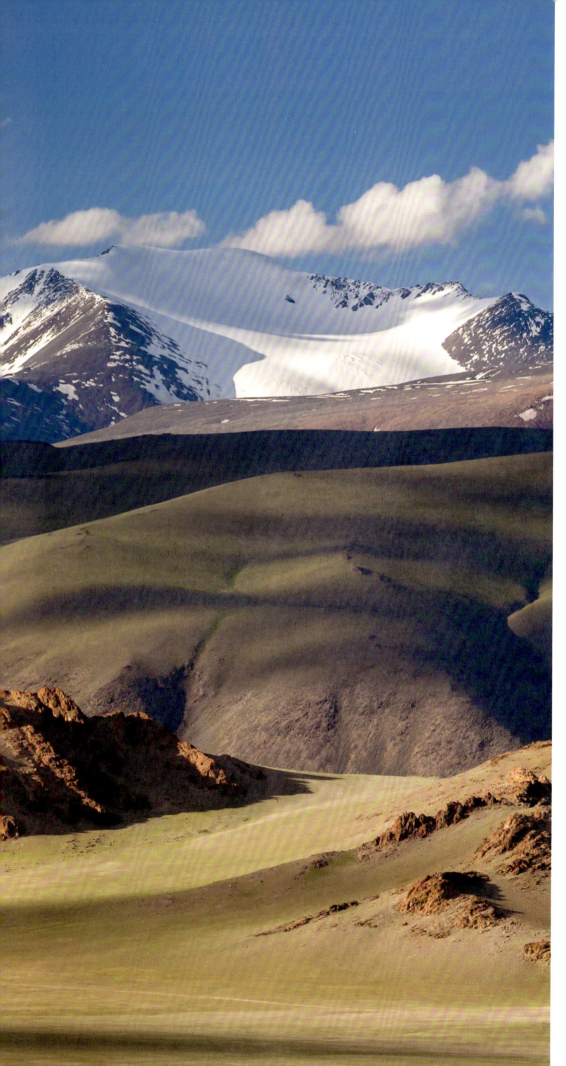

PRAIRIE AND STEPPE

MONGOLIAN STEPPE
This kind of shortgrass steppe of eastern Asia is indicative of a low annual rainfall. The mountains cast a shadow that blocks rain clouds and creates this beautiful natural sea of grasses, which was the native home of horses and the first horseback civilizations.

or rapid rainy season. Nevertheless, grasslands are generally given over to a continental climate, as opposed to a maritime or Mediterranean one. Rocky land is quick to heat up when compared to water, but will also lose its heat quickly too. As a result continental regions (those far from the oceans) see a rapid rise in daytime temperature through spring and summer. The high pressure weather systems that form due to the hot air rising from the ground leads to long periods of stable weather with big blue skies. All that solar energy drives high productivity in the food chain. Animals, such as deer and birds, actively migrate into the prairies and steppe to make the most of that opportunity to feed and breed.

However, as the day lengths shorten with the arrival of autumn, the grassland begins to lose its warmth. This is not the case in coastal habitats, where the proximity to the seas has meant that the summer temperatures have been cooled by the ocean breezes and not gone so high as inland, and when autumn and winter comes, the ocean has a warming effect, enough perhaps to ward off long months of frozen conditions. Back on the grassland, this effect is not available, so very

RIGHT:
PRICKLY PEAR
In drier regions of the prairies in the southwestern United States, where the grasslands border desert, this distinctive cactus begins to replace the grasses. The pads are actually flattened stems not leaves. The leaves are the prickles that deter predators coming for the fleshy pear-shaped fruits.

ABOVE:
CURIOUS OWL
These little owls break many of the rules. They do not live in trees but take over the abandoned dens of prairie dogs and other grassland mammals. And they do not hunt at night but come out during the day. Nevertheless, food is hard to find at any time of the day or night and this species supplements its diet of rodents with insects.

PRAIRIE AND STEPPE

RIGHT:
GRASSLAND FLOWERS
Flowers such as this iris bloom after the spring rains in the Mongolian steppe. The flowers are mainly pollinated by bees, which are also making nests in the moist soil. The flower's seeds will lie dormant through drought periods until the rain returns.

BELOW:
AMERICAN BADGER
While its Eurasian namesake is a woodland creature, the American badger is a creature of the open plains. It is a voracious hunter that digs down into the ground to catch burrowing rodents such as gophers. The burly badger, equipped with long spade-like claws, teams up with the coyote. The dog sniffs out prey, the badger then digs them out.

PRAIRIE AND STEPPE

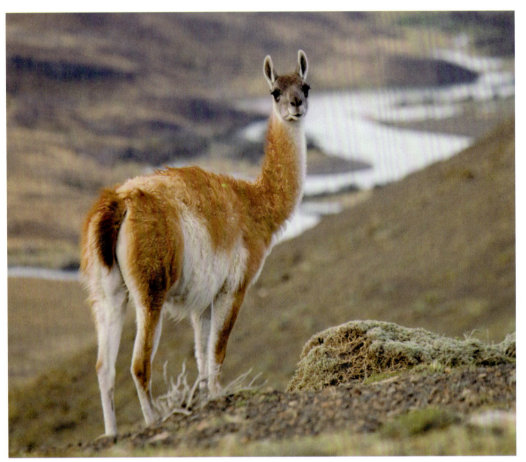

LEFT:
GUANACO
The Patagonian pampas is a cold and dry place, and one of the largest natural herbivores here is the guanaco. It is a grazer that is a close relative of the camels of Africa and Asia. It lacks the humps but has the adaptations for surviving in the cold, dry climate. The llama is a domesticated breed of guanaco.

BELOW:
PRAIRIE PURPLE
The asters, with their familiar star-shaped flowers, are a widespread wildflower in temperate grasslands. This species, known as the prairie purple, is found in the western United States.

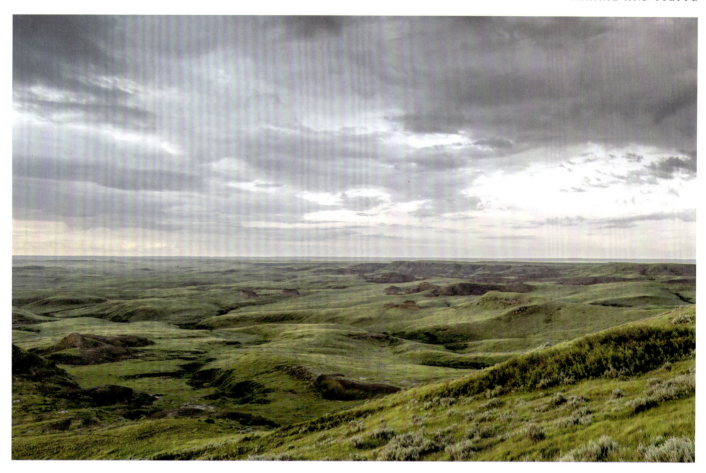

ABOVE:
VALLEY OF A THOUSAND DEVILS
This wilderness area in Grasslands National Park, Saskatchewan, shows how beautiful and bleak the treeless, grassland habitat can be. There is nowhere to hide, and nowhere to go. It is the same in all directions.

RIGHT:
VISCACHA
This little creature is one of the most abundant mammals in the pampas of Argentina. It resembles a rabbit but is a kind of rodent, related to guinea pigs. The females live in small social groups that construct communal burrows. One or two males will join the group to mate and then be moved on.

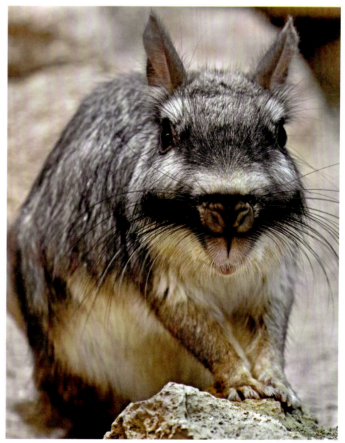

quickly, the habitat loses heat and light and plunges into a period of prolonged cold. Freezing conditions persist for weeks or more and snow is often covering the grass. Those animals that can get away, will already have left, and the rest have strategies to sit out the winter until the new beginning of spring.

READY TO GROW

Grasses are fast-growing plants that are found the world over. They sprout wherever there is a patch of bare earth, but are rapidly superseded by shrubs and trees when the water supply is adequate. Only in prairies and steppes will the grasses remain the dominant plant. Grasses grow from the base of the stem. The stem, or culm, is hollow. It provides support for blade-shaped leaves that sprout up and out. The aim is to create

PRAIRIE AND STEPPE

HERD OF BISON
The steam rises from the woolly backs of a herd of American bison. This herd is in Yellowstone National Park, one of the few places left where the bison roam wild.

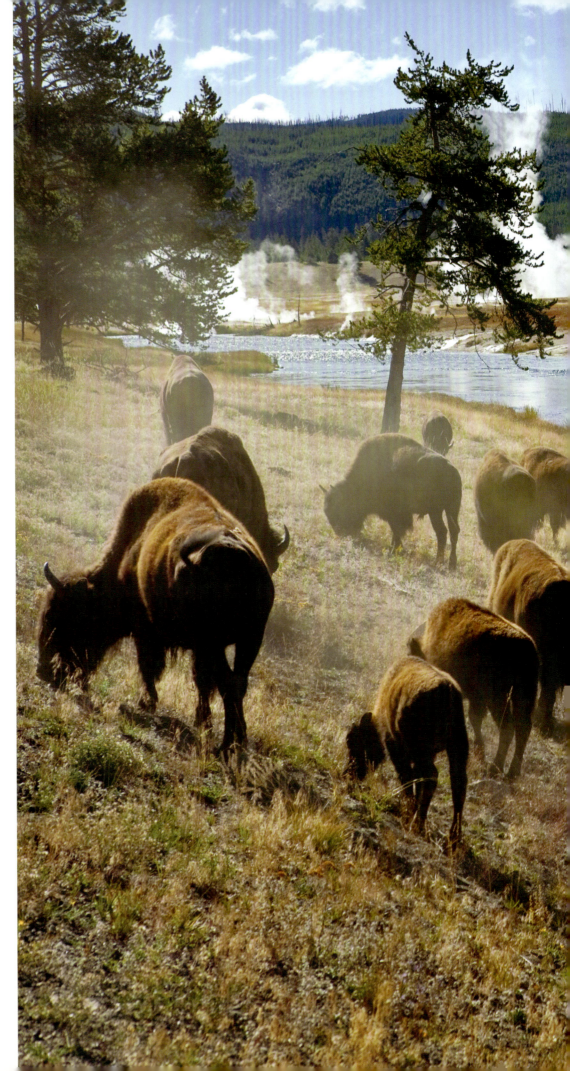

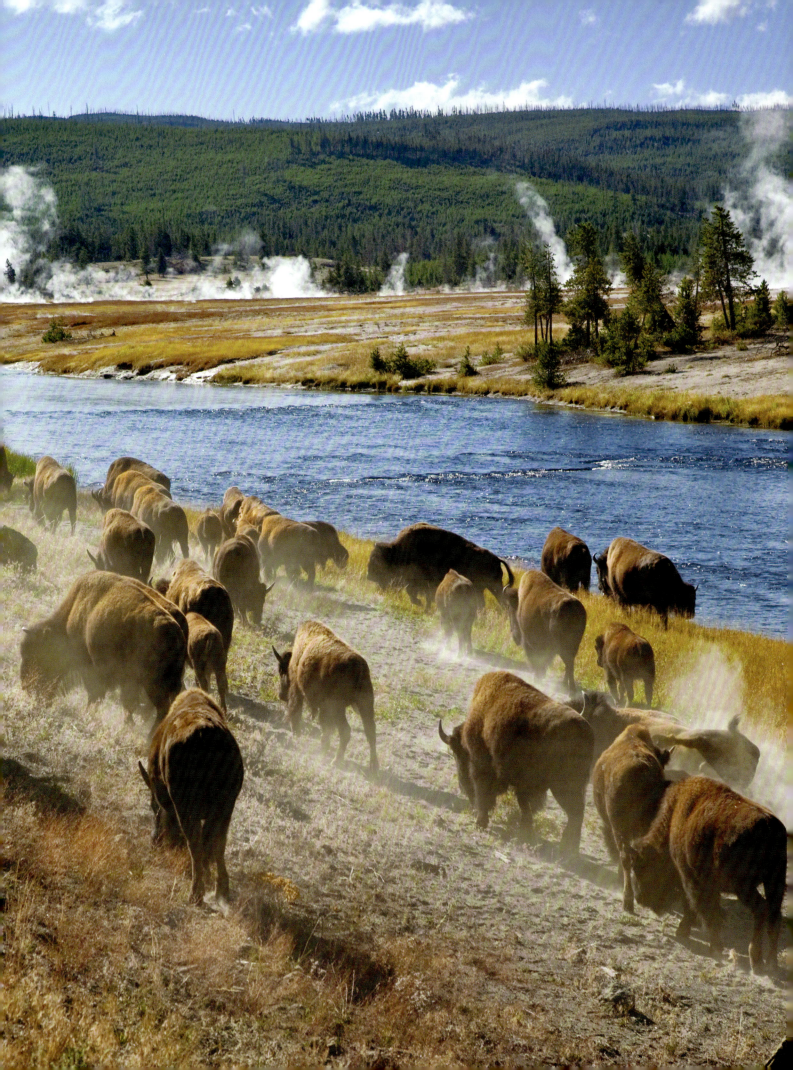

a vertical, unbranching plant that prioritizes height over spread. If the leaves or stem is damaged in some way – not to mention eaten – then few resources have been lost. The growing point, or meristem, right down at ground level is unaffected and the grass can just start again, racing up into the light. Grass plants can grow at speeds that outdo animal development. They increase length not through the costly process of cell division, but by the simpler act of cell elongation.

Prairie grasses are wind pollinated. They produce small flowers that have a fan structure called a spikelet. Many spikelets cluster together forming feathery infloresences. As these dry out they release ultrafine pollen grains, barely visible to the naked eye. Vast quantities of the pollen is wasted, but a few of the grains will be picked up by other grass flowers. The pollen is the vessel for the plant's male sex cells, which burrow into the heart of the flower to fuse with the female ovules.

ARTIFICIAL GRASSLANDS

Once fertilized, the ovules will develop into seeds, with several forming on each plant, often packed into rows called 'ears'. In wild grasses a ripe ear will 'shatter' at the slightest disturbance,

ABOVE:
COYOTE
This American canid is a small, solitary relative of the grey wolf. It is an opportunistic hunter and scavenger that sniffs out food with its sensitive nose, and uses its deep reserves of stamina to cross long distances to find it.

RIGHT:
SAGEBRUSH
This hardy shrub becomes more common in arid grasslands. The plant produces leaves filled with bitter oils, which make them less palatable to herbivores, helps prevent water loss and makes the plant more fire-resistant.

dropping the seeds to the ground so they can be ready to sprout when the time is right. Over the last 10,000 years, human farmers have been growing grasses where the ears cling together, even when ripped from the plant. For a wild grass, this is an unhelpful ability, but for the human race, which has a diet built on grasses, it makes it much easier to collect the seeds. Rice, wheat and corn (or maize) are the 'big three' grass, or cereal, crops. Together, these grains provide more than half of the calories consumed by humanity. Much of the world's temperate grasslands have been refocused on producing cereal crops. Other habitats, mostly temperate forests, have been cut down and turned into artificial grasslands for the same purpose. For many people, a landscape of fields of grasses, either grown to feed us or to feed cattle and sheep, is a natural scene, or as natural as they can access easily at any rate. However, if farming stopped here, within the span of a human generation, these 'grasslands' would have been overrun with thickets and forests.

BELOW:
GREATER RHEA
The greater rhea, a grassland bird, built to run not fly, is the largest bird in the Americas standing at 1.5m (5ft) tall and weighing 27kg (60lb). There are obvious parallels with the ostriches and emus of the tropical grasslands of Africa and Australia. Rheas eat mainly leaves, seeds and fruit, but will also snap up insects and small lizards, mice and even birds. Some have been recorded catching fish in wetland areas.

VEGETATIVE GROWTH

Grasses have another trick up their sleeve. They can reproduce without seeds. There are two ways to do it, but both are very similar. Creating new plants in this manner is called vegetative growth, and it ensures that a few plants that sprout from a few seeds can expand in every direction to add the grass to the grassland without having to move through the reproductive cycle of growing flowers, pollinating and setting seeds.

Vegetative growth is driven by sideways growths. Some grasses will send out rhizomes, which are roots that grow horizontally (rather than down). Once far away from the parent plant, the rhizome sends up a shoot, which grows out of the soil to form a new plant. It also puts down its own fresh roots, and will eventually sever the connection to its mother plant.

The alternative method used be other grasses is to send out stolons, which are horizontal stems that grow along the soil on the surface. Like rhizomes they will shoot up and sink roots when clear of the parent.

Grasslands that get higher rainfall, such as those in the central region of the United States, near to the western bank of the Mississippi River, grow taller grasses. Often the grasses will be 3m (10ft) tall, and this lush vegetation holds more moisture and provides opportunities for other non-grass species. These include wild onions, asters, oaks and maple trees.

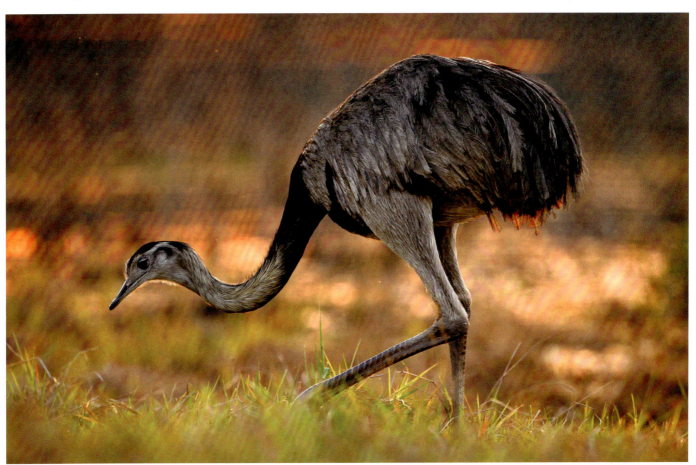

PRAIRIE AND STEPPE

Regions with less rainfall have shortgrass prairie or steppe. The grass plants are under more stress here and arid-resistant breeds such as blue grama and buffalo grass are more common, sprouting to about 1m (3ft). There are wildflowers and small yuccas here, but fewer non-grass species get a look in. A big reason is because with less biomass above ground, there is less of it below ground and the shortgrass prairies have thinner soils than the tallgrass prairies. The split between long and short vegetation is also seen in the Asian steppe, although flipped in orientation. The western grasslands are called the 'flower steppes'. They have heavy spring rains that produce tall grasses, and even taller flowers. To the west, beyond the Altai Mountains, the 'grass steppes' of Mongolia are drier and have shorter grasses.

LIFE ON THE GROUND

Grasslands are flat and wide-open places. Wherever you look, there's more of the same. For the plant-eating animals here, it looks like there is food as far as the eye can see. And danger as

RIGHT:
NOMADIC LIFESTYLE
A group of gers, or yurts, are visible in the distance among the ocean of green on the Mongolian steppe. The traditional way of life here means being on the move to find fresh grazing for herds – and taking your home with you.

BELOW:
SOCIABLE LAPWING
Most lapwings are waders, but these birds spend their summers far from the shore or other aquatic habitats by flying to the steppes of Kazakhstan to breed. They feast on the insects and other small animals that thrive after the spring thaw. Breeding pairs then lay their eggs among the grass in simple ground nests.

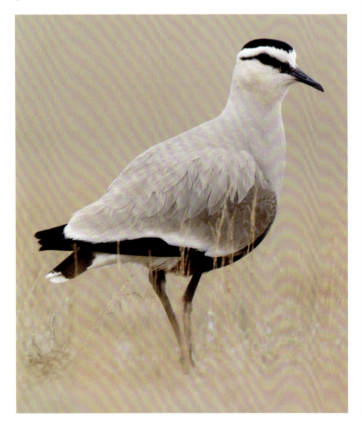

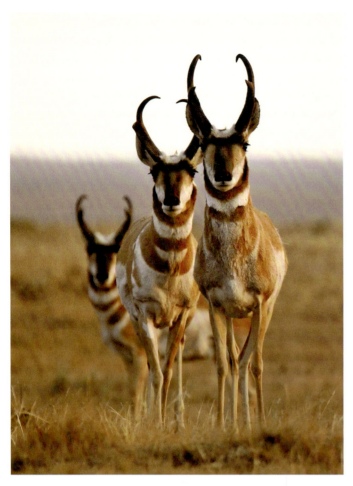

OPPOSITE:
PRZEWALSKI'S HORSE
This is the closest living relative to the wild ancestor of today's horses. It was long thought extinct until Russian explorer Nikolay Przhevalsky found a herd in the steppe of the Dzungarian Basin in what is now northwestern China. Today the horses are bred in captivity and are being reintroduced to steppelands across Asia.

well. Any threat, such as a soaring buzzard, swooping eagle or approaching puma, is clear to see for the sharp-eyed from some distance away. There is plenty of time to take action. However, what the grassland gives in terms of threat detection, it then takes away with respect to threat evasion. If prey can see the predator then the predator can see the prey. There is nowhere to hide. The top predators on the prairie and steppe are wolves. These are the biggest species of wild dog and are a near perfect balance between stamina, speed and strength. They cannot out muscle or out pace a lion or tiger, but those immense killers would struggle in these colder climes. Wolves take their time to kill. They have plenty of it. They follow their prey, trotting along behind for hours, even days if needed, until their prey is exhausted. It cannot fight back as the pack of wolves, takes it in turns to bite its rump, neck and face. Eventually the animal, no matter how much bigger than the wily dogs, will collapse – and the wolves will start to eat it before it is even dead.

As discussed in Chapter 3 in relation to large herbivores, there is nowhere for them to hide from wolves or other grassland predators, such as the coyote, cougar (known as puma in South America) – and, now very rare indeed, the

ABOVE:
PRONGHORNS
A trio of male pronghorns take a break in the prairies of Alberta, Canada. The pronghorn is named after the smaller spiked branch that sticks out of the horn. The horn has a core of bone, but the outer horn layer is shed each year and regrows. Female pronghorns have smaller horns than males.

RIGHT:
PRAIRIE FEATHER
Asters like this are widespread across North America and are a distinctive feature of that continent's grasslands.

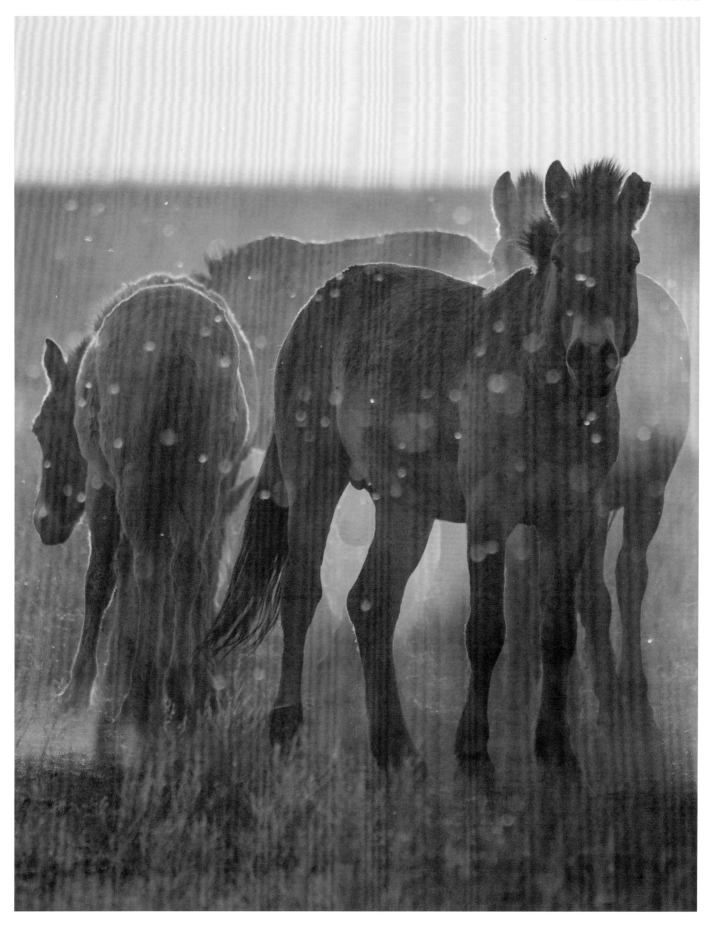

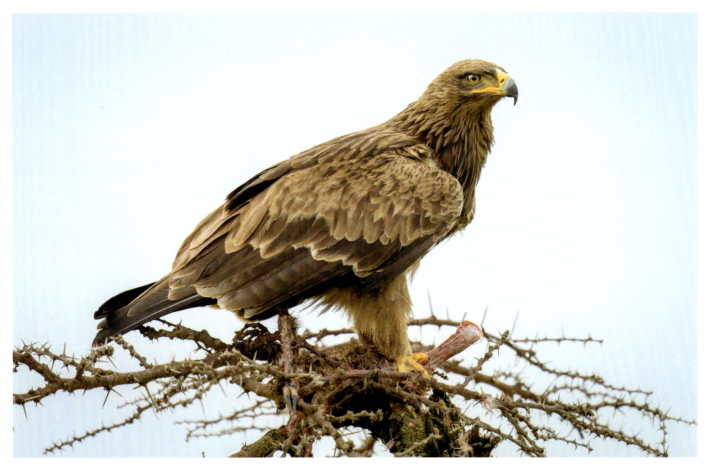

ABOVE:
STEPPE EAGLE
The steppe eagle is one of the largest birds of prey in Central Asia. It will fly to East Africa to escape the winter, although it is most at home in the skies above open steppes or deserts. Without a tree for its nest, this eagle has set up home on an area of high ground instead.

RIGHT:
STEPPE MARMOT
Marmots are common features of temperate grasslands. These are large ground squirrels that spend most of the year hibernating in underground burrows. They emerge in summer to breed and graze on the grasses.

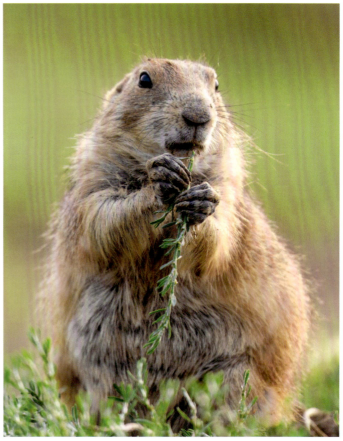

cheetah in arid Asian steppes. The herbivores have no real option other than to run – and keep running until the predator gives up the chase, or the worst happens. In North America these herbivores include deer, pronghorns and bison. Bison are popularly misidentified as buffaloes, which are in fact a relative but part of a distinct group found in Africa and Asia. The pronghorn is sometimes thought of as an antelope, akin to those of the African savannah, but it is probably more closely related to giraffes and with a more distant link to deer.

All of these are hoofed animals, which have feet where the bones are postured vertically, so only the tips make contact with the ground, protected by the hoof, which is a massive toenail. This gives the animals very long legs, with a stride that outpaces predators. This is true even of the bison, which despite being the largest animal in the Americas, can sustain speeds in excess of 48km/h (30mph). However, the

RIGHT:
PAMPAS DEER
These small deer – most are around 70cm (27in) to the shoulder – are a feature of the pampas though they move into woodlands when it get too cold out in the open. They are generally seen in small herds or grazing alone.

BELOW:
GOLDENRODS
An iconic American plant, these yellow flowers generally appear on the prairie in late summer and autumn.

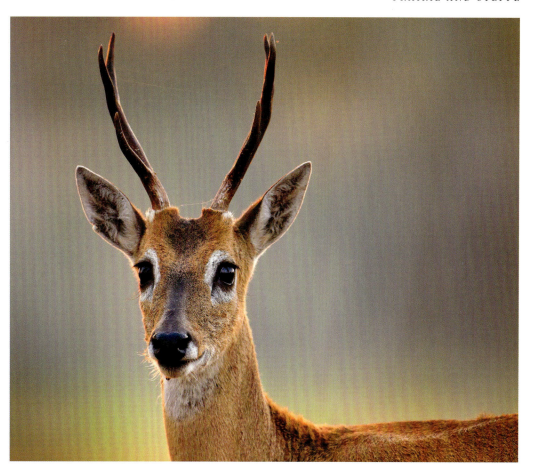

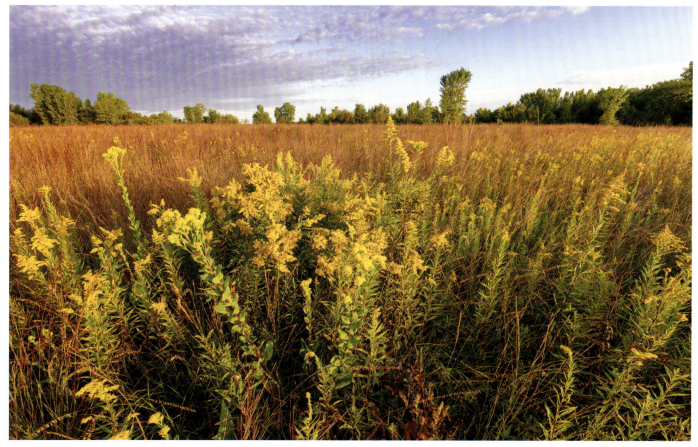

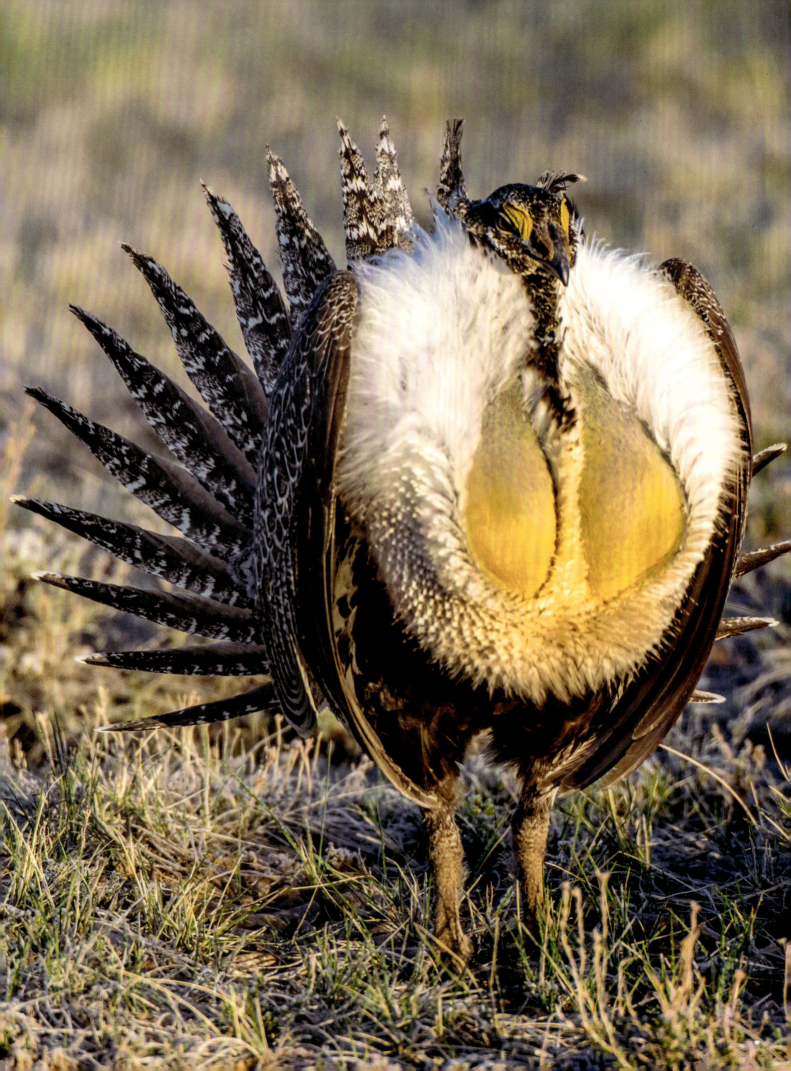

PRAIRIE AND STEPPE

LEFT:
SAGE GROUSE
This sage grouse cock is going all-out to attract mates in the spring breeding season. The males of this species, which live on the North American grasslands, purposefully gather together to put on their strutting displays.

BELOW:
SPRING BLOOMS
These meadow anemones are in the Kurai steppe in the Altai region of Siberia, Russia. Also known as wind flowers or prairie crocus, they typically bloom around Easter or Passover.

pronghorn holds the continent's land speed record, clocking in at 88km/h (55mph). It is thought that this prairie animal evolved its speed to evade the American cheetah, a relative of today's species that became extinct around 16,000 years ago.

DRY AND DUSTY

The Asian steppe is home to the two-humped Bactrian camel, which is as much at home in a dry grassland as a desert. The challenges of retaining water and scratching a living are much the same. It may not be a surprise therefore that the camel's other relatives are the guanaco and vicuña. The former is the largest mammal herbivore on the arid pampas grasslands of Patagonia, where it is the wild relative of the llama. (The vicuña is more often found higher in the Andes Mountains, and its softer, warmer wool means it is the wild ancestor of the alpaca.)

The steppes of Asia also have two notable large herbivores. (There is a Eurasian bison, the wisent, but this prefers to live in the vast woodlands of Eastern Europe.) One of the steppe animals is very familiar, the other is almost alien. The first is the horse, which evolved in the grass steppes of Mongolia, and became a staunch companion to humans over several millennia. It is no exaggeration that the speed and strength of horses drove the world before the invention of combustion engines 300 years ago. And that mix of intelligence, sensitivity and speed was a product of life on the steppe.

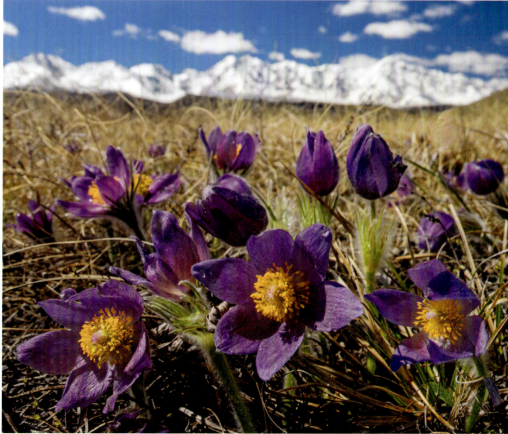

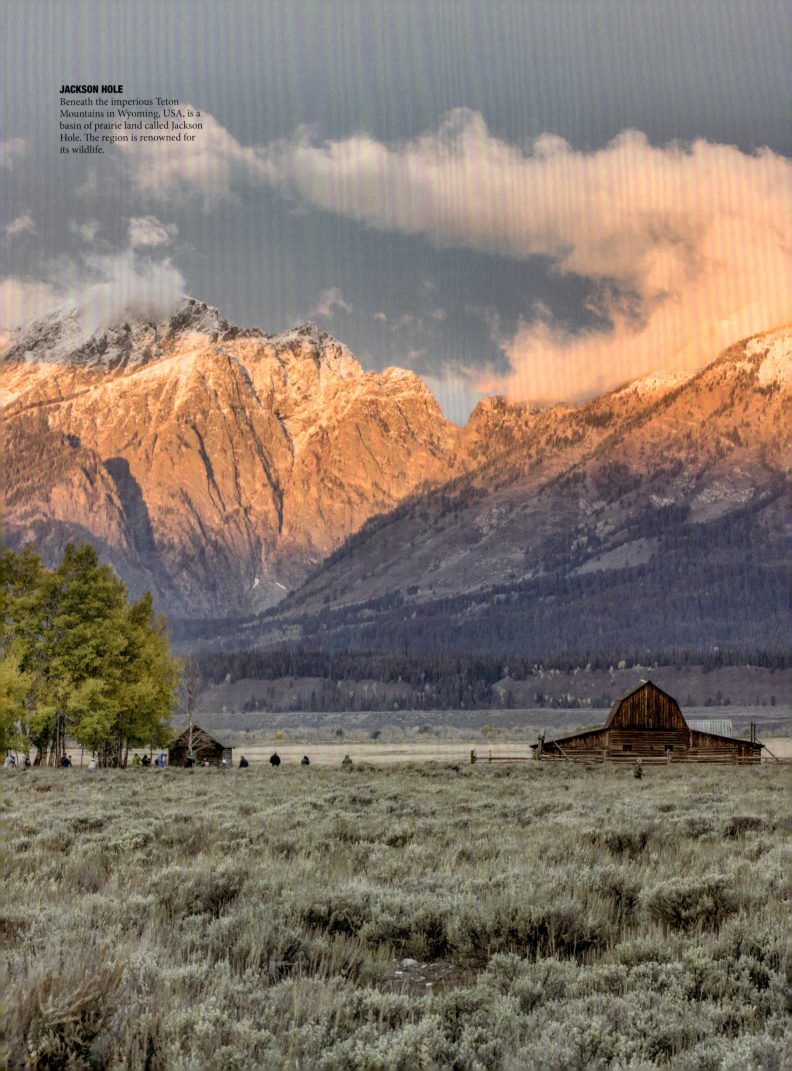

JACKSON HOLE
Beneath the imperious Teton Mountains in Wyoming, USA, is a basin of prairie land called Jackson Hole. The region is renowned for its wildlife.

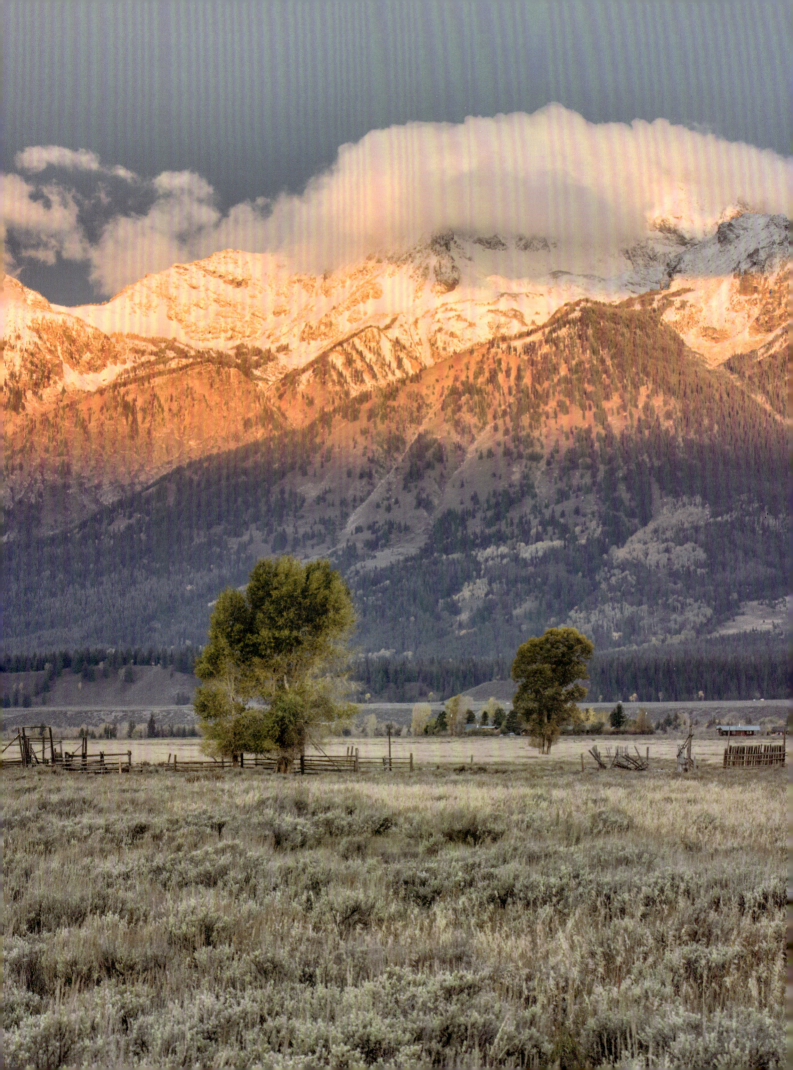

PRAIRIE AND STEPPE

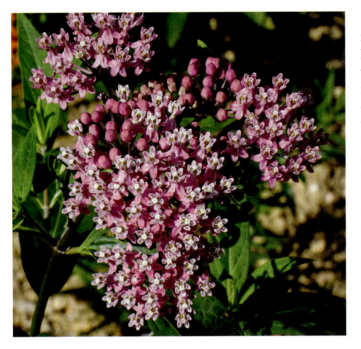

The second steppe creature of note is the saiga. This is in fact a relative of the antelope, but at first glance it looks more like a spoof animal created by AI. The goat-sized grazer lives in vast herds in Central Asia, where it is on a constant migration, following the rains to find fresh grass. Recent droughts and changes to land use have decimated the population, which was also the target of poachers because its spiral horns are in high demand with quack herbalists. The species remains endangered but thanks to new protections it is showing signs of recovery. As well as the horns, the saiga gets attention for its huge nose. The animal has an enlarged nasal cavity with a pair of prehensile nostrils. The purpose of this feature is to filter out the dust that fills the air during wind storms in the dry summers. Males also use their flabby nose to give a roar of dominance during the mating season, interspersed with many dust-busting sneezes.

The temperate grasslands is a tough place to live, although as we have seen animals and plants have evolved a multitude of surprising ways to survive there.

ABOVE:
SWAMP MILKWEED
This pink prairie flower is an essential food plant for the caterpillars of the monarch butterflies, which migrate through the American West every summer. The plants have a noxious latex that puts off most herbivores. The butterflies simply store the latex toxins in their body to make themselves unpalatable to predators.

BELOW:
GREAT BUSTARD
This is one of the heaviest flying birds on the planet and it takes great effort to get into the air. They prefer flat habitats where they can walk long distance as they forage for seeds and insects. They build their nests in tall grasses to keep eggs hidden from predators.

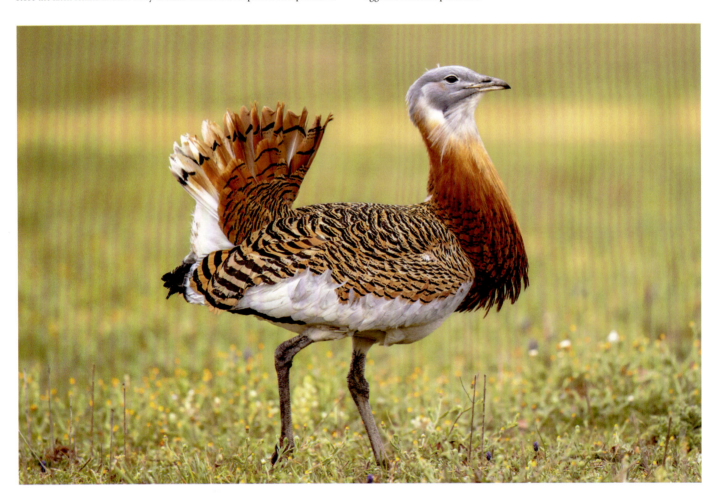

PRAIRIE AND STEPPE

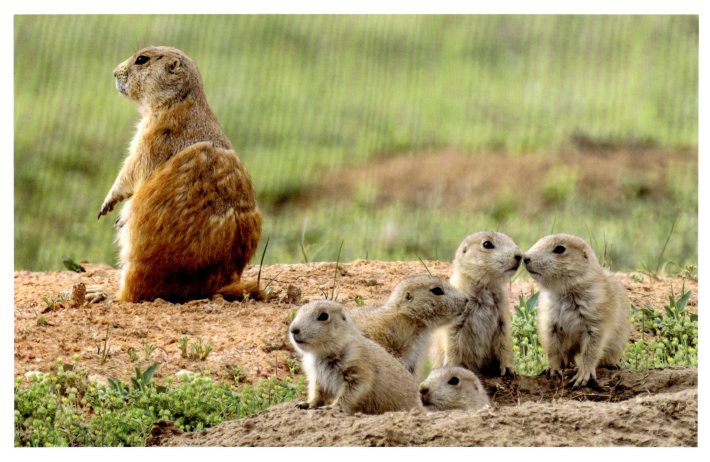

ABOVE:
PRAIRIE DOGS
A mother prairie dog keeps a watchful eye over the grassland as her pups come out to get some fresh air. Prairie dogs live in extensive underground tunnel networks called towns. Where several towns meet, it becomes a city. These rodents have been persecuted by ranchers who see the entrance holes to the towns as hazards for cattle.

RIGHT:
STEPPE POLECAT
A major hunter of burrowing animals in the steppes of Asia is this polecat, the wild relative of domestic ferrets. The polecat is slender enough to chase prey right into their burrows.

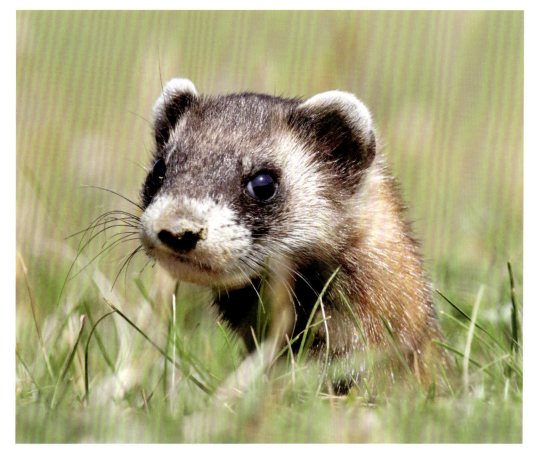

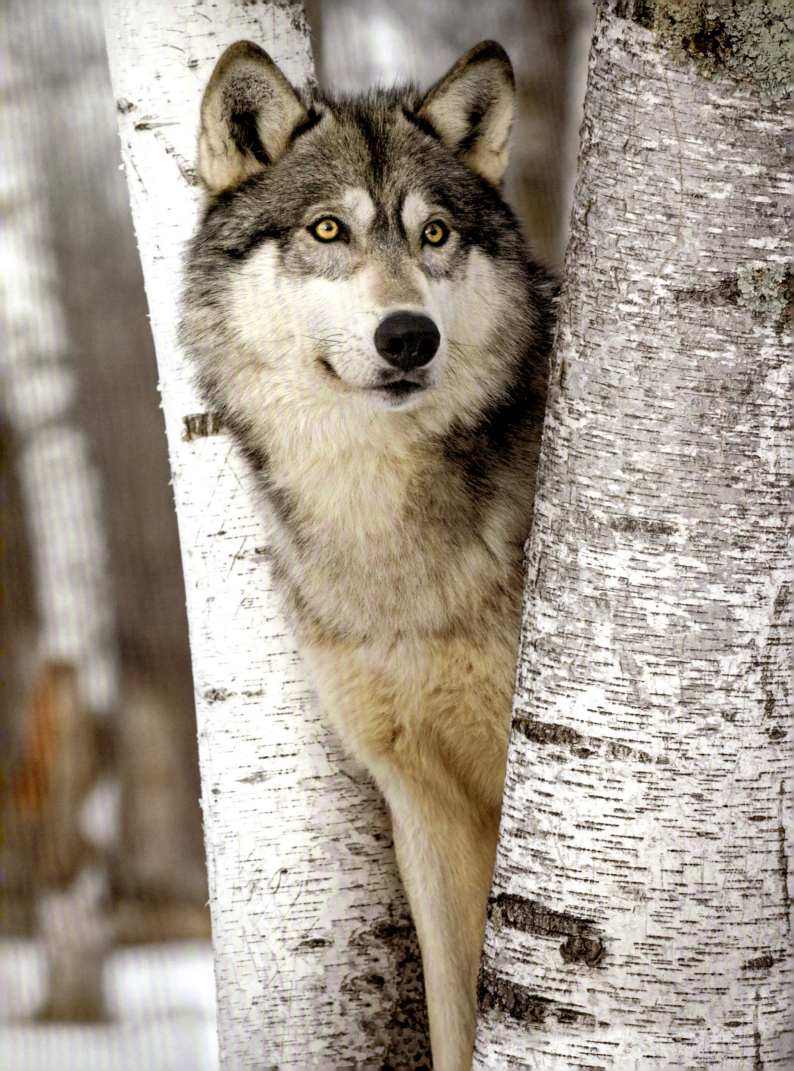

PRAIRIE AND STEPPE

OPPOSITE:
GREY WOLF
The wolf of the steppe is the top hunter across much of the Eurasian grassland, although it is less common than it once was. In North America packs living out in the open on the plains are very rare indeed. A recent reintroduction to the Yellowstone region has been very successful.

RIGHT:
PRAIRIE ROSE
The pink prairie rose is noted for its sweet-smelling flowers and its ability to thrive in all kinds of soils and harsh habitats.

BELOW:
JACKRABBIT
This jackrabbit is on full alert – its ears scanning the area for danger. If needed the long-legged animal will spring away at great speed. Jackrabbits are the American relatives of hares in Eurasia and Africa. They do not dig burrows but rest out of sight in simple nests called forms. Forms are hollows scraped into the ground.

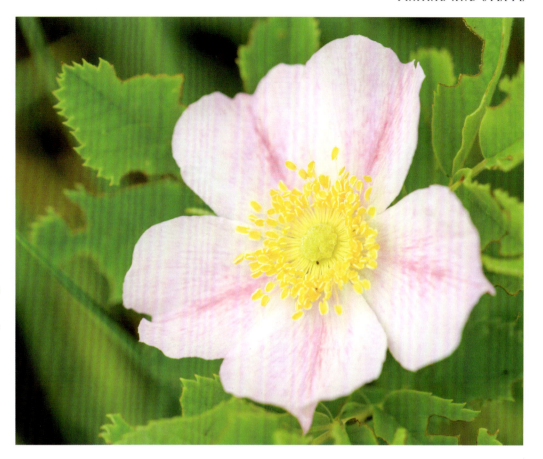

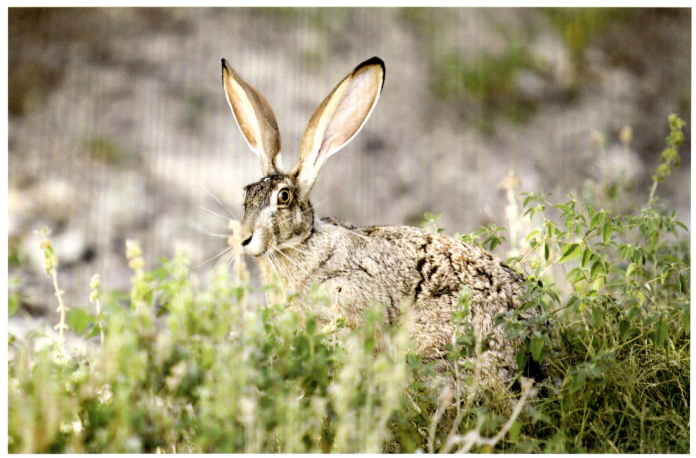

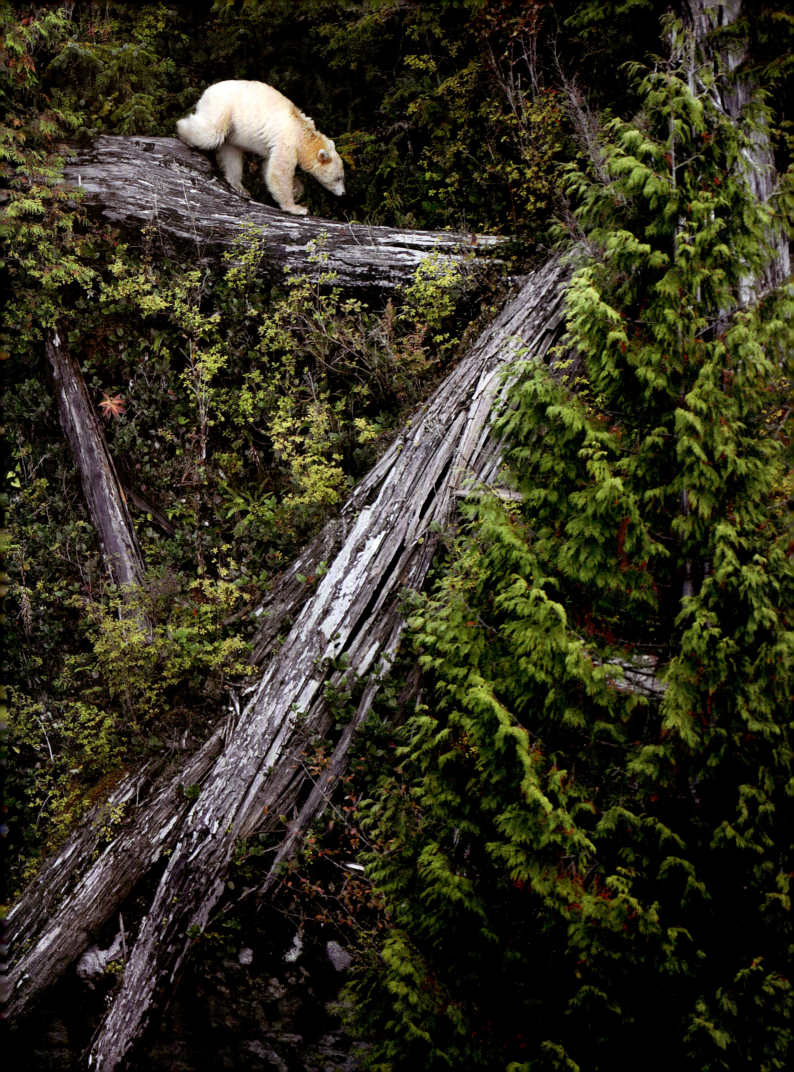

TEMPERATE FOREST

A temperate forest has the best of everything. It is temperate, meaning always mild. It is never too hot and never too cold, but more or less just right most of the time. And the forest means that life in this area is getting all that it needs to do well. There is enough light, heat and water for dense forests to grow. They are not as crowded as the steamy jungles, although the crowns of the trees still close up overhead to make a canopy of branches and leaves, a living ceiling above the forest floor, that is lush with mosses, ferns and shrubs. Areas where the canopy is broken are classified as the lesser habitat of woodland, indicating that there is less rain in these parts, or a thinner, looser soil that cannot hold water so well. Woodlands generally mark the transition to prairie and steppe. As the water supply is on the wane, so is the density of the trees.

OPPOSITE:
SPIRIT BEAR
This pale giant is not a polar bear, but a subspecies of American black bear that lives in the coastal forests of British Columbia, Canada. There are darker variants in this subspecies, which is known more generally as the Kermode bear (pronounced *ker-moh-dee*).

RIGHT:
YELLOWJACKET
These social wasps are widespread throughout temperate forests. The nests are built fresh every year, mostly in natural hollows or buried in soft soils or leaf litter. The familiar foragers, often reviled, can be seen out and about drinking sweet liquids, such as nectar and fruit juices. They also capture other insects and haul it back to the nest to feed the larvae.

FINDING A FOREST

Among all the plants live a wide range of animals from the wisent, or Eurasian bison, to the wily weasel, playful deer and wise owl. From the folk tales of Europe and Asia to the Disney animations of classic tales, the forest is very often a character in the story – as are many of the animals that live there. It is a forbidding place where the worlds of good and evil merge and are hard to tell apart. Monsters are lurking in every shadow.

That deep-seated association becomes clearer when one compares a map of human population density with

ABOVE:
CHIPMUNK
This is a small North American ground squirrel, although other species are found in Siberia. All chipmunks have stripes along their backs. They search the ground for seeds and store them in burrows to last through the winter. The burrows can be 3m (10ft) deep to ensure they are shielded from frosts. The eastern chipmunk of North America hibernates in winter, whereas the western species stays active.

the locations of the world's temperate forests. These regions are where most of us live. Temperate forests are the natural habitat of most of Europe, excluding Scandinavia and the Mediterranean coasts. It is also the biome that covers eastern China, Korea and Japan. Roughly 35 per cent of the world lives in these places, which cover around 15 per cent of the planet's land area.

CLEARED AWAY

The other area in the world that has large swathes of temperate forest is North America, from Maritime Canada south and west to the Appalachians of the United States. This land has a shorter history of being highly populated but it is among the most densely peopled regions in North America. Most people like temperate forests. Or at least they like the climate that creates them, with its distinct four seasons, where the winters are not overly long or cold, and the summers are warm but still wet. Rainfall is pretty consistent month on month, with between 80–150cm (30–59in) a year (although some places are much wetter).

The forests that form in these parts have long been in the way for humans. Only about a fifth of the primordial old-growth forest still survives. For example, before the Middle Ages (from the 5th to 15th century) half of the forest had been cleared away in Europe, especially in the west of the continent, and the single forest that covered the east of North America in 1600 is now highly fragmented. Instead the cleared land is used for agriculture and raising livestock, and the diversity of wildlife is inevitably reduced.

The same situation is reflected across China and East Asia. One particular temperate forest type in the mountains of southern China is dominated by massive bamboos. This forest has been under extreme pressure for centuries and now exists in a few protected reserves. The reason for the protection is that these forests are the only natural home of the giant panda. These herbivorous bears, with their distinctive black and white coats and cute black eyepatches, have become the universal symbol of the ecological emergency facing the planet, as humans cut down not only their forest, but degrade almost every fertile habitat across the world.

By chance, there is a lot more land in the temperate zones of the Northern Hemisphere, and so there is more forest up here as well as more people. The equivalent latitudes

TEMPERATE FOREST

– roughly 40° to 55° – in the south are mostly covered by ocean. There are nevertheless smaller regions of temperate forest along the coastal plain of Chile also lifting up into the foothills of the Andes, and in the southeast of the Australian mainland, such as Victoria, and most notably in Tasmania. New Zealand has some temperate forests, too, albeit with more native evergreens and ferns, than is typical of the forests in the Northern Hemisphere.

BROAD AND TEMPORARY LEAVES

The defining feature of a temperate forest is the way that most of the trees will shed their leaves in autumn, also aptly known as the fall. The reason for this is a finely balanced trade-off to use resources as efficiently as possible as the season changes. This is something that is unnecessary in the lush jungles of the tropics, where plants can generally grow all year round, and is unavailable in the icy northern forests, where there is no time during the fleeting weeks of summer to sprout fresh foliage from scratch.

ABOVE:
BROADLEAF
The leaves of trees and shrubs in the temperate forest are generally flat, thin and wide. This structure is called a broadleaf. It is the best way to capture sunlight and make sugars.

BELOW:
STRIPED SKUNK
This species is widespread across North America, but is not found anywhere else in the world. It is a relative of the badgers and otters, but widely familiar for its defence strategy of spraying a foul liquid over attackers from glands beside the anus.

TEMPERATE FOREST

MATURE WOODLAND
The New Forest National Park in England has been protected in one way or another for 1000 years and so the woodlands here can be very old – despite the name. This mature woodland has centuries-old trees and rotting branches on the ground.

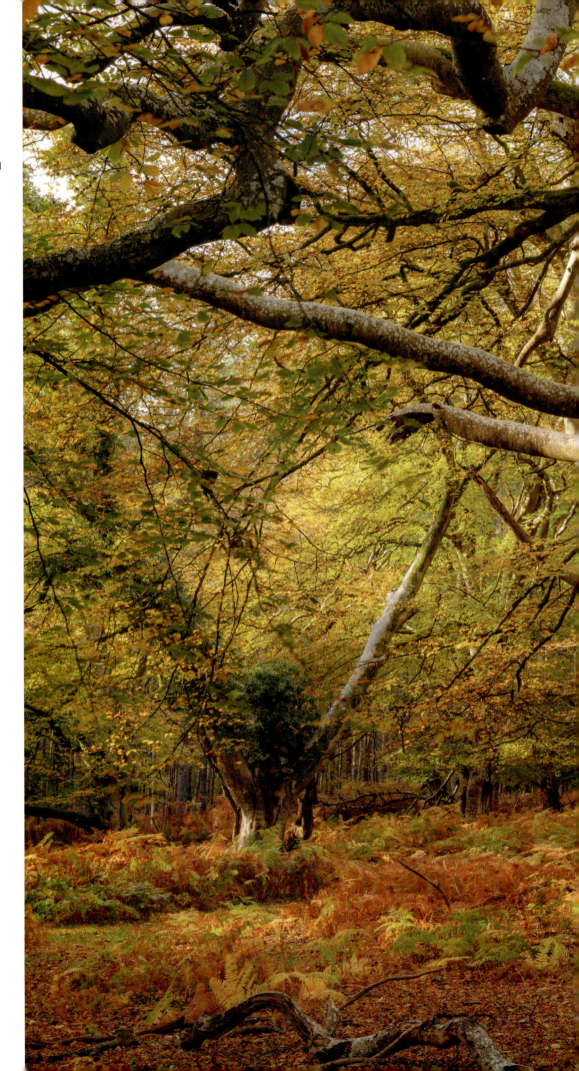

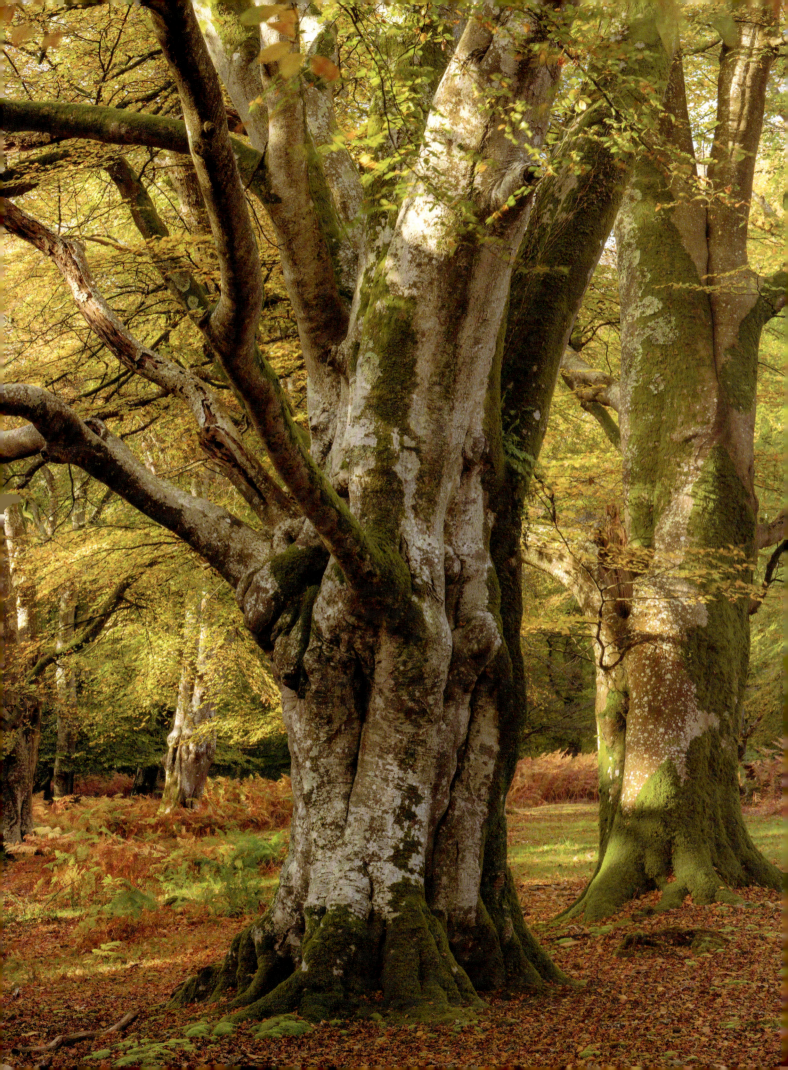

TEMPERATE FOREST

The noticeable difference between the temperate forests and their boreal neighbours to the north (boreal is a synonym for northern) is that the trees have flat leaves. Boreal forests are filled with pines and firs where the leaves are tiny needles. A leaf is essentially a plant's solar panel tasked with collecting the energy in sunlight. A flat surface is the best shape for doing this, and plants have a well-understood growth hormone system that makes them grow inexorably towards light. The broadleaf is a flexible but flimsy structure with a sandwich of photosynthetic tissues spread between a framework of stiff veins, which deliver water surging up from the roots as well as creating support.

The leaves have pores called stomata (stoma is the singular), mostly on the underside. When the sun shines, the light activates the cells around the stoma, making them shrink to allow gases to come in and out of the leaf. Carbon dioxide from the air is needed for photosynthesis and oxygen, the waste product of this process, is expelled from the leaf into the air. Water vapour also leaves through the stomata, and while the plant works to minimize that loss by waterproofing the rest of the leaf, it relies on this transfer of water to maintain a steady flow up from the roots.

The mechanism is a little complicated being based on a natural process called osmosis. Osmosis sees water move in and out of cells based on how many sugars and salts or other chemicals are dissolved in the cell's watery contents, or cytoplasm. Water moves from diluted cells to concentrated ones. The aim is to equalize all concentrations.

As a leaf loses water to the air, a process called transpiration, the concentration inside the leaf cells rises. There is less water in them now but the same amount of soluble material. This higher concentration causes water in the plant's vascular system to move by osmosis into the leaf. The result is a pressure in the vascular system that is always pushing water up from the roots. This pressure is powerful enough to lift water high into the air to reach the tops of trees. While smaller than their tropical counterparts, the trees in a temperate forest can be up to 40m (130ft) tall.

The photosynthesis happens in the top layer of the leaf, where columnar cells are arrayed to capture rays of light with green-coloured structures called chloroplasts. The green colour comes from the chemical chlorophyll, a name that helpfully means 'green leaf'. Chlorophyll molecules are able to capture the energy in the sunlight. They actually absorb energy from

BELOW:
EURASIAN BULLFINCH
This male bullfinch has a distinctive plum-pink breast, while the female is greyer (but with pinkish hues). The finches are resident across the temperate band of Europe and Asia. They raid woodlands (and orchards) for seeds and fruity buds. In the winter, the finches in the colder north of the range move to the south, heading into more arid habitats.

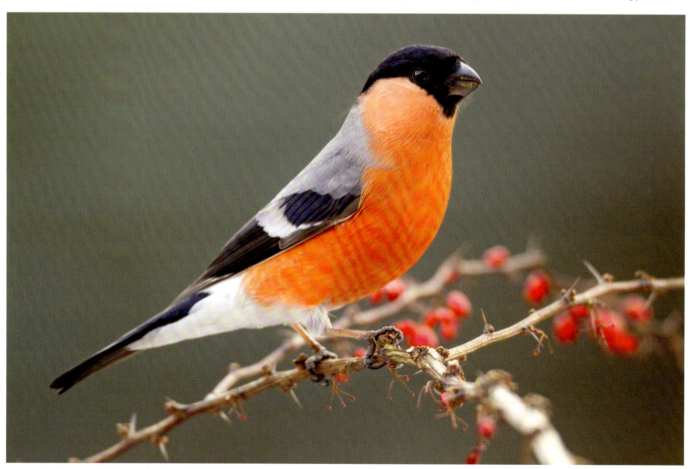

TEMPERATE FOREST

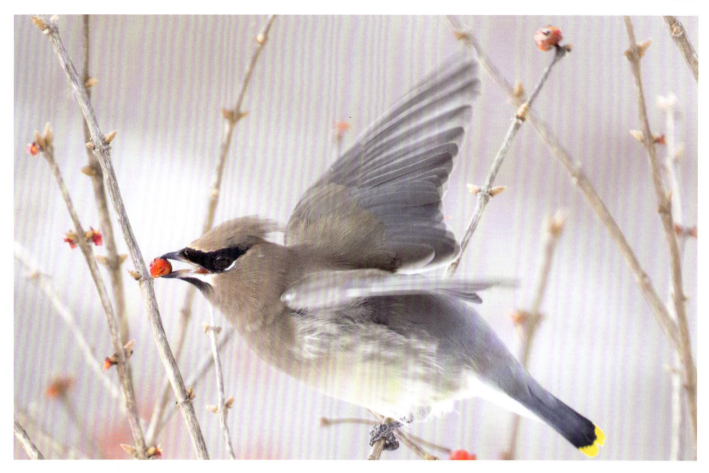

ABOVE:
CEDAR WAXWING
In winter this fruit-eating songbird migrates out of the pine forests of Canada into the temperate forests to the south. They may gather in large flocks wherever there is a food supply.

RIGHT:
ASH KEYS
These are the fruits of the common ash, a tree that is widespread throughout temperate Europe. The keys are also called 'helicopters'. Once fully desiccated, the keys will fall into the air and spiral down on the wind, dispersing the seeds inside away from the parent tree.

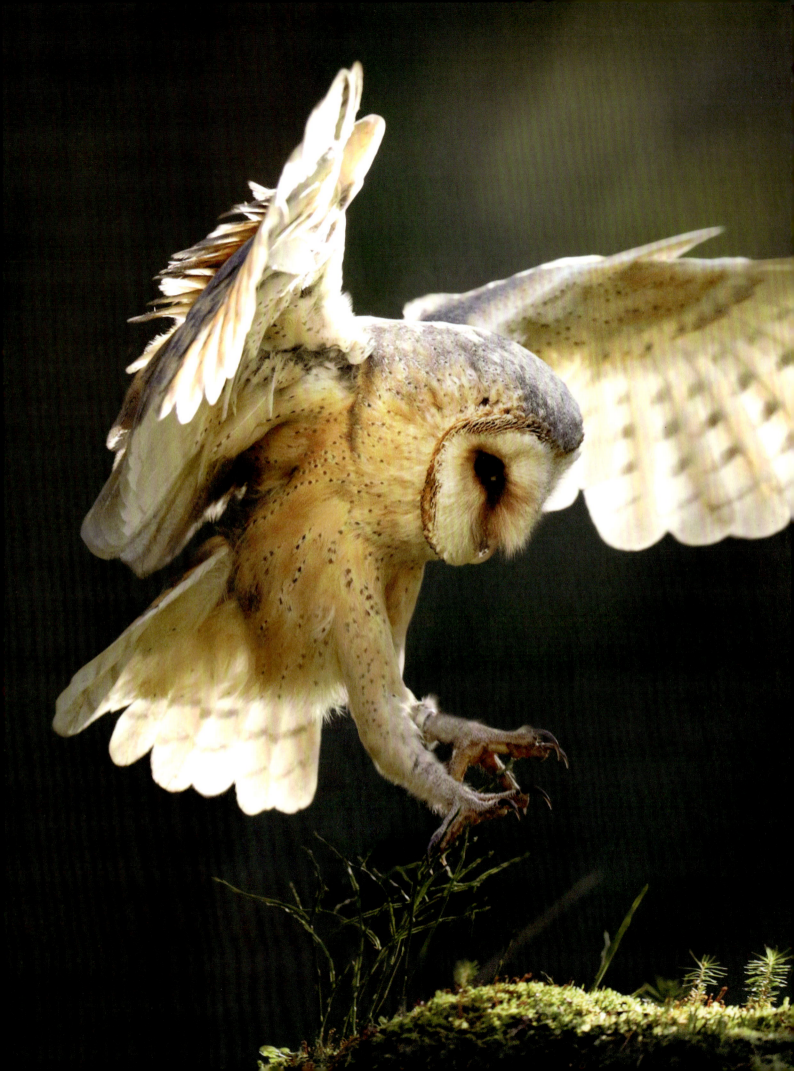

TEMPERATE FOREST

LEFT:
BARN OWL
This is the most widespread of all the owl species. It is a common hunter in temperate forests, where it is often known as a screech owl, due to its call.

BELOW:
DORMOUSE
This little rodent is clambering through a plum tree. It forages for fruits and seeds and has become rare in many areas where shrubs and hedgerows are becoming scarce. In winter, the rodent makes a cosy spherical nest out of leaves in the bushes.

red and blue light only. The green rays are reflected back, which is why plants – and large parts of our planet – look green. If chlorophyll were more efficient at grabbing all of the energy available, leaves would not reflect back anything and so would appear black.

CUTTING LOSSES

A broadleaf is a very lightweight structure with a little material spread thinly. It is quick to grow but not built to last. By the middle of calendar autumn – around October – the weather in the temperate zone has taken a turn for the worse. The days are getting shorter and the opportunity to photosynthesize is diminishing each day. Once winter hits, the days will be so short and gloomy that the leaves may never get a chance to open those stomata and collect carbon dioxide. The leaves are becoming increasingly redundant.

Despite this, the tree can enter a period of relative dormancy in the colder months, as seen in its growth rings. The rings are a concentric pattern of narrow darker bands and wider, pale ones. The thicker pale wood is the fast growth in summer, while the darker wood represents the much smaller amounts of new tissue laid down in winter. Each pair of light and dark rings represents a full year, and so can be used to age a tree (often after it has been cut down and killed, of course).

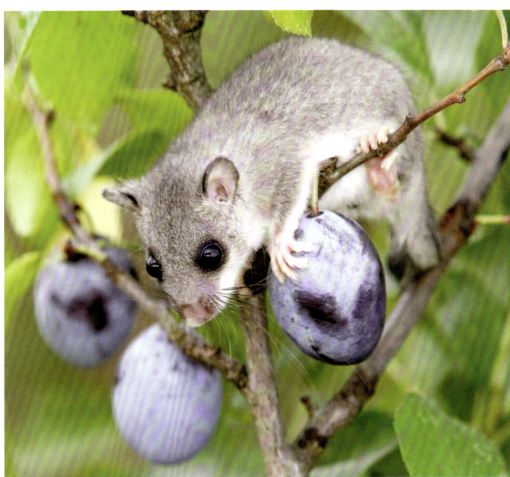

ABOVE:
EURASIAN RED SQUIRREL
This is the native tree squirrel of Eurasian woodlands. They collect acorns and seeds that are buried in underground caches for the winter. This one is searching for food at a forest pond in the Netherlands. However, the red squirrel is in decline across Europe, being pushed out of temperate forests by an invasive species of grey squirrel from North America.

However, getting back to the living trees, the temperature is also dropping as the cold seasons develop. Soon it will plunge below freezing during the night, and frosts would cause irreparable damage to the flimsy leaves. Ice crystals forming inside would swell and shred the cells. When the leaf thaws it will be in tatters. Following an icy winter those tattered leaves would not be fit to take up the challenge of photosynthesizing enough to feed the tree and power its next round of fast growth. As a result, most of the trees in a temperate forest are deciduous, meaning they drop their leaves in autumn to avoid the waste caused by frosts. They then grow fresh leaves in springtime. (This strategy is seen in some dry monsoon forests, where the trees drop their leaves in high summer to avoid damage from extreme heat. The governing factors are different but the strategy is the same.) Deciduous trees stand in contrast to evergreen ones which, as the name suggests, keep their leaves all year round. In temperate forests evergreens are few and far between. They stand out in winter, when all the trees around them are denuded. Temperate evergreens include holly and mistletoe, two plants that still have their leaves in

RIGHT:
EUROPEAN TREE FROG
This green frog is less than 4cm (1.5in) long. It is found in broadleaf forests but also in wetlands. Their loud croak can be heard just before a rainstorm. In the summer they clamber through flimsy branches looking for insects. In winter they hibernate under rocks or buried in a pile of leaves.

TEMPERATE FOREST

midwinter and are part of the symbols of Christmas and winter throughout Europe and North America.

CHANGING COLOURS

The process of dropping a leaf is called abscission. Essentially the process is about cutting water off from the leaf and its stalk-like petiole, which connects it to the branch. The leaf will disconnect the vascular tissue at the petiole, and the leaf will gradually dry out as its water is not replaced. Enzymes also work to sever the connection with the tree, so eventually a gust of wind is enough to break the leaf from the tree and it flutters to the ground. (Abscission is a process with further purposes other than preparing for extreme weather. Leaves that are infested with aphids or caterpillars will be cut loose in the same way to prevent the contagion from taking hold.)

At the same time as killing the unwanted leaf, the tree recovers anything of value inside it, which is primarily the chlorophyll. This green chemical is broken and taken into budding tissue in the branches, ready for use when the fresh

ABOVE:
HORSE CHESTNUTS
The horse chestnut tree produces inedible seeds popularly called conkers or buckeyes. It is native to much of temperate Europe but it has become endangered in much of its range due to attacks by fungi and insect infestations.

BELOW:
EUROPEAN HEDGEHOG
This little insect eater is preparing to hibernate through the winter. It will build a nest in a deep layer of fallen autumn leaves. The animal's famous spines are in fact thick hairs. The European species has several close relatives that are found across temperate Asia. There are also more hedgehog species found in warmer and drier habitats.

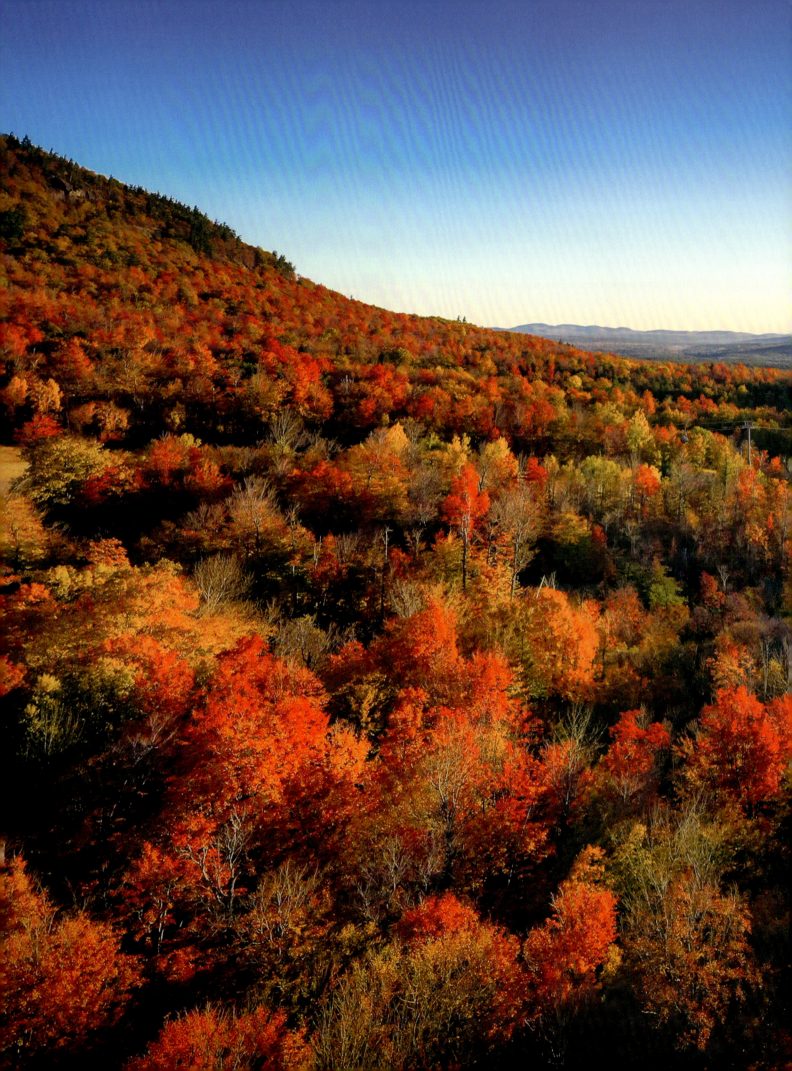

TEMPERATE FOREST

FALL COLOURS
The forests of the Adirondacks in upstate New York have turned from green to a gorgeous mix of golden browns. This is the New England Fall, where the leaves will soon do just that.

TEMPERATE FOREST

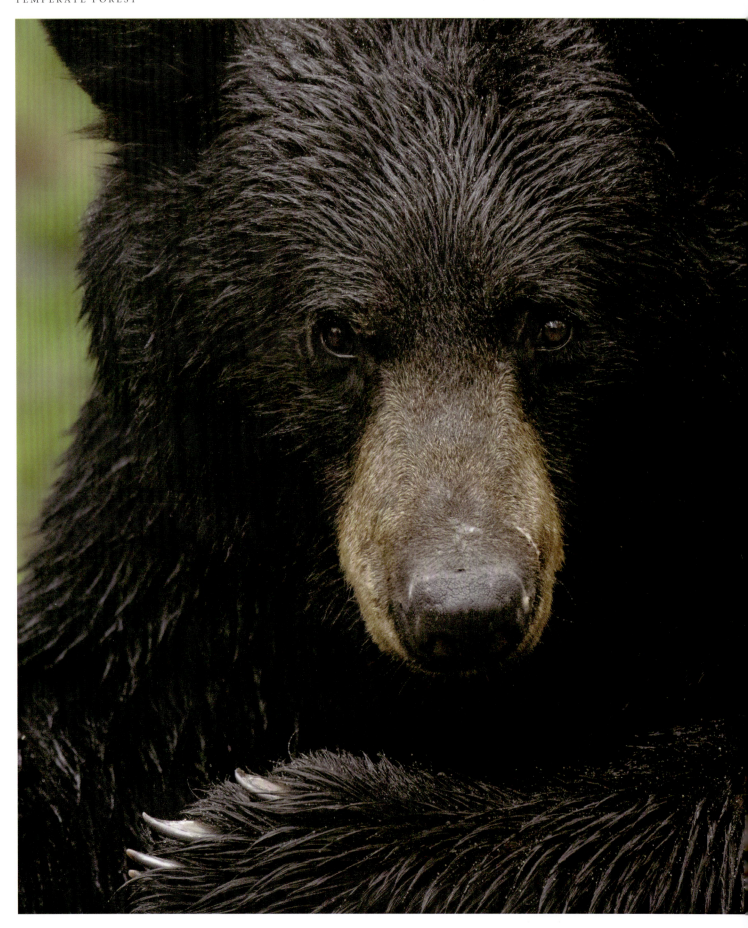

TEMPERATE FOREST

LEFT:
AMERICAN BLACK BEAR
The smaller of the two bear species in North America, the black bear is more common in the south of the continent, especially in the temperate forests. These bears are small enough to be able to climb into trees to find food, including the honey of bees.

BELOW:
TEMPERATE RAINFOREST
The forests along the Pacific coast of North America, in Oregon, Washington and British Columbia, are sandwiched between the ocean and the mountains. As such these forests receive a huge quantity of rain and this water supply drives substantial plant growth with tall trees, mosses and other epiphytes. The temperate forests here are dubbed rainforests as a result.

leaves sprout. The removal of the green chemicals creates the familiar change in leaf colour that is much admired across the world. With the dominating greens gone, the leaves take on a red-orange and golden hue. This is due to carotene chemicals, which are there to protect the leaf from high-energy ultraviolet rays. The carotenes absorb the dangerous UV and stop it from damaging the more sensitive chlorophylls.

The colour change across a forested landscape over the days and weeks of the autumn is one of the natural wonders of the world. The leaves will eventually fall away leaving a thick layer of 'leaf litter' on the forest floor. This litter provides a rich winter habitat for snails, slugs and other invertebrates that are somewhat protected from the freezing conditions above. The leaves fragment into a rich humus, creating an organic component of the soil. Each year, the forest soil is renewed by a fresh layer of leaves. The rich soil is an ideal habitat for fungi. The autumn leaf fall represents a bonanza for these innocuous decomposers, which unleash a wave of toadstools and mushrooms across the forest floor at this time of year.

HIDDEN CONNECTIONS

Toadstools and mushrooms are just the fruiting bodies of fungi, the small visible features of a much bigger organism that diffuses itself over and through its food. This may be the fallen leaves or rotting wood. It can also be whatever organic materials that are found in the soil itself. Fungi are saprophytes, which means that they digest their foods externally by secreting digestive enzymes. The enzymes turn the foods into simpler components, which the fungus then

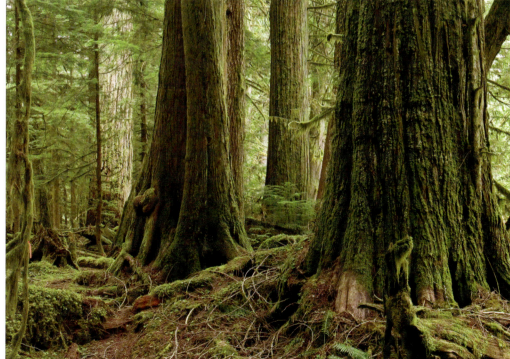

TEMPERATE FOREST

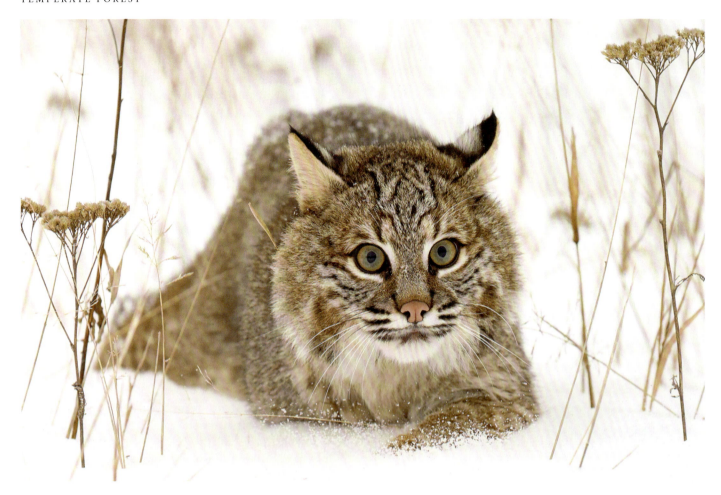

ABOVE:
BOBCAT
Named for its short and fluffy 'bobbed' tail, this is the smallest wildcat in North America. It is a solitary hunter that is active primarily at dawn and dusk. The cat preys on small mammals, birds and occasionally deer, which may become trapped in snow in winter.

RIGHT:
TAWNY OWL
Also known as the brown owl, this species lives across the temperate zone of Europe. They are larger in colder areas. This owl is responsible for the famed 'too-wit too-woo' call. It is actually an exchange between a breeding pair. The female says 'too-wit', the male replies 'too-woo' a fraction of a second later.

absorbs into its body. Along the way, the food, such as a leaf, fallen trunk or animal carcass will be seen to rot. It degrades, becomes moist and is liquified. All that mush is thanks to the fungi that grows as a network of fine hair-like strands. These may be invisible but can form a glistening web-like mass called a mycelium.

The soils are filled with mycelia, especially around the roots of trees. The roots and fungal strands form a symbiotic partnership called a mycorrhizae. These partnerships exist in all land habitats but are best known in broadleaf forests. The fungi are specific to the partner plant and they work as a team to collect the nutrients from the soil that they both need to thrive. The mycorrhizae forms a communication network by which trees are able to pick up information about neighbouring relations. A plant that needs certain nutrients that is not available to it, can receive supplies from its neighbours via the fungal links. This incredible network has been nicknamed the Wood Wide Web, and has revolutionized thinking about forest communities.

BIGGEST ORGANISM

Subterranean fungi are among the largest single organisms in the world. A honey fungus in Oregon is said to cover 10 sq km (4 sq miles) of ground, which dwarfs the blue whale, in size at least (the fungus does not weigh that much). Also, the fungus here is thought to be around 2500 years old and could be three times older, making it one of the oldest organisms on the planet. However, to the east, in Fishlake National Forest in Utah, the foothills of the Rockies look like they are covered in a temperate forest of quaking aspen. However, the entire forest is a single tree with some 47,000 stems sprouting from the soil skyward. This plant is called Pando, which is Latin for 'I spread', and it is the heaviest organism on Earth. It is beaten for size by the honey fungus, but Pando weighs 6000 tonnes in total, 30 times more than a blue whale.

Pando is a single quaking aspen that spreads via rhizomes, or roots that grow horizontally before sending up saplings that grow into a new stem. Each stem is about 120 years old but Pando has been living on this hillside for several thousand years.

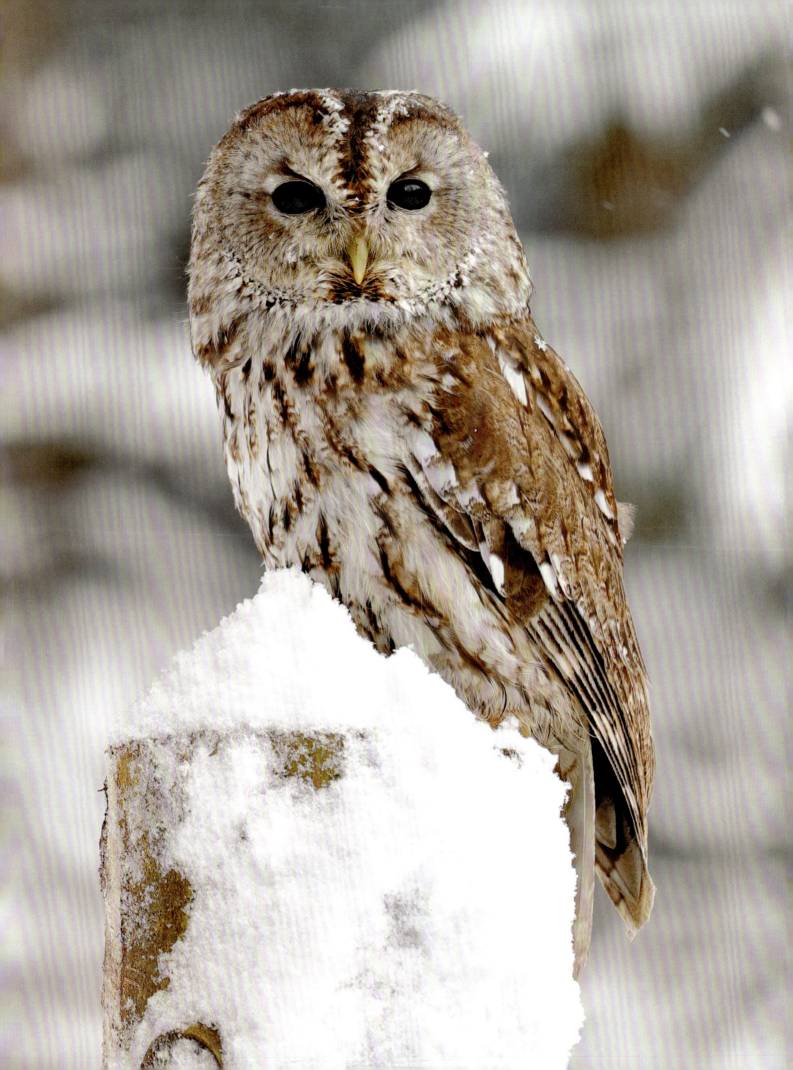

TEMPERATE FOREST

The upper estimate suggests that Pando is 14,000 years old, about as old as the first human settlements in the area.

Pando is not the only forest of quaking aspen clones in North America, but it is the largest. This tree species is named after the way its leaves appear to tremble (or quake) in the slightest breeze, creating a distinctive rustling. The leaves turn a golden yellow in autumn, and the different clonal colonies (groups of genetically identical trees) can be seen more clearly at this time of year because their stems change colour at slightly different times to their neighbours.

FOREST TREES

Another name for a quaking aspen is the trembling poplar. These are one of the faster-growing trees in this biome and can fill a gap in the forest with mature trees in a few decades. Other trees that are frequently seen in temperate deciduous forests include the beech, maple, elm and oaks. They take longer to become established and will eventually take over from the aspens and poplars. The oak is a particularly iconic member of the forest. These trees do well in soggy soils and can be a

RIGHT:
QUAKING ASPENS
The golden yellow leaves in this forest belong to quaking aspens, so named for the way their leaves tremble and rustle in the wind. This species of aspen, a deciduous tree, dominates temperate forests at the northern edge of their biome. North of here, evergreen pine trees, like these Douglas firs, take over.

BELOW:
EASTERN BETTONG
About the size of a large rat, this hopping marsupial is a grass eater that lives in the forests of Tasmania. It was once more widespread across the mainland of Australia but has been driven out by invasive species such as rabbits and red foxes.

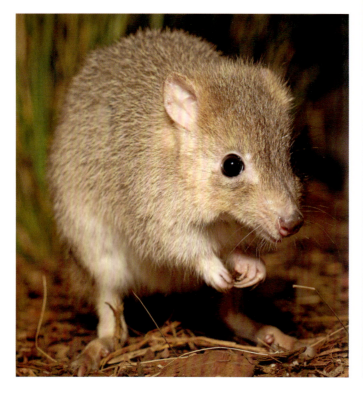

TEMPERATE FOREST

TEMPERATE FOREST

presence in the forest for hundreds of years. In that time the trees become a home for dozens of different organisms and a food for many others. The seed, or more correctly, the fruit of the oak is the acorn, which is food for songbirds, squirrels and other rodents the world over.

Maple is the common name for acer plants, which include horse chestnut, or conker, trees. They have the distinctive tripartite leaves (immortalized in the Canadian flag). The sugar maple of North America is the source of a syrup that adds sweetness to breakfasts across the continent daily. This syrup is a concentration of the sweet, but very watery, sap, that runs through vessels below the thin bark. The sap is also an essential

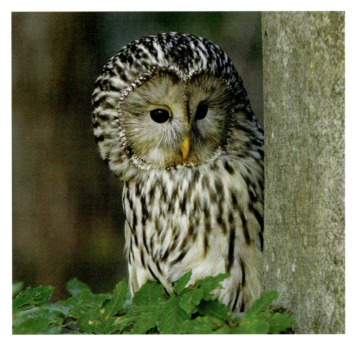

ABOVE:
URAL OWL
This owl is a generalist nocturnal hunter in the forests of temperate Asia. It is also a resident of the taiga, the colder forest habitat to the north. It is a perch hunter that uses its ring of feathers as an acoustic dish to capture the sounds of animals on the forest floor. As with all owls, the wings of this species reduce the sound of flight to a near silence. The targeted prey will never get any warning of an attack.

RIGHT:
WILD BOAR FAMILY
The Eurasian boar is the wild ancestor of the domestic pig. It is a very widespread species that takes in the whole of Europe and Asia. It avoids mountainous zones and deserts, and is most at home in mild temperate forests. This is a female with her piglet. She will care for it for a year or two. The males take four or five years to be fully mature; they are a third heavier than the females and have pronounced tusk-like, lower canine teeth.

BELOW:
BEECH TREES
Beech is a major component of broadleaf forests in North America and Eurasia. The trees readily stand for 300 years, perhaps longer in some places. A beech forest is slow to develop. A sapling is only 4m (12ft) tall after 10 years, and it will not produce large numbers of seeds until it is around 30 years old.

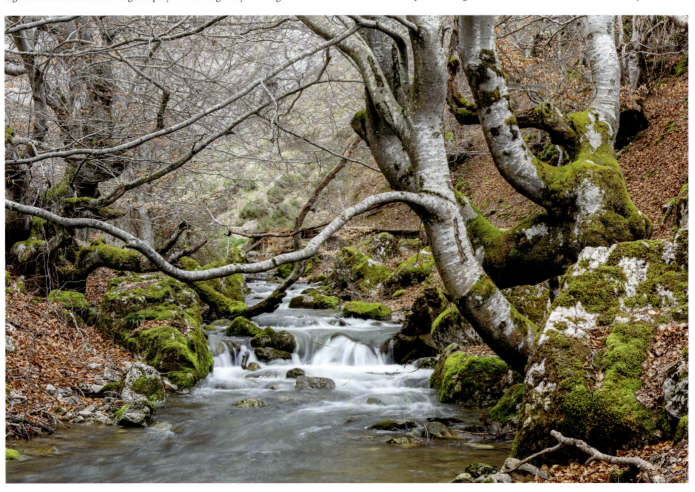

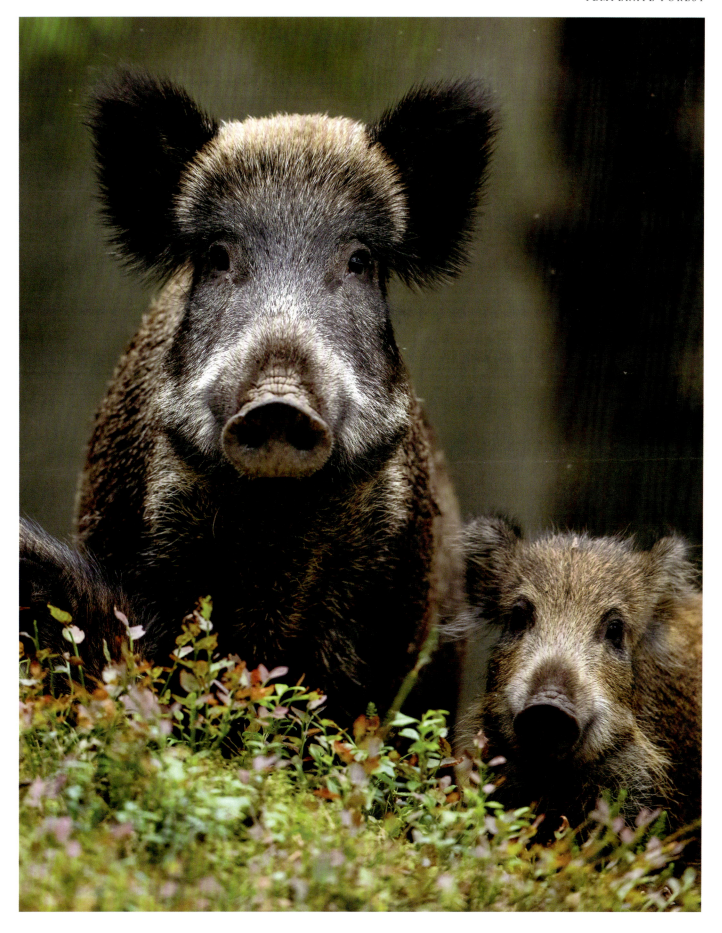

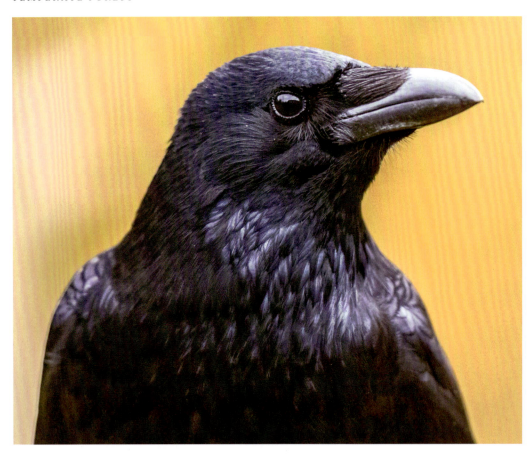

food source for aphids and other sucking bugs, which infest the trees in the sunny summer, when the sap is running fast. In winter, the tree has no leaves and so is not making any sugar by photosynthesis. As a result most of the insects will rush through several generations in summer and leave eggs in the soils around the trees in winter. Come the spring the suckers will re-emerge to plague the tree.

The aphids drink so much liquid sap that they produce a near constant supply of sweet urine. This has the more innocuous name of honeydew and it is a source of food for other insects. Some bee colonies make honey not from nectar but from the honeydew of aphids. Carpenter ants even go so far as to maintain a flock of aphids, which they 'milk' for their sweet wee.

DIFFERENT FLORA AND FAUNA

A very different set of trees live in the forests of Australia and New Zealand. Australia is famed for its eucalyptus trees, which deter predators by filling the leaves and bark with smelly oils, which signal that a meal of them will likely upset the stomach. The koala is an iconic leaf eater that is able to survive on a eucalyptus-only diet. It is a picky eater that only munches the choicest of leaves, which give off an aroma that indicates they have an acceptable concoction of oils inside. Once full, the koala must wait for a slow fermentation in its convoluted bowel to extract enough nutrients. In the meantime, the little marsupial goes to sleep.

ABOVE:
CARRION CROW
This distinctive black bird is a common sight in and around the temperate habitats of Europe, especially to the west, where the winters are milder. The species is also found in Japan. As its name indicates, this bird is a scavenger and will eat whatever food, plant or animal, it can find.

RIGHT:
AMERICAN ELM
Also known as the white elm, this species is a major constituent of the broadleaf forests of eastern North America, from the Mississippi Valley and Appalachians and the Atlantic Plain. It is hardier than the European elm and is better able to thrive after a harsh winter. Both species are in danger from Dutch Elm disease, a fungal disease spread by beetles.

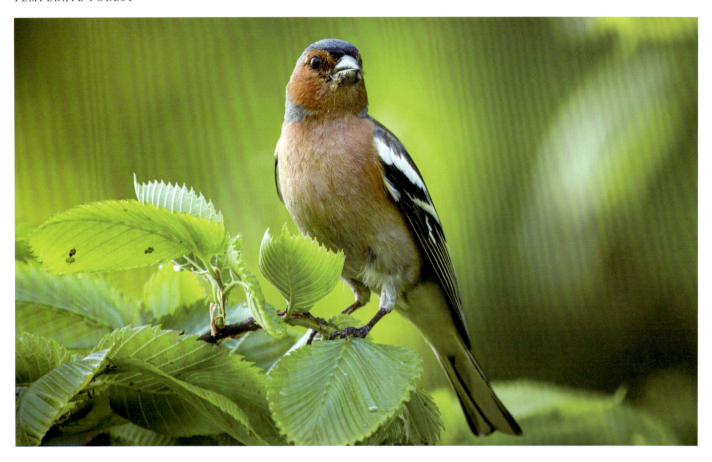

Elsewhere in Australia, along with patches in New Zealand and Chile, are the world's oldest continuously growing temperate deciduous forests. These forests have trees known as southern beeches. They are related to the beeches of the north, but only distantly. Other relatives include the walnut trees and birches. The southern forests are remnants of a habitat that covered Gondwana, an ancient southern continent that later broke up to create present-day South America, Australia, India and Africa.

The forests of New Zealand have even more ancient trees, including tall ferns with distinctive toothed fronds instead of the broad leaves of deciduous species. The deciduous trees spread using seeds, whereas the ferns have more convoluted life cycles and are dispersed in wind and water by spores.

Among these unusual New Zealand forests are even more unexpected sights. Along the southwestern coast of Fiordland, penguins can be seen waddling through the undergrowth. These are Fiordland penguins, which hunt close to shore during the day, and clamber back on to land to sleep in the safety of the forest by night. The waterbirds make their nests in thickets and hollows beneath trees.

RIGHT:
BLACKBERRIES
These are probably the most common edible fruits in temperate forests the world over. They are the fruits of the bramble plant, which is a sprawling, thorny plant that tangles into other shrubs. It is especially common along the edges of woodlands. The blackberries ripen in early autumn and are an important food for songbirds as they prepare for winter.

ABOVE:
COMMON CHAFFINCH
The vibrant reddish plumage and blue-grey cap show that this is a male chaffinch. The females are more muted in colouring. In the winter these forest birds survive by searching for fallen seeds among the leaves. In spring they turn to hunting for insects and similar prey. This turbocharges their diet as the birds move into the breeding season.

TEMPERATE FOREST

ABOVE:
CATKINS
These catkins are of a smaller type of willow tree, known as a pussy willow. Pussy willows are found in Europe and across North America, most commonly in the border region either side of the frontier between Canada and the United States. The fluffy, even silky, growth is the tree's flower bud. They emerge in spring, often before the tree has grown its leaves.

BELOW:
EURASIAN BADGER
In many parts of western Europe, where the fauna is impoverished after centuries of industrialization, the badger is the largest wild carnivore. Having said that they mostly target earthworms, fruits and roots. A badger is about the size of a spaniel, but with shorter legs. Badgers are nocturnal, and by day they live in large communal burrows, or setts, that are often dug around the roots of a forest tree.

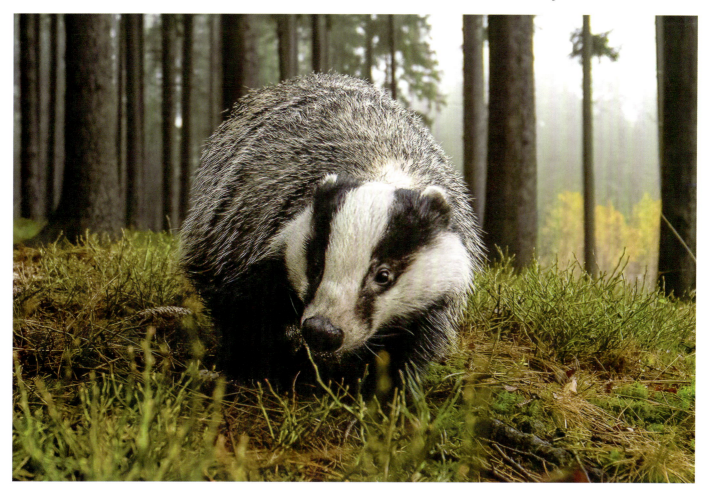

Flightless birds are a common occurrence in New Zealand – or at least they were. This isolated archipelago was only connected to Gondwana for a short while and became isolated by the oceans before mammals got there. As a result evolution has put birds into the places occupied by mammals in other forests around the world. One is the kakapo, which is a giant flightless parrot that eats shoots and seeds on the forest floor. It communicates by digging a hollow in the soil that helps to amplify a deep, booming hoot. The low frequency of the call means it spreads through the forest over a large distance. Sadly, due to persecution by cats and rats, there are very few kakapo in the wild to boom back a reply.

Almost as rare are the kiwis. These are another flightless New Zealand bird (their name is used as a nickname for the country's human inhabitants, too). Kiwis are nocturnal and work their way through thick forest undergrowth in search of prey. Unlike most birds, the kiwi has an excellent sense of smell, using tiny nostrils on the tip of its long spiked bill. The bird can smell buried prey, such as worms and grubs.

INSECT EATERS

The kiwis are, of course, not the only insect-eating birds to live in deciduous forests. The forests of the Old World have many insectivorous birds that are on the hunt. They have four main ways to catch their food. Flycatchers enter aerial combat and snatch flying insects in midair. Others will scratch through the leaf litter for ground beetles and ants. Some forest birds are gleaners, which means they search for insects that are on leaves or flowers. Finally probing birds, use their long bills to poke around in cracks of rocks in the bark for creepy crawlies. Divided by their different approaches, there is food and opportunity enough for a wide range of birds. Many of them arrive in summer from wintering sites in tropical climes to feast on the explosion of insects. They raise chicks and then head home in autumn.

Woodpeckers are a class of probing insect catchers that have taken it to the next level. They have sturdy, chisel-shaped bills that are cushioned against the skull so they can be used to chip holes through bark and into wood. The intention is to break into the tunnels dug by beetle grubs. The bird then uses an almost absurdly long tongue to slurp up the grubs.

SEED EATERS

Seeds, nuts and hard fruits like acorns are a plentiful forest food, at least in late summer when they are dropped to the ground as the trees prepare for winter. Many songbirds arrive around this time coming south from the Arctic tundra. They rely on a supply of seeds and nuts to see them through the winter.

Other forest dwellers have planned ahead. Squirrels and other forest rodents have collected acorns and buried them in a secret cache. This will keep them fed as they sit out the coldest parts of the winter in burrows and nests. And if they forget where a few nuts are buried, never mind. They will sprout into saplings come the spring, and be ready to fill the next gap that appears when an old tree falls.

HUNTERS LARGE AND SMALL

Hunting in a temperate forest is not quite as easy as in a jungle or savannah. There are fewer large herbivores, mostly because they have been driven to extinction – or near to it – by humans, And so without wild cattle and deer to hunt, there is less scope for big hunters to survive. The biggest non-predatory animals around are wild boars and deer. Nevertheless, the occasional wolf pack is reported in the forests of Europe, and more heading into Russia. The same is true of brown bears, which cling on in mountainous forests. Over in North America, wolves are still surprisingly rare in the temperate forests. They become more common in the colder, boreal forests to the north. In the Americas the most common bear in temperate forests is the black bear, which is smaller than the brown bear or grizzly.

Cats are generally the biggest solitary hunters in these parts. Over in the Far East, Amur tigers and leopards do stalk these woodlands, but they are vanishingly rare. More likely the biggest cat around is a lynx. This is an ambush predator about the size of a large dog. The lynx is one of the last truly wild European predators. It is more common in North America, where it is better known as the bobcat. Additionally, North America is home to the cougar, also known as the mountain lion, and into Central and South America, this hunter is known as a puma. The cougar is larger than the lynx, but is still a 'small cat' that can only growl and purr, not roar.

The hunters of the temperate forests also include much smaller creatures. They include the badger weasel and marten. These belong to the Mustelid mammal family, which mostly have long slender bodies that are flexible enough to wriggle into nooks and crannies or scamper through the branches after prey. A weary traveller crossing the dark forest by night is much more likely to cross paths with one of these little predators than a monster of myth and legend.

RIGHT:
GREAT SPOTTED WOODPECKER
This is the male of a species that is found across Europe and Asia. It uses its chisel-shaped beak to chip away at bark and wood to get at the beetle grubs and other insects inside. Once it breaks into a gallery dug by a woodworm, it unleashes a 10cm (4in)-long tongue that is coiled away in the head. The barbed tip snares the prey. The birds will use their pecking abilities to carve out a hollow nest in the trunk.

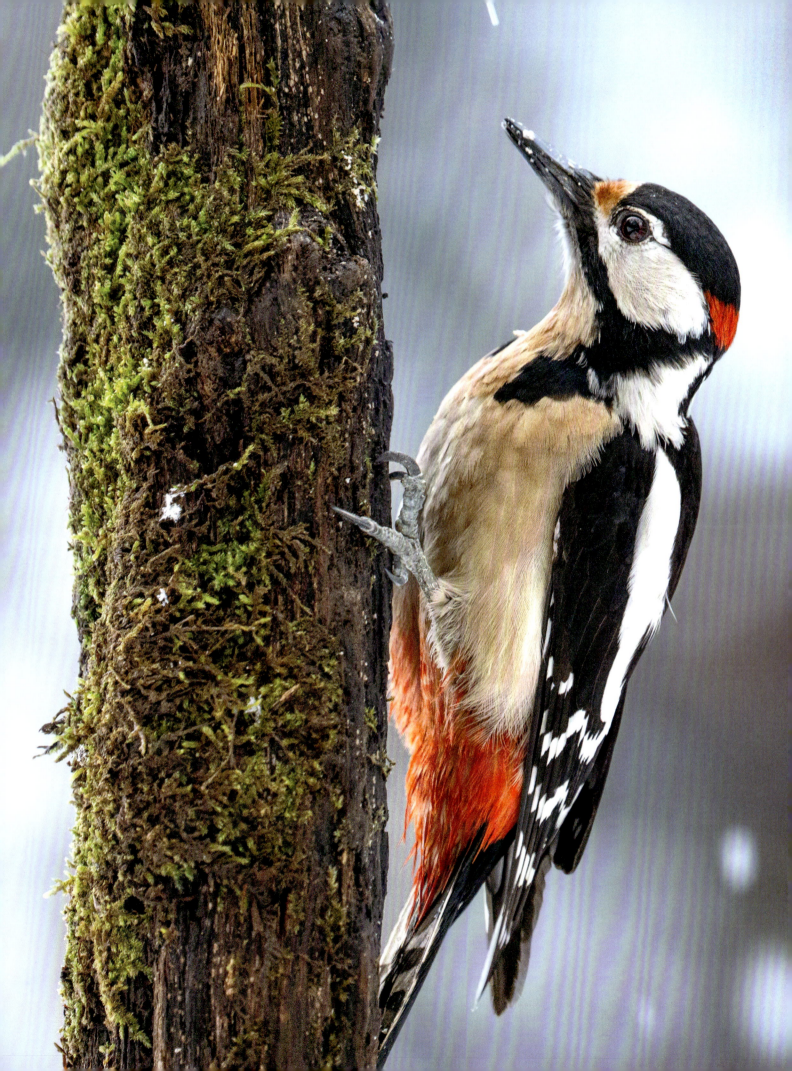

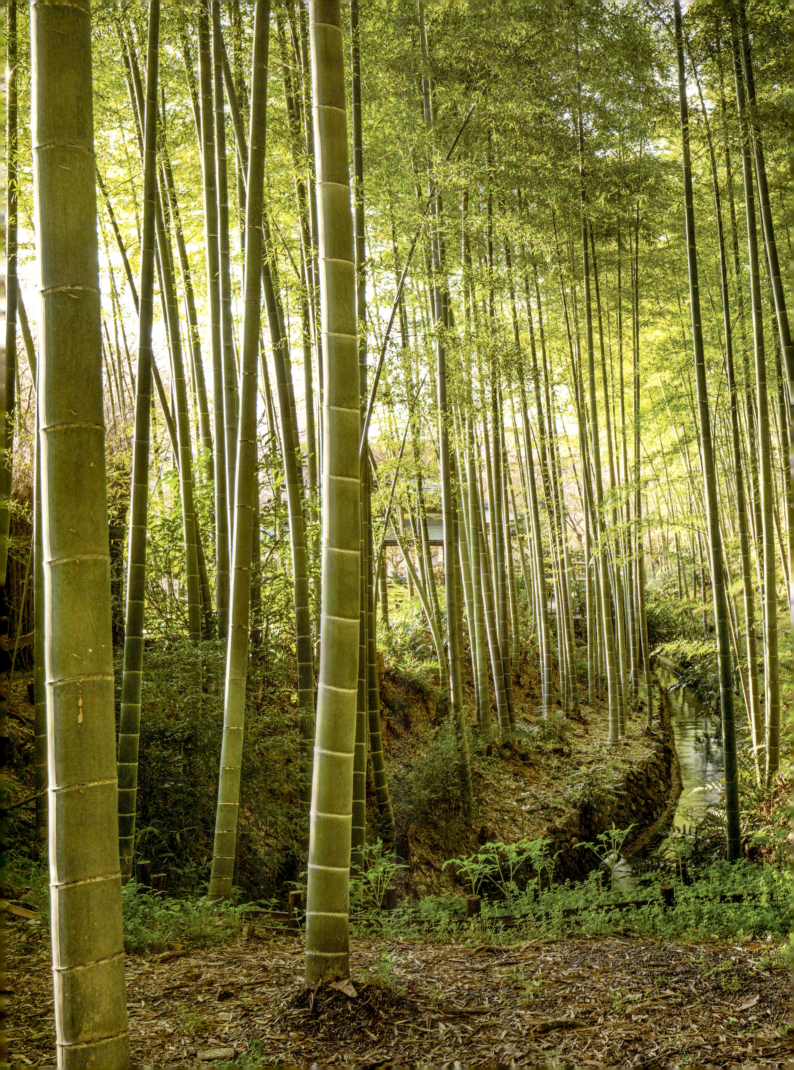

TEMPERATE FOREST

BAMBOO FOREST
A bamboo forest does not have trees. Instead, the taller plants are a kind of very fast-growing grass species. The stems are seldom more than 10cm (4in) across, but grow to 20m (66ft) tall. Some of them can grow 4cm (1.5in) an hour.

TEMPERATE FOREST

RIGHT:
EASTERN GREY SQUIRREL
This is the most common tree squirrel in the eastern forests of North America. They build messy nests in the tops of trees, called dreys, that are scrappy spheres of twigs and leaves. These are easiest to see in winter once the leaves have dropped. The long, bushy tail is used for balance and is held in various positions to signal to other squirrels.

BELOW:
MOSS
Damp conditions are ideal for mosses to grow on the trunks of forest trees or other available surfaces. Mosses are simple plants. They have no roots but cling to the trunk with small root-like extensions. There are no leaves either. Instead the whole upper body is a photosynthetic tissue.

OPPOSITE:
EUROPEAN STARLING
The yellow and black beak indicates that it is either spring or autumn. In summer, during the breeding season, the beak of this bird is yellow. In winter, when the bird prefers to be less visible, it is black. In common with many bird species, the starling can see ultraviolet light as well as the reds, blues and greens of visible light. To the starlings, their muted plumage shimmers with iridescence that is invisible to us.

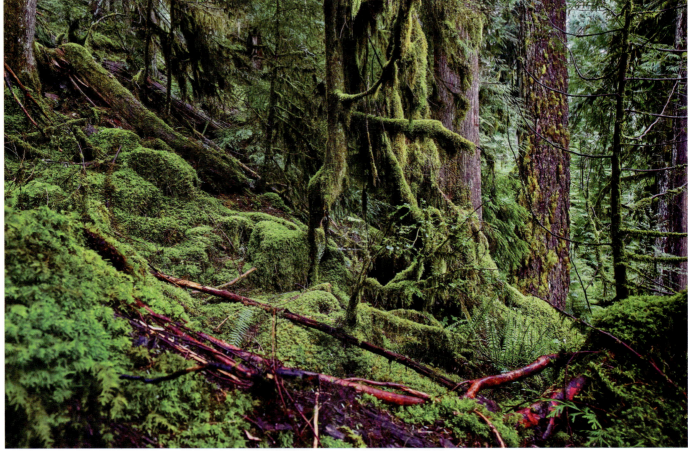

TEMPERATE FOREST

LEFT:
GIANT PANDA
One of the most familiar animals on Earth, this bear is native to a few patches of mountain forest in central China. The forest is filled with bamboo, which is the sole food of these bears. They must feed near continuously to get the nutrients they need to survive. They sit down, in a rather human-like posture, to chew on the leaves and fleshy stems.

BELOW:
RACCOON
This is a North American species that originated in the primordial temperate forest there. It is a generalist and opportunistic feeder that takes a zigzag path through the forest. This is a search pattern that maximizes its chances of finding food. The raccoon will investigate every nook and cranny it can. This foraging strategy works well in other habitats, including urban and suburban ones.

TEMPERATE FOREST

ABOVE:
BLUE TIT
Perhaps surprisingly for such a colourful bird, both the male and female share this striking plumage with the tell-tale black stripe through the eye differentiating it from other blue-hued birds. They are insect eaters that move out of colder regions in winter but do not migrate to a wintering ground. The little birds often flock together with great tits in winter.

BELOW:
MAPLE TREE WITH MOSS
There is barely any bark to be seen on this venerable maple as moss has taken hold across this temperate rainforest in Oregon. Maple trees are tapped for their sweet sap, which is made into syrup. In autumn, as the leaves fall, the sap sinks out of the branches to the lower part of the tree. In late winter it will start to rise again, taking energy supplies to the top of the tree where it will soon need to sprout fresh leaves.

TEMPERATE FOREST

ABOVE:
NORTHERN CARDINAL
A breeding pair of cardinals share a perch. The male is the show-off with the red feathers and crest. The female has no need to attract so much attention. The stout red bill indicates that these birds are seed eaters. The larger mouthpart makes it easier to hold the smooth, rounded foods. The birds also prey on insects to boost energy during the breeding season.

BELOW:
HICKORY FRUITS
The hickories are significant broadleaf trees in the temperate forests of Asia and North America. The pecan tree is a hickory that grows in the Mississippi Valley. Its fruits are a staple in traditional North American cooking.

TEMPERATE FOREST

ABOVE:
RED FOX
The Eurasian red fox is the most widespread of the fox species. It lives across Europe, Asia and North America, and is an important predator in the temperate forest. It dens underground, often forming extended family groups. The cubs from the previous year's litter may stay with their parents and help them raise this year's babies. This practice, known as alloparenting, improves the survival chances of all the foxes.

LEFT:
EUROPEAN RABBIT
The rabbit is one of those ubiquitous animals that seems to live everywhere. And in many cases this European species has succeeded in taking over in far-flung places. It has been introduced to Australia and New Zealand, to rather devastating effect, and in Chile. What may be less well known is that the rabbit is native to the Iberian Peninsula and was introduced to other parts of Europe, mostly by the Romans.

OPPOSITE:
WISENT
The European bison, or wisent, is a close relative of the American bison. Like its cousin, it is the heaviest animal on the continent. However, unlike it, the European species, is found in forest habitats. The mighty beasts were hunted to within a hair's breadth of extinction. Today the largest herds live in the Białowieża Forest on the borders of Poland and Belarus.

TEMPERATE FOREST

TEMPERATE FOREST

GIANT SEQUOIA
This is one of the largest trees in the world. Although it only reaches about 85m (280ft) in height, well below the records set by redwoods and mountain ash, it does grow a very thick trunk. The General Sherman tree in California, holds the record for the largest tree by volume in the world.

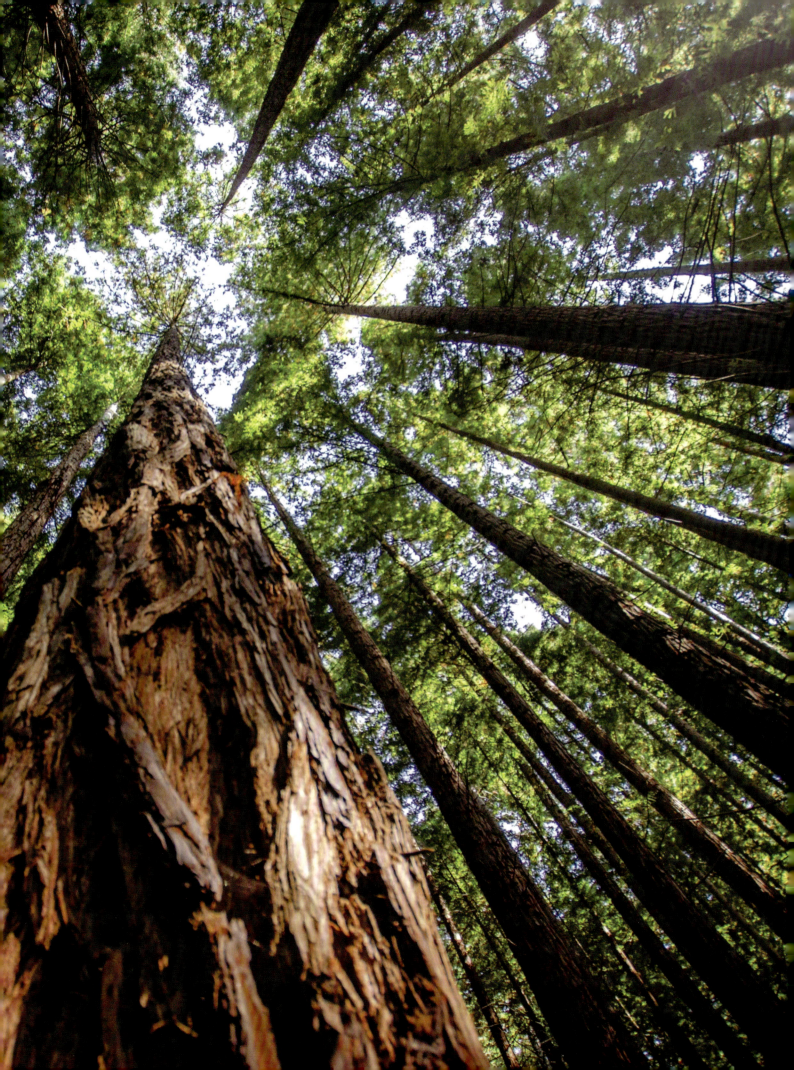

TEMPERATE FOREST
NORTH AMERICAN PORCUPINE
This quill-covered forest animal is one of the largest rodents in North America. It is odd therefore to see this animal, which has a body the size of a spaniel but looks bigger thanks to the 30,000 spikes sticking out of it, up a tree. It is foraging for leaves and fruits up there. If threatened the porcupine will charge backwards. Its quills are barbed and therefore hard and painful to remove.

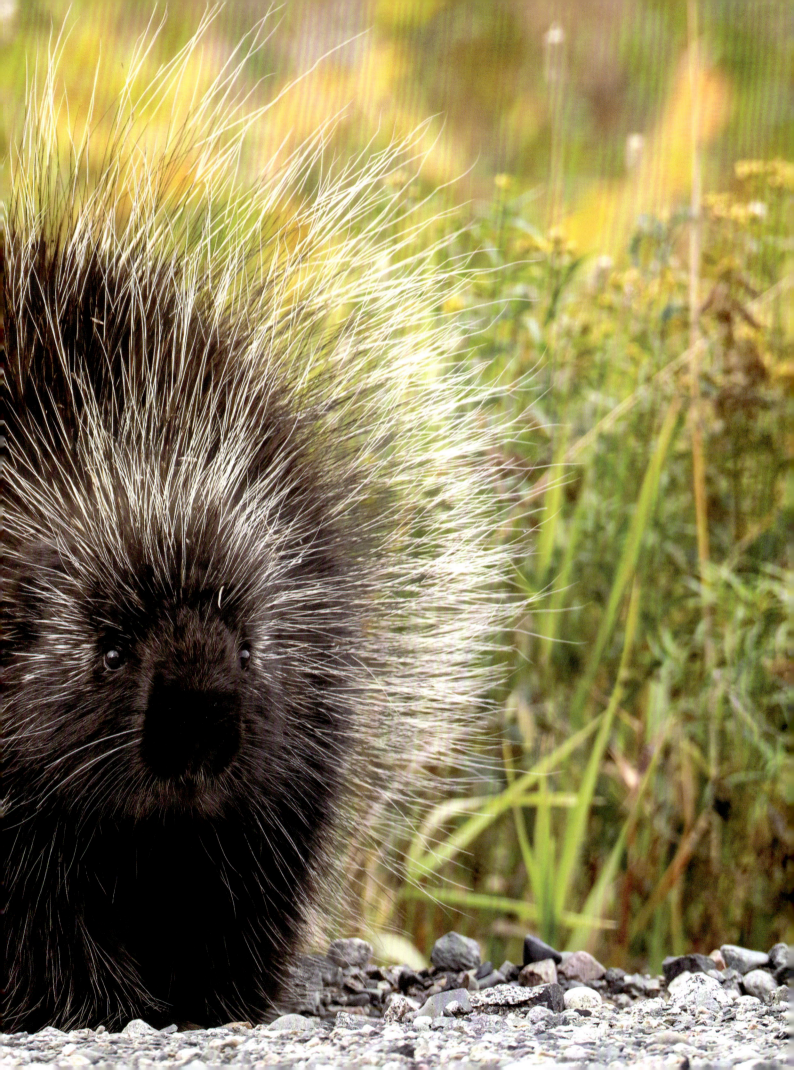

TEMPERATE FOREST

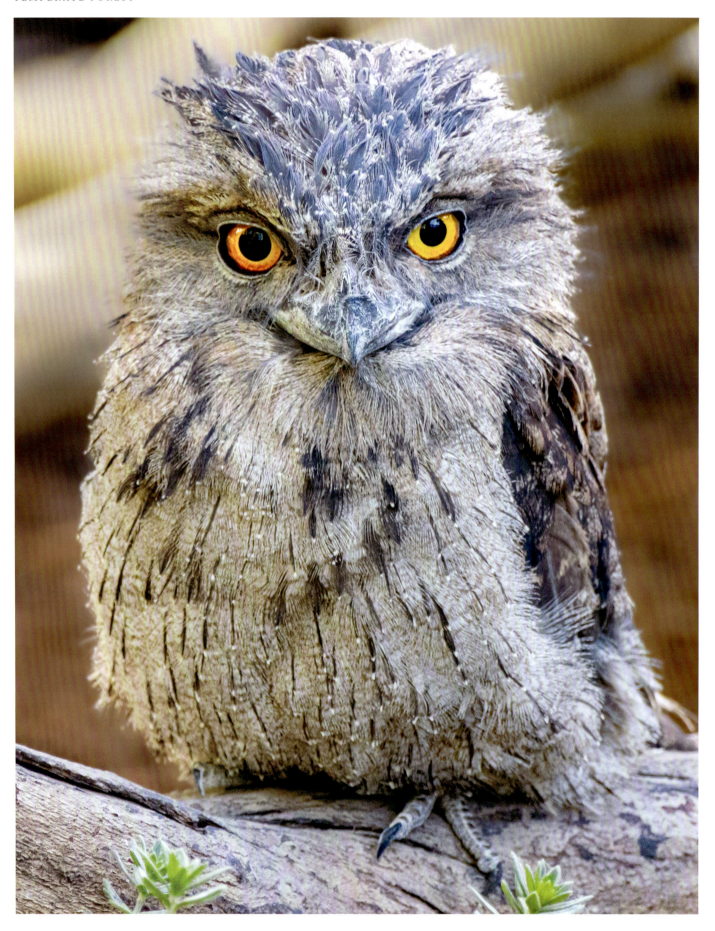

TEMPERATE FOREST

RIGHT:
EASTERN COPPERHEAD
With a head that does indeed have a coppered hue to it, this pit viper is one of the most venomous snakes in the east of the United States. (The rattlers are out west.) As a pit viper it relies on heat-sensitive pits on the snout to detect the body heat of warm-blooded prey, such as rodents and birds, in the dark. On summer days the snakes lurk in the leaves; the hourglass-shaped crossbands provide excellent camouflage. Despite being a ready biter, copperhead attacks are rarely fatal to humans.

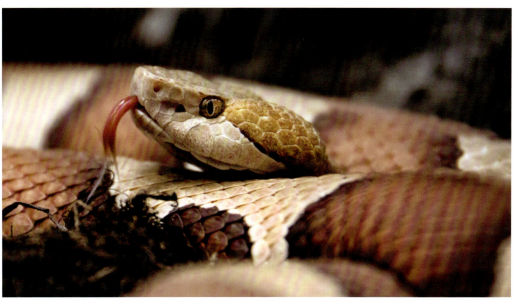

OPPOSITE:
TAWNY FROGMOUTH
By night this Australian forest bird is an avid insect hunter. It uses is eponymous frog-like mouth to snaffle them whole. They are poor fliers and so mostly work on foot. During the day, the simply hop onto a branch and stand motionless. Their scruffy grey plumage perfectly matches the bark and the bird resembles a little stump – that is as long as it keeps its eyes shut.

BELOW:
CLOSED CANOPY
In summer the leafy crowns of the deciduous trees do a good job of filling space and capturing all that light energy. Beneath the canopy, the forest is cast into a cool half-light.

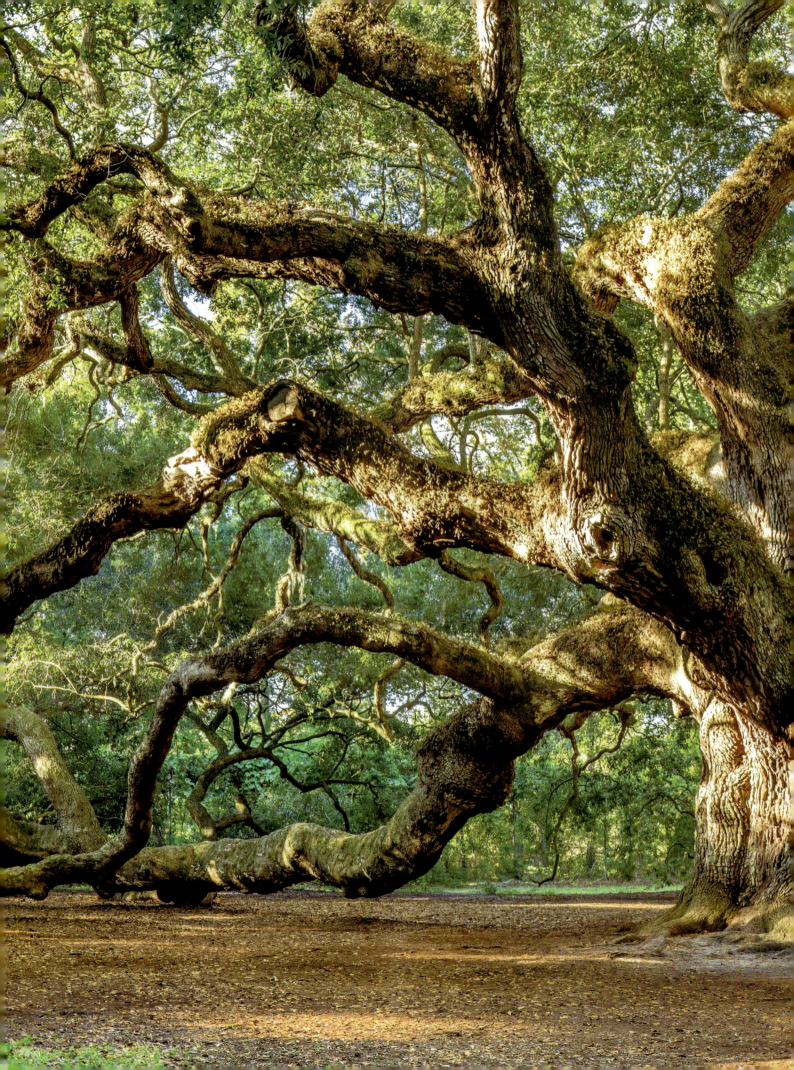

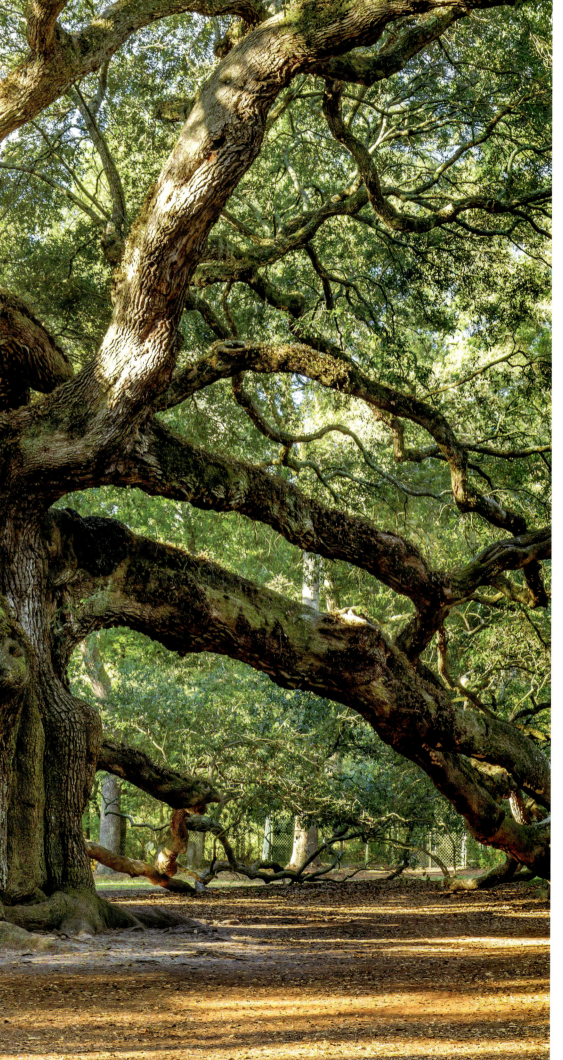

TEMPERATE FOREST

A MIGHTY OAK
The oak is a mainstay of a broadleaf temperate forest. This is the Angel Oak in South Carolina. It is thought to be around 500 years old, and would have been a sapling when European settlers arrived in America. In the intervening years, the tree, as typical of oaks, has sent out mighty limbs, almost horizontally to dominate a large area of the forest.

TEMPERATE FOREST

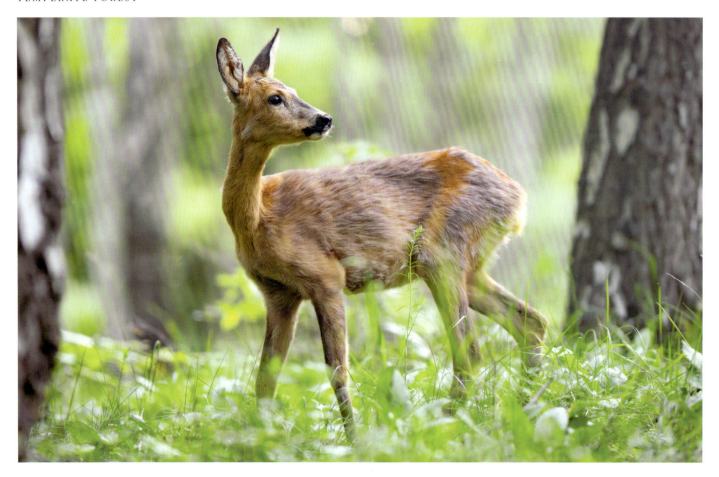

ABOVE:
ROE DEER
This roe deer is pausing to check the area. What has she heard? This medium-sized deer is found in forests from Britain to the Black Sea. They are most active at dawn and dusk, but might be seen sprinting away if disturbed during the day.

BELOW:
ELM LEAVES
Elm trees have simple, rounded leaves with a slight point at the tip. These ones are growing in an English woodland. Elm trees are very rare in the UK. The population was almost wiped out by an epidemic of Dutch elm disease in the 1970s.

TEMPERATE FOREST

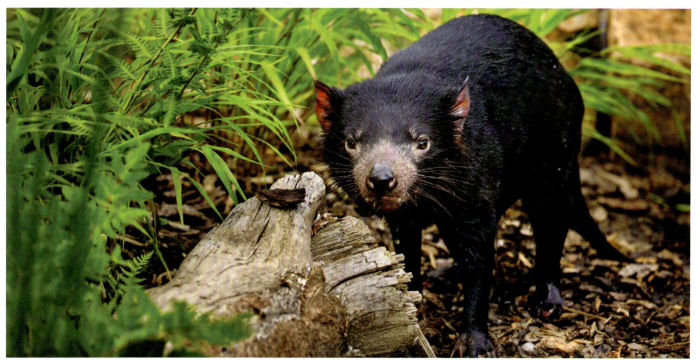

ABOVE:
TASMANIAN DEVIL
This is the largest living marsupial carnivore. The terrier-sized hunter was once widespread across Australia but is now confined to the bush of Tasmania.

BELOW:
ADDER
This venomous snake is the most widespread in the world. It is found from Britain to North Korea. In many places it is the only venomous animal around, yet its bite is largely harmless to people. The adder spends a lot of time hibernating in the northern parts of its range. The snake is noticeably darker in colder regions to help it absorb more heat on sunny days.

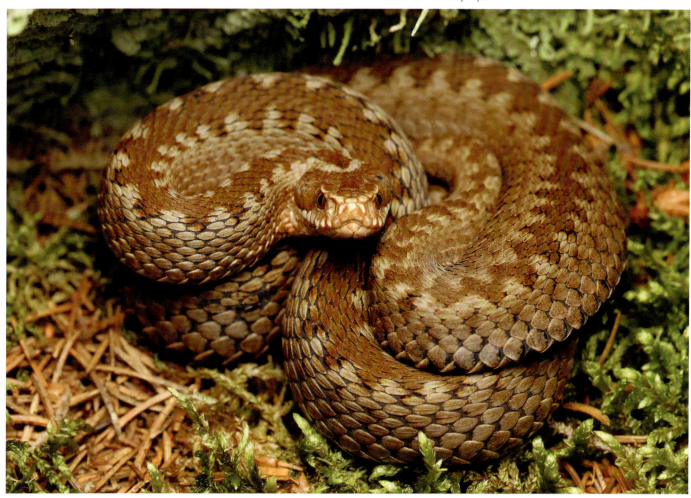

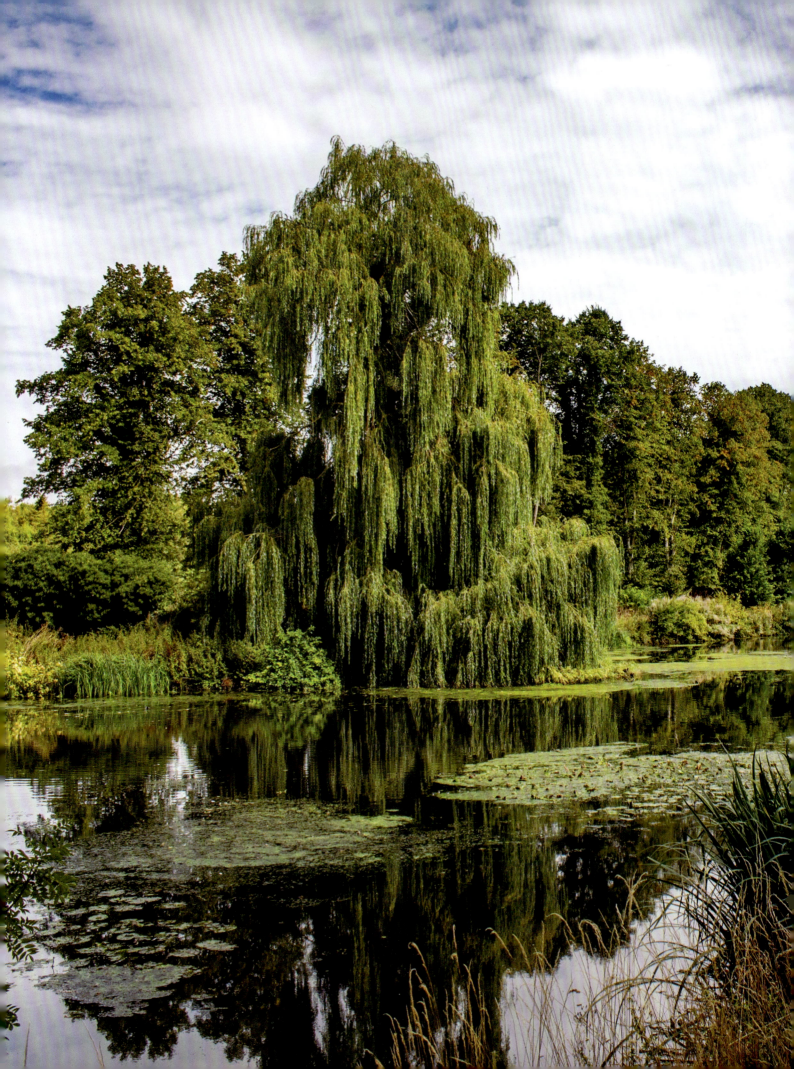

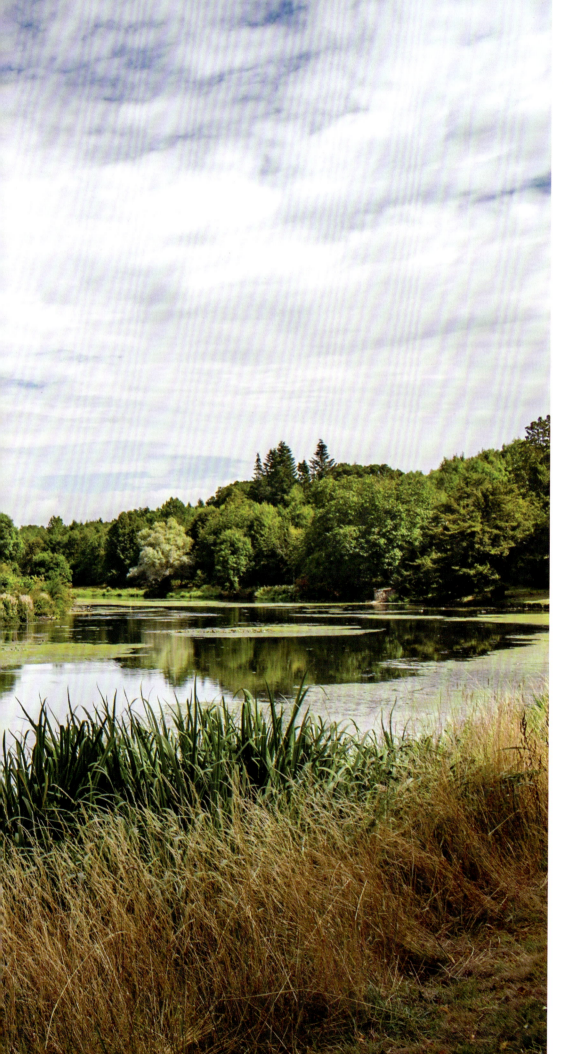

TEMPERATE FOREST

WEEPING WILLOW
A picturesque river and weeping willow tree in the wooded grounds of Hatfield House, Hertfordshire, England.

TEMPERATE FOREST

ABOVE:
WOOD WARBLER
Overwintering in tropical Africa, the wood warbler migrates to the deciduous forests of Europe each spring. The insectivorous songbird finds food high in the leafy canopy. Breeding pairs construct dome-shaped nests on the ground, hidden among dense vegetation.

BELOW:
SUGAR MAPLES
The autumn has arrived in the Great Smoky Mountains National Park of the eastern United States. The leaves of sugar maple trees have faded to a mix of yellows and oranges. This has happened as the green chlorophyll chemicals were extracted readying the tree to drop its leaves.

TEMPERATE FOREST

ABOVE:
BLUEBELL WOOD
The oak and ash woodlands of the British Isles, Belgium and Netherlands often produce a carpet of bluebells in spring. The flowers sprout from bulbs underground to capture sunlight before the leafy canopy closes over the woodland in summer to make the forest floor a shadier place.

RIGHT:
COMMON CUCKOO
This large bird arrives in the temperate forests of Europe in spring. After mating, the female uses its resemblance to the predatory sparrowhawk to scare away smaller songbirds so she can lay an egg in their nest. The cuckoo chick will kill her nest mates and fool their parents into supplying it with food.

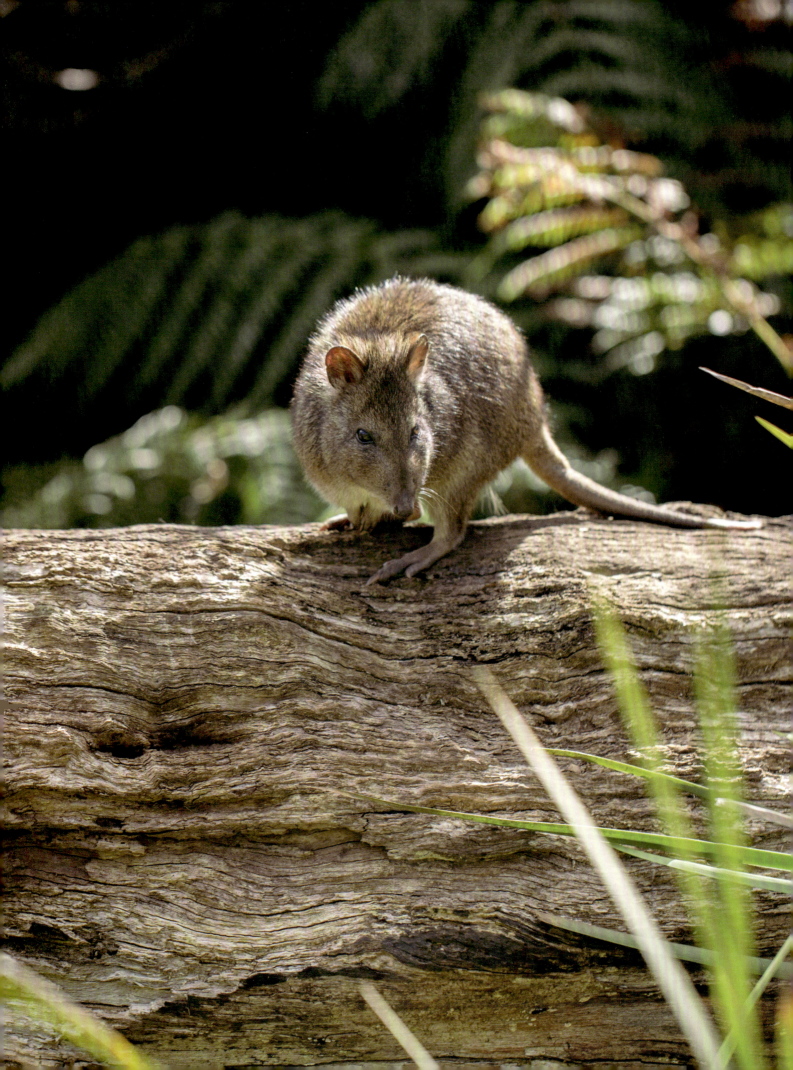

TEMPERATE FOREST

LEFT:
LONG-NOSED POTOROO
This small mammal is native to the forests and shrubland of southeastern Australia and Tasmania. Potoroos are nocturnal and live relatively independent lives apart from mating periods or when caring for young.

RIGHT:
WILD CHERRY BLOSSOM
These blossoms appear in spring on the wild cherry trees that are a feature of ancient forests in Europe and temperate parts of western Asia.

BELOW:
BLACKBIRD
This bird is one of the most widespread songbirds in the temperate forests of Europe and Asia. (The blackbird in the Americas is a very different species.) Only the males are actually black. The females benefit from a better camouflaged brown plumage.

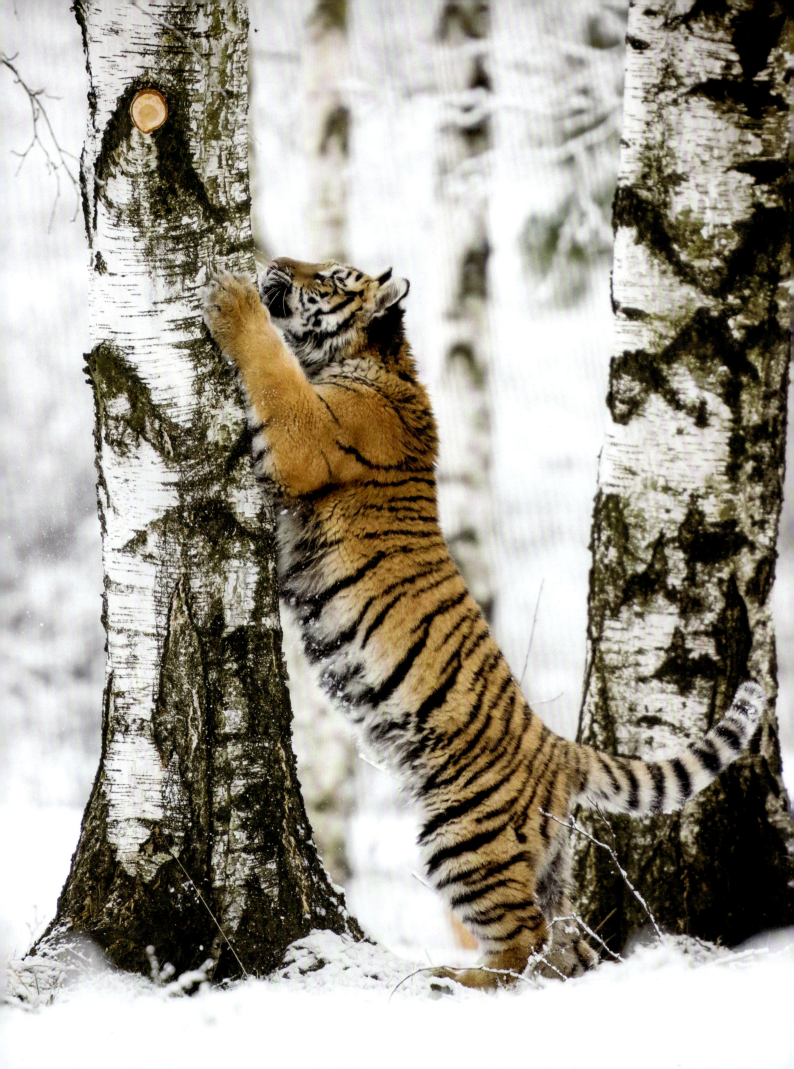

TAIGA

The world's largest forests are not the steamy jungles that teem with life, nor are they the fertile deciduous forests brimming with fresh growth in the mild, temperate lands. Instead, the biggest forest – indeed, the largest land biome of all – is the taiga. The taiga is a cold place that is dominated by conifer trees, which include spruce, firs and pines. The animals that live here are also cold-adapted, like caribou and reindeer, or they are the remnants of a more widespread species that have been driven out of the temperate and subtropical regions. Brown bears and wolves – also known as timber wolves – are good examples of this.

NORTHERN HABITATS

The word taiga was originally Russian. It means 'the uncrossable forest'. There is good reason for that name. The taiga is vast, covering a total of 17 million sq km (6.6 million sq miles). It is also inhospitable for much of the year. The taiga is typically so cold and dark that it is frozen for much of the time.

Another name for taiga is boreal forest. This requires another definition, perhaps. 'Boreal' refers to the north wind that brings icy weather from the Pole. This name is all the more apt in that boreal forest is exclusively found in the Northern Hemisphere. There are a few small forests that share similar features in climate and flora in the Southern Hemisphere, but these are mostly associated with mountainous regions. Boreal forest is generally a lowland habitat, with seasonal swamps

OPPOSITE:
SIBERIAN TIGER
A young tiger is reaching up the trunk of this birch tree to gouge deep scratches in the bark. This behaviour keeps the claws sharp, but more importantly it is a warning to other tigers to keep away. Passing tigers can see just how large this cat is from the height of the markings.

RIGHT:
SNOWSHOE HARE
It's all change for this North American species. In summer it has a brown coat, looking much like hares from warmer, southern habitats. However, in winter the hare's coat goes white so that it blends in better with the taiga snow.

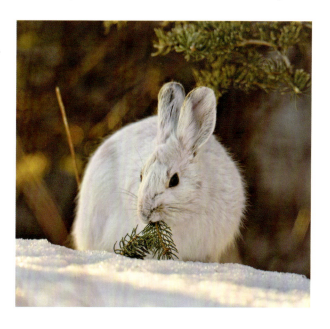

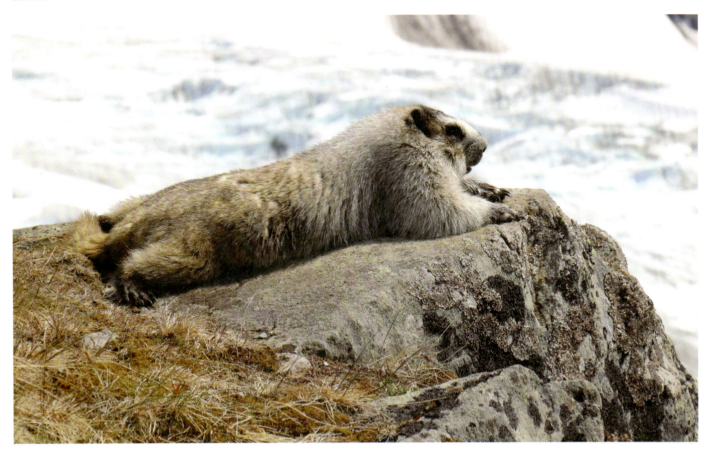

ABOVE:
MARMOT
This large ground squirrel is splayed on a warm rock. It is absorbing as much warmth as it can before the winter weather arrives. Then it will retire to a cosy burrow to hibernate. The squirrel will spend more than half of the year asleep underground.

BELOW:
DOUGLAS FIR CONE
The taiga is an evergreen forest dominated overwhelmingly by conifer trees, so called because they produce cones not flowers to spread pollen and make seeds. The Douglas fir is a common resident of western North America. The cones seen here are female and make the seeds.

forming in glades and clearings among the denser trees when the land thaws in summer.

COLD CLIMATE

The taiga biome forms a vast ring of forest around the top of the Earth, mostly butting up against the Arctic Circle from the south. The Arctic Circle marks the limit of the 'midnight sun'. (The Antarctic Circle does the same but most of that is crossing the Southern Ocean.) The term 'midnight sun' refers to the way the Sun does not set, staying visible in the sky 24 hours a day – and night. This is a consequence of the way Earth's axis of rotation is at an angle to the path it takes around the Sun. As a result, the North Pole leans towards the Sun in summer. At the North Pole itself the Sun is visible in the sky for the whole summer long, six months, day and night without end. At points to the south of the North Pole that period of constant day reduces. At the Arctic Circle, which is at 66°N, 2650km (1650 miles) away, the Sun stays up for a single 24-hour period on Midsummer's Day. For the rest of the summer, the land north of the Arctic Circle has very long days, with the Sun dipping below the horizon for just a few hours.

TAIGA

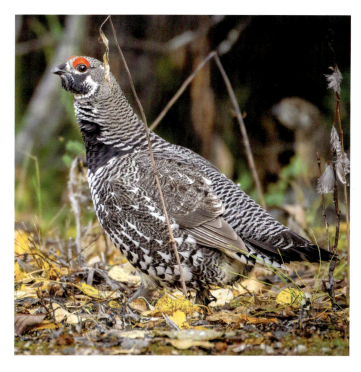

There is a further impact of the axial tilt. Despite the Arctic being bathed in light for long hours in summer, it is still cold here, at least colder than other biomes to the south. This is because the light is less intense than the sunlight at lower latitudes. The Sun is never overhead up at this region of the planet, and so the rays that hit here always arrive at a steep angle. That angle has a spreading effect, which means that per unit of area less heat and light energy arrives than in the same area to the south.

GROWING TIME

So with those impacts combined, the boreal forest occupies a space where there is enough solar energy in summer to drive the growth of trees. To the north of here it is just too dark for too long. Nevertheless, this is not the limiting ecological factor. The thermal energy, or heat, incident in this region means it is cold. This cold is ratcheted up by the long, dark winters, and there is little time in the summer for the land to store heat and thaw ice into water.

The area is by no means devoid of water. Around 100cm (40in) of rain falls in a typical year, but that is mostly in the form of snow. As a rule of thumb, 1cm (0.3in) of rain is equivalent to

ABOVE:
SPRUCE GROUSE
This ground bird scratches out a living in the dense spruce forests of North America. It eats the needles, using highly acidic digestive juices to break down the tough cuticles. This male is fattening up for the winter. The mottled brown and grey plumage helps it hide on the forest floor.

BELOW:
CATHEDRAL GROVE
Part of MacMillan Provincial Park on Vancouver Island, this is an old-growth forest filled with Douglas fir trees. The firs here are about 800 years old. They reach 90m (300ft) tall and have a circumference of 9m (30ft).

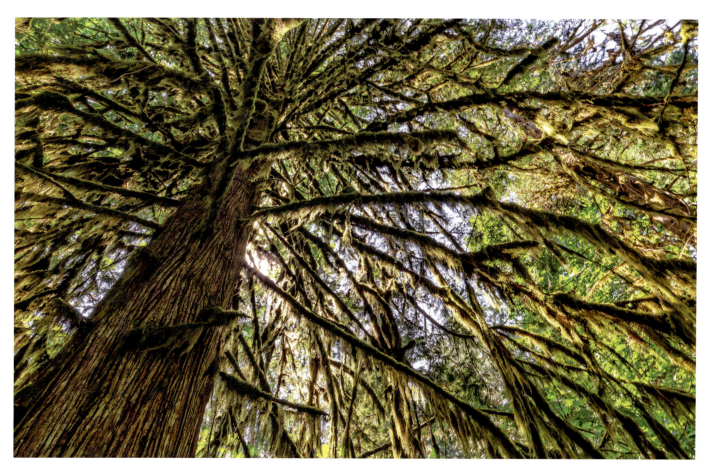

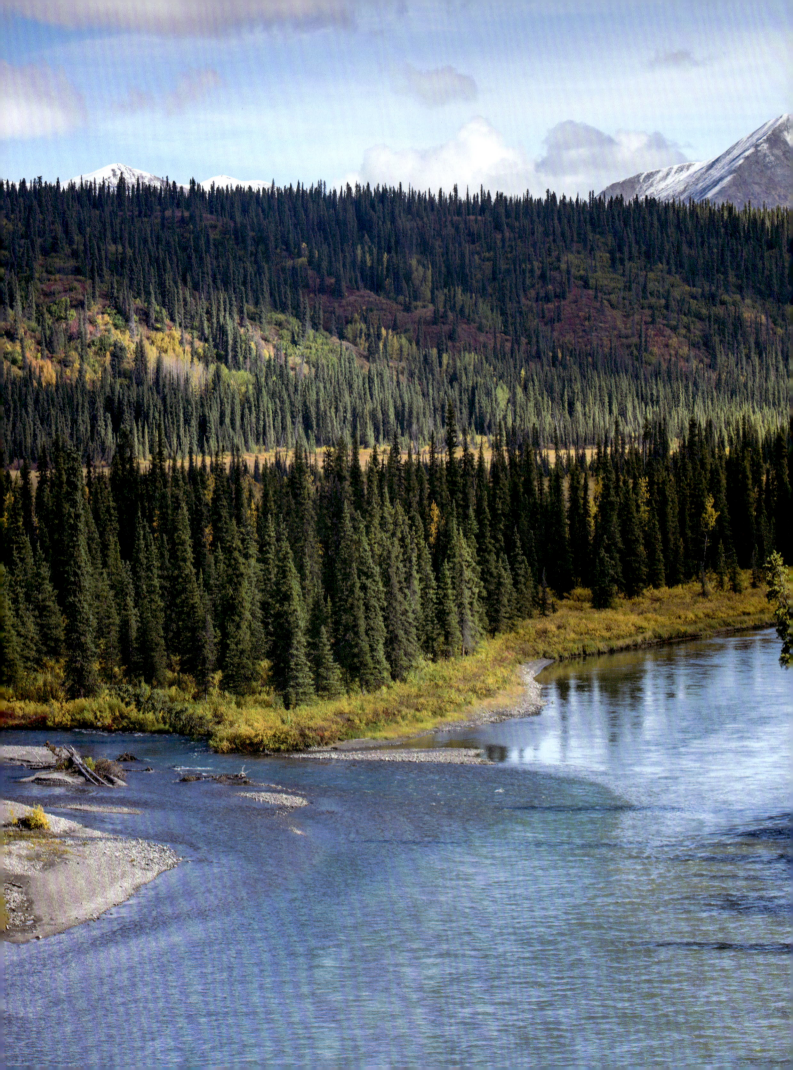

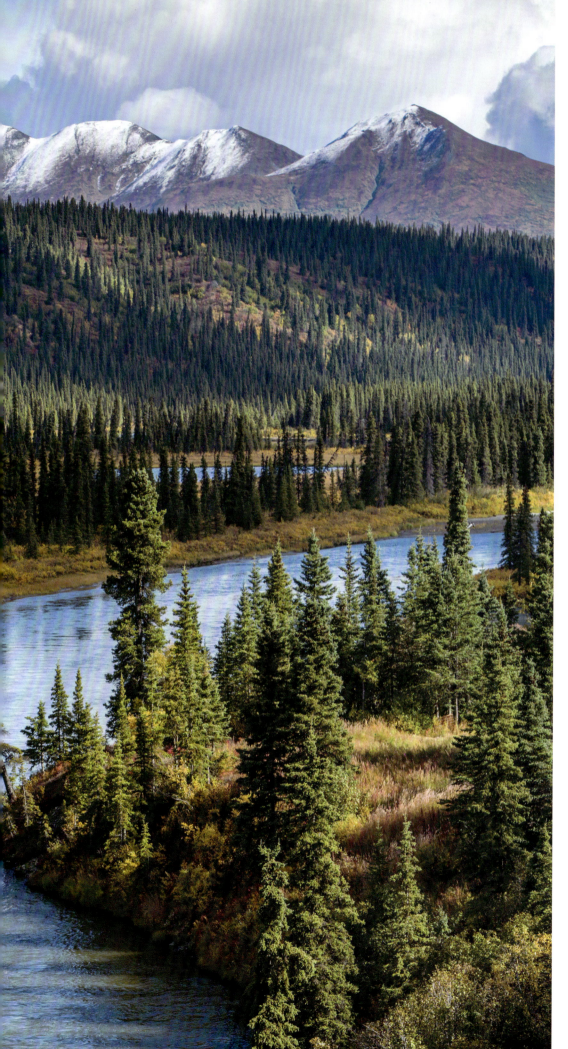

TAIGA

DENALI NATIONAL PARK
This region of mountains and taiga in Alaska, USA has several glaciers that form the clear and cold headwaters of several rivers.

10cm (4in) of snow, so the forest can be covered in deep drifts for many months. When this winter snow melts into liquid water, the plant life here has to seize the opportunity to grow and reproduce before the cold returns, and the forest ices up again. The upshot is that that the trees and other plants living in the taiga get a growing season of about four months a year.

WHERE IN THE WORLD

A look at a map shows that the taiga forms a green halo around the Northern Hemisphere, but its locations are not so firmly correlated to latitude. The typical growth period can be found far to the south of the Arctic Circle in places such as eastern Canada, Siberia and Manchuria. These places have continental climates where the winter conditions are consistently cold (and the summers are hot, too). The reason is that these locations are far from the ocean, and while land heats up fast in summer, it also loses its heat in winter. The ocean by contrast is slow to warm and slow to cool, so generally has a chilling effect in summer, and a warming one in winter. However, the Labrador coast of eastern Canada is fed by perennially cold currents, and so this patch of ocean at least does not provide a warming boost in winter. As a result the land in these parts freezes fast and thaws for only a few months each year. As a result taiga grows here. To illustrate this, we can look at the taiga habitats of Newfoundland, on the eastern tip of the Canadian territory, and compare them with the vineyards of the Champagne region of northern France, which share the same latitudes.

The taiga forests of Scandinavia are in contrast to those across the Atlantic. These spread high above the Arctic Circle, growing in places that see the midnight sun. Elsewhere these areas are too ice-locked to support forest growth, but Scandinavia is warmed by North Atlantic currents that connect with the warm subtropical waters of the Gulf of Mexico. This input of warmth is enough to keep northern Scandinavia, sometimes called Lapland, ice free longer than other areas, and taiga can thrive here.

BELOW:
BEAVER
The American beaver is the largest rodent in North America. It lives across much of the continent but it is most common in more remote regions to the north, especially the taiga. The rodents use their enormous front teeth to gnaw through small tree trunks and cut them into logs. The logs are then used to dam a stream to create a still pond, where lush grasses thrive. In summer, the beavers eat the grasses. In winter they survive by eating wood, which is left to soak and soften in the pond.

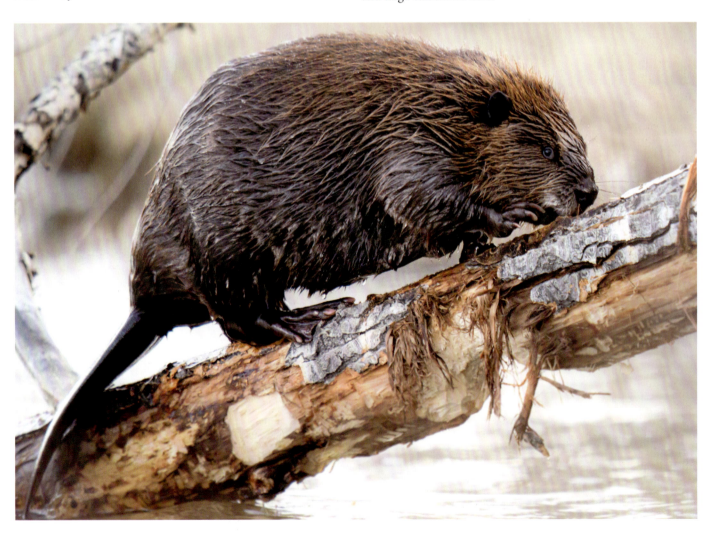

TAIGA

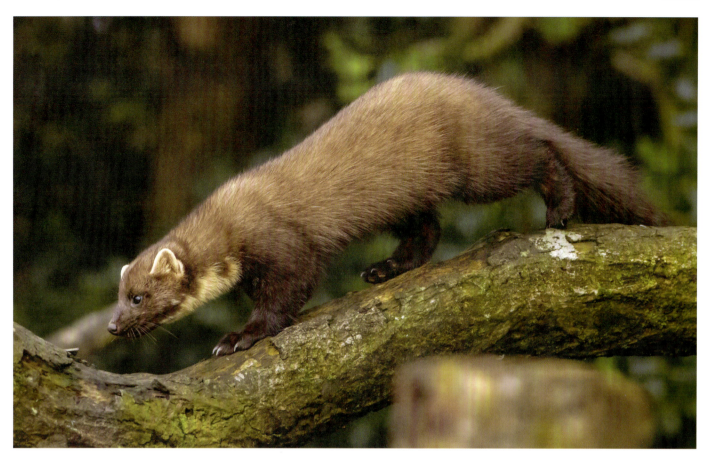

ABOVE:
PINE MARTEN
This relative of the stoat and otter is a tree-top hunter that lives in the pine forests of Europe and Asia. They build dens in tree hollows and forage for fruits to supplement their diet of birds, mice and insects.

LEFT:
ICELAND MOSS
This hardy lichen native lives in the forests that skirt the Arctic Circle and more barren subarctic habitats, as found in Iceland. Despite the name it is not a moss but a symbiotic organism in which fungus and algae work together. It is an important winter food source for forest herbivores, such as deer.

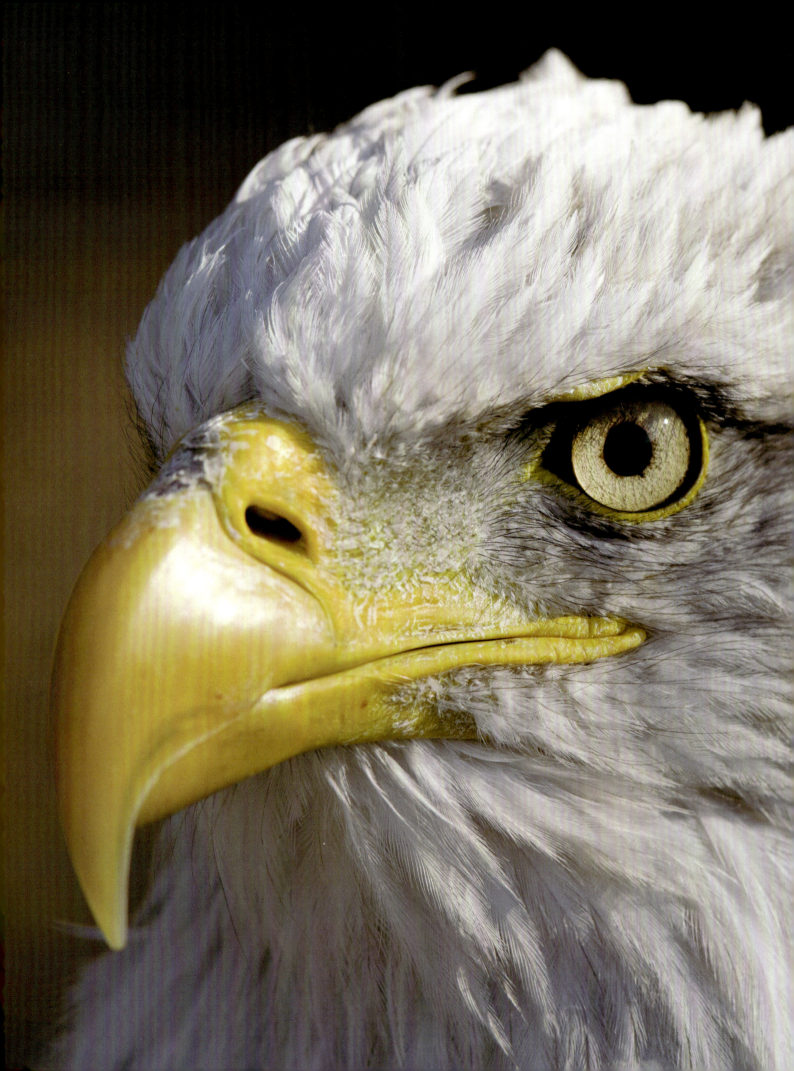

LEFT:
AMERICAN BALD EAGLE
This most iconic of American birds builds huge nests of sticks at the tops of trees or on cliffs. Some of the nests are reused for generations and are as big as a hot tub. Bald eagles are primarily fish eagles and often live near the coast or a lake.

BELOW:
LINGONBERRIES
These red berries are sprouting through a carpet of reindeer moss, another taiga lichen. The lingonberry plant spreads by sending out stems just under the soil, which then sprout from the surface.

NEEDLE LEAVES

So, the taiga biome offers light and liquid water in large enough quantities for forest of trees and shrubs to grow. But it offers them for only a short time. The conifers, the dominant taiga flora, handle these restrictions through a series of trade-offs that maximize efficiencies. The result of these trade-offs is the familiar Christmas-tree shape clothed in dark, glossy needles.

The first thing to notice is that these trees are evergreen. To the south, in temperate forests where conditions are milder, the trees drop their leaves in autumn to avoid frost damage in winter. So, why don't the conifer trees follow the same strategy? The answer is in the length of the taiga's growing season. A deciduous tree needs several months of above-freezing conditions to sprout fresh leaves, use them for growth and then claw back their useful contents before shedding them. That time is not available in the taiga, so the trees must be ready to photosynthesize and grow as soon as the Sun comes out and the soil thaws. This is what makes conifers the firm favourites for a midwinter symbol, such as a Christmas tree. They retain their fertile greenery even when other plants appear to have died.

For this to happen, the trees need leaves that can withstand the harsh conditions of a subarctic winter. It can drop to below −60°C (−76°F) but leaves need to come through undamaged by such deep frosts. The solution is to reduce the leaves to a

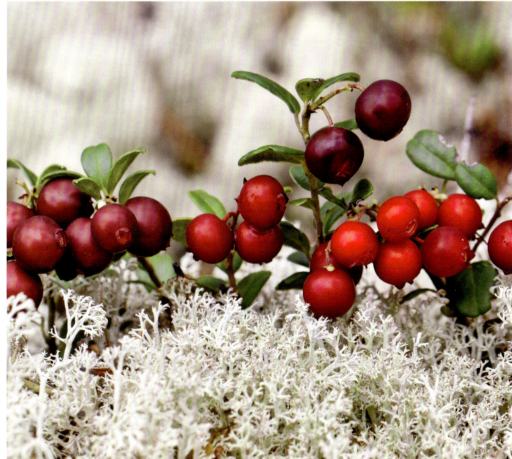

minimum surface area and minimum volume. In other words, the typical broad and flat shape of a leaf is contracted into a needle. The needle contains the green chlorophylls needed for photosynthesis, but it is coated in a thick resinous cuticle layer that waterproofs the surface. This keeps moisture in; the midwinter air is very dry and that stimulates evaporation from unprotected body features. The cuticle and other chemicals in the needle also make it darker than is typical of broadleafs. The darker hue is able to absorb more heat from even the faintest rays of sunlight, and thus ward off the excesses of the cold.

The trickery does not end there. The needles contain antifreeze chemicals that stop large and damaging ice crystals forming inside the cells. They would kill the needle, turning it to mush when it thawed out. Instead only tiny ice crystals form, and they are further reduced by the cells inside the needle pushing out some of their water to fill the spaces between

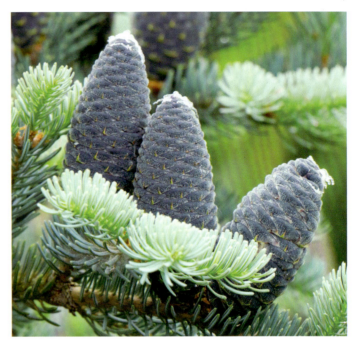

RIGHT:
BALSAM FIR
This evergreen conifer from the eastern boreal forests of North America has bluish-coloured cones. They will darken into a brown as they mature and dry out. As they dry out, the cones fragment and release seeds equipped with wings that catch the breeze.

BELOW:
NORTHERN LEOPARD FROG
This medium-sized frog is named after the large dark spots on its green back. It is a voracious hunter that gobbles up insects and even smaller frogs.

OPPOSITE:
WHITE-TAILED DEER
This is the first year that this young white-tailed deer stag has grown antlers. This is because the antlers have no branches, or tines. With each passing year, a new tine is added to the antlers when they regrow. The white-tailed deer is so named for the way it flicks up its tail as it runs to reveal a white rump. This startles and confuses pursuers.

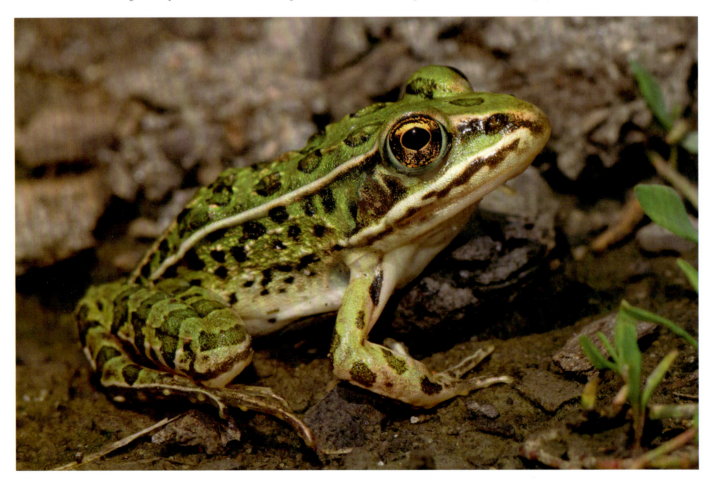

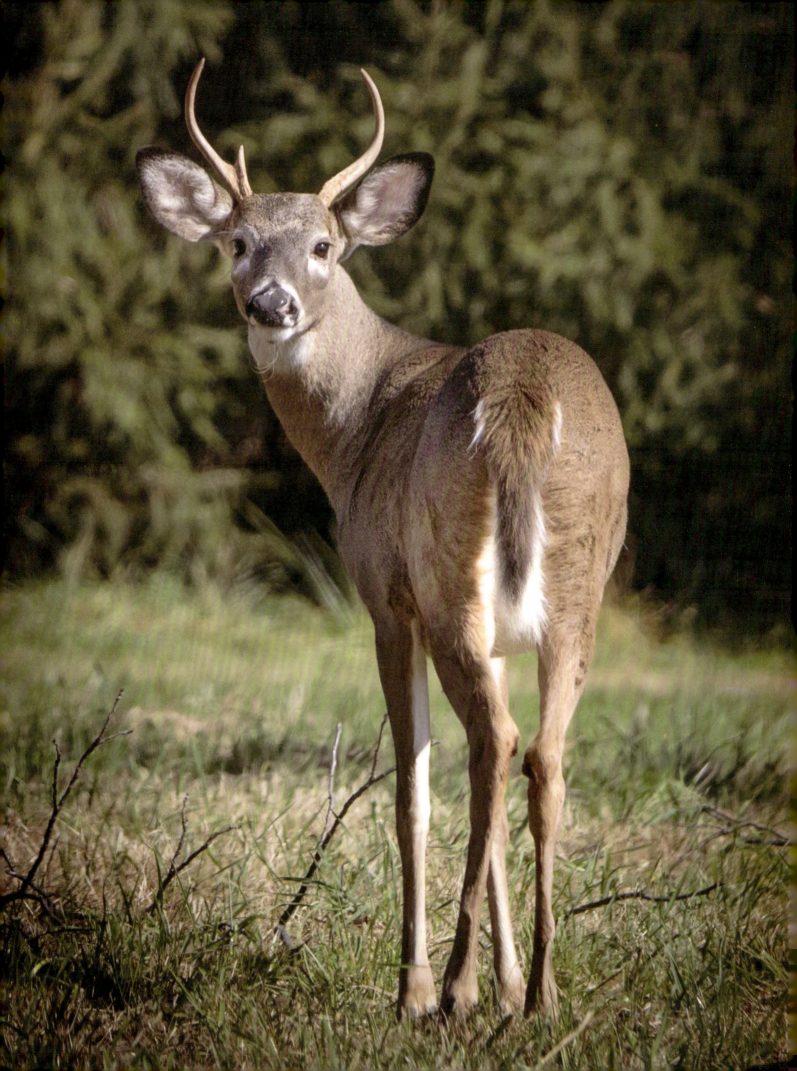

TAIGA

RIGHT:
PINE GROSBEAK
A female of this seed-eating species pauses on a perch. Their strong, thick bills are ideal for cracking seeds. They sometimes supplement their diet with insects in the breeding season.

OPPOSITE:
KOLI NATIONAL PARK
As this view of the taiga in Finland shows, this habitat has a warm and beautiful – if short – summer.

BELOW:
BLUE-SPOTTED SALAMANDER
This small amphibian, aptly named, lives in the forests around the Great Lakes region of North America. The adults are active hunters, feeding on worms and insects among the damp leaves on the forest floor.

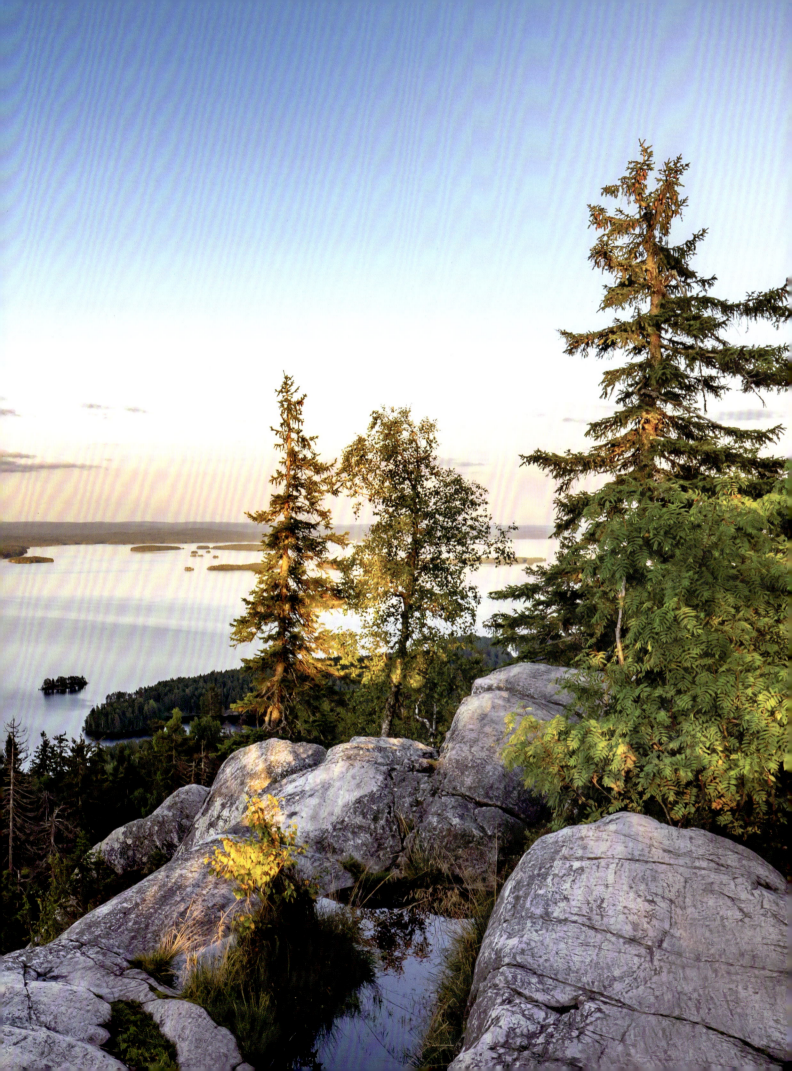

TAIGA

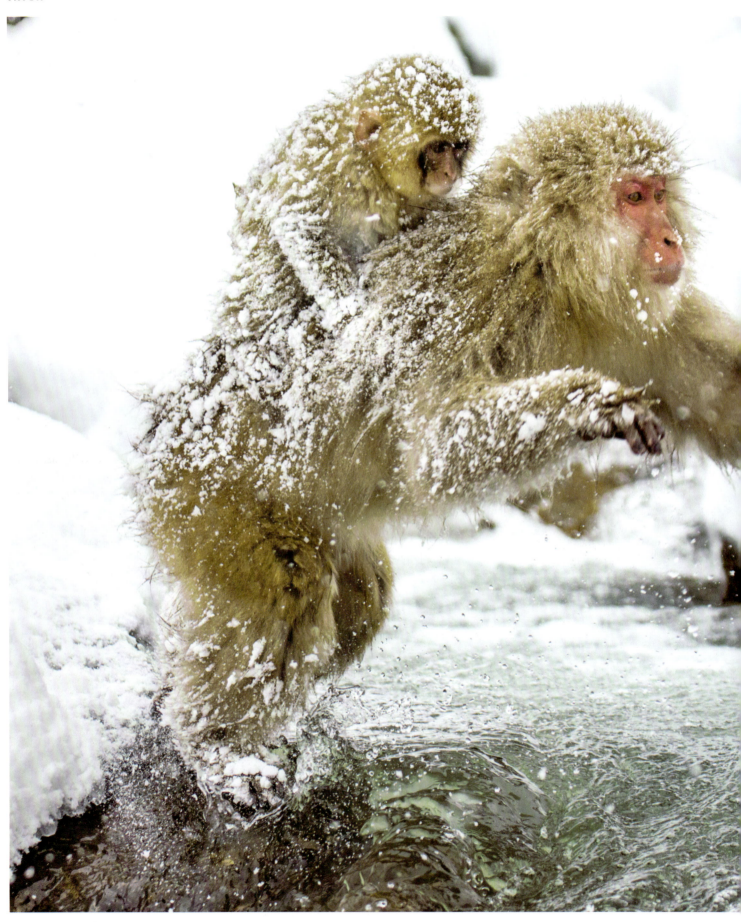

LEFT:
JAPANESE MACAQUE
These monkeys are the most northerly non-human primate species. There are populations living in the conifer forests of Hokkaido. Most will migrate to the south when the winter snows arrive, but small groups have learned to sit out the cold winter in warm, volcanic springs.

BELOW:
SIBERIA
This vast region of eastern Russia is mostly covered in forest. The area is generally divided into the east and west taiga, which are separated by the Yenisey River.

cells. At the same time, sugar stored in the main body of the tree is pushed into the needles to make the water there more concentrated. Just as adding salt to a road will stop ice developing there, so too does adding sugar. It reduces the freezing point of the contents of the needle.

BIGGER PICTURE

With their much-reduced surface area, an individual needle is much less effective at capturing solar energy and turning it into the sugars that power plant growth. However, the needles are arrayed in fans and sprays that approximate the shapes of a broadleaf. Additionally, the needles are more concentrated on the south side of the tree since that is where nearly all the light is coming from. (Nevertheless, some rays are scattered through the high atmosphere and arrive from the north.)

Once the needles are in place, a tree will typically hold on to them for several years, before they are dropped and new ones grow. This process of replacement is a continual one so there is no actual loss of leaf cover throughout the year. The needle leaves have an important role to play in winter as well as summer.

When picturing the typical conifer tree, one might think of a spruce, which has the archetypal Christmas tree shape. This has a straight trunk with a scattered spiral of branches poking out in all directions perpendicular to the main stem. These primary branches then divide several times in the same horizontal plane. The result is a broad, flat section of branches tipped with needles. Together these branches form layers, one on top of the other. The lower, older layers grow out wider to get out from underneath the ones higher up. The overall result is

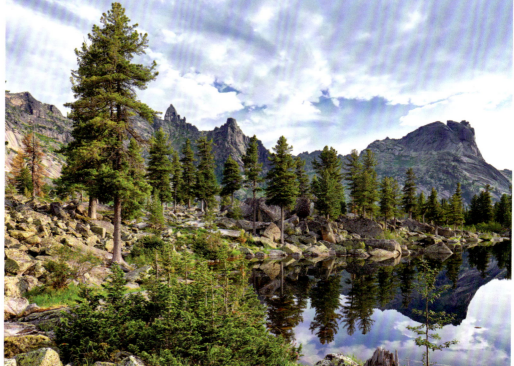

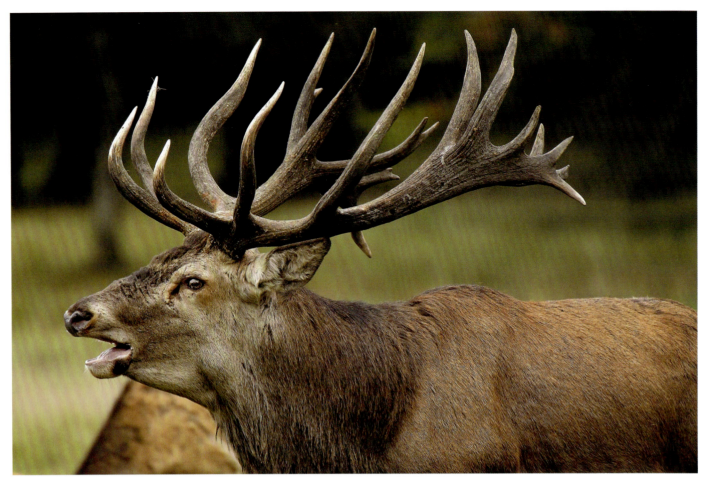

ABOVE:
RUTTING SEASON
This red deer stag is bellowing to make his presence felt. His antlers have shed their coating of velvet, which is a highly vascularized skin with a fuzz of short hairs. Now only bone core of the antlers is left, ready for use in fights over mates. The breeding, or rutting season, happens in autumn, with the calves born in spring. Once the fighting is over, the stag's antlers fall off. A new pair starts to grow in late winter.

RIGHT:
GREAT HORNED OWL
Also known as the hoot owl, this big bird is a widespread species. As well as living in the boreal forest of North America, it is also found throughout warmer regions and spreads down into South America where it lives widely east of the Andes apart from the Amazon Basin.

the cone-shaped tree, which has a distinct pattern of horizontal layers with gaps in between. That shape is not there to make it easy to draw. Instead it creates a flexible structure than can hold the not inconsiderable weight of snow. Additionally the layers will flex under the weight of a slab of snow, so it slides off the end, perhaps cascading down successive layers until reaching the ground around the edge of tree. What the snow does not do is sieve through the branches and build up underneath it. Few other conifers have quite the orderly look of a spruce, but they deploy the layered branch approach to make sure snow does not build up on the branches in damaging amounts and also falls away from the tree, not through it.

BENEATH THE PINES

In the southern zone of the taiga, the forest is said to be closed, in that the trees cluster close enough to form a near complete canopy. Little light penetrates through the trees and the forest floor is very dark. The fallen needles form a blanket, and their protective chemicals mean they are slow to decay. Few plants can grow in these conditions. Nevertheless, some hardy shrubs do make their home here, such as starflowers and cowberries. Mosses and lichens dominate in the gloomiest and dampest places. A lichen can look decidedly non-living. It is a crust, often colourful with some texture, that is composed of a fungal body that harbours symbiotic algae. The algae provide food to the fungus in exchange for a place to live. Some lichens have more elaborate branching structures that resemble plants. In the soils there are many fungi that live in close association with the trees, forming mycorrhizae. The plants and fungi share resources, helping each other collect the nutrients they both need.

Along the northern fringe of the taiga, where it gives way to the tundra, the trees are small and more sparse. The hardy taiga shrubs, moss and lichen fill the gaps. Gaps in the tundra also appear where meltwater tends to pool in summer. This creates a waterlogged marshland that is too wet for trees. Instead mosses, such as sphagnum, proliferate here.

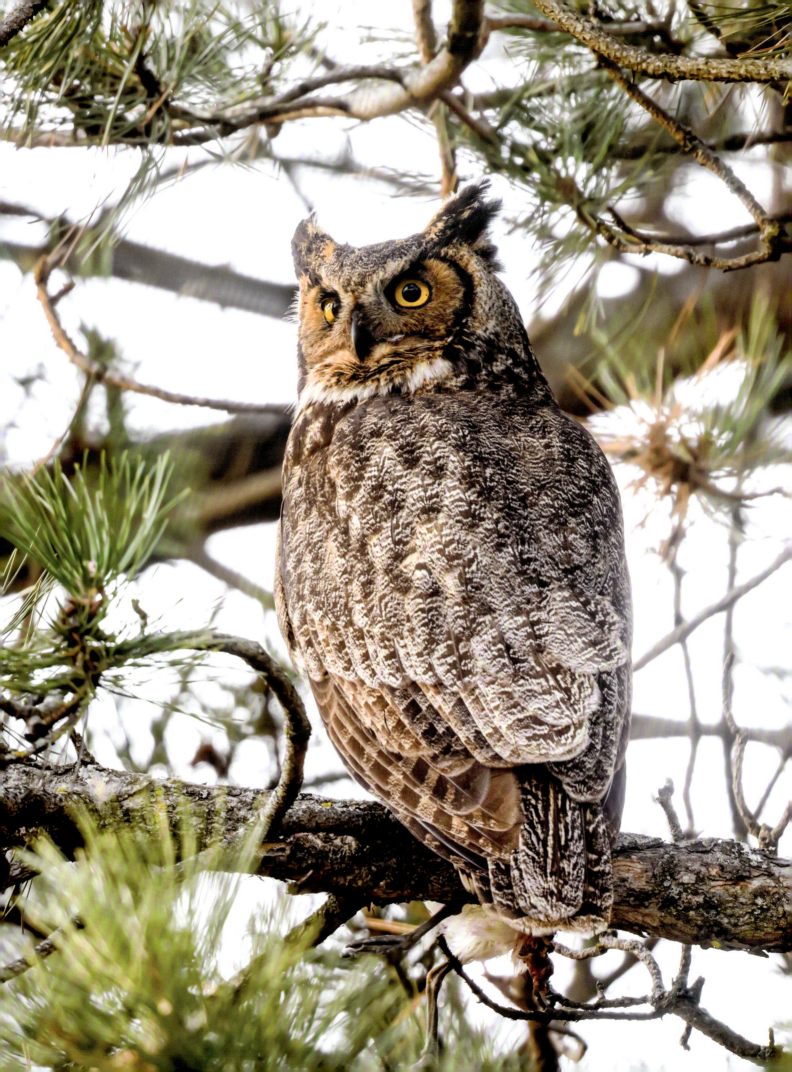

TAIGA

ABOVE TOP:
EURASIAN GOSHAWK
This medium-sized raptor is coming in to land. It is a daytime hunter that is more common in dense forests. It is mostly associated with taiga habitats of Eurasia but also lives in temperate forest and mountainous regions.

ABOVE BOTTOM:
BANK VOLE
This is a small European rodent that searches day and night for leaves, roots and nuts. It is a good climber but lives in a burrow in the ground, where it hoards a store of food.

RIGHT:
WOOD BISON WITH CALF
This subspecies of American bison, mostly associated with the prairies, lives in the forest region of Canada and Alaska.

TAIGA

BELOW:
BOG BILBERRY
These ripe berries are produced in later summer and are a useful food source for birds and mammals fattening up for the long winter.

ABOVE:
WHITE SPRUCE
This conifer is found widely across North America. The needles are four-sided, forming a diamond cross-section.

RIGHT:
HUSKY SLEDGE TEAM
This husky sledge team is running on a clear night with the northern lights, or aurora borealis, visible. The Siberian dog was bred to work in teams and haul sledges over the snow in winter.

FOREST ANIMALS

The plant foods provided by the taiga forest include seeds, berries, lush mosses, lichens and various mushrooms. In times of food scarcity in the winter, animals will resort to eating the needles and even the bark from the trees. This explains how the food supply in the taiga reduces rapidly and considerably in winter. All taiga animals have a strategy to cope with this. They either hibernate or become dormant in some other way, or migrate to somewhere warmer. There are, however, a few creatures that can do neither.

These differences can be illustrated by looking at some of the larger taiga animals, which are, in fact, also the largest of their kind found anywhere. The first is the grizzly bear, a subspecies of brown bear that lives in the boreal forests of northern Canada. It gets its name from its grizzled coat, which means the long guard hairs that form the outer later of fur are tipped with a silver grey, while the shafts retain their brown. Grizzlies vie for the position of top mammal land predator along with their cousins the polar bears. The two species are

ABOVE:
SABLE
This relative of the weasel lives in the Asian taiga. It hunts in trees and on the ground. Its long flexible body and short legs make it very sure-footed.

very closely related and readily form hybrids if they meet along the forest–tundra boundaries. As well as the difference in coat colour, the polar bear has a flatter face and smaller ears. These features give it that extra edge in withstanding the extremes of cold. There is a further subspecies of brown bear, the Kodiak bear, which lives in the forests of Kodiak Island, Alaska, and which is the official largest mammal predator. The males are 2.4m (8ft) long and weigh 0.75 tonnes. Their back feet are nearly 50cm (19in) wide.

WINTER SLEEPS

Brown bears are omnivores and forage on the berries, mushrooms and carcasses of other forest creatures. They also like to catch fish in the rivers during a salmon run and will hunt down and kill deer or wild boar. As this food source is more or less gone by the time the winter comes, the bear will prepare for a long, lonely winter by fattening up in autumn, adding about an extra third to its weight. Then it will find a secluded den, often high up a slope, under a tree or in a cave, and sleep through the winter. This strategy is often characterized as hibernation, but the term winter sleep is more appropriate for brown bears. During a hibernation the body enters a deep, dormant state in which metabolism slows considerably. Breathing and heart rate plummet, and the animal does not feed, urinate or defecate. While bears sleep a lot and enter a state of deep relaxation for days on end, they do stir

RIGHT:
WAPITI
A deer second only in size to the moose, the wapiti – also known as an elk – lives in small herds. The species is found in East Asia and North America.

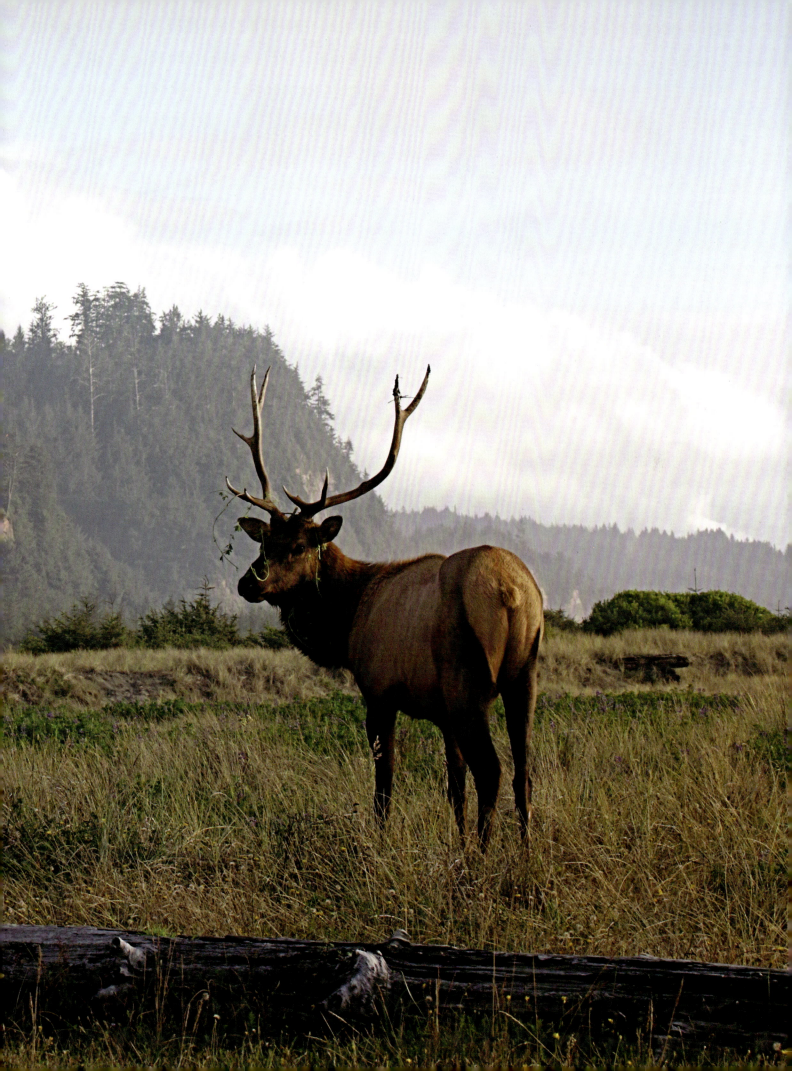

TAIGA

ABOVE LEFT:
EUROPEAN MINK
Peering over the trunk of a tree, this cheeky little hunter is known for its luxurious fur. The species is now highly endangered due to the introduction of the larger and faster-growing American mink, which was brought to Europe as stock for fur farms, but promptly escaped into the wild.

ABOVE RIGHT:
LOGANBERRY
This is a hybrid between the blackberry and raspberry. It is believed to be a wild cross but it was also created by accident by the American amateur botanist James Harvey Logan for whom the berries are named.

RIGHT:
RAVEN
This large relative of the common crow favours rugged forested areas. It has a wingspan of 150cm (5ft). The birds live across the Northern Hemisphere and these omnivores use a surprisingly high intelligence to get at all kinds of foods.

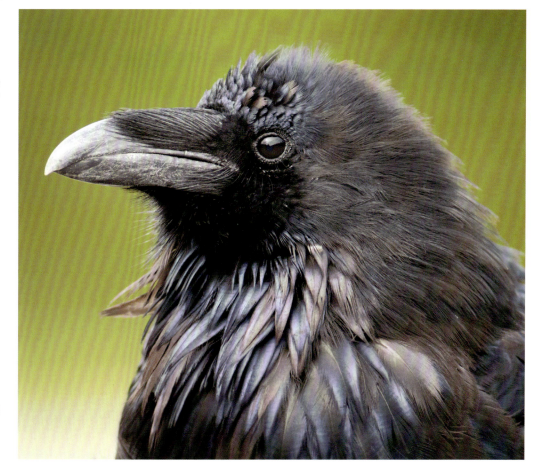

LEFT:
ORANGE BIRCH BOLETE
This chunky mushroom is the fruiting body of a hidden mycorrhizal fungus that is permeating the soil. The cap can grow to 15cm (6in) wide when it appears in autumn.

occasionally to perform bodily functions and may take a stroll during periods of good winter weather.

By contrast, some taiga animals are out for the count once winter comes. Good examples of hibernating mammals are marmots, or ground squirrels, which withdraw underground for the majority of the year. (The tree squirrels hunker down in their dreys during cold snaps but are still active all year round.)

There are reptiles that live this far north, most notably the adder. These forest vipers are darker in tone than their cousins living to the south, so they can absorb as much summer heat as possible. Before winter comes, the snakes take up lodgings in deep burrows and become dormant for several months. Their ectothermic nature (or so-called cold-bloodedness) means they do not expend energy on maintaining an internal body heat and so their bodies are highly efficient. Fasting all winter is not a tall order for such a creature.

The wood frog and other amphibians are able to do well in summer, feasting on the insects that live among the deep litter of needles and dead cones on the forest floor and the temporary ponds and marshes that form in the forest. However, amphibians have thin skin that offers little protection from the elements. The forest, all its rivers and much of its soil layer, too,

RIGHT:
SIBERIAN WEASEL
Known locally as the kolonok, this little reddish hunter is active across most of the Asian taiga. It is little more than 30cm (12in) long. The weasels hunt along and mark their territories with scents.

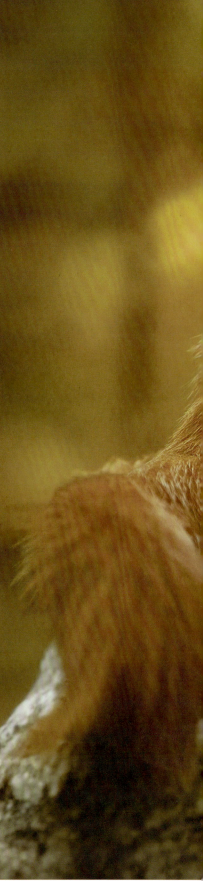

BELOW:
LINGONBERRY
These red berries are glistening with autumn rain. The lingonberry shrub grows low to the ground and is a valued source of food for bears, foxes and birds as winter approaches.

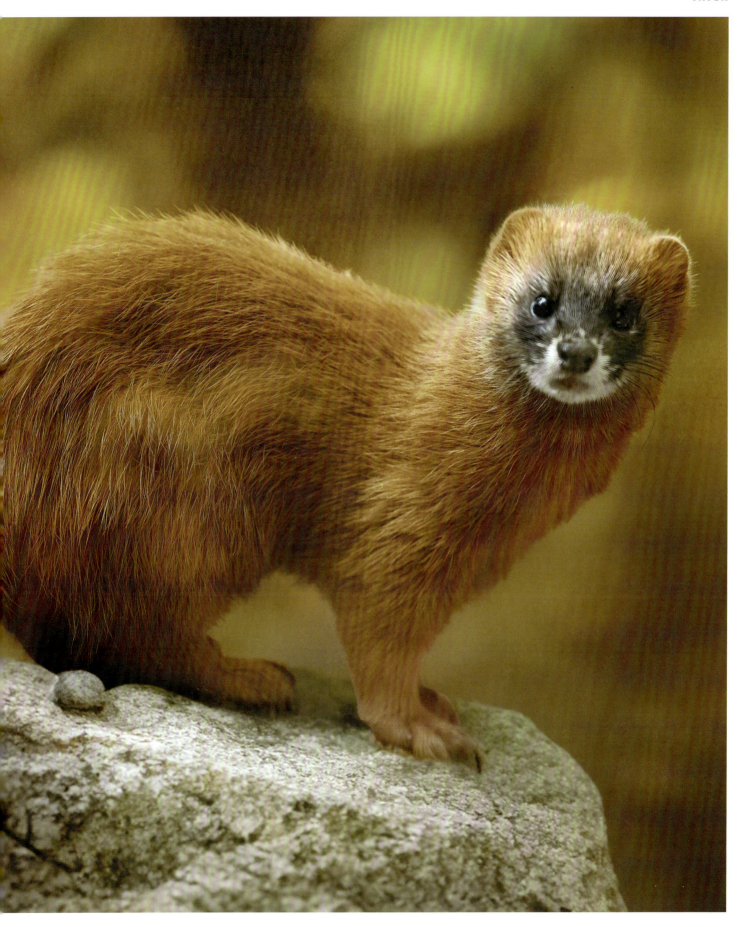

TAIGA

ABOVE:
SCOTS PINE
This European species of conifer has a blue-green tinge to the needles. These young cones will appear red in their early stage and then darken to a pale brown.

is about to freeze solid, but the wood frog is able to stay alive in its burrow in a river bank nevertheless. It does so by pumping urea, a metabolic toxin, into its organs as it becomes dormant for winter. The chemical acts as an antifreeze, so as the ground around it ices up the frog can fend off freezing.

ACTIVE ALL YEAR

The second giant animal that illustrates animal life in the taiga is the moose. This is one of the more familiar forest animals, although it the subject of some confusion. The moose is by far the largest deer species. It can stand 2m (7ft) to the shoulder and easily be 0.5 tonnes, and some bulls are double that. The males have distinctively wide antlers that are different to the spines more typical of red deer and others. Nevertheless, there is sometimes uncertainty over what a moose actually is.

RIGHT:
ARCTIC TREELINE
At the northern edge of the forest, such as here in Finnish Lapland, the conditions become incompatible with tree growth. Only a few hardy species can cling on. They grow very slowly and are twisted against the wind.

BELOW:
SITKA BLACK-TAILED DEER
This is a subspecies of the more widespread mule deer. They live in the coastal conifer forests of Alaska and British Columbia. The reddish summer coat creates camouflage in the forest in summer and autumn but darkens to a grey-brown for the winter.

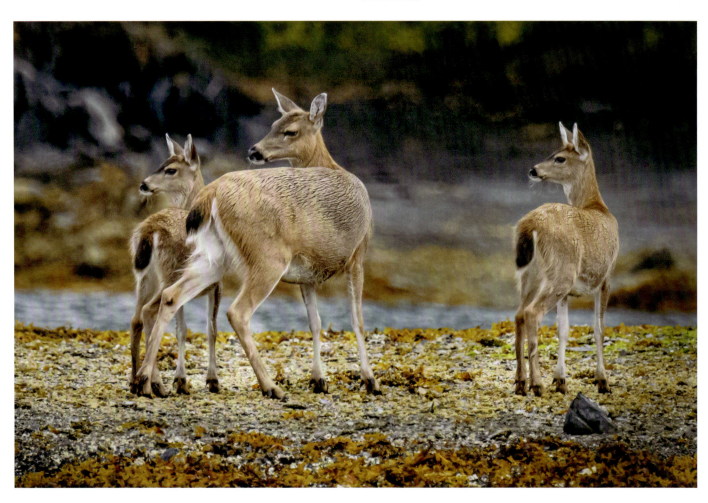

ABOVE:
LYNX
The lynx is the largest cat in many parts of the taiga. This is the Eurasian species, which is about 130cm (50in) long, a little larger than the Canada lynx. The latter species is able to live further north than the cougar, or puma, which is larger still but less common in the taiga.

BELOW:
WOLF LICHEN
This yellow-green lichen thrives on conifers. It is only present in areas with good air quality. The sickly green colour is a warning that it contains a nasty acidic compound. Lichen has been used traditionally as a poison for controlling wild wolf populations.

The species lives across the whole of the taiga, from Alaska to Kamchatka in far eastern Russia. However, whereas the American deer is called a moose, the English term for the moose in Eurasia is elk. Perhaps it would be easy enough to use both synonyms, if it were not for the term elk being used for another American deer, which is also called the wapiti. For a long time the wapiti (elk) was thought to be the American subspecies of the red deer, which is a large European species (and the archetypal highland stag). The red deer is found in the taiga but the species are more associated with temperate forests. The wapiti is now classified as a separate species to the red deer, and in fact most of the red deer in eastern Asia are now thought to be wapiti. Like its redder cousin, they are found in the taiga, but have a stronger link to mountain forests.

OPPOSITE TOP:
MILES CANYON
This picturesque forest is in northern Canada. It is autumn here as the stands of quaking aspen are turning gold, while the evergreen conifers keep their colours into the winter.

OPPOSITE BOTTOM:
GRIZZLY BEAR
The dominant brown bear subspecies in the North American taiga, the grizzly bear moves large distances through the forest each summer to find foods. This one has come to a pool in the forest of British Columbia. Fish are an important part of the grizzly's diet along with carrion and fruits.

TAIGA

TAIGA

LEFT:
KNIGHT'S PLUME MOSS
This is an actual moss, not a misnamed lichen, that grows on the forest floor of the taiga. It absorbs the moisture it needs from the damp air. This and other mosses are crucial in constantly renewing forest soil.

RIGHT:
BULL MOOSE
This big male moose still has velvet on its fresh set of antlers. This is the largest deer species in the world.

BELOW:
WOLVERINE
This dog-like creature is actually the largest member of the weasel family and is a stubborn and tenacious predator. In summer it focuses on smaller prey, such as hares and rodents. In winter it turns its attention to larger forest animals, even deer, that struggle to escape from it through the deep snows.

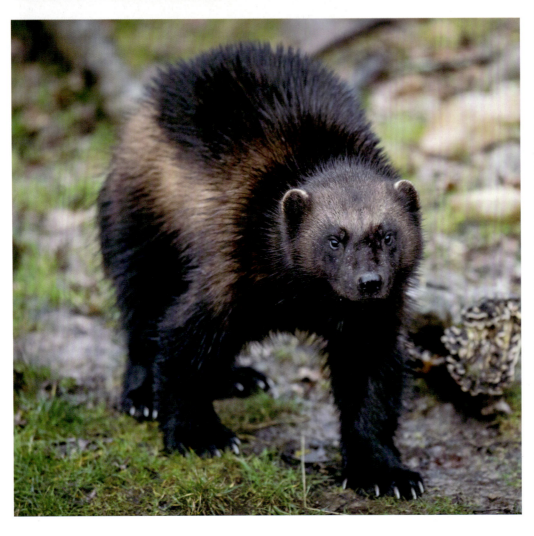

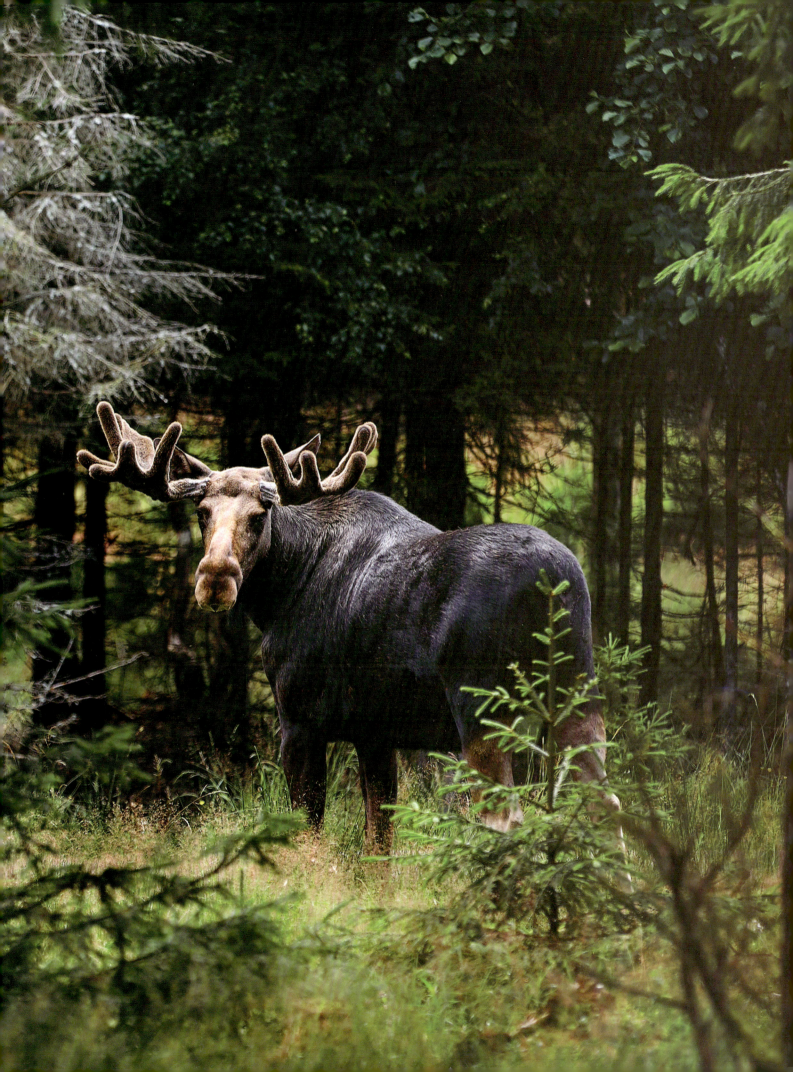

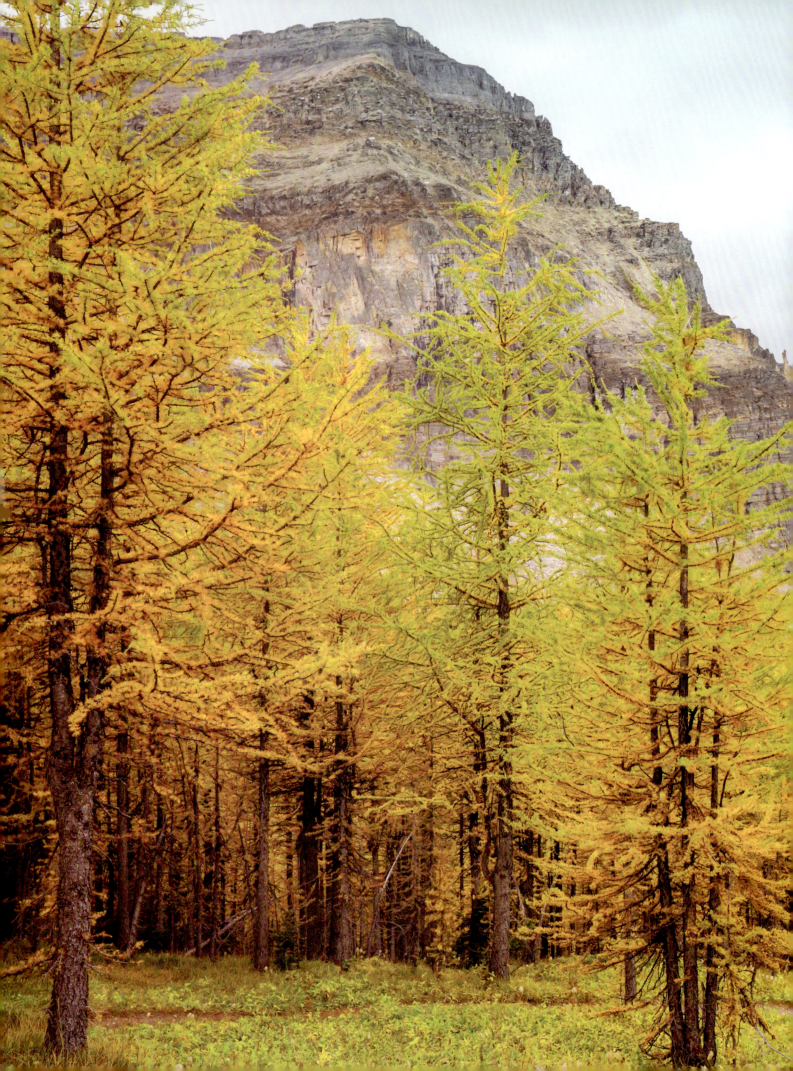

TAIGA

LEFT:
GOLDEN LARCH
Despite the name, these trees are not true larches. They are an east Asian species that is an unusual deciduous conifer. In autumn, the needles turn golden and fall off.

BELOW:
RED CROSSBILL
This songbird is named for the way its hooked beak does not meet at the tips. Instead they slide past each other like a pair of shears, all the better for cutting into cones to access seeds. This is a male; the females are more green.

The moose is well suited to life in the extreme north. In common with all giant creatures, its large body affords it a degree of efficiency. In summer, the deer browses on shrubs and lush vegetation around marshland. (It is known to wallow in water when summer temperatures get high.) The plant food is not sufficient for a large herbivore to pack on the body weight to sustain a winter sleep. The moose has no choice to but to keep foraging in winter. It is sustained by needles, twigs and lichens.

Moose and other deer are some of the very few creatures that stay on the move in the winter. They are a target of wolf packs and other predators like bobcats and lynx. The winter is a tough time for all of creatures, except that is the wolverine. Known as the glutton in Eurasia, the wolverine looks like a fluffy dog but it is in fact the largest member of the weasel family (and a distant relative of the badger). The wolverine has a broad stance and wide feet that act like snowshoes. This gives it a crucial advantage over both the sleek cats and dogs and the long-legged deer. These animals find it hard – exhausting in fact – to cross deep snow. While a wolf pack might give up chasing a moose when confronted with snow drifts, a wolverine need not. The small but tough predator – no bigger than a spaniel dog – can move across deep snow easily and attack a deer many times larger that has become trapped there.

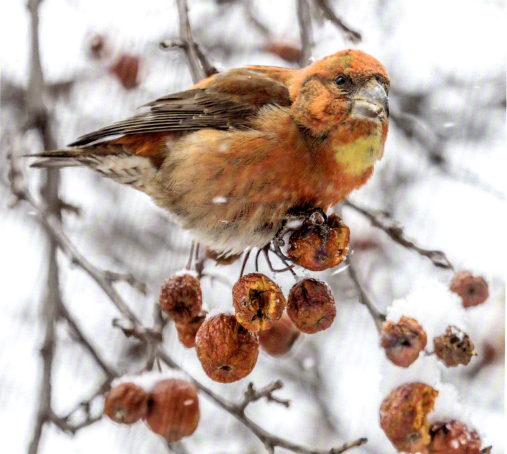

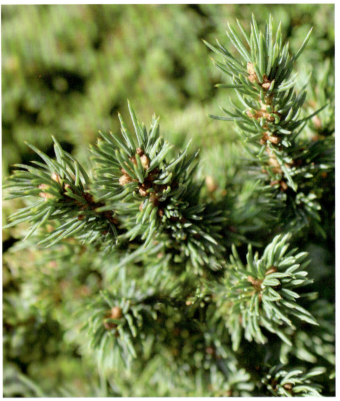

ABOVE:
WHITE SPRUCE
This American tree has the classic cone shape of a Christmas tree. It has many branches covered with short blueish needles. It is frost resistant and so more common in the northern fringes of the Canadian taiga.

BELOW:
RED-SIDE GARTER SNAKES
In winter, these snakes will slither into deep dens to avoid the intolerable icy temperatures. They will often share their hibernation spots with thousands of others gathering in the same spot. Once they stir in spring, the males start to search for mates among the throng.

VISITORS TO THE TAIGA

As is to be expected, when the taiga surges back into life in the summer, it offers feeding and breeding resources. Insects that have sat out the winter as eggs or perhaps dormant larvae, race to complete their life cycle. The forest is abuzz with biting gnats, which pupate in the seasonal ponds of meltwater and then feast on pollen and blood, and beetles that attack bark and wood, along with many other types. This irruption of insects attracts songbirds, who have migrated up from the south to nest and feed their chicks on all those bugs. The seeds being produced by the trees by the cone full are attracting a host of other birds, which shift north in summer following the wave of development that tracks the warming weather. In winter, these avian migrants may fly far away, or retreat to the warmer parts of the forest to the south, where the taiga merges into deciduous forest.

However, there is another migrant that arrives in the taiga from the north as winter approaches. This is the reindeer, or caribou as they are known in North America. These animals have spent the summer out on the tundra in vast herds, and now are fragmenting into bands that seek the cold comfort of the frozen forest in winter. The next chapter sets out the habitat and conditions of what they are leaving behind: the tundra.

RIGHT:
FISHER
Another member of the marten family, this fierce-looking hunter is not much of a fish eater at all. Instead it clambers through the trees looking for mammals to attack. It a primary predator of the American porcupine.

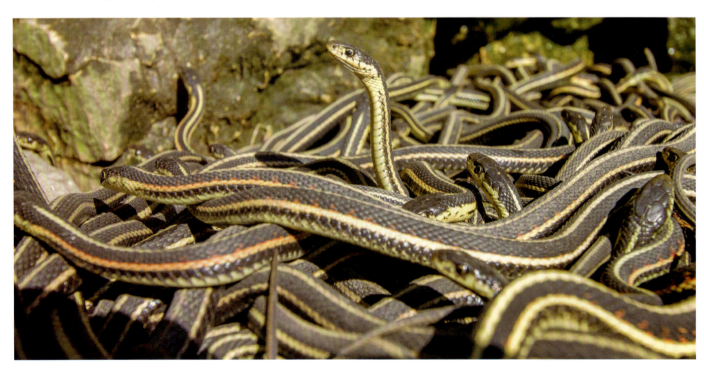

TAIGA

BIG BEAR
In the fading light of autumn, this grizzly bear is in a race against time to get enough to eat before it must withdraw for its winter sleep. At this time of year the rivers of the taiga are filled with spawning fish, most of which will die after mating and wash up on the banks. As a result this bear looks set for a good winter.

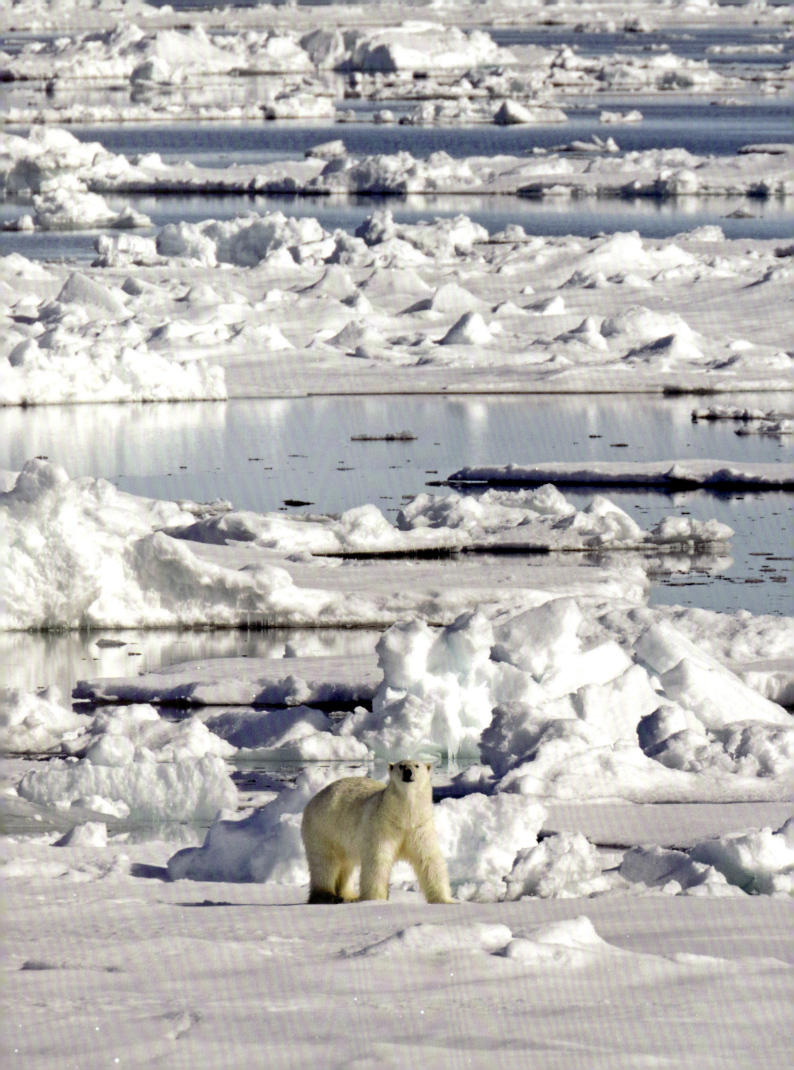

FROZEN LANDS

The conditions inside the polar circles are almost incompatible with life. The tilt of Earth's axis ensures that the winters here are very dark indeed, and while the converse is true in summer, what sunlight does arrive is too thin to deliver much thermal energy. As a result the seas and the land are extremely cold, often too cold for anything to live. However, around the edges, life has found a way to survive even here.

POLES OF COLD

The coldest temperature ever recorded is –89°C (–128°F) at Vostok Station in Antarctica. This location is now known as the Southern Pole of Cold, indicating it is the extreme cold point in the Southern Hemisphere (and the world). The Northern Pole of Cold is Oymyakon, a fur trading outpost in eastern Siberia. It can drop to –71°C (–97°F) here. This is a few degrees warmer than the record lows around the North Pole. The reasons for a place located just inside the Arctic Circle being consistently colder than the North Pole hundreds of miles further north are twofold. First, the local geography sees the cold air funnelling into Oymyakon between two mountain ridges, and this makes the climate colder than the surroundings. The second reason is due to how the polar regions of Earth are geographical opposites. The Antarctic is a land mass (actually two hidden under the deep ice) surrounded by ocean. The Arctic is an ocean, frozen for part of the year, surrounded by land masses.

OPPOSITE:
ON ICE
This polar bear is off the coast of Spitsbergen in Norway. The polar bear is in fact an ocean animal. The distinction is that it lives on the ice floes of a frozen ocean.

RIGHT:
ARCTIC TERN CHICK
A tiny chick sits in the tundra near the Barents Sea in northern Russia. The tern has the longest migration of any animal. The parents have migrated the length of the globe from Antarctica to meet here in the northern summer and breed. They and their fledgling will head back south as the Arctic winter arrives. In total they travel 70,000km (43,500 miles) a year.

FROZEN LANDS

Land is a heat sponge and warms up rapidly, but it also allows the heat to radiate away back to the heat sink of the atmosphere. Water as a material has a much higher heat capacity. This means for water to increase in temperature by the same amount as land, it needs to receive a larger quantity of energy. As a result oceans warm up very slowly compared to land but what heat they do receive they hang on to. This is why the Poles of Cold are on land. In the case of Antarctica that is in the heart of the southern continent, far from the warming effect of the ocean and not too far from the geographic South Pole itself. The Northern Pole of Cold also occupies a place far from the ocean, and due to to the geography of the Arctic that is far inland of Earth's largest land mass and also far from the geographic North Pole.

ARCTIC TUNDRA

This physics and geography lesson has profound effects on the biomes that occupy the polar regions. Beyond the northern fringe of the taiga, the Arctic land gives way to a habitat known

ABOVE:
CINQUEFOIL
A frost fringes the yellow flowers of this hardy perennial. The plant can reproduce without needing flowers to make seeds. Instead it sprouts from runners extending from the root network.

BELOW:
HOWLING WOLF
This tundra wolf is letting its pack mates know where it is. The howl will be heard far and wide. The wolves from the Arctic region have white fur so they are less visible in winter, and the hairs are thick enough to keep the animal warm even as it sleeps in the snow.

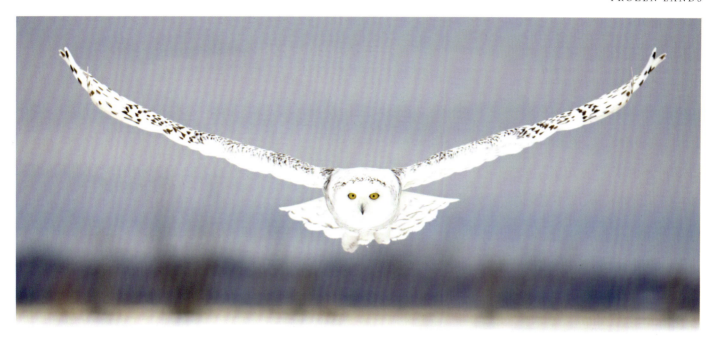

ABOVE:
SNOWY OWL
Having spent the winter in the taiga to the south, this owl has taken to the tundra in summer to hunt for lemmings and other small animals. It travels widely to find food and is actively hunting by day and night.

BELOW:
EMPEROR PENGUINS
A breeding colony of emperor penguins on the sea ice at Prydz Bay in East Antarctica. These tall seabirds are famous as the only animals that live in Antarctica over the dark winter.

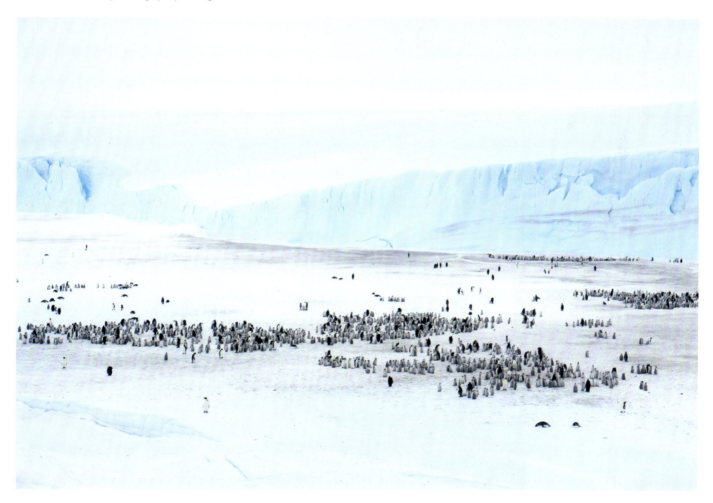

FROZEN LANDS

ADÉLIE PENGUINS
A group of penguins head out to sea to hunt. This medium-sized penguin is one of the most abundant species. One of its great advantages is that it can live and even breed on icebergs and has no need to find land to rest.

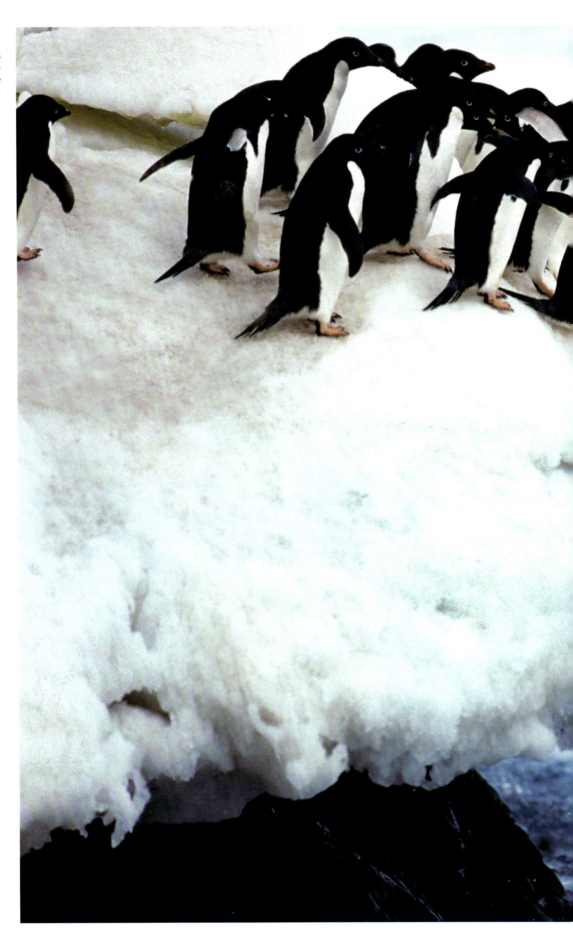

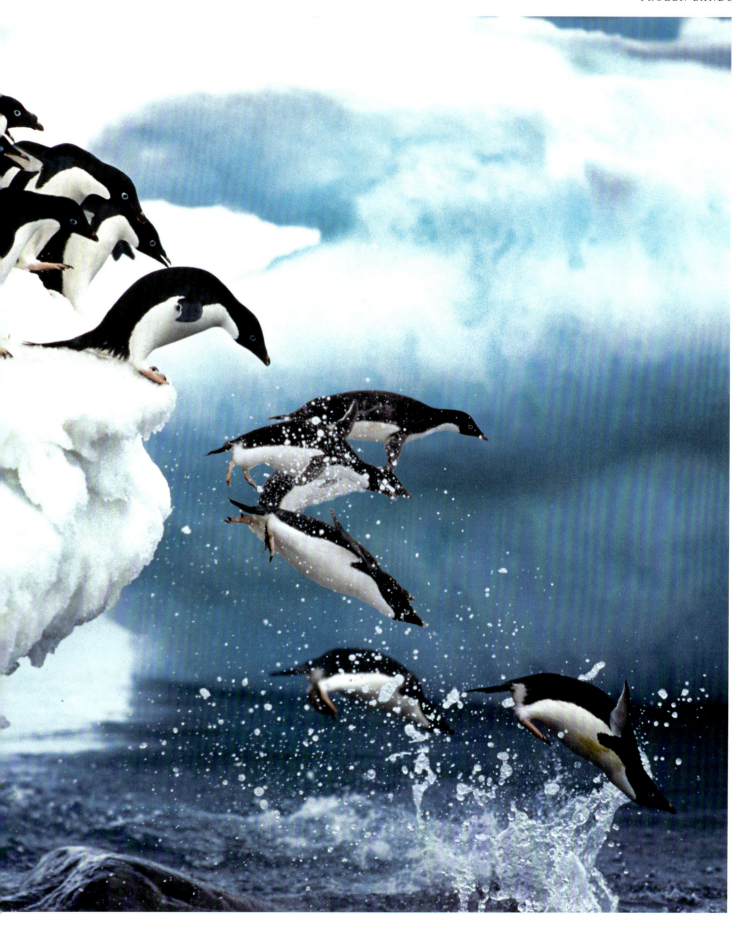

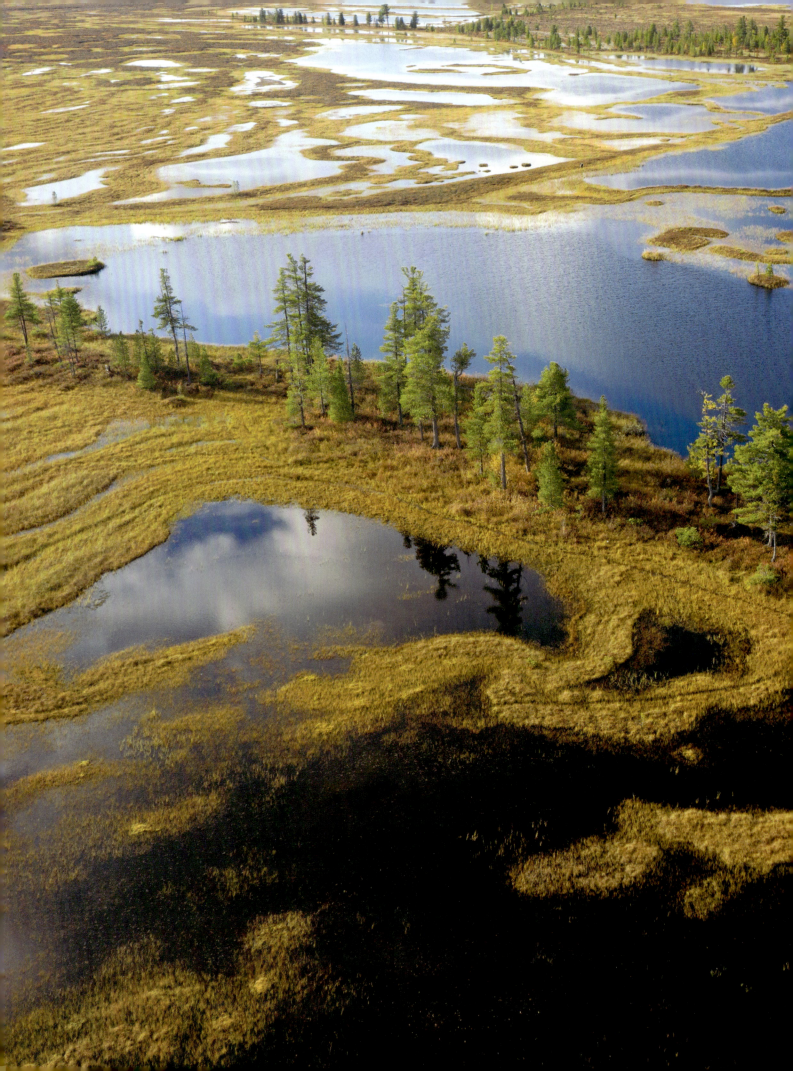

LEFT:
SUMMER MARSHLAND
The tundra of northwestern Siberia has become a marshland in summer as the surface layer of snow and ice melts into shallow pools.

BELOW:
GYRFALCON
This Arctic raptor is the largest falcon species of all. It has a wingspan of 1.5m (60in) and the feathers need frequent attention. The plumage turns white in the winter to help the bird stay out of sight as it hunts for rodents. In summer it preys on migratory birds.

as the tundra. This name means 'treeless plain' in Finnish, and the Finns have nailed the description. The tundra is barren lowland, where the wind whistles across the empty landscape, unencumbered by trees or any obstacle larger than a small shrub or thicket of grass. In winter the tundra is covered in a thick blanket of snow. In summer, the snows melt for a few short weeks as the temperatures soar from a persistent sub-zero to 20–30°C (68–86°F). The tundra is transformed into a land of fast growing mosses, sedge and grass speckled with glittering ponds and swamps. Despite the name, there actually are a few trees, or at least tree species, such as willows. On the tundra a willow tree can only grow to a few centimetres tall.

The place bursts with life as billions of insect eggs, which have lain dormant through the frozen months, hatch out and race through their life cycles. Flowers bloom within days of the thaw and are pollinated by the crowds of insects loading up on the freely provided nectar. Mosquitos and gnats are in search of a blood meal to energize their egg production. After the emptiness of the winter, there are now many large animals out on the tundra. They include vast herds of reindeer that have emerged from the taiga to spend the summer roaming the open lands. They had retreated to the forest to get out of the biting cold winds on the tundra. They are eager to get back to the tundra where the melting snows reveal grasses, herbs and small perrenial shrubs for them to graze on.

The reindeer (caribou in North America) will give birth to their calves out here in early summer. The tundra is relatively safe from predators at this time. They are mostly busy elsewhere.

FROZEN LANDS

RIGHT:
MUSKOX
An immense muskox and its offspring stand on high ground in the Norwegian Arctic. When the winter comes, they will congregate up here again, where the snow is thinner and easier to dig to get at grass beneath.

OPPOSITE:
HARP SEAL PUP
This baby seal is only a fortnight old. Its mother fed it a thick, fatty milk for 12 days before being forced to return to the ocean to hunt. The seal is left alone to complete its development, burning through its fat supplies for energy. It cannot defend itself but stays very still and relies on its snow-white fur to avoid detection.

BELOW:
SNOW GENTIAN
This little flower, only a few centimetres high, brings bright colours to the tundra each year.

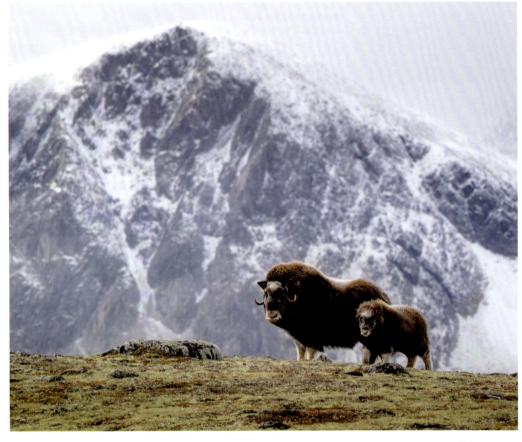

OPPOSITE:
STELLER'S SEA EAGLE
Steller's sea eagle is one of the largest eagles in the world with a wingspan of up to 2.5m (8ft). It lives around the coasts of the far northern Pacific between Alaska and Siberia and into the Arctic Ocean. It hunts for fish and seabirds using huge talons to snatch them from the water..

BELOW:
BROWN LEMMING
This is a Canadian species, but there are similar ones across the tundra of Scandinavia, Alaska and Siberia. Popular myth holds that these creatures throw themselves off cliffs but this is fanciful. The lemmings will leave overpopulated areas and may try to climb down slopes.

ABOVE:
MIDGES
The still, oxygen-rich pools that form on the tundra are a perfect breeding ground for midges and other swarming flies, many of which will bite. The eggs are laid on or in the water and hatch into maggots that breath air through snorkel-like tubes on the rear end.

The calves will grow strong throughout the summer, and the adults will breed again as the freezing weather returns in autumn. The bulls will expend all their spare energy sparring over mates. The females will be pregnant through the winter back in the forest.

A HUNTER ARRIVES

The main large predator on the tundra is the wolf, itself a summer migrant visiting from the taiga. The packs are not able to outrun the reindeer but they can doggedly chase a target for hours, days even as their intended victim seeks a refuge somewhere out on the endless wilderness. The wolf is the most widespread predator on Earth. As well as being top dog in the Arctic, it was once common all through the prairies as far south as Mexico. It also once lived in the forests and steppes across Europe and northern Asia, but is much less common there today. The wolf's success, now thwarted by humans who have purposefully eradicated wolves from most of their range, is due to the dog body plan, which puts a large engine of heart and lungs into a sleek and agile frame. A wolf – the wild ancestor of all pet dogs, remember – is able to trot along on its springy legs all day, every day.

Either hunting along or with a pack, a wolf's tactic is to not use speed and muscle to catch and kill like a big cat would.

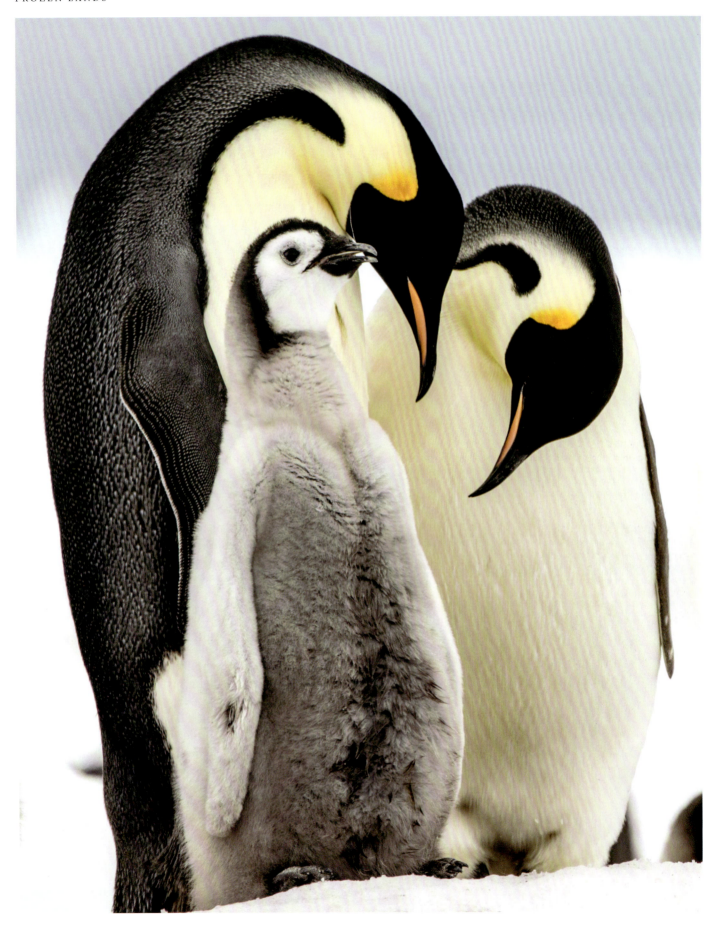

Instead it intends to exhaust its opponent, never letting it rest, relax and feed. A pack can take on a reindeer many times the size of one wolf. As the big deer tires, the dogs take it in turns to dash in and take a bite. They will aim for whatever spot is safe to target, but concentrate on the rump at first, attacking from behind. As the fight draws to a close, the wolves are brave enough to go for the face, bite the snout and haul the prey to the ground. Once down and out, the wolves will begin to eat their victim even as it lies exhausted but alive. Unlike a pride of lions, however, the wolf pack does not share food. It is up to each member to 'wolf down' as much food as fast as possible. If they delay, one of the other wolves will eat their share.

WINGED INVADERS

The tundra in summer is a mix of wetland and meadowland. While the caribou graze on the pasture, the wetland regions become a haven for birdlife. Hundreds of waterfowl species, such as ducks and geese, plus waders and cranes, fly north for the summer. They come to find a mate – perhaps reunite with one from previous years – build a nest and raise their chicks on a diet of nutritious insects. The chicks must hatch and fledge and get out of there with their parents before the winter arrives.

The arrival of the birds signals a jackpot for small predators on the tundra. These include the Arctic fox and the snowy owls. In summer these hunters target the birds that are seemingly everywhere. The Arctic fox, which has a pale brown coat in summer, also targets the fish that are running up the shallow rivers to breed. The tundra has little night in summer, so the snowy owl is active during the day unlike its relatives. By night, it seeks shelter from the wind, and may huddle in little gangs to keep warm.

When most of the birds fly away again, the fox and owl have a harder job finding foods. They do not hibernate, but instead target lemmings and hares, two hardy herbivores that stay active through the winter. The lemmings rummage through the thickets, eating blades of grass and other vegetation. They are a large kind of vole, but still small enough to be largely unseen among the plants. When winter comes, the life of a vole changes little. The difference is that they are now living under a blanket of snow. The rodents

LEFT:
PENGUIN FAMILY
A male and female emperor penguin pair get reacquainted after spending weeks apart. One hunts at sea while the other guards the chick on the ice. The male covers the dark midwinter shift, with the female returning as the Antarctic sun returns. With each leg of the relay after that, the journey to and from the ocean becomes shorter and easier as the ice melts away in summer.

BELOW:
PACK ICE
The Arctic Ocean freezes in winter and stays frozen for much of the summer. The white ice reflects away much of the sun's heat and light and so resists thawing. Eventually, of course, the pack ice will break up, generally in later summer and early autumn. However, as the climate warms the ice is clearing much sooner in places. This is a problem for seal and bear populations that rely on solid ice for breeding and hunting.

FROZEN LANDS

POLAR BEAR FAMILY
Bear cubs rarely stray far from their mothers in the first two or three years of life. The mothers are very protective of their young and will readily attack anything that comes too close.

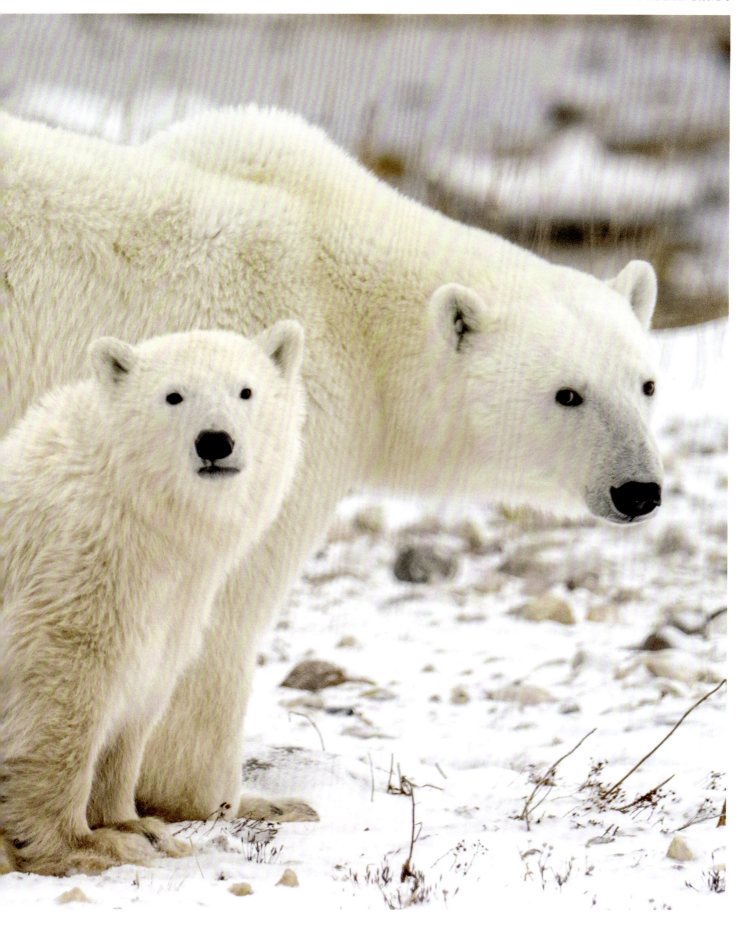

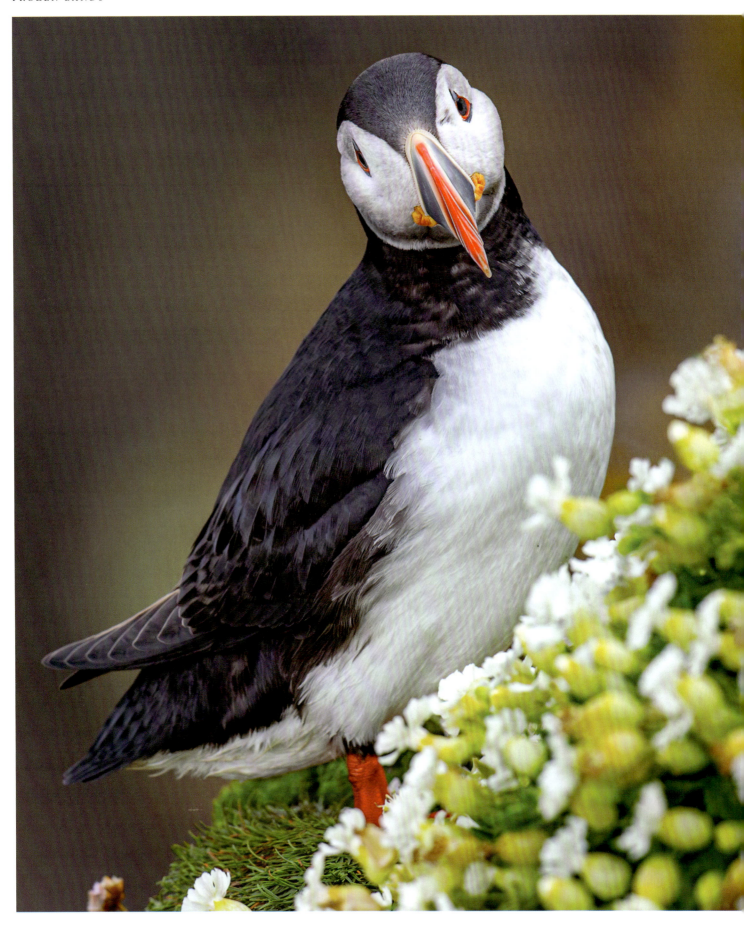

FROZEN LANDS

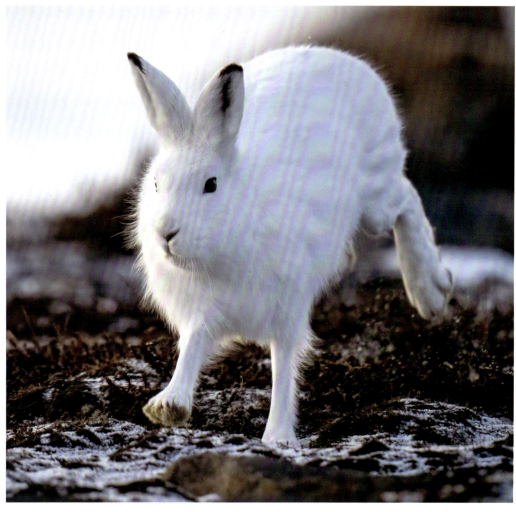

ABOVE:
ARCTIC HARE
Like other hares and rabbits, arctic hares are fast and can bound at speeds of up to 40 miles an hour.

LEFT:
ATLANTIC PUFFIN
These North Atlantic seabirds are famed for the bright colours on their beaks. These are only shown when the birds return to land to nest in deep burrows on the shore. Out at sea, feasting on fish, the birds are more drab.

create a network of tunnels through the snow so they can continue their activities.

The Arctic hare is a typical brown-grey in summer as it nibbles on tundra plants, but in winter its coat turns snow white, all the better for staying hidden from predators. The hare will dig down to get at grasses and other plants in winter. The hares also burrow in the snow to find respite from the cold, or use natural shelters under rocks or earth banks. They need to be sure not to blunder into a fox den when seeking shelter. Underground Arctic fox dens have been carved out over decades, even centuries, as generation after generation of foxes have lived here. The reason why these dens are such important features, is that it is very hard to dig fresh burrows into the tundra soil. This because it is permanently frozen solid – or permafrost.

ACTIVE LAYER

The permafrost is the core feature that gives the tundra its ecological character. At its shallowest, the permafrost penetrates around 1m (3ft) down. At its deepest the freezing conditions reach down 1.5km (1 mile). As well as stopping an Arctic fox or other tundra burrower from digging deep, the permafrost creates a barrier to the growth of deep roots that a tree needs to sustain

itself. This is why only small plants can grow on the tundra. In the spring, the top layer of soil will thaw creating a narrow strip of functional soil called the active layer. This can be up to 30cm (12in) deep in places. That is deep enough for grass and sedge roots, while mosses do not need to put down roots at all. The active layer is also big enough for a ground squirrel to dig a winter den and line it with a thick bed of dried grass, which will insulate it against the ice that will soon surround it.

Despite becoming a vast wetland in summer, the Arctic tundra has one of the lowest rainfalls of any biome. It receives little more than 25cm (10in) of rain a year, mostly in the summer and autumn. That puts it on a par with a desert. The difference is that those 25cm (10in) of rain trickle away through the sand and dust of the desert soil, while on the tundra the permafrost keeps it at the surface. It freezes in winter, but as it melts in spring the

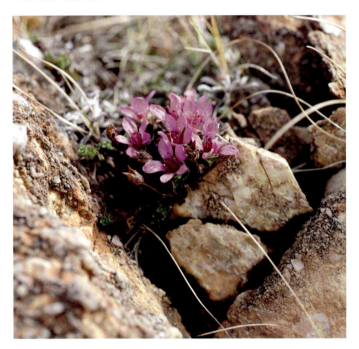

ABOVE:
PURPLE SAXIFRAGE
This resilient perennial is a common feature of the Arctic tundra as well as similarly barren alpine habitats. It prefers to grow in rocky areas and has thick leaves that resist the cold and retain moisture. It is among the first tundra plants to flower.

RIGHT:
CARIBOU
Better known as a reindeer in Europe and Asia, this tundra deer lives in big herds in the summer. As winter hits, the animals grow a thicker fur and head into the taiga to find some shelter.

BELOW:
ARCTIC FOX
One of wildlife's survivors, this Arctic fox has smaller ears, a blunter snout and shorter legs than its more agile cousins. These adaptations, along with the bushy coat and tail, help the animal hold on to its body heat and prevent frostbite. This is an example of Allen's rule that states that animals in colder habitats will have short appendages.

LEFT:
SNOW GOOSE
This snow-white waterfowl migrates from Mexico and the southern United States to the tundra of Arctic Canada and Alaska to breed in summer. The thawed wetlands up there offer excellent feeding grounds as the birds nest and raise chicks.

BELOW:
RINGED SEAL
After a long night hunting under the ice, this adult is having a rest on the floating ice. It makes breathing holes in the ice so it can travel under the frozen sea far from the edge. But when it comes up for air it must be careful that a polar bear is not lying in wait.

ABOVE:
KING PENGUIN
A adult king penguin stands among the fluffy chicks as they wait on the beach at Volunteer Point in the Falkland Islands. The chicks have been on this beach for nearly 18 months. Their parents had to pause their care during the first winter to avoid the cold weather. The chicks simply huddled together for warmth and waited for their parents to return.

BELOW:
GREENLAND ICE SHEET
Here in Greenland meltwater has carved a temporary river valley through the ice. Greenland has one of two of Earth's large ice sheets, or permanent ice, on land. The other is in Antarctica.

liquid water trickles into depressions and forms shallow ponds, which are the nurseries of so many midges, gnats and bugs.

OCEAN PREDATOR

Moving to the north, the average air temperature drops and with it the humidity of the air. The northernmost extent of the Arctic land masses get barely any rain at all, so permafrost or not, the prevailing conditions are barely able support a few hardy lichens. Animal life is equally as scant. That is unless a visitor from the ocean comes to call. The polar bear is in effect an ocean-going bear. It spends most of its waking days out on the Arctic sea ice, sniffing out the seals that are swimming underneath.

The sea ice grows in area in winter and shrinks through the summer. By August and September, the coverage is reaching its minimum size, and this pushes the polar bear in to the tundra. It is preparing to hibernate and will consider eating anything alive or dead.

At this time of year, the bears are likely to find the reindeer are heading away from them towards the taiga. The only large animal left on the tundra will be herds of muskoxen. Despite the name, these sturdy herbivores are in fact more closely related to sheep and goats than cattle. The muskox has a layer of fat beneath the thick woolly fur so they can survive out in the open during the polar winter. They will head for high windswept areas, where the snow is thinned out by the

ABOVE:
SNARES PENGUINS
These rare penguins are found only on the Snares Islands, a group off the southern coast of New Zealand. They are a type of crested penguin.

RIGHT:
KING EIDER
This sea duck lives along the Arctic coast, and is especially common in North America. The eiders are famed for their thick and fluffy down, which is second to none as a natural insulator.

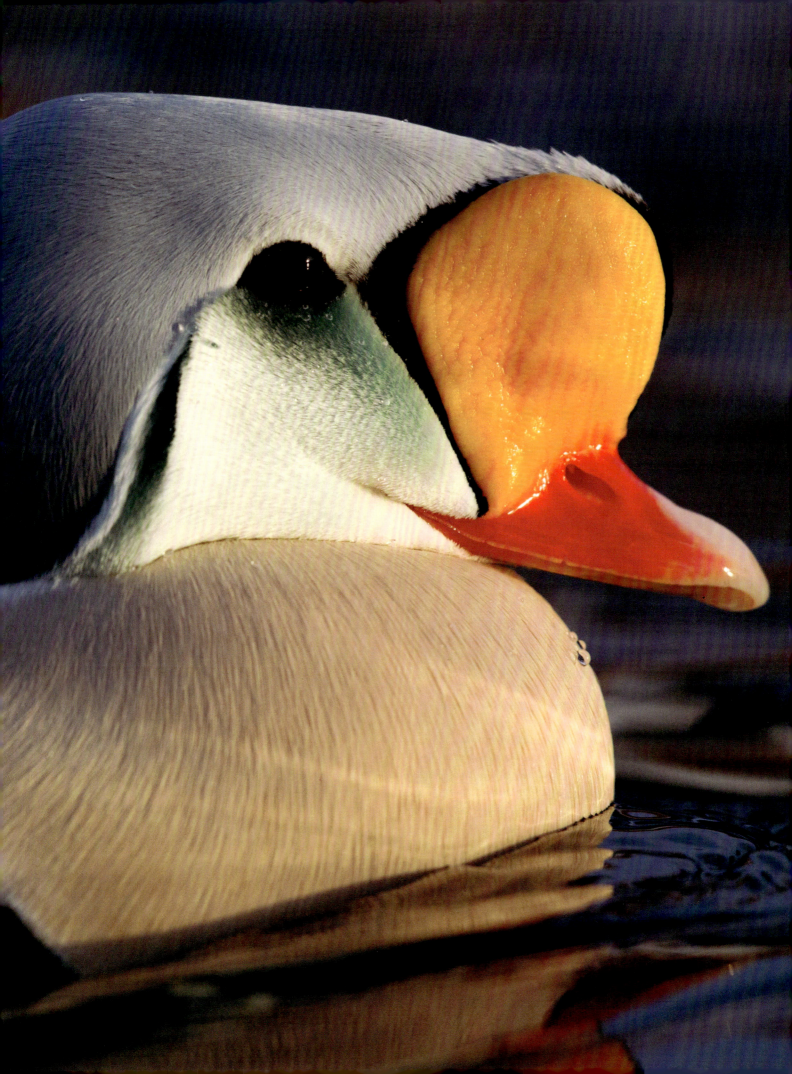

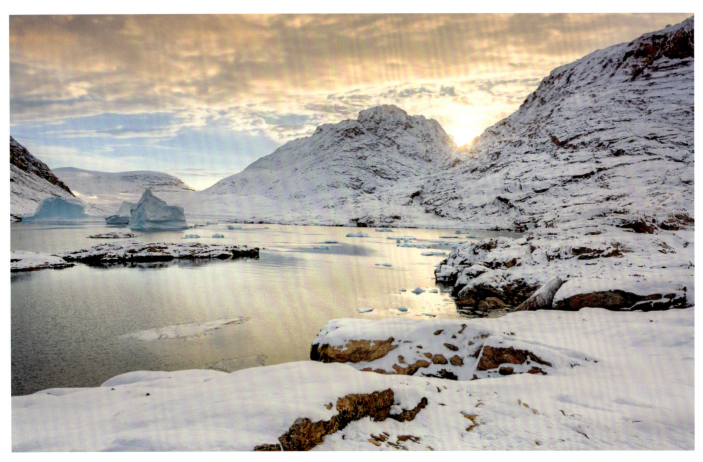

ABOVE:
HURRY INLET
This glacial inlet or fjord is in King Christian X Land on the east coast of Greenland.

BELOW:
ARCTIC WILLOW
While a true willow, this plant only grows as a shrub not a tree. These are the catkins, which use bright colours to attract flying insects to pollinate them. The shrubs stand through the winter, and their shallow but wide roots systems help to hold together the soil of the active layer above the permafrost

blasting winds. The herbivores then kick away the snow to reveal greenery beneath. That presents a tasty meal for a polar bear, but from their high vantage point muskoxen are ready to defend themselves. They larger adults muster together forming a solid wall of horns, muscle and wool, that the polar bear will think twice about attacking.

Reports suggest that due to the heating of climate change, the polar bears are appearing earlier each year and heading further inland, and are drawn to the rubbish dumps of Arctic settlements. This presents a danger to humans and bears alike. Polar bears are not meant to be in this place. They have evolved to live out on the ocean, being powerful swimmers as well.

POLAR DESERT

The High Arctic is mostly ocean, and so its low precipitation rate is inconsequential for the marine animals and plants that live there. However, down in the Antarctic the precipitation is around 2cm (0.7in) a year, which is less than that of the driest hot deserts. While the Antarctic continent is largely constructed of water, it is frozen solid as an ice sheet that is thousands of metres thick, and completely beyond the reach of

living things. Antarctica is therefore the driest place on Earth. Entire valleys remain ice-free year round, but nothing lives there. However, along the fringes of the continent, especially its northernmost point, the Antarctic Peninsula, and the subantarctic islands, an extreme land ecosystem has emerged. And this ecosystem is based largely on those icons of the Antarctic – penguins. The droppings of these birds, and others that come to plunder their eggs, creates a rudimentary soil for hardy mosses and lichens to get a foothold in summer, when the temperatures are above freezing.

Despite the undoubted link between the southern continent and these flightless seabirds, penguins are also found in Australia, New Zealand, southern Africa and South America. (They even creep into the Northern Hemisphere as they dive into the surprisingly cold waters off the Galapagos Islands.)

Penguins are highly adapted to life in the water, and each of the 18 species hunts for specific prey in specific places. Some spend months at sea while others, mostly those that live in

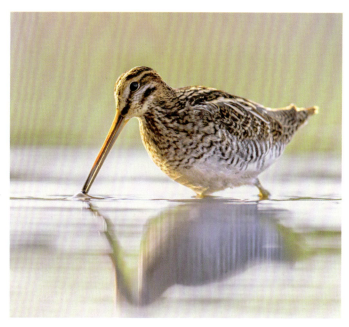

ABOVE:
COMMON SNIPE
In summer this wading bird flocks to the tundra to gather worms and other foods from the waters with its long bill. To attract the attention of mates, the snipes make fast flights and use their tail feathers to create a rhythmic whirring that is known as drumming.

BELOW:
ANTIPODES PARAKEETS
Parrots are not just tropical birds. These parakeets, the name for small parrots, live on the Antipodes Islands, which are part of New Zealand but which are far out to sea in a region of southern ocean called the Subantarctic. The ground-nesting birds use their small but sturdy beaks to eat grass and leaves and they also scavenge the flesh of dead seabirds. There are also reports that the parakeets hunt and kill smaller birds occasionally.

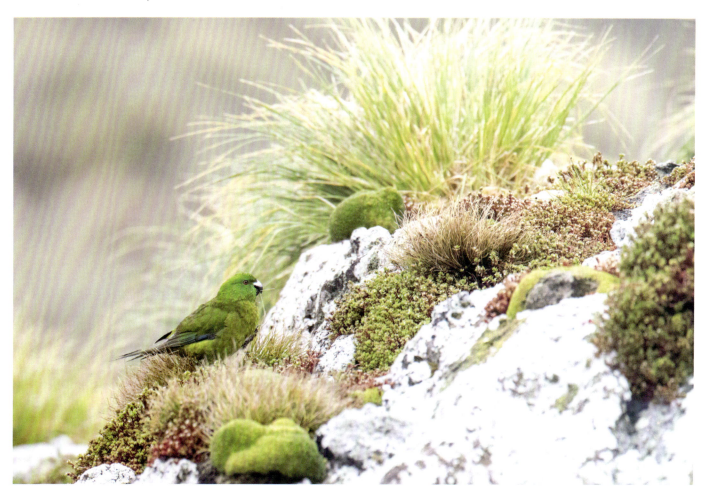

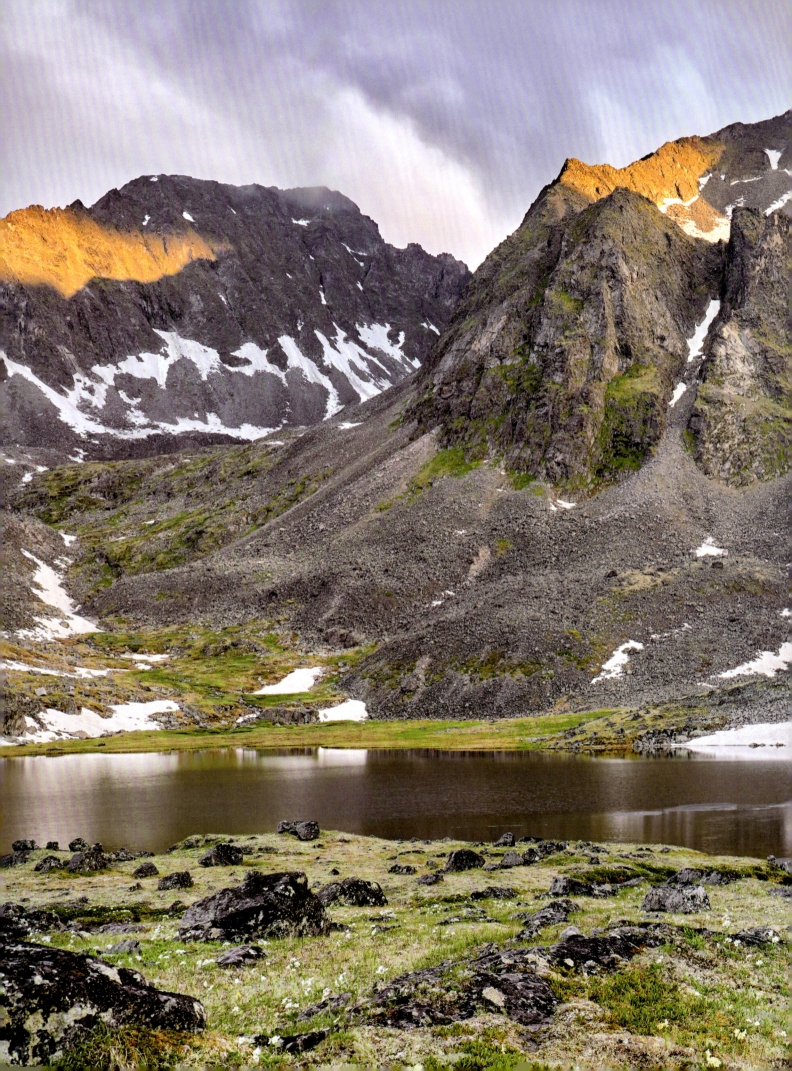

FROZEN LANDS

SIBERIAN SUN
The morning sunshine illuminates a rugged region of eastern Siberia, Russia.

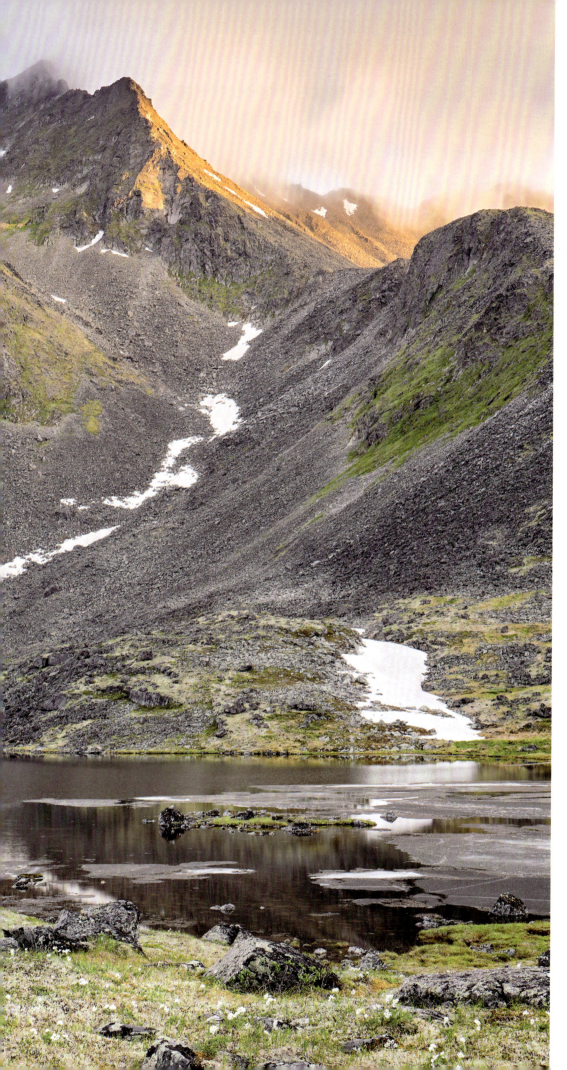

FROZEN LANDS

warm places, return to land regularly. The Adélie penguins spend much of their lives floating on icebergs and floes, but all penguins must return to land to lay eggs, and the chicks take time to grow into the buoyant, speed swimmers they need to be to survive out at sea. This is largely because the parents must travel great distances to find food and bring it back to their young. King penguin chicks spend 18 months standing on the tundra-like beaches of South Georgia, while the emperor penguins famously raise their chicks on the Antarctic mainland over the dark winter.

They are the only animals to live on this continent in winter, and again climate change is threatening this strategy. The emperors return to rookeries, where the ice will last long enough for the chicks to grow to independence under the watchful eye of their parents. Once they are ready to set off on their first year at sea, the edge of the ice is not too far away. However, due to artificial global heating, the danger is that these age-old rookeries will thaw and collapse before the chicks are old enough to swim. It is estimated that by 2100, the emperor penguin population will be a tenth of its size today. The hope is that there are as-yet undiscovered emperor rookeries in parts of Antarctica. Satellite surveys are looking for them.

ABOVE:
SPHAGNUM MOSS
This dense moss fills the pools of tundra in summer. It helps to create areas of thick soil, where larger plants will one day grow.

BELOW:
SUMMER GRAZING
These reindeer are grazing on the mosses and grasses that thrive in the dry tundra at higher levels.

RIGHT:
WALRUS
A mighty walrus has hauled itself out on to the beach. The tusks are to help it pull itself out of the water and signal dominance. The bigger tuskers rule, generally. It is now understood that the tusks are not used in feeding. Instead the walrus uses its moustachioed snout to snuffle through the seabed for shellfish.

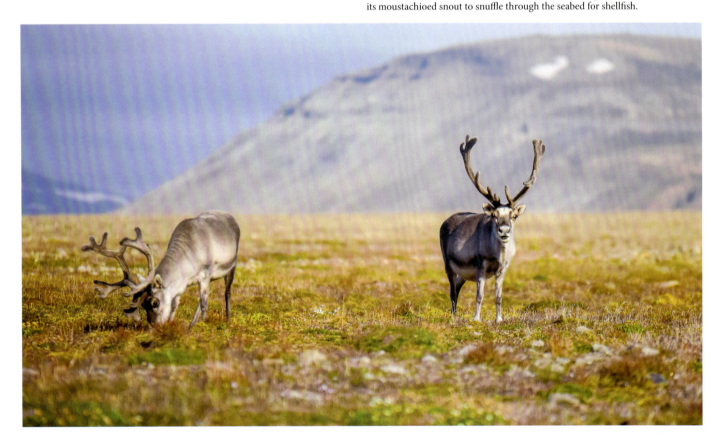

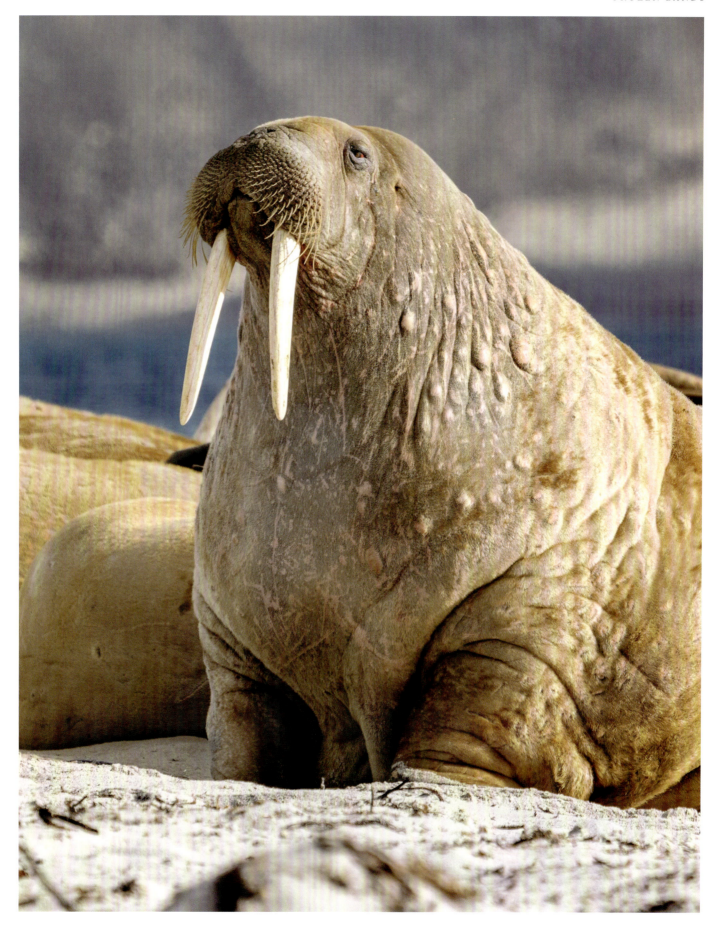

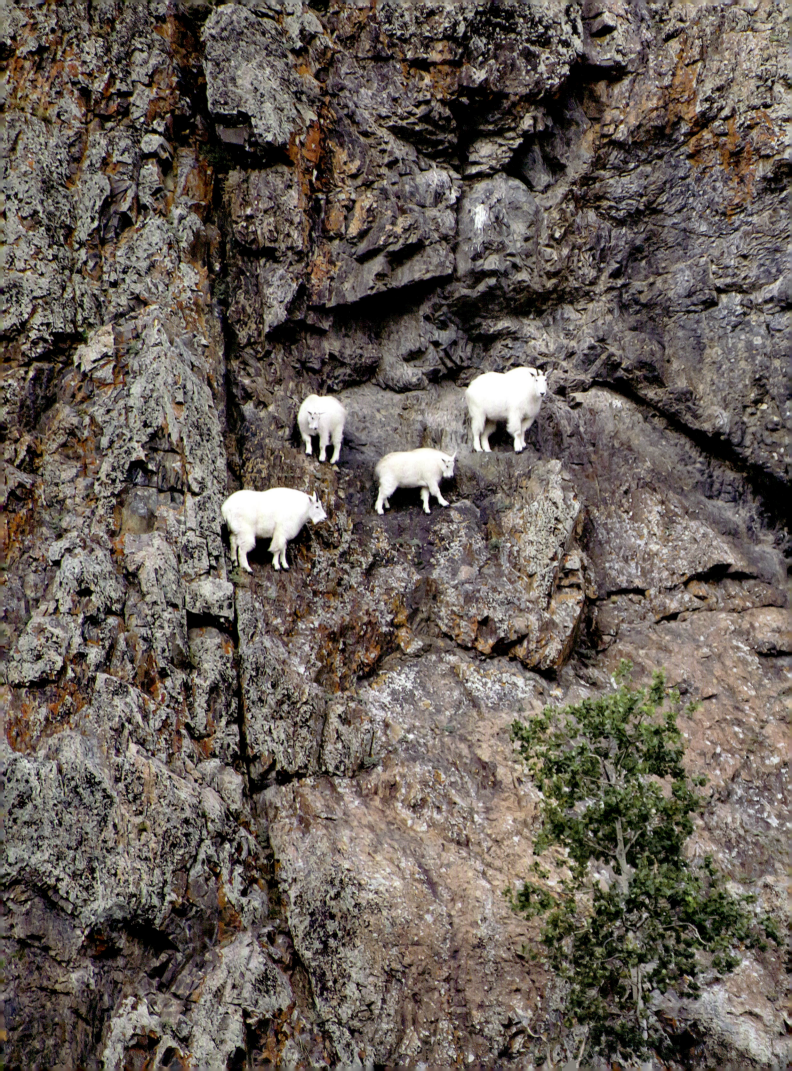

MOUNTAINS

Mountains constitute a biome that is an outlier to the rest. The biome's ecological character is defined primarily by altitude and gradient of slope. Those features then create not one but several climatic features that decide what wildlife lives where. In essence a mountain constitutes several biomes in one, as conditions become harsher with height. The tallest ranges will transition from a verdant forest or jungle in the foothills through drier, colder conifers forests, alpine meadows and tundra until the bare rock of the summits are analogous to a polar desert.

ON THE UP

A mountain is any land that typically exceeds about 300m (1000ft) above sea level. That is not that high considering it is the same as a 90-storey skyscraper. (There are currently 235 of these 'supertall' buildings.) However, varying authorities across the world will often take a different view. For example, in the United Kingdom and Ireland, only peaks over 610m (2000ft) are counted as mountains. (To date only three buildings exceed this limit.)

The average height of Earth's land is about 840m (2750ft) so that would suggest that most land is mountainous. However, to qualify as a mountain, the land also needs to have a distinct summit with a limited area that is free-standing from the surrounding landscape. It can get quite involved to define the precise topographical features of one mountain compared to another. But most people would know one when they

OPPOSITE:
MOUNTAIN GOATS
A flock of mountain goats take a stroll on a near vertical cliff in the Yukon region of Canada. Few predators can follow them up here. These animals are the epitome of sure-footedness. They have sharp hooves that grip the rock and ice, but they are also flexible, with the cloven sections spreading out, so a soft middle pad can grab the ground as well.

RIGHT:
ALPINE CHOUGH
This distinctive bird is a member of the crow family that is adapted to life in the mountains. It is found living across the alpine regions of Europe and America, where it sustains itself on a varied diet of insects, seeds and carrion.

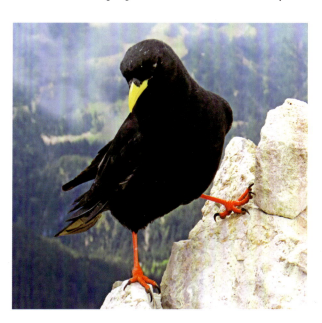

MOUNTAINS

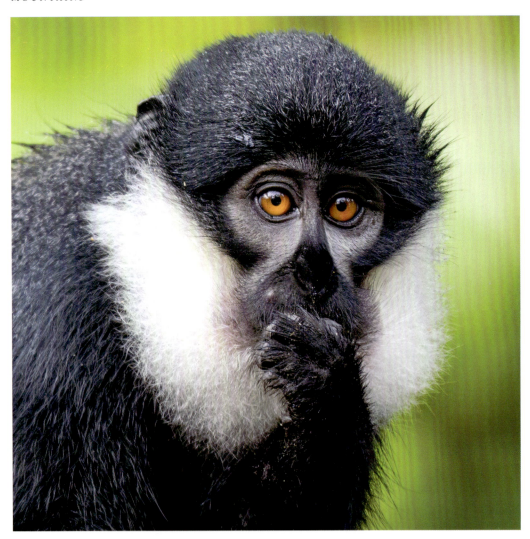

LEFT:
L'HOEST'S MONKEY
This Central African species is a specialist resident of montane forests, such as those in Rwanda, Uganda, and the Democratic Republic of Congo. These forests are dense and populated by small trees and thick shrubs. This monkey spends most of its time foraging on the ground.

BELOW:
ALPINE SALAMANDER
This amphibian is mostly black, which helps it absorb the heat it needs in the chilly alpine habitat. Unlike most amphibians, this species does not use the aquatic larval stage. Nor do they lay eggs. Instead the female salamanders give birth to fully formed juvenile forms called efts.

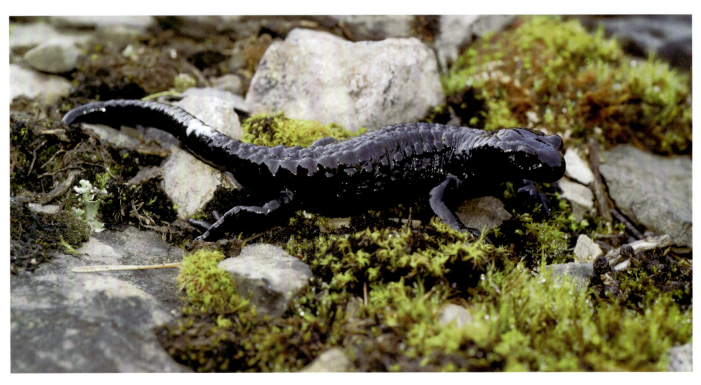

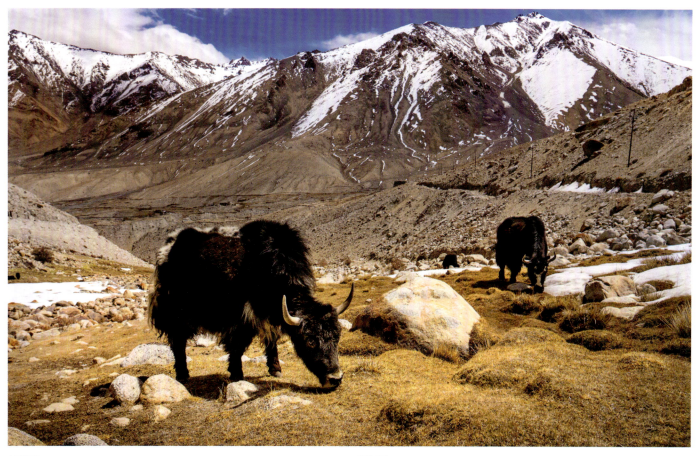

ABOVE:
YAK
These are domestic animals kept as beasts of burden in the villages of the Himalayas and Tibetan Plateau. There a wild population of yaks numbers around 10,000 adults. Along with humans, these are among the highest-living mammals in the world.

BELOW:
COTTONGRASS
This hardy grass is an important plant in alpine meadows. The grass can withstand the soggy and low-oxygen conditions in these habitats. They send out vegetative roots that sprout new stems and help stabilize the alpine soil.

see it, and, of course, Earth's mountains can be a lot taller than 300m (1000ft) or 610m (2000ft).

The highest mountain is Everest (known locally as Sagarmāthā, the goddess of the sky) on the border of Nepal and China. It is just under 8849m (29,032ft) tall and said to be still rising, pushed up 4mm (0.1in) a year by gargantuan forces deep in the Earth's crust. There are 13 other peaks over 8000m (26,247ft), all in the Himalaya or Karakoram ranges of South Asia. It is generally agreed that these peaks are in the 'death zone'. This means they are so high that the conditions there are not able to support human life, and not much of any kind of life.

SKY ISLANDS

Mountain ranges occupy a quarter of Earth's land mass. Most of this area is made up of low hills that are better treated as rugged regions of other biomes. Only where the gradient is high is it useful to think in terms of a mountain biome, with its many distinct levels or zones of climate. And this complex biome is located in every continent, each with a distinct flora and fauna. As a result evolution has filled the intricate ecosystem of each range with a great diversity of life. Mountains are particularly diverse

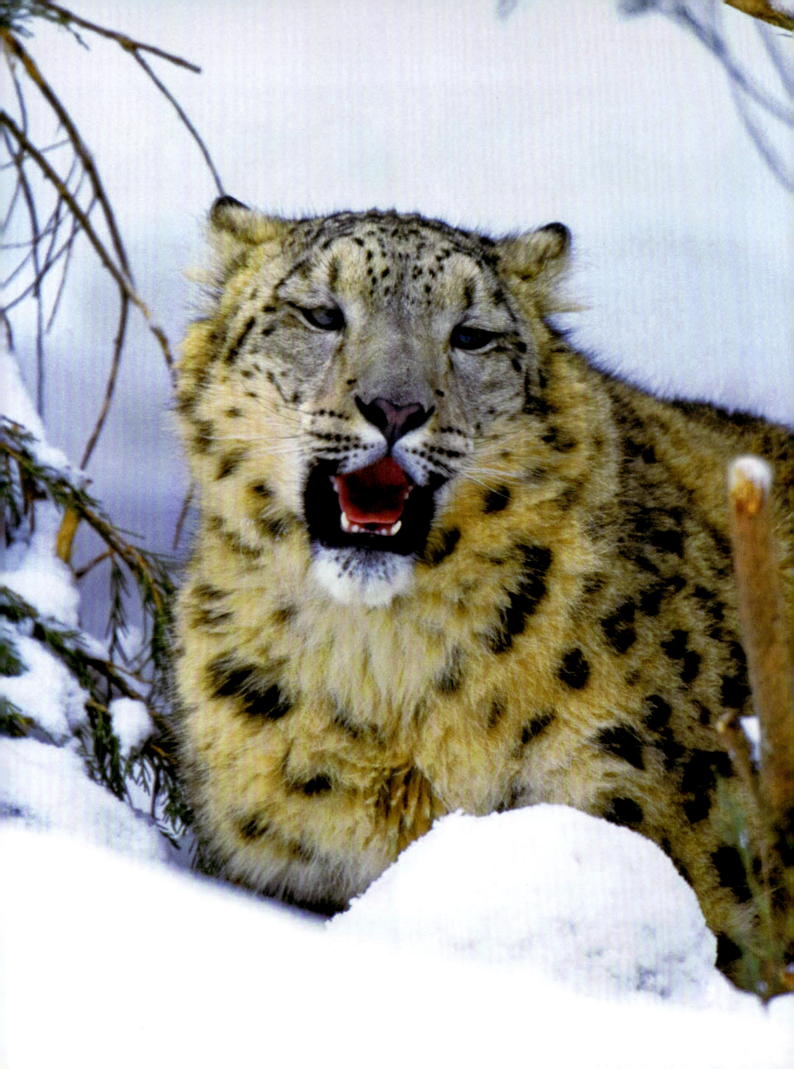

MOUNTAINS

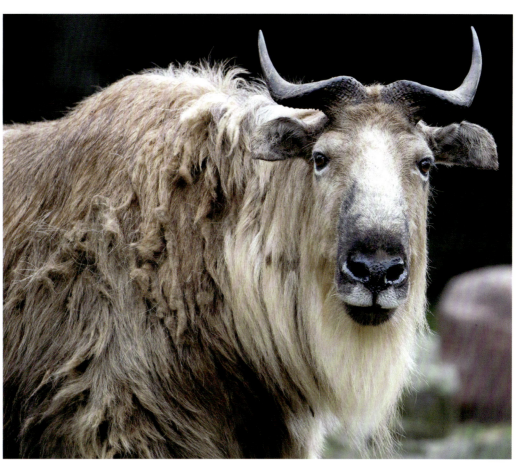

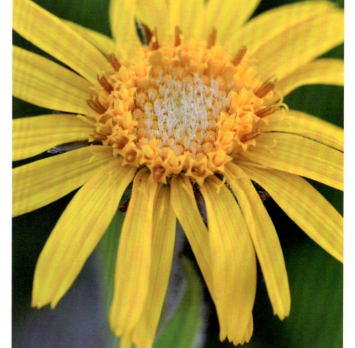

ABOVE:
TAKIN
A member of the wider goat and sheep family, this big Himalayan grazer is about the size of a donkey. It has long shaggy fur that keeps out the wind and rain and it lives in small flocks.

LEFT:
SNOW LEOPARD
The undisputed apex predator of Asia's mountains, the snow leopard will run the distance of a marathon every night to find prey. It also holds the record for the longest horizontal jump of any animal. It can cover 9m (30ft) in one leap.

RIGHT:
WOLF'S BANE
Also known as mountain arnica, this small yellow alpine flower found in Central Europe is slightly toxic. It has been traditionally used in painkilling ointments that numb wounds and reduce inflammation.

MOUNTAINS

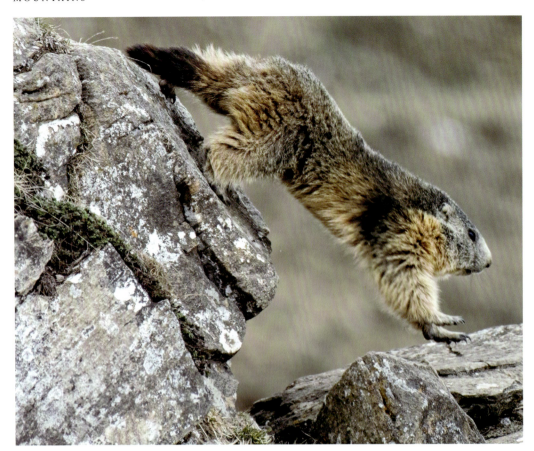

RIGHT:
SPECTACLED BEAR
This bear, so named for the patches around each eye, is the largest mammal carnivore in South America. Having said that it eats mostly plant foods and rarely kills for a meal. The bear lives in the mountain forests of the Andes. Its territory includes darkest Peru, so this is the species of the fictional Paddington Bear.

ABOVE:
ALPINE MARMOT
This large ground squirrel lives in the mountains of Europe. It gathers in loose family groups, feeding together on grasses and other alpine plants in secluded high meadows. The gang will all hibernate together in snug burrows beneath the rocks.

BELOW:
GLOBEFLOWER
These rounded yellow flowers are native to moist, mountainous regions of Europe. The spherical form creates a protective layer around the flower's organs so it – and any visiting insects – are sheltered from the cold.

in plants and amphibians, which are easily isolated on the high slopes. Ecologists often describe the upper reaches of mountains as 'sky islands' surrounded by inhospitable lowland habitats, just as the inhabitants of ocean islands are isolated by the sea.

WHERE IN THE WORLD

The biggest mountain region in North America is the Western Cordillera. This dominates the west of the continent and is mostly made up of the Rockies but there are smaller ranges towards the Pacific coast, such as the Cascades, Sierra Nevada and Sierra Madre ranges. In South America the main range is the Andes. This is the longest mountain chain in the world – and the second highest – and runs through tropical and equatorial regions all the way south to the subpolar tip of Cape Horn and Tierra del Fuego.

The biggest European range is the Alps, but there are others to the east, including the Carpathians and Caucasus (where the tallest European peak, Mount Elbrus, is located.) Further east are the Urals, which form a convenient frontier between Europe and Asia, but they are small fry compared to the Himalayas along the southern edge of the Tibetan Plateau. These lofty peaks are geologically distinct but ecologically linked to several other

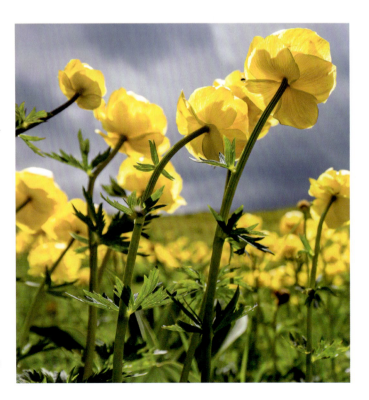

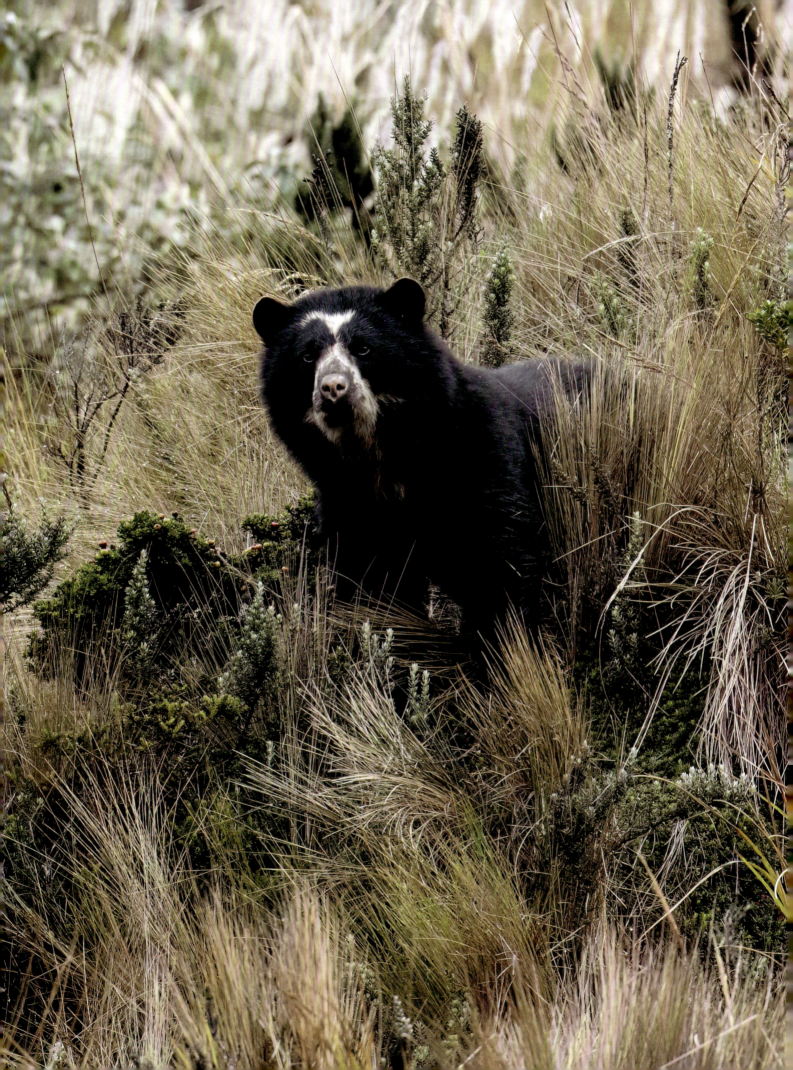

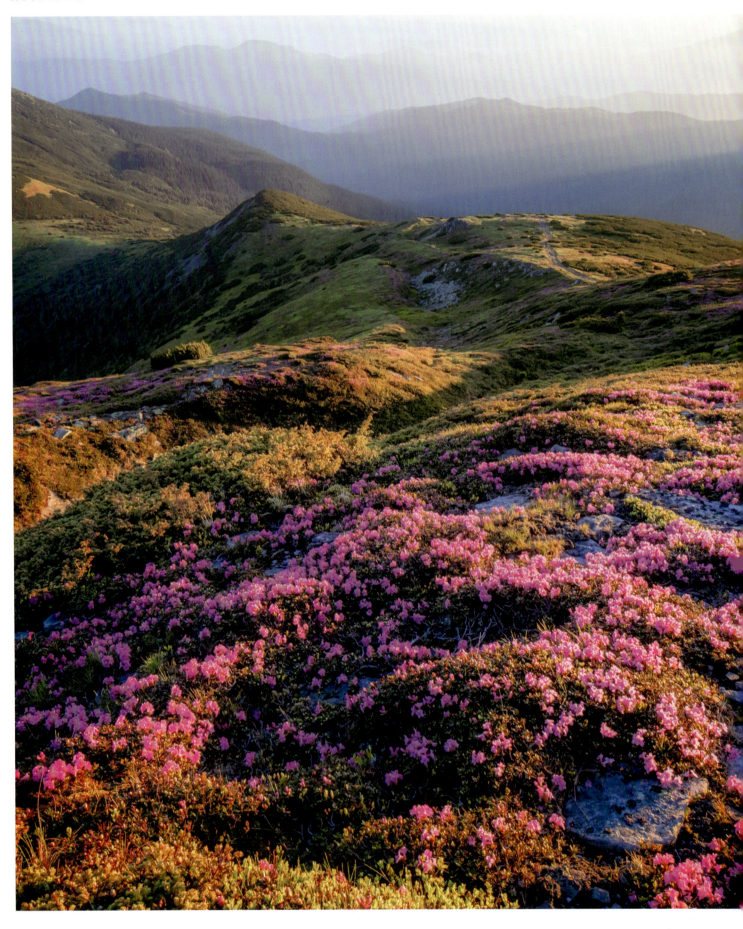

MOUNTAINS

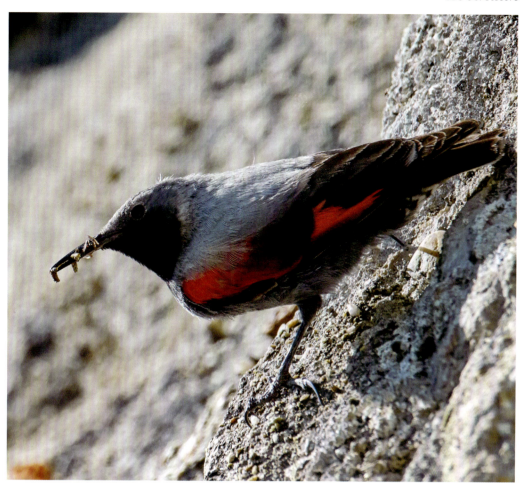

ABOVE:
WALLCREEPER
This small bird inhabits high rocky cliffs across Europe and Asia. As the name suggests it is well adapted for vertical rock climbing. Long, curved talons help them to grip surfaces and the tail feathers provide balance. The bird probes cracks with its curved beak to catch insects.

LEFT:
RHODODENDRON
With a name that means 'red tree', this woody shrub is native to the mountains of South and East Asia. Its flowers can colour the whole mountainside in reds, pinks and purples. The bushes prefer acidic soils, and they have since spread across the world as a garden and architectural plant.

mighty ranges, such as the Hindu Kush to the west and the Karakoram and Kunlun to the north.

Australia has older mountain ranges than most continents and so they are not particularly high. The Great Dividing Range running down the eastern coastal region is the largest and the centrepiece of the East Australian Cordillera. Antarctica has some high mountains, mostly volcanic in origin, but the conditions at the bottom are as inhospitable as at the top, so they have no ecological interest. The same cannot be said of the volcanoes of Africa, most notably Kilimanjaro in Tanzania, the tallest peak on that continent. It is also one of the most prominent, standing alone to rise out of the savannah. A trek up its gently rising slopes takes walkers through zones of unique tropical forests, shrublands and heaths. Elsewhere in Africa, the mountains each offer a distinct character, from the Atlas of North Africa to the Drakensberg of southern Africa. For example, the misty jungles of the Rwenzoris, east of the African Great Lakes, are home to mountain gorillas, now critically endangered. And the Ethiopian Highlands are home to clans of unique grass-eating monkeys called geladas.

AIR PRESSURE

The fact that it gets colder with altitude is self-evident. But why? After all, one is getting nearer to the Sun, albeit only slightly. Why

ABOVE:
ICE CAVE
Melting alpine glaciers may hollow out from the inside, creating summer ice caves like this one below the Aletsch Glacier in Switzerland.

BELOW RIGHT:
VICUÑA
The wild ancestor of the llama, this is a South American relative of the camels. It lives in the high alpine meadows of the Andes, which are arid and desert-like for much of the year.

OPPOSITE:
BEARDED VULTURE
Also known as the lammergeier, this mountain scavenger has a unique feeding method. The strong bird searches for the bleached bones of long-dead mountain goats or similar animals. It hauls a bone high into the air, steadily riding thermals to a great height above the rocky cliffs. It then drops its cargo so it falls and shatters as it hits rock. The vulture then searches out the bone fragments and swallows them whole, using a strong stomach acid to dissolve the hard minerals and get at the nutrient-rich marrow in the bone's core.

does it not get hotter at the top of mountains? The answer is in an understanding of air pressure. Air pressure is essentially the weight of Earth's atmosphere pushing down from above.

Air pressure is measured using a number of units, all useful in their way but none that illuminating for what is actually happening. For example, at sea level atmospheric pressure is around 1 atmosphere. However, at 8000 that has reduced by two-thirds. In terms of the force of the air, at sea level the column of gases above you pushes down with a force of 1kg per sq cm (14.7psi). That is quite a push but our bodies are built to withstand it. The force on the body is reduced with altitude, but that is not really biologically important. Instead, the problem life has is that the quantity of oxygen is in the air.

Air is a mixture of many substances but essentially it is 78 per cent nitrogen, 21 per cent oxygen and 1 per cent other gases. While the composition of the air is unchanged at altitude, its reduction in pressure does cause problems. A living body takes in oxygen from the air in various ways, but each mechanism is atuned to the oxygen in the air being at a high enough 'partial pressure' to make the move into the body. That partial pressure is reduced by half at 5500m (18,000ft) and down to around a third at 8849m (29,032ft), the top of Everest.

RIGHT:
MARKHOR
The male markhor, a large mountain goat from Central and South Asia, has immense spiralled horns, which can grow to 100cm (3.5ft) long, easily doubling the animal's height. The shaggy coat will thin out as the summer weather improves and before a fresh winter fur develops.

OPPOSITE:
GLACIAL HORN
Eons of erosion have carved away the peak of the Matterhorn on all sides to create this iconic spiked mountain on the border of Italy and Switzerland.

BELOW:
PINK BLOOMS
Small pendulous flowers brighten the hillsides of Kamchatka, a rugged volcanic region in the far east of Russia.

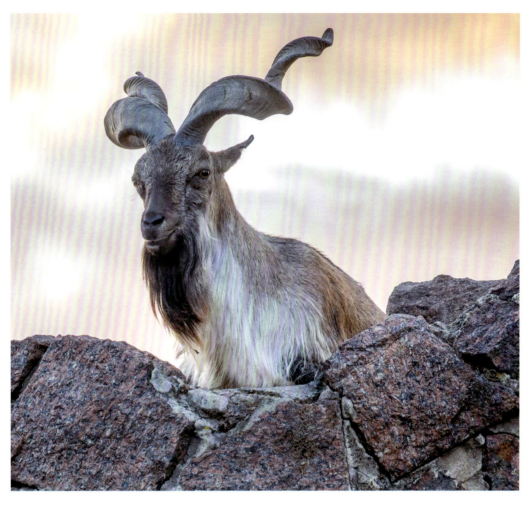

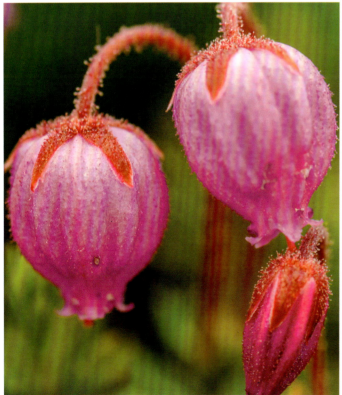

At these altitudes the body is taking in less oxygen and must respond in some way to avoid dying. Vertebrates, such as humans, will pack the blood with red blood cells to grab more oxygen with each breath. The heart beats faster and the breathing rate goes up. The fluids normally contained in the body begin to leak into the lungs or brain, creating acute medical dangers. Human climbers take oxygen tanks with them into these altitudes and must come and go in less than 24 hours.

Yaks, a domestic breed of cattle, are one of the highest-living animals, albeit having been bred for it by humans. These shaggy, sure-footed beasts live all year round 5000m (1600ft) high in the Himalayas and Tibetan Plateau. This is around the top of the safe limit for mammal life. However, in 2013, a yellow-rumped leaf-eared mouse was discovered at 6739m (22,110ft) on the summit of Volcán Llullaillaco, a dormant volcano on the border of Chile and Argentina. This is the altitude record for a mammal and no one is sure if this mountaineering mouse was simply very lost or represents a permanent population that lives higher up than once thought.

Birds are seen flying over mountains. Bar-headed geese even go high enough to fly past the peak of Everest. Birds have a more complicated respiratory system than the simple 'in and out' breath of mammals. Thanks to their dinosaur ancestors,

birds have hollow bones. This cuts weight without a reduction in strength, and it allows birds to channel air through the body to a series of air sacs. The function of the sacs is to allow oxygenated air to flow through the lungs during both the in and the out breath. The system creates a more efficient, unbroken supply of oxygen to the busy bird body as it flies. Those air sacs also work in the same way as the human mountaineers' gas tanks, keeping the oxygen levels in the blood topped up enough to maintain brain and body functioning.

ZONATION

As well as representing a problem at the highest peaks, the steady reduction in air pressure is what drives the climate changes seen as altitude increases. Low-pressure air is often better characterized as 'thin air'. Thinner air has fewer gas molecules in it, and so it can hold smaller amounts of energy. Therefore, the air gets colder with altitude.

As a benchmark the difference in air temperature experienced when rising 140m (460ft) up a mountainside is equivalent to moving one degree higher in latitude. So roughly speaking, if you were to climb to a height of 1500m (4900ft) above Madrid, Spain (40°N) the air temperature up there would be similar to the conditions in London, England (51°N).

The result of this cooling is a zonation of wildlife, with plants and animals living in distinct habitats that appear at specific altitudes. This zonation is one of the drivers of the high diversity of the mountain biome, but it is estimated that with every 100m (330ft) climb, 40 fewer species are supported by the higher ecosystem.

RIGHT:
ANDEAN CONDOR
The condor is considered to be the largest carnivorous bird on the planet. It has a wingspan of 3.3m (10.75ft). This length is surpassed by wind-soaring birds such as the albatrosses, which have longer but narrower wings. The condor rides thermals up the windward side of the Andes, and as such has deeper wings with a much larger surface area than its rivals. The condor does not kill but scavenges for carcasses. It may glide down to the coast to feed on whale blubber and then ride the thermals back up to the rocky peaks.

BELOW:
ACONCAGUA
The remains of a once-mighty volcano, Aconcagua is still the tallest peak in the Andes, the tallest in the Americas, the tallest in the Southern Hemisphere, and the tallest mountain outside of Asia. It has an elevation of 6961m (22,838ft).

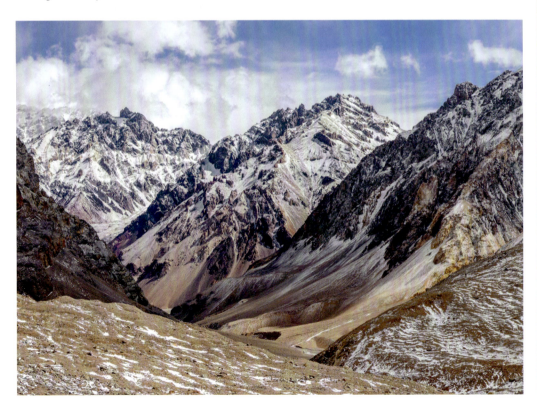

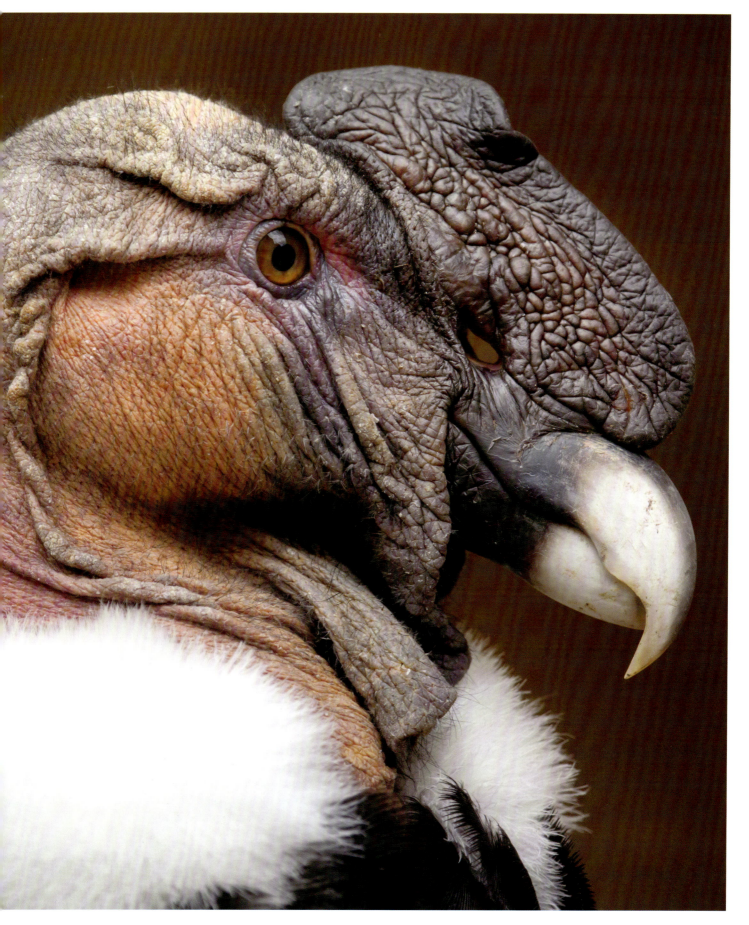

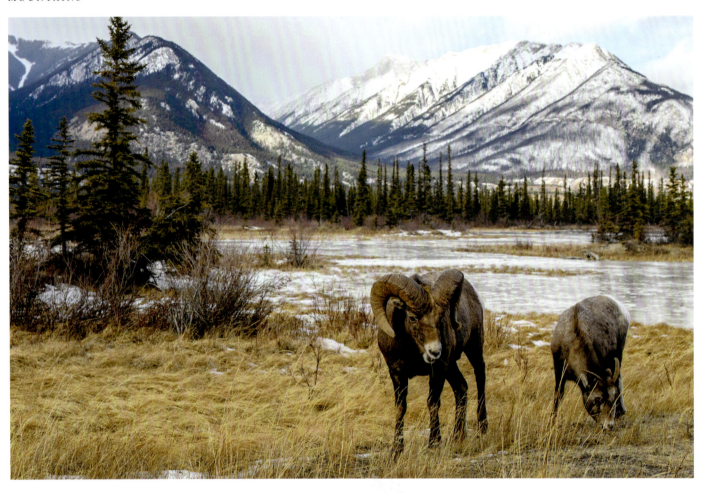

ABOVE:
BIGHORN SHEEP
This is one of North America's iconic mountain grazers. Obviously named for the large hooked horns of the rams (the ewe's horns are by no means small, either), this wild sheep lives in flocks on the high meadows of the American West, especially the Rockies. The flocks are often on the move to avoid attention from predators, such as bears and eagles.

RIGHT:
CHAMOIS
Pronounced '*sham-wah*', this relative of the goat is the traditional source of the soft leather cloths known as 'sha-mees', although that link has long ended. This agile herbivore lives in the mountains north of the Mediterranean and east of the Black Sea.

LEFT:
ALPINE BLUE
These trumpet-shaped flowers, mostly a striking blue, are a common feature of the nutrient-poor soils of alpine meadows and crags. The plants are filled with bitter-tasting chemicals to deter the herbivores that venture to these precipitous locales. The flowers require insects to pollinate them but can self-fertilize if necessary.

The foothills of the mountain will have the same climax habitat of the surrounding lowlands. For the sake of argument we shall assume this is a deciduous forest. Moving upwards this transitions into a montane forest, sometimes called cloud forest. The reduction in air temperature has caused the water vapour in the air to condense into clouds that hug the slopes. The montane forest therefore is not short of water, but the trees there will be smaller and grow more slowly.

SUBALPINE

Moving higher still the trees in the forest will become more cold adapted, transitioning into a subalpine forest. At first aspens and birch take over. Then conifers with their frost-

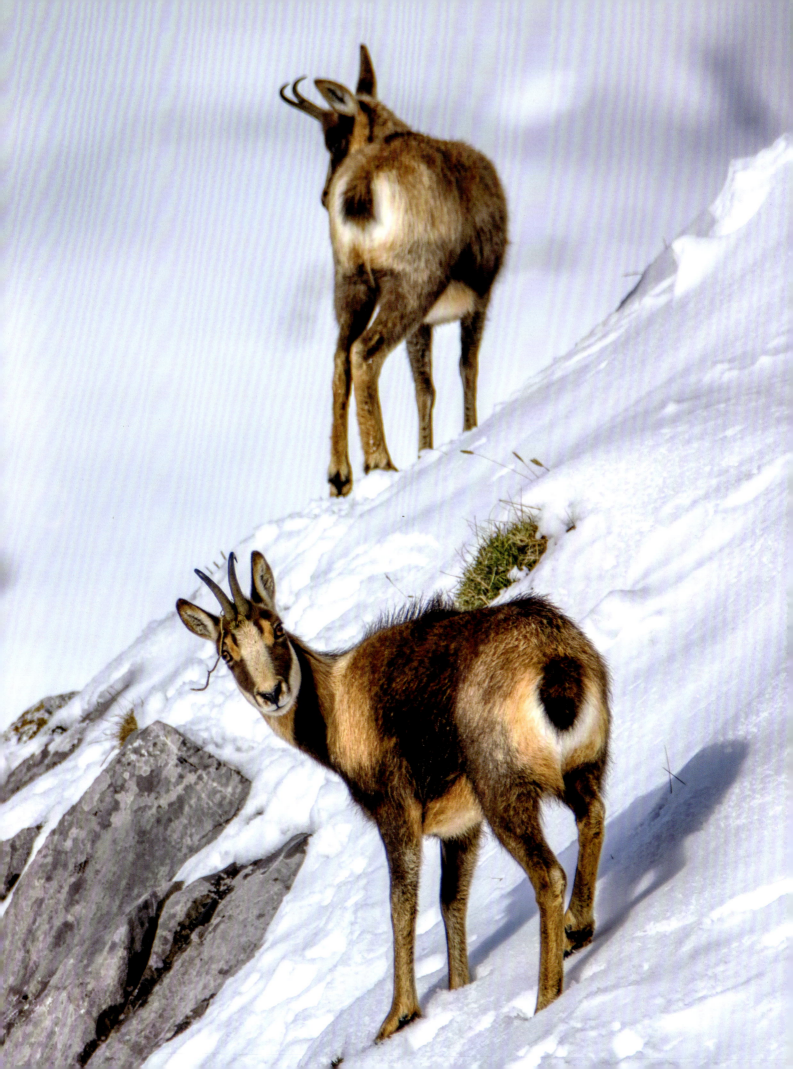

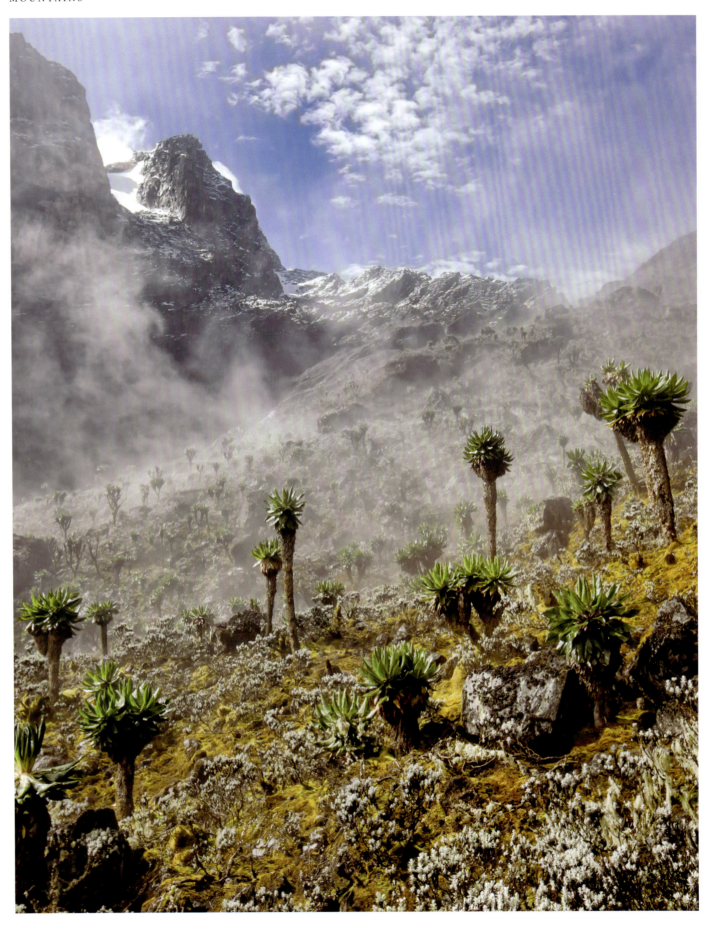

MOUNTAINS

ABOVE LEFT:
LOBELIA
This alpine plant is seen in the Rwenzoris of East Africa and the Himalayas. Its fleshy leaves cling to moisture in much the same way succulents do in hot deserts at lower altitudes.

OPPOSITE:
RWENZORI NATIONAL PARK, AFRICA
The alpine habitat below the summit of Mount Stanley is very unlike the meadows that fringe the treeline in other parts of the world. This mountain is the highest peak in the Rwenzoris, an African mountain range that straddles the borders of Rwanda, Uganda and the Democratic Republic of Congo.

ABOVE RIGHT:
SPOTTED NUTCRACKER
There is good reason to plump up the breast plumage. This bird is sitting out a cold spell in the Swiss alps, where the winter temperatures are around −15°C (5°F) during the day. The bird is sustained through the harsh times by stashes of nuts harvested in the autumn and buried in several caches nearby.

BELOW:
MOUNTAIN BEAVER
Despite the name, this rodent is not a close relative of the dam-building, tree-felling, river engineers of the lowlands. Their only link is that the mountain beavers must drink copious amounts of water and so live near streams. They also dig burrows in the alpine forest and store extensive supplies of leaves and ferns.

resistant needle leaves and resinous wood will steadily become more common as we move up in this habitat. In the taiga, the trees are contending with the extreme shift in day and night length. That may not be such an issue on the mountainside, although they may find themselves in shadow for large parts of the morning or afternoon, once the sun sets behind the ridges towering overhead. However, the main reason the conifers are here is that this zone of the mountain will be above the winter snow line. The conifers can outcompete the deciduous trees come the thaw without the need to grow fresh leaves in the short time in which growth is possible.

Higher still and we reach the timber line. This is where the conditions makes it impossible for trees to grow, due to the combination of a lack of liquid water and short growth seasons due to a long winter period of snow and ice. The trees along the timber line are described as krummholz, from the German for 'twisted wood'. The trees have tried to grow here but can only manage to produce a stunted, twist of trunk and branches that grow close to the ground.

MOUNTAINS

ABOVE THE TREES

The treeline gives way to shrubs that hug the ground to stay out of the desiccating mountain winds. The winds will eventually make it too dry for woody plants to grow, and the shrubland will transition into an alpine meadow. This resembles the tundra, with hardy sedges, grasses and moss clinging on to the thin soil. Water is supplied by the trickle of meltwater from the permanent snow line higher up still.

In spring and summer, sure-footed mountain goats and wild sheep climb up from the sheltered forest lower down the slope where they spent the winter. They come to the alpine pastures above the treeline as soon as the snow thaws. Up here they graze on the herbaceous plants and give birth to kids and lambs conceived the previous autumn. (In South America, the grazers in the high meadows are vicuñas, the wild ancestors of llamas.)

LEFT:
GOLDEN EAGLE
Living across the Northern Hemisphere, this large raptor is well adapted to hunting in the mountains. It is a perch predator so is able to stand on tall crags and cliffs to scan the valleys and slopes for prey. They mostly target mammals, such as marmots and rabbits, although they will occasionally try to snatch a newborn lamb or goat kid.

OPPOSITE:
ETHIOPIAN WOLF
Looking distinctly foxy, this rare dog species is a member of the wolf subfamily. It is limited to the Ethiopian Highlands, where it lives in small packs that occupy burrows under the high grassy meadows. Unlike other wolves, this species hunts alone and targets mole rats that dig through the ground up here.

BELOW:
EDELWEISS
This is an iconic mountain flower from the Alps. It has distinctive white, star-shaped blooms covered in tiny hairs. These woolly hairs help it to withstand the cold, intense sunlight and strong winds at high altitude.

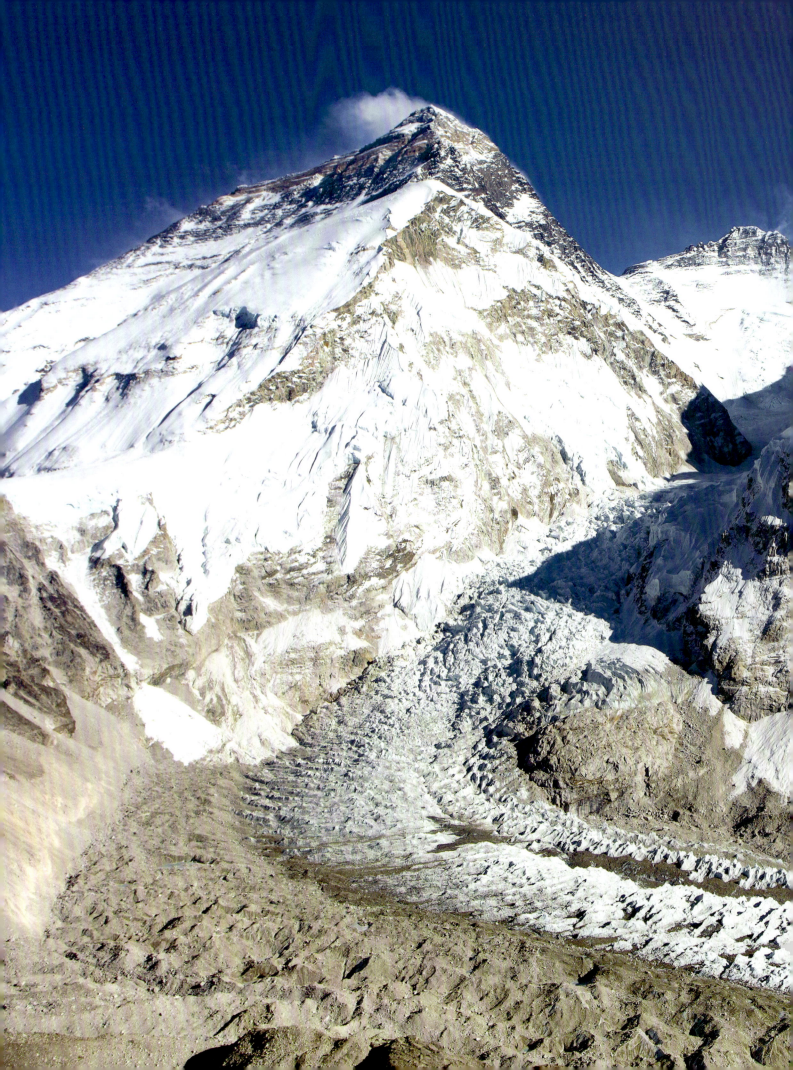

MOUNTAINS

MOUNT EVEREST
Flanked by Lhotse and Nuptse, Everest looms higher than any other point on Earth. Nothing much lives up here – and not for long anyway.

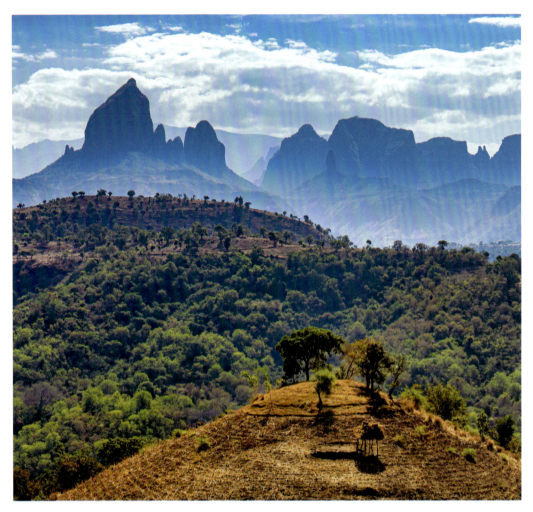

There are always threats to the goats and especially their young. Golden eagles target the newborns, which are still small enough to be snatched into the air with a well-timed swoop. The adults are too large to be threatened by these raptors and would be able to run out of the way anyway. However, the young are too slow to evade bird attacks. The only place to hide is underneath their mother. She will see off the attack with a shake of her horned head.

UNDER ATTACK

A greater threat comes from large mountain carnivores. Wolf populations are clustered in the mountains of North America, Europe and Asia, where they are less likely to come into conflict with humans. They seldom hunt above the timber line. In the Americas another top mountain predator is the puma. This is also called a cougar in North America, and specifically a mountain lion when it hunts in alpine habitats (although it is found in all kinds of wilderness.) Despite this name, the mountain lion is actually a small cat, related to house cats and lynx, and not a big cat like a true lion or tiger. The mountain lion cannot roar, just purr – and snarl and hiss.

The pre-eminent mountain hunter is the snow leopard. This is a member of the roaring, or big cats. The leopard has an

ABOVE:
SIMIEN MOUNTAINS
These jagged peaks are located in northern Ethiopia. They tower over a landscape of deep valleys and sheer escarpments. The mountains are volcanic in origin and there are active craters nearby. They harbour uniquely diverse, and often endangered, wildlife, including the gelada, Ethiopian wolf and Walia ibex.

RIGHT:
GELADA MOTHER AND BABY
Frequently mistaken as a baboon, the gelada follows a distinct lineage. The unique primate is primarily a plant eater, and the troops spend long hours in rocky meadows munching on grasses, roots and flowers. They are sometimes called the bleeding heart monkey because both sexes have a red patch on their chests.

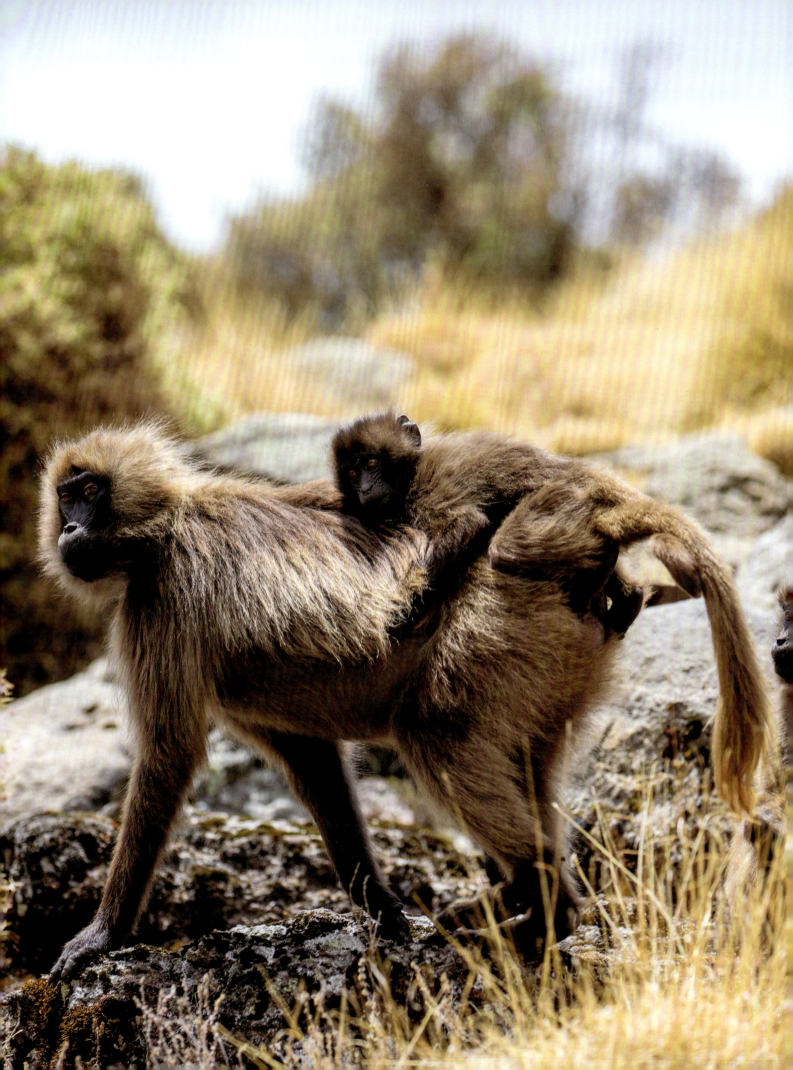

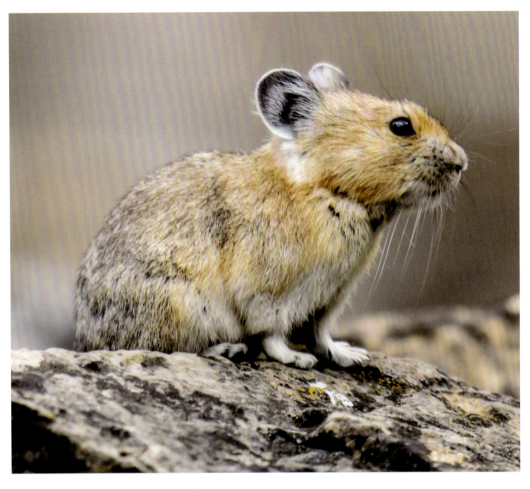

LEFT:
PIKA
These little creatures are relatives of the rabbits and hares that are found mostly in rocky mountainous regions. They have shorter legs and ears than their lowland relatives, and a thicker coat that gives them a more rounded plump look. The pikas eat grasses and herbs and will assemble hay piles inside or near their burrows for eating during the winter.

OPPOSITE:
ROCKY MOUNTAINS
Huge boulders surround the calm waters of Chipmunk Lake in Rocky Mountain National Park, Colorado.

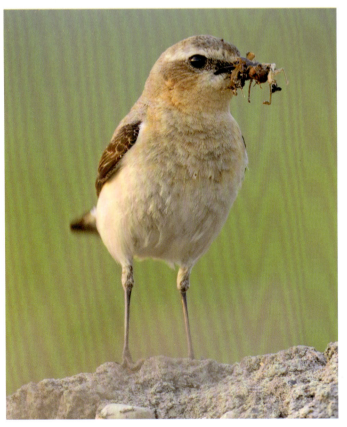

BELOW LEFT:
WHEATEAR
This insectivorous songbird is widespread across North Africa, Asia and Europe. It likes to nest in rocky crevices and so is a common resident of highland regions.

immensely long tail that helps to keep its balance as it makes huge leaps from rock to rock.

To evade attacks, the mountain herbivores run uphill, to ever more vertiginous points that are out of reach of predators. (Domestic sheep still do this instinctively by staying downhill.) Mountain goats have remarkable grip thanks to hooves that work much like a climbing shoe fitted with crampons. The outer edges of the hoof are hard and sharp, able to cut into ice and grip rock. Meanwhile, the sole of the hoof is soft. As the animal puts weight on the hoof, the two halves are pushed apart and then spring back together so the foot pinches the ground. The soft sole then acts like a suction cup to provide extra grip.

After grazing all summer and evading predators in the alpine meadows, the goats and sheep will head down to lower altitudes. The flock has a leader, generally the oldest female, who will lead the group safely down. They walk down through the snow to spend winter in secluded valleys, where they will also select a mate. Next year the vertical migration will begin all over again.

NIVAL ZONE

Above the alpine tundra is the nival region. This is little more than rock and probably has snow all year round. Apart from

MOUNTAINS

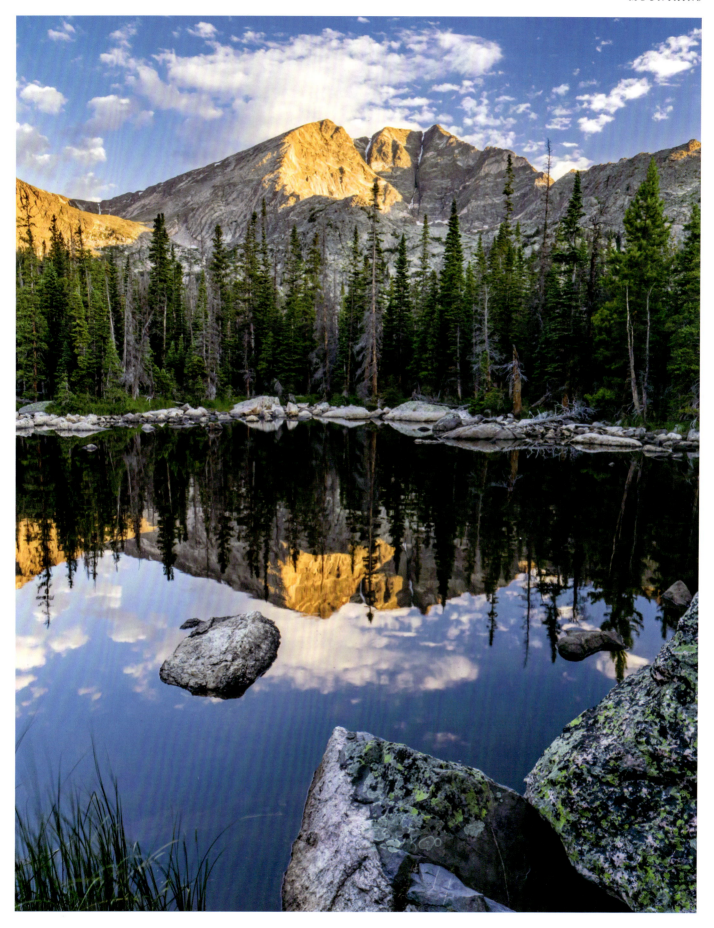

human adventurers, other occasional visitors to the nival region are vultures and condors. They might perch here before soaring away to scour the alpine meadows below for the carcasses of goats that were not able to evade predators.

Summit rocks have been frozen and thawed for millennia and that makes them crack and crumble. The broken rocks fall to the slopes below forming scree. These slopes of shattered rocks form a subnival region, where grasses can find a foothold between the stones. (The scree is the ideal hiding place for the snow leopard. Its grey rosettes help it blend in with the uneven background.) The scree is home to pikas, small relatives of rabbits, which do not need to burrow. Instead, they set up cosy homes in ready-built shelters among the rocks. Despite all the difficulties and harsh conditions, life takes hold wherever possible.

While the nival region is akin to a polar desert in some ways, it is not as devoid of life. The rocks may have lichens and algae growing on them, but nothing with roots or leaves survive on the highest peaks. Almost no animals live up here full time either. The highest-living animal of all is the Himalayan jumping spider. This has been seen at the top of Everest, where it feeds on wingless insects called springtails that are grazing on the lichens. Even at the top of the world, life has found a home.

ABOVE:
MOUNTAIN STREAMS
A fast, steep flow heads down a rocky slope in the Rwenzori Mountains of Uganda. Mountain streams are cold, clear and full of oxygen. That makes them an ideal place for wildlife, so long as they can handle the fast current.

RIGHT:
MOUNTAIN GORILLA SILVERBACK
This is the leader of a troop of mountain gorillas, a critically endangered subspecies of the eastern lowland gorilla that clings on in the misty forests of the Virunga Mountains of Central Africa, especially the Bwindi Impenetrable Forest of Uganda. The gorillas are adapted to colder habitats with thicker fur and a more robust physique than their lowland cousins.

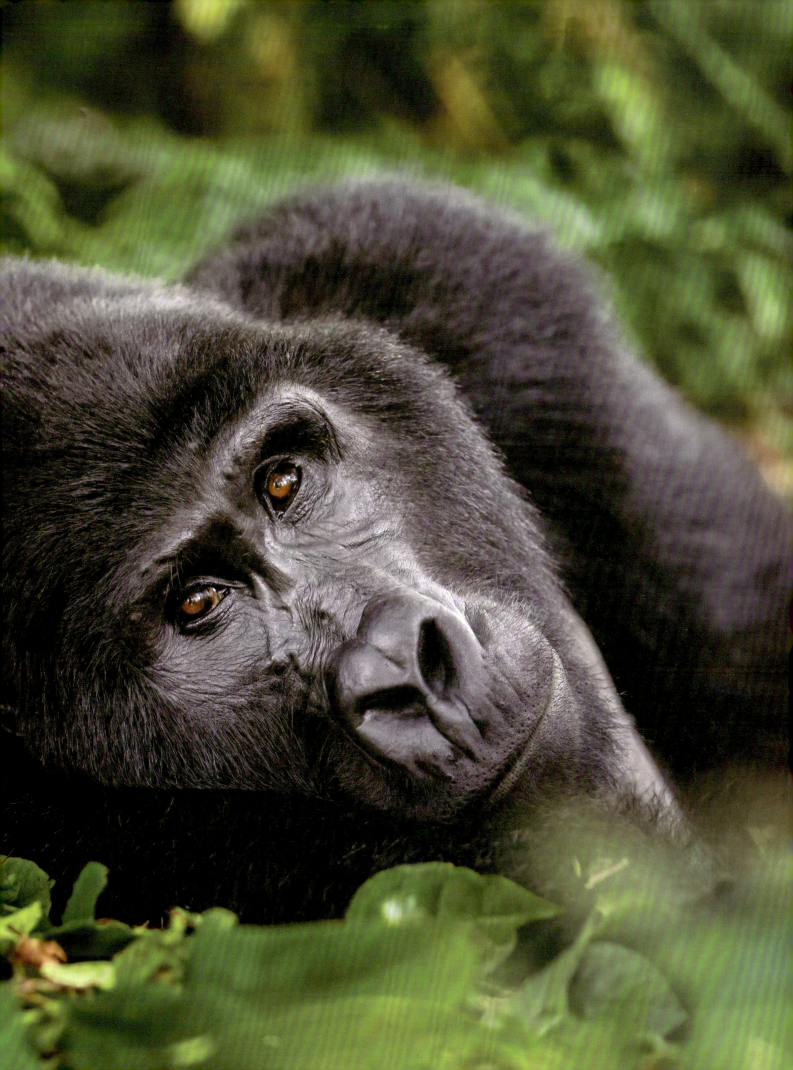

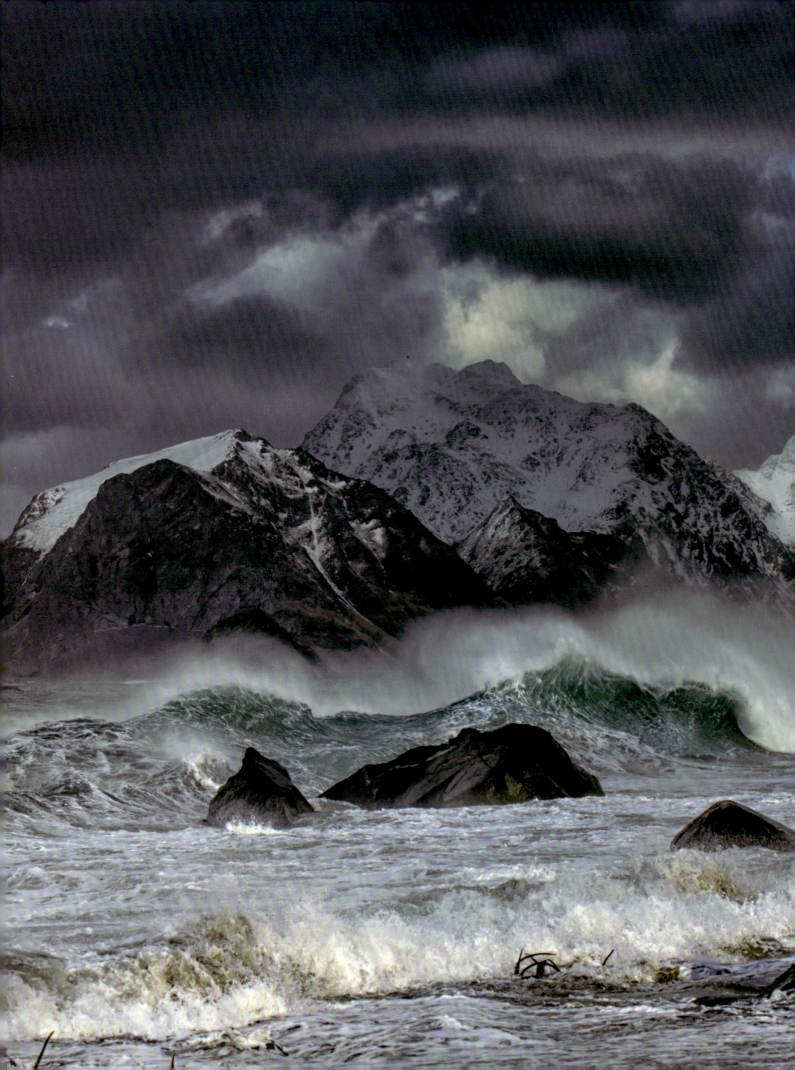

SALTWATER

Earth is a water planet. Almost three-quarters of the surface is covered in oceans. The average depth of that sea water is 3.7km (12,000ft) and so the oceans form by far the largest sector of the biosphere. The biosphere is the region on or around the surface of the Earth where the conditions for life exist. It extends high into the atmosphere and down into the depths of the ocean, and even deeper into the rock of Earth's crust where bacteria are known to consume certain minerals.

The roughest calculation concludes that due to their sheer volume, the oceans make up 95 per cent of the biosphere. However, all that living space does not translate into a large amount of life. While it is more or less beyond doubt that life emerged from non-living materials in the oceans – probably in its warm, chemical-rich sediments – around 3.8 billion years ago, once that life found its way on to land around 600 million years ago, it really got going.

Today, the oceans are estimated to contain 6 gigatons of biomass. Biomass is material created by living things, so constitutes living bodies, their waste and the remains of the dead. All of that material, is the product of solar energy being harnessed by plants and other photosynthetic organisms, like seaweeds and algae. On land the equivalent figure is 470 gigatons of biomass. But why is there such a huge difference by a factor of almost 80? Why is it that vast oceans, the cradle of life on Earth, are actually so empty of living things compared to land biomes?

OPPOSITE:
STORMY SEA
The oceans are a turbulent place, on the surface at least, such as here along the coast of the Lofoten Islands in the Norwegian Arctic. However, beneath the surface, going deeper and deeper, the conditions in the dark, cold water are remarkably stable and unchanging, day and night, month after month.

RIGHT:
SEA SLUG
This type of mollusc, more precisely known as a nudibranch, is a distant relative of the gastropod slugs and snails that live in our gardens. Off the coast of Indonesia, this one is in search of a sea pen to eat.

SALT OF THE SEA

'Water, water, everywhere, Nor any drop to drink,' so goes the famous line from Samuel Taylor Coleridge's 1798 poem 'The Rime of the Ancient Mariner'. The water in the oceans is, of course, salty, completely unpalatable and actually very dangerous for humans to drink in any large quantity. Sea water has an average salinity of about 3.5 per cent, which means that there is 35g (1oz) of salt in every litre of seawater. Most of this salt is sodium chloride, but there are other ions in there, such as potassium, bromide and iodide. These are dissolved out of rocks by rainwater falling on mountains and washed into the sea. The salts are also released by hydrothermal upwellings, where water has soaked into the rocks of the seabed and been heated by volcanic activity deep down. The heat serves to release minerals into the suboceanic water, which eventually mingles with the open water above it.

The ocean's water is constantly on the move. It is saltier near the equator and less so at the poles. This difference is based on the relative temperatures of the water in these places, and the gradients of temperature and salinity set up a slow but immensely significant current called the thermohaline circulation. (The 'haline' part refers to salt; the natural form of sodium chloride found in dry rocks is called halite.) The thermohaline flow sees surface waters spreading from the equator to the poles. There the equatorial water sinks and returns as deepwater flows that head back to the tropics, where they surge back to the surface as upwellings. It is estimated that a water molecule takes at least 1000 years to complete the entire circuit. The circuit is also known as the global conveyor.

ABOVE:
BLUE STARFISH
This echinoderm is a feature of Australia's Great Barrier Reef. It crawls in slow motion over the corals and rocks grazing on algae. The blue colour signals to predators that the starfish contains toxins. If it is attacked, the starfish will drop a limb to make an escape, and regenerate a replacement.

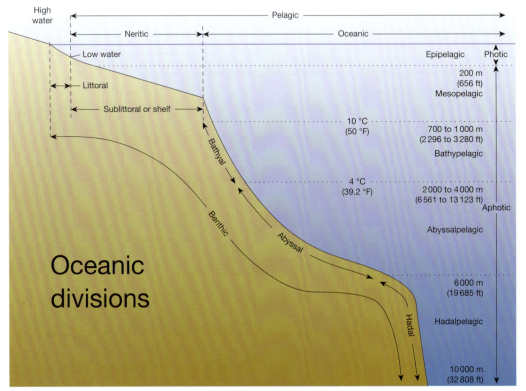

LEFT:
OCEAN ZONES
The oceans can be seen as several zones, with a tidal zone near the shore, a seafloor that slopes down into the deep and a water column that is divided up by depth, light level and water temperature.

OPPOSITE:
GIANT KELP
This is the dominant species in the underwater kelp forests off the coast of California. These massive brown algae can grow up to 60m (196ft) long and have gas-filled bladders that keep them afloat in the sunlit water column.

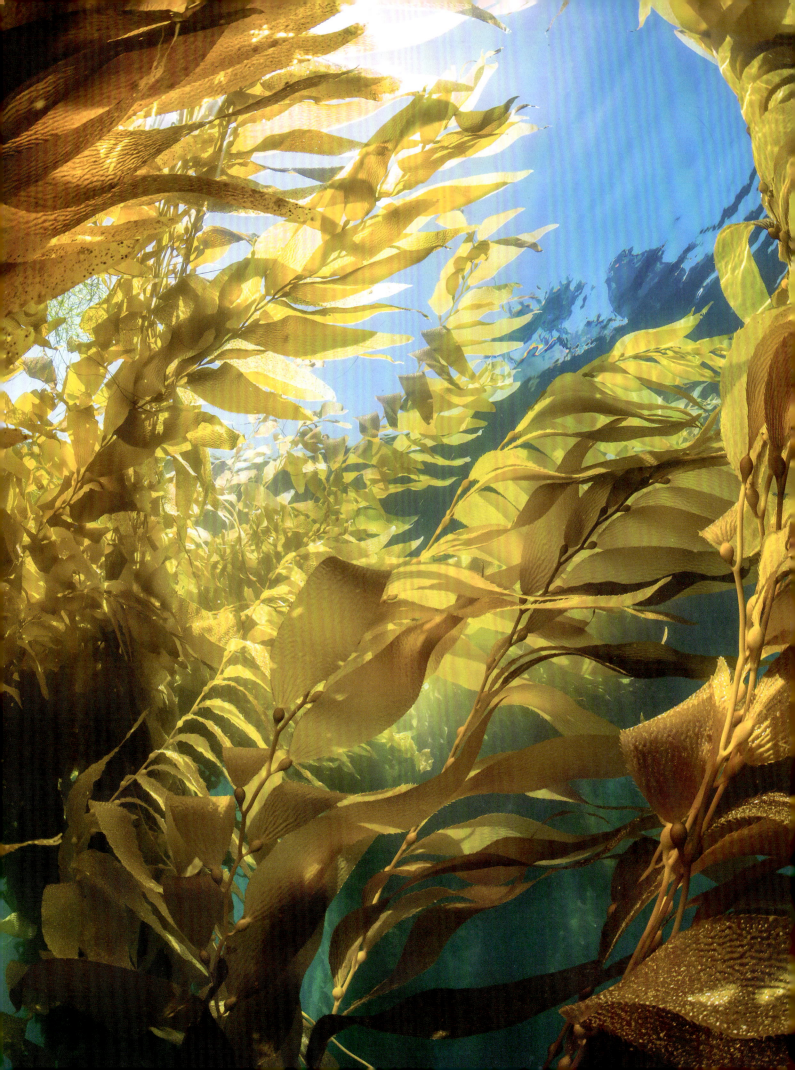

SALTWATER

BLUE WHALE
The largest animal on Earth is seen here swimming beneath the surface of the Indian Ocean just off Sri Lanka. The vast 30m (98ft)-long creature filters shoals of tiny crustaceans from the water. The blue whale is migratory and travels thousands of kilometres each year.

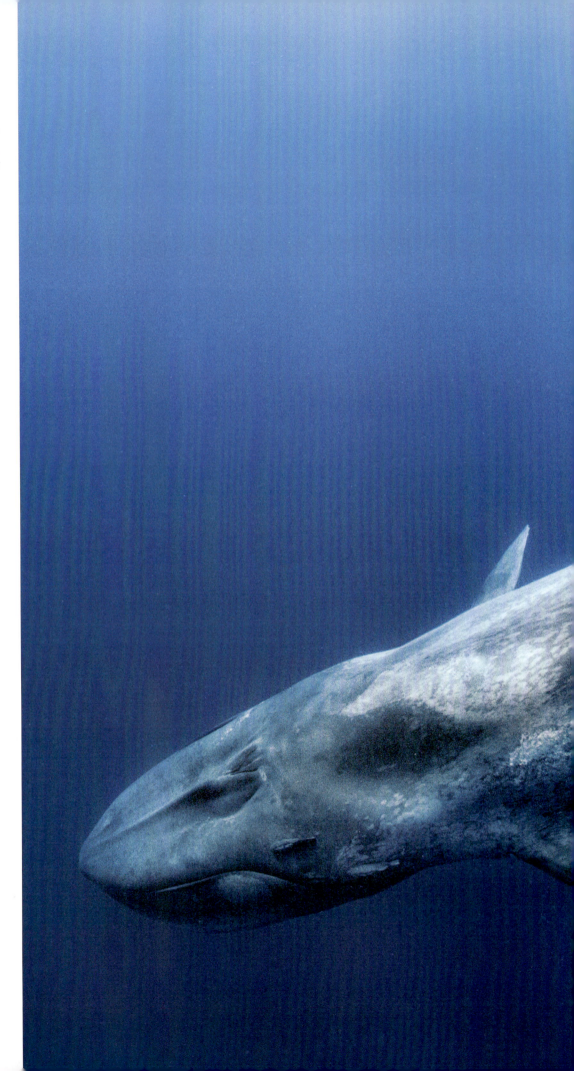

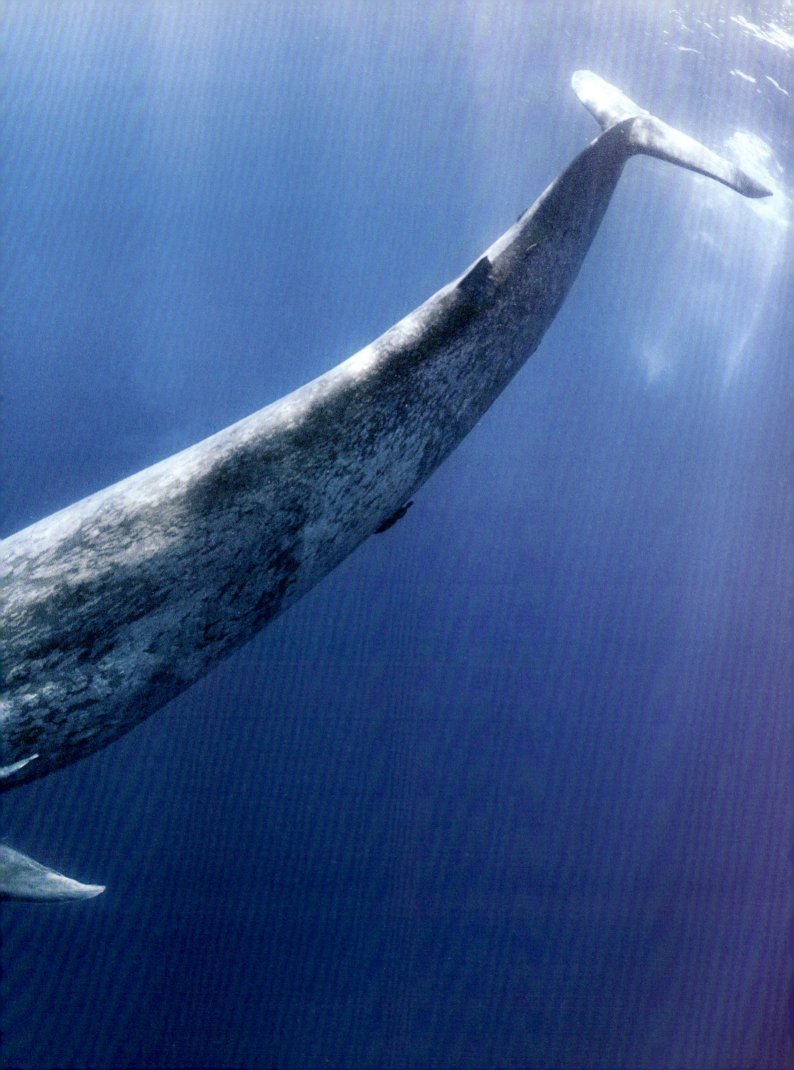

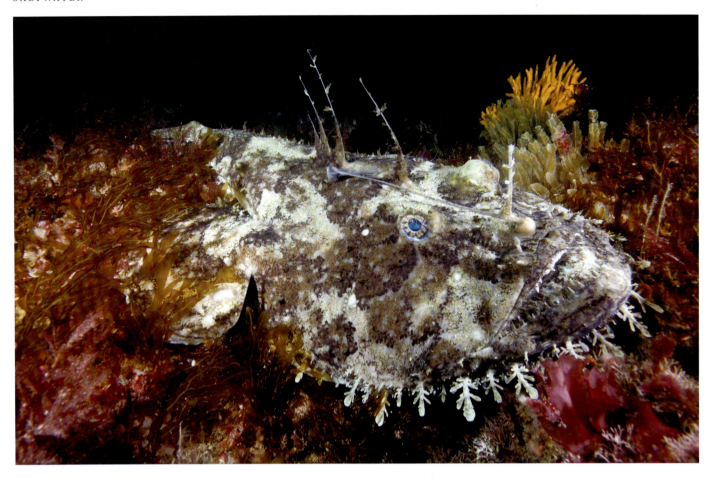

ABOVE:
ALLMOUTH ANGLERFISH
This predatory fish is lurking on the dark seabed, using feathery fringes to blend into the seaweed. The fish has a large hinged jaw lined with sharp, inward-pointing teeth that allows it to snaffle prey almost as large as itself. It has a bioluminescent spine poking out of its head, which attracts its victims closer.

This is because, despite being sluggish in the context of a single molecule, it is shifting vast amounts of water, delivering oxygen to the deep water and bringing up important minerals and nutrients to the surface.

Another way water moves is as it evaporates into the air to form rain clouds. This departing water leaves any dissolved salts behind – that is why rainwater is not salty – but even so the oceans are not getting saltier. Around 4 billion tonnes (4000000000000kg) of fresh salt are dumped into the oceans each year, but that is matched by the quantity of dissolved salt that is removed from the ocean and deposited as solid material on the ocean floor – largely in the shells and skeletons of once living things.

LIVING IN SALT WATER

The problem with salt water, for terrestrial life at least, is that it is saltier, or more concentrated, than the fluids in the body. In chemical jargon, salt water is hypertonic. This is an issue because of a physical process called osmosis. Osmosis is a kind of diffusion that happens in and between cellular structures. Diffusion is a phenomenon that results from the random motion of particles in fluids. Given time, a mixture of particles, such as atoms and molecules, will mix perfectly. This is because their random motion this way and that results in them spreading out to fill all available space, going from where it is tightly concentrated to where it is not. The result is it becomes evenly concentrated across the whole space. Diffusion is not a goal of the material to do this but simply one feature of its motion – and a very useful one. Life relies on diffusion. For example, oxygen travels into the body by diffusion where it is in short supply and in low concentration.

Osmosis is diffusion that occurs across a cell membrane. The membrane allows water and other small molecules to move through in either direction, but other substances are stuck on one side or the other. During osmosis the water's movement has the effect of evening out the concentrations of the fluids either side of the membrane. So when a body cell is surrounded by seawater, the concentration on the outside is higher than on the inside. As a result water leaves the cell, thus increasing the concentration of the fluid inside. When the concentrations inside and outside are equal, the water does not stop moving . Instead, it moves at an equal rate in both directions, creating a stable equilibrium.

Osmosis is used in the vascular systems of plants to create a force that pushes water up the stem. In the salty ocean, osmosis has the effect of drawing fluid out of cells and out of bodies, which effectively dries them out even though they are surrounded by water.

SALTWATER

RIGHT:
BOTTLENOSE DOLPHINS
This widespread species is famed the world over for its intelligence and playful nature, helped in part by the apparent smile on its lips. The dolphins live in complicated social groups called pods and may move between several in a lifetime.

BELOW:
AZURE VASE SPONGE CORAL
The shape and colour of this reef coral matches the description. The colonial filter feeder plays a crucial role in filtering materials from the waters of the Caribbean Sea.

SALTWATER

LEFT:
ANEMONEFISH
Better known as a clownfish, this species is one of the most famous tropical reef fish in the world. This little fish seeks protection from the stinging tentacles of a sea anemone. The fish is coated with mucus, which prevents stings. Predatory fish cannot get close to it.

BELOW:
WARTY COMB JELLY
This small gelatinous creature is often mistaken for a jellyfish. However, it is a ctenophore, belonging to a different phylum. It devours the microscopic zooplankton floating in the dark water.

One solution to this problem is to maintain the same concentrations inside the body as outside. This is called being an osmoconformer. Most marine invertebrates are osmoconformers. They include jellyfish, crustaceans and molluscs. This strategy is not quite as simple as it first sounds. For example, there are plenty of sodium and chloride ions in the body tissues of an osmoconformer, and both of them are highly involved in multiple metabolic pathways, such as nerve signals and muscle contraction. However, they need to be balanced out with other ions, such as potassium, and the organism works hard to collect this from the water.

There are also vertebrate osmoconformers. Primitive jawless fish do it in the same way as sharks. (The sharks represent a separate lineage to that of the bony animals of which fish and all the land vertebrates share.) Sharks elevate the concentration of their body fluids by storing urea in the blood. Urea is the toxic chemical expelled in urine. High concentrations are deadly, so sharks have to counter its effects with large amounts of other chemicals.

Another option is to stop the water leaving the body, and work constantly to replace whatever is lost. Seaweed does this, for example, but by coating themselves in gooey gel. Many fish

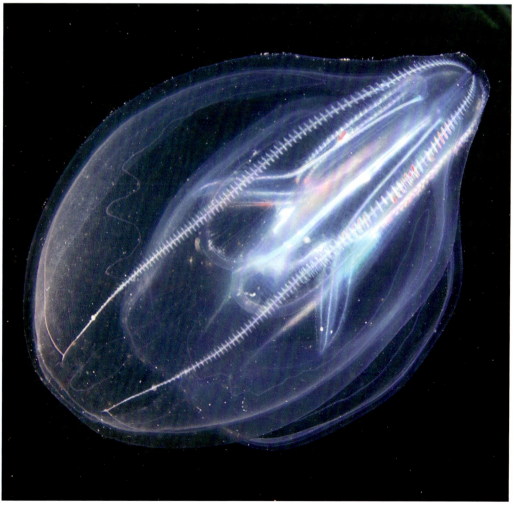

SALTWATER

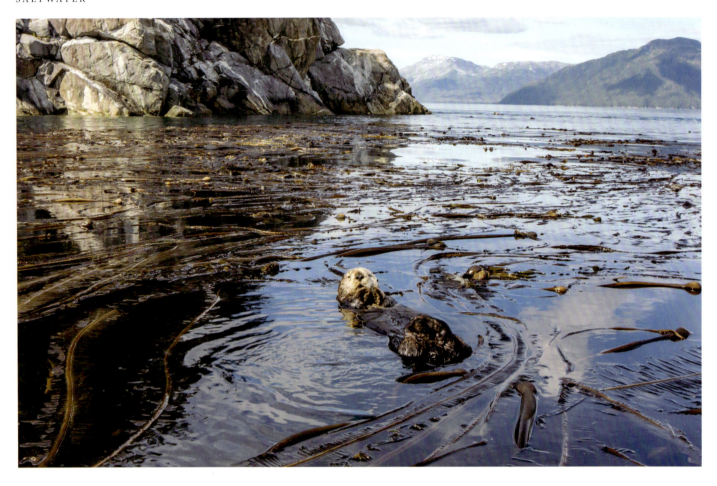

ABOVE:
SEA OTTER
A sea otter floats on its back, cleaning its fur. These animals rely on a thick coat and a layer of blubber to stay warm in the consistently cold waters off the northern Pacific coast. To catch their diet of shellfish, they dive into the kelp forest to catch a meal, return to the surface and smash it open with a pebble held in their paws. The sea otters eat the sea urchins that graze on kelp, and in so doing the sea mammals help to sustain underwater forests, which absorb storm waves and reduce coastal erosion.

also take this approach. The only source of water available is salty, and so marine fish are drinking it almost constantly, and all the while pumping out the unwanted salts, generally via the gills.

UNDER PRESSURE

The problems of salt are the same across all the world's oceans. However, the oceans contain several zones where life has to contend with a host of different ecological challenges. The two most significant are light and pressure. Taking the second of those first, water pressure increases with depth and fast. The pressure exerted at the ocean's surface – the sea level – comes from the weight of the column of atmosphere pushing down from above. It takes a column of water just 10m (33ft) deep to exert the same pressure. So by 100m (328ft) depth, the pressure of the water is 10 atmospheres. At the average ocean depth, it is 370 atmospheres, and at the deepest points on the seabed, which are more than 10km (6 miles)

BELOW:
JAPANESE WIREWEED
This large brown algae is native to the Western Pacific. It has been spread worldwide on ship's hulls and is proving to be a highly invasive species along the coasts of Europe and North America.

underwater, the pressure is 1000 times that at sea level, or the equivalent of a tonne of force pushing on every square centimetre of a body.

For a human diver, pressure is a deadly factor that puts severe limits on diving and also on submarine travel. (Few craft are built to withstand the forces of a deep-sea dive.) For a marine creature the impact is less drastic. For most the pressure inside the body is equal to the pressure outside, so there is no risk of crushing injuries. For diving animals that breathe air with lungs but dive to great depths, such as the sperm whale, elephant seals and emperor penguins, things are not so simple. The internal pressure starts out as equal to that of sea level.

As the animals dive, the water begins to crush the body. The weak point is the thoracic cavity, where the lungs and other vital organs are located. Unlike a land animal, which stores air in the lungs as a source of oxygen, the diving animals shift the oxygen to the blood and muscles. That means they can allow the lungs to be collapsed safely by the pressure. The whales even have articulated ribcages that fold down as the water pushes in.

BELOW:
CLEANING SERVICES
A pufferfish is being given a good clean by two bluestreaks cleaner wrasses. The smaller fish are nipping lice and other parasites from the bigger fish. This is an example of a biological relationship called mutualism. Both species are gaining from their association.

ABOVE:
GOOSE BARNACLES
It was once thought that these barnacles were an embryonic, undeveloped form of barnacle geese. The two species share the same colours, and live in the same habitats, but the science of biology intervened to reveal the truth about reproduction, embryology and evolution. When submerged, the barnacles will unfurl their feathery legs and filter food from the water.

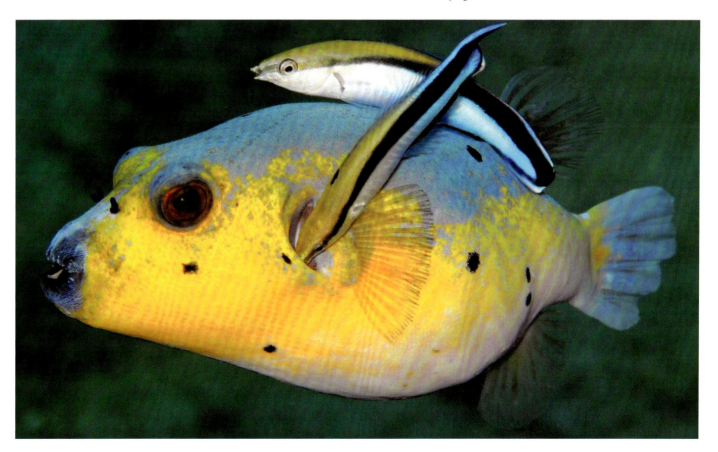

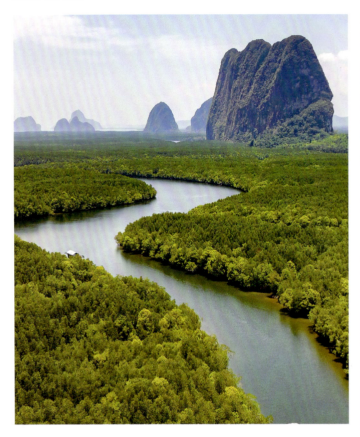

ABOVE:
MANGROVE
The tidal flats of Phang Nga Bay in southern Thailand are filled with mangrove forest. This is a tropical habitat where the trees grow out of the waterlogged sediment. The woody roots of a mangrove tree are not confined to underground as is typical of a plant's roots. Instead they rise into the air, so they can access oxygen even as the water levels around the trees rise and fall each day.

RIGHT:
AMERICAN CROCODILE
This species lives along the tropical coasts of the Americas from Florida and Baja in the north to Peru and Venezuela in the south. It is one of just two crocodilian species that is able to move with ease from salt water to fresh water. The other is the saltwater crocodile of the Indo-Pacific.

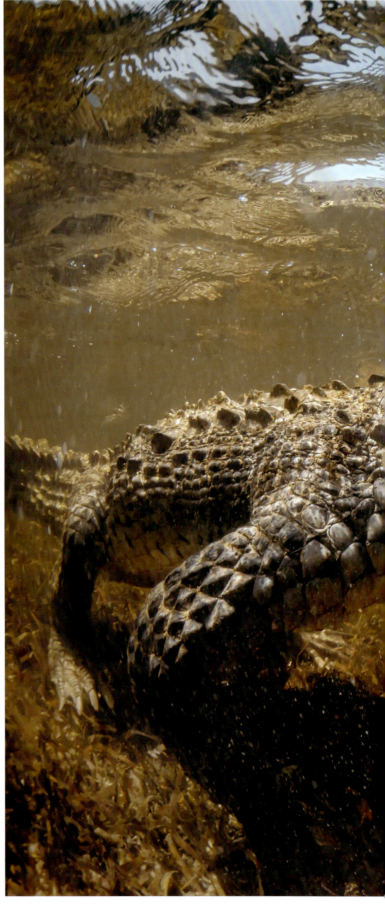

Most fish will stay at around the same depths, although some will make extensive vertical journeys. Their bodies are elastic enough to handle the pressure changes, which are only gradual. Most fish also handle pressure changes using a swim bladder. This is an internal bag that inflates with gas, most often oxygen, that bubbles out of the blood. (Some fish use oil instead of gas.) The bladder gives the fish control over its buoyancy. Absorbing the gas back into the body makes the animal sink, while pumping in more makes it float up to the surface.

Deep-sea fish living under pressures of 100 atmospheres or more, cannot use swim bladders so easily. The quantity of gas needed to maintain an adequate pressure would simply be too great. Instead deep-living fish have flexible gelatinous bodies that are compressed into a more conventional fish shape by the great pressure, and thus maintain a density near to that of the surrounding water (therefore they float). When these fish are

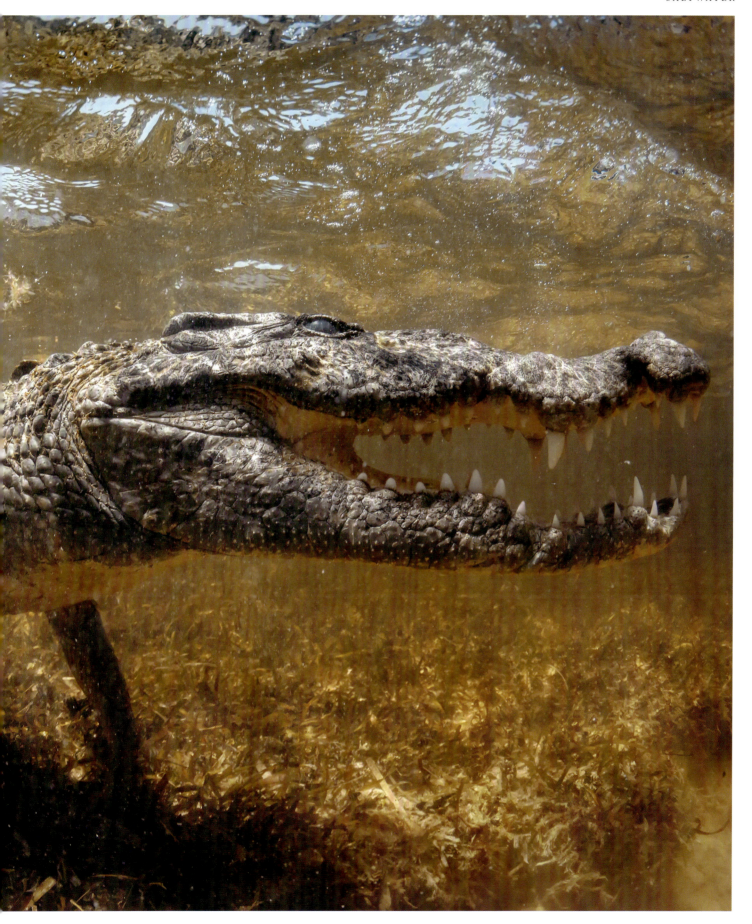

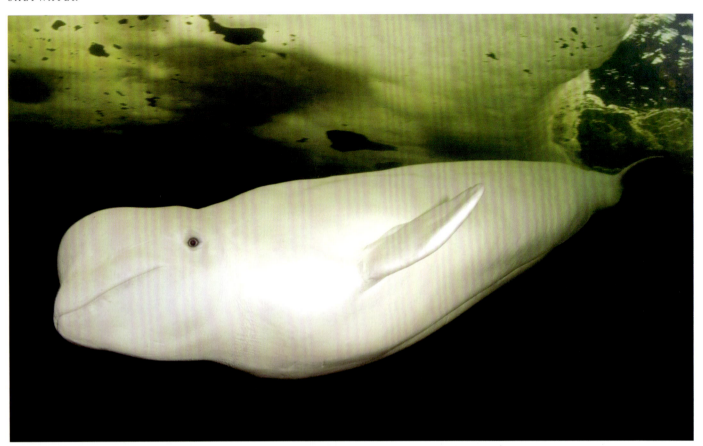

ABOVE:
BELUGA WHALE
The name of these distinctive whales means 'white' in Russian. The white whales live along the edge of the Arctic sea ice, and their colouring helps them appear to be small chunks of ice. The beluga is sometimes known as the 'canary of the sea,' because some of their vocalizations are audible to humans – even through the hulls of ships.

LEFT:
GREEN ALGAE
A mass of filamentous algae has formed in the shallow, warm waters of the eastern Atlantic off Galicia, Spain. The algae are forming a bloom, where the growth conditions are near perfect so the organisms form a green layer at the surface.

OPPOSITE:
BELCHER'S SEA SNAKE
This snake hunts in the coral reefs of West Papua in the Pacific Ocean. The snake can stay underwater for hours, absorbing oxygen through the skin but still surfaces to breathe. The snake only comes onto land to lay eggs.

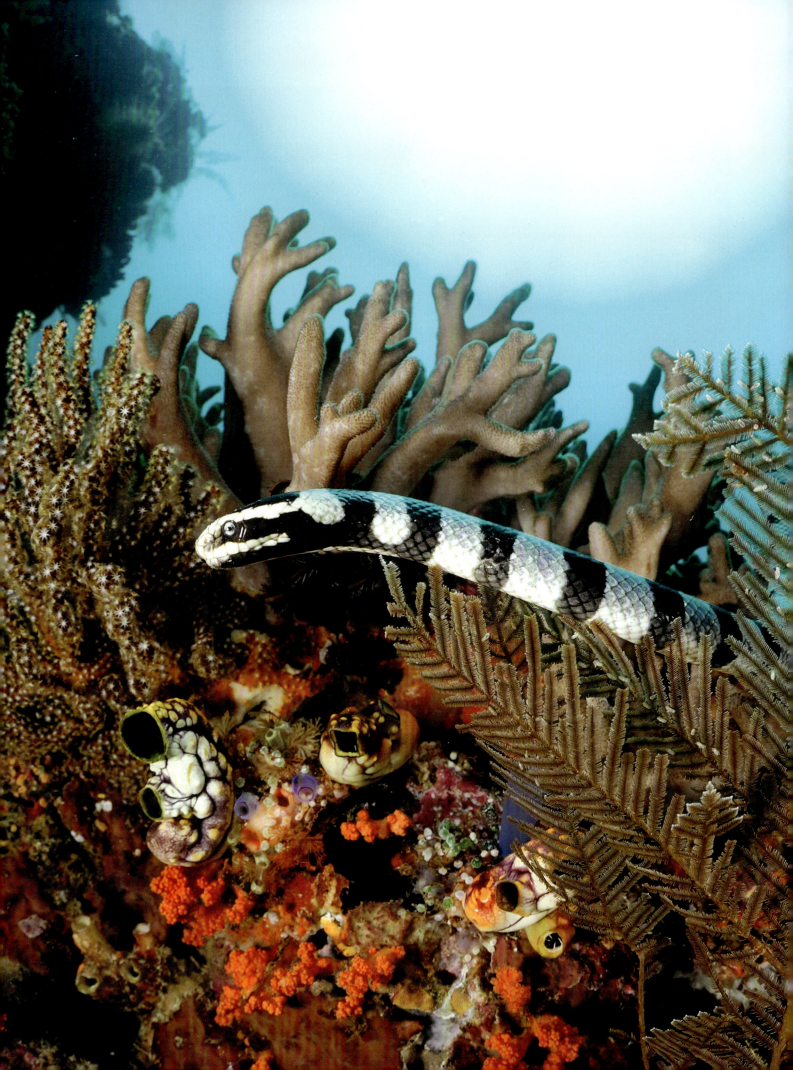

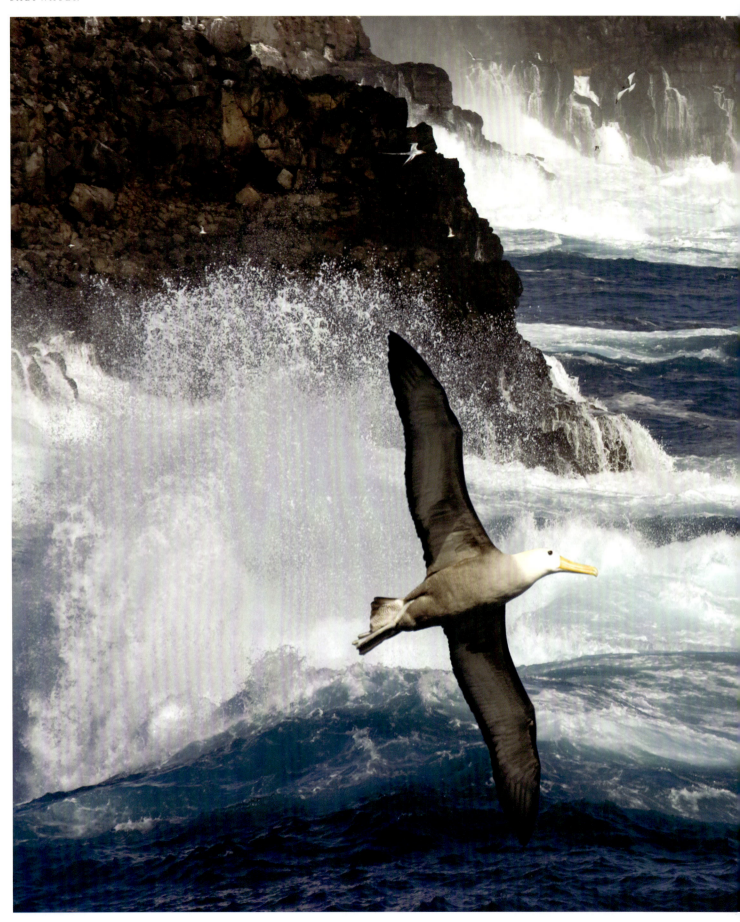

SALTWATER

LEFT:
WAVED ALBATROSS
This magnificent seabird has a wingspan of 2.5m (8ft). This allows the bird to soar on the ocean wind. At night they dip down to the water, grabbing squid as they come up to the surface to feed in the dark. The birds gather in remote island cliffs to breed.

BELOW:
FINAL VIEW
If you see this in real life, your chances are slim. A white shark, the largest predatory fish, prefers to eat blubbery seals. It will take a bite from its target to assess the taste, and generally spit out humans unlucky enough to be attacked.

hauled to the surface, the reduction in pressure makes them transform into a literal blob.

LIGHT ENVIRONMENT

Just as pressure is increasing with depth, the amount of light in the oceans decreases. The changing light levels create three zones in the open ocean, defined by depth. The first is the euphotic zone, otherwise called the sunlit zone. It extends from the surface to a depth of 200m (650ft) in clear water. This lower limit is set at where algae and seaweeds can get enough light to photosynthesize. In waters obscured by sediments, the euphotic zone may only extend down a few metres.

All photosynthesis, all primary production, takes place in this top, narrow sliver of ocean. All the energy that will power the lives of every ocean creature, great and small, is captured here. No plants or plant-like organisms can survive deeper down, and almost all life found outside of the euphotic zone is nevertheless reliant on it. (The exceptions are the communities around hydrothermal vents.) This, in a nutshell, is why the seas are so comparatively empty of life compared to the land. However, one should not think of the oceans as lifeless. Don't forget that they are home to the largest animals on Earth, vast schools of fish, and some of the most terrifying hunters. And many of those are found deeper down.

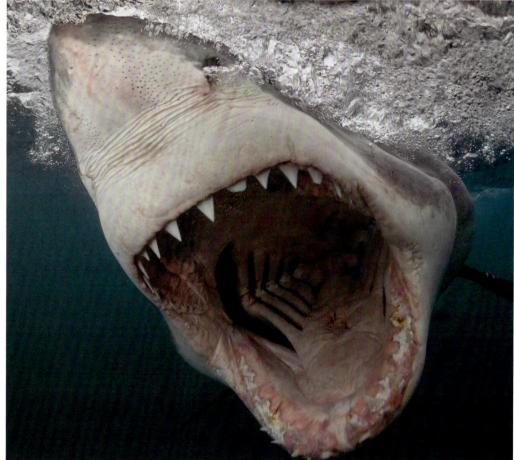

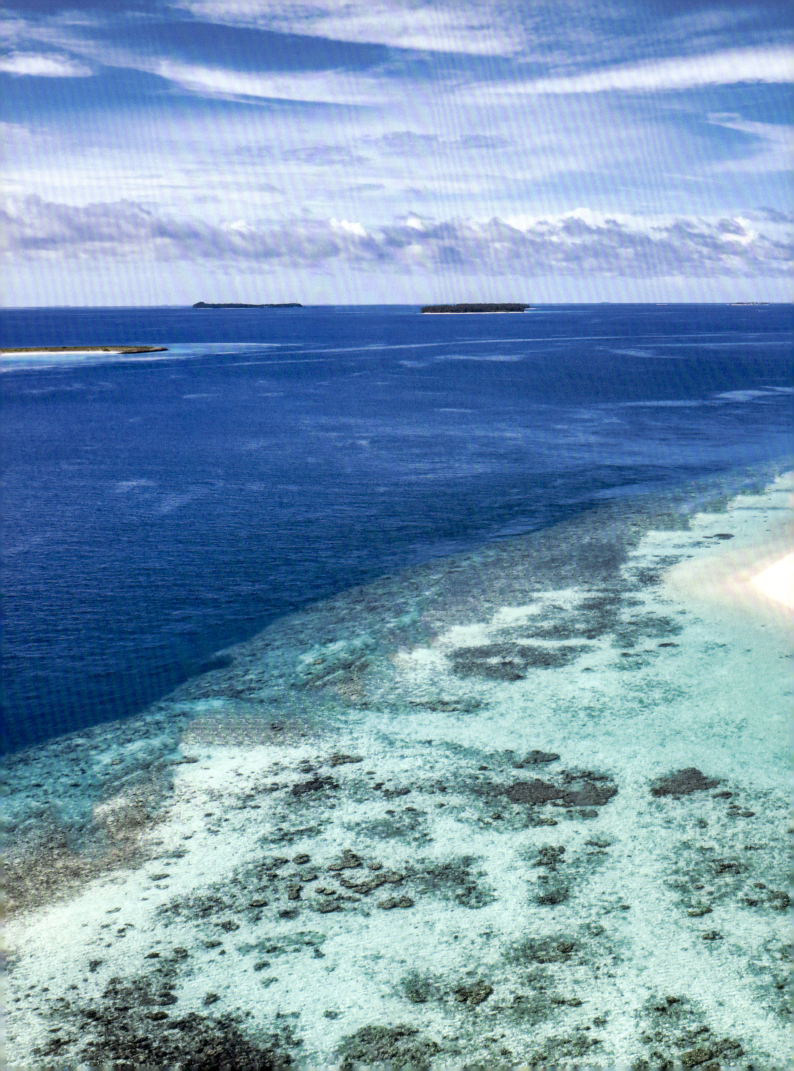

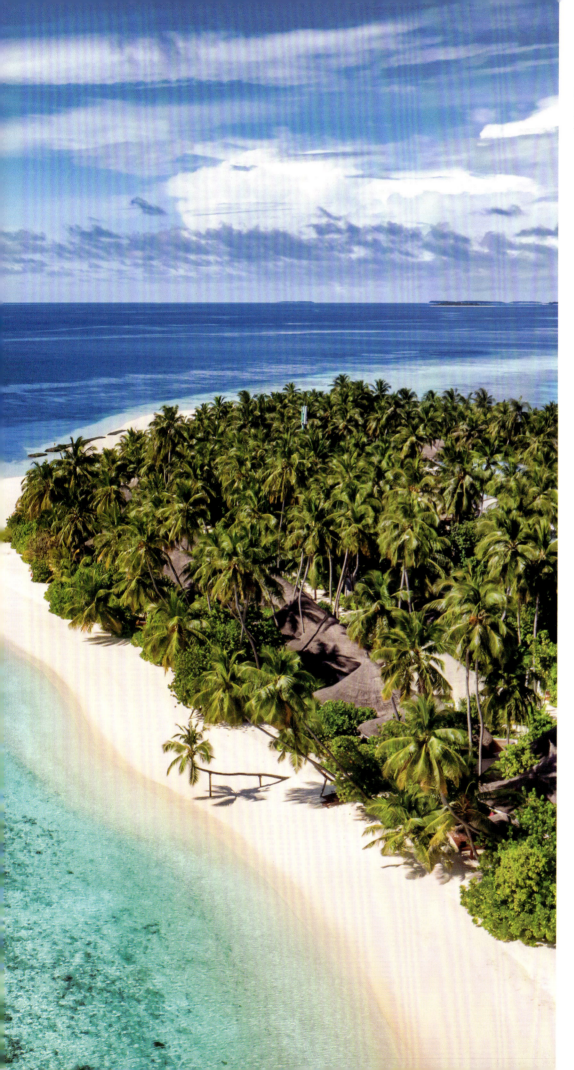

SALTWATER

DESERT ISLAND
Remote ocean islands, such as these in the Maldives, are a haven for unique wildlife in and out of the water.

ENTERING TWILIGHT

At the base of the euphotic zone, the water transitions to the dysphotic zone, otherwise called the twilight zone. Light is still able to penetrate here during the day, but it is too gloomy for photosynthesis. There is enough light to discern night from day as far down as 1000m (3290ft), which marks the end of the dysphotic zone.

There may be no plant-like organisms here, but the dysphotic zone is actually rather crowded with animals. These include a wide range of fish, squid, copepods (microscopic crustaceans) and jellyfish-type beasts. Many are bioluminescent, producing flashes of their own cold lights. The lights may be lures to draw smaller creatures close enough to eat or they may be to communicate with other members of the species, to attract mates or maintain schooling formations.

The dysphotic zone is used by these animals as a hiding place. Down here in the gloom, they are invisible to the organisms swimming higher up in the euphotic zone. Looking down into the twilight water reveals only a gathering darkness. However, looking up to the sunlit surface reveals stark silhouettes of the creatures swimming overhead.

Twilight zone hunters, such as sharks, will target prey from beneath and then surge up into the sunlit zone to strike only becoming visible when it is too late. To defend against this kind of attack, marine animals deploy countershading. This is when the top of the animal is dark in colour, while the underside is

RIGHT:
CUTTLEFISH
This relative of the octopus and squid is a master at changing colour. The skin has thousands of chromatophores, which hold pigments and expand and contract to create colours. The cuttlefish uses this skill to camouflage itself and express mood.

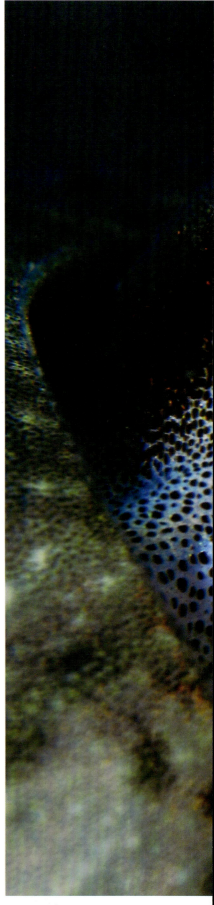

BELOW:
ROCKY SHORE
A coast made of rocks is a violent place. The hard rock does not absorb the energy of the ocean swell like a sandy beach, shingle ridge or mudflat does. Instead the energy is reflected back, creating a crash of water and fountains of spray. Anything living here needs to withstand these turbulent waters.

ABOVE:
BIGFIN REEF SQUID
This species from the Indian Ocean and West Pacific is typical of squid. It has a torpedo-shaped body and tentacle-like arms. The squid is a mollusc, which makes it a relative of a snail or oyster. The arms are actually the same structure as a snail's foot, the slimy slab of flesh that it crawls on. The arms emerge from the head and surround the squid's beak-like mouth. The squid generally swims head first, propelled by squirts of water.

RIGHT:
MEET THE RELATIVES
This blue tube-shaped creature is a tunicate living in the waters off Komodo Island, Indonesia. It is our closest invertebrate relative. A pair of colourful isopod crustaceans are scavenging on its surface.

OPPOSITE:
YELLOWFIN TUNA
This is a highly migratory fish that is found worldwide in warm tropical and subtropical waters. Its streamlined body is packed with resilient muscles that can power it through the water at high speeds. The fish also has grains of iron oxide in the snout, which might allow them to track Earth's magnetic field as they make long journeys.

pale. These patterns make it harder for predators looking from either above or below to spot a target.

There is another way to stay hidden in water, one that is very common in fish that swim in the sunlit and twilight zones. The colour of water is blue. It appears colourless when viewed in small amounts, but get enough of it together and it looks blue. So perhaps the best colour to be in the sea is blue. That way a fish would blend in with the water. In the same way, grasshoppers are green to stay out of sight in a meadow.

However, comparing these two habitats is to make a category error. The water in the sea is akin to the air in the meadow. To blend in with air, the grasshopper needs to be transparent.

SALTWATER

Water is blue because it has absorbed all the red and green light arriving as sunlight. It transmits the blue wavelengths, and these rays reflect from ocean life illuminating them to be seen by others. A colourful fish will absorb some of the rays and reflect others and thus appear as a darker object in the water. Colour has less meaning down here; it is all about contrasts.

So what do small fish do in this situation? They have mirror-like scales that reflect all the light that hits them. The light from one direction is much the same as the light from another, so reflecting light back is a rough equivalent of allowing light to shine right through the body. The result is that in the water, the mirror scales give the fish an invisibility cloak.

VERTICAL MIGRATION

The camouflage of creatures dwelling up in the euphotic zone will not keep them safe from most of the predators lurking down in the dysphotic zone. They are waiting for it to get dark before they attack. As night falls at the surface, the whole ocean goes dark, and the squid, fish and other predators at lower depths head up to the surface to feast there. Around 90 per cent of marine life is in the photic zone so this is the place to come to feed. There are predators specialized to target all kinds of prey

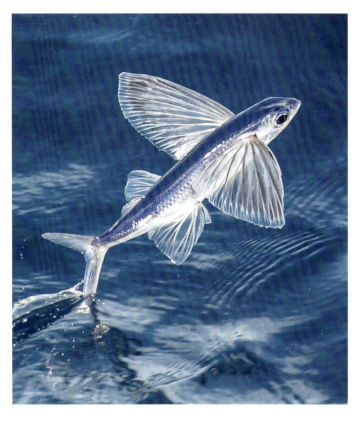

ABOVE:
FLYING FISH
This fish is under attack. There are predators, probably tuna, under the surface and the way to escape is to leap out of the water. The fish uses rapid flicks of the tail to throw itself through the surface, and then it glides as far possible on its wing-like fins. It does not actually fly.

BELOW:
ORCA
Better known as a killer whale, this is the largest member of the dolphin family. They are instantly recognizable with their black and white colouring. These highly intelligent and social animals live in complex pods. Orcas are apex predators, and each pod specializes in targeting fish, squid, seals, dolphins and even larger whales.

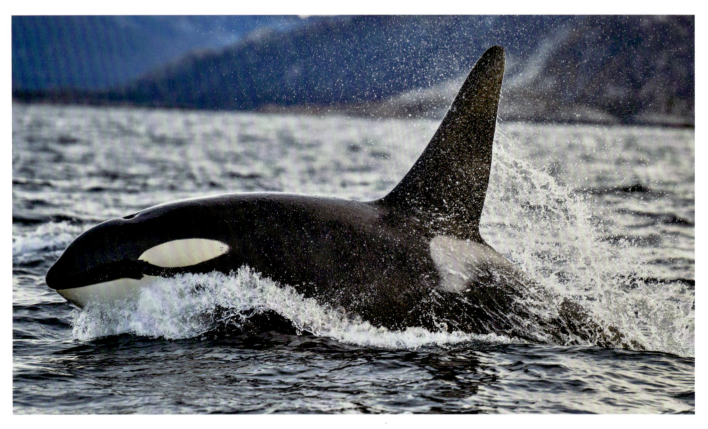

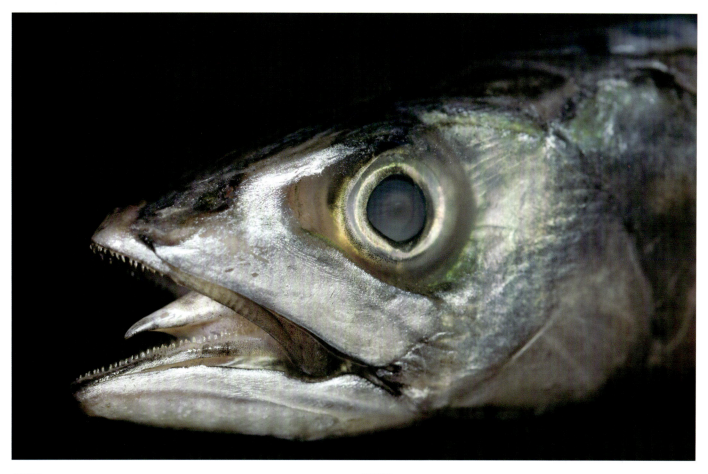

ABOVE:
MACKEREL
A highly migratory fish that moves in large schools, this is a carnivore, feeding on smaller fish, crustaceans and plankton. Mackerel are in turn an important prey for larger marine predators like tuna, sharks and seabirds.

BELOW:
FUR SEAL
So named as their coats are thicker and shaggier than the seals, this species is actually a sea lion. The big clue is that it is standing on long front flippers, which allow it to crawl on land. The sea lion also has obvious ears. A true seal has shorter flippers and can only shuffle on land.

from the tiny planktons up. They are using the bioluminescence to set traps and lure in victims.

The result is the largest migration on Earth known as the diel vertical migration (DVM). The DVM sees uncountable masses of animals swimming up at dusk and then down again at dawn. They are getting out of sight before the daytime hunters, such as tuna, that rely on vision are able to target them. Among the migrators are small fish called bristlemouths. These prey on zooplankton (tiny animals in the plankton) and are said to be the most abundant vertebrates on Earth. Quadrillions, or millions of billions, of them are on the move each day.

APHOTIC ZONE

The twilight zone ends at around 1000m (3280ft) down. Below that we move into the so-called midnight zone, but better termed as the aphotic zone. As that word suggests there is no light at all here. It's as if it were midnight 24 hours a day. Up or down the view is the same. It is perpetual darkness.

The midnight zone makes up around 70 per cent of the oceans' water, but it is very empty of life, and poorly understood.

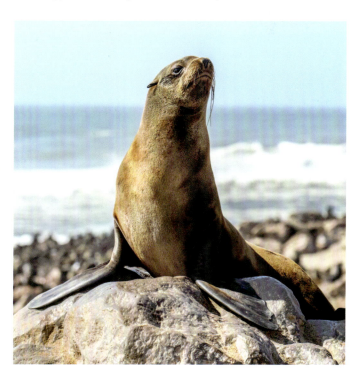

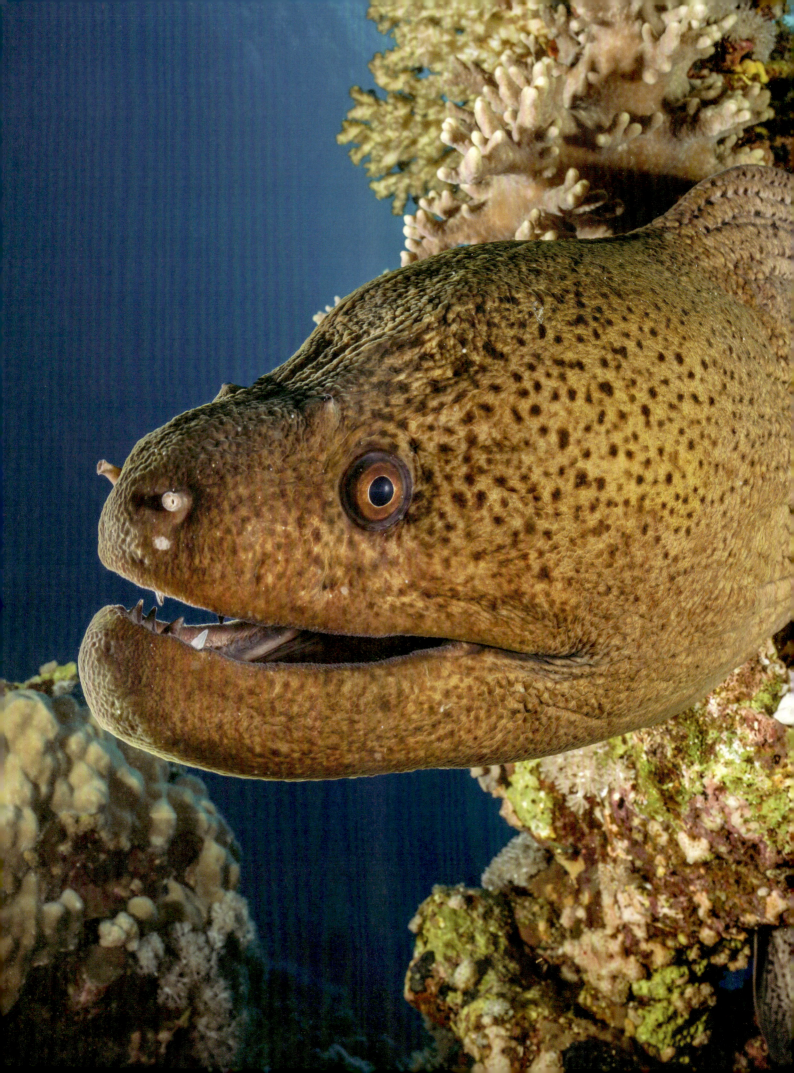

SALTWATER

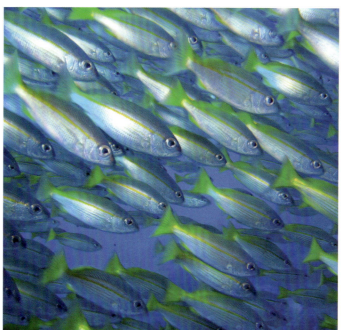

LEFT:
SHOAL
Fish often form a shoal or school that appears to move as one. Each fish is attempting to reach the middle, where it is safer from attack.

OPPOSITE:
GIANT MORAY EEL
A formidable predator found in the warm waters of the Indo-Pacific region, this fearsome fish has a long flexible body and a powerful bite with sharp teeth. These eels are ambush predators, using their keen sense of smell to detect prey and pounce as they swim by.

BELOW:
GREAT SPIDER CRAB
A spider crab clambers up the fronds of kelp in the cold Arctic waters of the Barents Sea near Russia.

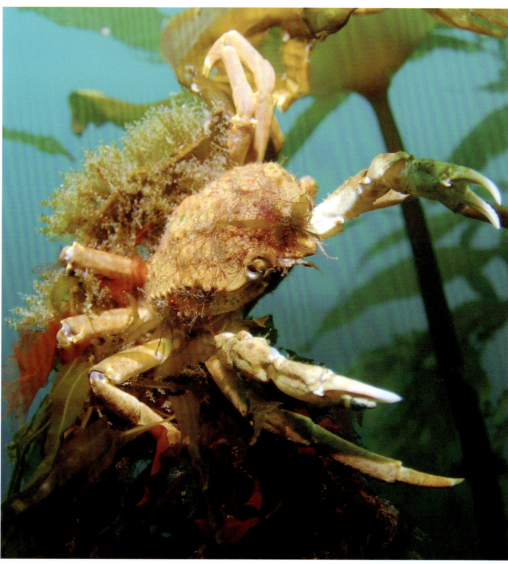

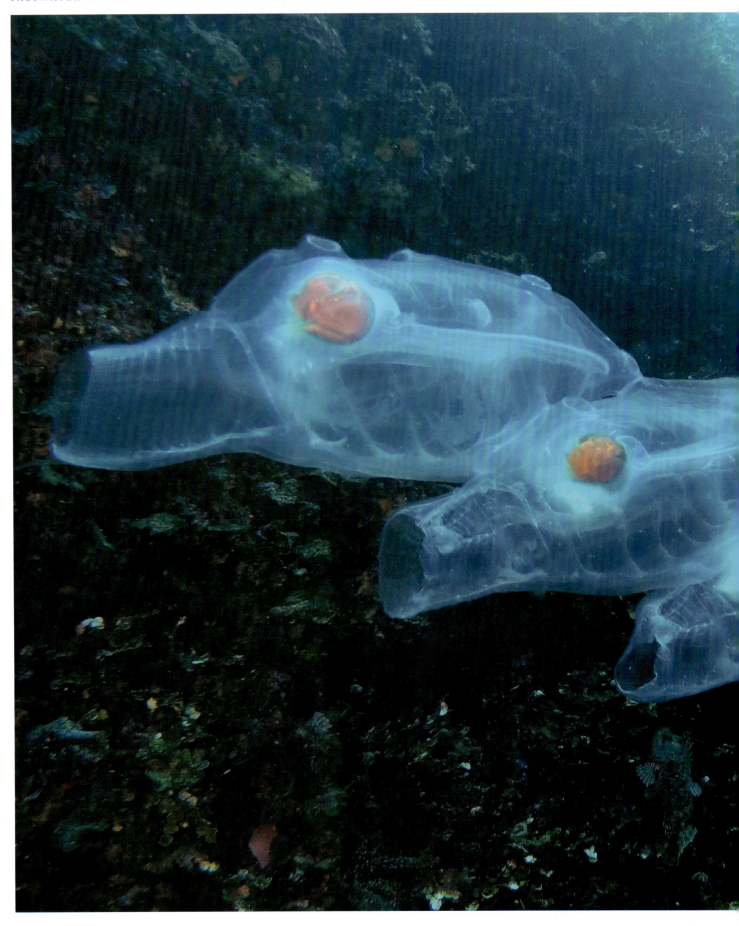

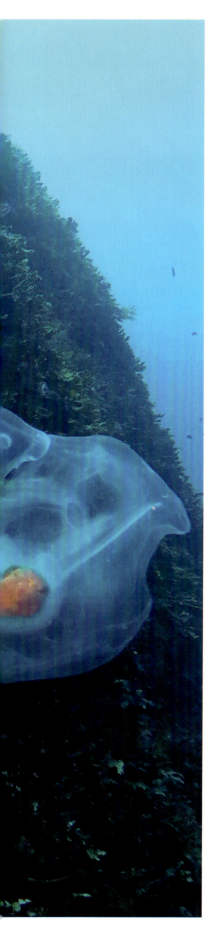

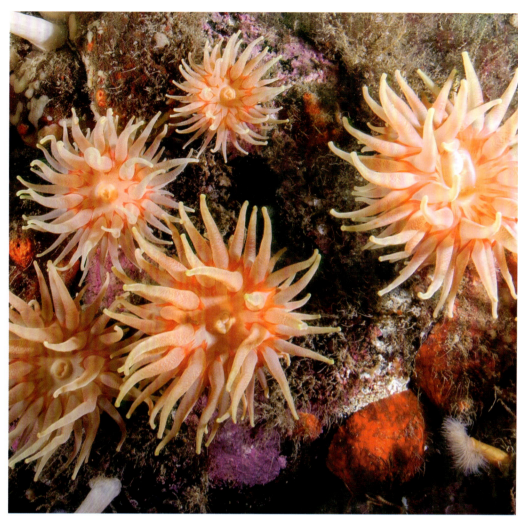

Nearer the surface, oceanographers are taking samples of water that are filled with life. Their sonars are also showing them the vast schools of fish moving around, while radio trackers on sea mammals and sharks have built up a picture of their movements and behaviours. The deeper the oceanographers look, the less they find. Sample nets and cameras lowered into the dark reveal nothing much at all. Life is not missing, it is just thinly spread out, and so the chances are that it goes unseen. However, piece by piece the ecology of the midnight zone is slowly revealed.

It is a long journey to the euphotic zone from these depths. Few creatures embark on the DVM from here. One exception is the giant squid. This is the longest invertebrate on the planet, and so rarely seen that it holds a semi-mythical status. Only one has been seen in its natural habitat, observed by oceanographers on a deep dive in a submersible to the midnight zone. The giant squid can grow to 13m (43ft) long. (There are reports that another species, the colossal squid, which is confined to the Southern Ocean, is a little longer.)

Like an octopus, a squid, giant or otherwise, has eight muscular arms, but there are an additional two feeding tentacles, which are much longer. The tentacles of the giant octopus reach out about 10m (33ft) to snatch fish, smaller squid and

ABOVE:
SEA ANEMONE
An anemone is a relative of the jellyfish. It has the same basic body structure: a rounded body and several tentacles covered in microscopic stinging cells that unleash barbs into anything that touches them. The difference is that the anemone lives the other way up to the jellyfish, with the tentacles facing up, and the body cemented to the seabed.

LEFT:
SALPS
These are planktonic, or floating, tunicates that are forming a colony as the individual bag-like animals cling together. Colonies can grow to several metres in length.

whatever else is around. The giant squid launches raids into the twilight zone, targeting entire schools of fish, which it snares in its suckered arms – the suckers also have claws – before withdrawing to the safety of the dark.

But it is not completely safe down there. The world's largest predator, the sperm whale, is a specialist squid killer. It dives to great depths to do battle with the giant squid. The whale uses echolocation, a biological version of sonar, to locate prey in the total darkness. A clash between sperm whales and giant squid has never been seen, but we know it happens because the whales accrue scarring around their square heads from the injuries inflicted by a squid's claws and beak as it fights back.

RIGHT:
PUFFERFISH SKIN
These spines are held flush to the body most of the time. When the pufferfish is under attack, it earns its name and inflates its body to not only look much larger, but also to force these spikes into a erect position. The flesh of the pufferfish is also laced with the most toxic chemical made by animals, tetrodotoxin, which is 1000 times more potent than cyanide.

BELOW:
WHALE SHARK
This is the largest known fish species, growing to 18m (59ft) long. Despite the immense size and shark lineage, this is a gentle filter feeder that consumes plankton. But stay out of the way – whale sharks have a sieve-like structure in the gills that collects food as they swim along.

OPPOSITE:
GIANT CLAM
This is the largest living bivalve. Older individuals are more than 1m (3ft) long and weigh 200kg (440lb). They live in the coral reefs of the Indo-Pacific region. The colourful flesh inside the shell is due to a symbiotic relationship with photosynthetic algae called zooxanthellae inside.

SALTWATER

LEFT:
DAY OCTOPUS
This species is native to the warm parts of the Indian and Pacific Ocean. Unlike most octopods, which are nocturnal, this animal is active during the day. This is partly due to the animal's remarkable abilities to camouflage itself.

BELOW:
HARD CORALS
Corals are microscopic jellyfish-like animals called polyps that sift food from the water using tentacles. Coral reefs grow on a hard foundation of solid stone, which is composed of the calcium carbonate remains of generations of coral polyps.

Another long distance migrator is the cookiecutter shark. This has been found more than 3km (2 miles) down and each night it swims to the surface during the daylight hours, timing its ascent to reach the surface at dusk. Then it turns tail and swims back down. The aim of this migration is for the fish to encounter as many larger animals, mostly fish but also sea mammals, crossing its path. The little shark (it is about the length of an arm) has a very wide gape when it opens its mouth. It chomps down on its target and then twists its whole body. The result is a brutal bite that cuts out a circular plug of flesh. Larger sharks and whales may receive dozens of these nasty bites, while small fish are unlikely to survive one.

MARINE SNOW

Putting the gargantuan efforts of the midnight zone migrators aside, most of the inhabitants of this region rely on a food called marine snow. This is literally the waste and remains of the life living higher up that sinks through the water column. Zooplankton are there to receive this 'snow', which is more correctly described as particulate organic matter. The midnight zone foragers sweep up this zooplankton. A good example is the gulper eel, which has a jaw that is a quarter of its total body length. This vast mouth leads to an elastic stomach that could expand to contain food the same size as itself. However, large prey like this would be rare. Instead the eel swims into plankton swarms and sucks in big mouthfuls of tiny crustaceans and other critters.

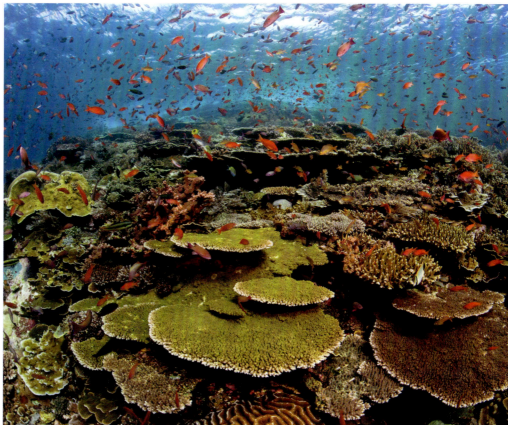

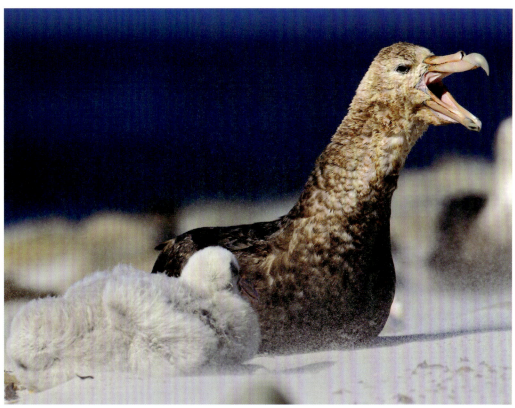

ABOVE:
GIANT PETREL
This is a robust seabird found in the Southern Ocean of Antarctica. It is a scavenger, feeding on the remains of seals and penguins. It is known for its aggressive defence of its eggs and chicks.

LEFT:
PORTUGUESE MAN-OF-WAR
Floating through the Sargasso Sea near to Bermuda, this animal is named for the way it uses a gas-filled balloon to keep it at the surface and catch the wind like the sail of an old warship. This is not a jellyfish, but a colony of specialized, genetically identical individuals called zooids. For example, the long, trailing tentacles will sting and snare fish and then haul them up to be eaten.

Other midnight zone predators are more targeted. The anglerfish (often sold as monkfish back on land) are famous for their glowing lure that dangles on a spine above the mouth. The blue-white light the lure emits is typical of the colours produced by bioluminescencing creatures. They mistake it for a mate, a fellow member of the species pulling the shoal together, or a tasty morsel of food. It's a big mistake; the black anglerfish remains completely invisible as it opens its fanged mouth, thus creating an inward current that sucks the prey inside.

The dragonfish is another midnight zone hunter. It too has specks of blue lights emitting from photophores (light organs) along the body. This helps it blend in with a background of lights created by smaller creatures in the water. The dragonfish also has a larger red photophore under the eyes. These send out beams of dark red light that create a searchlight in the water. Few marine mammals can see this wavelength; humans can just about see the dark light, and the dragonfish uses it as a searchlight, pinpointing fish and other squid that have arrived to feed on the smaller creatures in the area.

GOING DEEPER

By definition, the aphotic zone extends all the way to the bottom, but oceanographers place a floor on the midnight zone at around 4000m (13,000ft) down. The pressures are enormous, so much so that they will deform the molecular shapes of proteins and other crucial metabolic substances. To counter this problem, the animals have stabilizing chemicals in their body fluids. In most oceans, the seafloor is around the bottom of the midnight zone,

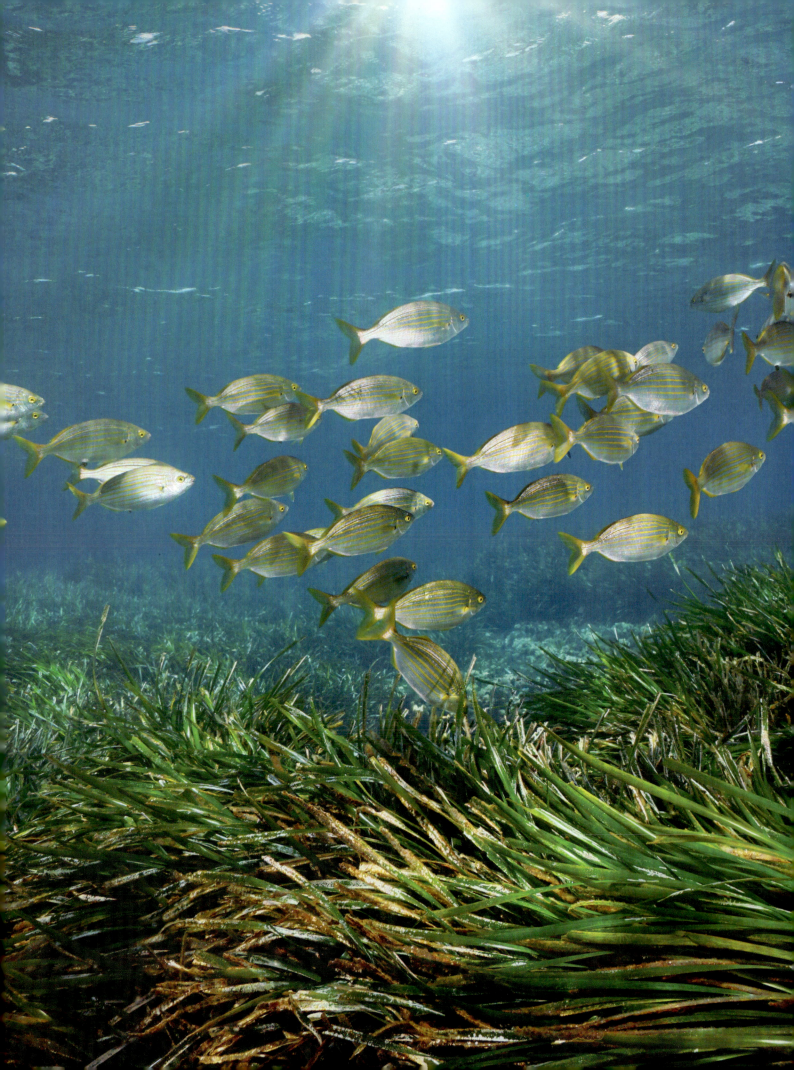

SALTWATER

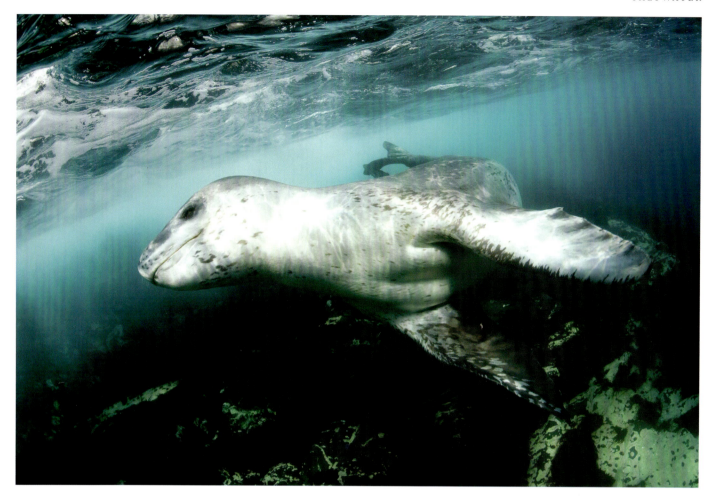

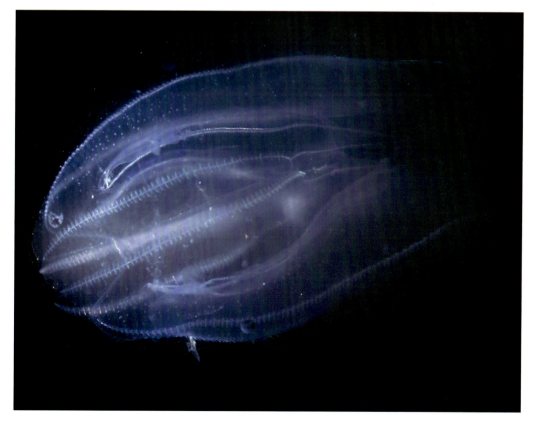

ABOVE:
LEOPARD SEAL
This fierce hunter swims near to Astrolabe Island in Antarctica. Named for its spotted coat, the seal grows up to 3.5m (11ft) long and weighs almost 500kg (1100lb), making it the second-largest seal species in the world. It primarily hunts for penguins but will also target fish and smaller seals.

RIGHT:
SEA WALNUT
This is the alternative name for the warty comb jelly, a kind of ctenophore living in the western Atlantic.

OPPOSITE:
SEAGRASS
While seaweeds belong to separate groups of photosynthetic organisms, broadly collected together as algae, seagrass is a marine representative of the plant kingdom, which dominates freshwater and land habitats. Seagrass forms meadows in shallow, sunlit seas that are a significant food source.

SALTWATER

RIGHT:
GANNET COLONY
Seabirds, such as these gannets, are able to feed out at sea for days or longer, but they must return to land to breed, nest and raise chicks. They frequently form large colonies in inaccessible regions where they benefit from safety in numbers.

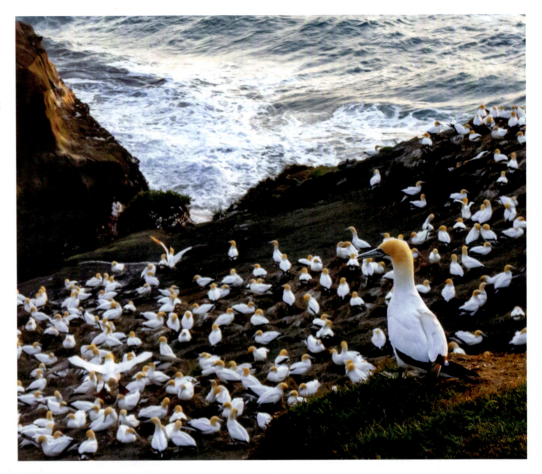

BELOW:
GIANT ANTARCTIC ISOPOD
Marine isopods are generally microscopic in size, or nearly so. However, this deep sea species is huge in comparison. The crustacean, a relative of woodlice on land, lives in the cold seafloor around Antarctica, grazing on the rocks and reaches 20cm (8in) in length. This is an example of polar gigantism.

and so the ecological zone changes with this change in conditions. Oceanographers call this part of the ocean, the abyss. The seafloor of the deep sea is the abyssal plain, an endless plain covered in a fine ooze not made of sand or stones so much, but fragments of shell and the indigestible remains of plankton and other life.

There is life in this ooze, such as worms, shellfish and other filter feeders, and fish, crabs and octopods are patrolling the seafloor seeking them out. There are also scavengers searching for something more substantial to descend through the water. The biggest of such a bonanza is a whale fall, where the carcass of a dead whale sinks to the deep seabed. One whale carcass constitutes around 2000 years of marine snow, arriving all at once.

Nothing is wasted, scavengers such as hagfish will strip the carcass of flesh. That takes a few years, by which time the area has become an island of plenty in the empty abyss. Worms and echinoderms such as brittlestars and sea cucumbers are sifting nutrients that have leached out from the whale into the sediments. After about 10 years all that is left is bones and there are specialists for that. Zombie worms drill into the bones consuming the marrow inside. After 50 years, the carcass is a

OPPOSITE:
GIANT MANTA
As the name suggests this is the largest species of ray. It has a 'wingspan' of 7m (23ft), and it will swim with a flying motion through the sunlit zone. The ray is a filter feeder and it uses forward-facing cephalic fins to channel water into its mouth. Particles are then removed by specialized gill plates.

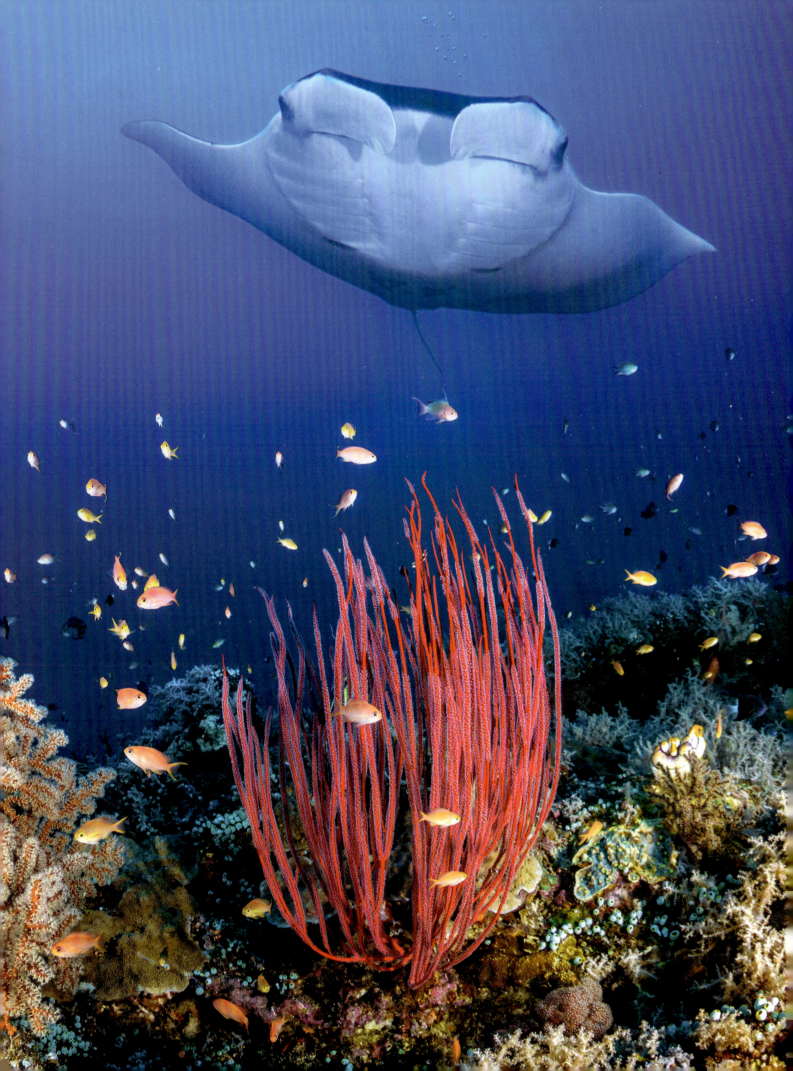

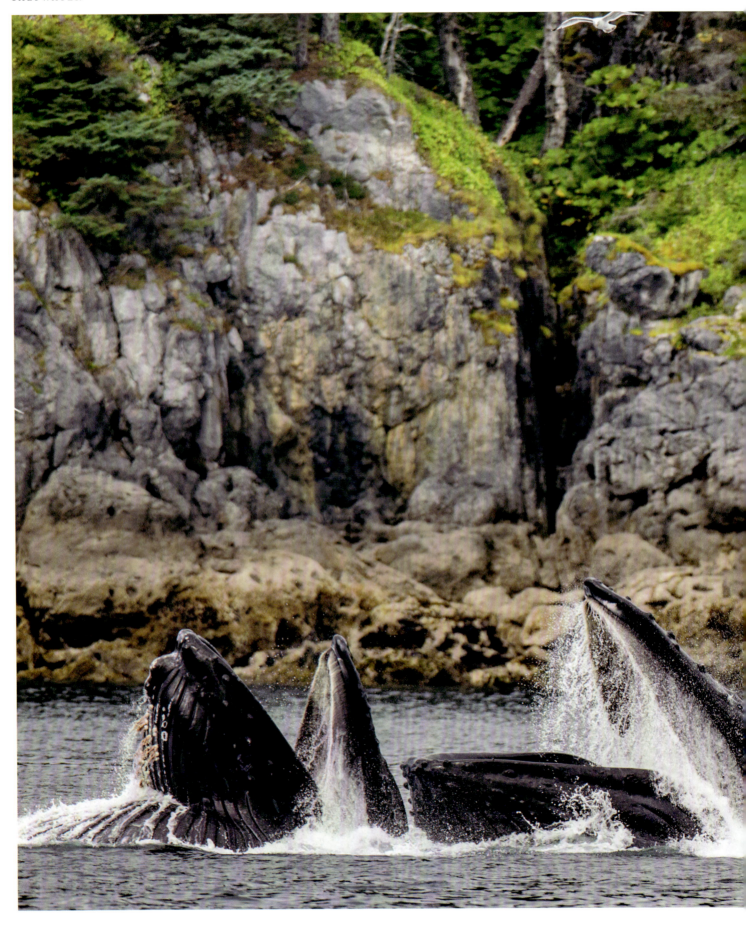

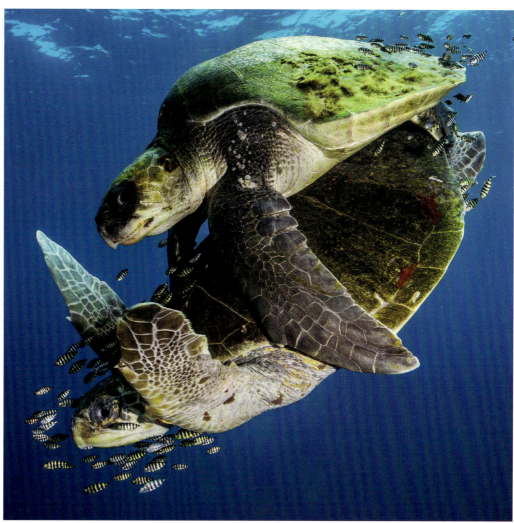

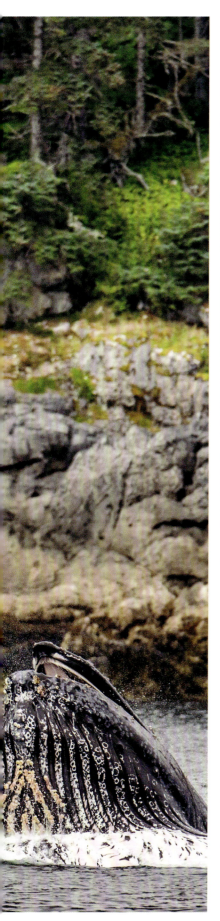

ABOVE:
OLIVE RIDLEY SEA TURTLES
A pair of these sea turtles are seen mating in the Pacific Ocean, off Baja California. The male will stay out at sea for life, but the gravid, egg-bearing female, will return every year or two to the beach where she hatched and bury the eggs in a nest in the sand.

RIGHT:
SEA LETTUCE
The rocks at Porthbeer Cove in Cornwall, England, are draped in the flat leaf-like thalli (singular thallus) of this edible seaweed, a member of the green algae.

LEFT:
HUMPBACK WHALES
A pod of humpback whales surface, mouths agape, as they gobble up a shoal of fish. These whales work together to herd the fish into a tighter ball using a bubble net. The whales circle the shoal, spiralling upwards as they breathe out bubbles that surround the fish. The fish then move closer together so the feeding whale can grab more of them at once.

SALTWATER

BLACK-VEINED PARROTFISH
This coral fish gets its name from the sturdy beak-like mouth, which it uses to scrape the surface of corals, crunching up the calcareous substrate to extract the organic content. The fish then poops out a fine coral sand.

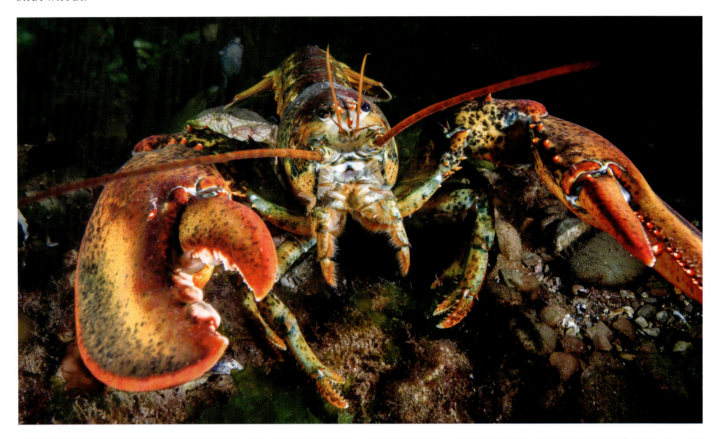
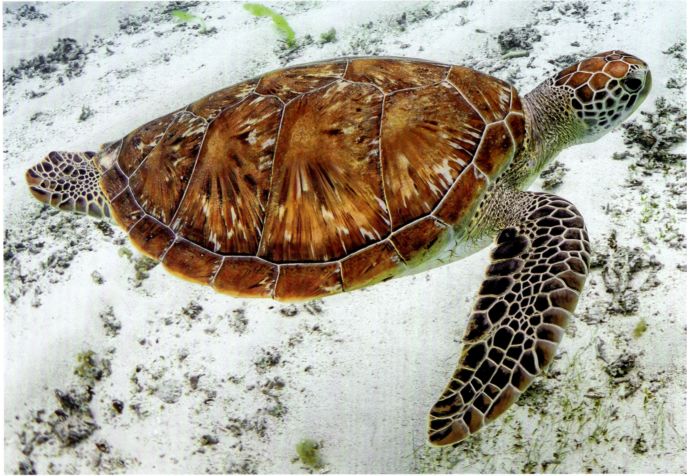

RIGHT:
RIGHTEYE FLOUNDER
As an adult, this famous flatfish, as the name suggests, lies flat on the seabed looking upward to scan for threats. However, the young swim upright with eyes facing sideways. As they grow older, the left eye moves around to the right side in one of the more bizarre developmental processes thrown up by evolution.

OPPOSITE TOP:
AMERICAN LOBSTER
This is one of the larger crustaceans living in the continental shelf regions of the oceans. This species is found along the east coast of the North Atlantic, but is typical of those found elsewhere. It has one big claw for crushing the shells of prey and a smaller one for cutting them up. These big lobsters can live for decades.

OPPOSITE BOTTOM:
LOGGERHEAD TURTLE
As with all sea turtle species, this worldwide species is vulnerable to extinction. It is suffering due to a lack of safe nesting beaches and disruption to its feeding sites.

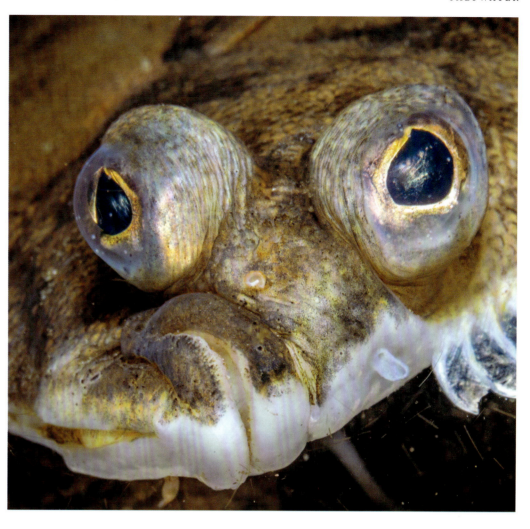

heap of bone fragments, with a nutrient-rich sediment filled with bacteria. The larva of a sea anemone will settle on a bone piece, as one of the few patches solid ground among the soft ooze. The long-gone whale has started something. One day, this patch of seabed may be filled with sedentary animals, like sponges and even deep-sea corals.

THE HADAL ZONE

The very deepest parts of the ocean are ocean trenches that form great cracks in the seabed, many thousands of metres deep. The waters inside the trenches is designated as the hadal zone, named after Hades, the god of the underworld. The deepest point in Earth's hadal zone is Challenger Deep in the Mariana Trench in the western Pacific. It is 10,920m (35,827ft) below the waves, easily deep enough to cover Mount Everest, with 2km (1 mile) of empty water above the summit. This part of Earth is at the extremes of human exploration. Only 22 people have ever been there.

FOLLOW THE SEABED

The oceans are vast basins in Earth's crust that have been filled with water. The seabed is made up of a thin layer of rock called an oceanic plate. The rocks in this plate are dense and heavy, and sink low in the hot, liquid rock that constitutes the deeper regions of the planet. Land masses are made up of continental plates composed of much thicker and less dense kinds of rock that float higher on the surface of the planet. The coast, where ocean meets land, rarely forms where the continental crust and oceanic crust meet. Much of that transitional region is submerged under the coastal seas. The geological features of these coastal seas makes them the most fertile zones in the ocean. About 90 per cent of marine life is found here, on average within 80km (50 miles) of the shore.

The seabed that stretches away from the low water mark is called the continental shelf. This is the edge of the continental plate that is below sea level. The water here from surface to seabed is mostly in the sunlit, euphotic zone. Vast shoals of fish and other sea creatures, such as shrimps or krill, are seen here feasting on the plankton communities that thrive in these waters. Whales, dolphins, seals and seabirds are common sights as well.

At the seaward edge of the continental shelf, the seabed plunges away steeply. This is the continental slope. Water flowing off the land into the coastal seas, brings with it sediments and minerals. These settle out of the water and over the centuries topple down the continental slope – a key driver

SALTWATER

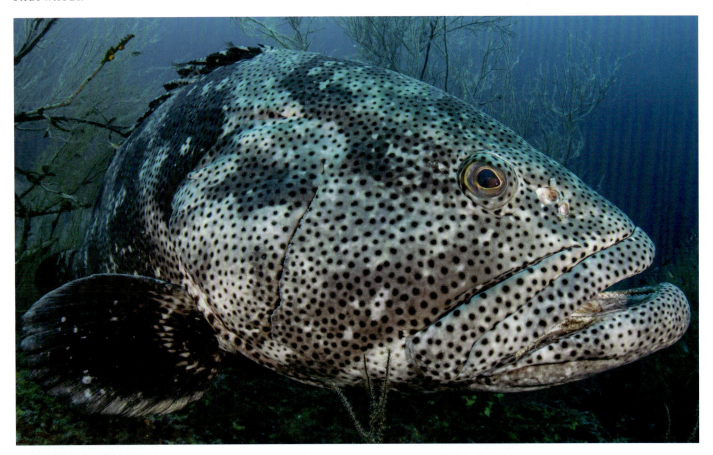

ABOVE
MALABAR GROUPER
Also known as the blackspot or greasy grouper, this is a big fish – 2m (6ft 5in) long – that lives in the Indian and Pacific regions. It is a predator, using its strong jaws to chew on fish, crustaceans and shellfish. The species is a protogynous hermaphrodite, which means it begins life as a female, and the strongest individuals transition to males as they get older.

LEFT:
VOLCANIC VENT
Volcanic gases bubble from the seabed. Volcanic activity on the seafloor changes the chemistry and temperature in deep waters.

OPPOSITE:
MAGNIFICENT FRIGATEBIRD
Soaring effortlessly on its 2m (6ft 5in) wingspan, this bird can stay aloft above the sea for days on end. It steals the food captured by other birds or swoops down to grab fish from the surface of the ocean.

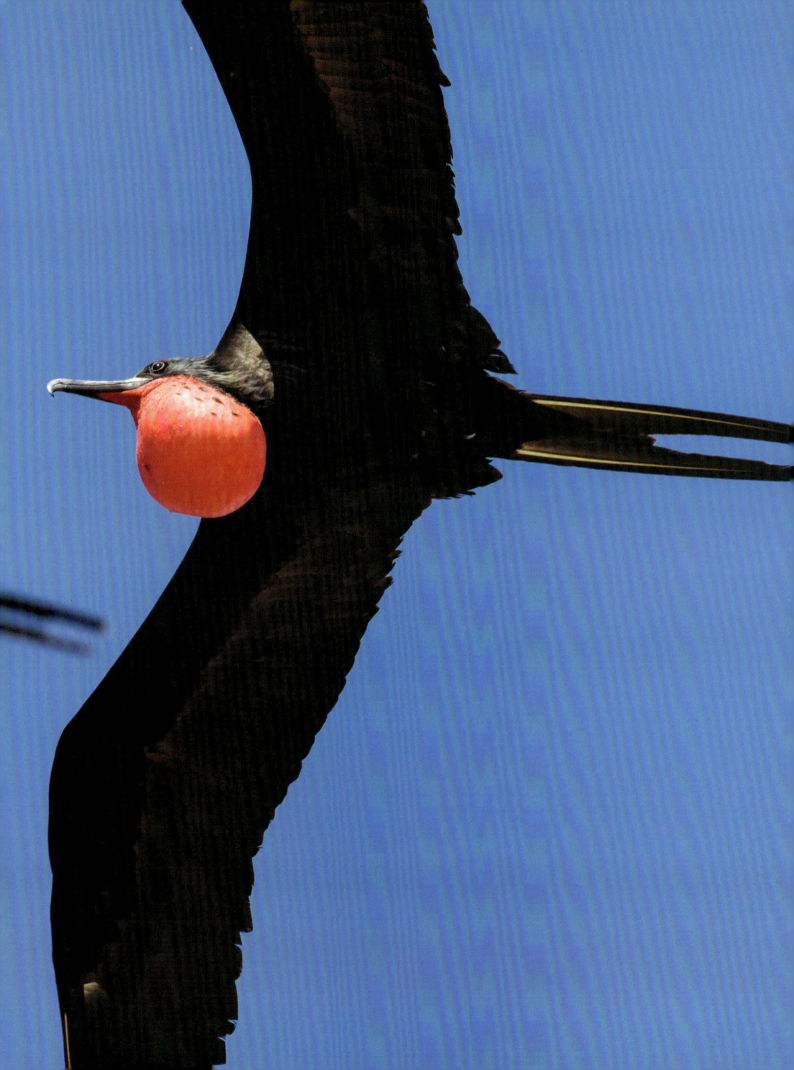

SALTWATER

in delivering minerals to the deep ocean. On occasion, the slope sees a vast mudslide, gargantuan in scale if it were on land but all unseen beneath the waves. (Nevertheless, the displacement of all that material can cause tsunamis.) The fallen material builds up at the base of the slope, creating a feature called the continental rise. This then forms a gentle descent to the emptiness of the abyssal plain.

SEAMOUNTS AND REEFS

The seabed is not exclusively flat and lacking in features. The largest mountains on Earth are located here. Some, such as Mauna Kea, are tall enough to rise above the surface. This Hawaiian volcano measures 10,210m (33,497ft) from its base on the seabed to its highest point (which is 4207m/13,800ft above sea level.) So Mauna Kea is the tallest mountain in the world, whereas Everest is the highest. Despite this, there are even larger volcanoes hidden under the sea. The biggest is Tamu Massif in the north Pacific to the east of Japan. The deep-sea mountain covers an area that is more than three times bigger than Ireland. These underwater peaks are called seamounts. They create a haven for wildlife among the relative emptiness of the surrounding deep.

A mountain creates turbulence in the deep sea as the water moves past. This forms large eddies that churn the water spreading oxygen and nutrients to areas otherwise depleted in them. The deep water also rises up one side of the seamount, creating zones of habitats up the slope, analogous to the bands of habitat on a terrestrial mountain. (The far side of the seamount is more denuded of life.)

LEFT:
ICEBERGS
Vast pieces of floating ice form a temporary, but essential, terrestrial habitat for polar wildlife, such as penguins.

BELOW:
ELEPHANT SEAL PUPS
Young elephant seals rest on the beaches of California, crowding together to keep warm and out of the way of marauding adult males.

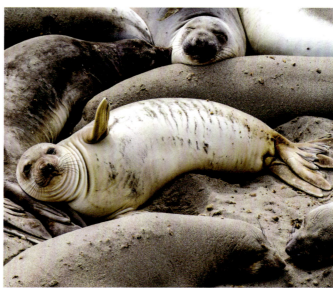

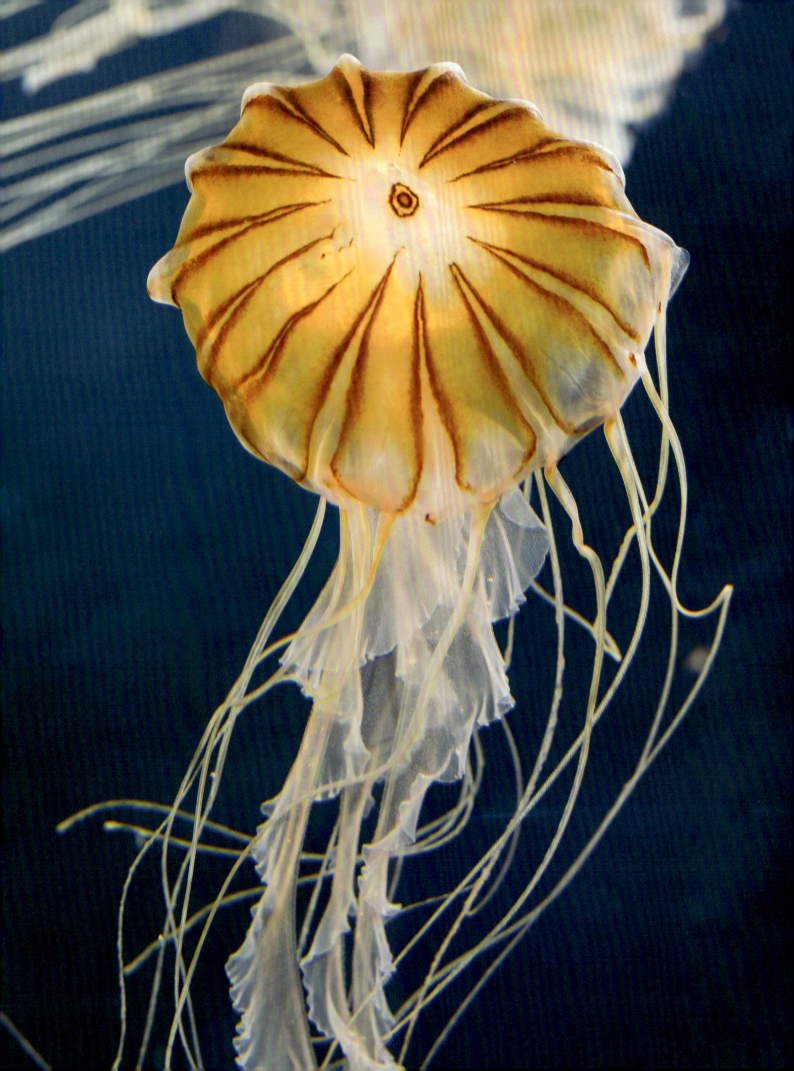

Once the upwelling water reaches the euphotic zone, it supports a plankton community that forms the basis of the ocean food chain. Seabirds, sharks and dolphins gathering out in what seems to be empty ocean are probably targeting a community of wildlife based on a seamount deeper down.

Coral reefs, those tropical idylls blazing with colourful life, can also form on the eroded peaks of seamounts touching the surface. Coral reefs need clear, shallow and warm water. The microscopic coral polyps are tentacled relatives of jellyfish and anemones. They cluster into colonies that all sit with the tentacles facing up to collect food from the water. The polyps supplement their diets by hosting symbiotic algae, or zooxanthellae, inside their tissues. The algae photosynthesizes and provides the coral with sugars in return for a place to live. It is also these microscopic lodgers that give the corals their amazing colours.

Coral reefs create a sheltered habitat for a large wildlife community. Some say that coral reefs are the rainforests of

OPPOSITE:
COMPASS JELLYFISH
This North Atlantic species is distinguished by the 16 V-shaped stripes, which resemble a compass rose. Although not deadly, its sting can cause pain and skin irritation.

BELOW:
KELP
Wide fronds of kelp, a brown algae, float in deep water to catch the sunlight. This seaweed can be seen at the low water line and below where it is generally submerged even at low tide and is able to extend to its full length when the tide is high.

ABOVE:
LANTERNFISH
This small, bioluminescent fish has been caught in a fishing net. In the wild the small fish lives in the deep oceans, typically between 200–1000m (650–3000ft) down. They are named for the way light-producing organs called photophores are lined up along the body. These help with camouflage and communication in the dark. The fish take part in the vast vertical migration as it rises to the surface by night and then swim back down at dawn.

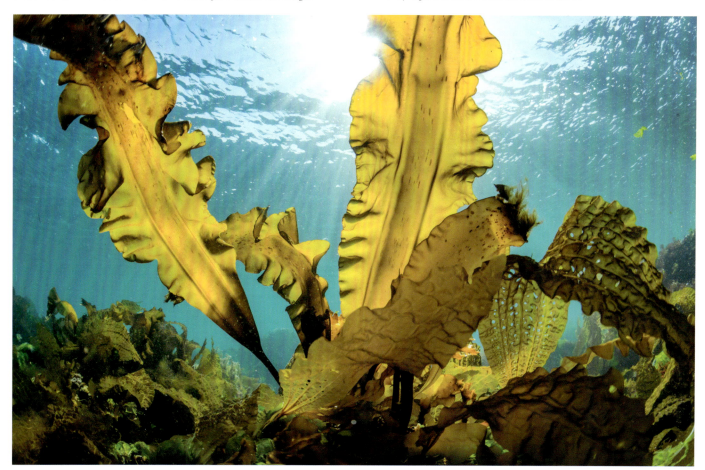

SALTWATER

the ocean. Around a quarter of all marine species are found living around a reef. The rising ocean temperatures caused by climate changes, and the acidification of ocean water due to the extra carbon dioxide produced by humans dissolving in the seawater, is stressing the corals. Their first option is to expel the zooxanthellae, which makes the coral go white, or bleach. Coral bleaching is a growing phenomenon and indicates that the ancient reefs of today's oceans are not going to survive the new climates in their current locations.

Other biodiversity hotspots are found at the bases of volcanic seamounts, where hydrothermal vents spew out superheated chemical-rich waters. When the hot water hits the cold ocean, the dissolved chemicals come out of solution forming a dark cloud in the water. These vents are known as black smokers as a result. The chemicals in the water are consumed by chemosynthetic bacteria, which form the basis of the food chain in place of photosynthetic organisms. An entire animal community of worms, crabs, molluscs and much more has grown up around the vents where they eat the bacteria.

ABOVE:
SEAGULL
Despite the name, gulls like this are land birds. They exploit the world's most common edge habitat, where the ocean meets the land. They do not go out to sea to feed, but scavenge on whatever turns up on the shore – and further inland.

BELOW:
NARWHALS
A pair of these unusual whales take a breather at the edge of an Arctic ice floe. The species is best known for its long, spiral tusk, which is an elongated upper canine, normally the left one, erupting through the top lip. In males, the tusk can be 2m (6ft 5in) long, twice that of a female. The tusk is used in displays of dominance but is not a weapon. It is highly innervated with nerves and may be sensitive to chemicals in the water, helping the whales share details of feeding locations. The whales feed on fish and squid at depths of about 1000m (3280ft).

ABOVE:
STRIPED HERMIT CRAB
This is a species of the eastern Atlantic and Mediterranean. The crab is peering out from what looks like a whelk or limpet shell. When it has grown too big for this house, the soft-shelled crab will move to a larger dwelling.

RIGHT:
ANTARCTIC KRILL
It is more common to see these little shrimplike crustaceans in swarms made up of many millions of individuals. Some swarms can have 30,000 krill in every cubic metre of seawater.

SALTWATER

TIDAL ZONE

Hydrothermal vents are very extreme places to live. It is perhaps hard to think of somewhere more extreme in the oceans, apart from every shoreline. The gravity of the Moon pulls the ocean water up and down the shore twice every 24 hours. These are the high and low tides. Every month, the positions of high and low water also vary, as the pull of the Sun combines with the Moon and then works against it. A bumper spring tide is followed two weeks later by a smaller neap tide, and so on.

This sequence of tidal changes is seen the world over. Living in the tidal zone means being able to withstand the constant crash of waves, the transition from being completely submerged to being out in the air, and back again. The location on the shore has its own air-water timetable, which creates a zonation of habitats, where the seaweeds grow in bands with each one adapted to survive without water for a certain period.

Rock pools save some water as the tide recedes, but for the plants and animals trapped inside, the clock starts ticking. The sun heats the water and evaporation means the saltiness of the pool is going to gradually rise. How long will it be before the seawater returns to refresh the pool? Despite all these difficulties, the tidal zones are packed with life that has found a way to cope with these never-ending cycle of extremes, and presents enthusiasts with a opportunity to explore marine natural history up close.

RIGHT:
CORAL REEF
A coral reef has the same productivity as a tropical rainforest. On average it is able to fix the same amount of carbon dioxide from the atmosphere (or water) as the trees of a mature forest.

BELOW:
DUGONG
One of the three surviving species of sea cow, the dugong lives in the warm, shallow waters of the Indo-Pacific. This seafloor grazer is not related to seals or cows, but is most closely linked to elephants.

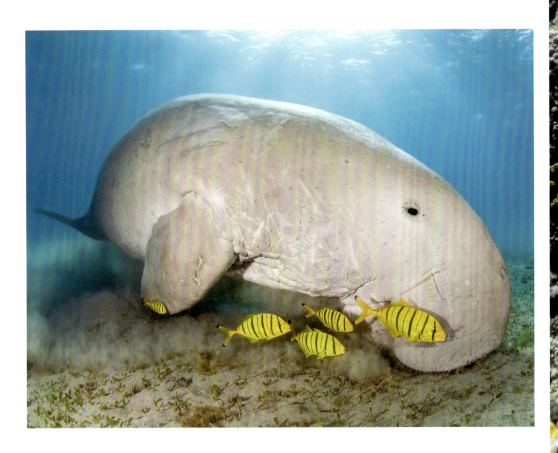

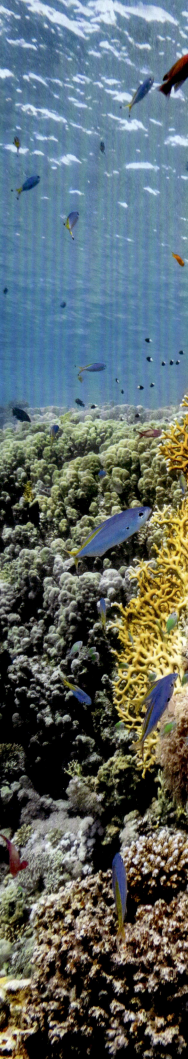

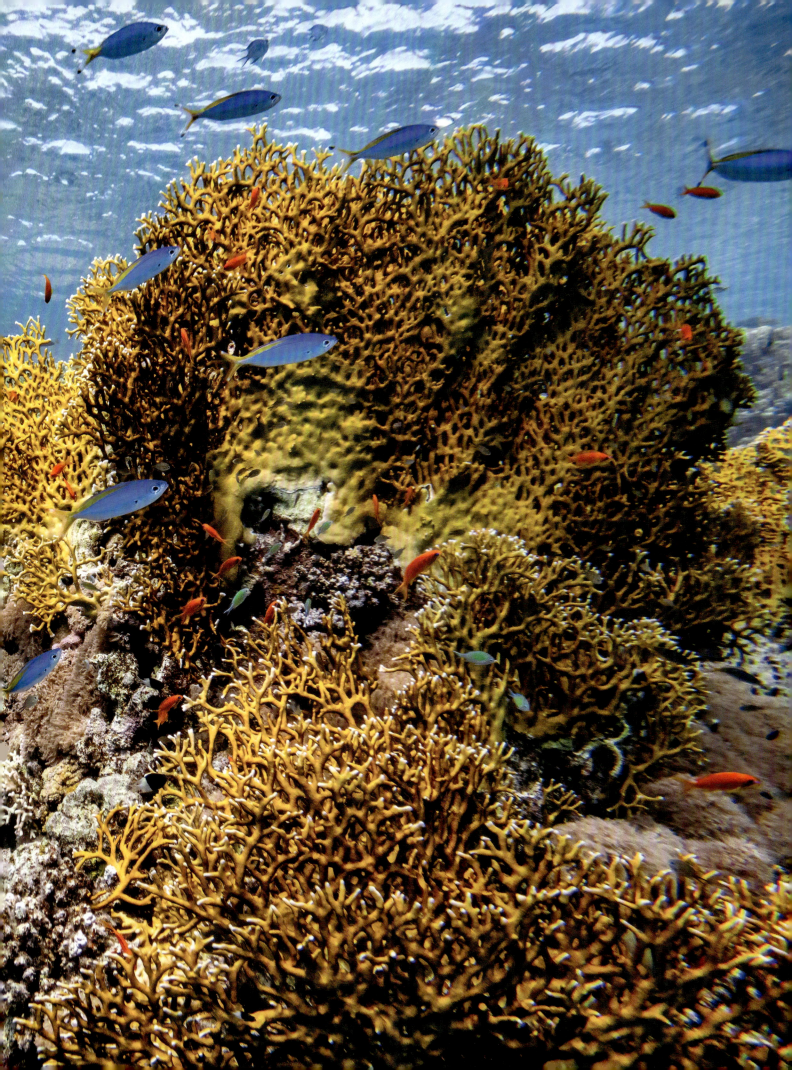

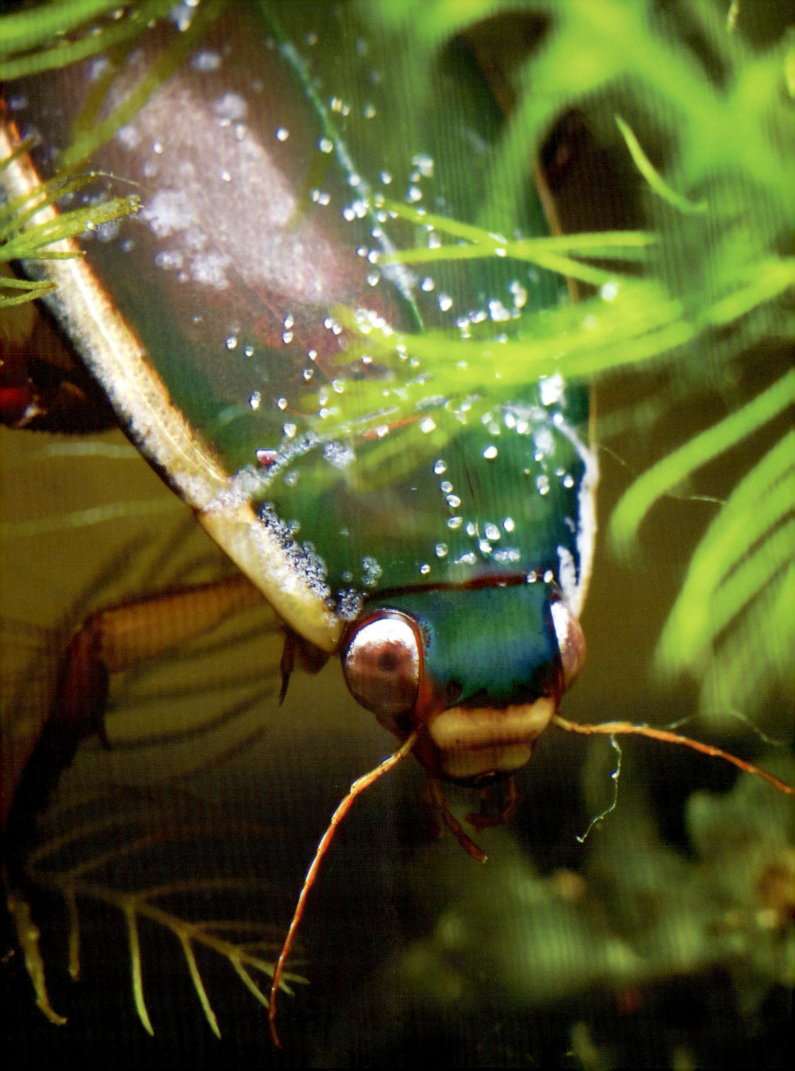

FRESHWATER

Almost half of the world's fish, 41 per cent to be precise, do not live in the sea. Instead they are found in fresh water, where the water is ultimately sourced from precipitation, mostly rain and some snow. The falling water contains little or no dissolved salts. The main solutes are two gases from the air – oxygen and carbon dioxide. The presence of the latter makes the water slightly acidic. This acidity makes rainwater corrosive, and it steadily eats away at rocks.

As such fresh water is not salty, but does contain traces of rock-forming and soil minerals including compounds containing nitrogen, calcium, sulphur and phosphorus. The fresh water ultimately empties into the ocean and is an important source of these sorts of minerals needed by marine life. Along the way the fresh water creates a wealth of highly significant habitats from fast-flowing mountain streams to sluggish marshland.

Around three per cent of the Earth's water is fresh water, and 85 per cent of that is locked away in the ice caps and glaciers as solid ice. Around 0.2 per cent of the water is hidden away in groundwater. This is soaked into permeable rocks with microscopic spaces between the crystals. The water percolates deep underground and reappears as springs wherever these rock strata contact the surface. All the rivers, lakes and wetlands on the surface are filled with the remaining 0.3 per cent of Earth's water. This seemingly small amount of water is providing a home to a stellar list of animals

OPPOSITE:
GREAT DIVING BEETLE
An adult male diving beetle hides out among some hornwort as it looks for prey. The beetle is not unusual in that its larval form is an aquatic animal (not uncommon for insects), but it is unusual that the adult returns to the water. Without gills, the adults dive down with a bubble of air trapped under the wing covers.

RIGHT:
MALLARDS
One of the most widespread and widely recognized of dabbling duck species, the mallard lives across North America, Europe and Asia. The males are known for their distinctive colourful plumage, while females have more mottled brown feathers.

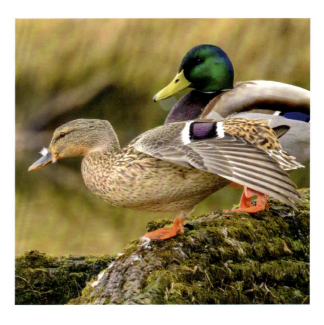

FRESHWATER

that includes crocodiles, hippos, piranhas, beavers, hellbenders (giant newts) and multiple catfish. Additionally, the water is the nursery for almost all frog species, and many insects, not least the mosquitoes, get their start underwater.

TOO MUCH WATER

Freshwater life does not have to contend with the problems caused by swimming in water that is saltier than the body. However, it has problems that go the other way.

The process at the heart of this is osmosis, where water is free to move through a semipermeable barrier, such as a cell membrane, while other materials, such as salts and sugars, are not. Fresh water has less material dissolved in it than the contents of a living cell. That makes it hypotonic. When bathed in hypotonic fluid as a fish is when swimming in a river, osmosis will cause water to flow into the body. This will dilute the contents of the body, and cause cells to swell. If uncontrolled that

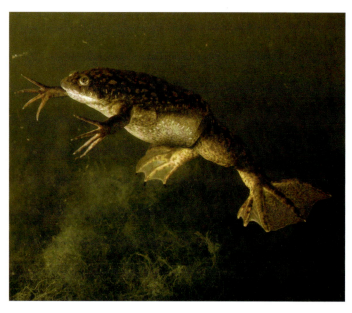

BELOW:
MOUNTAIN STREAM
A bright, clean and cold stream of water is flowing fast down the slope of Grossglockner, the tallest peak in Austria. This fresh water is delivering minerals and oxygen to the aquatic habitats lower down.

ABOVE:
AFRICAN CLAWED FROG
This frog spends its whole life in the water. It is native to sub-Saharan Africa, but has been spread elsewhere over the last century or so. It has a flattened body, webbed feet and distinctive claws on its hind limbs, which it uses to tear apart food.

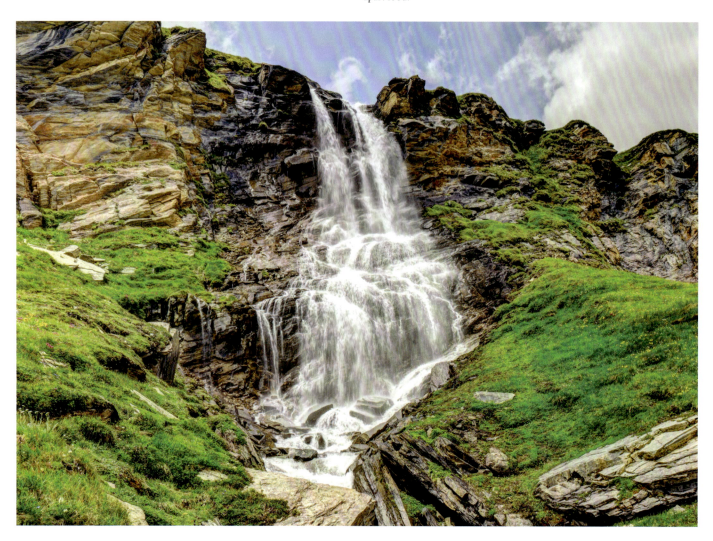

FRESHWATER

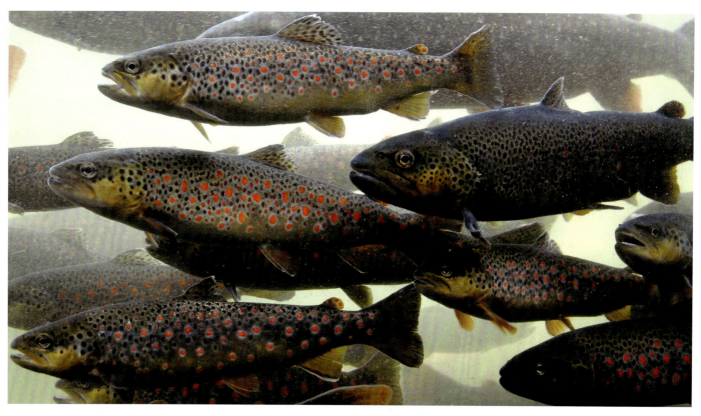

ABOVE:
BROWN TROUT
This healthy shoal of brown trout shows that the river is uncontaminated with plenty of oxygen and invertebrates for these widespread European and western Asian freshwater fish.

BELOW:
COMMON CRANE
This wading bird spends the winter in northern Europe and Asia where it stalks through shallow pools looking for invertebrates. In winter, the bird flies south to the Nile Valley and other big river systems in South and East Asia.

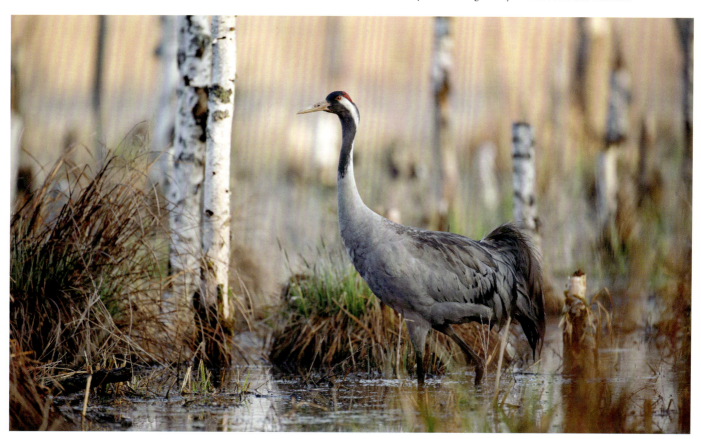

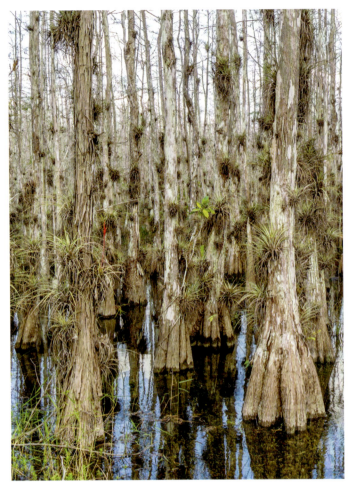

ABOVE:
EVERGLADES
Covering 600,000 hectares (1.5 million acres) of Florida, the Everglades is one of the largest wetlands on Earth. Here pond cypress trees are growing out of shallow waters that are washed with the tides twice a day.

RIGHT:
FRESHWATER CROCODILE
Known in Australia, as a 'freshie' these crocodiles are smaller and found further inland than the monstrous 'salties' or saltwater crocodiles. The freshwater species has a narrower snout that is better suited to hunting fish.

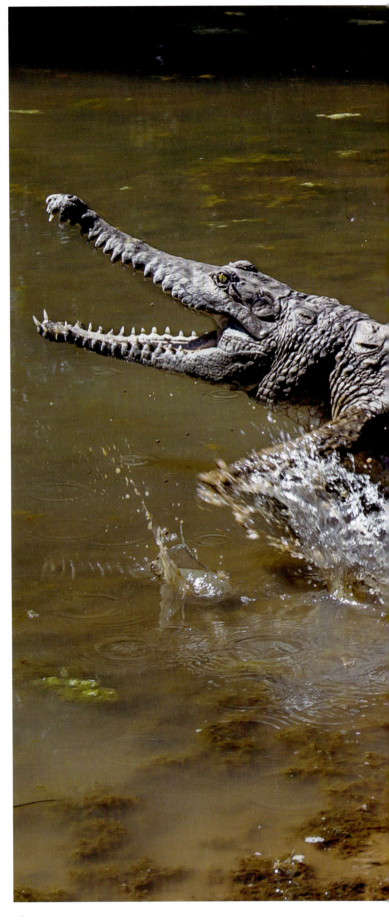

inward flow would make body cells burst, in animals at least. Plants make use of this phenomenon to draw water into the cells, which are contained in sturdy box-like cell walls that can contain the pressure. The cells do not burst and they form a rigid structure that keeps the plant standing tall. (This is why plants droop when they lack water.)

Controlling water in the body is called osmoregulation, and one of the strategies employed by marine animal life is to match the internal concentrations with those on the outside and thus stop any net transfer of water. This is called osmoconformation. There are no freshwater animals that are osmoconformers. It is simply impossible to regulate a body that is filled with almost nothing but pure water (or at least nearly pure).

So freshwater fish and their fellow aquatic life have no other option but to essentially pee out excess water almost all the time. They are flushing away toxins in a very diluted form to shed

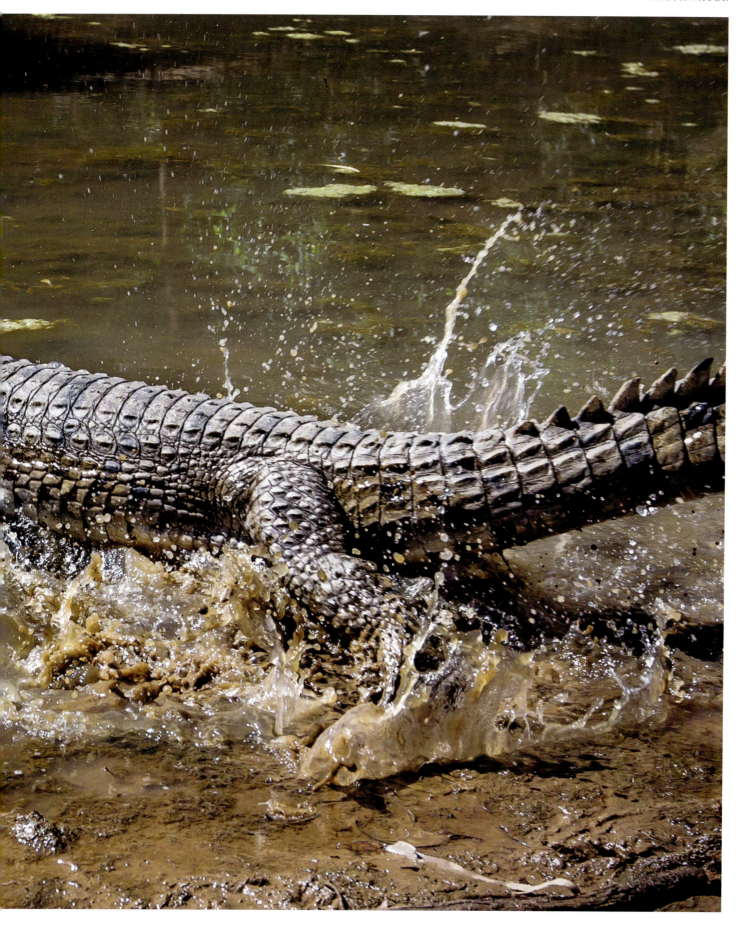

ABOVE:
BOLIVIAN RAM CICHLID
This small fish lives in slow-moving rivers in the Amazon Basin. The species is omnivorous and feeds on small invertebrates, algae, and plant matter. They lay their eggs in the sediments and both parents guard the nest.

BELOW:
CAECILIAN
It looks like a snake, big worm or an eel but this limbless creature is a relative of frogs and salamanders. Some live in soil, others are freshwater creatures. Most are oviparous, which means it gives birth to its young instead of laying eggs.

the water and so maintain the salt concentration in their cells and body tissues. Additionally, while marine animals pump out unwanted salts through the gills, their freshwater kin are taking in whatever salts they can extract from the water (mostly sodium, potassium and chloride ions).

HABITAT TYPES

There are three main types of freshwater habitat. Wetlands are places where the soil is waterlogged for much of the year, and the water table will rise above the surface for long periods creating swamps, marshes and temporary lakes. For some of the year, the water also drops away beneath the surface again. Wetlands are an enormously important habitat. Their muddy soils are able to hold large amounts of biological carbon, even more than a tropical rainforest. Wetlands are a valuable resource as natural carbon sinks in the fight against climate change. However, wetlands have been consistently drained and converted into space for farms and cities, or their water sources are diverted for irrigation of crops elsewhere upstream. In the last 50 years, a third of the world's wetlands have gone. They have been removed three times faster than forests. One silver lining is that healthy

wetlands are easier to restore than tropical forests. Hopefully efforts to restore them will increase.

The second kind of freshwater habitat are so-called lentic systems, which is a rather obscure term for lakes, pools and ponds. Here the water is a permanent presence and any currents are quite slow. (Lentic means 'lingering' in Latin.) The distinction between a lake and a pond is not clear cut. A lake is rarely as deep as the ocean (an exception is Lake Baikal in Siberia, which goes down more than 1600m/1 mile). Nevertheless, the relative shallowness of lentic habitats means they do not have the same complex stratification with depth. A pond or a pool (which is just a large pond) has only two layers: a euphotic zone and benthic zone. The term euphotic (sometimes simplified to photic) means the water receives enough light energy to support photosynthesis. In a pond this feature extends all the way to the bottom. The benthic zone is the bottom of the pond (or lake). The rocks, mud and sands down here create a rich living space for different forms of life. That includes some of the world's biggest fish, such as the wels catfish, which lurks

ABOVE:
BROAD-LEAVED PONDWEED
This aquatic plant is found in temperate and subtropical regions. It has long, slender stems and oval to lance-shaped leaves that float on the water's surface. The leaves that are under the water are narrower. The roots are anchored in the sediment. The flowers poke out of the surface and attract insect pollinators.

BELOW:
AMAZON RIVER DOLPHIN
Known locally as the boto, this freshwater mammal lives in the Orinoco Basin as well as the Amazon. The pink colouring gets brighter with age; younger dolphins are a pale grey. The dolphins live in small pods, and seek out slow-moving waters. Compared to their marine cousins, this river dolphin's neck is much more flexible so it can weave through the roots and stems of aquatic plants.

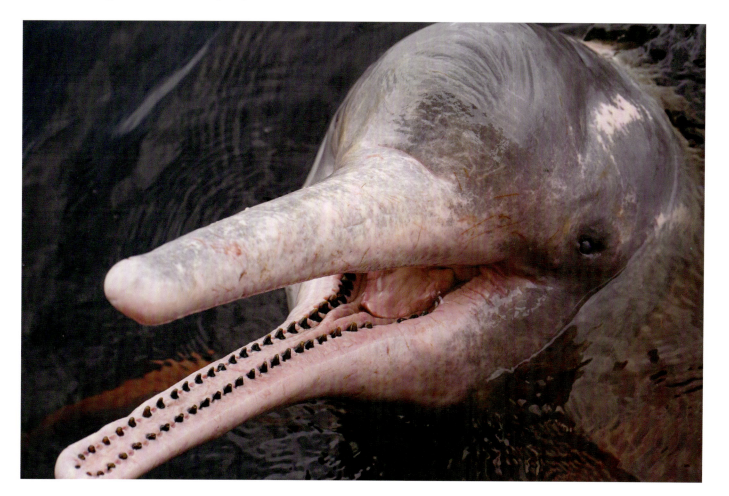

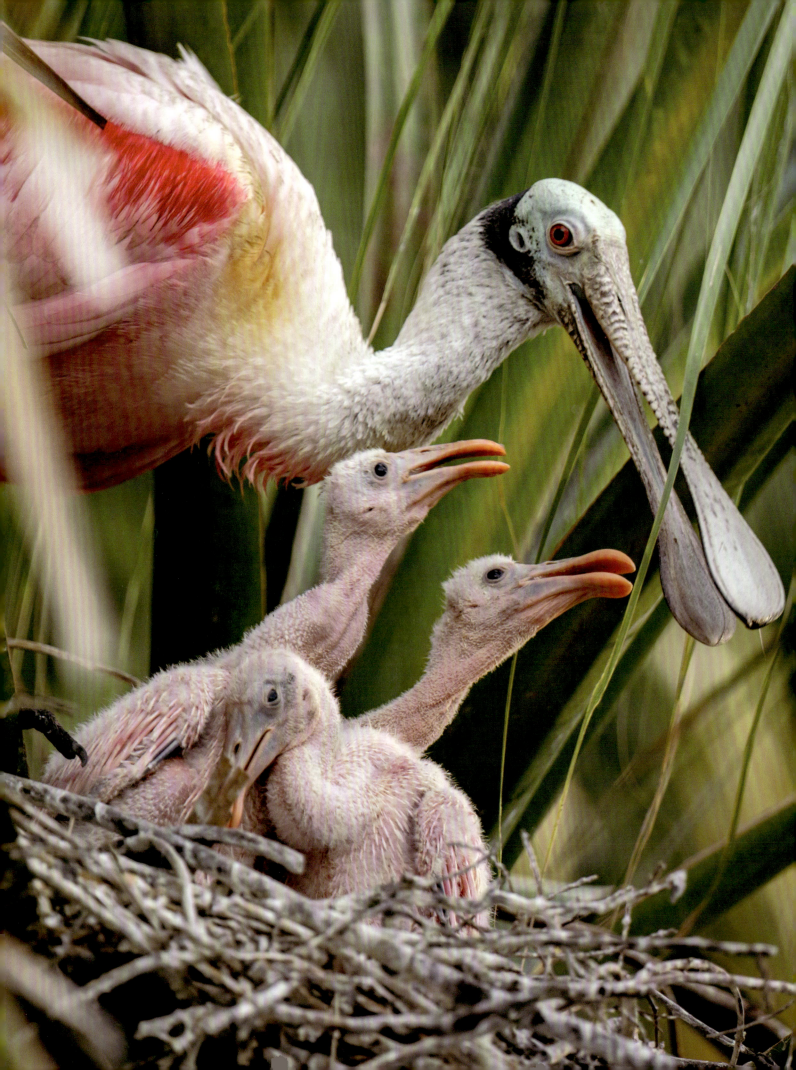

FRESHWATER

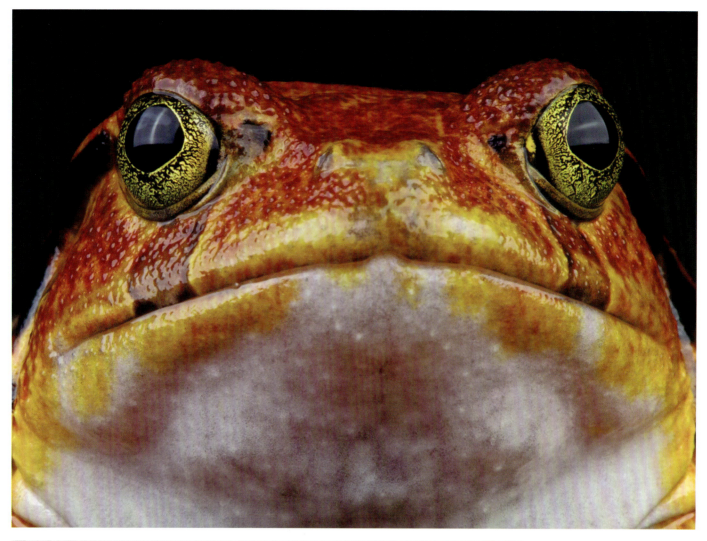

ABOVE:
TOMATO FROG
This amphibian from Madagascar uses its bright red skin to warn predators that it is not a pleasant meal. Its skin is coated in a glue-like mucus that makes it hard to eat.

LEFT:
SWAMP
Wetland habitats are often overlooked for more beautiful and accessible habitats. Swamps are not always pleasant places but they are a very significant haven for wildlife and a store of organic carbon.

OPPOSITE:
ROSEATE SPOONBILL
A doting parent cares for its chicks in Florida. It does not take much to unlock the meaning of the common name. The pink plumage comes from the chemicals in their crustacean diet. The spoon-shaped bill is used to sift this from muddy waters.

FRESHWATER

down there gobbling up all the other fish and growing to 3m (10ft) long. There are also tiny insect young, such as dragonfly naiads that are fierce hunters in this world.

A lake also has these two zones, but it is deep enough to have a aphotic zone, where it is too dark to photosynthesize (or see much, if anything). In fresh water this deeper region is called the profundal zone. In the open ocean, light levels begin to fade fast from about 200m (650ft) down. However, the gloomy profundal will generally start at a shallower depth than this because lake water is habitually filled with sediment, debris and plant growth, which all absorb more of the light.

A lake's profundal zone is also significantly colder than the euphotic zone above it. This is largely due to the lack of churn and currents that mix the deeper water with those higher up. Therefore the profundal can become depleted in dissolved oxygen, which does not penetrate this deep. That has an impact on what animals dominate down here. Invertebrates, such as worms and the larvae of insects such as gnats do best in this anoxic habitat.

FLOWING WATER

The most familiar freshwater habitat is the river. Ecologists refer to them and any other body of flowing water as lotic ecosystems. (Again this scientific word is Latin in origin and means 'to have washed'.) Each lotic ecosystem is very complex and can also be the source of the water for wetlands and lakes.

Every river system collects the water that falls in a distinct area called its watershed. The watershed is defined by geography in that all liquid water that finds itself here, either falling as rain or melting from alpine snow and ice, will move in the same

RIGHT:
CAPYBARA
Despite being known as a water pig by the locals in South America, this is the world's largest species of rodent. It is about the size of a large dog. Capybaras live in herds and graze on lush riverside plants. If disturbed, the herd gallops into the water for safety.

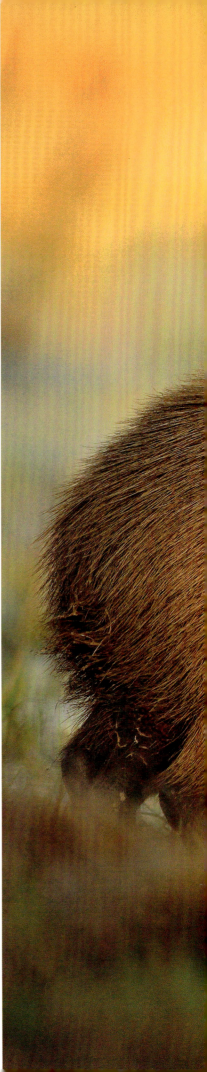

BELOW:
WELS
Also known as the European giant catfish, this is the largest species of freshwater fish in Europe. It can grow to 5m (16ft) long and weigh 300kg (660lb).

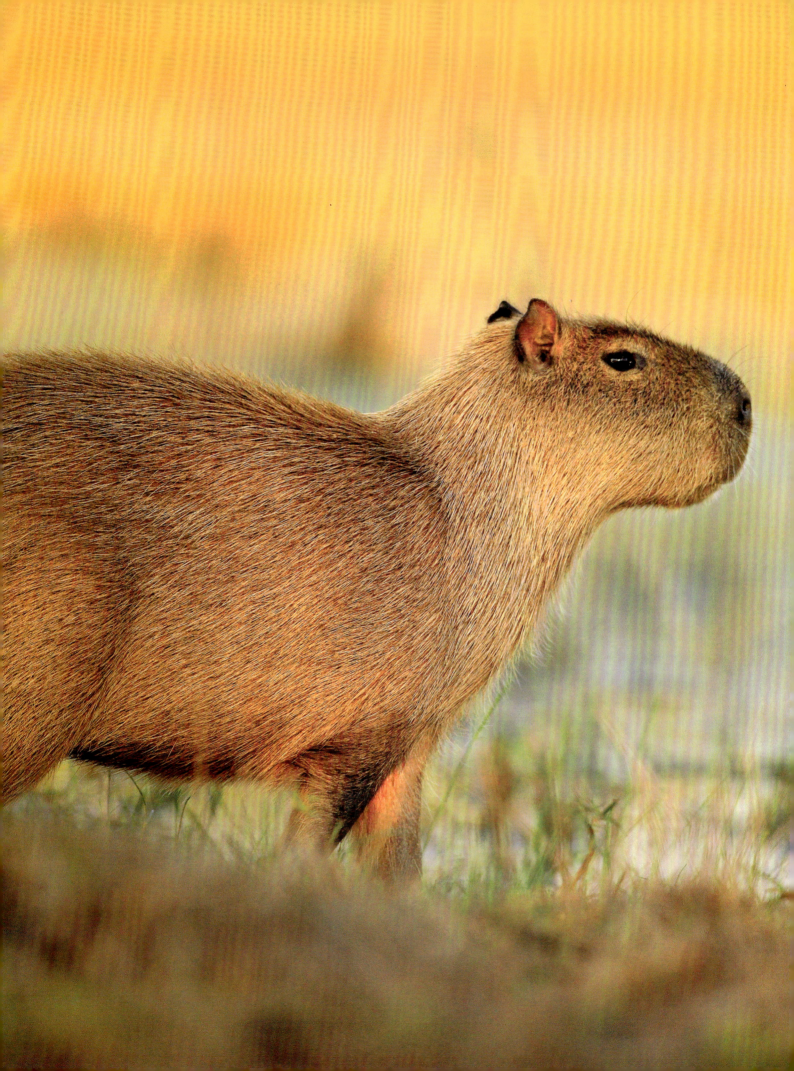

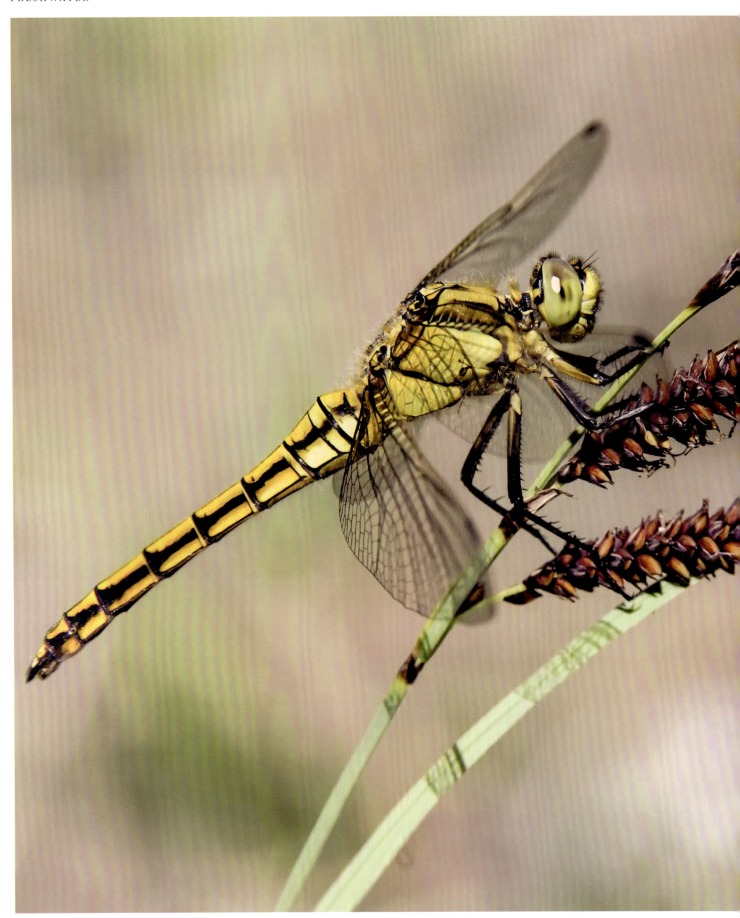

FRESHWATER

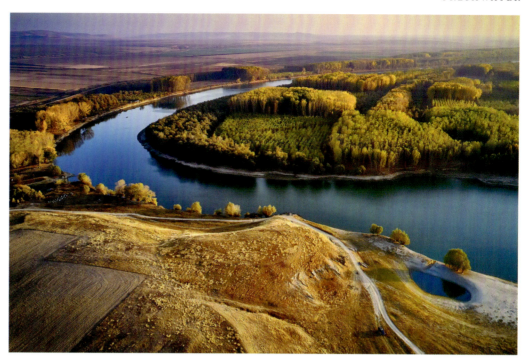

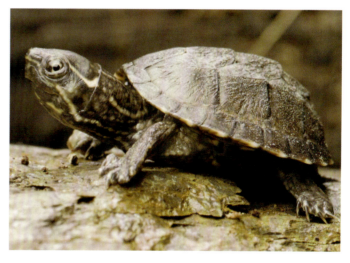

ABOVE:
DANUBE DELTA
The Danube is one of Europe's biggest and longest rivers. By its mouth, along the Black Sea shore of Romania, it has split into many small channels that meander with slow-flowing water through the landscape.

RIGHT:
COMMON MUSK TURTLE
Better known by those well-acquainted with them as the stinkpot, this is a small freshwater turtle found in North America. When handled it exudes a musky fluid from glands near its tail to deter predators.

LEFT:
BLACK-TAILED SKIMMER
A female black-tailed skimmer rests on a rod of rush in spring. As adults, all the dragonflies are voracious aerial predators, often close to water. Their larvae, known as naiads, are equally as fierce but live on the bed of ponds and rivers.

direction downhill due to gravity. To start with this water moves across open ground as run-off. The trickles of run-off coalesce into large flows and eventually a distinct stream forms. The process repeats many times over as smaller watercourses merge into larger ones. Eventually a raging torrent is on the move, flowing downwards.

This fast water is very turbulent, which means it is mixing with the air a lot. This, combined with the fact that the stream is also often very cold meltwater, means that these mountain streams in the upper part of the river system contain plenty of oxygen. These waters are attractive to amphibians and insects that thrive in clean, oxygen-rich streams. To survive, they just need to withstand the force of the current. Being small helps with that. The crocodile species that exploit mountain rivers are invariably dwarfs that are several times smaller than their monstrous lowland cousins.

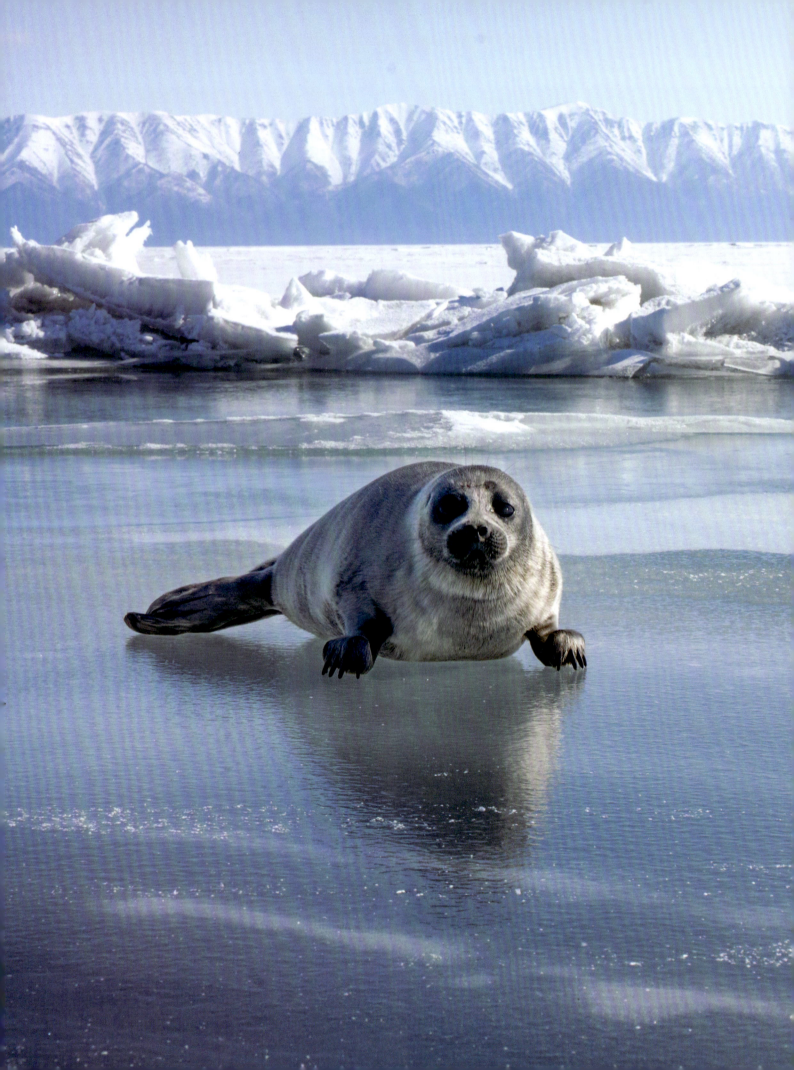

FRESHWATER

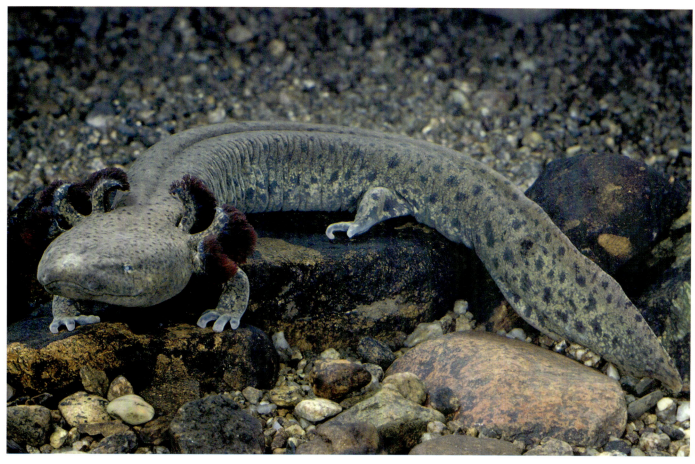

ABOVE:
COMMON MUDPUPPY
While most salamanders will emerge from the water as adults, this North American species spends its whole life in the water. The adult grows four legs but retains the gills of the tadpole-like young form.

RIGHT:
SUNDARBANS
This satellite image shows the world's largest mangrove forest. It is located at the delta of the Ganges, Brahmaputra and Meghna rivers in India and Bangladesh. The Sundarbans is home to the endangered Bengal tiger.

OPPOSITE:
BAIKAL SEAL
A young cub sits on the ice of Lake Baikal. This is the only freshwater species of seal, which, rather amazingly, lives more than 600km (370 miles) from the ocean. Lake Baikal in Russia is the largest and deepest freshwater lake in the world, too big in places to see the opposite shore.

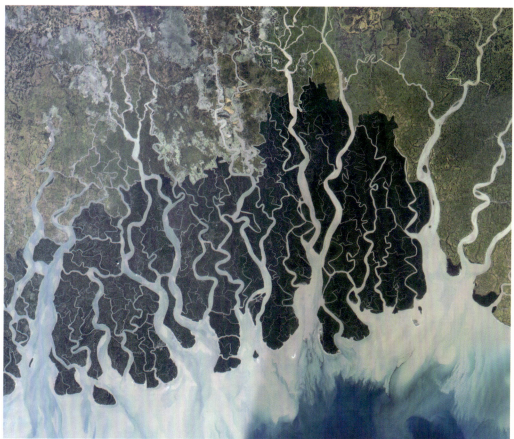

FRESHWATER

When the river reaches lower altitudes, the gradient also reduces and so the water slows down. The watercourse is now wider with a bigger volume and it has accrued large amounts of sediment picked up by its turbulent journey to this point.

The larger stones are dropped from all but the fastest currents, but sand grains and smaller silts will travel farther downstream. As the river finds its way through the landscape, it will twist and turn to find the path of least resistance. On the inside of one of these turns, or meanders, the water slows considerably, and so the heavier sand grains are able to fall to the riverbed. Over time sand banks appear in these parts of the river, often rising above the waterline for much of the year. Sandbanks are a haven for river wildlife, such as birds and certain crocodiles, especially those, like the gharial, which hunt fish in the water. Many rivers have been tamed by people to bend them to our will and make them more navigable. That invariably reduces the width of the river and makes it deeper through the year. As a result river sandbanks are a now a dwindling habitat.

By its lower reaches the water is dark with fine silts and clays. The settling sediment is full of organic material and it creates a fertile substrate for the river bed. Some aquatic plants can grow under the water where water is shallow enough

RIGHT:
DIVING BELL SPIDERS
A pair of diving bell spiders are making breeding overtures. The spiders are named after the way that haul a bubble of air under the water, seen here around the spiders' abdomens. This bubble, held by a scaffold of hairs, provides the animal with air while they hunt underwater. Some species build a silken refuge underwater filled with air.

BELOW:
FROG SPAWN
The eggs of a frog, and those of other amphibians, do not have a hard shell. Instead the embryo is encapsulated in a nutrient-rich gel. Eggs like this will dry out quickly, and so amphibians must lay them in water, or at least in another very damp habitat.

FRESHWATER

for light to penetrate, and if the current is forgiving enough, they send out long stems so the leaves can float at the surface. However, most river vegetation is along the banks where the current is slower. Here the roots are underwater, but the stems and leaves rise into the air.

When the river nears the sea, its waters will mix with the tidal flows that come in and out of the river mouth, forming an estuary. Estuaries are generally very muddy places, with the river's turbid water and sediments charging far out to sea before they are mixed into the ocean blue. The estuary has its own ecosystem. The water here is saltier thanks to the mixture of seawater, but it is not as saline as the ocean itself. Additionally, the ever-changing currents racing in and out churn up the mud creating a thick, brown water that is too cloudy for much photosynthesis, and so the estuarine wildlife is based on shellfish and other animals that

OPPOSITE:
CRAYFISH
Freshwater lobsters are called crayfish, crawfish, mudbugs and yabbies. This one is a signal crayfish, a native of North America, which is now spreading through European river systems.

ABOVE:
ELECTRIC EEL
This startling fish lives in the rivers of South America. They produce strong electric discharges – up to 600 volts – mostly for stunning or killing prey in the water. Despite the name, it is not a true eel but belongs to another group called the knifefishes.

BELOW:
OKAVANGO DELTA
A wetland appears in Botswana, southern Africa, every year as the rains that fall on a vast swathe of the surrounding grasslands, drain into an inland basin. The water makes the land green and creates a haven for aquatic animals.

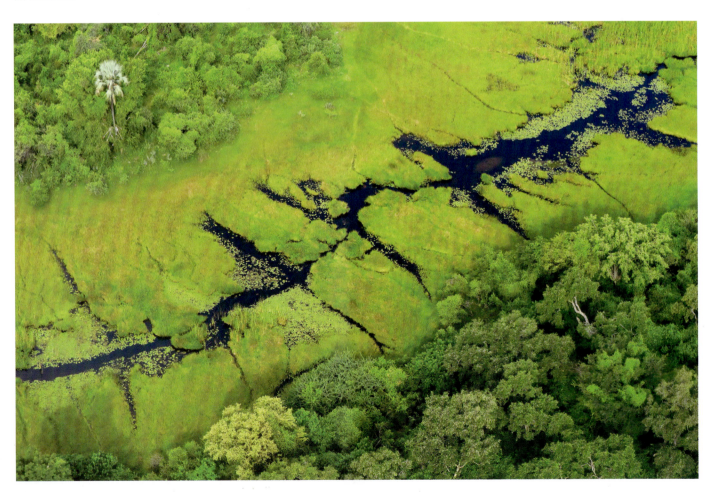

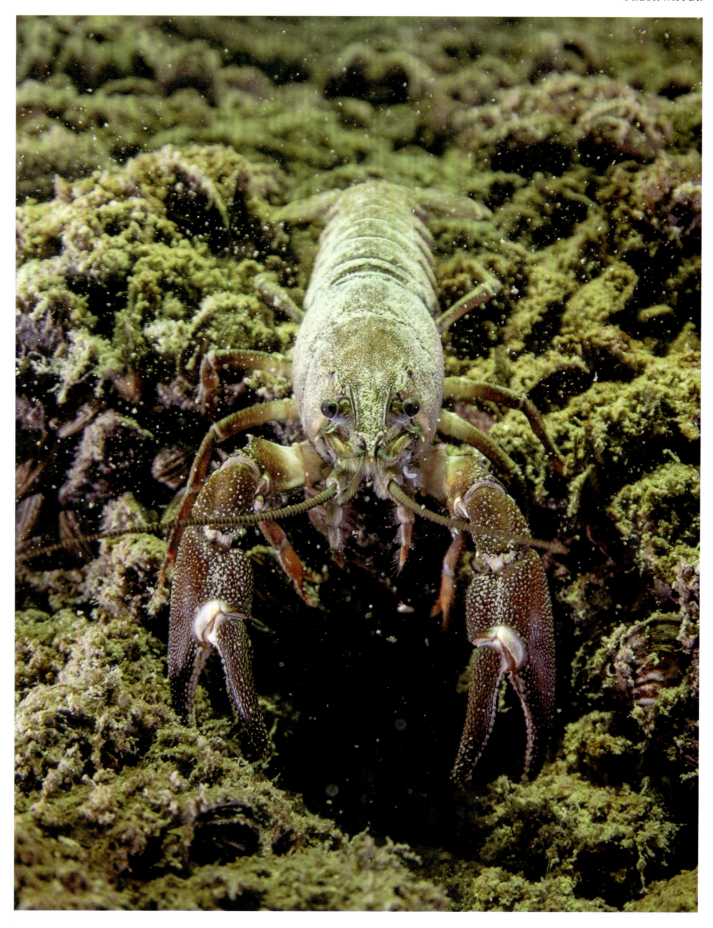

FRESHWATER

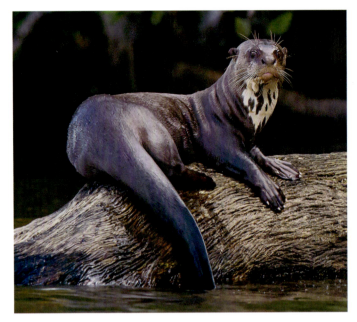

ABOVE:
GIANT OTTER
At 1.8m (6ft) long, the giant otter is the largest member of the mustelid family. It lives in the Amazon and Orinoco River basins. These sociable predators gather in family groups on sandy riverbanks. They hunt primarily for fish, crustaceans and small mammals. They may work as a team to target this prey.

RIGHT:
GIANT WATER LILY
The *Victoria regia* lily grows the largest leaves on the planet. Each of its pads will grow to 3m (10ft) across. However, it is not quite buoyant enough to hold the weight of a person. The flower will open at night, first with white petals, but by dawn the bloom will have turned pink.

feed on the organic materials in the murky waters, and predators that want to find them hide in the mud.

AFRICAN WATERWAYS

Every region is defined by its rivers, and each river system presents a distinct wildlife community. North Africa is dominated by the Nile, which is the second-longest river in the world after the Amazon. The river that meets at the vast delta on the Mediterranean coast of Egypt is the product of two big rivers. The Blue Nile empties a watershed in the Ethiopian Highlands. This mountain ecosystem receives heavy rains peaking in July and August and all that water flows down into the Nile – mostly by way of Lake Tana. Most of the Nile's water arrives via this route, but the second tributary, the White Nile is much longer. It extends south into Kenya, where it is the drainage channel for Lake Victoria, Africa's largest by area.

Lake Victoria is one of several 'Great Lakes' that form in this part of the continent, known as the Rift Valley. Geological forces are spreading the land, creating depressions that fill with water. Lake Victoria and a few other smaller lakes feed the Nile. To the southwest, Lake Tanganyika, which has a smaller surface area than Lake Victoria, but is much deeper and contains more water, is the main source of the Congo. This river, second only

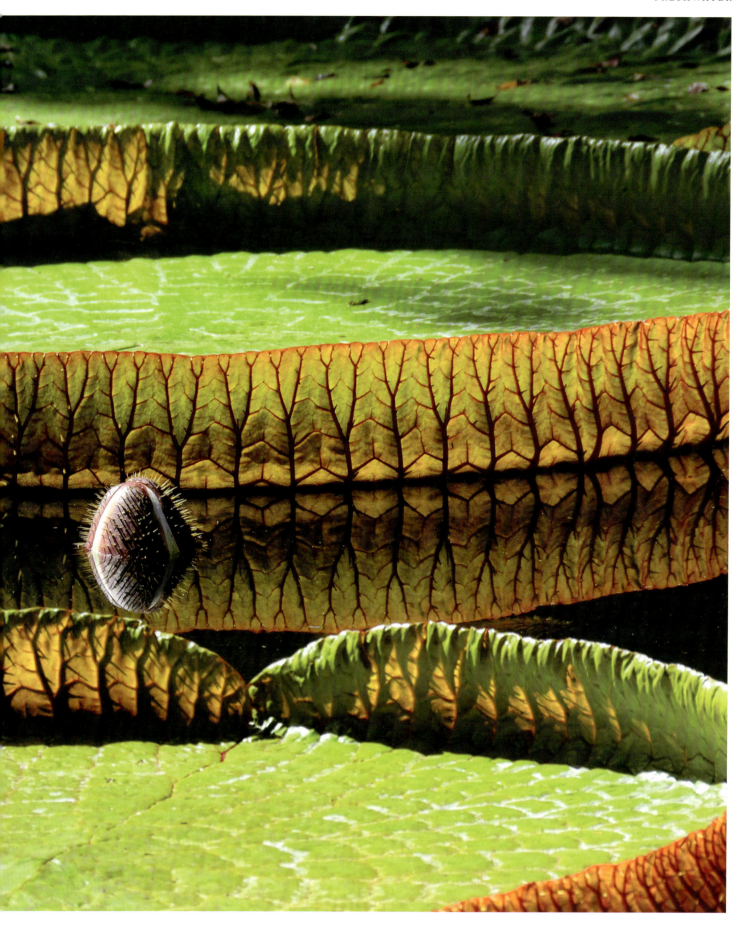

FRESHWATER

in volume to the Amazon, flows through Central Africa to the Atlantic and forms the heart of that continent's equatorial rainforests. To the south, Lake Malawi feeds a third African river, the Zambezi, which heads east to the Indian Ocean.

Despite their geographic links, the watersheds of these lakes and rivers are quite separate, and so under the water they harbour unique ecosystems of fish that are adapted to specific conditions. For example, Lake Tanganyika is on average 14 times deeper than Lake Victoria. The fish population of the rivers is based on their source lakes. The deeper lakes like Tanganyika and Malawi have a greater diversity of fish, especially cichlids. Lake Malawi alone has an estimated 1000 species of these fish.

Nevertheless, on the surface, the rivers that spread out from the African Great Lakes seem to share much in common. They are home to the hippopotamus, the third-heaviest land animal, and by some measures the wild mammal that is most dangerous to humans. They do not hunt for us, but will charge and bite if tourists get too close, especially if people get between them and the water. Hippos spend the day in the water. They wallow in water that is more or less in their depth. They can swim, but are not that agile. By night, these vast herbivores waddle out onto land are graze on the lush riverbank plants in the relative safety of the night. If they detect a hint of a threat, they might thunder back into the water, trouncing anything, or anyone, that gets in the way.

Nile crocodiles are not confined to the Nile. They are found all over the continent bar the deserts of the north and south. They are not quite as large as the saltwater crocs of the Indo-

ABOVE:
PONDSKATER
Better known as the common water strider, this bug is seen on the surface of calm water. It has tiny hydrophobic hairs on the legs that push away the water, enabling it to stand on the water without falling through the surface.

RIGHT:
ELECTRIC EEL
An electric eel, with its sturdy electrified body, explores the dense aquatic vegetation as it looks for prey.

FRESHWATER

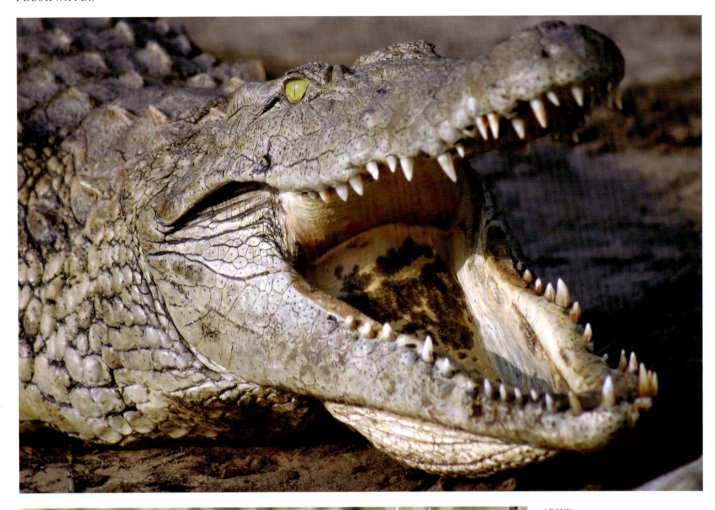

ABOVE:
NILE CROCODILE
The largest African reptile is able to take it easy for much of the time. It rests like this with its mouth open to expel excess heat.

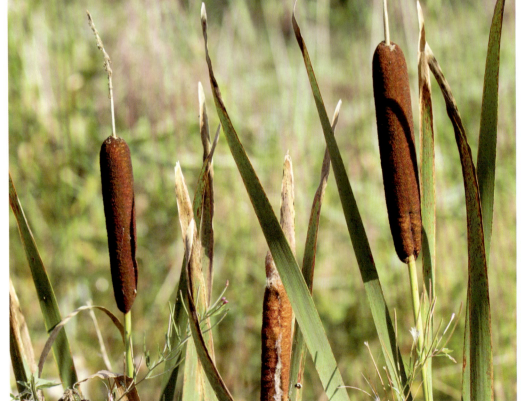

LEFT:
BULRUSH
This tall aquatic plant has distinctive triangular stems and long narrow leaves. The tiny flowers form sausage-shaped catkins.

FRESHWATER

Pacific region, but they pack a more powerful bite, the strongest of any living animal today. It uses its bite strength to grab large prey from the riverbank and pull it under the water. Escapes are a rarity, and the victim drowns to death.

NO RIVER MOUTH

Another important Africa river is the Okavango. However, this river has no mouth. Instead it drains from the highlands that surround a vast inland depression in Botswana and Namibia. Much of the basin is desert, but in summer mountain rains flood a portion of the basin creating the Okavango Delta. This is the largest wetland in Africa, and all the water that arrives here eventually evaporates away. Come the winter months, the delta dries out to form a patchwork of muddy pools.

The Okavango Delta is an example of an endorheic basin, where river systems flow into a landlocked depression. The largest of all is the Caspian Sea, which is fed by the vast Volga, Europe's largest river that drains most of European Russia. The world's largest seasonal wetland, the Pantanal, is formed in an

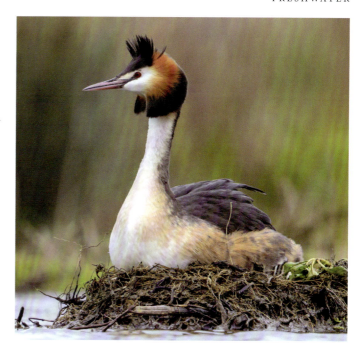

BELOW:
COASTAL GIANT SALAMANDER
This amphibian from the Pacific Northwest is 33cm (13in) long, which is big for a salamander. However, despite the name it is only small compared to the Asian giant salamanders, which are almost 180cm (6ft) long.

ABOVE:
GREAT CRESTED GREBE
This large waterbird lives in freshwater habitats where there is no strong current. It is found across Europe, Asia and North Africa. It is easily identified by the black crest and ruff around its head. They build floating nests anchored to aquatic plants.

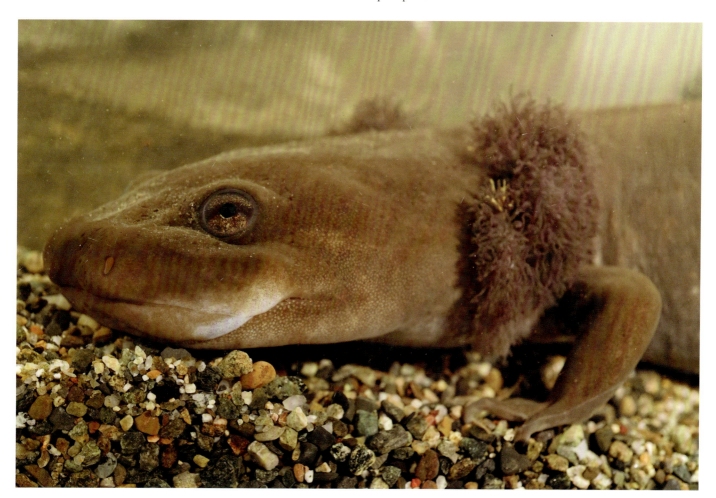

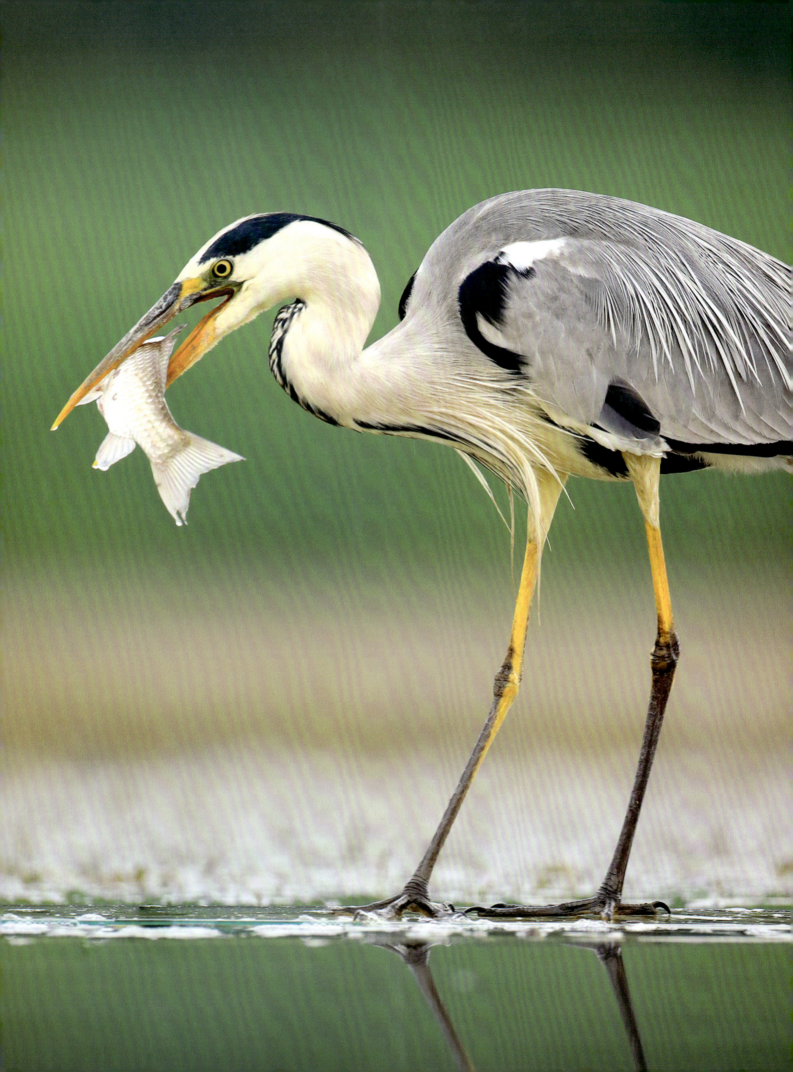

FRESHWATER

LEFT:
GREY HERON
This predatory bird is widespread across rivers, lakes and wetlands in Europe, Asia and northern Africa. They use their sharp beaks to catch fish, amphibians and small mammals. Their hunting technique is to stand still in shallow waters, waiting for prey to approach and then stalk it slowly before striking.

RIGHT:
RED-BELLIED PIRANHA
This fish is the stuff of nightmares due to its reputation for stripping prey to the bone. The fish can give a nasty bite, but the feeding frenzy associated with it would only occur if the fish were crowded into a small shallow pool – and the prey could not extricate itself.

BELOW:
NILE VALLEY
Turning a sliver of the Egyptian desert green, the Nile is the world's longest river.

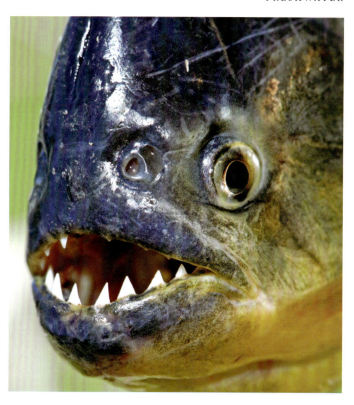
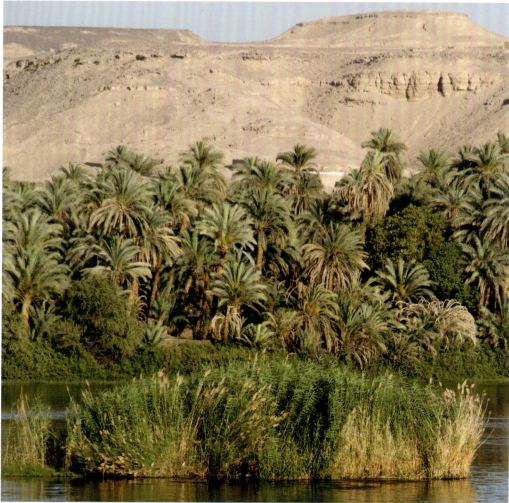

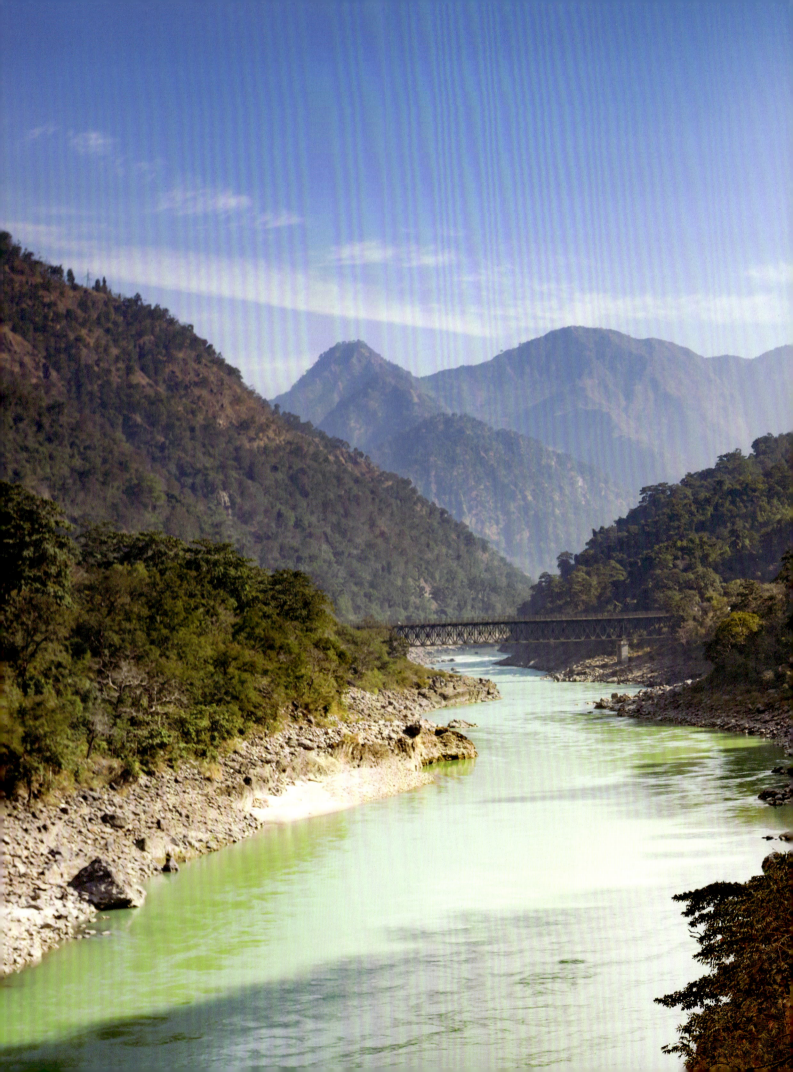

FRESHWATER

GANGES RIVER
The Ganges–Brahmaputra–Meghna system is the second-largest river on Earth by volume of discharge.

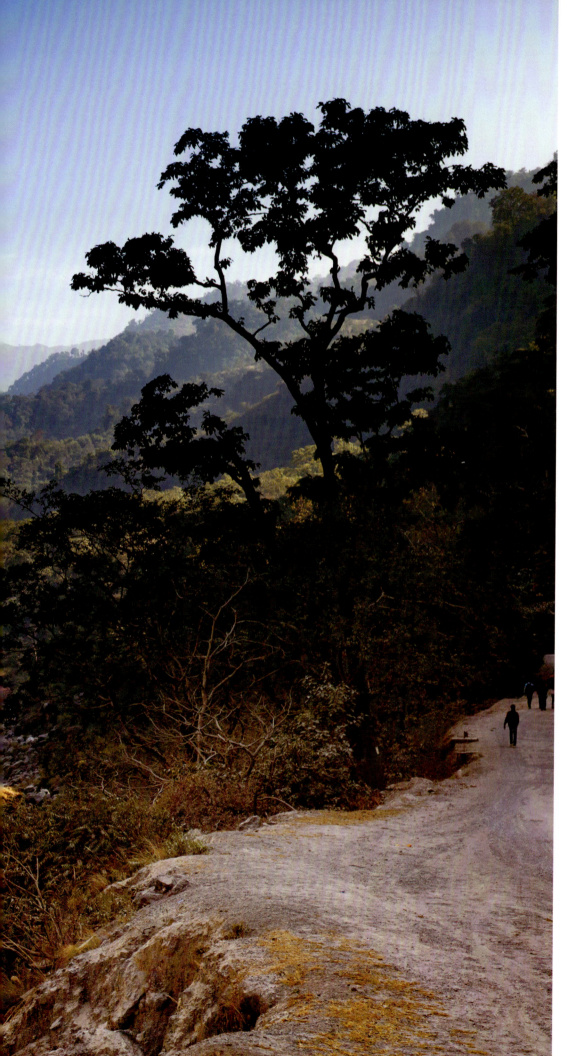

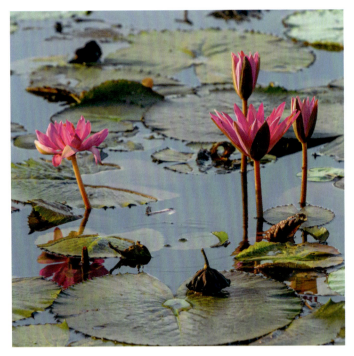

ABOVE:
WATER LILY
Pink flowers poke out from the sluggish waters of the Mekong Delta.

RIGHT:
HIPPOPOTAMUSES
A mother and calf make their way out of the river after a cooling dip.

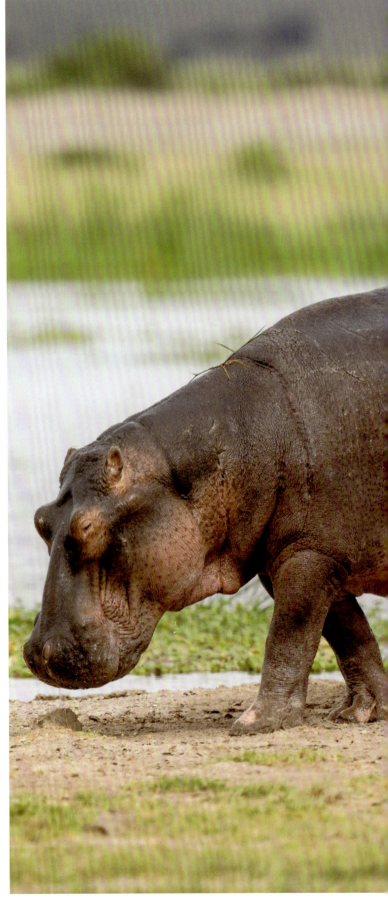

endorheic basin in southwestern Brazil. The water here has fallen as rain on the Planalto Highlands. These are uplands that form the southern boundary of the Amazon Basin, the world's largest river system by far. Water that falls on the northern flank enters the Amazon, while to the south, it flows down into a basin filled with grasslands and seasonal pools. The Pantanal is a haven from wildlife, not least giant otters, capybaras, anteaters and tapirs. The water levels rise and fall out the year, and slowly drain to the Atlantic via the River Paraguay.

MIGHTY RIVERS

There are many, many more significant wetlands and freshwater ecosystems, such as the Mississippi and Everglades in North America, the Danube in central Europe, and the Mekong Delta and Tonlé Sap River in Southeast Asia. The latter of these, in Cambodia, is the only river in the world that changes the direction of its flow – filling the Tonlé Sap Lake during the monsoon season, and emptying it during drier times of year.

Freshwater habitats are fragile as they are prone to pollution from industrial and agricultural, and even hot water discharges can upset the delicate balance. There are countless other smaller river systems all harbouring a unique wildlife community and often creating an easily accessible haven for nature among our cities or otherwise exploited lands. They are worth protecting simply because of that, as a well as a whole host of other important reasons.

FRESHWATER

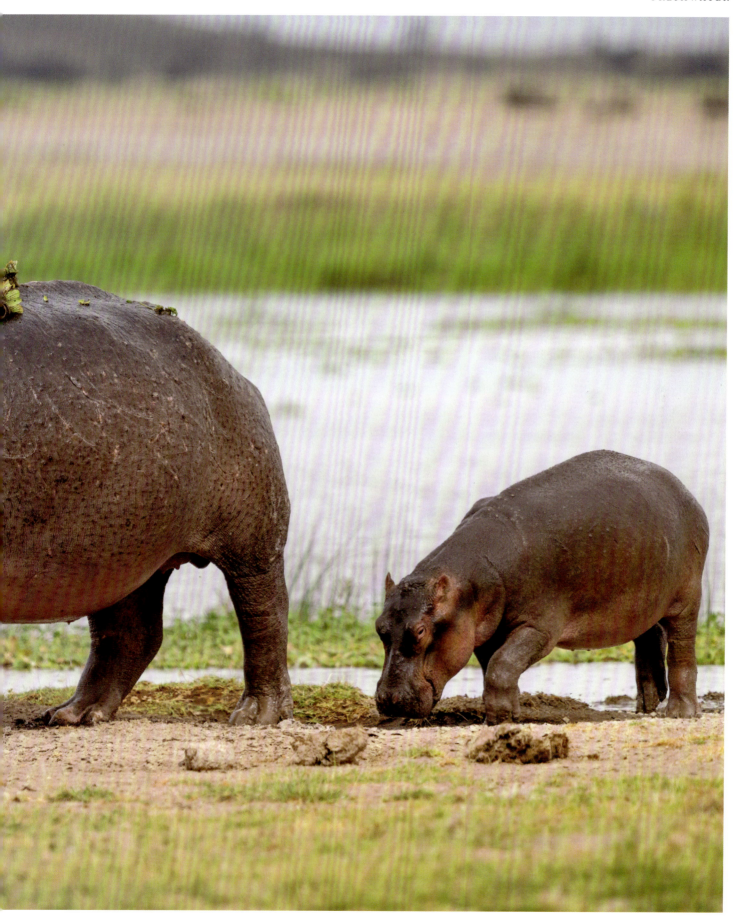

INDEX

Page numbers in *italics* denote images.

aardvark *86*
aardwolf *145*
abscission 213
abyssal plain 391, 394, 401
acacia trees *84–5*, *123*
Acers 222, *236*
Aconcagua, Andes 340
addax *162*
adder *249*, 282
Adélie penguin *300–1*, 321, 324
Africa, lakes and rivers 432, 434
African bush elephant *58*, 61, 63, *74–5*
African clawed frog *414*
African forest elephant 61, *68–9*
African wild dog *107*
agouti *26*
agriculture 67, 70, 187, 204
air plants *44–8*, 150
air pressure 335–6, 339–40
allmouth anglerfish *362*
aloe vera *135*
alpine blue *342*
alpine chough *327*
alpine marmot *258*, 282, *332*
alpine meadow 347
alpine salamander *328*
Alps 332
Altai mountains *8*
Amazon rainforest 28, *36–7*, *53–4*
Amazon river *47*, 437, 442
Amazon river dolphin *419*
American badger *181*
American bald eagle *264–5*
American beaver *262*
American bison *173*, *274–5*
American black bear *203*, *216*, 217, 228
American crocodile *368–9*
American elm *224–5*
American lobster *400*, 401
Andean condor *340–1*
Andes 332, 340
anemonefish *364–5*
anglerfish *362*, 389, 391
anoles 66
Antarctic krill *409*
Antarctica 297–8, *320–1*, 335
antelopes *102–3*, 107, 115, 118, 121

Antipodes parakeet *321*
antlers 107, 109
ants *108*, 126
apes 52, 61
aphids 222, 224
aphotic zone 381, 385–6, 389, 391, 422
aquifers 155
Arabian Desert 138–9
Arabian horned viper *142*, 143
the Arctic 258, 297–8, 318, 320
Arctic fox 309, 313, *314*
Arctic hare 313, *313*
Arctic tern *297*
Arctic willow *320*
ash keys *209*
Asian elephant 22–3
asters *182*, *190*
Atacama desert 139, *140–1*, 143
Atlantic puffin *312–13*
Atlantic rainforest 22, *30–1*
Australia 77, *100–1*, *126–7*, 139, *155*, 205, 224, 335
autumn 205, 211–13, *214–15*, 217, 252
aye-aye *71*
azure vase sponge coral *363*

Bactrian camel 164, *165*, 195
Baikal seal *426*, 427
balsam fir *266*
bamboo forest 204, *230–1*
bank vole *274*
baobabs *72*, 73
bar-headed goose *339*
barn owl *210–11*
barrel cactus 136, *137*
bateleur *110–11*
baya weaver *89*
bearded dragon *157*
beech trees *222*
beetles, fog 150
Belcher's sea snake 370, *371*
beluga whale *370*
benthic zone 419, 422
bigfin reef squid *378*
bighorn sheep *342*
bioluminescence 376, 380, 391
biomes 6, 9, *10–11*, 31, 257, 327
birds of paradise *21*
bison *184–5*, 192

black mamba *90*
black panther *66*
black rhino 77, 111
black-tailed skimmer *424–5*
black-veined parrotfish *398–9*
blackberries *226*
blackbird *255*
blackspot *402*
blooms, mass *114*, *146*
blue morpho *38*
blue-spotted salamander *268*
blue starfish *358*
blue tit *236*
blue whale *360–1*
bluebells *253*
bobcat *218*, 228, *286*
bog bilberry *276*
Bolivian ram cichlid *418*
boreal forest 256–95, *260–1*, 268, *269*
boto *419*
bottle tree *136*
bottlenose dolphin *363*
breeding 115, 118, 121
broad-leaved pondweed *419*
broadleaves 205, *205*, 208, 211–13, 217
bromeliads *15*, 44, *47*
brown algae 358, *359*, *366*, 407
brown bear 228, *276*, 278
brown hyena *170*
brown-throated sloth *53*
brown trout *415*
buffalo thorn *90*
bulrush *436*
burrowing owl 167, *180*
bush dog *60*
bushmaster snake *63*

cacti *144–5*, 157, 160
caecilians *418*
camel spider *164*
camels 150, *151*, 161, 164, *165*, 195
camouflage 66, 376, 378
candelabra tree *95*, *115*
canopy *13*, *21*, 34, *245*, *272*
Cape buffalo *81*
capybara 422, *423*
caracal *73*
caribou 292, 303, 307, 314, *315*, 324
carrion crow *224*
Caspian Sea 437
castanheira tree *62–3*
catkins *227*

cattle egret *97*
cedar waxwing *209*
cereals 186–7
Cerrado, Brazil 77, *118–19*
chacma baboon *76*
Chaco 77
chameleons 66
chamois 342, *343*
cheetah 99, *116*, 117
cherry blossom *255*
chimpanzee *52*, 61
chipmunk *204*
chlorophyll 208, 211, 213, 217, 266
cinquefoil *298*
cleaner wrasse *367*
climate
 continental 180, 183, 262
 desert 133, 135–9, 143–6
 microclimates 22, 24
 monsoon 22
 polar 297–8, 320
 prairie and steppe 175–83
 savannah 77, 81, 83
 taiga 258–9, 262
 temperate forest 203
 tropical forest 13–16, 28, 70
climate change 146, 320, 324, 408
climax habitats 31, 173, 342
cloud forest 16, *21*, *42*
clouded leopard *35*
coastal deserts 139, 143
coastal giant salamander *437*
coastline *376*, 410
common chaffinch *226*
common crane *415*
common cuckoo *253*
common death adder *130*
common marmoset *44*
common mudpuppy *427*
common musk turtle *425*
common snipe *321*
common wallaroo *82–3*
compass jellyfish *406*, 407
Congo river 432
conifers 265–6, 271–2, 342, 345
 see also taiga
continental shelf 401, 405
cookiecutter shark 386, 389
coral reefs *363*, 389, 407–8, *410–11*
Corsac fox *8*
cottongrass *329*
cougar 228, 350
countershading 376, 378

444

INDEX

coyote *186*
crayfish *430, 431*
crested oropendola *43*
crocodiles *416–17*
crucifix toad *96*
ctenophores *365, 393*
currents *143, 358, 362*
cuttlefish *376, 377*

Danube delta *425*, 442
date palm *150*
day octopus *388–9*
deciduous trees *211–13, 217*
deep-sea fish *368*
deer *63, 66, 102, 107, 109, 286, 291*
deforestation *53–4*, 204
deltas *425, 430, 437, 442*
Denali National Park, Alaska *260–1*
desert *132–71, 155*
desert rain frog *148, 162*
diel vertical migration (DVM) *381*
dingo *91, 95, 104*
diving bell spider *428–9*
dormouse *211*
Douglas fir *258, 259*
dragonfish *391*
dromedary *150, 151*
dry season *81, 83*
duchess protea *76*
dugong *410*
dung beetles *109*
dysphotic zone *376, 378, 380*

eastern bettong *220*
eastern copperhead *245*
edelweiss *347*
electric eel *424, 430, 435*
elephant grass *74*
elephant seal *405*
elephants *114*
 African bush *58*, 61, 63
 African forest *61, 68–9*
 Asian *22–3*
elk *286*
emerald tree boa *27*
emergent trees *21, 40, 42*
emperor penguin *299, 308, 309, 324*
emu *114*
epiphytes *44–8*, 150
equatorial climate *13–16*
estuaries *430*
Ethiopian wolf *346*, 347
eucalyptus trees *224*

euphotic zone *373, 401, 407, 419*
Eurasian badger *227*
Eurasian bullfinch *208*
European bison *238, 239*
European giant catfish *419, 422*
European goshawk *274*
European hedgehog *213*
European mink *281*
European rabbit *238*
European starling *232, 233*
European tree frog *212*
Everest *329, 348–9*
Everglades, Florida *416*, 442
eyes *51–2, 64*

fall *205, 211–13, 214–15, 217, 252*
farming *67, 70, 187, 204*
fennec fox *158*, 159
ferns *226*
Fiordland penguin *226*
fisher *292, 293*
fjords *320*
flowers, superblooms *114, 146*
flying fish *380*
fog *149–50*
fog beetle *149*
food chains *33, 51, 87*
forest
 bamboo *204, 230–1*
 gallery *24*
 mangrove *368, 427*
 monsoon *21–2, 48*
 montane *16, 21, 42*
 taiga *256–95*
 temperate forest *202–55*
 tropical forest *12–71, 24*
 see also rainforest
forest floor *15, 34, 38, 42–8, 70*
freshwater *412–43*
frill-necked lizard *112–13*
frogs *51, 428*
fruit bats *51*
fungi *217–18*
fur seal *381*
fynbos *97*

gallery forest *24*
Ganges river *440–1*
gannet *394*
gazelles *99, 102, 156*
geckos *32, 52, 133, 160*
gelada *350, 351*

gemsbok *121, 154,* 155
giant Antarctic isopod *394*
giant anteater *87*
giant clam *386, 387*
giant hairy scorpion *136*
giant kangaroo rat *175*
giant manta ray *394, 395*
giant moray eel *381–2*
giant otter *432*
giant panda *204, 234–5*
giant petrel *391*
giant sequoia *240–1*
giant squid *385–6*
Gibson Desert, Australia *155*
gila monster *134*
giraffe thorn *123, 164*
giraffes *84–5,* 109
glaciers *336*
glass frog *64,* 66
glasswing butterfly *70*
gliding *51*
globeflower *332*
gnus *106–7, 121–2*
Gobi Desert *135*
golden eagle *347, 350*
golden larch *290–1*
goldenrod *193*
goose barnacles *367*
gorillas *50, 58, 58,* 61, *354–5*
grain *186–7*
grasses *83, 87, 183, 186–8*
grasslands *6, 9, 126–7, 183*
 prairie and steppe *172–201*
 savannah *72–130*
greasy grouper *402*
great bustard *198*
great-crested grebe *437*
great diving beetle *412*, 413
great horned owl *272, 273*
great spider crab *383*
great spotted woodpecker *228, 229*
Great Victoria Desert, Australia *139*
greater bird of paradise *48*
greater pasque flower *7*
greater rhea *187*
green algae *370, 397*
green glass frog *32*
green iguana *26*
Grenada tree anole *41*
grey heron *438–9*
grey wolf *190, 200,* 201, *228, 307, 309, 350*
grizzly bear *276, 278, 286, 287, 294–5*

ground pangolin *128*
groundwater *155*, 413
growth rings *211*
guanaco *182*, 195
gulper eel *389*
gyrfalcon *303*

hadal zone *401*
hagfish *394*
harp seal *305*
harpy eagle *48–9*
herbivores *87, 89, 91*
herds *91*
hibernation *278, 282*
hickory fruits *237*
Himalayan jumping spider *354*
Himalayas *332*
hippopotamus *434, 442–3*
hoatzin *61*
honey fungus *218*
hooves *91, 192, 352*
horned frog *177*
horns *103, 107, 109, 118, 121*
horse chestnuts *213, 222*
horses *190, 191,* 195
hummingbirds *33*
humpback whale *396–7*
hunting *see* predation
husky *276, 277*
hydrothermal vents *408*

ice, sea *309, 318, 320*
ice sheet, Greenland *317*
icebergs *404–5*
Iceland moss *263*
impala *99, 117*
Indian rhino *111, 117*
indigo bunting *177*
inland taipan *161*
insects *228, 292, 303, 314*
irises *176, 181*
islands *374–5*
isopods *394*

jackalberry *102*
jackrabbit *201*
Jackson Hole, Wyoming *196–7*
jaguar *46, 66, 130, 131*
jaguarundi *125*
Japanese macaque *270–1*
Japanese wireweed *366*
jarrah tree *94*, 95
Javan rhino *22*
javelina *125*

INDEX

jerboa *134*
Joshua tree *162–3*

kakapo 228
kangaroos 95, 99
katydids 25
keel-billed toucan *14*
kelp 358, *359*, 407
kermode bear *203*
Kilimanjaro 335
killer whale *380*
king eider *318–19*
king penguin *317*, 324
kiwi 228
koala *83*, 224
Kodiak bear 278
krill *409*

lakes 419, 422
 African 432, 434
 prairie *176*
lanternfish *407*
leaf insects *40*
leaves 44, 48
 broad 205, 208, 211–13, 217, *248*
 needles 265–6, 271–2
lemmings *307*, 309
lemurs 52
leopard *78*, 79
leopard seal *393*
L'Hoest's monkey *328*
lianas 47
lichens *263*, 272, 286, 354
light 31, 34, 38, 373–80
lingonberry *265, 282*
lion *98*, 99, 102–3
Llanos, Venezuela 77
lobelia *345*
loganberry *281*
loggerhead turtle *400*, 401
long-eared hedgehog *170*
lynx *218*, 228, *286*

mackerel *381*
magnificent frigatebird 402, *403*
mahogany tree *67*
Malabar grouper *402*
Maldives *374–5*
mallard *413*
mandrill *20*
maned wolf *77*
mangrove forest *368, 427*
mantled howler monkey *59*
maples 222, *236*
marabou stork *96*
marine snow 389, 391
markhor *339*

marmot *258*, 282, *332*
Masai Mara, East Africa 77, 121–2
Matterhorn, Switzerland *338–9*
Mauna Kea, Hawaii 405
meadow anemone *195*
meadows, alpine 347
meerkat *105*, 126, 130
microclimates 22, 24
migration *106–7*, 121–2, 292, 381
Miles Canyon, Canada *286, 287*
mist 149–50
Mongolian steppe *178–9, 188–9*
mongooses 126
monkeys 52
monsoon forest 21–2, 48
montane forest 16, 21, 42
moose 284, 286, 288, *289*, 291
mosses 232, 236, 272, *288*, *324*
mountain arnica *331*
mountain beaver *345*
mountain goat *326, 327*, 347, 350, 352
mountain gorilla *58*, *354–5*
mountain lion 228, 350
mountains 326–55
musk ox *304*, 318, 320
mycelia 218

naked mole rat *104*
Namaqua chameleon *159*
Namaqua sandgrouse *143*
Namib Desert *132*, 133, 143
narwhal *408*
needles, leaves 265–6, 271–2
nests *43, 88–9*
New Zealand 205, 226, 228
Nile crocodile 434, *436*
Nile river 432, *439*
nival zone 352, 354
North American porcupine *242–3*
northern cardinal *237*
northern leopard frog *266*
nudibranchs *357*

oak tree 220, 222, *246–7*
oases 150, *152–3*, 155
oceanic plates 401
oceans 356–411
oil palm *56, 57*, 67

okapi *61*
Okavango delta, Botswana *430*, 437
olive ridley sea turtle *397*
orange birch bolete *280*, 281
orangutan *29*, 56
orca *380*
orchids *16, 34, 39, 59*
ornate tree-kangaroo *42*
osmoregulation 365, 416, 418
osmosis 208, 362, 365, 414
Outback, Australia 77, *100–1*

palm oil *56, 57*, 67
pampas 173, 175
 see also prairie
pampas deer *193*
Pando (quaking aspen) 218, 220
Pantanal 437, 442
peccaries 114, *125*
penguins *299, 300–1, 308, 309, 317, 318*, 321, 324
permafrost 313–14
phasmids *33*
Philippines *18–19*
photophores 391
photosynthesis 31, 208, 266, 373, 407
pika *352*, 354
pine grosbeak *268*
pine marten *263*
pipewort flowers *118–19*
pitcher plants *42, 50*
plankton 381, 389
poison dart frog *24*
polar bear *296, 310–11*, 318, 320
polar regions 296–8, 318–24
pollination 186
ponds 419
 see also lakes
pondskater *434*
Portuguese man-of-war *390–1*
prairie *172*, 172–201
prairie dog *199*
prairie feather *190*
prairie rose *201*
predation
 desert 167
 mountains 350, 352
 ocean 380–1, 386, 389, 391
 prairie and steppe 190, 192, 195

savannah 91, 95, 99
taiga 291
temperate forest 228
tundra 307, 309
pressure, water 366–8, 391
prickly pear *180*
primates 52–3, 56, 61
profundal zone 422
pronghorn *190*, 192, 195
pronking 102
Przewalski's horse 190, *191*
pufferfish *367, 386*
puma 228, 350
purple saxifrage *314*
pussy willow 227

quaking aspen 218, 220, *220–1*
quetzal *12*
quiver tree *92–3*

raccoon *235*
rainfall
 Arctic tundra 314
 desert 133, 135, 149
 prairie and steppe 175–6
 savannah 74
 taiga 259, 262
 tropical forest 13–16
rainforest 16, *16*, 34, 38
 Amazon *28, 36–7*, 53–4
 Atlantic 22, *30–1*
 see also tropical forest
rainshadows 139, 175–6
raven *281*
red-bellied piranha *439*
red-billed oxpecker *117*
red crossbill *291*
red deer *272, 286*
red-eyed tree frog *31*
red fox *238*
red grass *80*
red kangaroo *122*
red-legged seriema *120*, 121
red saltwort *9*
red-side garter snake *292*
reindeer 292, 303, 307, 314, *315, 324*
respiratory system, birds 339–40
rhinos *22, 77*, 109, 111, 114, 115, *117, 124*, 125
rhizomes 187, 218
rhododendrons *334–5*
righteye flounder *401*
ring-tailed lemur *34*
ringed seal *316*
rivers 422–42

roadrunner *138*
rock pools *410*
Rocky Mountains *332*, 352, 353
rocky shore *376*
roe deer *248*
roots *25*, 40, 161
roseate spoonbill *420*, 421
rubber tree *65*
ruminants *87*
Rwenzori National Park, Africa *335*, *344*, 345

sable (weasel) *278*
sable antelope *123*
sage grouse *194–5*
sagebrush *186*
saguaro cacti *169*
Sahara Desert *145*
Sahel *77*, *80*, 128, *129*
saiga *174–5*, 198
salps *384–5*
salt flats *170*, *171*
salt water *358*, 362, 365–6
saltwort *138*
sand *148–9*
sand cat *149*
sand dunes *132*, 133
sand goanna *128*, *167*
sandbanks *428*
sandfish *166*
sap *222*, 224
savannah *72–130*
saxaul *148*, *166*
scarlet macaw *56*
scavengers *130*
Scots pine *284*
scree *354*
sea anemones *385*
sea cows *410*
sea grass *392*, 393
sea lettuce *397*
sea otter *366*
sea slugs *357*
sea walnut *365*, *393*
seabed *401*, 405, 407–8
seas *356–411*
seasons *177*, 180
secretary bird *108*, 122
seed eating *228*
seeds *186–7*
Serengeti, Tanzania *77*, *111*
serval *103*
sexual selection *115*, 118, 121
sharks *365*
shorelines *376*, 410
short-toed snake eagle *103*
Siberia *271*, *322–3*

Siberian tiger *256*, 257
Siberian weasel *282–3*
sidewinder *139*
Simien Mountains, Ethiopia *350*
Sitka black-tailed deer *284*
sleeping, winter *278*
 see also hibernation
sloth bear *118*
slow loris *60*
Snares penguin *318*
snow *259*, 262, 272
snow gentian *304*
snow goose *316*
snow leopard *330–1*, 350, 352, 354
snowshoe hare *257*
snowy owl *299*, 309
sociable lapwing *188*
soil *148–9*, 217, 218, 321
Sonoran desert *139*, *169*
southern cassowary *38*
speckled tanager *39*
spectacled bear *332*, *333*
sperm whale *386*
spinifex grass *77*, *156*
splendid fairywren *109*
spotted hyena *81*, 130
spotted nutcracker *345*
springs *155*
spruce grouse *259*
squirrels *139*, *212*, 228, *232*
Steller's sea eagle *306*, 307
steppe *172–201*
steppe eagle *192*
steppe marmot *192*
steppe polecat *199*
stick insects *33*
stolons *187*
stomata *208*
stotting *102*
strangler fig *47–8*, *67*
streams *354*, *414*, 425
striped hermit crab *409*
striped skunk *205*
subalpine *342*, 345
succulents *160*
sugar glider *53*
sugar maple *222*, *252*
sulphur-crested cockatoo *122*
Sundarbans, Bangladesh *427*
sunlight *31*, 34, 38, 373–80
superblooms *114*, *146*
Surinam horned frog *6*
swamp milkweed *198*
swamps *421*
swim bladders *368*

taiga *256–95*, *260–1*, 268, 269
takin *331*
Taklamakan desert *135*, *143*
tap roots *161*
tapir *47*, 63
tarsier *17*
Tasmanian devil *249*
tawny frogmouth *244*, 245
tawny owl *218*, *219*
temperate climate *176–7*, 180, 183
temperate forest *202–55*
temperature *38*, 133, 135–6, 297–8, 340
termite mounds *86*, *105*, 126
thermohaline circulation *358*, 362
thorny devil *146*, *147*
thyme *160*
tidal zone *410*
Tillandsia *150*
tomato frog *14*, *421*
Tonlé Sap River *442*
transpiration *208*
tree line *284*, *285*, 345, 347
tropical deserts *136*, 138–9
tropical forest *12–71*, *24*
tropical grassland *72–130*
tropics *13–14*
tumbleweed *155*
tundra *298–314*, *302–3*
tundra wolf *298*
tunicates *378*
tusks *114*

umbrella trees *84–5*
understory *15*, 34, 38, 42–8, 70
Ural owl *222*
Urals *332*
urea *365*

vegetative growth *187*
veldt *77*
Victoria Falls *24*
vicuna *336*, 347
viscacha *183*
Volga river *437*
vultures *95*, 130, 336, *337*

Wadi Rum desert, Jordan *159*
wallcreeper *335*
walrus *324*, *325*
wapiti *278–9*, 286
warthog *79*, 114, 126
warty comb jelly *365*, *393*

water *9*, 33, 40, 42–4, 208
 pressure *366–8*, 391
 table *155*, 160–1
water lily *432–3*, *442*
waterfowl *309*
waved albatross *372–3*
weaverbirds *88–9*, 122, 126
wedge-tailed eagle *157*
weeping willow *250–1*
wels catfish *419*, *422*
Welwitschia *161*
West African Gaboon viper *44–5*
Western Cordillera *332*
western lowland gorilla *50*
western water-holding frog *167*
wetlands *97*, *416*, 418, *430*, 437, 442
whale shark *386*
wheatear *352*
white elm *224–5*
white rhinoceros *109*, 111, *124*, 125
white shark *373*
white spruce *276*, *292*
white-tailed deer *254*, 255, 266, *267*
wild boar *222*, *223*
wildebeest *106–7*, 121–2
wind *149*
winter sleeps *278*
 see also hibernation
wisent *238*, *239*
wolf's bane *331*
wolverine *288*, 291
wolves, grey *190*, *200*, 201, 228, 307, 309, 350
wombat *126*
wood bison *274–5*
wood frog *282*, 284
wood warbler *252*
woodlands *203*, *206–7*

yak *329*, 339
yellow-rumped leaf-eared mouse *339*
yellowfin tuna *378*, *379*
yellowjacket *203*
Zambezi river *432*
zebras *91*, *115*
zebrawood *79*
zombie worms *394*
zones
 mountain *340–7*, 352, 354
 ocean *358*, 373–80, 381–94
zooplankton *381*, 389

PICTURE CREDITS

Alamy: 16 bottom (Steve Taylor ARPS), 25 bottom (Arterra Picture Library), 26 bottom (All Canada Photos), 30/31 (Octavio Campos Salles), 44/45 (Fabrice Bettex Photography), 48 (Arterra Picture Library), 60 top (Pacific Imagica), 71 (Panoramic Images), 79 bottom (Christopher Scott), 80 bottom (Nsp rf), 88 (Nature Picture Library), 90 bottom (AfriPics.com), 96 bottom (Marc Anderson), 102 (Biosphoto), 105 bottom (Octavio Campos Salles), 115 bottom (imageBroker.com), 126 & 127 (Ingo Oeland), 129 (Pascal Mannaerts), 130 (BiosPhoto), 131 (Octavio Campos Salles), 135 (Yulia Babkina), 136 top (Survivalphotos), 139 top (Nature Picture Library), 144 (Dennis Frates), 148 top (imageBroker.com), 149 top (Nature Picture Library), 149 bottom (Nature Picture Library), 150 (Aleksandrs Tihonovs), 155 bottom (Michal Sikorski), 156 bottom (tamer yilmaz), 157 top (Panther Media GmbH), 157 bottom (Michal Sikorski), 170 bottom (Minden Pictures), 175 (BiosPhoto), 176 bottom (Brandon Smith), 177 bottom (Tom Uhlman), 188 (Agami Photo Agency), 190 bottom (Dominique Braud), 193 bottom (Dominique Braud), 195 (Pavel Filatov), 198 top (Michael McKinne), 205 bottom (robertharding), 206/207 (Adam Burton), 212 bottom (Arterra Picture Library), 218 (Dominique Braud), 225 (H. Mark Weidman Photography), 227 top (Aleksandrs Jemeljanovs), 230/231 (Sean Pavone), 236 bottom (Dennis Frates), 237 bottom (David Dobbs), 238 bottom (Andrew Darrington), 252 bottom (Daniel Dempster Photography), 253 top (Westend61 GmbH), 256 (Ivana Tacikova), 257 (Don Johnston), 266 top (Botany vision), 268 bottom (Michelle Gilders), 274 top (Mario Cea Sanchez), 276 top (Jennifer Booher), 278 (Nature Picture Library), 281 top left (blickwinkel), 281 bottom (Minden Pictures), 292 bottom (Nature Picture Library), 293 (Michelle Gilders), 296 (Naturfoto Online), 298 top (Henri Koskinen), 299 bottom (Nature Picture Library), 305 (imageBroker.com), 308 (Patty Tse), 309 (Arterra Picture Library), 315 (Mircea Costina), 316 bottom (Agami Photo Agency), 319 (Agami Photo Agency), 326 (Prisma by Dukas Presseagentur GmbH), 330 (blickwinkel), 331 bottom (Arterra Picture Library), 338 (Radu Rad), 340 (Darya Ufimtseva), 344 (Morgan Trimble), 345 bottom (All Canada Photos), 352 top (Brandon Smith), 356 (Room the Agency), 357 (Brandon Cole Marine Photography), 359 (Blue Planet Archive LLC), 360/361 (Nature Picture Library), 362 (Nature Picture Library), 365 (imageBroker.com), 366 top (robertharding), 370 (Andrey Nekrasov), 371 (Nature Picture Library), 373 (Media Drum World), 378 top (F1online digitale Bildagentur GmbH), 378 bottom (Helmut Corneli), 380 top (Anthony Pierce), 380 bottom & 381 top (imageBroker.com), 382 (WaterFrame), 383 bottom (Andrey Nekrasov), 384 (BiosPhoto), 386 bottom (Reinhard Dirscherl), 388 (David Fleetham), 389 (Christian Loader), 390 (Nature Picture Library), 393 top (Stocktrek Images, Inc), 394 bottom & 395 (BiosPhoto), 397 bottom (Bob Barnes), 398/399 (David Fleetham), 406 (blickwinkel), 407 top (Morgan Trimble), 408 bottom (Todd Mintz), 409 top (BiosPhoto), 409 bottom (Dmytro Pylypenko), 414 top (Nature Picture Library), 414 bottom (Arto Hakola), 416/417 (Brad Leue), 421 bottom (Mark Conlin), 422 (Minden Pictures), 424 (BiosPhoto), 425 bottom (Premium Stock Photography GmbH), 427 top (E.R. Degginger), 428/429 (blickwinkel), 439 top (imageBroker.com), 439 bottom (megapress images)

Dreamstime: 5 (Artushfoto), 6 (Matthijs Kuijpers), 7 (Afhunta), 8 top (Jana Ščigelová), 8 bottom (Dimaberkut), 10/11 (Designua), 12 & 14 top (Ondrej Prosicky), 15 top (Artur Bogacki), 16 top (Pavel Muravev), 21 bottom (Salparadis), 26 bottom (Tinglee1631), 29 (Sergey Uryadnikov), 31 right (Ondrej Prosicky), 32 top (Rinus Baak), 32 bottom (Natador), 33 top (Ondrej Prosicky), 34 top (Huy Thoai), 38 top (Mun Lok Chan), 39 bottom (Pornsatid Khumpharat), 41 (Donyanedomam), 42 bottom (Taweesak Sriwannawit), 43 (Douglas Olivares), 44 left (Vladislav Jirousek), 50 top (Siam Pukkato), 50 bottom (David Moreno Hernandez), 52 bottom (Mgkuijpers), 56 top (Tan Kian Yong), 59 top (Natador), 60 bottom (Petr Kratochvil), 61 top (Vankok), 63 right (Luis Tejo), 64 (Kikkerdirk), 65 bottom (Toon525), 66 (Alexandrebes), 67 top (Coffe72), 67 bottom (Djaka7615), 70 top (Khblack), 70 bottom (Suzbah), 74/75 (Adogslifephoto), 77 (Cathywithers), 78 (Timbooth2770), 79 top (Jonathan Pledger), 95 top (Ecophoto), 97 bottom (Andrew Allport), 99 (Herlinde Noppe), 106/107 (Antonella865), 107 bottom (Wayne Marinovich), 108 top (Fultonsphoto), 108 bottom (Claffra), 112/113 (Dwi Yulianto), 114 bottom (Miroslav Liska), 116 (Stu Porter), 118 (Ondrej Prosicky), 123 bottom (Tomas Drahos), 133 (Henkbogaard), 134 top (Jay Pierstorff), 134 bottom (Yerbolat Shadrakhov), 136 bottom (Vladimir Melnik), 137 (Ken Jacques), 145 (Cathywithers), 151 (Annemario), 152/153 (Vladimir Melnik), 154 (Ondrej Prosicky), 156 top (Rozenn Leard), 160 top (Wanouwawa123), 161 (Ken Griffiths), 162 (Rontav123), 164 bottom (Mark Baker), 165 (Pierre Jean Durieu), 168/169 (Brent Coulter), 170 top (Ecophoto), 174 (Victortyakht), 176 top (Oleg Kovtun), 180 top (Smitty411), 180 bottom (Dwight Hegel), 181 top (Zbynek Burival), 181 bottom (Holly Kuchera), 182 top (Andrey Gudkov), 184/185 (Linda Bair), 186 top (Elizabeth Cummings), 187 (Ondrej Prosicky), 190 top (Pictureguy66), 192 top (Nick Dale), 192 bottom (Wirestock), 193 top (Ondrej Prosicky), 194 (Kerry Hargrove), 198 bottom (Rudmer Zwerver), 200 (Holly Kuchera), 201 top (Pat Smith), 201 bottom (Camerashots), 203 (Roman Milert), 210 (Jmrocek), 212 bottom (Henkbogaard), 213 top (Lochstampfer), 217 (Timothy Epp), 219 (Ondrej Prosicky), 220 (Wirestock), 227 bottom (Jiri Vlach), 232 top (Ondrej Prosicky), 234/235 (Hungchungchih), 238 top (Alexandrebes), 244 (Elias Bitar), 248 bottom (Sandra Standbridge), 258 bottom (Srekap), 259 bottom (Delstudio), 264 (Nemeoo), 303 (Lukas Blazek), 317 top (Jeremy Richards), 321 bottom (Agami Photo Agency), 329 bottom (Lukaschaloupka), 334 (Ivan Kmit), 336 bottom (Kseniya Ragozina), 337 (Petrsalinger), 339 bottom (Pavel Pukhov), 341 (Wrangel), 342 top (Franky), 346 (Yulia Ryabokon), 347 top (Luca Nichetti), 351 (Artushfoto), 358 top (Aquanaut4), 363 bottom (Tim Gurney), 366 bottom (Seadam), 367 top (Photographieundmehr), 372 (Steve Allen), 376 (Kontrymphoto), 383 top (Slh2010), 391 (Ondrej Prosicky), 392 (Seadam), 393 bottom (Irina Kozhemyakina), 401 (Jeremy Brown), 404/405 (Helena Bilkova), 410 (Berndneeser), 412 (Valeronio), 415 top (Zagor), 418 top (Mikhailg), 420 (Harry Collins), 421 top (Matthijs Kuijpers), 430 bottom (Ondrej Prosicky), 432 left (Pixattitude), 432/433 (Znm), 434 (Leo Malsam), 436 top (Wcpmedia), 437 top (Sander Meertins), 437 bottom (Henk Wallays), 438 (Ondrej Prosicky)

Getty Images: 178/179 (Anton Petrus), 188/189 (Francesco Vaninetti Photo), 402 (Alexis Rosenfeld) dd
Public Domain: 358 bottom (K. Aainsqatsi), 427 bottom (NASA/Jesse Allen)

Shutterstock: 9 (T.Schofield), 13 (Atthapon Niyom), 14 bottom (Krisda Ponchaipulttawee), 15 bottom (Nok Lek Travel Lifestyle), 17 (Ondrej Prosicky), 18/19 (Martin Pelanek), 20 (Pagina), 21 top (Ryan Boedi), 22 (creative photographer 11), 23 (Oriol Querol), 24 top (Roger de la Harpe), 24 bottom (Dirk Ercken), 25 top (Jordi Jornet), 26 top (Martin Pelanek), 27 (Piotr Przybysiak), 28 (Photo Spirit), 33 bottom (Mark Brandon), 34 bottom (Martin Pelanek), 35 (Amitrane), 36/37 (Viagem Com Cafe), 38 top (Sem Lingerak), 38 bottom (mujiri), 40 (anek cg), 42 top (Jane Rix), 46 (Bildagentur Zoonar GmbH), 47 top (Signature Message), 47 bottom (Lostwithsony), 49 (Wirestock Creators), 51 top (Anton Watman), 52 top (Sergey Uryadnikov), 53 top (Anom Harya), 53 bottom (Milan Zygmunt), 54/55 (Paralaxis), 56 bottom (Ondrej Prosicky), 57 (Jonas Gruhlke), 58 (Martin Prochazkacz), 59 bottom (Milan Zygmunt), 61 bottom (Vladimir Turkenich), 62/63 (Paralaxis), 65 top (FotoRequest), 68/69 (Roger de la Harpe), 72 (Framalicious), 73 (Diego Grandi), 74 (Ifan Subiyanto), 76 top (Paco Como), 76 bottom (Danny Schwarz), 80 top (Harmattan Toujours), 81 top (Abdelrahman Hassanein), 81 bottom (Ahmed Abubasel), 82 (Martin Pelanek), 83 (worldswildlifewonders), 84/85 (Marc Stephan), 86 top (Geno EJ Sajko Photography), 86 bottom (Serge Goujon), 87 (Ondrej Prosicky), 89 (Rajh Photography), 90 top (NickEvansKzn), 91 (Earth And More), 92/93 (JR Gale), 94 (alybaba), 95 bottom (Oleg Znamenskiy), 96 top (Andrzej Kubik), 97 top (Chris Ison), 98 (Maggy Meyer), 100/101 (Hans Wismeijer), 103 top (Coulanges), 103 bottom (Howard Klaaste), 104 top (Neil Bromhall), 104 bottom (Hyserb), 105 bottom (Lars Royal), 109 top (Boris Edelmann), 109 bottom (Martin Pelanek), 110 (Paco Como), 111 (dktirol), 114 top (EcoPrint), 115 bottom (Sunny Photos), 117 top (Bruce Crossey), 117 bottom (simantaKphotos), 119 (Kelly Richter), 120 (Robert Limouze), 121 (Travelvolo), 122 top (fergug), 122 bottom (Martin Pelanek), 123 top (Artush), 124 (Gunter Nuyts), 125 top (Diego Grandi), 125 bottom (Oleg Kovtun Hydrobio), 128 top (Chris Watson), 128 bottom (Vladimir Turkenich), 132 (Vladimir Lutsenko), 138 top (Olga V), 138 bottom (MelaniWright), 139 bottom (Charles T. Peden), 140/141 (PositiveTravelArt), 142 (Sheril Kannoth), 143 top (AZ Outdoor Photography), 143 bottom (rweisswald), 146 top (Kiwisoul), 146 bottom (Danita Delimont), 147 (Alessandro Bruno Varanini), 148 bottom (Lauren Suryanata), 155 top (Wirestock Creators), 158 (Martin Mecnarowski), 159 top (Bildagentur Zoonar GmbH), 159 bottom (Chantelle Bosch), 160 bottom (Ray Karyman), 163 (imageBroker.com), 164 top (Dmitry Fch), 166 top (Kurit afshen), 166 bottom (Poliorketes), 167 (Little Adventures), 171 (Stephen Bridger), 172 (badboydt7), 173 (Little Vignettes Photo), 177 top (Vaclav Sebek), 182 bottom (Alex Manders), 183 top (James Gabbert), 183 (Mikhail Blajenov), 186 top (Thi Nhu Quynh Nguyen), 191 (Alexey Kharitonov), 196/197 (Rolf 52), 199 top (Georgi Baird), 199 bottom (aaltair), 202 (Wirestock Creators), 204 (Jay Himes Photography), 205 top (Lillac), 208 (gergosz), 209 top (Mircea Costina), 209 bottom (Flower Garden), 211 (Coulanges), 213 bottom (Serenity Images23), 214/215 (Engel Ching), 216 (Agnieszka Bacal), 220/221 (Marieke Peche), 222 top (Vaclav Matous), 222 bottom (LFRabanedo), 223 (Erik Mandre), 224 (Rudmer Zwerver), 226 top (Mariia Zarai), 226 bottom (Jaz Studio), 229 (Dronenation), 232 bottom (Nicholas J Klein), 233 (Behramkhan03), 235 (Leka Sergeeva), 236 top (Mariia Zarai), 237 top (Bonnie Taylor Barry), 239 (Lima 84), 240/241 (EduBFoto), 242/243 (LarryDallaire), 245 top (vadviz studio), 245 bottom (cosminmicoara), 246/247 (Pierre Leclerc), 248 top (Branislav Cerven), 249 top (Vaclav Matous), 249 bottom (Petr Muckstein), 250/251 (Sam Tanno), 252 top (gergosz), 253 bottom (Nick Edge), 254 ((David Whidborne), 255 top (vveronka), 255 bottom (Albert Beukhof), 258 top (Wirestock Creators), 259 top (LarryDallaire), 260/261 (Zhang Jun), 262 (Ghost Bear), 263 top (David OBrien), 263 bottom (Alexander Varbenov), 265 (Nata Naumovec), 266 top (Paul Reeves Photography), 267 (cwieders), 268 top (Aline Bedard), 269 (ArtBBNV), 270 (Gudkov Andrey), 271 (Nikitin Victor), 272 (slowmotiongli), 273 (FotoRequest), 274 bottom (Monika Surzin), 274/275 (Jukka Jantunen), 276 bottom (Nata Naumovec), 277 (CherylRamalho), 279 (Tom Reichner), 280 (Kaisa Hovilainen), 281 top right (Ian Peter Morton), 282 (Kersti Lindstrom), 283 (Martin Mecnarowski), 284 top (Maksym Bezruchko), 284 bottom (Laura Hedien), 285 (Mikadun), 286 top (Ondrej Prosicky), 286 bottom (Geartooth Productions), 287 top (Scalia Media), 287 bottom (Capitan Crizelini), 288 top (HHelene), 288 bottom (AB Photographie), 289 (Petr Salinger), 290 (Galyna Andrushko), 291 (Dark Side), 292 top (Nahhana), 294/295 (NaturesMomentsuk), 297 (Nick Pecker), 298 bottom (Martin Pelanek), 299 top (Jim Cumming), 300/301 (slowmotiongli), 302 (Grigorii Pisotsckii), 304 top (Bjorn H Stuedal), 304 bottom (Wiert nieuman), 306 (makieni), 307 top (IhorM), 307 bottom (Nick Pecker), 310/311 (Craig Durling), 312 (ibrahim kavus), 313 (Nick Dale Photo), 314 top (Ingrid Maasik), 314 bottom (Alexey Seafarer), 316 top (Cavan Images), 317 bottom (Daphne Nilsson), 318 (Risto Raunio), 320 top (Steve Allen), 320 bottom (Andrei Stepanov), 321 top (Rudmer Zwerver), 322/323 (Nikitin Victor), 324 top (kuenlin), 324 bottom (ginger polina bublik), 325 (Zaruba Ondrej), 327 (Mario Krpan), 328 top (Richard Juilliart), 328 bottom (HWall), 329 top (Pisit Kitireungsang), 331 top (Janusz Pienkowski), 332 top (Dario Pautasso), 332 bottom (Brum), 333 (FotoRequest), 335 (aaltair), 336 top (schame), 339 top (Dark Side), 342 bottom (Psps), 343 (StockPhotoAstur), 345 top left (Nikolai Link), 345 top right (Danita Delimont), 347 bottom (Kluciar Ivan), 348/349 (Daniel Prudek), 350 (Framalicious), 352 bottom (gergosz), 353 (Colin D. Young), 354 (Nikolai Link), 355 (Jane Rix), 363 top (Tropicalens), 364 (Kim Briers), 367 bottom (blue sea.cz), 368 left (Richard Whitcombe), 368/369 (Alexander Machulskiy), 370 bottom (Damsea), 374/375 (icemanphotos), 377 (Rui Palma), 379 (Jsegalexplore), 381 bottom (Smit), 385 (Rls Photo), 386 top (Wild Skin), 387 (kai egan), 394 top (inProgressImaging), 396 (Gudkov Andrey), 397 top (Chimera Visuals), 400 top (Rls Photo), 400 bottom (David Havel), 402 (John Back), 403 (BlueBarronPhoto), 405 right (Randy Runtsch), 407 bottom (divedog), 408 top (GemsTravelGems), 411 (P. Heitmann), 413 (Robert Adami), 415 bottom (Jaroslaw Kochnio), 416 left (TasfotoNL), 418 bottom (reptiles4all), 419 top (CinemaPhoto), 419 bottom (juerginho), 423 (Ondrej Prosicky), 425 top (aaltair), 426 (Alexey Kharitonov), 428 left (Artur Bociarski), 430 top (Snapsy), 431 top (Martin Prochazkacz), 435 (Danny Ye), 436 bottom (Ian Peter Morton), 440/441 (Roman Sulla), 442 left (CravenA), 442/443 (Zaruba Ondrej)